# ETERNAL EGYPT

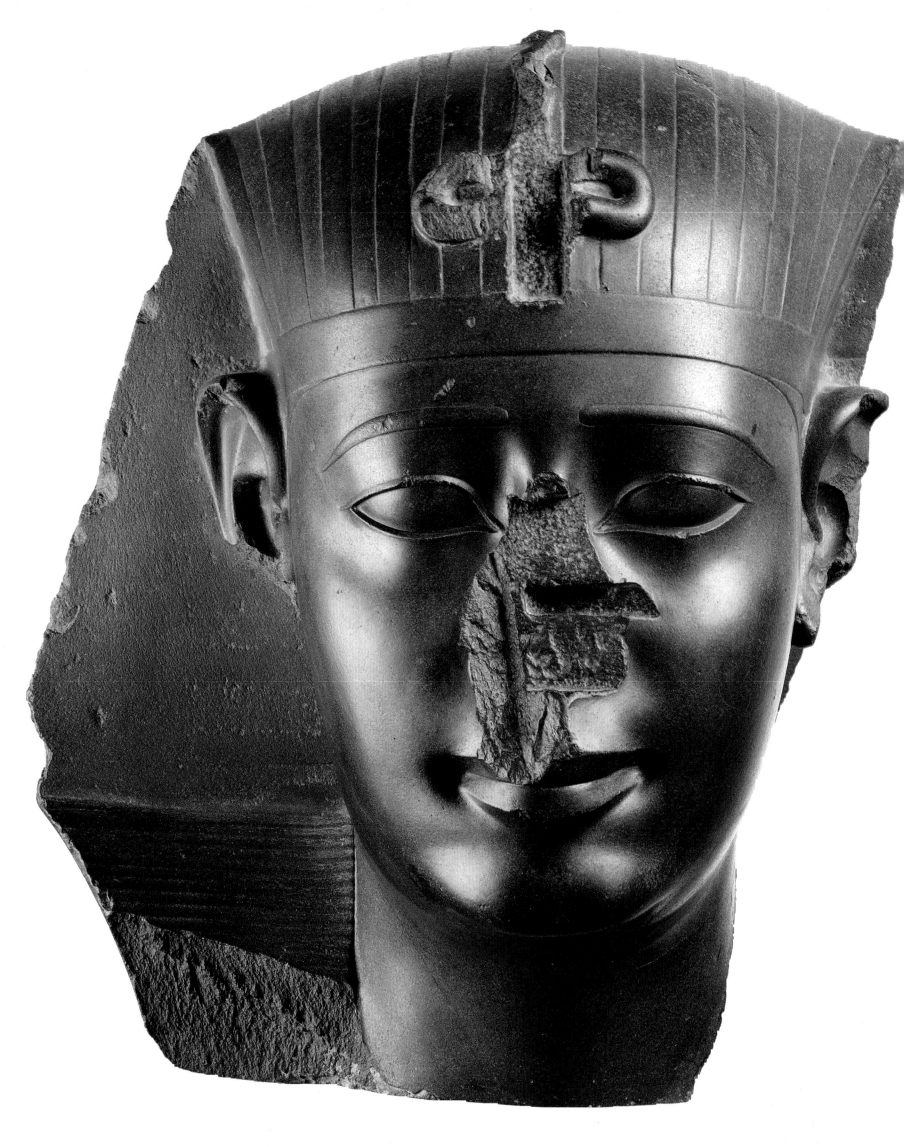

# ETERNAL EGYPT

## MASTERWORKS OF ANCIENT ART
## FROM THE BRITISH MUSEUM

Edna R. Russmann

Preface by W. V. Davies

Essays by T.G. H. James and Edna R. Russmann

Entries by Carol Andrews, Dorothea Arnold,
Edward Bleiberg, Marianne Eaton-Krauss, Biri Fay,
Richard A. Fazzini, Marsha Hill, T.G.H. James, Gay Robins,
Edna R. Russmann, James F. Romano, Hourig Sourouzian,
Nigel Strudwick, and John Taylor

University of California Press
in association with the
American Federation of Arts

This catalogue has been published in conjunction with *Eternal Egypt: Masterworks of Ancient Art from the British Museum*, an exhibition organized by the American Federation of Arts and the British Museum.

*Ford Motor Company*

The exhibition and its national tour are made possible by Ford Motor Company.

Additional support is provided by the Benefactors Circle of the AFA.

The American Federation of Arts is a nonprofit art museum service organization that provides traveling art exhibitions and educational, professional, and technical support programs developed in collaboration with the museum community. Through these programs, the AFA seeks to strengthen the ability of museums to enrich the public's experience and understanding of art.

First published in 2001 by the British Museum Press, a division of the British Museum Company Ltd, 46 Bloomsbury Street, London WC1B 3QQ, England, and the American Federation of Arts, 41 East 65th Street, New York, New York 10021.

University of California Press
Berkeley and Los Angeles, California
Published in association with the American Federation of Arts by arrangement with the British Museum Press.

Library of Congress Cataloguing-in-Publication Data
Eternal Egypt : masterworks of ancient art from the British Museum / preface by W.V. Davies, Edna R. Russmann; essays by T.G.H James and Edna R. Russmann; entries by Carol Andrews ... [et. al.].
  p. cm.
  Published in connection with a traveling exhibition.
  Includes bibliographical references and index.
  ISBN 1-885444-19-2 (museum paper edition)
  ISBN 0-520-23086-8 (trade paper)
  ISBN 0-520-23082-5 (trade cloth)
  1. Art, Egyptian—Exhibitions. 2. Art, Ancient—Egypt—Exhibitions.
3. Egypt—Antiquities—Exhibitions. 4. Art—England—London—Exhibitions.
5. British Museum—Exhibitions. I. James, T.G.H. (Thomas Garnet Henry)
II. Russmann, Edna R. III. British Museum.
N5350 .E87 2001
709' .32'07442142—dc21
                                        00-067590

Unless otherwise indicated, photographs are supplied by the owners of the works and are reproduced by their permission.

Publication Coordinator, BMP: Coralie Hepburn
Publication Coordinator, AFA: Michaelyn Mitchell
Book Design: Carroll Associates
Printed in Spain by Grafos S.A. Barcelona

Frontispiece: *Head of a King*. Late Period, Thirtieth Dynasty (cat. no. 135). Page 6: *Detail of Papyrus with Satirical Vignettes*. New Kingdom, Nineteenth or Twentieth Dynasty (cat. no. 78).

Exhibition Itinerary

The Toledo Museum of Art
Toledo, Ohio
March 1–May 27, 2001

Wonders, Memphis International Culture Series
Memphis, Tennessee
June 28–October 21, 2001

Brooklyn Museum of Art
Brooklyn, New York
November 23, 2001–February 24, 2002

Nelson-Atkins Museum of Art
Kansas City, Missouri
April 12–July 7, 2002

The Fine Arts Museum of San Francisco
California Palace of the Legion of Honor
August 10–November 3, 2002

The Minneapolis Institute of Art
Minneapolis, Minnesota
December 22, 2002–March 16, 2003

The Field Museum
Chicago, Illinois
April 26–August 10, 2003

Walters Art Museum
Baltimore, Maryland
September 21, 2003–January 4, 2004

# Sponsor's Statement

Among the many styles and periods, the art of Egypt is unique in its ability to inspire people of all ages and backgrounds. The majesty of the Pyramids, the mysteries of the ancient tombs, and the magic of Egyptian decorative arts touch people around the world.

In elementary schools throughout the United States, Egyptian culture is a foundation for the early study of history, written communications, art, archaeology, and social studies. In London's British Museum, it is the foundation for one of the world's most outstanding art collections. *Eternal Egypt* crosses the boundaries of time, geography, and culture to bring the masterpieces of the British Museum's collection to eight American cities for the first time.

Ford Motor Company is committed to the preservation of our global heritage and the education and enjoyment that come from experiencing extraordinary cultures. We salute the British Museum, the American Federation of Arts, and the eight museums participating in this historic exhibition.

*William Clay Ford, Jr., Chairman, Ford Motor Company*

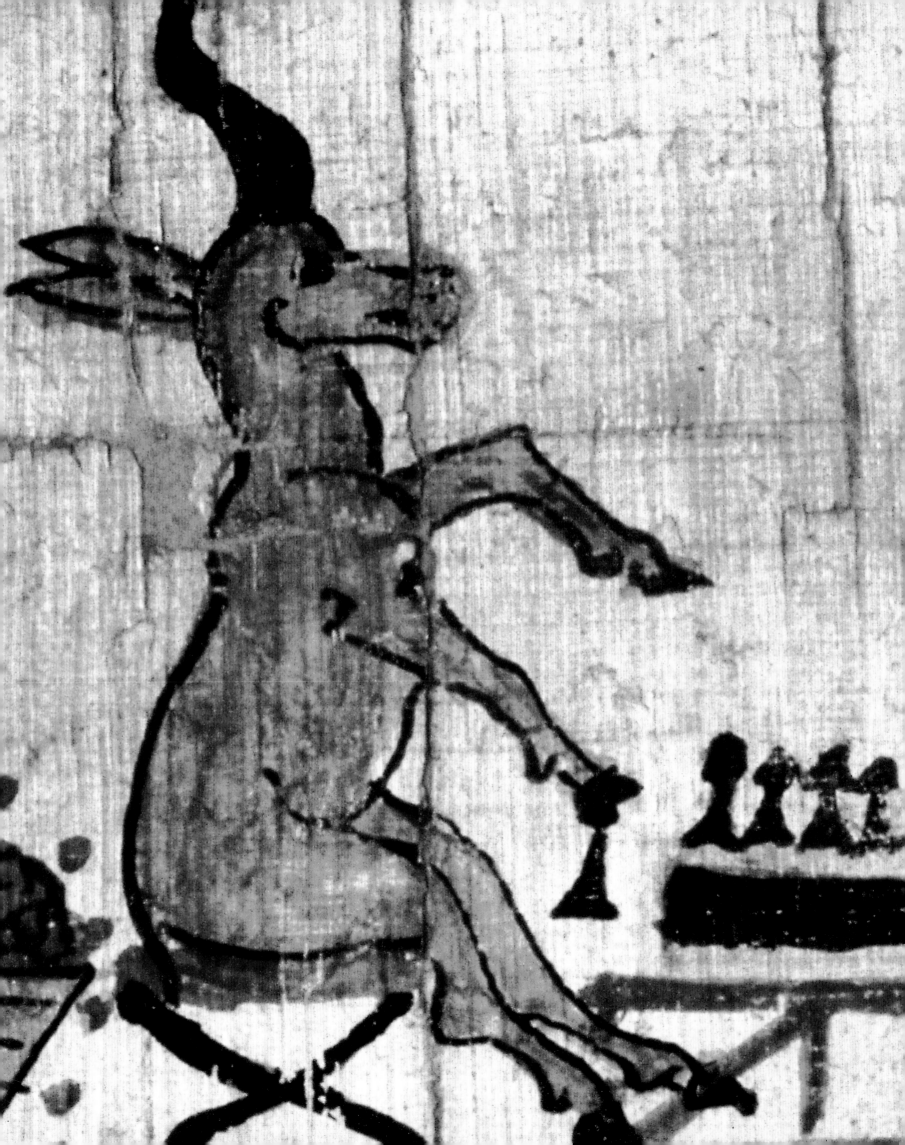

# Contents

# Preface

*Eternal Egypt: Masterworks of Ancient Art from the British Museum* is one of the greatest loan exhibitions ever to have been mounted from the collections of the British Museum. Designed to illustrate the development and achievements of ancient Egyptian art over a period of three thousand years and more, it consists of 144 representative works of diverse type, including sculpture, relief, papyri, ostraca, jewelry, cosmetic objects, and items of funerary equipment. Almost all have been drawn from the Museum's permanent exhibitions, many are among the finest examples of their kind to have survived from antiquity.

It has been possible to loan them only because of current rebuilding work in the Museum, which has necessitated their temporary removal from display. The Museum is delighted at the opportunity, so well exploited by the exhibition, to take its collections to new and interested audiences. Over the next three years, the show will travel to eight venues in the United States, a country with which the British Museum enjoys increasingly strong and productive links.

The existence of the exhibition is due largely to the initiative of Thomas Padon and Suzanne Ramljak of the American Federation of Arts, who have displayed great energy and tenacity in pursuing their goal and have played a vital coordinating role throughout. We have enjoyed working with them and other members of the AFA team enormously.

The exhibition's curator, specifically requested by the British Museum, is Edna R. Russmann of the Brooklyn Museum of Art, New York, who has collaborated closely with the staff of this department, and in particular Nigel Strudwick, in selecting and preparing the content, a process to which the British Museum's Conservation Department has also made an invaluable contribution. Dr. Russmann, one of the world's leading authorities on ancient Egyptian art, is the editor and main author of this splendid catalogue, which includes contributions by a number of other expert colleagues. As well as serving as an accessible introduction to Egyptian art and to the British Museum's collections, the volume, as we had intended, marks a substantial step forward in scholarly

understanding of its subjects, embodying the results of the very latest research and containing many new and original insights and observations. We acknowledge the skills and cooperation of the Museum's Photographic Department and of the British Museum Press in bringing it to such handsome fruition.

*Eternal Egypt* is no ordinary exhibition. A choice collection of highly important pieces, thoughtfully assembled and beautifully displayed, it presents the visitor with a remarkable opportunity to experience, explore, and encompass the creative genius of the world's most extraordinary civilization.

*W. V. Davies, Keeper, Department of Egyptian Antiquities, The British Museum*

# Acknowledgments

As befits the cultural achievement of ancient Egypt, this exhibition was a monumental undertaking requiring the efforts of countless individuals and institutions. The litany of thanks certainly begins with the British Museum—in particular R. G. W. Anderson, director, and Suzanna Taverne, managing director—without whose generous cooperation this exhibition would not be possible. Foremost, we are grateful to W. V. Davies, keeper of Egyptian antiquities, for his willingness and foresight to lend these treasures, many of which have never traveled from the British Museum, to be part of this historic exhibition. The entire staff of the Museum's Egyptian Department was essential to the success of this undertaking, in particular Nigel Strudwick, who was instrumental in coordinating the logistics on behalf of the department. We would also like to acknowledge T. G. H. James, the Museum's former keeper of Egyptian antiquities, for contributing a lively and useful history of the British Museum's Egyptian collections to this catalogue.

The vision for this exhibition is due entirely to the guest curator, Edna R. Russmann, curator in the Department of Egyptian, Classical, and Ancient Middle Eastern Art at the Brooklyn Museum of Art, whose keen eye and superb scholarship has insured the exceptional caliber of the exhibition and this publication. We would also like to acknowledge the many scholars who contributed entries to this catalogue and helped to further illuminate the importance of the objects on view: Carol Andrews, Dorothea Arnold, Edward Bleiberg, Marianne Eaton-Krauss, Biri Fay, Richard A. Fazzini, Marsha Hill, T. G. H. James, Gay Robins, James F. Romano, Hourig Sourouzian, Nigel Strudwick, and John Taylor.

*Eternal Egypt* is among the largest and most ambitious exhibitions in the AFA's ninety-year history and has required years of dedication on the part of the AFA staff. Recognition goes first and foremost to Thomas Padon, director of exhibitions, who has developed and skillfully overseen this unprecedented exhibition. Other staff members who share a great deal of the credit for the success of this project are Suzanne Ramljak, curator of exhibitions, who expertly guided every aspect of the project; Michaelyn Mitchell, head of publications, who in tandem with the British Museum Press, skillfully

coordinated the production of this impressive book; and Diane Rosenblum, registrar, who handled the daunting challenges of preparing and touring the exhibition with exceptional ease. I also wish to recognize Donna Gustafson, chief curator, who played an important role in the complex negotiations and contracts associated with the exhibition; Kathleen Flynn, head registrar, who oversaw the safe travel of the artworks; Meg Calvert, curatorial assistant, who meticulously coordinated countless project details; Beth Huseman, editorial assistant, who has given her attention to innumerable details on the publication; Lisbeth Mark, director of communications, and Stephanie Ruggerio, communications associate, who oversaw the promotion and publicity for the project; Deborah Schwartz, education consultant, who developed the educational materials accompanying the exhibition; Erin Tohill, registrar assistant, who ably assisted the registrars; and Doris Palca for her invaluable help in obtaining permissions for the publication.

Warm thanks go to our collaborators at the British Museum Press, Coralie Hepburn and Emma Way, with whom we have forged a rewarding collaboration to meet the challenges of this publication. We would like to also acknowledge Exhibition Design Associates who developed and implemented the exhibition design. A special thanks is due the venues on the tour—the Toledo Museum of Art; Wonders, Memphis International Culture Series; the Brooklyn Museum of Art; the Nelson-Atkins Museum of Art, Kansas City; the Fine Arts Museum of San Francisco; the Minneapolis Institute of Art; the Field Museum, Chicago; and the Walters Art Museum, Baltimore—for graciously hosting this exhibition and sharing the grandeur of ancient Egypt with their respective communities.

I would also like to acknowledge the important role of Serena Rattazzi, the AFA's former director. Without her remarkable leadership and support this project would not have been possible.

Finally, for the generosity they have extended toward *Eternal Egypt*, our gratitude goes to the Ford Motor Company. We are proud to have now twice been the recipient of Ford's outstanding patronage of the arts. We also wish to express our sincere thanks to the Benefactors Circle of the AFA for their role in the realization of this splendid exhibition.

*Julia Brown, Director, American Federation of Arts*

# Acknowledgments

Years ago, as a graduate student doing research in New York, I found that I needed to examine a statuette in the British Museum. I made my request to T. G. H. James, who was then keeper of Egyptian antiquities and known to me only as a foremost British Egyptologist. When I reached London and presented myself at the British Museum, I was ushered into a study room in the department where I found the figure, temporarily removed from its case in the galleries, waiting for me. I saw what I needed to see and learned what I needed to know. What I remember most vividly, though, is going to the gallery afterward, before the figure could be replaced in its case, to see the "temporarily removed" sign put there just for me. It was a tiny epiphany, but it helped to seal my decision to become a curator.

Since then, I have often enjoyed the company and the professional courtesy of Harry James and of his successor as keeper, Vivian Davies. It was Vivian who encouraged initial discussions of this project, who suggested that I might be interested in working on it, and whose commitment at every stage has made it so extraordinary an event. I am deeply grateful to him. Having taken on the infinitely complex task of organizing and administering this major project, Thomas Padon and all the staff at the American Federation of Arts have provided unflagging encouragement and support. In particular, I would like to recognize Suzanne Ramljak, who coordinated the entire exhibition, and Michaelyn Mitchell, who skillfully oversaw the production of the catalogue.

I thank T. G. H. James for drawing on his unparalleled knowledge of the history of the Department of Egyptian Antiquities to write an essay for this catalogue, as well as several entries. Thanks also to the other colleagues—Carol Andrews, Dorothea Arnold, Edward Bleiberg, Marianne Eaton-Krauss, Biri Fay, Richard A. Fazzini, Marsha Hill, Gay Robins, James F. Romano, Hourig Sourouzian, Nigel Strudwick, and John Taylor—who consented to write about objects on which they have special expertise. I suggest the reader watch for their initialed entries, which provide not only the results of new and ongoing research but also different approaches to the subject than mine, and different points of view.

In the course of preparing the exhibition and this catalogue, I have received help from virtually everyone in the British Museum's Department of Egyptian Antiquities. John Taylor and Richard Parkinson, in particular, have helped to make possible the loan of funerary material and papyri in their care. Most of all, my thanks go to Nigel Strudwick, who, as liaison with New York on this project, helped to prevent or solve many problems and patiently answered my constant requests for information.

I am grateful to my colleagues in the Department of Egyptian, Classical, and Ancient Middle Eastern Art at the Brooklyn Museum of Art: Richard A. Fazzini, chairman of the Department, James F. Romano and Edward Bleiberg, Paul O'Rourke and Madeleine Cody, for their advice, cooperation, and, on occasion, forbearance. Without the unparalleled resources of the Brooklyn Museum of Art's Wilbour Library of Egyptology, it would have been impossible to write this catalogue; I thank Diane Bergman, the former Wilbour librarian, and Mary Gow for all their help.

Finally, to Meg Calvert, curatorial assistant at the American Federation of Arts, who, in addition to handling innumerable details with cheerful efficiency, has also transcribed most of this work into the computer, a very special thanks.

*Edna R. Russmann*

# Contributors to the Catalogue

**Carol Andrews**
Former Assistant Keeper, Department of Egyptian
Antiquities, The British Museum

**Dorothea Arnold**
Lila Acheson Wallace Curator in Charge, Department of
Egyptian Art, The Metropolitan Museum of Art, New York

**Edward Bleiberg**
Associate Curator, Department of Egyptian, Classical, and
Ancient Middle Eastern Art, The Brooklyn Museum of Art

**Marianne Eaton-Krauss**
Research Associate, Berlin–Brandenburg Academy of
Science and Humanities, Berlin

**Biri Fay**
Independent scholar specializing in Egyptology, Berlin

**Richard A. Fazzini**
Chairman, Department of Egyptian, Classical, and Ancient
Middle Eastern Art, The Brooklyn Museum of Art

**Marsha Hill**
Associate Curator, Department of Egyptian Art,
The Metropolitan Museum of Art, New York

**T. G. H. James**
Former Keeper, Department of Egyptian Antiquities,
The British Museum

**Gay Robins**
Professor, Art History Department,
Emory University, Atlanta, Georgia

**James F. Romano**
Curator, Department of Egyptian, Classical, and Ancient
Middle Eastern Art, The Brooklyn Museum of Art

**Edna R. Russmann**
Curator, Department of Egyptian, Classical, and Ancient
Middle Eastern Art, The Brooklyn Museum of Art

**Hourig Sourouzian**
Art historian and archaeologist, German Archaeological
Institute, Cairo

**Nigel Strudwick**
Assistant Keeper, Department of Egyptian Antiquities,
The British Museum

**John Taylor**
Assistant Keeper, Department of Egyptian Antiquities,
The British Museum

*The author of each catalogue entry is identified by his or her
initials.*

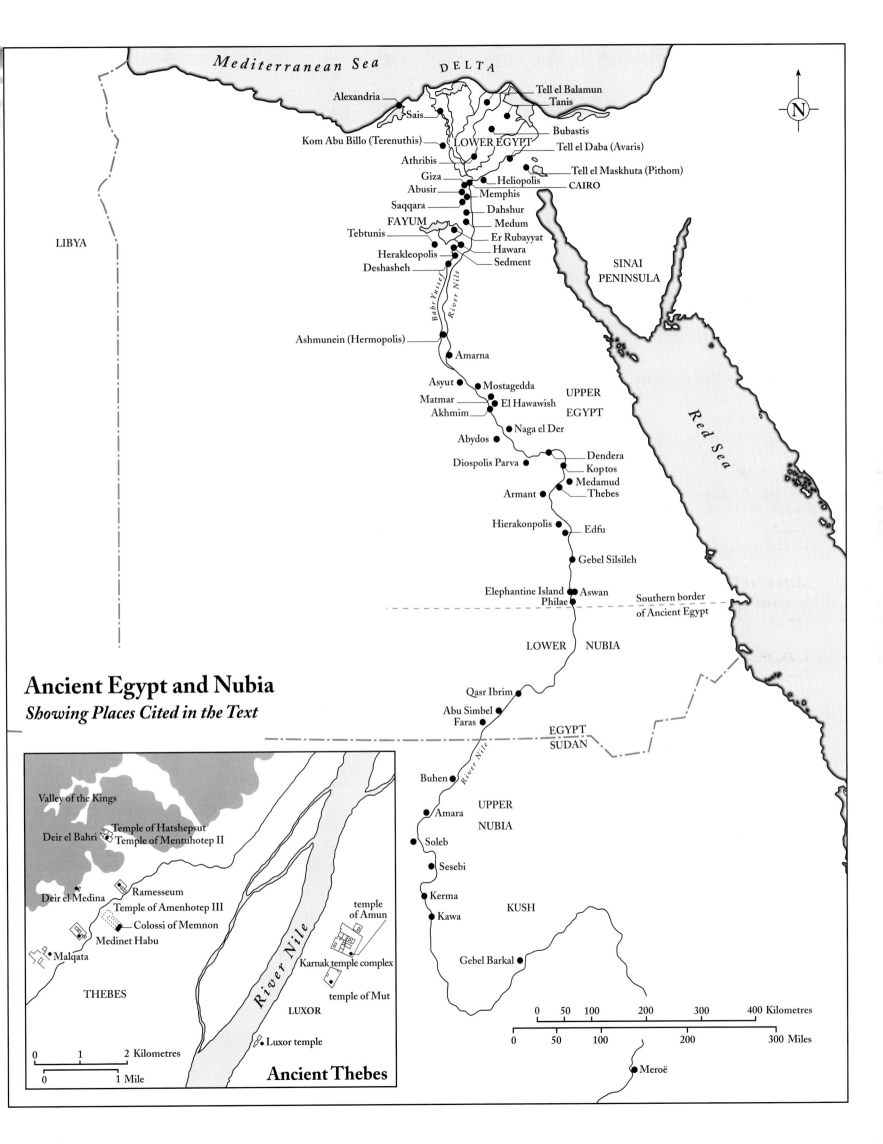

Mediterranean Sea

DELTA

Alexandria
Sais
Kom Abu Billo (Terenuthis)
Athribis
LOWER EGYPT
Tell el Balamun
Tanis
Bubastis
Tell el Daba (Avaris)
Tell el Maskhuta (Pithom)
Giza
Abusir
Heliopolis
CAIRO
Memphis
Saqqara
Dahshur
FAYUM
Medum
Tebtunis
Er Rubayyat
Hawara
Herakleopolis
Sedment
Deshasheh

LIBYA

SINAI
PENINSULA

Bahr Yussef
River Nile

Ashmunein (Hermopolis)
Amarna

Asyut
Mostagedda
Matmar
El Hawawish
Akhmim
Naga el Der
Abydos
Diospolis Parva
Dendera
Koptos
Medamud
Thebes
Armant
Hierakonpolis
Edfu
Gebel Silsileh
Elephantine Island
Aswan
Philae

UPPER
EGYPT

Red Sea

Southern border
of Ancient Egypt

LOWER   NUBIA

## Ancient Egypt and Nubia
*Showing Places Cited in the Text*

Qasr Ibrim
Abu Simbel
Faras

EGYPT
SUDAN

River Nile

Buhen

UPPER

Amara

NUBIA

Soleb

Sesebi

Kerma

KUSH

Kawa

Gebel Barkal

Valley of the Kings

Temple of Hatshepsut
Deir el Bahri
Temple of Mentuhotep II

Ramesseum
Deir el Medina
Temple of Amenhotep III
Colossi of Memnon
Medinet Habu
Malqata

temple
of Amun

Karnak temple complex

THEBES

temple of Mut

River Nile

LUXOR

Luxor temple

0    1    2 Kilometres

0         1 Mile

## Ancient Thebes

0   50  100    200    300    400 Kilometres

0   50  100    200         300 Miles

Meroë

# A Historical Overview of Egyptian Art

## Edna R. Russmann

Most of the works in this catalogue are arranged in chronological order—the best way to keep track of more than three thousand years of Egyptian art. More importantly, it allows the viewer to see how greatly this art changed over time.

Egyptian art is part of a cultural continuum that emerged during the Predynastic Period, centuries before Egypt became a unified kingdom. By the beginning of the Early Dynastic Period (First and Second Dynasties, ca. 3100–2686 B.C.), the Egyptian religion was well established, as were the attributes and rituals of kingship, including the red and white crowns, the royal bull's tail (see fig. 1), and the *sed*-festival (see cat. no. 1). Many of the basic conventions for hieroglyphic writing and two-dimensional imagery and their complex interaction had been established (see cat. no. 2). Enormous tombs, both royal and private, manifest an early striving for monumentality. Surviving statues and statue fragments, though few in number, show that the basic types of seated figures and of male figures standing with the proper left foot forward had been developed.

The early part of the Old Kingdom (Third and Fourth Dynasties, ca. 2686–2494 B.C.) was a period of experimentation, during which the still-archaic characteristics of Third Dynasty art were regularized and took their classical form. The Step Pyramid of King Djoser at the beginning of the Third Dynasty—the first monumental structure in stone—was followed, in the Fourth Dynasty, by true pyramids, which, after several failed attempts under King Sneferu, culminated in the Great Pyramid of Cheops and the almost equally large pyramid of Chephren at Giza. These and the nearby Great Sphinx represent the apex of monumentality in ancient Egyptian art; even today, they are benchmarks to which other colossal works are compared (see fig. 2).

Following experiments with very bold and very low relief, raised relief settled at a more or less standardized middle height, and sunk relief was introduced.

In relief and sculpture, the proportions and poses of figures were regularized (see cat. nos. 5 and 6). Negative space, already in use on Third Dynasty stone statues, became standardized in the Fourth Dynasty, which also introduced the back pillar. This quintessentially Egyptian feature, found on almost all standing figures and with some other poses as well, is not found on archaic sculpture. Since it serves no technical or functional purpose, its meaning is presumably symbolic, but this has never been satisfactorily explained.

The archaic practice of showing a nonroyal man with his identifying craftsman's tool or emblem of rank (see cat. no. 4) was discontinued in the Fourth Dynasty, in favor of simpler poses with the hands at the sides (fig. 3) or resting on the lap. It may not be a coincidence that private portraits began at about the same time that attributes of profession and rank were being eliminated. Portraiture provided another means of identifying a figure. Royal portraiture was by now well established, having begun at least as early as Djoser, at the start of the Old Kingdom.

The later part of the Old Kingdom (Fifth and Sixth Dynasties, ca. 2494–2181 B.C.) has left us a quantity of tomb statues and reliefs mostly from Saqqara, but also from other cemeteries near Memphis, the capital of the Old Kingdom. In this period, reliefs proliferated on tomb walls (see fig. 4), especially the scenes of "daily life" (see cat. no. 7), discussed below (p. 31). The expansion of these subjects, with their lively scenes and sometimes deliberately amusing details, may have been

inspired by royal reliefs with similar subjects on the walls of pyramid causeways and in the solar temples built by several Fifth Dynasty kings.

Although Fifth and Sixth Dynasty kings continued to build pyramids (though now quite small) with attached funerary temples, surprisingly little of their sculpture has survived. The recent discovery of statues of the short-lived Fifth Dynasty king Neferefre in his hitherto unknown, unfinished pyramid complex at Abusir serves only to underscore the extent of this lacuna. Consequently, we lack the framework of royal works that might help us to date more precisely private statues imitating the kings' features and perhaps better understand their context. As the Old Kingdom advanced, the bureaucracy and service sector grew, with the result that more people were able to provide themselves with tombs. This "democratization" of Egyptian society (as some scholars have anachronistically described it) is held responsible for the existence of numerous tomb statues, most quite small, all with blandly smiling, idealized faces (see fig. 5).

The extent to which this represents an "industrialization" (another scholarly anachronism) of tomb sculpture in the Fifth Dynasty is questionable. The idea of portraiture had disappeared from royal, as well as private, art. Since more statues were being placed in the tomb, several small figures would have been preferred to one large one. One of the goals may have been to provide variety: statues from a single tomb almost always differ in pose and composition and/or costume and hairstyle. It is ironic that modern researchers tend to focus on the stylistic and compositional similarities in these small Old Kingdom tomb statues when we should also be looking at their differences.

*Fig. 1. Palette of King Narmer. From Hierakonpolis. End of Predynastic Period (ca. 3100 B.C.). Graywacke, ht. 25 1/4 in. (64 cm). Egyptian Museum, Cairo (CG 14716). Fig. 2. Giza, Great Sphinx with Pyramids of Chephren (right) and Mycerinus (left). Fourth Dynasty (ca. 2558–2503 B.C.).*

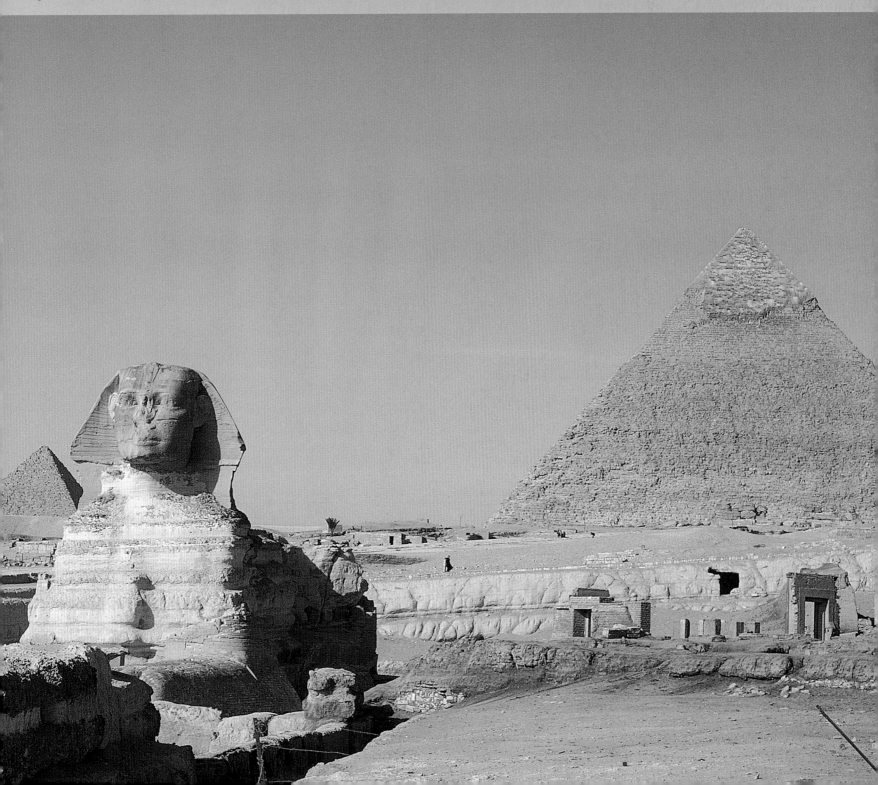

An abrupt change in the style of sculpture and relief can be traced to royal representations at the end of the Fifth Dynasty, which continued throughout the Sixth (see fig. 6). A number of changes in funerary customs occurred at about this time, including the inscription of Pyramid Texts on interior walls of pyramids and new types of private burials, in which the statues, instead of being above ground in statue chambers, were placed underground in the tomb shaft or the burial chamber. These late Old Kingdom private statues—most, though not all, of wood—are typically quite small with characteristically mannered physiognomies and anatomies. Uniquely for ancient Egyptian representations of the elite, both men and women are sometimes shown nude (see cat. nos. 8–11). This is the earliest deliberate stylistic change yet documented in the history of world art. The meaning of this innovation and that of the shift in funerary and possibly religious beliefs that must have inspired it remain unexplored.

In the later Sixth Dynasty, some of the great officials in the court at Memphis began to build their tombs in their provincial home cities. These local loyalties, perhaps symptomatic of incipient governmental breakdown and decentralization, helped to spread the late Old Kingdom style from its original center in Memphis and Saqqara into the provinces, where it developed during the First Intermediate Period (Seventh–Tenth Dynasties, ca. 2181–2025 B.C.) in a number of regional variations (see cat. nos. 12–14). The Theban version of this style became royal style when the Theban prince Mentuhotep II reunified Egypt to found the Eleventh Dynasty (ca. 2125–1985 B.C.) and initiate the Middle Kingdom (see cat. nos. 15–18). Soon after the reunification, influences from the earlier Old Kingdom style of the Memphite cemeteries began to trickle into Thebes (see cat. no. 16).

As the Middle Kingdom continued, the kings of the Twelfth Dynasty (ca. 1985–1795 B.C.), though also of Theban origin, moved their capital to the North. There, they were buried under pyramids that were so badly constructed that most today are mere heaps of rubble and sand. However, their funerary reliefs and statues—and those of the courtiers who were buried nearby—were carved in a style derived from the Memphite Old Kingdom. In this first major wave of archaism, we can see how the Egyptians made use of earlier models. Though clearly derivative, the early Twelfth Dynasty works are not copies of their prototypes; the bodies are less muscular, the faces devoid of any hint at portraiture. Old Kingdom classicism and naturalistic beauty had been transformed into a new, more muted style (see cat. no. 21). Features of this style were imported into the Twelfth Dynasty tombs of provincial officials (see cat. no. 24), but the tomb reliefs often maintained characteristics of local First Intermediate Period styles (see cat. nos. 22, 23).

During the Third Dynasty, some nonroyal people had placed their statues in temples, but in the Fourth Dynasty this privilege seems to have ended. In the Middle Kingdom, private persons (almost always men) once again began to erect statues in temples, as well as in their tombs. The influence of this new practice is apparent in the greatly increased use of the more durable hard stones, in more extensive inscriptions, often containing appeals to passersby for prayers, and, most probably, in the respectful passivity reflected in such poses as cloaked forms (see cat. no. 28) and block statues (see cat. no. 25). An invention of the Twelfth Dynasty, the block statue was originally used in both tombs and temples, but it quickly became one of the major types of temple sculpture.

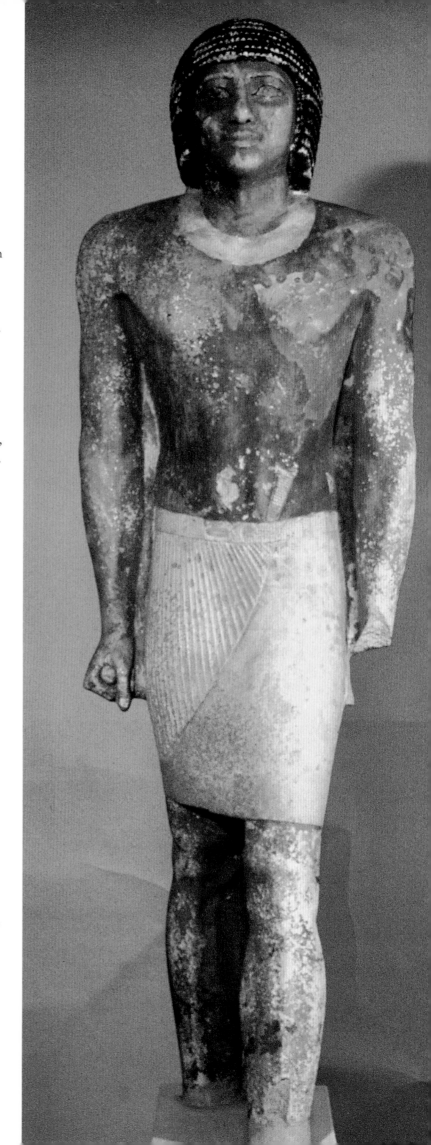

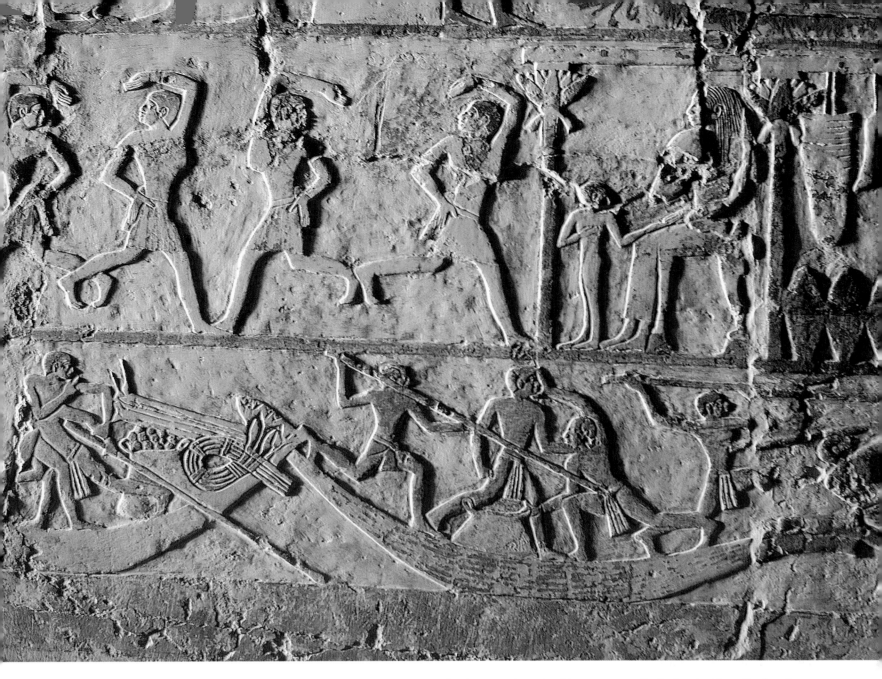

*Fig. 3. Standing Statue of Nenkheftka. From Deshasheh. Fifth Dynasty (ca. 2400 B.C.). Painted limestone, ht. 51 in. (134 cm). The British Museum (EA 1239). Fig. 4. Saqqara, Tomb of Nefer and Kahay. Fifth Dynasty (ca. 2445–2345 B.C.). Detail of painted wall reliefs: female dancers before tomb-owner's wife and daughter, with food storage kiosk; below, marsh workers in boats, fighting (a stock scene).*

It is probable that the cloaked forms and serious facial expressions of much private sculpture from the second part of the Twelfth Dynasty also reflect the pessimistic mood of Middle Kingdom literature. This literature, much of which concerns the burdens and even the dangers of kingship, found royal expression toward the end of the dynasty in the portraits of Sesostris III (cat. nos. 29, 30, fig. 22) and his son Amenemhat III (cat. no. 31, fig. 7). There can be little doubt that this re-emergence of Egyptian portraiture is based on the features of these two men; but as I argue below (pp. 35–36), their sometimes disturbingly somber expressions should not be interpreted as reflections of their individual personalities. Rather, they make visible a literary and philosophical theme.

This pessimistic attitude was expressed only briefly in royal sculpture of the succeeding Thirteenth Dynasty (ca. 1795–1650 B.C.) (see cat. no.

38), whose much weaker kings were usually depicted with smiles (see fig. 8) or noncommittal expressions (see cat. no. 39). Their subjects, however, often commissioned statues with somber facial expressions, composed of features taken from Sesostris III and Amenemhat III. The great majority of the "late Middle Kingdom private portraits" are not portraits at all (see cat. nos. 40, 41). For the sake of the desired expression, these people modeled their faces, not on the likeness of the reigning king, as was customary, but on those of past kings. This particular version of archaism is without parallel in Egyptian art.

If ever Egyptian art truly declined, it was during the Second Intermediate Period (Fourteenth–Seventeenth Dynasties, ca. 1750–1550 B.C.), when the foreign Hyksos kings ruled the North and the powerful kingdom of Kush was threatening from the south. What little sculpture and painting can be attributed to this period tends to be small and often very crude. Significantly, the best work comes from Thebes, where a dynasty of warrior princes fought the Hyksos for several generations before Ahmose finally expelled them and then invaded and decimated Kush, to found the Eighteenth Dynasty (ca. 1550–1295 B.C.) and the New Kingdom.

A head in New York, another in Khartoum, and a *shabti* in the British

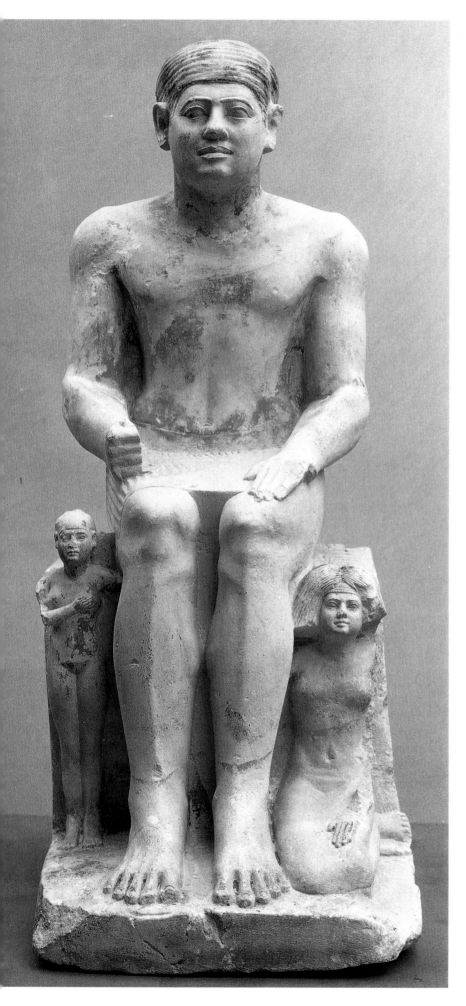

Museum (cat. no. 110) are our only statues of this important ruler, whose tomb has never been located by archaeologists. The two heads, like representations on Ahmose's stelae, reflect an archaizing return to the Theban monuments of the great Middle Kingdom kings Mentuhotep II and Sesostris I. The *shabti* seems to point already to the Thutmoside style of his descendants Hatshepsut (see fig. 11), Thutmosis III (cat. no. 43), and Amenhotep II, and their subjects (cat. nos. 44–47). One of the most highly idealized, non-individualized styles ever developed in ancient Egypt, it may have developed as a refinement—a very sophisticated refinement —of the archaizing simplicity of the art in the founder's generation.

The military campaigns of Thutmosis III (cat. no. 43, fig. 16) and other Eighteenth Dynasty kings brought imperial Egypt unprecedented power and wealth. Much of this wealth was expended on temple construction. The earliest surviving large temples date from the New Kingdom. The kings, whose tombs were in the Valley of the Kings at Thebes, built separate funerary temples near the cultivated land on the West Bank. The best preserved of these are the temple of Hatshepsut (now substantially restored) at Deir el Bahri (fig. 10), with graceful terraces that may have been inspired by the ruins of the Middle Kingdom funerary temple of Mentuhotep II, just to the south (fig. 47); and the huge temple of Ramesses III at Medinet Habu. Luxor Temple, on the East Bank of the Nile at Thebes, was largely built during the Eighteenth and Nineteenth Dynasties, as was much of Karnak Temple, including the Hypostyle Hall and all but one of its ten pylons (fig. 16).

Egypt's imperial role was also reflected at court and in elite private society, in a new lavishness, a new formality of dress and appearance, and new ideas, some of them from abroad, all of which seem to have reached their peak in the reign of Amenhotep III. But while the elaborately garbed representations of his subjects had faces based on the king's likeness (see cat. nos. 55, 56, 127), the royal imagery itself was very much involved with Amenhotep's program of self-deification (see cat. nos. 52, 53). I have discussed this below (pp. 36–37) as portraiture of a consciously manipulative type, which was continued and carried even further by Amenhotep's son Akhenaten. The portraits of that king (cat. no. 60) are so programmatic as to be untrustworthy in details.

Akhenaten's reign provides evidence of the king's direct involvement with artistic style (p. 32). Given the important role of art in Egyptian religion, it is not surprising that it was so integral a part of his religious revolution. What is most remarkable is the extent of his success. However his artists, including the great Thutmose (p. 37), were chosen and directed, they produced one of the most appealing and attractive styles ever created (see cat. nos. 57–61). Today that style still resonates in many ways. For Akhenaten's successors, determined to bury all memory of his heresy and return Egypt to the old traditional ways, the Amarna style proved almost impossible to resist (see cat. nos. 62, 63).

*Fig. 5. Statue of Ny-Ka-Re, his Wife and their Daughter. Fifth Dynasty, reign of Niuserre or later (ca. 2445–2345 B.C.). Painted limestone, ht. 22 1/2 in. (57 cm). The Metropolitan Museum of Art, New York; Rogers Fund, 1952 (52.19). Fig. 6. Kneeling Statuette of Pepy I. Sixth Dynasty (ca. 2321–2287 B.C.). Graywacke, ht. 6 in. (40 cm). Brooklyn Museum of Art; Charles Edwin Wilbour Fund (39.121).*

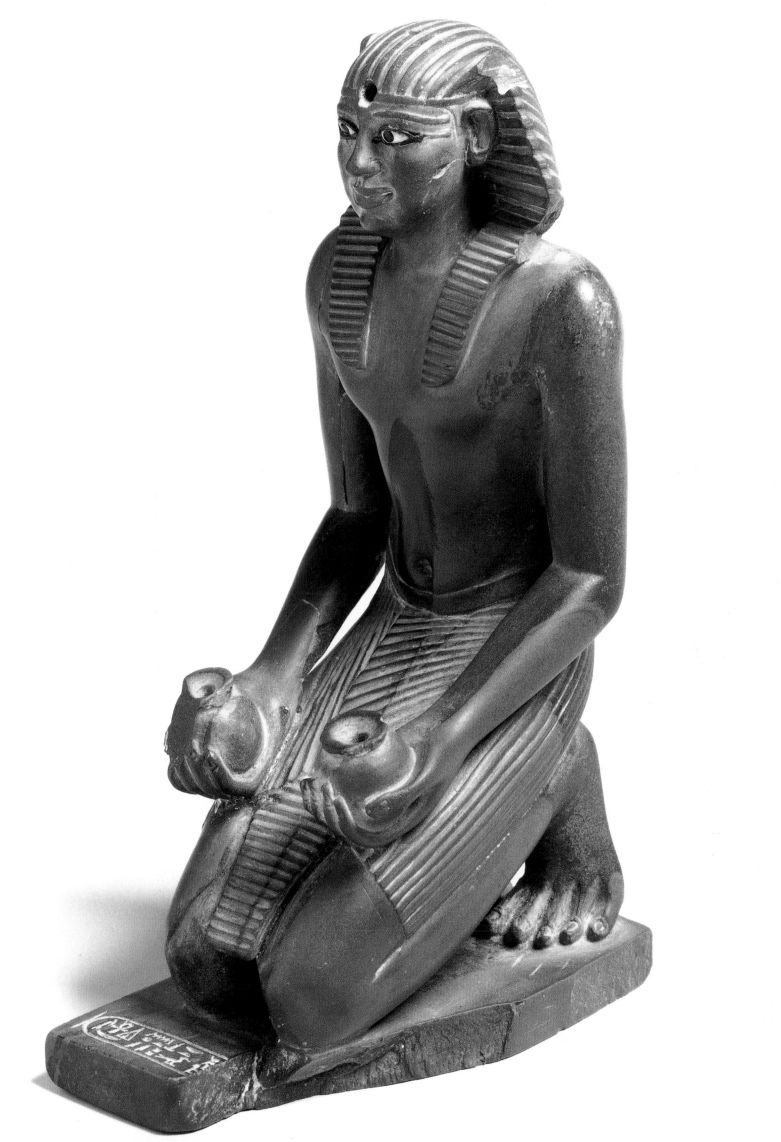

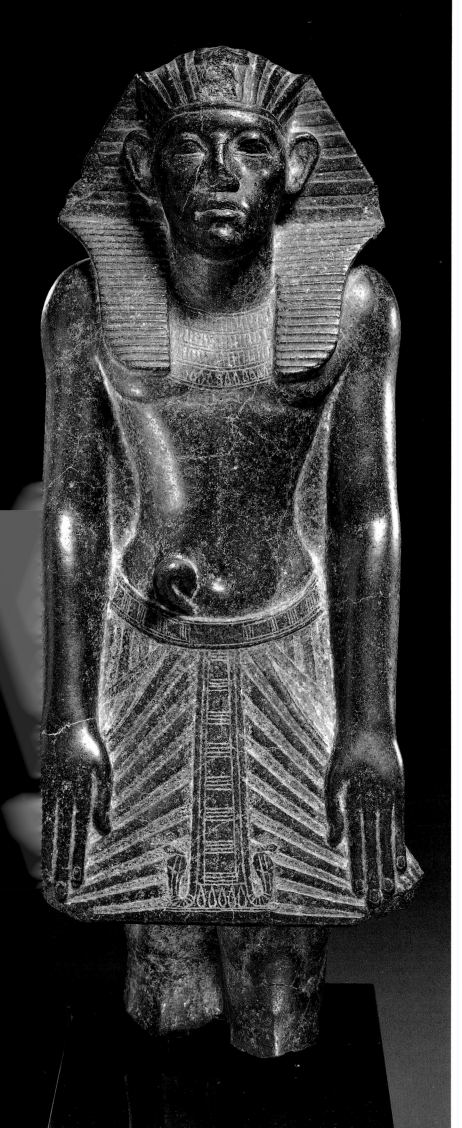

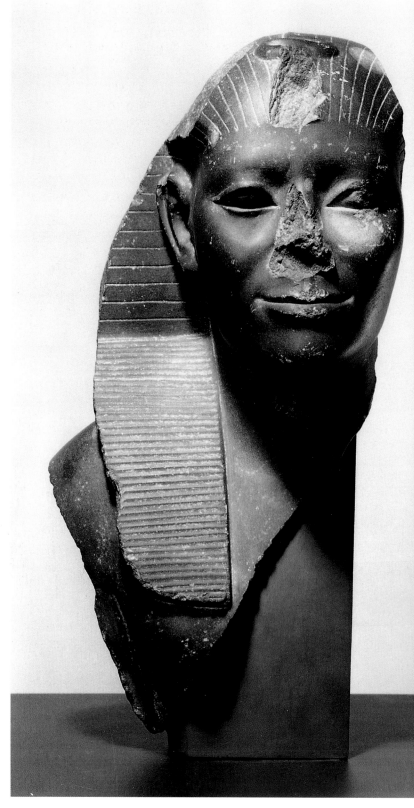

*Fig. 7. Standing Statue of Amenemhat III. Twelfth Dynasty (ca. 1854–1808 B.C.). Granodiorite, ht. 20 1/8 in. (51 cm). The Cleveland Museum of Art; Purchase from the J. H. Wade Fund (1960.56). Fig. 8. Bust of Amenemhat V. From Aswan, Elephantine Island. Thirteenth Dynasty (ca. 1750 B.C.). Graywacke, ht. 13 3/4 in. (35 cm). Kunsthistorisches Museum, Ägyptisch-Orientalische Sammlung, Vienna (ÄOS 37).*

Art in the later New Kingdom or Ramesside Period (Nineteenth–Twentieth Dynasties, ca. 1295–1069 B.C.) was dominated by the figure of Ramesses II (Ramesses the Great), whose statues and structures are still notable for their quantity and their huge size (see fig. 9). Succeeding kings took Ramesses' name and often tried to emulate his monuments and his representations. It is ironic, therefore, that the sculpture of great Ramesses never achieved a coherent style, nor was a specific representation of his features ever developed. The faces on many of his statues still have features derived from the Amarna style (see cat. no. 89). A few have the delicate, aquiline profile of his father, Sety I. Others appear coarse, bloated, and exophthalmic. His figure may be long and slim (see cat. no. 89) or stocky and squat. Most of the same characteristics appear throughout the Ramesside Period on various statues of Ramesses' successors and on the sculpture of nonroyal persons, who, as often in the past, used their king's image as the model for their own (see cat. nos. 94, 95, 97). The problem

was not one of artistic competence. Some royal statues (cat. no. 90) and quite a few private ones (cat. nos. 92, 93, 96) are beautifully made. The lack of a clear stylistic direction thus seems to reflect a lack of direction from above.

The situation is somewhat better with regard to Ramesside relief and painting. The scenes carved over acres of temple walls—both the standard repetitive subjects of greeting and offering to the god and the busy, bombastic battle and tribute scenes—are at least stylistically coherent. But the most ambitious of them, the huge, elaborate depictions of the king with his army in foreign lands, still owe much to the vast architectural compositions in Amarna relief. The finest and least impersonal two-dimensional art of the later New Kingdom is probably to be found in painting: in the tomb of Sety I in the Valley of the Kings, in Queen Nefertary's tomb and others in the Valley of the Queens, in private tombs, and on the best of the illustrated *Books of the Dead* (cat. nos. 101–103). Seldom, however, do the lively undercurrents glimpsed on some of the sketches on ostraca (see fig. 13) survive into finished work, such as the "Animal Fable" papyri (cat. no. 78).

*Fig. 9. Abu Simbel, Façade of Great Temple. Nineteenth Dynasty, reign of Ramesses II (ca. 1279–1213 B.C.).*

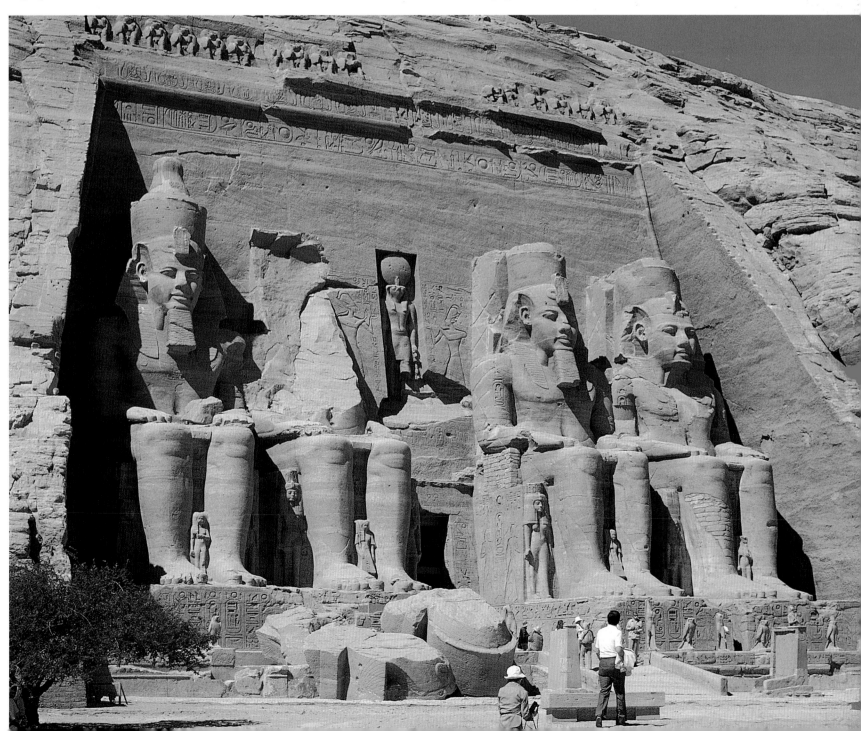

Archaism and portraiture were the major determinants of sculpture and relief during the Third Intermediate Period (Twenty-first–Twenty-fifth Dynasties [ca. 1069–656 B.C. ]) and the Late Period (Twenty-sixth–Thirtieth Dynasties [664–343 B.C. ]); these are discussed below (pp. 37–38, 43–44). Perhaps no period in Egyptian art is so complex. Modes of self-presentation and artistic traditions from several past eras were constantly appearing in new combinations that are not always easy to interpret (see cat. nos. 133, 134). Monumental temple structures continued to be built, though few have survived (see cat. no. 112). Bronze became a major medium for sculpture (see cat. nos. 114, 115, 117, 130).

Probably the most significant development of all was the creation of a distinctive figural style, often called the Saite style, during the Twenty-sixth Dynasty. To modern viewers, this highly idealized style may not seem particularly appealing. Considered within its historical context, however,

*Fig. 10. Thebes, Deir el Bahri, Funerary Temple of Hatshepsut. Eighteenth Dynasty (ca. 1472–1458 B.C.). Fig. 11. Seated Statue of Hatshepsut (detail). From Thebes, Deir el Bahri. Eighteenth Dynasty (ca. 1472–1458 B.C.). Red granite, ht. of statue 65 3/4 in. (167 cm). The Metropolitan Museum of Art, New York; Rogers Fund and Edward S. Harkness Gift, 1929 (29.3.3).*

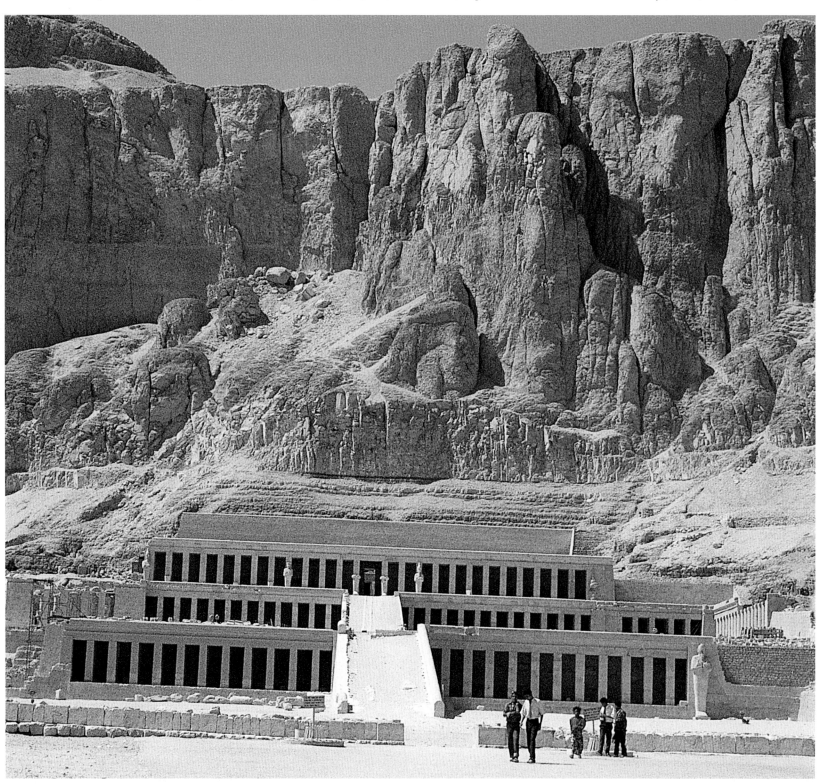

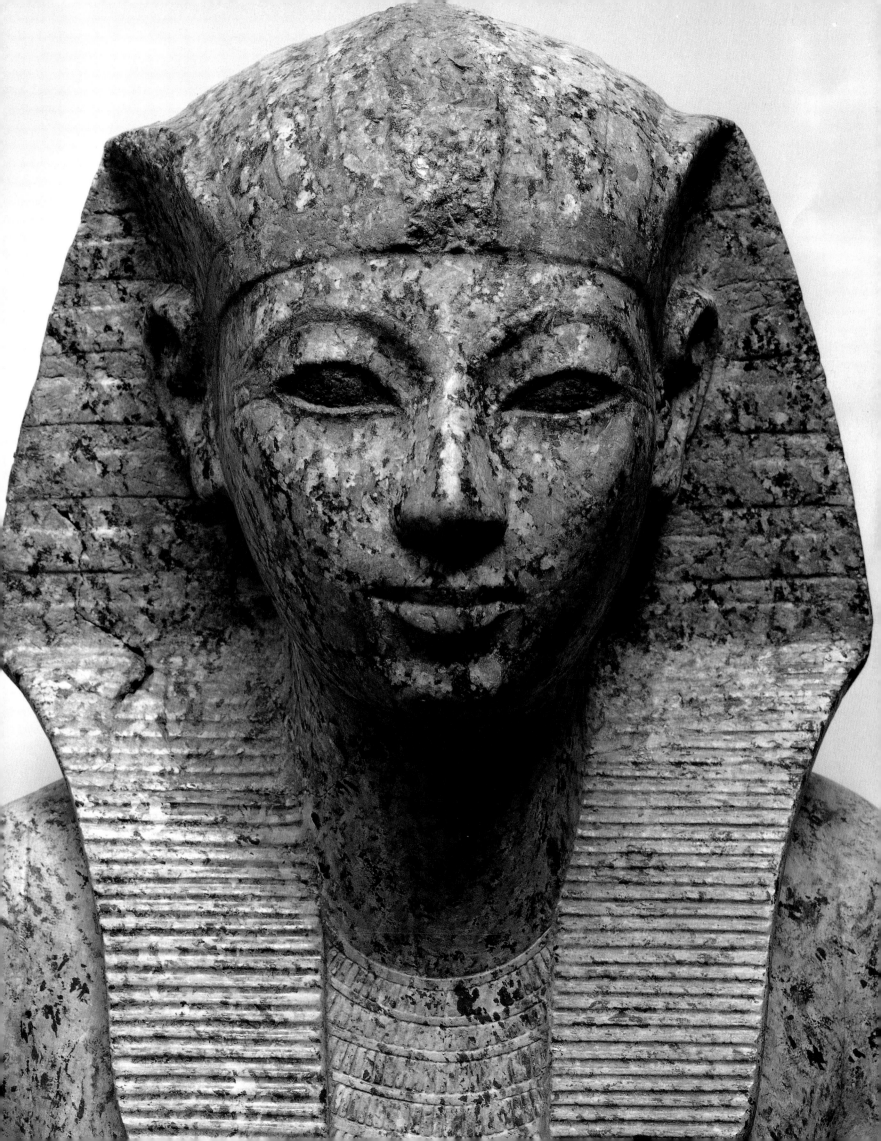

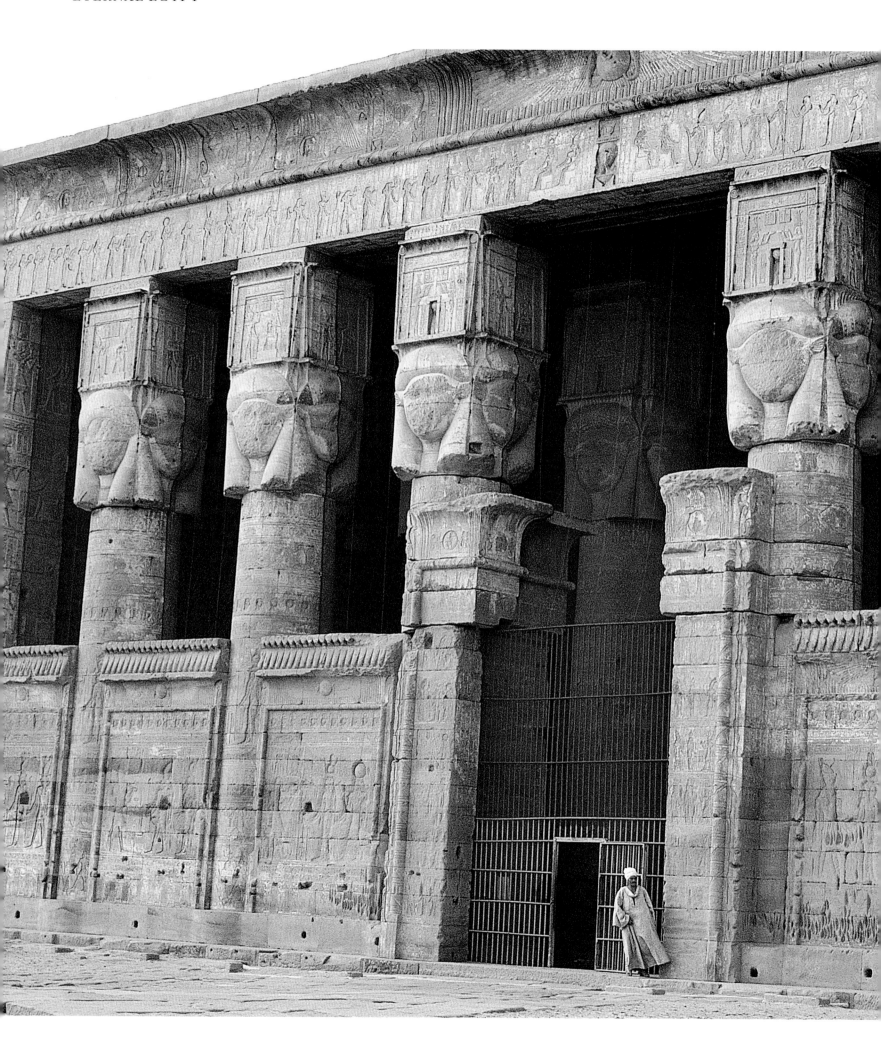

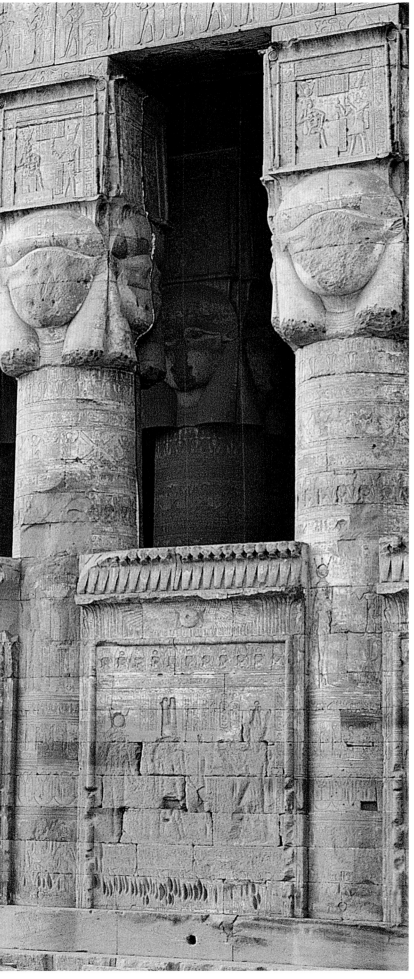

against the background of the eclectic incoherence of later New Kingdom art and the rampant archaism of the Third Intermediate Period, it emerges as a major achievement. Archaizing elements continued to be incorporated into the Saite style, especially during its earlier stages (see cat. no. 126). The inspiration for the style may well have been the strong, highly idealized Thutmoside style of the early New Kingdom (cf. cat. nos. 43, 44). But the Saite style had its own direction, toward fleshier, more softly modeled forms (see cat. no. 131). In the Thirtieth Dynasty, the Saite style, which had come to be regarded as the "Egyptian" style par excellence, was the basis for most royal and private sculpture and reliefs (see cat. nos. 135–37). For the same reason, it was adopted by the Ptolemies for their representations in Egyptian style (cat. nos. 138, 139).

The Ptolemies were a foreign dynasty (305–30 B.C.) who used temple reliefs and statues in Egyptian style to insinuate themselves into the religious system as a means of winning their sometimes rebellious subjects' loyalty, or at least their quiescence. These rulers encouraged the restoration and rebuilding of temples, with the result that most of the great temples still standing are, for the most part, products of the Ptolemaic Period or later (see fig. 12). But the royal lifestyle at the court at Alexandria was Hellenistic, and the kings and queens were also portrayed in Hellenistic style. In a number of statues, they are represented in hybrid mixtures of Egyptian and Hellenistic styles (see cat. no. 143). Inevitably, Hellenistic portrait elements began to enter the Egyptian portrait tradition in private sculpture, a development discussed below (p. 38). But the Ptolemaic private portraits remain enigmatic. Even though our knowledge, gleaned from texts and archaeological analysis, of the interactions between Egyptians and Greeks during the Ptolemaic Period is increasing rapidly, it is only in rare cases that we know whom the portraits represent. We are often uncertain even of when they were made within the three centuries of Ptolemaic rule.

*Fig. 12. Dendera, Temple of Hathor: Façade with Screen Walls and Hypostyle Hall with Hathor Columns. Roman Period, First Century A.D. Fig. 13. Ostracon with "Animal Fable" Vignette: A Cat Waiting on a Mouse. From Thebes. Nineteenth or Twentieth Dynasty (ca. 1295–1069 B.C.). Ink on limestone, 3 1/2 x 6 5/8 x 7/16 in. (8.9 x 16.9 x 1.1 cm). Brooklyn Museum of Art; Charles Edwin Wilbour Fund (37.51E).*

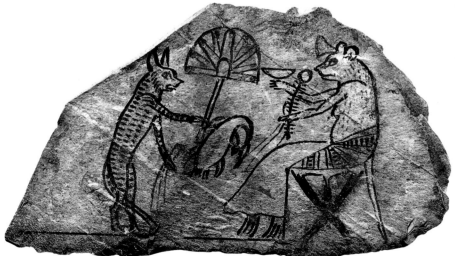

# Aspects of Egyptian Art

## Edna R. Russmann

One of the greatest of the many great achievements of ancient Egypt—Africa's oldest known civilization, and one of the earliest in the world—was its art. The finest Egyptian works of art rank among the best produced anywhere, at any time. But the full magnitude of this achievement is too seldom appreciated. In part, this is probably due to the fact that, although examples of "Egyptian art" are displayed in most museums, only the great collections, such as that of the British Museum, contain numerous works of the highest quality. In addition, however, there are two significant barriers to our engagement with Egyptian art.

The first barrier is inadequate knowledge. Even among scholars, this ignorance encompasses not only basic questions about the dates of some works, but also larger and more pervasive uncertainties about meaning, purpose, and function. We do know that almost all Egyptian art was in some sense religious: produced in the service of funerary beliefs or for the worship of gods in temples, chapels, or domestic shrines. Even objects made for personal use (see fig. 14), such as jewelry, cosmetic containers, and furniture, were decorated with religious symbols and allusions. Many were intended to accompany their owner to the tomb, which is where most surviving examples have been found.

But what did the ancient Egyptians actually see in these arts? What was their perception of what we call symbols, and of what looks to us like reality? The many surviving texts and inscriptions provide only limited help with such questions, for the Egyptians seem seldom to have written about matters that they thought were better expressed through imagery (a fact that Egyptologists too often forget). Modern theorizing is further complicated by the fact that our ideas about art differ so greatly from those of the ancient Egyptians—who never, for example, felt the need of a general word for "art." In the following essays about three important aspects of Egyptian art, I have discussed some of these problems. They are worth considering—not least because the better we understand Egyptian art, the better we will understand the culture that produced it.

There is, however, a second, and more insidious barrier to appreciating Egyptian art. It is one that we create ourselves, if we allow our imperfect understanding of these objects, or the obvious cultural differences they embody, or the sheer distance in time that separates us from them and their makers, to inhibit direct responses to the many visual pleasures they offer. The universality of art is difficult to describe, but it should not be denied. In Egyptian art, creativity, the grappling with artistic problems, the love of beauty, a joy in life, are all there to be seen, if we will simply look.

## Two-dimensional Representation

When we think of Egyptian two-dimensional art, we tend to think of the way in which it depicts the human figure as a combination of frontal and profile views. Those conventions, which had been established by the beginning of the First Dynasty (see fig. 1), are discussed below (see especially, cat. nos. 2, 6, 20) and need not be further elaborated here. But while the individual catalogue entries discuss the figural conventions and their interactions with hieroglyphic writing as a means of conveying information, another aspect merits consideration: namely, the flatness of these figures and of all Egyptian two-dimensional art. This absence of depth is very apparent to modern viewers, who usually, and quite understandably, assume it to be a failure in the rendering of space. In fact, it was as deliberate as (though less conscious than) the flattened effects achieved by modern painters as different as Matisse, Picasso, and de Kooning. Like the Egyptians, these painters sometimes distorted their figures to avoid suggestions of depth. But whereas these modern works represent individual solutions to the problem of maintaining the two-dimensionality of the surface, the Egyptians' was a cultural solution.

Like most of the other main characteristics of Egyptian two-dimensional art, its flatness was a product of its close relationship with writing, with which it usually shared the same space. Writing is wholly on the surface; regardless of whether the signs are letters of the alphabet or hieroglyphs, the eye does not expect to see behind or beyond them. For the Egyptians, that was equally true of their graphic imagery—a fact that helps to explain their emphasis on outlines. It may also account for such peculiarities as the undifferentiated right and left feet (cf. cat. nos. 6, 20) and the habit of representing frontal figures by joining two profiles.[1]

*Fig. 14. Mirror Handle in the Form of a Nude Girl Holding a Kitten. Eighteenth Dynasty (ca. 1390–1352 B.C.). Wood, traces of paint, ht. 5 1/4 in. (13.3 cm). The British Museum (EA 32733).*

Fig. 15. Stela of Wep-em-nefret. From Giza, Tomb of Wep-em-nefret. Fourth Dynasty, reign of Cheops (ca. 2589–2566 B.C.). Painted limestone, ht. 18 in. (45.7 cm). Phoebe Apperson Hearst Museum of Anthropology, University of California at Berkeley (6-19825).

Certain scenes necessitated the representation of figures positioned side by side. In the most frequent of these cases, that of a couple standing or sitting together, the figures are separated so that both are fully visible, the woman always behind the man (see cat. nos. 27, 100). Since an Egyptian viewer would have known they were next to one another, and even which side the woman was supposed to be on, this convention conveyed the necessary information while avoiding any suggestion of depth. Rows of figures were shown overlapping or in a tighter echelon formation. In the latter case, they are often colored alternately dark and light (see cat. no. 101). This convention is not intended to (and does not) suggest depth; it simply makes the figures easier to count.

Buildings and landscape features were rendered as a combination of plans and elevations (see cat. no. 100) or, in the case of more complicated settings, imaginary maps and elevations (cat. no. 103). These were not naïve or primitive attempts to demonstrate spatial depth, but effective ways to avoid it.[2] In some Early Dynastic representations of stools, the seat is shown from the top and the legs in profile; in other words, the furniture was rendered as a combination of plan and elevation. In addition to its architectural logic, this composite approach may also have been dictated by a desire to indicate the composition of the caned or wicker seat. But since the tomb owner had to be shown sitting on the results,[3] the awkwardness of this particular solution was abandoned in favor of a simple profile view. In the early Third Dynasty Tomb of Hesy-Re, a series of beds and stools are represented, some in composite and some in profile views.[4] Hesy-Re himself sits on a stool that is shown in profile.[5] The oddly distorted composite versions of stools that appear in two finely decorated tombs from the beginning of the Fourth Dynasty (see fig. 27),[6] and occasionally later in the Old Kingdom, should probably be considered early examples of archaism (see below, p. 41).

The concept of the surface as neutral and entirely without depth also applies to Egyptian relief, in both a practical and a theoretical sense. At the practical level, every relief actually began as a drawing (cat. no. 27), which was often very detailed.[7] When the carving was finished, the relief would be fully painted; in cases where the paint is well preserved, it can be difficult to see whether there is carving beneath (see fig. 15).[8]

Egyptian relief is best understood, in fact, as a means of reinforcing paint. Egyptians were painting vignettes on tomb walls by the late Predynastic Period, so they learned very early how vulnerable and often evanescent this medium can be.[9] It is no accident that First Dynasty royal labels were incised rather than painted (see cat. no. 2). Yet color was considered an essential factor in the magical animation of images. The solution was painted relief. The surviving reliefs from the late Predynastic Period and through the First Dynasty decorate small objects that may or may not have been painted (see fig. 1). In the reign of the Second Dynasty king Khasekhemwy, however, an ambitious series of reliefs was carved on a granite gateway (?) in the "fort" at Hierakonpolis.[10]

With the exception of an ambitious but unsuccessful attempt, at the beginning of the Fourth Dynasty, to create permanent paintings by inlaying the pigments into the tomb walls,[11] relief was the preferred medium in decorating tombs and temples. Palaces and other dwellings, which were considered ephemeral and built of mud bricks, had painted walls and floors, only a few of which have survived.[12] Painted walls in temples and tombs, however, are an indication either of hasty finishing or, in the case of rock-cut tombs, of stone of such poor quality that it could not be carved. There is irony in the fact that the wonderful painted tombs of Thebes are directly due to rotten rock.

Relief offered other advantages, such as the possibility of modeling muscles and other anatomical features that could not be well represented by means of the Egyptian conventions in drawing or painting. But this kind of elaboration did not affect the basic concept of the figure in relief as essentially flat. There is never the slightest suggestion that it is emerging from the surface, as if it were a three-dimensional form embedded in a matrix. That concept of relief, which we have inherited from the Greeks and Romans, was already partially realized in Near Eastern relief as early as the Akkadian Period,[13] and it recurred sporadically, most notably in colossal Assyrian relief. Egypt, by contrast, developed sunk relief in which the surface is left at its original level above the figures carved into it (see fig. 16). Whether sunk relief was a labor-saving technique, as some have theorized, is debatable. It was usually applied to exterior walls, where the strong sun cast shadow lines that emphasized the figures' contours. One might almost say that depth, in sunk relief, was a means of drawing with light and shadow. The uncarved surface, clearly not a background, has to be considered spatially neutral.

Because of their religious content, the scenes on stelae and on temple and tomb walls blend reality with myth, combining realistic and symbolic elements. Since "realistic" details could also have symbolic meaning, scenes that appear straightforward and mundane to us may have several layers of meaning, or might even signify something quite different (compare the discussion of cat. no.

*Fig. 16. Thebes, Karnak, Temple of Amun, Seventh Pylon, south face, west wing: Thutmosis III Smiting Enemies. Eighteenth Dynasty (ca. 1458–1425 B.C.).*

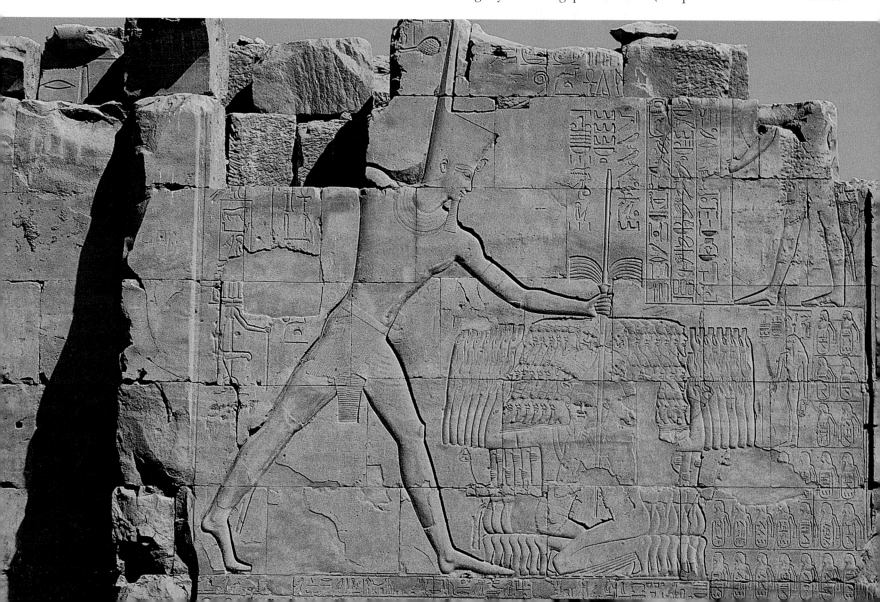

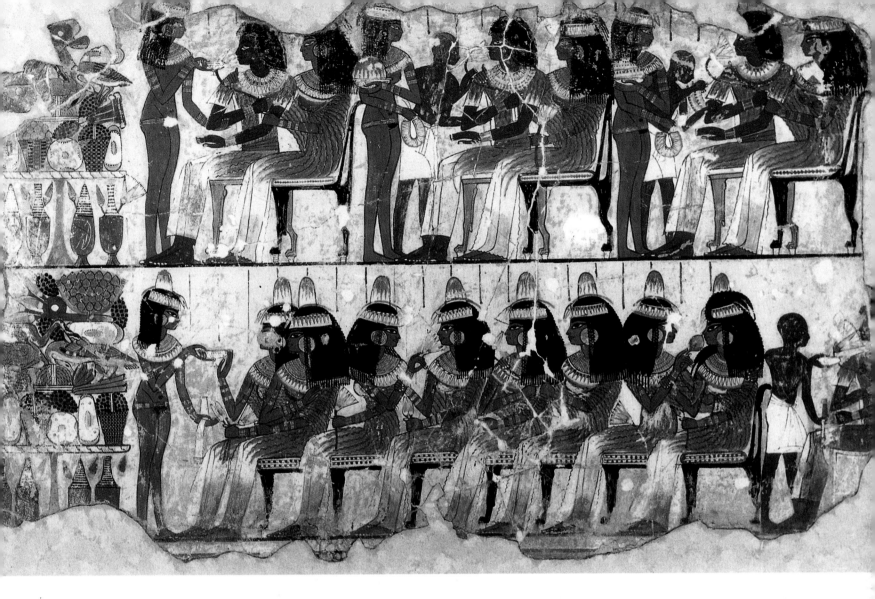

This is especially true of the so-called "scenes of daily life" found on the walls of most nonroyal tombs from the Old Kingdom (cat. no. 7) into the Late Period.[14] To the extent that they represent reality, these scenes provide a wealth of detailed information about Egyptian life. But can they always be trusted? Take, for example, the "banquet scenes" found in almost all Eighteenth Dynasty private tombs (see fig. 17).[15] To what extent can we rely on them for information about social events in the New Kingdom? Were single male and female guests really separated, while married couples sat together? Were young female servants actually assigned to wait only on women and couples, and kept away from the single young men?[16] Were these the sedate affairs they appear to be with only the very occasional male or female drunk?[17] Or does the real significance of these scenes lie in an erotic and even orgiastic symbolism that may link them with the excesses of certain religious festivals and sexual conceptions of rebirth?[18] And what of the scenes, ubiquitous from the Old Kingdom into the Late Period, that show the tomb owner with his family in festive attire, fishing or fowling in the papyrus swamps (see fig.18)[19]: do these represent actual holiday outings as some scholars maintain,[20] or are they a wholly symbolic fiction?[21] As for catalogue number 7, what *are* those children in the middle register really up to?

How much control over the composition and details of such scenes was in the hands of the artist—or at least the draftsman who

*Fig. 17. Fragment of Wall Painting: Banquet Scene. From Thebes, Tomb of Nebamun. Eighteenth Dynasty (ca. 1390 B.C.). Paint on plaster, ht. 30 in. (76 cm). The British Museum (EA 37986). Fig. 18. Fragment of Wall Painting: Fowling in the Marshes. From Thebes, Tomb of Nebamun. Eighteenth Dynasty (ca. 1390 B.C.). Paint on plaster, ht. 31 7/8 in. (81 cm). The British Museum (EA 37977).*

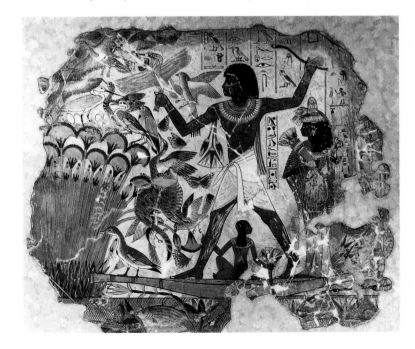

laid them out—is in almost all cases impossible to gauge. The practice of copying scenes from one tomb to another is known as early as the Old Kingdom; but such imitation, like the creation of scenes that appear to be unique, including catalogue number 7, might have been ordered by the client. In the Eighteenth Dynasty painted tombs at Thebes, however, there is strong evidence that painters, no doubt encouraged by the relative spontaneity of their medium, were experimenting and innovating on their own account and paying close attention to each other's work. New genre subjects and newer, livelier versions of poses were invented, and those considered most successful were copied. The breasts of nude female musicians were drawn in front view[22] and, after fifteen centuries of Egyptian art, for the first time all five toes were shown on the near foot (see figs. 17, 18)[23] These experiments had no symbolic value and they were not officially sanctioned, at least in their inception, for they were first tried out on representations of lowly female musicians and servants. Soon, toes were being represented on the tomb owner's daughters and, in one case, his wife, but never on the master himself.

Some of these innovative painters went with Akhenaten to Amarna, where their figural style, combined with Amarna mannerisms, can be seen in a surviving fragment of palace painting.[24] I think it likely that their work also inspired some of the "naturalistic" renderings of plants and animals in relief. They were certainly the source for an Amarna relief representation of a female torso shown frontally[25] and for the depictions in relief of all five toes on the near foot (cat. nos. 59, 60).[26] But what had worked in paint was less successful in Egyptian relief, because the width of the foot and, even more, the shapes of the breasts created real and perceptual depth, violating the fundamental convention of flatness, with somewhat awkward results. No matter—these were no longer artistic experiments but compliance with royal fiat. At Amarna, the frontal bosom and five-toed feet appear only on representations of the royal family.[27] This could only have been done on the orders of Akhenaten himself, who thereby transformed innovative renderings of anatomy into symbols of royalty.

## Portraiture

Our understanding of the very complex subject of Egyptian portraiture is bedeviled by those who, on the one hand, tend to call every representation, no matter how idealized or standardized, a portrait and those at the other extreme who deny the very notion of portraiture in ancient Egypt. These simplistic approaches, and others, reflect a failure to consider what is actually meant by the term "portraiture." Far from denoting a clearly defined concept, this word is an accretion of historical layers ranging from the ancient Greeks and Romans through all phases of Western culture to Andy Warhol and Lucien Freud, radically revised by the invention of photography (and, as digital imaging becomes widespread, soon to be revised yet further). Used indiscriminately, as it usually is, "portraiture" can mean just about anything the user wishes.

More sophisticated attempts to define portraiture in a way applicable to Egyptian art too often employ the premise that mere likeness does not suffice for a portrait; the viewer must also be given a sense of the subject's individual personality. Historically and psychologically, this attitude is somewhat naïve. "Mere likeness" may mean little enough to someone who need only click a camera button; but for a sculptor working on hard stone with ancient tools and techniques, it was a substantial achievement. Moreover, interpretations of personality from purely visual cues are notoriously unreliable, even within a shared culture. When applied to Egyptian portraiture, they can lead to foolish conclusions.

Even a minimalist definition along the lines of "a recognizable depiction of the actual features of a real individual" is not without problems. Even when we can verify the recognizability of an Egyptian image and the reality of the person portrayed, we must take the "actual features" on faith. But inasmuch as we do so routinely for Greek and Roman portraits, for portraits of the European Renaissance and, for that matter, portraits of George Washington, it seems reasonable to extend the premise to Egyptian images, especially those that meet the other criteria. Since the Egyptians were probably not the first to make images of real people, there is no reason to assume that they were the first to attempt portraiture. They appear, however, to have been the first with sufficiently developed artistic skills and traditions to achieve recognizable portraits. Certainly theirs are the earliest to have survived. In that sense, at least, we can say that the ancient Egyptians invented portraiture.

Ancient Egyptian portraiture has a curious, apparently discontinuous history. It surfaces at least once in the art of every major period, but each time with a different meaning, reflected in different stylistic emphases and devices. In the intervals between these episodes, interest in portraiture seems virtually to disappear. I shall review below the main periods in Egyptian portraiture, their disparate features, and what, if anything, we can glean about their meaning.

The strongest evidence for portraiture in an ancient or otherwise remote culture is the reproduction of the same set of distinctively individual features in a variety of works, especially if these include different media, materials, or stylistic approaches. Representations of Djoser, at the beginning of the Third Dynasty, meet these criteria, as do the statues of all the Fourth Dynasty kings for whom we have multiple images: Djedefre, Chephren, and Mycerinus. Djoser's face—with its low forehead and heavy, somewhat prognathous jaw and its mustache—was replicated in two media: in the statue from his pyramid complex, now in the Cairo Museum, and in reliefs still in situ in subterranean chambers in the pyramid complex.[28] The surviving portraits of Djedefre, Chephren, and Mycerinus (see figs. 19, 20) are all statues, carved in most of the stones utilized by Egyptian sculptors, from limestone and Egyptian alabaster to graywacke, quartzite, and gneiss. These kings' features are so individualized that even small fragments of their faces are identifiable.[29] Yet almost every one of their images

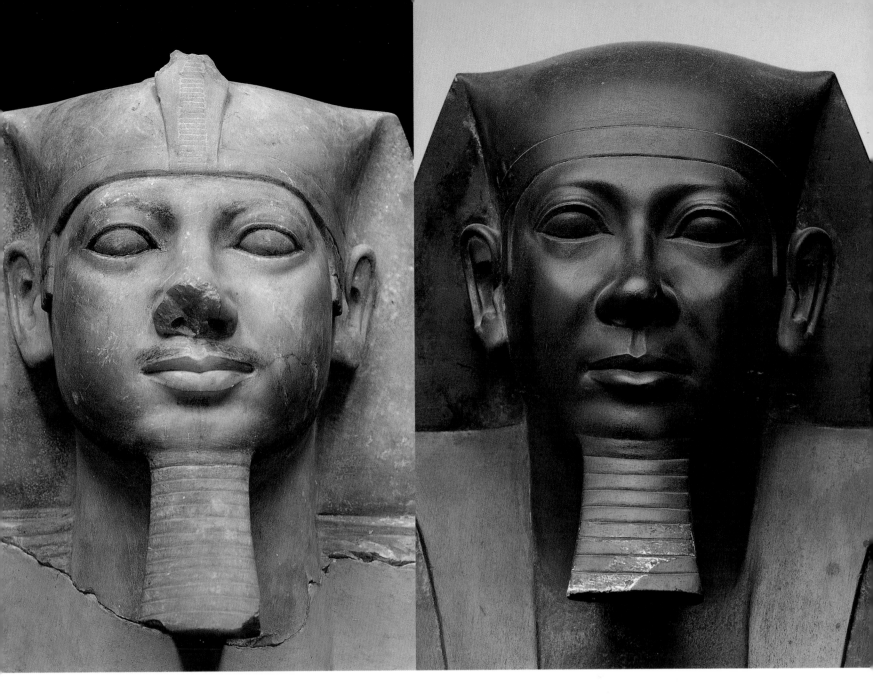

*Fig. 19. Colossal Seated Statue of Mycerinus (detail). From Giza, Mycerinus Pyramid Temple. Fourth Dynasty (ca. 2532–2503 B.C.). Egyptian alabaster (calcite), traces of paint, ht. of statue 92 1/2 in. (235 cm). Harvard University-Museum of Fine Arts Expedition; Museum of Fine Arts, Boston (09.204). Fig. 20. Standing Statue of Mycerinus and a Queen (detail, head of Mycerinus). From Giza, Mycerinus Valley Temple. Fourth Dynasty (ca. 2532–2503 B.C.). Graywacke, traces of paint, ht. of statue 54 1/4 in. (137.8 cm). Harvard University–Museum of Fine Arts Expedition; Museum of Fine Arts, Boston (11.1738).*

differs somewhat from the others. These variations are too consistent to be considered accidental[30]; whatever their specific meanings may have been, they too were part of the Old Kingdom concept of royal portraiture.

The royal features need not be confined to representations of the king himself: Djoser's heavy profile and mustache also appear on the tomb reliefs of two of his officials.[31] These are the earliest datable examples of imitation of the king's features by his subjects, a phenomenon that was to dominate the representations of nonroyal individuals in most of the succeeding periods until at least the beginning of the Late Period. At the same time, however, a distinct genre of private portraiture, seemingly the opposite of this imitative trend, was being developed. It made its appearance almost as early in the Old Kingdom, by at least the beginning of the Fourth Dynasty.[32] The reign of Cheops, the second king of the dynasty, produced the statue of Hemiunu (see fig. 21), whose commanding head and corpulent body make it one of the most closely observed and beautifully realized portrait statues ever made. Unlike Fourth Dynasty royal portrait statues, which range in scale from small to colossal, the earliest private portrait statues were almost all life-size, even when made as a bust[33] or as heads.[34]

Old Kingdom private portraits differ from the royal examples in at least three important respects. In the first place, all are one of a kind. We cannot verify that they are portraits by comparison with corresponding examples[35]; we must take them on faith. But since the idea of portraiture was present, since the possibility of imitating royal features was established, and since

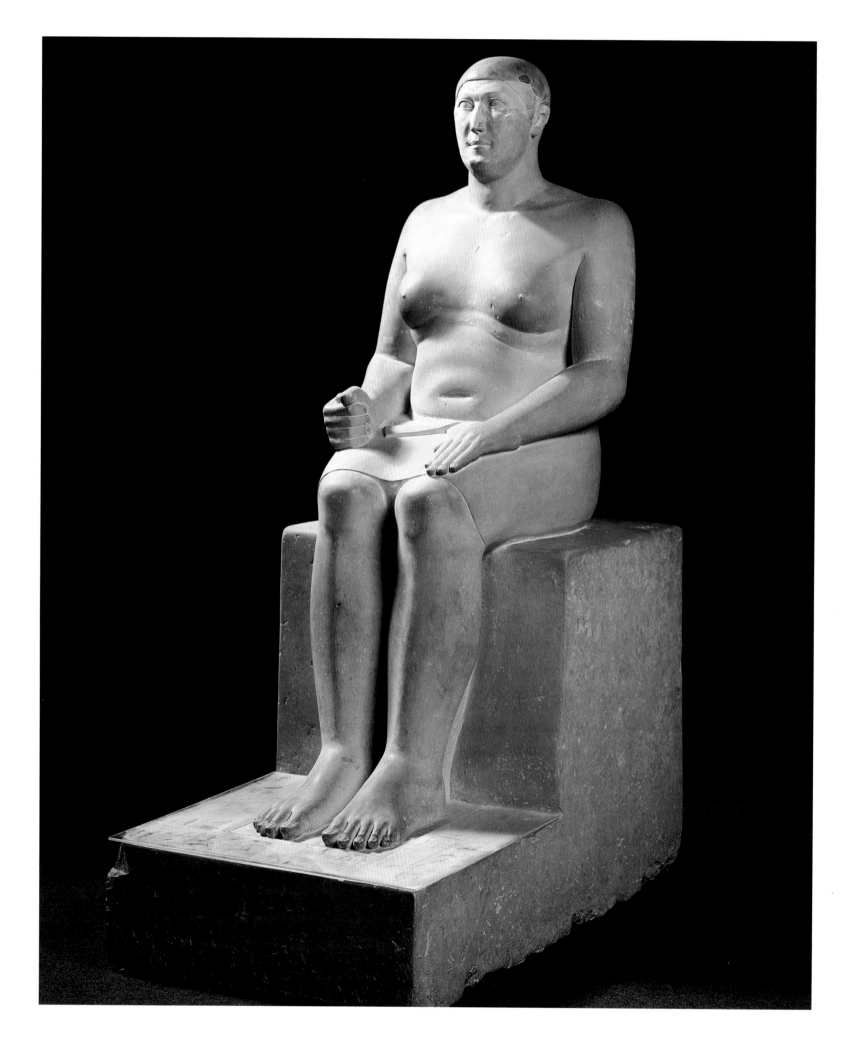

no two Old Kingdom private portraits have the same features, no great leap of faith would seem to be required. A second difference between the faces of Fourth Dynasty royal and private portraits is their age: the kings' faces are youthful,[36] while portrait representations of their subjects always show men of at least middle age. Finally, though both types of statues were funerary, they had different functions. Kings' images were placed in royal funerary temples for the cult of the divine ruler. The private portraits were sealed away in the tombs, in statue chambers that also contained at least one other representation of the tomb owner as a young man, such as fig. 3. For tomb images, therefore, variety was at least as important as portraiture.

Despite the differences in function and meaning between royal and private sculpture, the main impetus to portraiture in both types in the early Old Kingdom appears to have been the need to preserve the subject's features in imperishable form. Thus the main goal of these earliest portrait images was recognizability, very possibly to compensate for the failures of early mummification techniques. It is often suggested that the plaster masks and body coverings found on some Old Kingdom mummies are linked to the development of Old Kingdom portraiture. Although all known Old Kingdom mummy masks and covers are considerably later than the private portraits,[37] both emphasize the preservation of the physical semblance of the body.

Perhaps because they functioned as objects of offering cults, or perhaps because they were products of a highly formalized society, Old Kingdom portraits, whether royal or private, are extremely formal. The identifying features are reproduced, perhaps even somewhat exaggerated, but all small details and, of course, any blemishes are omitted. These faces are sometimes described—and criticized—as expressionless.

*Fig. 21. Seated Statue of Hemiunu. From Giza, tomb of Hemiunu. Fourth Dynasty, later reign of Cheops (ca. 2570 B.C.). Limestone, traces of paint, ht. 61 in. (155.5 cm). Roemer–und–Pelizaeus-Museum Hildesheim (1962). Fig. 22. Head from a Colossal Statue of Sesostris III. Twelfth Dynasty (ca. 1874-1855 B.C.). Yellow quartzite, ht. 17 3/4 in. (45 cm). The Nelson-Atkins Museum of Art, Kansas City, Missouri; Purchase Nelson Trust (62-11).*

But they do not lack expression; we simply do not know how to read them: as confident, as authoritative, or—quite possibly, in the case of royal portraits—as divine.

The decline of royal and private portraiture in the Fifth Dynasty deserves study, especially since this was followed by a new style that repudiated recognizable portraiture.[38] The stylized, exaggerated facial and anatomical features of late Old Kingdom figures seem designed to express other aspects of the individual than his or her physical being. But figures in this late Old Kingdom style were often shown nude (see cat. nos. 8-11). In some cases the representation of the individual at several stages of life—youth, manhood, maturity, old age— seems to have been carried further than earlier in the Old Kingdom. Though not portraits, these statues suggest that the Egyptians had as complex an idea of the individual's physical being as of his soul.[39]

By the end of the Old Kingdom, the late non-portrait style, originating in the royal center of Memphis and its cemetery at Saqqara, had spread into the provinces, where, during the decentralized First Intermediate Period, it developed into a number of regional variations. When a Theban dynasty reunified Egypt to found the Middle Kingdom, it was the Theban version of this style that formed the basis for royal representations and their nonroyal imitations (cat. nos. 15, 19). Not until the next dynasty, the powerful Twelfth Dynasty, was the idea of portraiture revived for royal representations. This may have begun as early as mid-dynasty[40]; it culminated in the arresting portrait representations of Sesostris III (cat. nos. 29, 30, and fig. 22) and his son, Amenemhat III (cat. no. 31 and fig. 7).

The strikingly distinctive features of these two kings survive in numerous statues and statue fragments. Like the Fourth Dynasty royal portraits, they are almost always recognizable. In other respects, however, these late Twelfth Dynasty royal portraits have little in common with their Old Kingdom predecessors, for they show their subjects as aged or aging and with somber expressions that strike modern viewers as weary, sad, or even brutal.

These heads are frequently assumed to express the "character" or "personality" of Sesostris III or Amenemhat III, and thus to approach portraiture in a modern sense.[41] In fact, we know from

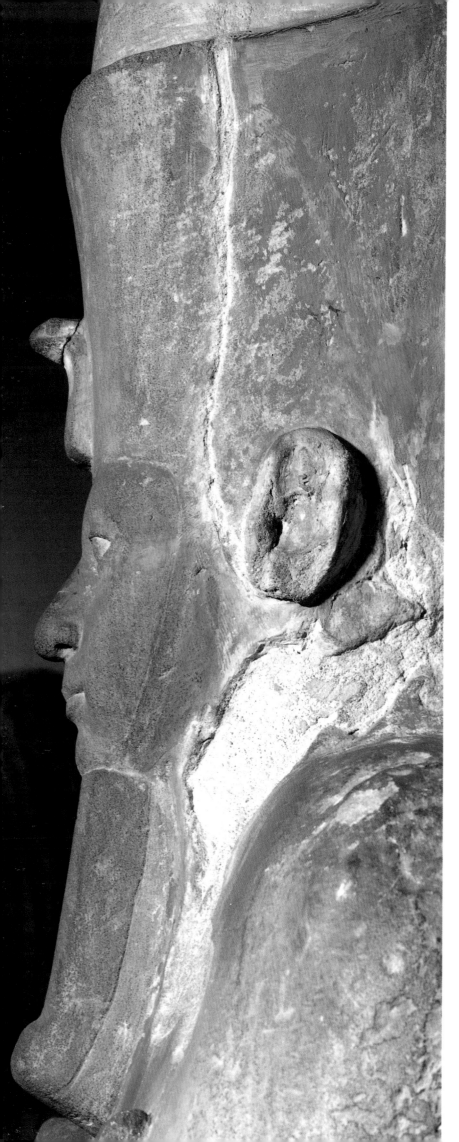

Middle Kingdom literary texts that their expressions are meant to reflect the mood of the period, which was one of pessimism and distrust. Kingship was a heavy responsibility, reflected in the faces of these two kings. However internalized these attitudes may have been, their expression in Twelfth Dynasty royal portrait sculpture is ideological.[42] The fact that we could not interpret these portraits correctly had the literary evidence not survived should give us pause. We cannot assume that what we see in an Egyptian portrait is what it was intended to convey.

Nonroyal imitations of the representations of Sesostris III and Amenemhat III during their lifetimes were few.[43] After their deaths, however, and especially in the succeeding Thirteenth Dynasty, private statues were frequently made with features borrowed from Sesostris III or Amenemhat III, or a combination of both, and with some version of their sober expressions.[44] This appears to be the only time in the history of Egyptian art when nonroyal sculpture emulated the features of former, rather than reigning kings. It seems that these officials, priests, and a few women (see cat. no. 40) chose to express the ethos of the late Twelfth Dynasty at a time when their kings were usually being represented with smiling faces (see fig. 8). Ironically, these statues are often referred to as "late Middle Kingdom private portraits," which, with a few possible exceptions,[45] they clearly are not.

Like the Middle Kingdom, the New Kingdom was founded by a Theban dynasty, the Eighteenth, whose earliest representations are derivative from early Middle Kingdom royal representations at Thebes. An apparent portrait likeness was developed for the second king of the dynasty, Amenhotep I (fig. 23).[46] Possibly derived in some way from his archaizing imitation of early Twelfth Dynasty royal representations in relief (see below, p. 42), it seems to have been a wholly isolated phenomenon.[47] Amenhotep's Thutmoside successors were represented in one of the most highly idealized styles of royal representation ever developed in Egypt (cat. nos. 43, 49, 50 and fig. 11).

With Amenhotep III, portraiture reappeared in yet another form. The king's unmistakable features (cat. no. 52 and fig. 24) were carved in versions ranging from babyish to apparently naturalistic to mask-like to, occasionally, elderly.[48] Only about fifteen years ago, it was suggested that the infantile heads of Amenhotep III indicate that he ascended the throne at a very young age. Since then, however, intensive research on this king has demonstrated that the juvenile heads were actually made toward the end of his long reign, with the intent of showing the king, after his third *sed*-festival, reborn as a juvenile god.[49] Amenhotep had an

*Fig. 23. Standing Osiride Statue of Amenhotep I (detail). From Thebes, Deir el Bahri, funerary temple of Mentuhotep II. Eighteenth Dynasty (ca. 1525–1504 B.C.). Painted sandstone, ht. of statue 110 in. (269 cm). The British Museum (EA 683). Fig. 24. Head of Amenhotep III. Eighteenth Dynasty (ca. 1390–1352) B.C.). Dark red quartzite, ht. 17 1/2 in. (44.5 cm). The Metropolitan Museum of Art, New York; Rogers Fund 1956 (56.138).*

elaborate program of self-deification, in which his personal imagery played a leading role. Every variant of the royal features was intended to convey its own message. The manipulation of his portraiture was both blatant and highly sophisticated.

The manipulation of royal portraiture was carried even further by Amenhotep III's son Akhenaten. This king's images, which in terms of recognizability must be considered portraits, range from the extreme forms of his early years at Thebes[50] to the softer, less exaggerated versions developed later at Amarna (see cat. no. 61).[51] Although it is widely known that Akhenaten's self-presentations were meant to reflect and expound his revolutionary religion of Aten worship, many interpreters still rely on their own responses. We still read new theories about the nature of his "deformities"[52] based on someone's personal reaction to a supremely ideological form of portraiture.

At Amarna, as the portrait style softened, an individual portrait likeness was developed for Nefertiti and apparently for each of her six daughters. To modern eyes, these portraits look quite naturalistic and, in the case of Nefertiti, beautiful. But these reactions are also somewhat misleading. The "naturalism" was fully as programmatic as the earlier exaggeration; and Nefertiti's beauty was, in fact, an open sexuality, made explicit by her voluptuously swelling belly, hips, and thighs, under a garment that appears to be open, or, at least, completely transparent, in front. In the absence of the traditional goddesses, banished by her husband, Nefertiti was the principal embodiment of female fertility.

The remains of several sculptors' workshops at Amarna provide some idea of how this style was arrived at. Among these studios, the richest in finds was the establishment of the sculptor Thutmose, whose responsibilities seem to have included the establishing of official royal likenesses for certain kinds of sculpture. The famous head of Nefertiti in her characteristic cylindrical blue crown,[53] almost certainly the work of Thutmose's hands, was a sculptor's model for lesser masters to imitate. The studio also yielded

numerous plaster faces, some of them looking like life masks, but all showing signs of having been reworked. These suggest, as others have noted,[54] that Thutmose created his likenesses by progressively refining the features of an original cast. However, the numerous plaster masks of people, most of them mature or elderly, for whom no sculpture is known to exist[55] suggest a deeper or more experimental interest in portraiture on the part of Thutmose, who deserves to be recognized as one of the world's great portrait sculptors. It is worth noting that Akhenaten had recognized his quality.

Tutankhamun's portrait likeness originated at Amarna, before he became king (cf. cat. no. 58). It is possible to trace the development of his royal representations from a juvenile to a more mature style. Though recognizable, these representations are drenched in a sensuous style that so strongly recalls Amarna that it seems to contradict the revisionist, traditional ideology they were supposed to embody (cat. no. 63).

The lack of royal portraiture in the later New Kingdom is probably related to the absence of any strong artistic style. It is worth noting, however, that Ramesses II, who commissioned so many statues and usurped so many others—the faces and bodies of which were often re-carved to bring them up to date—never had a portrait likeness. His representations managed to remain generic, while varying considerably in detail (see cat. no. 89).

Elsewhere in this catalogue (cat. no. 120), I have discussed the representations of the Twenty-fifth Dynasty Kushite kings whose likenesses, despite individual variations, were essentially ethnic images, carefully modified to suit their role in Egypt. We are reminded again of the considerable sophistication the ancient Egyptians brought to portraiture, and it is well to keep this in mind when considering private portraiture of the Twenty-fifth Dynasty.

It was probably not to be expected that native Egyptians, no matter how loyal, would have their features modeled after those of foreign kings. The consequent need for a new private sculptural style may have spurred the increase in archaism in this period (see below, p. 43) which led, directly or indirectly, to a new form of portraiture, inspired by the "late Middle Kingdom private portraits" (see p. 36 above). The Twenty-fifth Dynasty versions are middle-aged or elderly faces, more individual-looking than their prototypes. They also have different expressions; instead of the sad

or worried cast on the faces of Middle Kingdom examples, the Twenty-fifth Dynasty portraits are frowning or even scowling. But just as most of the late Middle Kingdom private portraits are not portraits, so it is questionable whether their Twenty-fifth Dynasty successors can be automatically considered portraits. To be sure, at least one individual is frequently represented with a grossly fat body and a broad, round head.[56] But the finest and most detailed portraits, on two statues made for Mentuemhat,[57] are difficult to reconcile with each other and with Mentuemhat's many other statues, on which the faces, though idealized, differ among themselves.[58] In part, Mentuemhat's different visages may represent a Late Period version of the deliberate variety already noted in Old Kingdom private tomb sculpture. But the possibility remains that the scowling faces are merely elaborate faces with scowls—the expression, in this context, certainly connoting authority and power.

The nature or even the existence of portraiture in the rest of the Late Period is very difficult to judge. A possible upsurge at the end of the Twenty-sixth Dynasty (cf. cat. no. 133) may be linked to the development of the only royal portrait likeness of the Twenty-sixth Dynasty, that of the penultimate king, Amasis (see fig. 25). Amasis was a usurper of unknown origin. We do not even know whether, like the family he overthrew, he was of Libyan descent. It is suggestive, therefore, that his narrow, slightly slanted eyes, which appear to be set very high in the head, closely resemble New Kingdom conventions for representing ethnic Libyans.[59] Like the "portraits" of the Kushite kings, the message of Amasis' representations may have little to do with his individual appearance, but rather express his ethnic relationship, whether real or fictive, to his predecessors. One must also question the striking "portraits" on the architectural slabs of Nectanebo I (cat. no. 134), Psamtik I, and Psamtik II. In this case, a shared context seems to have dictated the poses of all the figures, their very unusual headdresses, and thus also, quite possibly, the apparently individualized but otherwise unparalleled representations of their faces.

So murky is the status of portraiture at the end of the Thirtieth Dynasty that the appearance of Ptolemaic private portraiture comes as something of a relief, because we can be quite sure that most, perhaps all, examples are individual likenesses (see fig. 26).

Despite arguments to the contrary,[60] I see little reason to doubt that they are true portraits. They may well represent a continuation of the Egyptian portrait tradition, which by this time was very long and varied, but they may also reflect the influence of Hellenistic portraiture, which was used for representations of the Ptolemies in Hellenistic style.

The powerful men for whom Ptolemaic private portraits were made were, to judge from the shaven heads of most of them, priests, members of a group who were well acquainted with the culture of their rulers (cf. cat. no. 140).[61] This familiarity is evident in the incorporation into their portraits of Hellenistic stylistic details (see cat. nos. 141, 144).

It is partly because each example is unique that Ptolemaic private portraits have thus far resisted all attempts to arrange them within a convincing chronological framework. Systems based on classifying the head shapes of the shaven skulls or on the classifier's interpretation of facial expressions[62] are almost guaranteed to fail, and they do. A recent division into earlier and later groups, on the basis of the costumes and inscriptions of the few complete examples,[63] offers a more practical starting point. Continuing efforts to classify this important group of Egyptian sculpture should also take into account the existence of major regional traditions and artistic schools, centered on the great temples. Finally, we need to investigate the progressive blending of Egyptian and Hellenistic portrait traits and ask why, as this blending progressed toward a new composite style at the end of the Ptolemaic Period, interest in portraiture itself seems to have been diminishing in favor of more expressively exaggerated visages (cat. no. 144).[64]

*Fig. 25. Head of King Amasis. Twenty-sixth Dynasty (570-526 B.C.). Dark red quartzite, ht. 11 in. (27.5 cm). The Walters Art Gallery, Baltimore (22.415). Fig. 26. Portrait Head of a Man. From Saqqara. Ptolemaic Period (ca. 200 B.C.). Graywacke, ht. 4 1/4 in. (10.8 cm). Museum of Fine Arts, Boston; Purchase of Edward P. Warren, Pierce Fund, 1904 (04.1749).*

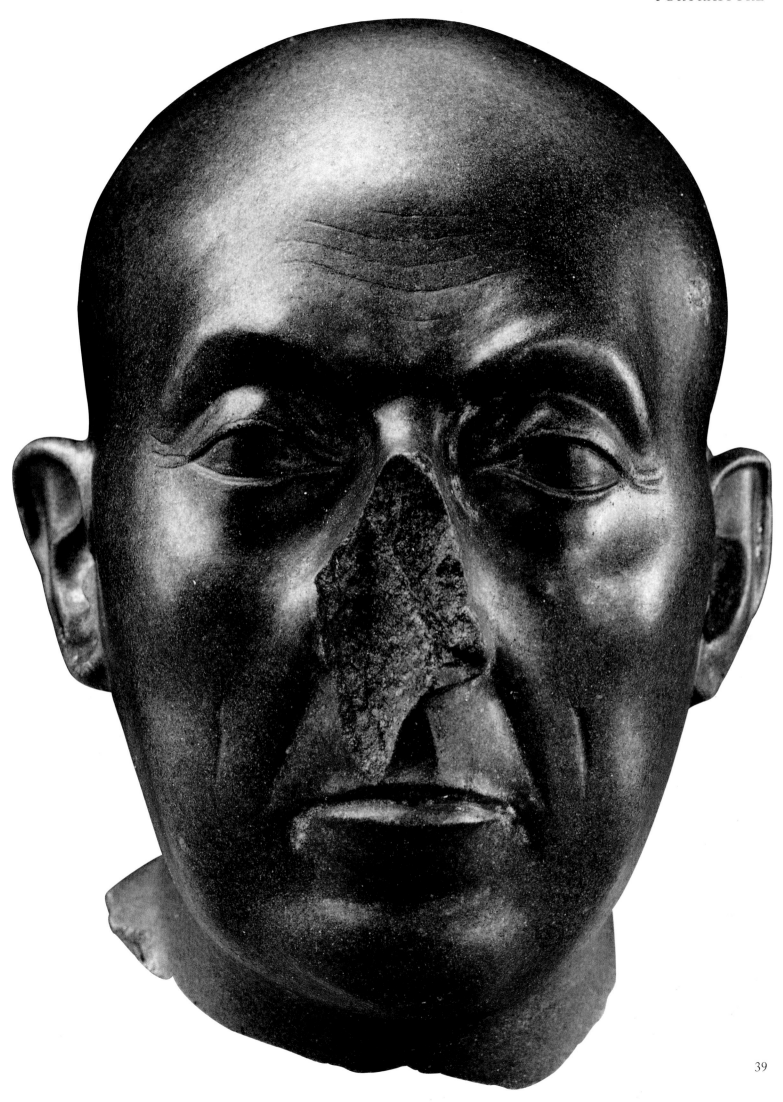

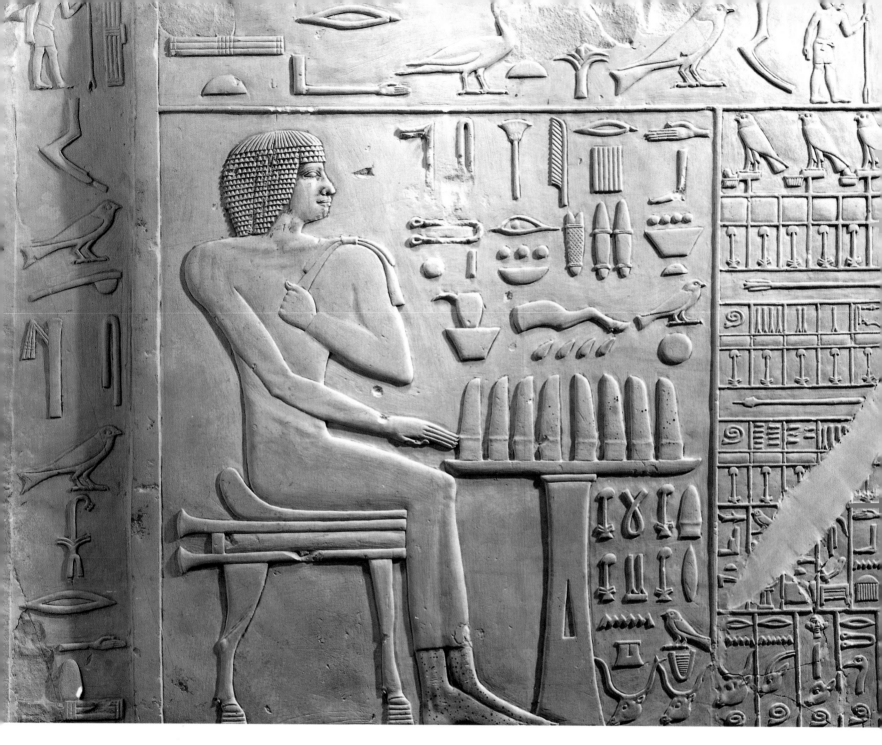

## Archaism

In ancient Egypt, archaism—here defined as the imitation or emulation of older works—is found in forms as diverse as art and architecture, writing, and personal names and titles.[65] To date, the most detailed and precise studies of archaism have dealt primarily with written texts;[66] when such studies also include art, the latter is treated in a markedly more cursory manner.[67] This essay, dealing only with Egyptian sculpture and relief, will discuss some of the salient aspects of Egyptian archaism and some of the problems and possibilities that merit future study.

It is important to note that archaizing Egyptian art is almost never an exact copy. Egyptian artists trained by copying, and throughout their careers they were expected to imitate models, which could sometimes, as in the features of a royal likeness, be complex and subtle in their detail. When these artists wanted to

*Fig. 27. Wall Relief with Offering Scene (detail). From Medum, Tomb of Rahotep. Fourth Dynasty, reign of Sneferu (ca. 2600 B.C.). Limestone, formerly painted, ht. of entire fragment, 31 ¹/₈ in. (79 cm). The British Museum (EA 1242).*

produce facsimiles, they could; but archaism usually involved, not only the selection of suitable prototypes, but also some degree of reinterpretation and, on occasion, "improvement." Thus, any "archaizing" Egyptian work that seems almost identical to its purported models needs to be examined with extra care. The recent recognition that some private statues supposedly dating from the Twenty-fifth Dynasty but made in the style of the late Middle Kingdom actually date to the Middle Kingdom,[68] along with the growing consensus that a number of "Third Intermediate Period" royal representations considered to be archaizing imitations of the Thutmoside Eighteenth Dynasty are, in fact, Eighteenth Dynasty

originals (cat. no. 49),[69] testify to the hazards of overly facile attributions of archaism. Since modern viewers cannot expect to recapture all stylistic nuances that would have been apparent to the artist, problems of this kind can be resolved only by the most exacting observation and analysis.[70]

An even greater obstacle to understanding and recognizing archaism in Egyptian art is imposed by accidents of survival. We are very well informed about archaizing Egyptian art in a few periods and a few places, most notably Thebes in the Twenty-fifth and the Twenty-sixth Dynasties. For other times and in other locations, material is scanty, or, all too often, almost nonexistent. As a result, it is often difficult to decide whether a particular example is the product of an archaizing revival or a continuous, though ill-attested tradition. The Eighteenth Dynasty cloaked statue of Senenmut (cat. no. 44) is a case in point: is it based on cloaked prototypes of the Middle Kingdom (cf. cat. no. 28), or was this type of statue made at Thebes throughout the turbulent and monument-poor Second Intermediate Period, as a few early Eighteenth Dynasty examples suggest? Such questions can have significant bearing on our understanding of larger issues, such as political and religious practices. Representations of the *sed*-festival, for example, are so few and so fragmentary that the Twenty-second Dynasty reliefs showing Osorkon II's *sed*-festival (cat. no. 113) are routinely combined with examples as early as the First Dynasty for purposes of describing and analyzing this very important ritual. But can we assume that the later representations, made at a time when archaism was a major component of royal representations, accurately reflect the rite as it was practiced in the Twenty-second Dynasty? And to the extent that they are archaizing, what were their models and how faithfully were these imitated?

The most problematic period of Egyptian archaism is undoubtedly the Old Kingdom. Specialists in this period tend to minimize the significance of archaism at such an early date, and some refuse to admit that it existed at all. It has certainly not been sufficiently taken into account in recent thoroughgoing revisions of the dates of Old Kingdom tombs and statues.[71] This is particularly unfortunate because the cemeteries of Old Kingdom Memphis —Saqqara, Giza, Dahshur, Medum, Abusir—have produced quantities of royal and private sculpture and reliefs, which span the full period from the Third through the Sixth Dynasties. Comparative material from the First and Second Dynasties is, of course, much scarcer and more scattered, but even so, parallels can be drawn. I have discussed above the composite representations of stools on some Early Dynastic reliefs and suggested that the reappearance of this feature in the Fourth Dynasty (see fig. 27), and even later in the Old Kingdom,[72] is an archaism. The scholar who has most recently discussed this type of stool in Old Kingdom tomb reliefs dismisses the possibility that they are archaizing.[73] But the distribution of these examples argues against that conclusion, as does the fact that the Old Kingdom versions have been "improved" by greatly reducing the width of the seat top between the two side frames to soften the visual discrepancy with the side views of the

cushion above and the stool legs below. This type of alteration strongly suggests conscious archaism.

The role of archaism in the art of the early Middle Kingdom is widely recognized. While the Theban dynasts and their subjects at the beginning of this period were represented in a style that is clearly a regional variant of late Old Kingdom style (see cat. nos. 13–15, 18), influences from the Old Kingdom monuments of the Memphite area can be discerned at Thebes soon after the reunification of Egypt (see cat. no. 16). The Twelfth Dynasty, having moved its capital closer to Memphis, adapted Old Kingdom royal representations to create the classical style of the Middle Kingdom (see cat. no. 21).[74]

The reappearance of royal portraiture later in the Twelfth Dynasty, especially for Sesostris III (see cat. nos. 29–30) and Amenemhat III (see cat. no. 31), appears to have been independent of any influence from Old Kingdom portraiture. However, certain representations of Amenemhat III give the strong impression of being archaizing, albeit from prototypes that have not survived. The most striking of these is a bust of the king, apparently in the guise of a priest.[75] His leopard-skin vestment is fastened on his proper left shoulder with an archaic form of knot that went out of continuous use during the Old Kingdom. Under the usual artificial royal beard, his own heavy beard can be seen. This feature appears to be unique for royal sculpture from the Old Kingdom through the Late Period, as is the form of Amenemhat's heavy wig, which seems to consist of thick tresses laid across the head and bound at the ends. There is evidently a prototype for this wig, however, on a very archaic (First Dynasty?) statue found in the early temple at Hierakonpolis.[76] This figure also has a natural beard. It is most unlikely that it or equally early examples were prototypes for Amenemhat's statue, which incorporates additional features such as the leopard pelt, a dangling ritual necklace, and two slender falcon-headed standards. But the archaic quality of Amenemhat's costume and accessories, and perhaps even the pronounced modeling of his heavy portrait features, strongly suggest an archaic prototype, perhaps from the reign of Djoser, at the beginning of the Third Dynasty.

Admittedly, this reconstruction of late Twelfth Dynasty archaism is purely hypothetical. But two other versions of Amenemhat III's representations also suggest the imitation of very early models. On a double statue of the king holding altars laden with fish and papyrus stalks, and on a bust of him as well,[77] he wears, not the royal headdress found on New Kingdom versions of kings presenting altars (cf. cat. no. 63), but another heavy, archaic type of wig, together with an otherwise unattested flap-like beard. Sphinxes of Amenemhat III that show only his face, encircled by a lion mane and ears,[78] may have been invented for this king; but if so, they were a reinvention. The earliest known sphinx, which represents a royal woman, shows only her face with lion ears and a combination mane/headdress.[79] Taken together, these suggestions of archaism in the sculpture of Amenemhat III are too numerous to ignore.

The second reunification of Egypt by a Theban dynasty at the

beginning of the New Kingdom was accompanied by a revival of the Theban style of the early Middle Kingdom.[80] Since there would also have been quantities of reliefs and statues of the later Middle Kingdom, including the portraits of Sesostris III and Amenemhat III and the slightly later private "portraits," these kings' choice of models in the earlier style must have been deliberate, to emphasize the new regime's Theban heritage and possibly to associate them with the great kings of the past—Mentuhotep II, the first re-unifier of Egypt, and Sesostris I, who had left numerous monuments in Theban temples. In particular, relief representations of Amenhotep I at Karnak closely resemble the Karnak reliefs of Sesostris I. Amenhotep's archaizing representations differ from their models in a slightly different shape of the nose and mouth and greater emphasis on the carving of the nostrils. These same features are combined with other distinctive forms, such as round, full cheeks, on what appear to be portrait statues of Amenhotep I (see fig. 23). Amenhotep's statues do not resemble any known statuary of Sesostris I; but since they clearly have some relationship to the earlier king's reliefs, and since Sesostris I's sculptural imagery at Thebes was exceptionally varied (cf. the discussion of cat. no. 21), one wonders whether another variation, now lost, may have provided the prototype for Amenhotep I's portrait (?) statues. Amenhotep I was the only king of the Eighteenth Dynasty before Amenhotep III, some six generations later, for whom a distinctive likeness was developed. Archaism was certainly a contributing factor in this development, and possibly the decisive one.

In the private sculpture and relief of the Eighteenth Dynasty, archaism is hard to recognize. Some possible examples, such as the cloaked figure of Senenmut (cat. no. 44) mentioned above, may in fact represent the last vestiges of a continuous tradition. Two unmistakable instances of archaism, however, can be found in statues of Amenhotep III's great official Amenhotep son of Hapu, who was by all indications a remarkable man. On the most famous of his statues, the inscription states that he was eighty years old, and the corresponding image shows him with an aged face. The pose of this statue, the costume, and the wig are all derived from Middle Kingdom private sculpture, and so, of course, is the face.[81] Amenhotep having decided to be represented as an old man, in a time when age was not depicted in private sculpture or reliefs, he or his sculptor evidently turned to the only models available, late Middle Kingdom private "portraits." A second statue of Amenhotep son of Hapu shows him with a youthful face, but with a wig, prayerful pose, and stylized fat folds of Middle Kingdom type.[82] Thus it would seem that this extraordinary individual had developed an interest in archaism. If that was indeed the case, it may have been

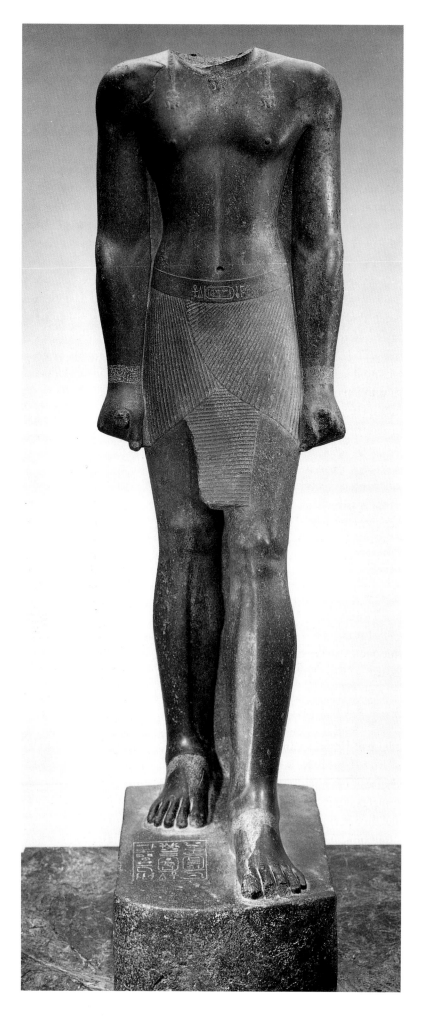

*Fig. 28. Standing Statue of King Tantamani. From Gebel Barkal. Twenty-fifth Dynasty (664-ca. 656 B.C.). Granite, ht. 79 1/2 in. (202 cm). Toledo Museum of Art (49.105). Fig. 29. Standing Statue of a Man. Thirtieth Dynasty, reign of Nectanebo I (381–362 B.C.). Diorite, 20 -3/16 in. (51.2 cm). Brooklyn Museum of Art; Charles Edwin Wilbour Fund (52.89).*

the existence of Middle Kingdom models for age that inspired him to commission his eightieth-year statue.

Perhaps the most interesting aspect of archaism in the New Kingdom is its failure to materialize as a significant force at a time when one might have most expected it: during the counter-reformation of the late Eighteenth and early Nineteenth Dynasties against the Amarna heresy. Although the Amarna style was very closely associated with Akhenaten's religious beliefs, no real attempt seems to have been made to eliminate it until after the death of Horemheb. Under Sety I and Ramesses II, numerous archaizing elements from several styles of the earlier Eighteenth Dynasty can be detected, but no clear pattern emerged. This apparent lack of direction is characteristic of Egyptian art in the Ramesside Period, which, though it produced many impressive monuments (see fig. 9), never developed a distinctive, unified style.

So much has been written in recent years about archaism in the Third Intermediate Period and Late Period[83] that it may be most useful here to point out certain facts and problems that deserve further consideration and investigation. However much we may be missing from earlier periods, there can be no question that archaism flourished from the Twenty-first Dynasty into the Twenty-sixth, to so great an extent that it might almost be called a movement. It is also clear that this movement began in representations of kings and local rulers of Libyan descent in northern Egypt and that the prototypes were intially drawn from Old Kingdom sculpture and relief.[84] During the Twenty-second Dynasty, the images of Libyan rulers, both in the north and in the south, at Thebes, were sometimes based on New Kingdom models, probably specifically representations of the much-revered Thutmosis III.

Throughout this last and greatest phase of Egyptian archaism, models seem to have been selected primarily on the basis of what was still accessible in temples, and perhaps in tombs. In the north, where the focus was apparently on Memphis, the sources for royal and private archaism were preponderantly from the Old Kingdom (cf. cat. no. 23),[85] though later periods were by no means excluded (cf. cat. no. 133). In the south, power was centered at Thebes, where little or no Old Kingdom material was available; Theban archaism relied on Middle Kingdom and New Kingdom

models (cat. nos. 122, 129). Opportunistic and accidental though it seems to have been, this divergence of source materials constitutes a major difference between Third Intermediate Period and Late Period archaism in the north and in the south. This difference is too often overlooked, as is the fact that our knowledge of archaism in this period derives almost exclusively from the abundance of examples from Thebes. Attention to the regional differences would surely produce results, as the following examples may show.

The archaizing aspects of representations of the Kushite Twenty-fifth Dynasty kings—the forms of their bodies, their costumes (see fig. 28), even the "Egyptian" qualities of their faces (cf. the discussion of cat. no. 120)—are entirely Old Kingdom and thus Memphite in origin.[86] This underscores the fact that it was Memphis, rather than their power base at Thebes, that had central meaning for these rulers. If only for its strategic importance, Memphis was where they resided, and, whether deliberately or not, it was from the Memphite Old Kingdom models that their self-presentation as Egyptian kings derived. Examples of this Old Kingdom archaizing are occasionally found at Thebes in Twenty-fifth Dynasty private tombs and statues.[87] These are clearly importations of royal style by Kushite loyalists. They can be compared to the Old Kingdom elements on a few Theban statues of the early Twenty-sixth Dynasty, which must be related to that city's acceptance of the northern ruler Psamtik I (see cat. no. 126).[88]

I have questioned above (p. 38) whether Theban "portraits" of the Twenty-fifth and early Twenty-sixth Dynasties are in all cases portrait likenesses or whether some represent elaborate depictions of age and authority, inspired by, as well as derived from, the numerous available late Middle Kingdom examples. Similar questions apply to the emergence of naturalistic-looking, expressive faces (see cat. no. 132) and possibly portraits at the end of the Twenty-sixth Dynasty. This appears to have been a wholly northern development, which may represent the continuation of a Twenty-sixth Dynasty 'portrait' tradition in the north, of which little has survived.[89] But scattered examples such as catalogue number 133 may also be our only evidence of a new wave of archaizing, turning to Middle Kingdom sources in the north.

There is also the possibility that catalogue number 133 was itself modeled on a Twenty-fifth or early Twenty-sixth Dynasty archaizing statue. If so, it would be a forerunner of a number of archaizing private statues of the Thirtieth Dynasty, whose prototypes were Twenty-sixth Dynasty statues imitating Old Kingdom originals (see fig. 29, and cf. cat. no. 123 and fig. 3).[90] For the modern observer, this immediately raises the question of just what these latest archaizing sculptors and their clients thought they were imitating. Though we cannot be sure, some slight clues and inscriptions,[91] together with the very strong Twenty-sixth Dynasty influence on idealizing private and royal representations (cf. cat. nos. 135–37), suggest that the models were selected because they were known to belong to the Twenty-sixth Dynasty, with little thought or, probably, knowledge of their antecedents.

The meaning and purpose of Egyptian archaism are important subjects, dealing as they do with basic issues of the meaning of Egyptian art, the sense of self and self-presentation, and, perhaps most intriguingly, knowledge and awareness of the past.[92] It is not enough to say that this extremely conservative culture, which abhorred change, used archaism to resist and reverse change, though that is certainly true. But as I have tried to suggest, reasons for reviving the past varied perceptibly among different periods and occasionally even among individuals. It cannot be accidental that the greatest wave of archaism, in the Third Intermediate Period and the Late Period, occurred in an era of major political, social, and economic change and instability. But the recent explanation that archaism was devised by priests, with the purpose of reasserting the power of the ruling class,[93] is far too narrow, not least because it ignores the fact that Third Intermediate Period archaism was instigated and sustained by rulers who were either of foreign (Libyan) descent or foreign (Kushite) birth. These kings and princes, often embattled and weak, had a great need to establish their authenticity as pharaohs, a need made very nearly explicit in some Kushite royal texts. For them, as for most ancient Egyptians, Egypt was old; "true" Egyptian art was truly old; and so was true Egyptian kingship.

## Notes

1 Examples: Ikram/Dodson 1998, p. 237, fig. 315; Taylor 1989, p. 58, fig. 47; also the more confused version p. 52, fig. 41.

2 For a comparison of these conventions with technical drawings, see Rauschenbach 1996, pp. 76–80. It is hardly necessary to conclude, with him, that this represents a different concept of space. For recent attempts to interpret representations of buildings, see Doyen 1998, and works cited therein.

3 E.g., Saad 1969, p. 150, pl. 70.

4 Quibell 1913, pls. 18–20.

5 Smith, W.S. 1949, pl. 31b.

6 Petrie 1892, pls. 13, 20, 24; in pl. 15, the owner and his wife sit on stools in profile. The seated figure of pl. 13 is now British Museum EA 1242: fig. 27.

7 E.g., the drawing for unfinished tomb reliefs of Nespakashuty: Fazzini/Romano/Cody 1999, no. 75, p. 126.

8 E.g., the early Fourth Dynasty relief of Wep-em-nefret (Berkeley, P.A. Hearst Museum 6-19825): fig. 15.

9 E.g., the Hierakonpolis painted tomb: Quibell/Green 1902; most recently, Adams 1999b, pp. 23–25, and Cialowicz 1998.

10 Alexanian 1999.

11 Petrie 1892; *Egyptian Art* 1999, no. 24 A–C, pp. 199–201; Saleh/Sourouzian 1987, no. 25a, b.

12 Freed/Markowitz/D'Auria 1999, p. 93, fig. 64; nos. 82, 83, p. 229; Saleh/Sourouzian 1987, no. 170.

13 Russmann 1980, pp. 62–63, fig. 1.

14 For their infrequency during the Ramesside Period, see Strudwick 1994, pp. 323–24.

15 Not indexed in PM I, 1 1960, but see pp. 469–70 (24, 25).

16 These are impressions drawn from personal observation. Banquet scenes have not been compiled or tabulated, so far as I know.

17 There are several representations of male guests vomiting, e.g., in Theban tomb 38: Davies, N. de G. 1963, pl. 6; at least one example, in Theban tomb 49, shows a woman: Davies, N. de G. 1933, pl. 18.

18 Manniche 1997.

19 PM III 1981, p. 903 (1a, b); PM I, 1 1960, p. 467 (17); also Feucht 1992.

20 Feucht 1992; cf. Van Walsem 1998, p. 1212.

21 For a religious, mythical interpretation, see Kessler 1987.

22 Shedid/Seidel 1996, p. 52; Peck 1978, pl. 7.

23 Russmann 1980.

24 Now in the Ashmolean Museum, Oxford University: Freed/Markowitz/D'Auria 1999, p. 93, fig. 64.

25 Freed/Markowitz/D'Auria 1999, no. 54, p. 220 (New York MMA 1985.328.6).

26 Also Freed/Markowitz/D'Auria 1999, no. 59, p. 222 (Brooklyn BMA 60.197.7).

27 Russmann 1980, pp. 68–71.

28 The statue (Cairo JE 49158): Russmann 1989, no. 3, pp. 14–16; Saleh/Sourouzian 1987, no. 16. The reliefs: Firth/Quibell 1935, II, pls. 16–17, 40–42; cf. Smith, W. S. 1949, pl. 31a.

29 Djedefre: *Egyptian Art* 1999, no. 54, pp. 248–50; Smith, W. S. 1949, pl. 11. Chephren: *Egyptian Art* 1999, nos. 56–61, pp. 253–59. Mycerinus: ibid., nos. 67–70, pp. 268–76; Smith, W. S. 1949, pl. 13.

30 Particularly telling are the variations on Mycerinus' faces in his intact triads, part of a set, all in the same stone and all the same size; e.g., *Egyptian Art* 1999, no. 68, pp. 272–73; Smith, W. S. 1949, pl. 13c.

31 Hesy-Re: *Egyptian Art* 1999, no. 17, p. 188 (Cairo CG 1430); Saleh/Sourouzian 1987, no. 21; Terrace/Fischer 1970, no. 4, pp. 33–36, (Cairo CG 1427). Khai-bau-Sokar: Terrace/Fischer 1970, no. 5, pp. 37–40 (Cairo CG 1385).

32 The seated figure of Rahotep (Cairo CG 3): Russmann 1989, no. 4, pp. 17–19; Saleh/Sourouzian 1987, no. 27.

33 Bust of Ankh-haf (Boston MFA 27.492): *Egyptian Art* 1999, p. 61, fig. 32; Smith, W. S. 1949, pls. 14, 15a.

34 The so-called reserve heads (a few of which are slightly over life-size): Catherine H. Roehrig in *Egyptian Art* 1999, nos. 46–49, pp. 72–81, and pp. 234–41.

35 Note, however, the similarity between the relief representation of one Nofer and the profile of his reserve head, on which the nose was reworked: Smith, W. S. 1949, pl.48d-e. A second comparison, between the statue of Hemiunu (fig. 21) and a relief that may represent him is, in my view, less convincing: ibid., pl. 48b, c; *Egyptian Art* 1999, nos. 44–45, pp. 229–32.

36 Djoser's heavy features (references in n. 28) give an impression of greater maturity. The possibility of a connection between the depiction of age on archaic *sed-*

festival representations of kings (cf. cat. no. 1) and the beginnings of royal portraiture is interesting, but the evidence is very scanty.

37 *Egyptian Art* 1999, no. 197, p. 476; other examples: Smith, W. S. 1949, pl. 9, c, f.

38 Russmann 1995.

39 On the Egyptian concept of the soul, see the discussion of cat. no. 107.

40 E.g., a representation of Sesostris II (Vienna ÄS 5776): Seipel 1992, no. 43, pp. 158–59.

41 Cf. Polz 1995, pp. 251–54; for a more nuanced view, Assmann 1991, pp. 150–59; Assmann 1996, pp. 71–79.

42 Assmann's observation (1991, p. 157; 1996, pp. 77–78) that personality is largely a social construct evades the real issue of *individual* personality.

43 Examples: Louvre E 11053 (with the cartouche of Amenemhat III), A 47: Delange 1987, pp. 69–71, 81–83. It should be noted, however, that unsmiling expressions are characteristic of private sculpture from the mid-Twelfth Dynasty on; the expression predates private imitation of royal features.

44 Robins 1997, p. 117, fig. 129 (British Museum EA 1785); Russmann 1989, nos. 31–33, pp. 69–75.

45 Russmann 1989, no. 33, pp. 74–75.

46 Romano 1976, pp. 97–102, pls. 26, 27; Russmann 1989, no. 36, pp. 81, 82.

47 Except for a feminized version on the coffin of his wife, Merytamun (Cairo JE 53140): Saleh/Sourouzian 1987, no. 127.

48 Respectively, Cleveland 61.417: Kozloff/Bryan 1992, no. 8, pp. 124, 159–61; Cleveland 52.513: ibid., no. 11, pp. 166–67, 187; no. 52 in this catalogue; Cairo JE 59880: Freed/Markowitz/D'Auria 1999, no. 11, p. 204.

49 Bryan in Kozloff/Bryan 1992, pp. 198–99.

50 Freed/Markowitz/D'Auria 1999, nos. 22–24, p. 208.

51 Saleh/Sourouzian 1987, no. 160; no. 60 in this catalogue.

52 Most recently, a "diagnosis" of Marfan's syndrome: Burridge 1993.

53 Berlin 21300: often illustrated, e.g., Arnold, Do. 1996, pp. 64, 66, figs. 58, 60; Freed/Markowitz/D'Auria 1999, p. 84, fig. 57.

54 Arnold, Do. 1996, pp. 46–51; Assmann 1991, pp. 148–49; Assmann 1996, pp. 68–69.

55 E.g., Arnold, Do. 1996, p. 35, fig. 28; p. 46, fig. 36; Freed/Markowitz/D'Auria 1999, no. 139, p. 247. For suggestions as to the uses or identities of the nonroyal masks, see Arnold, Do. 1996, pp. 49, 51.

56 For the known statues of this man, Harwa, see Gunn/Engelbach 1931; cf. Tiradritti 2000, p. 10, n. 1. Two of his statues are in the British Museum: EA 32555, 55306. A similar relief representation in his tomb: Russmann 1983, p. 146, fig. 5; Tiradritti 2000, fig. 7, p. 30.

57 Russmann 1989, nos. 78, 79, pp. 172, 173.

58 His statues are illustrated in Leclant 1961, pls. 1–28.

59 E.g., Saleh/Sourouzian 1987, nos. 206 (central captive), 226 (left). For a Twenty-sixth Dynasty private statue with "Libyan" features, see Bothmer 1960, no. 18, pp. 20–21, pl. 16.

60 Bianchi 1988, pp. 55–59.

61 Vittmann 1998, especially pp. 74–75.

62 Bianchi 1988, pp. 57–59; Schmidt 1997.

63 Kaiser 1999.

64 See Brooklyn BMA 58.30: Fazzini/Romano/Cody 1999, no. 93, p. 147; and Cairo CG 697: Russmann 1989, no. 92, pp. 201–203; both having distinctive features, but with exaggerated eyes and a lessening of naturalistic detail.

65 For a summary of these categories, see Brunner 1975.

66 E.g., Grimal 1981.

67 E.g., Der Manuelian 1994b.

68 Josephson 1997b, pp. 3–5.

69 Also a royal bust in the Metropolitan Museum of Art, now exhibited in the Third Intermediate Period galleries, but more probably a representation of Thutmosis III (44.4.68): Hayes 1959, p. 145, fig. 80.

70 The best example published so far is Sourouzian 1991.

71 E.g., Cherpion 1989; *Egyptian Art* 1999.

72 Cherpion 1989, pl. 41b (Ptahhotep).

73 Cherpion 1989, pp. 32, 109.

74 For these developments, see Arnold, Do. 1991.

75 Cairo CG 395: Russmann 1989, no. 29, pp. 66–68; Saleh/Sourouzian 1987, no. 103.

76 Quibell/Green 1902, pl. 1.

77 Respectively, Cairo CG 393: Saleh/Sourouzian 1987, no. 104; Vandier 1958, pl. 69/2–4; Rome, Museo Nazionale Romano 8607: Barberi/Parola/Toti 1995, no. 2, pp. 132–34; Vandier 1958, pl. 70/3–4; Wildung 2000, no. 59, pp. 133, 187.

78 E.g., Cairo CG 394: Russmann 1989, no. 28, p. 65; Saleh/Sourouzian 1987, no. 102.

79 Cairo JE 35137: Fay 1996, no. 1, p. 62, pl. 83a–d.

80 Romano 1976.

81 Cairo CG 42127: Russmann 1989, no. 51, pp. 106–10; Sourouzian 1991.

82 Cairo CG 551: Vandier 1958, pl. 171/4.

83 E.g., Bothmer 1960; Shubert 1989; Der Manuelian 1994b; Neureiter 1994; Josephson 1997b.

84 Cf. Fazzini 1972, pp. 64–68.

85 Also the standing figure of the northern vizier Bakenrenef (Boston MFA 1970.495): Myśliwiec 1988, pp. 52–53, 120, pl. 57a,b.

86 Taharqa sent Memphite sculptors to Kawa, in Kush, where they decorated temple walls with copies of Old Kingdom royal reliefs: Macadam 1949, 1955, p. 21, n. 51, pl. 9.

87 For Old Kingdom influence in Theban tomb reliefs, see Russmann 1983, pp. 140–42, and figs. 1–3, pp. 144–45 (Harwa, Theban tomb 37); Russmann 1997, pp. 28–30, with fig. 4 (Mentuemhat, Theban tomb 34). Statues: Russmann 1989, nos. 78, 80, pp. 170–72, 175–77.

88 Also the scribe statue of Nespakashuty (cf. cat. no. 129), who was Psamtik's southern vizier: Russmann 1989, no. 83, pp. 178–82 (Cairo JE 36662).

89 E.g., the scribe statue of a ruler of the Delta city of Mendes under Psamtik I, whose distinctive aged face differs in both style and expression from its Theban counterparts (Palermo 145): Bothmer 1960, no. 20, pp. 22–24, pls. 18–19.

90 See Fazzini/Romano/Cody 1999, no. 79, pp. 131–32; cf. Bothmer 1960, pp. xxxvii, 100–104.

91 E.g., Jansen-Winkeln 1997.

92 Much has been written on this subject; for a critical review of the main theories, see Neureiter 1994, pp. 222–33.

93 Neureiter 1994, especially pp. 253–54.

# The Formation and Growth of the Egyptian Collections of the British Museum

## T. G. H. James

An independent Department of Egyptian Antiquities has existed in the British Museum only since 1955, when the existing Department of Egyptian and Assyrian Antiquities was divided. But Egyptian antiquities have formed part of the collections of the British Museum since its foundation in 1753; and since the early years of the nineteenth century, and the arrival of the Rosetta Stone (fig. 31), they have occupied a notable position among the museum's exhibitions.

The establishment of the British Museum in the mid-

eighteenth century may be attributed generally to the atmosphere of the European Enlightenment but quite specifically to the interests and the initiative of one man, Sir Hans Sloane (fig. 30). With his wealth and influence, Sloane was a towering presence in an intellectual society of great distinction. Born in

*Fig. 30. Sir Hans Sloane (1660–1753), the founding father of the British Museum. Fig. 31. The Rosetta Stone. Ht. (max.) 3 ft. 9 in. (1.14 m). The British Museum (EA 24).*

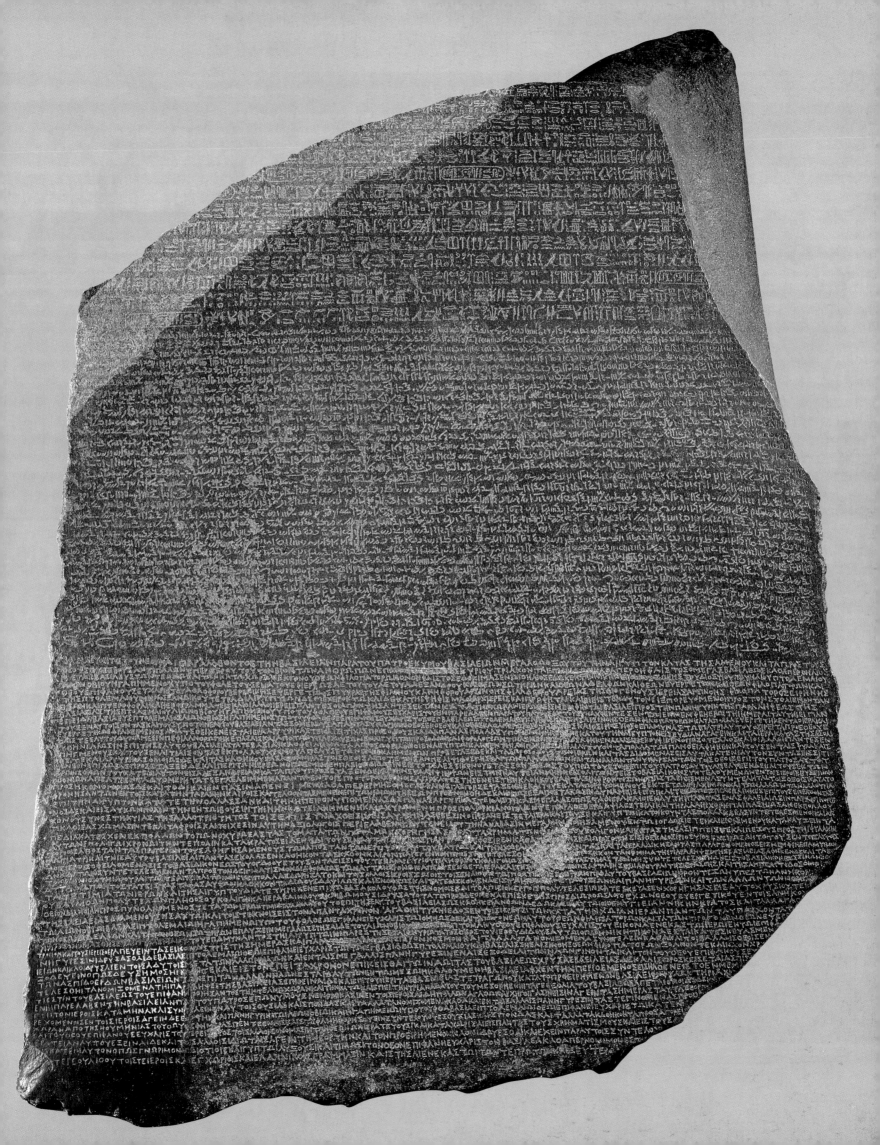

1660, he qualified as a physician in 1683; from 1719 he was president of the Royal College of Physicians, and from 1727, president of the Royal Society, the premier intellectual institution in Great Britain.[1] He was also a collector of great discrimination, building up holdings in most fields of human interest—books, manuscripts, works of art, flora and fauna, geology, coins, and antiquities. He established a cabinet of curiosities without parallel in the country, engaging friends and strangers to bring back from abroad anything that might contribute something new to his huge private museum.

Toward the end of his long life, Sloane set about installing his collections and library in his home, the manor house of Chelsea, then in the suburbs of London, and he developed the wish to have

*Fig. 32. Montagu House, the first home of the British Museum.*

what he had gathered together preserved as a permanent public museum for the British nation. Provisions to that end were included in his will, and when he died in January 1753, the Sloane collection was offered to the king, as representative of the country, for £20,000. With unusual speed Parliament passed an act making provision for the raising of funds to purchase and house the collection, and also those other collections that had been given or promised to the nation. With money raised by a national lottery, Sloane's museum was secured, and Montagu House (fig. 32) in Bloomsbury was acquired to house it.[2] It was a very happy outcome, the benefits of which continue to this day. The British Museum still

occupies the original site, and Sloane's enlightened wish has been fully realized.

Along with the British Museum was born also its Egyptian collection. A small group of antiquities from Egypt, about 150 pieces in all, seems to have come into Sloane's possession by chance.[3] There is no evidence that he displayed any particular interest in ancient Egypt, and he did not belong to that small company of distinguished collectors and dilettanti who had formed the short-lived Egyptian Society (1741–43). Among the usual small antiquities—*shabti* figures, divine bronzes, amulets, scarabs—Sloane had possessed one rather more substantial piece, the stela of Nekau.[4]

The Nekau stela had been illustrated in a series of plates published by Alexander Gordon that also included illustrations of other objects in the possession of various members of the Lethieullier family, who had strong connections with Egypt and the Levant through trade and travel.[5] William Lethieullier, who died in 1756, bequeathed his antiquities to the "Public Museum in Montagu House"; they included the first mummy and coffin to enter the collections. These were accompanied shortly by another mummy and coffin, donated by Pitt Lethieullier, a nephew of William; and other small objects were presented by Smart Lethieullier in 1758. The Lethieulliers had been members of the Egyptian Society and well represented the slow but growing interest in things Egyptian during the mid-eighteenth century.[6] This was a time when a few adventurous travelers visited Egypt and published illustrated accounts of the land and its monuments. Among these were Frederik Ludwig Norden and Richard Pococke; the former, a Danish naval officer, surveyed Egypt for King Christian VI in 1738, his *Travels in Egypt and Nubia* being published posthumously in 1755; the latter, an Anglican clergyman, published his *Description of the East, and Some Other Countries* in two volumes in 1743-45.[7] There was, however, little to nourish the interest of the generally educated person, and the few Egyptian objects in the British Museum scarcely represented a strong attraction for the general public.

The pace of collecting scarcely changed for the rest of the eighteenth century, with just a few monumental pieces coming from the "archaeological" activities of Edward Wortley Montagu, a disreputable scion of a distinguished family, who was attracted to Egypt as his mother had been to Turkey.[8] His modest excavations produced some inscribed slabs from Delta temples that he passed to his brother-in-law, the Earl of Bute, who directed them on to the British Museum by way of King George III. It cannot be said that British interest in Egypt, except from a political standpoint, was active in the later eighteenth century until the scene was dramatically altered by Napoleon's invasion of the country in 1798. The outcome of this ill-starred enterprise was crucial for the beginnings of Egyptology as an academic discipline and fundamental for the creation of a substantial and wide-ranging collection of Egyptian antiquities in the British Museum.[9]

The most important result Egyptologically of the French invasion of Egypt was the discovery of the Rosetta Stone during the reconstruction of the Qait Bey Fort (renamed Fort St. Julien by the French) at Rashid (Rosetta), on the Delta coast. The credit for recognizing the potential significance of the three bands of text in different scripts must go to Lieutenant Pierre Bouchard, who sent the precious monument, by way of his commanding officer, to Cairo, to the learned Institut set up there by Napoleon.[10] With the capitulation of the French forces in Egypt in 1801, the Rosetta Stone, along with a number of other large antiquities, was confiscated, brought back to Britain, and in due course deposited in the British Museum. There it has remained, apart from a brief excursion to Paris in 1972 to assist in the commemoration of the 150th anniversary of Champollion's announcement of his breakthrough in the decipherment of the hieroglyphic script.[11] The most unexpected discovery concerning the monument was made quite recently, when an examination revealed that the stone was not black basalt, as had always been claimed, but a species of granite.[12]

Of the other large stone monuments that came to the museum from the Egyptian campaign, most notable were some life-size granite figures of the lioness-goddess Sakhmet from Thebes and a huge conglomerate sarcophagus. The Sakhmets were just the kind of "idol" to typify the arcane religion of ancient Egypt, as far as the general public was concerned; the sarcophagus, a wondrously massive container, covered with inscriptions inside and out, was already provided with its own fanciful mythology. It had been found in the courtyard of the Attarine mosque in Alexandria, previously the site of the church of St. Athanasius. Used as an ablution tank, it was traditionally thought to be the sarcophagus of Alexander the Great, and it was as such that it had been removed by the French and then appropriated by the British army. So it was shown in the British Museum, and it remained the sarcophagus of Alexander the Great long after the true ancient occupant was identified as King Nectanebo II of the Thirtieth Dynasty (360–343 B.C.), the last native Pharaoh of Egypt.[13]

The acquisition of so many large and heavy stone monuments created something of a problem in Montagu House, where domestic flooring was not capable of supporting huge weights. A new range of galleries was therefore built to accommodate the Egyptian sculptures and the recently acquired Townley Marbles, a large collection of classical sculptures. Soon the Sakhmets and "Alexander" were to be joined by an even larger and weightier monument, the so-called "Younger Memnon," a massive granite bust of Ramesses II.

Important consequences of the French expedition to Egypt were the opening up of the country to diplomatic missions and travelers and the tentative start of a real scholarly interest in the antiquities of Egypt. Among the more learned visitors to Cairo in the first decade of the nineteenth century was a Swiss, Jean-Louis Burckhardt, who had been sent to the Near East by a

British society to collect Arabic manuscripts and to undertake explorations into the little-known parts of Africa and the Levant.[14] Burckhardt formed an alliance with Henry Salt (fig. 33), the British consul-general in Cairo, to bring down from Thebes the great bust of Ramesses lying in the Ramesseum, the mortuary temple of the king, with the ultimate intention of presenting it to the British Museum. To this end they engaged an adventurer, Giovanni-Battista Belzoni (fig. 34), theatrical strongman and entrepreneurial engineer, to remove the great sculpture. It had earlier been greatly admired by William Hamilton, an agent of Lord Elgin, who later became a trustee of the British Museum.[15] In those early times the Ramesseum had been identified as the Memnonium, a structure described in Greco-Roman sources where it is associated erroneously with a mythical King Memnon.

A vast colossus in the temple, now tumbled and broken, was thought to be the statue of Memnon, and the bust, from a much smaller colossus, was in consequence called the Young, or Younger, Memnon, or even just the Memnon. Belzoni carried out his commission with complete success, and the sculpture arrived in London in the spring of 1818.[16] It went on exhibition in the Townley Gallery with great acclaim, and may even have inspired Shelley's famous sonnet "Ozymandias."[17]

Henry Salt, with the encouragement of some of the trustees of the museum, followed this success with a collecting campaign of heroic proportions, in which he was assisted by Belzoni. With a general permission granted by Muhammad Ali, Pasha of Egypt, Belzoni conducted campaigns chiefly in the Theban area, and in the years 1817-19 he built up a remarkable collection of large and important sculptures from East and West Thebes: from Karnak, statues of Thutmosis III, Sety II, and Sheshonq II (as Hapy); from the temple of Mut, a colossal head of Amenhotep III (fig. 35) (possibly modified for Ramesses II) and several more Sakhmet statues; from West Thebes, many royal pieces from the mortuary temple of Amenhotep III and also wooden royal figures from tombs in the Valley of the Kings.[18] There were papyri, small objects in all categories of common Egyptian antiquities, and later the very important paintings from the supposed tomb of Nebamun, a Theban official. The Salt acquisitions established the Egyptian collections in the British Museum in the range and variety of holdings that were to characterize its nature for the future. It was not to be a collection of works of art but an assemblage of material representing every side of Egyptian antiquity.

There was, in fact, little chance of its becoming a collection of works of art, because in the early nineteenth century there existed little artistic appreciation of Egyptian antiquities except among those few people who had enjoyed the chance of visiting the country and seeing Egyptian sculpture, relief, and painting in their proper environment. When Salt sought some financial compensation for his efforts and personal expenditure on behalf of the museum, the trustees took fright and reminded him that "John Bull may be easily induced to withhold his purse-strings." As for the much-acclaimed bust that Salt and Burckhardt had presented to the museum, Joseph Banks, the famous naturalist and a trustee, reminded Salt in an unkind way: "Though in truth we are here much satisfied with the Memnon, and consider it as a *chef d'oeuvre* of Egyptian sculpture; yet we have not placed that statue among the works of *Fine Art*. It stands in the Egyptian Rooms. Whether any statue that has been found in Egypt can be brought into competition with the grand works of the Townley Gallery remains to be proved." So much for Salt's efforts and personal expenditure![19]

It was not the first, nor would it be the last case of trustee ingratitude to well-disposed benefactors. Salt had simply hoped for some modest recompense for all his efforts. Finally, the trustees offered him £2,000, a sum that was in the event

*Fig. 34. Giovanni-Battista Belzoni (1778–1823), agent for the excavation and collecting of antiquities for Henry Salt.*

accepted; but it had been "a painful and, in a national sense, a mortifying transaction."[20] Shortly afterward, Salt sold a second, far less substantial collection to the French for 250,000 francs (about £10,000). For the future it would not be so easy for the museum to acquire antiquities on the cheap, and indeed in the years following the Salt debacle, a more realistic attitude to purchases had to be adopted.

During the late 1820s and the 1830s large collections of Egyptian antiquities came on the London market, and the Keeper of Antiquities, Edward Hawkins, was unusually successful in persuading the trustees to buy on a relatively generous scale. It was a time when Egypt had become established on the route of the Grand Tour, and few travelers returned to Britain without large consignments of antiquities, in which they rapidly lost interest. In

1833 John Barker, Henry Salt's successor as consul-general in Egypt, disposed of his collection, and the museum purchased many papyri and funerary inscriptions. A special parliamentary grant of £2,500 enabled the museum in 1834 to purchase privately the collection of Joseph Sams, a well-known bookseller and antiquarian. In 1835 the remains of Salt's collection were auctioned, and the museum spent £4,800 on its purchases at this sale—more than twice what it had paid to compensate Salt for his earlier and most important acquisitions for the British Museum. By these and other similar purchases the Egyptian side of the Department of Antiquities was immensely strengthened, and the foundations were laid for its future development as a collection particularly strong in written and inscribed documents and in large quantities of rather humble antiquities that provided it with great historical depth. It was still too early—certainly as far as the trustees were concerned—to think in terms of Egyptian art; but by chance, if not always by choice, important pieces were obtained

that would in time be considered outstanding examples of Egyptian artistry and craftsmanship. Such were the two granite lions of the late Eighteenth Dynasty brought back from the Sudan by Lord Prudhoe and presented to the museum in 1835.[21]

Apart from large acquisitions, the mid-1830s were years of great significance for the Egyptian collections: a new gallery was built for Egyptian sculptures and other large stone monuments, and the museum's first Egyptologist was recruited. The new gallery, which still houses Egyptian sculpture, formed part of the great new building designed by Robert Smirke to replace Montagu House. The gallery was completed in 1834, and the sculptures were moved from the adjacent Townley Galleries to occupy the northern part of the new exhibition space. The move was effected by a detachment of gunners of the Royal Artillery (fig. 36), who worked, according to Edward Hawkins, "with zeal and skill." At last Egyptian sculpture was given the space to be seen and appreciated for its own special qualities, and separated from those competitive "works of Fine Art," some of which were placed in the southern part of the new gallery (fig. 37).

More important for the development of the Egyptian collections was the arrival in the museum of Samuel Birch in 1836 (fig. 38). Birch was a young man with interests in Egyptian and Chinese languages, in antiquity generally, and in numismatics in particular. He came from a family of successful London businessmen; his grandfather had been Lord Mayor of London—who, on being told by young Samuel that he was cataloguing Chinese coins, replied, "Good God, Sammy! Has the family come to that?" Birch switched his main allegiance to things Egyptian soon after he entered the museum, and while he did not by any means abandon Chinese and numismatics, he remained principally an Egyptologist until his death in 1885, by which time he had been Keeper of Oriental Antiquities for twenty-five years.[22] Although he had received no formal university training, Birch had the instincts of a true scholar, and he was one of the first group of experts who were to guide and develop the collections of the British Museum throughout the rest of the nineteenth century. His own passion was Egyptian texts, and one of his first triumphs was to persuade the trustees, through his keeper, Edward Hawkins, to have all the Egyptian papyri transferred from the Department of Manuscripts to his own department. It was still less than twenty years since Champollion had announced his decipherment of hieroglyphs, and there was little published by which a young scholar could pursue studies in the Egyptian language. Yet by 1841 Birch had published the first volume of *Select Papyri in the Hieratic Character from the Collections of the British Museum*, and throughout his career he continued to produce publications of texts that

Fig. 35. *The excavation of the colossal breccia head of King Amenhotep III in the king's mortuary temple in Western Thebes by Belzoni in 1818–19. A pencil drawing by Henry Beechey, secretary to Henry Salt, and Belzoni's assistant at the time.*

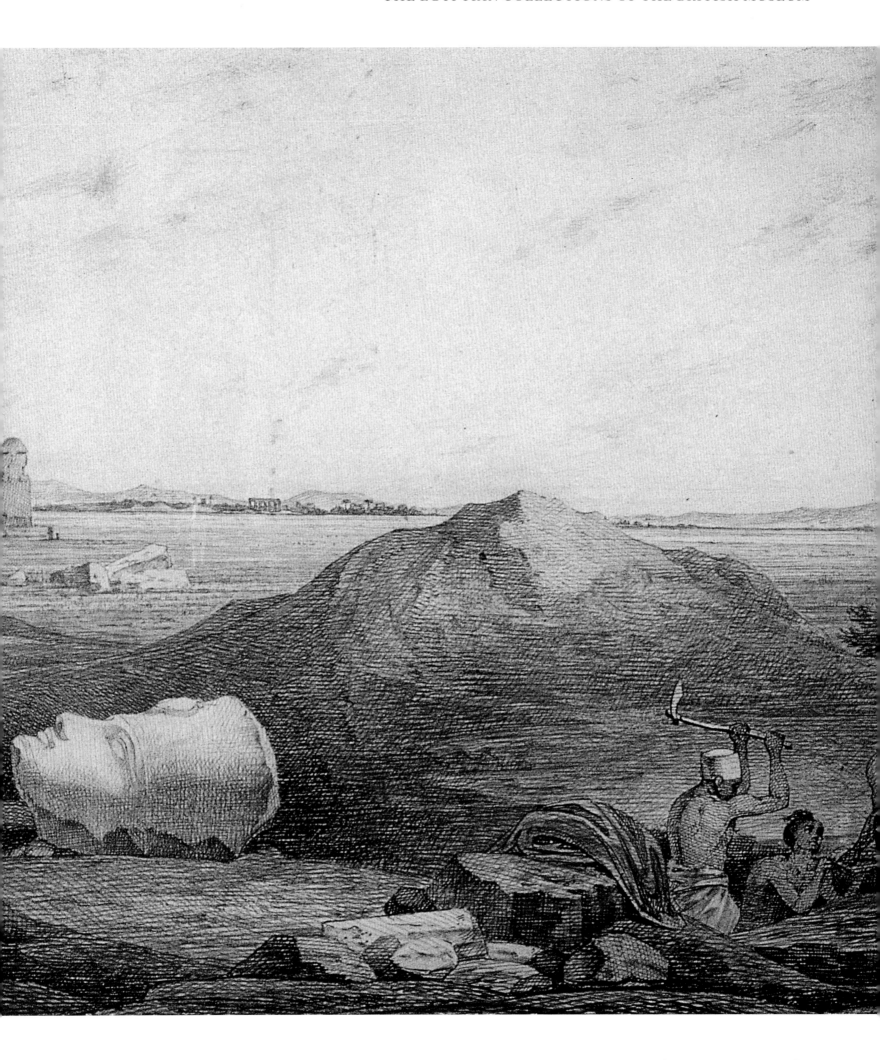

demonstrated his remarkable grasp of the fundamentals of ancient Egyptian.[23]

There was at this time no institution in Britain where a young student could learn about ancient Egypt in a formal way, and Birch conceived it as a duty to facilitate the studies of promising scholars. After his death (see fig. 39), his son wrote:

> Dr. Birch was one of those who saw in the British Museum ... not only a store-house of historical treasures not only a show place for holiday recreation of the masses but the true and indispensable home of the proficient master, and the proper and constant resort of the enquiring student; a university, in fact, where education in the most recondite branches of knowledge should be bountifully bestowed on all those who sought it.[24]

This engagement in scholarship has remained a general concern of all departments in the British Museum, but few have maintained such a commitment to the academic publication of its collections as Samuel Birch's Department of Oriental Antiquities, followed by its descendants, the Department of

*Fig. 36. A detachment of soldiers of the Royal Artillery prepare to move the great "Memnon" bust of Ramesses II from the Townley Galleries in 1833. Fig. 37. The new Egyptian Sculpture Gallery in 1836. The "Memnon" can be seen in the distance on the left.*

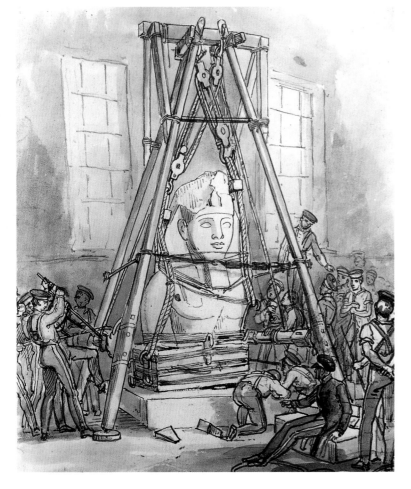

Egyptian and Assyrian Antiquities (1886–1955) and Department of Egyptian Antiquities (since 1955). The pattern was established by Birch, who was in many respects an ideal curator. While he remained an assistant under Edward Hawkins, he pursued Egyptological studies, setting up avenues of communication with other British enthusiasts for ancient Egypt—it was almost too soon in Britain to describe them as Egyptologists—and with scholars abroad, especially in France and Germany, where Egyptological studies were already promoted and supported at the highest levels.

Birch was not an active collector for the museum, but he did not

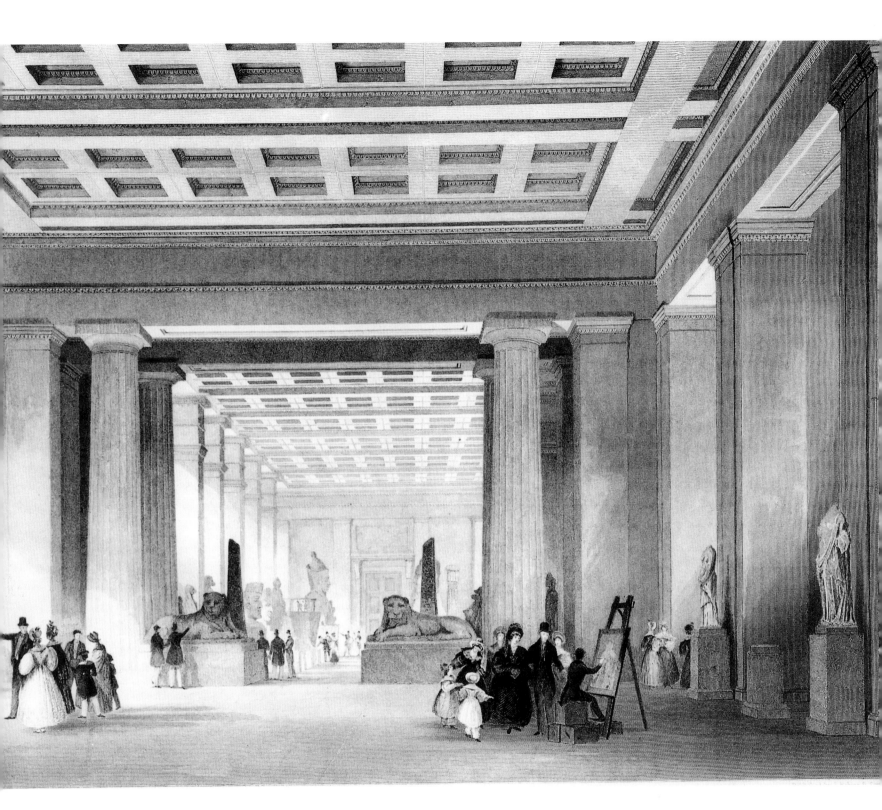

neglect opportunities to acquire important pieces when possible. In 1837, for example, at the sale of the collection of J. F. Mimaut, former French consul-general in Egypt, he persuaded the trustees to buy the king-list from Abydos. This important historical text had been found by William John Bankes in the temple of Ramesses II in 1819, but subsequently removed by Mimaut.[25] Many important papyri were netted by Birch's initiatives: in 1857, the Abbott papyrus, containing the official report on tomb-robbing in the reign of Ramesses IX; in 1863 the Rhind Mathematical papyrus; in 1872 the Harris papyri, among which was the Great Harris, the longest papyrus text (134 feet [41 meters]) so far discovered.

The flood of other objects that had poured into the museum in the 1830s and 1840s from dispersed collections ceased to flow so strongly in the middle years of the nineteenth century. Greater control over the ancient sites in Egypt after the establishment of the Antiquities Service in 1857 inhibited the activities of indiscriminate collectors. Nevertheless, quantities of small objects entered the British Museum, particularly through the activities of regular travelers to Egypt, such as the Reverend Greville Chester (fig. 40), from whom eighty-five groups of objects, some running to several hundreds, were entered in the departmental register of acquisitions between 1864

and 1891. Chester collected carefully, mostly small antiquities, noting provenances where possible and providing the museum with a mass of documented archaeological material at a time when such objects were regarded as being of little value.

Samuel Birch neglected nothing under his charge in the Egyptian field. Every object, from fragmentary amulet to great sculpture, from inscribed stone to written papyrus, was carefully described; texts were copied, transliterated, and translated on slips now bound up in over one hundred volumes. He dutifully answered the inquiries of the public and countered the demands of those who asked too much of him and the museum. He was by nature a sympathetic and friendly person. His successor, Budge, in a fond account remarked, "His greyish-green eyes were deep set . . . and when he was moved to mirth they laughed before the muscles of his mouth relaxed." His last years, sadly, were clouded by a disagreement with those well-intentioned scholars and interested amateurs who were engaged in setting up the Egypt Exploration Fund. Its purpose was to conduct fieldwork in Egypt, and its principal advocate was the redoubtable Amelia B. Edwards, successful novelist and author of *A Thousand Miles up the Nile* (1874).[26] Birch saw nothing in this new enterprise that would be of use to the British Museum, and he was adamant in refusing to support it. His opposition greatly saddened Miss Edwards, who had the highest regard for his scholarship and usual helpfulness. Birch was, however, mistaken in believing that work sponsored by a British society would not produce a return for the museum. Before he died he would see sculptures from excavations at Tell el Maskhuta, in the Wadi Tumilat, east of the Delta, presented to the museum in 1883 by the Egypt Exploration Fund; these, a sculpture of an official and a large granite falcon of Ramesses II, would be but the first of many thousands of objects donated to the museum by the Fund and its successor, the Egypt Exploration Society, over the next century.[27]

There was little reason for Birch to foresee how excavated objects would in the future enrich the Egyptian collections. The significance and value of pieces with pedigree were not yet fully appreciated, and indeed it would be some time before a satisfactory relationship between the museum and field-workers in Egypt was established. Birch's successor, Peter Le Page Renouf (1886–1891), was equally unwilling to support the Egypt Exploration Fund, and was not even prepared to accept personally objects presented to the museum by the Fund. Renouf's successor, Ernest Wallis Budge (fig. 41), while readily receiving whatever might be presented by excavating institutions, was more inclined to enlarge the collections of his department by regular purchasing, especially in Egypt itself. Budge made his first buying trip to Egypt in 1886 and was initiated into the ways of antiquities dealers by the experienced Reverend Greville Chester. With youth on his side, along with a good knowledge of ancient Egyptian scripts, and unbounded self-confidence, Budge pursued what he considered to be the interests of the trustees of the museum with energy and devotion.[28]

Up to World War I he made many trips to Egypt, acquiring for the museum large quantities of funerary material of all periods,

Fig. 38. Samuel Birch (1813–1885), the first Egyptologist in the British Museum. Fig. 39. Samuel Birch's gravestone in Highgate New Cemetery in North London.

many papyri in a variety of scripts, and incidentally works of art in all media, especially sculpture. In spite of his unconventional methods of operating, he maintained generally good relations with the Antiquities Service in Egypt, but he was occasionally seen as something of an embarrassment in diplomatic circles because of his cavalier attitude to officialdom. In the Egyptian field his major acquisitions included the Amarna Tablets, written in cuneiform, but of great importance for Egyptian history; among his purchases of papyri were the *Books of the Dead* of Ani, Nu, and Nakht and the semi-philosophical work known as *The Instruction of Amenemipet*; of sculptures there was a remarkable group of fine pieces said to have been found at Karnak, including two of Senenmut, steward (and perhaps more than confidant) of Queen Hatshepsut.[29] Although Budge took no steps to involve the museum directly in excavations, he did not prevent members of his staff from participating in the work of the Egypt Exploration Fund, and he showed no reluctance in accepting the antiquities offered to the museum by the fund.

*Fig. 40. The Reverend Greville Chester (1830–1892), a major acquirer of antiquities for the British Museum, in the temple of Luxor, in about 1885. Fig. 41. Sir E. A. Wallis Budge (1857–1934), Keeper of Egyptian and Assyrian Antiquities from 1894 to 1924.*

From Flinders Petrie's excavations at Abydos and Diospolis Parva there came a wide range of Early Dynastic objects and complete series of predynastic pottery and related material. From work at Deir el Bahri, in which H. R. H. Hall of the department participated, three masterly statues of King Sesostris III of the Twelfth Dynasty formed part of the museum's share in the distribution of finds received by the Egypt Exploration Fund.

Budge's keepership ended in 1924. It had been an immensely profitable period as far as the growth of the Egyptian collections was concerned. When Birch had made his initial classification of the Egyptian holdings of the department in about 1870 (see fig. 42), the total amounted to around 10,000 objects. When Budge retired in 1924 the number had advanced to about 57,000.[30] In this matter of acquisitions Budge's activities had been phenomenal. But he is principally remembered, both in the museum and by the general public, as one who wrote and wrote and wrote. His output of official publications—mostly editions of

the *Book of the Dead* and other religious texts—was on a prodigious scale; his popular publications were even more numerous and diverse in character. There was no current bandwagon on which he was unwilling to leap as opportunity occurred, producing with ease a pertinent volume of several hundred pages. Sadly, he was not a careful scholar; he wrote too quickly, he did not keep abreast with the remarkable developments in Egyptian language studies and archaeology, and he did not hesitate to repeat himself in a generous manner. Yet at the time, his books, of which he produced more than 140 (some in several volumes), provided a huge stimulus to popular interest. Unfortunately many have been kept in print long after their usefulness has been exhausted.

In the period between the two world wars, the focus of growth in the Egyptian collections rested in the yields of excavation. The Egypt Exploration Society, as the Fund had become in 1919, continued to make generous donations to the British Museum from its work, in particular that at Amarna, the short-lived capital of the so-called heretic pharaoh, Akhenaten. Two excavations at Mostagedda and Matmar, in Middle Egypt, conducted in the name of the museum by a remarkably able archaeologist, Guy Brunton, provided the collections with unusual and important material, chiefly from the earliest predynastic periods and the First Intermediate Period. From the other end of the historical spectrum came objects from Armant, just south of Luxor, the center of the Buchis-bull cult that flourished in the Greco-Roman Period; and the museum continued to attract, principally by gift and bequest, significant acquisitions of papyri (see fig. 43). In 1929 the Ramesseum Dramatic Papyrus, concerning the coronation of Sesostris I of the Twelfth Dynasty, was presented by Alan Gardiner and Petrie's School of Archaeology in Egypt; in 1930 Mr. and Mrs. Alfred Chester Beatty donated a group of literary, religious, and medical texts from Thebes, including the unusual *Dream Book*. Substantial numbers of secular documents in the demotic script were obtained throughout the 1930s, particularly from Tebtunis, in the Fayum. In 1937 Alan Gardiner presented a long papyrus of religious spells related to the Coffin Texts of the early Middle Kingdom. Papyri have continued to arrive in the department in rich profusion from many sources. The greater part of a Fifth Dynasty archive from Abusir was purchased in 1950; in 1956 the complete *Book of the Dead* of Pinudjem II, High Priest of Amun in the Twenty-first Dynasty, was presented by Mrs. Olive Douglas Methuen Campbell. Recently, the papyri obtained in Egypt in 1815 and 1818–19 by William John Bankes have come to the museum—a gift from the National Trust. The documentary collection in the Egyptian department is unparalleled in its size and scope, and its publication is continuing in the various series started by Samuel Birch in the nineteenth century.

Publication has remained an important part of the activities of the Egyptian department, and it is now the active policy to involve foreign scholars as well as departmental Egyptologists in the preparation of object and documentary volumes. The opening of the collections to students has been a process of liberation,

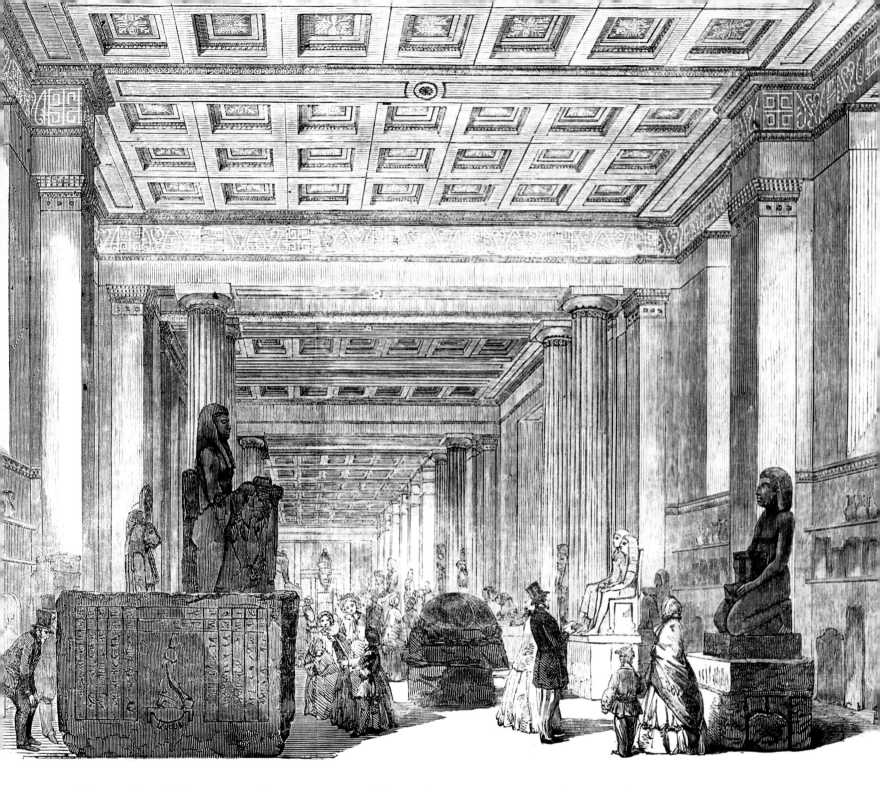

following the stultifying regime of restriction exercised during the keepership of Wallis Budge, and, to a lesser extent, subsequently. A recent and very welcome development in this respect has been the start of a new series devoted to *Books of the Dead*, in which the collections are particularly rich. Similarly, after the establishment of the Egyptian department as an independent unit in the museum in 1955, a new series dealing with categories of antiquities other than papyri and inscribed stone monuments was initiated.

The division of the old Department of Egyptian and Assyrian Antiquities in 1955 into separate departments of Egyptian and of Western Asiatic Antiquities allowed both sides of the old department to develop with a freedom previously unimagined. In a sense this freedom came rather late for Egypt. The possibilities for growth by acquisition from excavation were greatly reduced as

restrictions on the export of antiquities became increasingly tight. At the same time, the new independence enabled the Egyptian department to become even more a center of Egyptological studies in Great Britain than it had been previously. Changes of policy in the museum, especially in the spheres of involvement with the public and the wider world, have considerably influenced the

*Fig. 42 The Egyptian Sculpture Gallery in about 1870. Fig. 43. The great hall of Boughton House, Northamptonshire in 1941. The Duke of Buccleuch made part of this house available for the storage of objects from the British Museum in the early years of World War II. In this drawing by C. O. Waterhouse, a museum artist, boxes containing Egyptian and Assyrian antiquities are shown. The bundles on the tops of the boxes contained papyri.*

activities of the Egyptian department. Greater attention is now applied to the interpretation of the collections through permanent exhibitions. The series of new installations in the departmental galleries, begun some years ago with Egyptian sculpture, continues actively and will develop even further than originally planned when new spaces are provided as a result of the departure of the British Library from the Bloomsbury site. Greater specialization on the part of departmental staff leads to better-conceived and better-planned exhibitions. In parallel manner, the development of large-scale loan exhibitions abroad has greatly stimulated research into the departmental collections, while at the same time engrossing the staff of the department in what would previously have been considered marginal activities. To make available the Egyptian collections is increasingly seen as a consequence of past success in the construction of what is probably the largest and most diverse assemblage of Egyptian antiquities outside Egypt.

And still the collections increase. Excavations undertaken in support of the International Campaign for the Saving of the Monuments of Nubia brought important groups of objects from Saqqara, in northern Egypt, and from Qasr Ibrim and Buhen, in Nubia itself, during the 1960s and 1970s. Subsequently, however, the general limitation on divisions of finds from excavation applied by the Egyptian authorities has brought to an end the long and fruitful arrangements whereby the British Museum benefited from the results of the fieldwork of the Egypt Exploration Society. But the continuance of fieldwork in Egypt remains an active purpose of the Egyptian department. Since the formation of the independent department, financial support has been given by the museum to the Egypt Exploration Society; and since the early 1980s the departmental staff has mounted excavations in threatened sites in Egypt, at Ashmunein (Hermopolis), in Middle Egypt, the city of the god Thoth, and at Tell el Balamun, in the northern Delta, a much-neglected site of great size and antiquity (see fig. 44). Other excavations, carried out by departmental staff and substantially sponsored by the museum, have been mounted in the Sudan by the Sudan Archaeological Research Society; and these have produced significant acquisitions for the museum.

The large and important collections of objects from the Sudan and Egyptian Nubia enabled the department to mount recently a permanent exhibition of antiquities from those southern countries with which Egypt had such intimate relations throughout antiquity. The first great monuments to enter the museum from the Sudan were the two Prudhoe lions in 1835, already mentioned. Budge carried out explorations—scarcely excavations—at several places in the Sudan and successfully negotiated the acquisition by the museum of an imposing relief from the pyramid chapel of a female ruler at Meroë dating to the second century B.C. Fine pieces, including royal sculpture, came from the work of the Oxford University Expedition to Nubia in 1912 (at Faras) and in the 1930s (at Kawa). Excavations by the Egypt Exploration Society in the late 1930s and postwar at Amara and Sesebi, and later at Buhen, continued the Sudanese

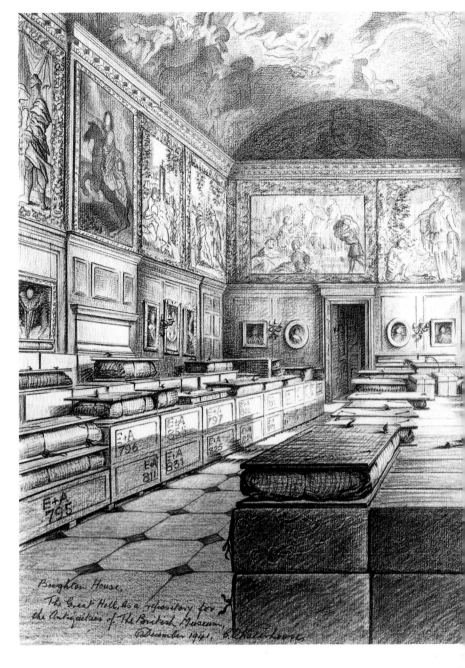

Boughton House,
The Great Hall, as a repository for
the Antiquities of The British Museum,
December 1941, [signature]

connection, with further, but less spectacular, presentations being made to the museum. Future work planned in the stretch of the Nile Valley between the Third and Fourth Cataracts promises interesting archaeological and historical results, and should yield more additions to the departmental collections.

As the Department of Egyptian Antiquities approaches the completion of its first half-century of complete independence, it is appropriate to consider the extent to which it has sustained and even extended what Samuel Birch saw as the purposes of the British Museum: "not only a store-house . . . not only a show-place . . . but the true home of the proficient master, the proper resort of the enquiring student." These are worthy aspirations that have been diligently fulfilled by the Egyptian department. The collections, as is to be expected, come first; and standing now at more than 100,000 objects, they provide the material for the many and diverse activities conducted by the department's academic and support staff, in the British Museum itself, in the field in Egypt and the Sudan, and in

the world in general, preparing and supporting exhibitions and offering specialist help when required. Publications are prepared, conferences mounted, scholars received and generously helped, the public, both young and old, welcomed. Birch would be astonished at the range of duties undertaken, and the amount of business transacted. The twinkle in his eye, which so struck the young Wallis Budge, would surely indicate his quiet satisfaction.

*Fig. 44. View of the high settlement mound at Tell el Balamun, site of British Museum excavations; work is shown in progress on the Twenty-sixth Dynasty fort.*

## Notes

1 For a general survey of Sloane's life and collecting activities, see A. MacGregor, "The Life, Character and Career of Sir Hans Sloane," in MacGregor 1994, pp. 11–44. On the history of the Egyptian collection, see James 1981.

2 On the foundation and early history of the British Museum, see M. Caygill, "Sloane's Will and the Establishment of the British Museum," in MacGregor 1994, pp. 45–68; Caygill 1992.

3 Bierbrier 1993, pp. 15–33.

4 In 1737 Alexander Gordon, an antiquary, published a set of *Twenty-five Plates of All the Egyptian Mummies and Other Egyptian Antiquities in England*. These plates may have been issued as an unbound portfolio, of which Plate IV contained an engraving of the stela of Nekau. The plates are, however, often associated with two essays by Gordon, also published in London in 1737: *An Essay Towards Explaining the Hieroglyphical Figures on the Coffin of the Ancient Mummy Belonging to Capt. William Lethieullier* and *An Essay Towards Explaining the Ancient Hieroglyphical Figures on the Egyptian Mummy in the Museum of Doctor Mead*. For the stela of Nekau, see De Meulenaere 1983, pp. 35ff.

5 On the family and its collections, see Bierbrier 1988, pp. 220–28.

6 Dawson 1937, pp. 279ff.

7 For the influence of these publications on public interest, see James 1997, pp. 41ff.

8 His mother was Lady Mary Wortley Montagu (1689–1762), the well-known letter writer, traveler, essayist, feminist, and eccentric. On the son, see Curling 1954.

9 James 1997, pp. 30ff.

10 For Bouchard and the Institut in Cairo, see Solé/Valbelle 1999, pp.10–12, 15ff.

11 The negotiations leading up to this loan, as reported in Solé/Valbelle 1999, pp. 171–74, do not entirely accord with the records and memories of the British Museum Department.

12 Parkinson 1999, pp. 23ff.

13 For early publications of the sarcophagus, see PM IV, pp. 3ff.

14 On Burckhardt generally, see Sim 1969; on his collaboration with Salt and the commissioning of Belzoni, see James 1981, pp. 9ff.

15 Hamilton 1809, pp. 59ff.

16 For Belzoni's own description of this operation, see Belzoni 1822, pp. 41–44 and 62–79.

17 On the sonnet and the Younger Memnon, see James 1991, pp. 43ff.

18 James 1981, pp. 12ff.

19 The quotations are from letters to Salt from W. J. Hamilton and Sir Joseph Banks; see Halls 1834, pp. 303, 305.

20 On the dispute between Salt and the trustees, see Halls 1834, pp. 295ff.

21 The lions were published by Edwards 1939a; see also Bryan in Kozloff/Bryan 1992, pp. 30ff. For further information, see the entry for one of these lions (cat. no. 51).

22 An informal and sympathetic portrait of Birch is sketched in Budge 1920, pp. 16–37.

23 A full list of Birch's publications is included in Budge 1886, pp. 1–41.

24 Walter de Gray Birch's introduction to *Biographical Notices of Dr. Samuel Birch from the British and Foreign Press* (London 1886), pp. viiiff.

25 For its discovery, see Bankes 1830, p. 251; for early bibliography, PM VI 1939, pp. 35ff.

26 On the foundation of the EES, see M. S. Drower, in James 1982, pp. 9ff.

27 See James 1988, pp. 20ff. The relationship between the British Museum and the EES is charted in James 1982, passim.

28 His activities and methods of acquisition are described in Budge 1920.

29 The problems concerning this discovery are set out in James 1976, pp. 7–30. Three statues from this group are in the present catalogue: cat. nos. 44 (EA 174), 47 (EA 888), and 122 (EA 1574).

30 This information and indeed most of the details contained in the rest of this account of the Egyptian collections have been taken from departmental records and from personal knowledge.

CATAL

OGUE

# 1

## Statuette of a King

From Abydos, excavated by Petrie in the area of the
early temple
Early Dynastic Period, perhaps mid-First Dynasty
(ca. 3000 B.C.)
Ivory
Height 3 ½ in. (8.8 cm)
EA 37996, acquired in 1903, gift of the Egypt
Exploration Fund

The artistry and sophistication of this ivory
statuette are unmistakable, even though much
detail, especially in the face, has been blurred by
weathering. It is the figure of a beardless king
wearing a white crown, the weight of which
seems to be pushing out the tops of his huge
ears. Wrapped in a short, stiff robe, he strides
forward on his left leg. Perhaps the most
striking aspect of the figure is the sense of age

conveyed by the stoop of the king's shoulders,
the forward thrust of his neck, and the droop
(possibly somewhat exaggerated by weathering)
of his long, pointed chin. Though a few would
disagree,[1] most believe, as I do, that this is a
depiction of an aged king.[2]

The robe is the type worn by kings during
the *sed*-festival. This ceremony of royal rejuve-
nation was already in existence at the beginning
of the First Dynasty. It lasted at least until the
first millennium B.C., when part of the ritual was
depicted on a relief discussed elsewhere in this
catalogue (cat. no. 113). Here, the garment
has the form of robes shown on other Early
Dynastic representations of this ceremony.[3]
Unlike other versions of the robe, however, the
material is patterned, with a design of diamond
shapes bordered by two bands of guilloche.[4]
The designs were carved with such plasticity
that even the under-and-over intertwining of
the strips in the guilloche bands can still be seen.
The effect strongly suggests woven designs in a

heavy fabric, rather than painting on leather, as
has sometimes been suggested.[5]

The most singular feature of the robe is a
sort of flap that hangs down over each shoulder.
These "epaulets" are worn and cracked and
extremely hard to see, but the better-preserved
example, on the left shoulder, apparently has a
scalloped edge. The objects appear to be unique,
and no one has yet come up with a satisfactory
identification or explanation, apart from a
tentative (and unlikely) suggestion that they
might represent animal paws.[6]

The statuette was found in the area of the
early temple at Abydos, in a deposit of
discarded temple objects that Petrie dated to
the First and Second Dynasties. However, the
archaeological context is vague. The date of the
deposit is almost certainly later than Petrie
thought, and the dates of the objects thrown
into it are more heterogeneous.[7] These
difficulties have led a few scholars to question
whether this figure is as early as formerly

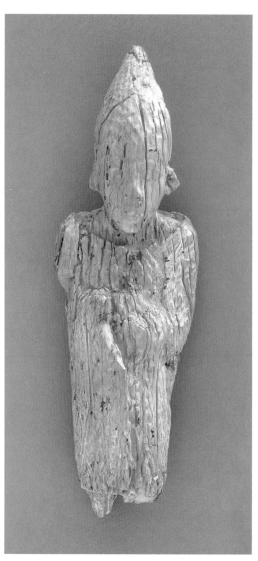 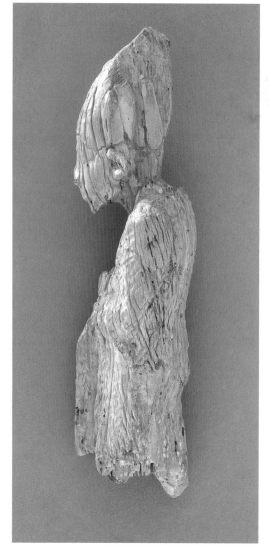 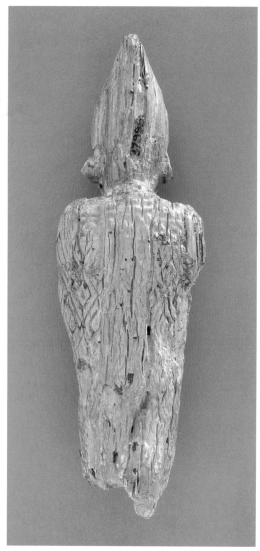

thought and even to imply that it might be as late as the Middle Kingdom.

Certainly there is need to be cautious about an Early Dynastic date, especially since we know so little about the development of sculpture during the First and Second Dynasties. On the other hand, we know enough about royal representations during the Old and the Middle Kingdoms to be quite sure that this figure does not fit into either of those periods. By a process of elimination, then, an Early Dynastic date for the statuette is still the most plausible. Dating it to a period before the development of sculptural standards and conventions during the early Old Kingdom also provides the most convincing explanation for such apparently archaic anomalies as the robe's pattern and "epaulets."

The accomplished technique of the ivory carving at so early a period should be no surprise. Ivory figures were already being made in early predynastic times, and they continued to be produced throughout the Predynastic Period. But while predynastic ivory figures are very stylized, this statuette has an assured naturalism that can most tellingly be compared to a two-dimensional representation of King Den (cat. no. 2), which was also found at Abydos, and probably comes from the king's tomb. Both representations evince a trend toward more naturalistic renderings of the figure, whether in two or three dimensions, and it seems probable that they were made at or about the same time. (**E.R.R.**)

### Notes

[1] E.g., Glanville 1931, p. 66.

[2] Thus already Petrie 1903, p. 24; Spiegelberg 1918, pp. 71–72.

[3] EA 67153: Spencer 1980, no. 16, pls. 8–9; but there are also later archaizing examples: Sourouzian 1994, pp. 501–502.

[4] Two other possible representations of decorated robes: Sourouzian 1994, no. 55, pp. 501, 523, and n. 47, p. 507.

[5] Brock 1995, p. 11, after Riefstahl 1944, p. 6.

[6] Riefstahl 1944, p. 6.

[7] Kemp 1968, pp. 153–55.

### Bibliography

Spencer 1980, no. 483, p. 67, pl. 55 (with earlier bibliography).

James/Davies 1983, p. 23, fig. 21.

Quirke/Spencer, 1992, p. 70, fig. 50.

Sourouzian 1994, no. 1, p. 50.

Robins 1997, fig. 33, p. 37.

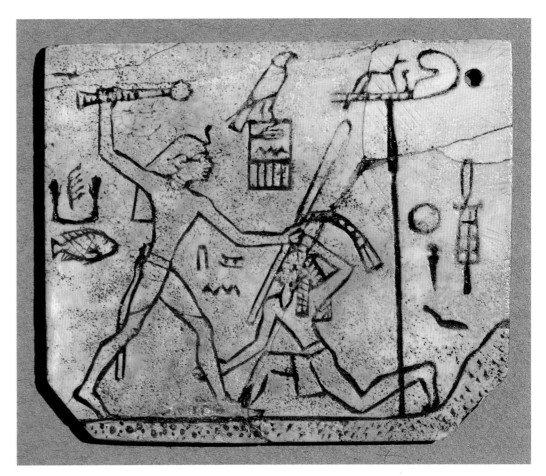

# 2

## Plaque with Den Smiting an Easterner

From Abydos, almost certainly from the tomb of Den
Early Dynastic Period, mid-First Dynasty, reign of Den (ca. 2985 B.C.)
Ivory
1 ³/₄ x 2 ¹/₈ in. (4.5 x 5.4 cm)
EA 55586, acquired in 1922 at the sale of the Macgregor Collection

Most First Dynasty ivory plaques were made as labels for various commodities. The pair of sandals incised on the back of this one (fig. 45) indicates that it was a label for sandals, which were extremely prestigious items. Such labels were usually decorated with representations of important events. Here, King Den lunges forward with upraised mace, about to bring it down on the head of his vanquished enemy.

Den is preceded by the standard and symbols of the jackal god, Wepwawet, signifying the support of Egypt's gods. The king is identified by his name, written in a *serekh* (a stylized palace) topped by the royal god Horus,

*Fig. 45. Plaque with Den Smiting an Easterner. Reverse Side with Incised Pair of Sandals (drawing). The British Museum (EA 55586).*

and by his royal regalia. He wears a bull's tail, symbolic of fertility and ferocious power. This tail, like the red and white crowns, was already a standard royal accessory (see fig. 1). Instead of a crown, however, Den wears an archaic version of a royal headcloth,[1] with the rearing neck and head of a royal uraeus cobra at his forehead. This is perhaps the earliest representation of a king

wearing a uraeus. That this symbol should make its debut on a royal headcloth is no coincidence, for throughout the Old Kingdom the uraeus was represented only on the king's headcloth. It did not appear on crowns until the beginning of the Middle Kingdom.[2]

In later smiting scenes, the king grabs his foe by the hair (see fig. 16). Presumably Den is doing that here, but it is hard to tell whether the long, tassel-like object above the enemy's head is meant to represent a braid or forelock or some other object. Whatever it is, Den manages to hold it, along with a long, club-shaped staff and perhaps also the prisoner's raised hand, as he presses him to the ground.

The action, which takes place in a desert land outside Egypt, is identified in the inscription on the right side of the plaque as the "first occasion of smiting the East." That the enemy is an Easterner is indicated by his long locks and pointed beard, which resemble those on later depictions of Asiatic foes (see cat. no. 17).

Like all Egyptian reliefs, this plaque demonstrates the interaction between graphic imagery and hieroglyphic writing. Both Den's figure and his name face right; the king's image can actually be read as an ideographic component of his name. Throughout Egyptian history, the rightward orientation, which is shared here by the Wepwawet standard, was preferred, both for dominant figures and for writing. Thus even the prisoner's leftward orientation defines him as subordinate and inferior. A gravel-spotted desert serves as a ground line. At the right, it extends upward into a small hill that may symbolize the home of the Easterner. More significantly, it also recalls the three desert hills that make up the hieroglyphic sign for "foreign lands." Taken as a whole, the vignette can be read as an ideographic complement of the text "smiting the East," in the same way that Den's figure completes his name.

Two more inscriptions, on either side of Den's body, are too archaic to be read with certainty.[3] The figures, on the other hand, are stylistically much more developed than the schematic renderings on most other First Dynasty images (see fig. 1). Den's long-limbed body is well proportioned. In marked contrast to the smiting king on the Narmer palette, a strong forward movement is conveyed by the angle of

his body and by the way in which his heel is raised from the ground. The raised heel was later the standard means of indicating running or vigorous striding in two-dimensional figures; see cat. no. 7. In later smiting scenes, the enemy's despair is indicated primarily by his supplicating gestures; here, his desperation is more vividly conveyed by the awkwardness of his unbalanced stance.

A modern viewer is likely to think of these innovations primarily as improvements in naturalistic representation. Given the very early artistic stage at which this relief was carved, however, its most impressive innovation is simply the creation of a picture—one that not only completes the text but also illustrates it. Despite its miniature size and very archaic style, this relief foreshadows the unique duality of later Egyptian reliefs and paintings, which function simultaneously as ideograph and illustration.[4]

The smiting scene was one of the longest-lived subjects in Egyptian art, with its roots in the Predynastic Period and its last appearances in the Roman Period, some 3,500 years later.[5] Many factors, such as the obvious propaganda value, contributed to this longevity, but the real power of the smiting scene was magical. By perpetuating the image of the mighty, victorious king, it caused the king to be mighty and victorious.

On this example, however, unusual attention has been given to the still-living prisoner. His out-flung hand and one foot are crossed by the king's leg, his other leg is cut off by the Wepwawet standard, and his raised hand is trapped in (or behind?) the king's fist. Thus all his extremities are blocked. This is not due to poor planning. On the contrary, the composition has been carefully planned in order to immobilize him with images of royal and divine power. This total symbolic control was not applied to representations of prisoners in other smiting scenes, most of which were in temples. It may have been considered necessary here because the plaque was destined for the king's tomb. Comparable magical precautions appear in the inscriptions on some later coffins, where lines have been drawn or cut through the necks of

hieroglyphic signs representing potentially dangerous animals, in order to prevent them from harming the deceased.[6] (E.R.R.)

### Notes

[1] It resembles the type of headcloth later called a khat, for which see Eaton-Krauss 1977, especially p. 26, n. 38.

[2] Evers 1929, II, pp. 21–22.

[3] Spencer 1980, p. 65; Godron 1990, pp. 151–54.

[4] This example is not unique. Re-excavations of Den's tomb have turned up fragments of two very similar plaques that show Den in much the same pose but wielding a harpoon: Petrie 1900, p. 21, pls. 11/8, 14/8 (wearing the same kind of headcloth); Dreyer 1998, p. 163 (d), pl. 12 d (with a red crown).

[5] Hall, E. S., 1986, pp. 4–45.

[6] Ikram/Dodson 1998, p. 204; the major work on this subject is still Lacau 1913. I thank James Romano for his help in locating this reference.

### Bibliography

Spencer 1980, no. 460, p. 65, pls. 49, 53 (with earlier bibliography).

Godron 1990, pp. 151–54, 210 (under "Tablette Macgregor"), pl. 11.

# 3

## Game Piece in the Shape of a Lion

From Abydos, subsidiary grave in Djer tomb complex
First Dynasty, reign of Djer or earlier (ca. 3050 B.C.)
Ivory
1 1/2 x 1 1/8 in. (3.8 x 2.7 cm)
EA 35529, acquired in 1901, gift of the Egypt Exploration Fund

The tiny figure of a crouching lion has lost its front legs and been blackened by fire, but the details of the carving are very well preserved. The animal is male; his mane and his chest and

[9] For a similarly archaic lion found in another mid-First Dynasty context, see Spencer 1980, no. 497, p. 70, pl. 58 (EA 52920).

[10] Several other gaming pieces are pierced, e.g., EA 64093, which has a hole through the belly: Spencer 1980, no. 498, pl. 58.

**Bibliography**

Spencer 1980, no. 496, p. 70, pl. 57 (with earlier bibliography).

belly hair are depicted in relief as a series of overlapping scallops carved in considerable detail but with very little plasticity. His tail runs up the center of his back and ends in a curve to the left. His open mouth, bared teeth, and creased muzzle suggest that he is snarling.

In contrast to the calm majesty of later Egyptian statues of lions, such as the great lion of Amenhotep III (cat. no. 51), the earliest depictions of the animal look fierce and rapacious. By the beginning of the Old Kingdom, a lion was conventionally represented with its mouth closed and its tail to one side of the body, curling up around the flank. But the earliest lions have open mouths and tails held, as here, on top of the back. This curious position may be an attempt to indicate that the tail is erect, a detail that would have been impractical to represent in three dimensions.[1]

The lion is one of a group of miniature ivory animals, including crouching figures of lionesses and dogs, that were used as playing pieces in board games.[2] Most, if not all, come from First Dynasty tombs, and they have survived in sufficient numbers to suggest that, like the board games depicted in tombs from the Old Kingdom onward,[3] the archaic games had symbolic significance for the well-being of the deceased. In any case, the games really were played. The underside of this lion is worn from use, as are the surfaces on either side, where a player would have held it.[4]

Although this gaming piece was buried near the middle of the First Dynasty, its style suggests that it is considerably older, especially when it is compared with other examples from the same funerary complex.[5] Lion gaming pieces often have manes rendered as a stylized pattern of overlapping scallops or arcs.[6] On this example, however, the design is much flatter and more schematic than on most, and

*Fig. 46. Part of a Relief-decorated Palette (The "Hunters' Palette". Late Predynastic Period (ca. 3200 B.C.). Graywacke, length 26 1/4 in. (66.8 cm). The British Museum (EA 20790 and 20792).*

there is a remarkably close counterpart in relief: the rendering of two lions on the "Hunters' Palette" (fig. 46).[7] These lions also have open mouths and the same long creases across the muzzle; one (mortally wounded) is holding its tail erect. Stylistically, the "Hunters' Palette" is considered one of the most archaic of the relief-decorated palettes; most authorities would date it earlier than the Narmer Palette (fig. 1), which was made at the beginning of the First Dynasty.[8] This three-dimensional version is probably as old.[9]

All the tombs of First Dynasty kings seem to have contained material from the reigns of their predecessors. Presumably the royal storerooms had to be raided to supply the required quantity of burial goods. However, what seem to be heirlooms have also been found in Egyptian burials, and this may be another example. The hole through the head of this lion suggests that it was worn as an amulet, possibly after the end of a long playing career.[10] (E.R.R.)

**Notes**

[1] Schäfer 1974, pp. 11–12.

[2] For examples, see Saleh/Sourouzian 1987, no. 12; others cited by Spencer 1980, no. 496, n. 1, p. 70.

[3] Decker/Herb 1994, pls. 355–75; cat. no. 78 (in this catalogue) includes a satirical illustration of a board game.

[4] Spencer 1980, no. 496, p. 70.

[5] Petrie 1925, pl. 7, nos. 1, 3, 4, 13 (the last of which looks almost Old Kingdom).

[6] E.g., EA 64093: Spencer 1980, no. 498, pl. 58; Petrie 1925, pl. 7, no. 4.

[7] EA 20790, 20792: Spencer 1980, no. 575, p. 79, pl. 63.

[8] Ibid.: "Late Predynastic."

## 4

## Seated Statue of Ankhwa

From Saqqara
Old Kingdom, Third Dynasty
(ca. 2686–2613 B.C.)
Granite
Height 25 7/8 in. (65.5 cm)
EA 171, acquired in 1835 at the sale of the Salt Collection

The shipwright Ankhwa sits on a stool with inverted U-shaped braces reinforcing the juncture of its straight legs with the seat. This type of household furniture was depicted in relief and painting on tomb walls, alongside other prerequisites for the owner's afterlife, in so-called inventory lists. It is also a diagnostic feature in the composition of several statues made during the Third Dynasty.[1] In the canonical seated figure that made its appearance shortly thereafter, the seat is reduced to a simple block.

Another precanonical element of Ankhwa's statue is the position of the hands and arms. In the fully evolved seated figure both hands rest on the lap; and in those few canonical compositions showing one hand raised, it is the right arm that rests on the figure's chest, not the left. Here Ankhwa raises his left arm, and in his left hand he grasps an adze, a woodworking tool indicative of his trade.

Other stylistic traits that date this statue to the Third Dynasty include the disproportionately large head and its awkward relationship to the torso: it sits almost without benefit of a neck upon the shoulders. The striations of Ankhwa's flaring coiffure undulate near the crown of his head; two ridges at the lower ends suggest crimping. The same hairstyle, which may in fact represent a wig, is known from contemporaneous reliefs, as well as from another Third Dynasty statue.[2]

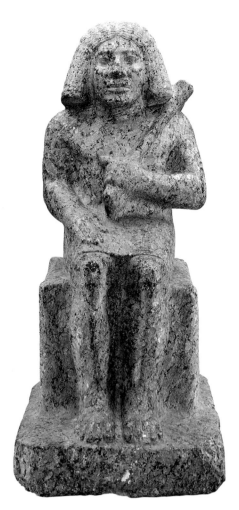

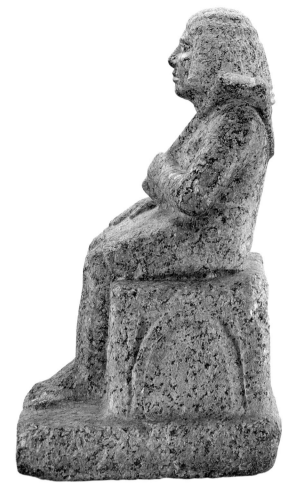

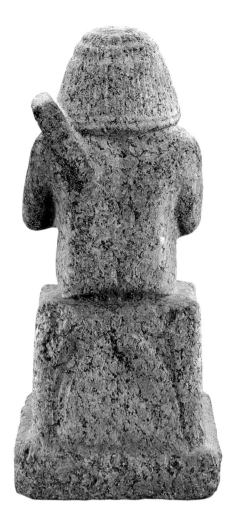

The broad mouth, with its rounded corners, dominates the frontal view of the face. The crisp carving of the lips contrasts with the modeling of the eyes, which lack any indication of the lower lids. But in profile, this disparity is minimized, for the contours of the upper lids and the cheekbones clearly define the eye area, while the prominence of the nose mitigates the breadth of the mouth. In fact, the optimal vantage point from which to study the sculpture is the figure's left side, since it allows the viewer to identify the adze, as well as to see the face in profile. Seen from in front of the statue, the tool's long handle is not distinctive.

The position of the inscription, cut in raised hieroglyphs on Ankhwa's lap, is another hallmark of the sculpture's early date, for in canonical statuary the label identifying the subject is relegated to the base or another structural element, such as the seat in the composition of seated figures. Here the text informs us that Ankhwa was a smith as well as a shipwright. (The former designation was once read "Bedjmes" and interpreted as the statue-owner's name.) A third title mentioned in the inscription ranked Ankhwa among the favored few who, though not directly related by blood to the king, were nevertheless associated with the court.[3] Ankhwa's statue confirms his status, for its quality and material (granite, whose quarrying was at the king's pleasure) attest its manufacture in a royal atelier. (M.E.-K.)

**Notes**

[1] See Eaton-Krauss 1998b, pp. 213f. and nos. 2, 3, 7, 8, 9, 10, 11 (Ankhwa's statue), 12, 13, and 17 in the appended catalogue, pp. 218–21, as well as the statue of the "Turin princess" (ibid., p. 210).

[2] Louvre E 25578; ibid., no. 18, p. 221.

[3] For these titles, see Kahl/Kloth/Zimmermann, pp. 222f.

**Bibliography**

Spencer 1980, no. 1, p. 13, pl. 1.

PM III 1981, 728.

James/Davies 1983, p. 16, with fig. 15.

Quirke/Spencer 1992, p. 154, fig. 118.

Robins 1997, p. 53, with fig. 48.

# 5

## A Royal (?) Woman

Provenance unknown
Old Kingdom, Fourth Dynasty (ca. 2613–2566 B.C.)
Calcite (Egyptian alabaster) with traces of paint
Height 17 1/2 in. (44.5 cm)
EA 24619, acquired in 1893

Neither this woman's dress nor her attitude reveal whether she is a commoner or a member of the royal family.[1] During the Old Kingdom, the simple sheath dress was worn by both royal and non-royal women, and the pose[2]—standing with both arms at the sides and palms resting beside the thighs—was not restricted to either class of women.

In his fundamental study of the Old Kingdom, William Stevenson Smith pointed out that the fine modeling and the sensitivity to the subtle forms of the woman's body implied that the statue was a product of a royal studio.[3] Her full breasts, flat abdomen (but for the slight mound below the navel), and, in profile, the firm, protruding buttocks and full thighs all

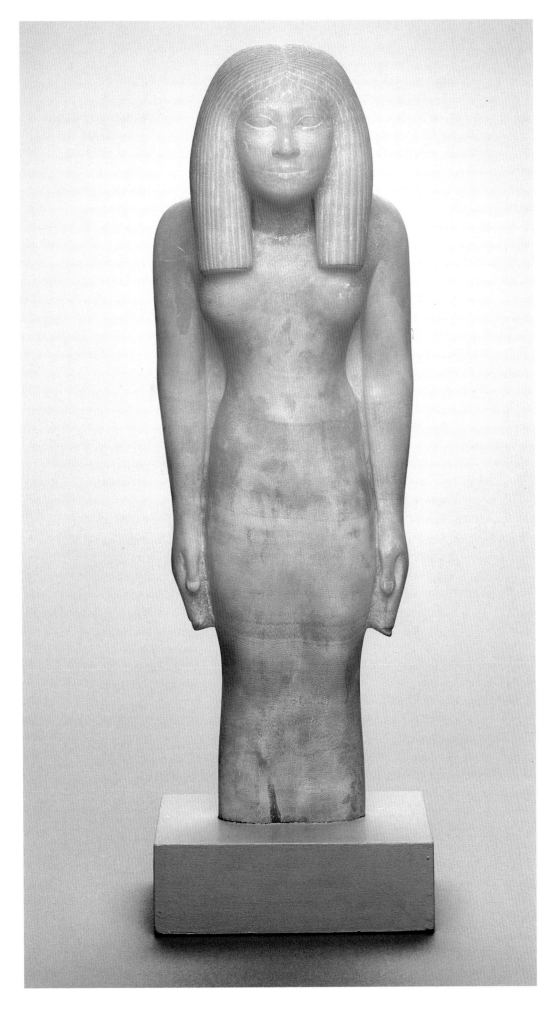

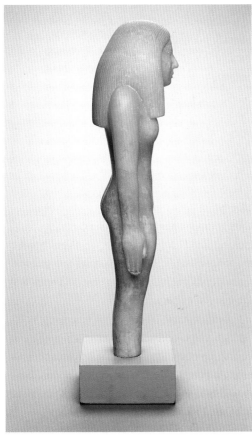

seem to belong to a nubile young woman.[4]

Since Smith's writing, primarily during the past decade, new work in the field of Old Kingdom art[5] not only substantiates Smith's evaluation of the statue but also suggests that it represents a royal woman. Beyond the excellent quality of the carving, the proposed royal attribution is also suggested by the type of stone from which it is carved. Initially, at least, white calcite appears to have been restricted to royal use. Here, the slight roughening of the surface around the wrists, for wide bracelets, and at the neck, for a deep collar—unnecessary preparations if paint were to be applied—probably indicate that gold leaf or foil was affixed to these areas, also favoring a royal attribution.

An early Fourth Dynasty date is generally recognized for this statue, although several stylistic elements—for example, the woman's short neck, which gives the impression that the head has sunk between her shoulders, and the absence of a back pillar—recall the Third Dynasty. Also, the form of the tripartite wig recalls sculptures of the earlier period, when the section resting at the back over the shoulder blades was longer than the sections at the front, and in profile, bulged out about halfway down the back of the head. The curtain-like rendering

of the woman's natural hair at her forehead beneath her wig, however, is a stylistic feature datable to the Fourth Dynasty, and at least originally was a royal fashion.[6]

In contrast to the great sculptures datable to the Third Dynasty[7] with broad, round faces, large, flat eyes, and wide mouths with full lips, this woman's more delicate features are stylistically similar to those found on several limestone reserve heads datable to the reign of Cheops.[8] The features on these reserve heads show a similar treatment of the narrow, barely arching, and faintly incised brows, the almond-shaped eyes, with distinct upper lid line and tear ducts deeply cut in, the well-preserved nose, and the narrow, well-defined lips.

Unfortunately, there are no images of Sneferu and Cheops, the first two kings of the Fourth Dynasty, whose dates approximate those proposed for the British Museum woman, that are either large enough or well enough preserved to be used for a meaningful comparison. However, the stylistic and iconographic analysis presented above in support of her royal status, suggests that she may have been either a wife or daughter of either of these kings. (B.F.)

### Notes

[1] I am indebted to Lynda Beierwaltes for discussing this woman's possible identity with me.

[2] Eaton-Krauss 1998b, pp. 209–10, discusses the British Museum woman and three precanonical standing female statues.

[3] Smith, W. S. 1949, p. 43, pl. 16.

[4] The three-dimensionality of the woman's body is pronounced in profile, giving full effect to the thighs and buttocks. In back view, her body is flat, except for a slight crease in the buttocks, suggesting their natural rounded forms.

[5] See the summary of this work in *Egyptian Art* 1999, pp. XXII–XXIII, to which should now be added Arnold, Do. 1999.

[6] Cherpion 1998, pp. 98–99.

[7] See Eaton-Krauss 1998b, pp. 209–25, and Fay 1998b, pp. 159–60, 170–71.

[8] For example, Vienna ÄS 7787; Catherine H. Roehrig, in *Egyptian Art* 1999, pp. 240–41.

### Bibliography

*Treasures* 1998, no. 7. pp. 50–51.

Arnold, Do. 1999, pp. 36–37.

*Egyptian Art* 1999, no. 26, pp. 205–206, where previous bibliography is cited.

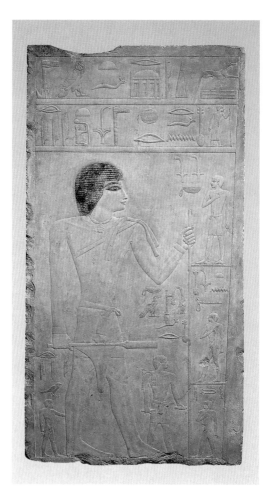

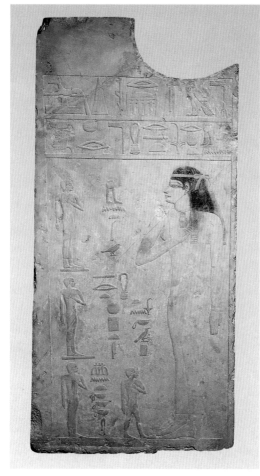

## Three Elements of Tomb Doors

From the tomb of Iry and Inet at Saqqara or Giza
Old Kingdom, Fourth Dynasty (ca. 2613–2494 B.C.)
Limestone with remains of black paint
(a) 38 x 20 7/8 in. (96.5 x 53 cm)
(b) 43 x 21 1/8 in. (109 x 53.5 cm)
(c) 29 x 25 5/8 in. (73.5 x 65 cm)
EA 1168, 1170, 1171, acquired in 1896

These three blocks of raised relief are part of a group of fragments from the tomb of Iry and his wife, Inet.[1] The tomb was situated somewhere in the vast Old Kingdom Memphite cemeteries of Saqqara and Giza, but its exact location is not known. The two vertical fragments come from the thicknesses of a doorway, very likely the entrance door in the sloping tomb façade, to judge from the slight upward taper of the edge opposite each main figure. Iry and Inet faced outward, toward the world of the living. The smaller figures, identified only by name, presumably represent the couple's children, some grown and some still small enough to go about naked. Typically, the daughters are shown with their mother, along with a boy who is probably still young enough to spend most of his time in the women's part of the house.

The upper panel would have been set over the lintel of a false door. The false door was just that: an imitation door, with no real opening. Its purpose was to enable the spirit of the deceased to travel from the subterranean burial chamber to the world of the living above. In the Old Kingdom, the false door was also the focus of offerings made to the deceased. The jambs were decorated with standing figures of the tomb-owner or owners, which faced inward toward the "opening." Above the lintel, a panel such as this one showed the deceased sitting at an offering table covered with tall loaves of bread and in the presence of other foods and commodities.

During the first reigns of the Fourth Dynasty, the archaic characteristics of Third Dynasty art (see cat. no. 4) gave way to the classical, canonical style of the Old Kingdom. A late stage in the transition can be seen in an alabaster statue of a woman (see cat. no. 5) and on these blocks, where the composition of each scene and most details of the figures exemplify

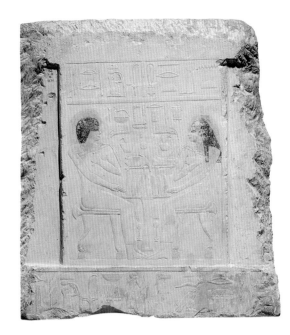

the full-fledged Old Kingdom relief style. The figures are stocky but well proportioned. If the heads of Iry and Inet still seem a bit large, it may be due in part to the fullness of their wigs.

The convention of representing the human body in profile, except for frontal shoulders and eye, was already well established in the First Dynasty (see fig. 1 and cat. no. 2). By the Fourth Dynasty it had become second nature to Egyptian draftsmen and sculptors, who had also added certain refinements. Feet, for example, continued to be shown as identical views of the inner side, each with a high arch and one big toe, and this wholly unnaturalistic rendering was even embellished. When the feet were close together, as on the standing figure of Inet and on both of the seated figures above, the heel of the foot on the far side can be seen under the arch of the near foot (cf. cat. nos. 23, 66). This conceit so appealed to Egyptian artists that they carried it still further: in other two-dimensional representations from the Old Kingdom (and later), the arch of a man's advanced foot may reveal the foot of his small son on the other side, or even the paws of a pair of dogs.[2] More than a millennium was to pass before Egyptian relief carvers and painters began to depict both sides of a pair of feet.[3]

Since the dominant direction for figures and hieroglyphic writing was toward the right (see cat. no. 2), it is the husband here who, as on most marital monuments, faces that way, both in the doorway and in the offering scene. Though Inet has as much space, it is on the secondary side. Her leftward orientation is the reason for the impossible position of her hanging "left" hand

(cf. cat. no. 20). But since the open hands of rightward-facing figures are also shown with both thumbs on the wrong side (see cat. no. 13), this convention is probably intended to indicate that the palm is facing toward the back.

The modeling of the reliefs is sparing and confined for the most part to important features such as faces and Iry's leg muscles. The surfaces of both the figures and the hieroglyphs have been enlivened by the judicious use of incised detail. Note especially the bent, balding, bony man in the upper panel, just below Iry's feet.[4] This is a hieroglyph, a writing of the word "old;" it is also a vivid vignette of what old age meant to the ancient Egyptians. (E.R.R.)

### Notes

[1] Another relief of Iry is British Museum EA 1169: *HT* I² 1961, no. 1, p. 3, pl. 3; *Art and Afterlife* 1999, no. 17, p. 44; four more door elements in Chicago, Field Museum of Natural History, are unpublished: A. 31707, 31708, 31728, 31730: PM III 1981, p. 692.

[2] Russmann 1980, p. 58, with n. 6.

[3] Russmann 1980.

[4] Enlarged drawing and discussion: Fischer 1963, pp. 23–24, fig. 1.

### Bibliography

EA 1168-1171: PM III 1981, p. 692; *HT* I² 1961, nos. 2–4, pp. 3–4, pl. 3.

EA 1168: Robins 1994, p. 14, fig. 1.14; *Treasures* 1998, no. 13, pp. 68–69.

EA 1170: Robins 1994, p. 14, fig. 1.15.

EA 1171: Robins 1993, p. 158, fig. 66; *Art and Afterlife* 1999, no. 16, p. 45.

## Raised Relief: Daily Life, Children

From Giza (?)
Old Kingdom, Fifth Dynasty (ca. 2494–2345 B.C.)
Limestone
20 x 35 ½ in. (50.8 x 90 cm)
EA 994, acquired in 1879, purchased via the Reverend Greville Chester

Every element of an ancient Egyptian tomb was intended to help the deceased achieve life after death. The tomb itself served as the spirit's eternal home, where it could receive the offerings and prayers necessary for sustaining life through endless time. Reliefs and paintings decorating tomb walls usually depicted idealized versions of everyday happenings, enabling the tomb owner to dwell forever in a familiar environment. Some tomb scenes representing recurring events, such as annual rituals and the seasonal harvesting of grain, had deeper significance. The Egyptians believed that by associating themselves with such cyclical events, they would increase their own chances of experiencing the cycle of birth, death, and rebirth.

The upper and lower registers of this relief fragment, reportedly from Giza, show several standard scenes of everyday life. The uppermost register illustrates three stages in boat-building: cutting down a tree (right), transporting a log (center), and sawing planks and scraping the deck with an adze (left). At the bottom of the relief, three scenes illustrate the provisioning of

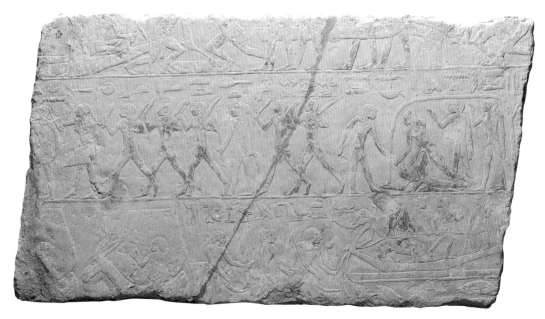

food for the tomb. At the far right, four sailors catch fish in a net; next, a trio of workers cut grain; on the left, two men lead a pair of donkeys laden with huge bags of grain. All three vignettes are well known from other Old Kingdom tombs.

The central register shows something far more difficult to explain. At the far left, two women raise their hands to their mouths. Behind them appears a group of six figures. Five are naked boys; they are running or dancing, and their bodies are painted red. Each wears his hair in a braided sidelock, signifying youth, and holds a short stick and a sheaf of grain. In the middle of this group stands a white figure wearing a loincloth and what seems to be a mask with pointed ears, enormous nose, and long hair falling over his shoulders and onto his back. In his right hand he grasps a scepter ending in a human hand; in his left is a long piece of cloth. The hieroglyphic text above the group seems to read, "Dance of the youths." Finally we see four boys inside a curved structure usually interpreted as a hut. One of them struggles to escape while another holds him down. Outside of the enclosure a fifth lad admonishes his struggling companion, "You must flee from it [the enclosure] alone."

Initially scholars guessed that this scene represented a circumcision ritual or a rite of exorcism.[1] The importance of agricultural themes and cyclical iconography in Old Kingdom tombs, however, led other Egyptologists to suggest that the relief portrays events in a seasonal harvest festival intended to ensure the renewed fertility of the land once the crops had been gathered.[2] The female figures were dancers or singers who belonged to a train of musical performers found at most important Egyptian ceremonies. The central group depicts boys dancing around a harvest deity (perhaps shown as a statue) who guaranteed fecundity once reaping was done. The scene of the boy struggling to escape the hut may be part of a puberty ritual marking his transition to a state when he, like the fertile land, could create new life.[3] (J.F.R.)

### Notes

1 Capart 1930–31, pp. 73–75; Stracmans 1952, pp. 427–40; Wild 1963, pp. 76–77.

2 Smith, W. S. 1949, pp. 210–11; Janssen/Janssen 1990, p. 65.

3 Pinch 1994, p. 122.

### Bibliography

Capart 1930–31, pp. 73–75, pl. [8].

Smith, W. S. 1949, pp. 209–11, fig. 83.

Vandier 1964, pp. 402–403, 520–21, 524–27, fig. 209, pl. 18.

Sourdive 1984, pp. 48–52, fig. 1.

Janssen/Janssen 1990, pp. 63–66, fig. 27.

Quirke/Spencer 1992, p. 23, fig. 10.

Decker/Herb 1994, I pp. 629–30, 787; II, pl. 349.

Pinch 1994, pp. 121–22, fig. 63.

Romano 1998, pp. 94–95, fig. 2.

## Nude Figure of the Seal Bearer Tjetji

Probably from Akhmim, cemetery of el Hawawish
Old Kingdom, Sixth Dynasty (ca. 2321–2184 B.C.)
Wood, traces of paint, inlaid eyes
Height 29 3/4 in. (75.5 cm)
EA 29594, acquired in 1898

Tjetji is shown in the classic pose of a standing official, with his left leg advanced, a long staff in his left hand, and a *sekhem* scepter (now lost) held horizontally in his right hand.[1] As in most wooden statues in ancient Egypt, where fine wood was scarce and expensive, the arms of this statue were made separately and pegged to the body, and the feet tenoned into a separate base.[2] The staff and scepter were also separate pieces, inserted through the holes in Tjetji's hands. The figure was once fully painted according to the usual conventions, with the body dark red, the hair and nipples black, and the finger- and toenails white.[3] The eyes are inlaid with white limestone and obsidian, set in copper frames.

Stone statues of men in this pose have back pillars, negative space between the limbs, and, as substitutes for the slender implements, rolled cloths, the button-like ends of which are barely visible within their fists (cat. no. 123 and fig. 3).[4] Since wooden statues were free of these conventions,[5] they tend to look less rigid and more natural. But Tjetji's statue, the work of a fine sculptor, has an unusually lively, alert quality that makes it one of the finest expressions of the style of the late Old Kingdom.

The hallmarks of late Old Kingdom style are all present here—long, slender torso and limbs with little indication of musculature; a

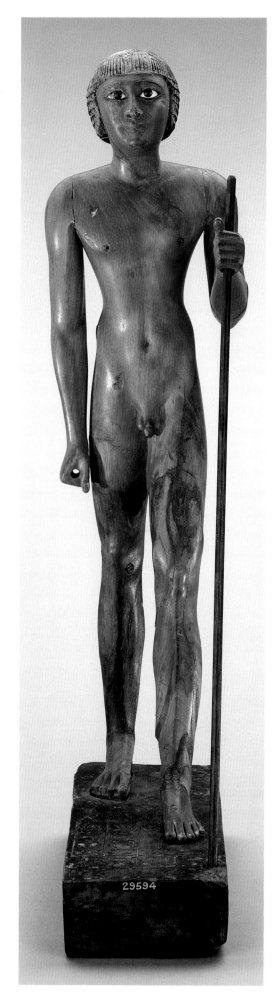

29594

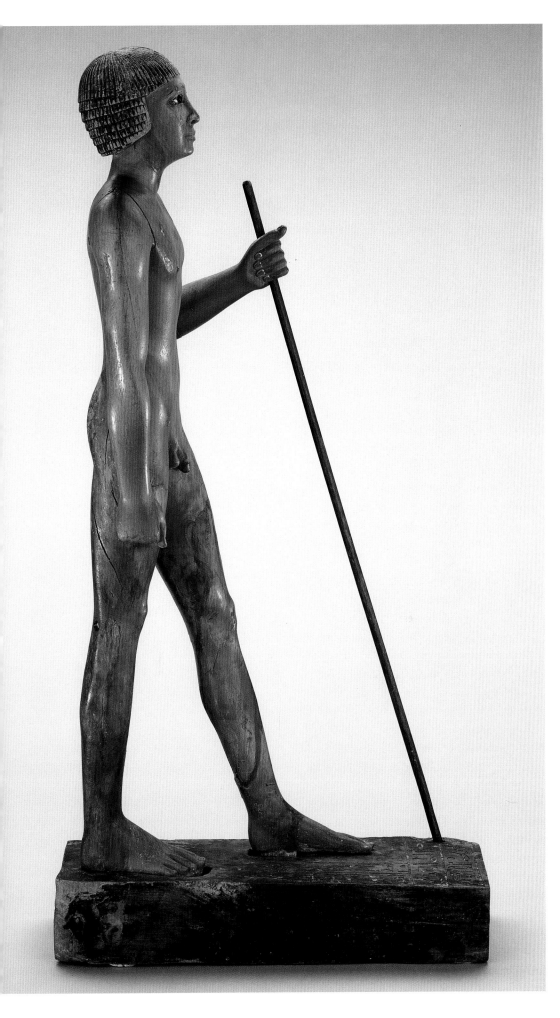

somewhat overlarge head and very large eyes; a face that tapers to a narrow jaw, with a broad mouth curved in a tense-looking smile, set off by folds descending from the nostrils. The asymmetry found to some degree on many late Old Kingdom statues, such as catalogue number 11 and, most notably, catalogue number 9, may be expressed here by the slight raising of Tjetji's head.[6] Most significant of all, perhaps, is his nakedness. Nude statues of tomb-owners were made only during the second half of the Old Kingdom; all but the one or two earliest examples are in late Old Kingdom style.[7]

In Egyptian art, young children are represented naked (cat. no. 6), and so are some of the lowliest manual laborers. Tjetji certainly did not belong to the latter group. As one would expect from the high quality of his statue, Tjetji's titles show that he held high administrative rank. Nor is he a child, for he has been circumcised. Circumcision was apparently performed at puberty.[8]

Clothing was an important indicator of one's social status and profession in ancient Egypt—both on earth and in the afterlife. Why, then, during the relatively short period of the late Old Kingdom and First Intermediate Period, did Tjetji and others choose to have tomb statues devoid of these visible trappings? We really do not know. Some tomb-owners had both clothed and unclothed statues. Tjetji himself seems to have had at least one other statue which shows him wearing the long kilt of a middle-aged man.[9] But all three statues of Meryrahashtef (cat. no. 9) are naked.

Recent excavations at the Old Kingdom cemetery of el-Hawawish, near modern-day Akhmim, have located the tomb that probably belonged to Tjetji.[10] Like the style of the statue, the tomb supports a date in the mid-Sixth Dynasty and reinforces the likelihood that he was a member of the local family of nomarchs. (E.R.R.)

## Notes

1 For the two-dimensional version of this pose, see cat. no. 20.

2 Other wooden statues constructed in this way: cat. nos. 11 and 24.

3 Other examples of black-painted nipples and white-painted nails: cat. nos. 11 and 24.

4 For these objects see Fischer 1975.

[5] There are exceptions, e.g., cat. no. 93.

[6] Note, however, that Egyptian statues with raised heads, though rare, are found in every period; see, for example, cat. no. 131.

[7] For a fuller discussion of late Old Kingdom sculptural style see Russmann 1995.

[8] For what little we know of the practice in ancient Egypt, see Ghalioungui 1963, pp. 91, 95–97.

[9] Louvre E 11566: *Egyptian Art* 1999, no. 191, pp. 465–66.

[10] Though probable, this identification is not certain: Kanawati 1987, pp. 57–58.

**Bibliography**

Seipel 1992, no. 36, pp. 142–43.

Harvey 1994, no. A54, pp. 93–94, 197 (with copy of inscription), pl. 31 c–e.

Robins 1997, p. 21, fig. 10.

*Egyptian Art* 1999, no. 180, p. 464 (with bibliography).

## Striding Figure of Meryrahashtef

From Sedment
Old Kingdom, Sixth Dynasty (ca. 2345–2181 B.C.)
Ebony and sycamore
Height 22 ⁷/₈ in. (58.1 cm)
EA 55722, acquired in 1923, purchased with the assistance of the National Art Collections Fund

Conventions in any form of art provide frameworks within which well-trained practitioners can exercise their skills with confidence, whether in writing a sonnet, composing a fugue, or designing a building in a particular style. In Egyptian sculpture fairly strict conventions governed the proportions, forms, and attitudes, and a great many pieces have survived from antiquity to demonstrate the success of these conventions in the production of good pieces. However, good pieces may—through their observing of conventions—provide standards for assessment, even if they are not *ipso facto* masterpieces. Skill is one thing, artistry another. Most Egyptian sculptors working in the great centers for royal and very influential clients, produced works of superlative skill, sometimes touched by an artistry that transcended skill. In provincial places standards of skill might not be so high, and it could not generally be expected that the necropolis of Sedment, seventy miles south of Cairo, to the west of the Nile, would

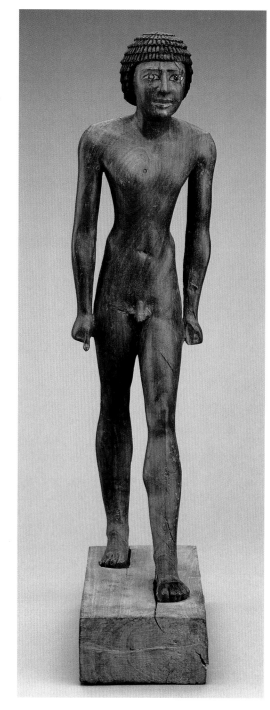

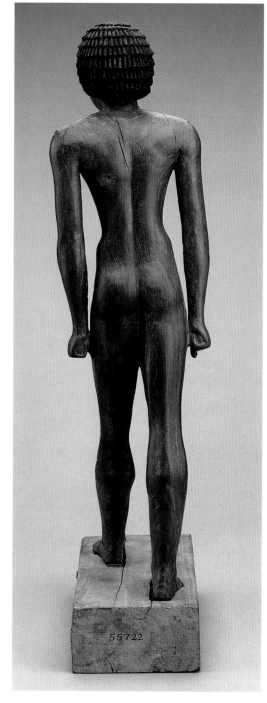

contain a masterpiece of funerary sculpture.

The tomb of Meryrahashtef, a modestly placed official of the Sixth Dynasty, with the commonplace titles "unique friend and lector priest," was found by Sir Flinders Petrie in the winter of 1920–1921.[1] Three male figures, one female figure, and three servant models were found in the filling of a shaft, at the bottom of which there was a simple burial chamber with the remains of a wooden coffin and a fine calcite headrest, inscribed with the titles and name that identify the burial as that of Meryrahashtef. Of the three wooden figures, presumably of the tomb-owner, this one shows the subject as a

young man, probably in his teens. It is carved from a single piece of ebony and mounted on a simple base of sycamore wood. The form is conventional: the young man is shown, rather exceptionally, in the nude (as is the case with all the figures from this tomb), striding forward, his left leg advanced, his arms at his sides, fists clenched, holding truncated cylindrical objects which have been identified as small rolls of cloth.[2] The head is covered with the conventional curled wig, very carefully carved and painted black, and the eyes, which in a superior commission would have been inlaid, are simply painted. The delineation of the facial details is

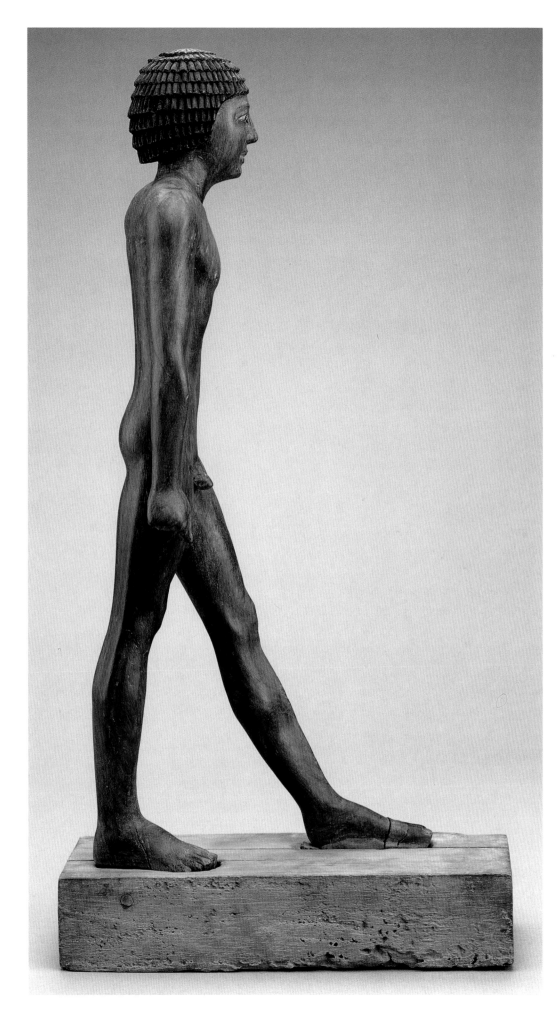

sensitive and restrained: the eyebrows are lightly indicated, the nose subtly modeled, the unemphasized mouth slightly unbalanced, suggesting a wry smile.

It is, however, the body of the figure that demands attention. For a master sculptor's assessment of the carving, let Henry Moore speak: "What I admire about this statue is its tension. If you run your hands down the legs or across the shoulder blades you can feel the tautness and hardness of the muscles. The Egyptian sculptor has squeezed tense physical energy into the whole piece."[3] Moore puts his finger right on the spot in this comment, made after one of a series of visits he made to the British Museum in 1980, when he was allowed to handle some of the pieces that particularly interested him. He needed no prompting to appreciate the quite remarkable skill of the artist who carved this statue, even though he was unaware of the features in the piece that render it special for the student of Egyptian sculpture. This statue was conceived as a whole, to be carved from a single block of ebony, without the separate carving of arms and feet, as was common with wooden figures. Although the attitude is conventional, it is not treated in a conventional way; the body turns and bends in a lithe manner, which was undoubtedly the intention of the artist, and not the result of a warping of the wood. The impression of energy generated is emphasized by the elongation of the left leg that strides forward.

A comparison with the other two, somewhat larger, figures of Meryrahashtef, reveals the exceptional genius of the sculptor of this piece. It alone, among the group, transcends the common tradition of Old Kingdom provincial woodcarving. From the first, Petrie appreciated its special quality, noting, "The attention to the anatomy is more detailed than in any other Egyptian work. The muscles of the trunk are most carefully rendered, on the back as well as the front."[4] But in addition to detailed anatomy and naturalistic posture, this piece has a refined elegance that is rare in Egyptian sculpture of the Old Kingdom. (T.G.H.J.)

**Notes**

[1] Petrie/Brunton 1924, p. 3.

[2] See Fischer 1975. The object is rather attenuated in this Sedment sculpture and not easily seen as the kind of linen roll

identified by Fischer; it may, however, be a degeneration of the roll, the significance of which was no longer understood.

[3] Moore 1981, p. 28.

[4] Petrie/Brunton 1924, p. 3. On the musculature, see also the comments of C. Ziegler in *Egyptian Art* 1999, p. 461.

### Bibliography

Petrie/Brunton 1924, pp. 2f., pls. 7, 8, 11.

Vandier 1958, p. 141, pl. 45, 3.

Moore 1981, pp. 28, 30–31.

James/Davies 1983, pp. 23f.

Robins 1997, p. 71.

*Egyptian Art* 1999, p. 461.

# 10

## Statuette of a Standing Woman

From Sedment
Old Kingdom, Sixth Dynasty (ca. 2345–2181 B.C.)
Sycamore(?) wood
Height 14 ³/₄ in. (37.3 cm)
EA 55723, acquired in 1923, purchased with the assistance of the National Art Collections Fund

The excavation of the tomb of Meryrahashtef by Sir Flinders Petrie in 1920–1921 yielded three male figures and one female. On the basis of the inscriptions on a calcite headrest found in the burial chamber of the tomb, it has commonly been accepted that the male figures represent Meryrahashtef himself, although the identification is by no means certain. The figures were found not in the burial chamber, but high on the filling of the tomb shaft. A further general assumption (at least in the British Museum) has been that the female figure represents the tomb-owner's wife. This assumption is reasonable in spite of the absence of inscriptional evidence.[1]

The wood from which the figure is carved is less rare than the ebony of the three male figures; it is probably sycamore—that is, the sycamore fig (*Ficus sycomorus*), a native of Egypt. It is a dense, reasonably hard wood, suitable for wooden sculptures, not inclined to splitting but often displaying small knots and an uneven texture. This sculpture is a good example of a piece in the process of being worked. The figure has been roughed out in the form commonly used for many Old Kingdom sculptures of women. The subject is shown

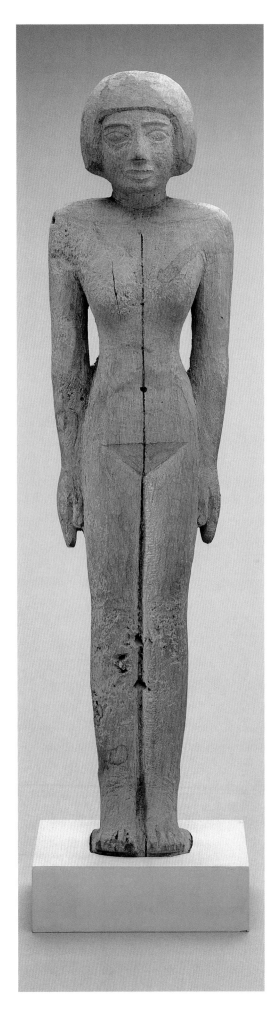

standing with her legs close together and her arms at her sides, with the hands open, the palms resting on the thighs.[2]

A line in black paint runs down the front of the body from between the clearly marked clavicles down through the navel (marked by a black spot), over the pubic area (sharply marked as a triangular feature), and between the legs, petering out at about the level of the knees. This median line was undoubtedly intended as an aid for the carver, to secure a balanced figure which would be essentially the same on each side of the line. It was almost certainly the last in a series of guidelines used from the start of the roughing-out of the carving from the original, unshaped piece of wood. Ultimately the line could be removed in the final smoothing of the surface; or it could simply be concealed by the finishing of the piece with painted gesso-plaster.

Although some parts of the figure have been worked almost to a finished state, much remained to be done to complete it to a standard comparable with that achieved for the three figures of Meryrahashtef. The head is particularly informative. The facial features are clearly established but by no means molded to acceptable forms. The eyebrows are strongly marked but need a fining down suitable for a female figure; the eyes are marked out as simple lentoid shapes; the nose is a triangular protuberance awaiting detail; the mouth is pronounced and unshaped. The wig is covered with small tool marks, little facets produced by a chisel, or, more probably, a small adze.

The body of the figure, however, is in an almost finished state. The breasts are neatly modeled, the waist slender and set rather high, as is common in figures of the late Old Kingdom; the buttocks are well formed and somewhat prominent. Viewed from the side, the sculpture presents a very pleasing appearance, confirming the overall competence of the carver. The arms and legs, in contrast, are lacking in modeling, and the fingers and toes are simply marked out by grooves.

No suggestion of dress is apparent in this carving.[3] In an unfinished piece the clearest indication of dress would be found in the sharply defined line marking the bottom of the skirt of a long garment, finishing at ankle level. Other details of dress including neckline, shoulder straps, even jewelry, could finally be added in

paint, particularly if the piece were to be covered with gesso. Several questions, therefore, need to be raised: Was this statuette ever intended for further finishing? Was it to be gessoed and painted? Was it to be left, finished, without gesso, but with some detail to be added in paint? Was it perhaps made at the last minute for the burial of Meryrahashtef—a wife-figure to join the three well-finished figures of the man—a piece for which there was no time for finishing, but which would nevertheless be able to perform its posthumous function as wife or concubine? Whatever the reason may have been—and there seems no chance of discovering what it was —this statuette provides some indications of the stages by which a figure was carved in the late Old Kingdom. It was, moreover, potentially a figure of some distinction; it remains one of considerable charm. (T.G.H.J.)

### Notes

1 Petrie/Brunton 1924, p. 3, do not claim that the figure does represent Meryrahashtef's wife.

2 For the form, see Vandier 1958, p. 63, the "attitude classique."

3 Nudity in female figures in wood is not without precedent in the late Old Kingdom and First Intermediate Period; see Vandier 1958, p. 111.

### Bibliography

Petrie/Brunton 1924, p. 3, pl. 11.

James/Davies 1983, p. 16.

Seipel 1992, no. 38, pp. 146–47.

# 11

## Standing Nude Woman

From Asyut, Tomb XLVa, excavation of D. G. Hogarth
Late Old Kingdom or First Intermediate Period (ca. 2345–2025 B.C.)
Wood, painted
Height 8 ¹/₂ in. (21.6 cm)
EA 45200, acquired in 1907

This small figure of a nude woman shows her standing in the typical female pose, with her feet together and her open hands at her sides. As on many Egyptian wood statuettes (see cat. no. 8), the arms are separately carved pieces of wood, as is the base. Traces of gesso (?) suggest that the figure may once have been fully painted, but all

that can now be seen is white on the eyes, finger, and toenails, and black on the wig, eyes and eyebrows, nipples, and pubic area.[1] The pubes is rendered as rows of dots.[2]

The posture of this figure is as exquisitely balanced as that of the much earlier Old Kingdom calcite statue of a woman (cat. no. 5). But their bodies are quite different. Whereas the slenderness of the calcite figure conveys the impression of a firm, strong young body, the more attenuated forms of this woman give her an air of delicacy, even fragility, which is heightened by the fact that she is naked.

Neither of these statues is a portrait; the differences between them are entirely differences between the style of the early Old Kingdom and the style developed toward the end of that period. The wooden figure exhibits all the stylistic traits described above (cat. no. 8), as well as extremely elongated fingers, another characteristic of late Old Kingdom style.

The symmetry of the woman's pose is broken by a slight turn of her head to her right. This was surely intentional. Most Egyptian statues show small asymmetries; for example, one eye is very often higher than the other. In part, these may have been due to ancient working methods, but they seem also to have been appreciated for their enlivening effect. On statues of the late Old Kingdom, noticeable asymmetry occurs too frequently to be accidental. In at least one case, it was carried to a striking extreme (cat. no. 9).

The painting of the pubes on this figure leaves no doubt that it, like catalogue numbers 8–10, is nude. While it is rather surprising that some male tomb owners of the late Old Kingdom and First Intermediate Period chose to have tomb statues that represented them naked and thus deprived of the status indicators of their clothing (see cat. nos. 8 and 9), it seems astonishing that women of high social rank, during this period, sometimes did the same. For although women of ancient Egypt did not suffer the legal and economic restrictions imposed on women in many other cultures, they were certainly subject to strong dictates of propriety. It is true that statues of women, particularly in the Old Kingdom, frequently emphasize sexual characteristics barely veiled by an impossibly skintight dress (see cat. no. 5); but the existence of that dress is seldom in doubt.

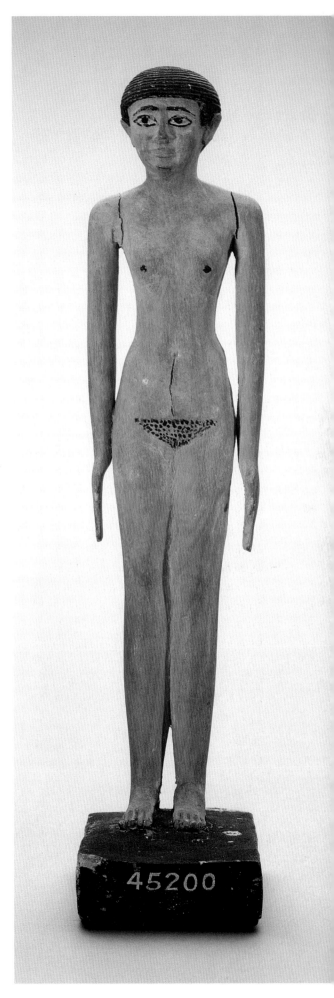

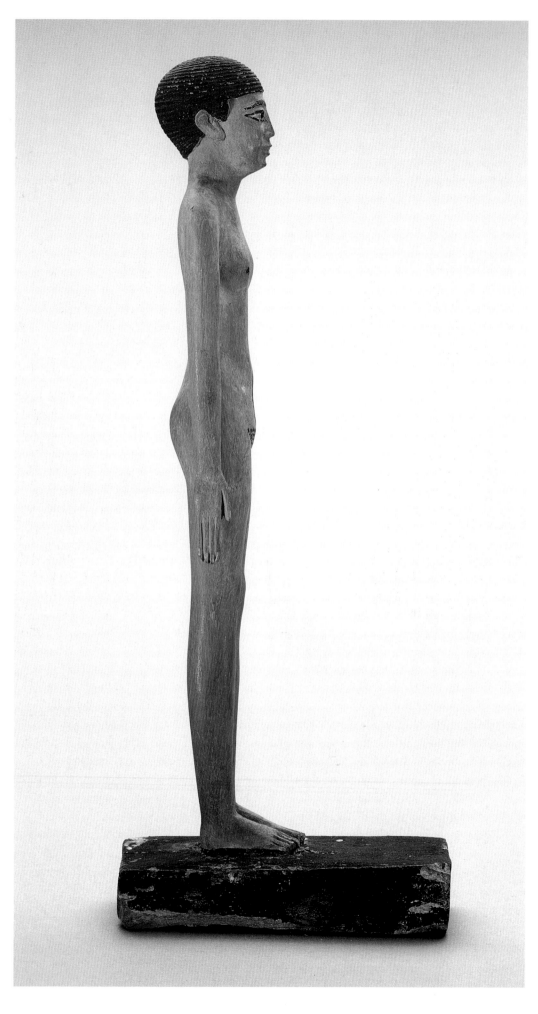

Yet this anonymous statuette, along with catalogue number 10 and perhaps a dozen more wooden figures of nude females, very probably represents a high-ranking woman. The great majority of those with known provenance come from women's tombs at provincial sites outside the Memphite area: Asyut, Sedment (cat. no. 5), Naga el Der.[3] In some places, the use of nude female tomb statues may have continued into the early Middle Kingdom,[4] by which time the statues of their male counterparts were once again clothed.

Until recently, all statues of nude women were assumed to represent "concubines," placed in tombs to serve the needs of male tomb-owners. We now know that their functions were much more varied. The most blatantly sexual of them were fertility figures, deposited as votive offerings in hope of a child.[5] Some were found in tombs, but others have been found in houses,[6] and many come from the shrine or temple of a goddess.[7]

Other naked female figures appear to be servant girls or dancers, whose nudity is undeniably suggestive but also a sign of their extreme youth.[8] In the New Kingdom, most such representations, such as catalogue number 81, a cosmetic vessel, and figure 14, a mirror handle, functioned as luxury objects that were used by male or female owners before being deposited with them in the tomb.

This statue was found in a tomb at Asyut, a provincial town that flourished during the First Intermediate Period and early Middle Kingdom. Most statues from its necropolis date to this period. However, this figure is so close in style to examples made elsewhere before the end of the Old Kingdom (see cat. no. 8) that it may well be one of the earliest statues from this site. (E.R.R.)

### Notes

[1] For the same conventional colors on nails and nipples, see cat. nos. 8 and 24.

[2] Black dots were also used to indicate the stubble of hair on shaven heads of male figures; see Russmann 1989, no. 25, pp. 59–61.

[3] Harvey 1994, p. 42. For two examples from Naga el Der, see C. K[eller] in Thomas 1995, nos. 48A and B, pp. 138–39.

[4] E.g., Louvre E 3931, E 20576, E 22909: Delange 1987, pp. 116-17, 188-89, 200-201; also Arnold, Di. 1981, pp. 65–66, pl. 59h.

[5] For the function of these figures and the typical forms of the

Middle and New Kingdoms, see Pinch 1993, pp. 198–226, pls. 46–51.

[6] E.g., Capel/Markoe 1996, no. 16b, pp. 66–67.

[7] Pinch 1993, p. 225.

[8] For an early Middle Kingdom example, see Louvre E 12003: Delange 1987, pp. 156–57.

**Bibliography**

Unpublished; for the tomb, see Ryan 1988, pp. 71–72.

# 12

## Stela of Inyotef, Son of Ka

Almost certainly from Thebes
Eleventh Dynasty, early reign of Nebhepetre
Mentuhotep (ca. 2102–2070 B.C.)
Limestone, traces of paint
28 1/8 x 40 in. (71.3 x 101.5 cm)
EA 1203, acquired in 1897, purchased via the
Reverend C. Murch

The stela of Inyotef is perhaps the British Museum's best example of what is usually termed "provincial art" of the First Intermediate Period. Old Kingdom artistic styles for relief and painting were usually remarkably homogenous throughout the kingdom, whether around the capital, Memphis, or in the provinces. Following the collapse of central control at the end of the Eighth Dynasty, styles become very localized, as if the craftsmen employed had no experience in working in the controlled, formal style particularly associated with Memphis. Thus it is perfectly feasible for modern scholars to assign provenances and dates to some First Intermediate Period objects purely on the basis of provincial forms of the hieroglyphs.

Theban products do not generally exhibit the more extreme features seen at other sites, such as very narrow waists and general divergence from the conventional system of proportions in use; some stelae—for example, that of Tjetji (cat. no. 13), follow conventional proportions, with local influence primarily in the form of the hieroglyphs. The features that distinguish the stela of Inyotef are the crudeness of the carving, the depth of the relief, and the rather inelegant handling of the heads and shoulders of the figures.[1]

Inyotef is shown standing, receiving an offering from a small male figure who stands in front of him; the positioning of this figure and the scale are very characteristic of the First Intermediate Period. Behind Inyotef are three female figures, all referred to as his wives, named Mery, Iutu, and Iru. It should not be assumed that the juxtaposition of these women indicates that Egyptian society accepted polygamy, as it is quite possible that they could have succeeded one another; death in childbirth must have taken many lives in ancient Egypt, and divorce was not unknown, although whether a divorced wife would be shown on a monument is a moot point.[2]

The principal text of the stela, which runs horizontally at the top and then continues vertically at the right side and then in front of the lower parts of the principal figures, is a mixture of offering formulas, important historical information, and phrases that form parts of standard idealized biographical texts. Thus Inyotef indicates that he ferried over the river the man who had no boat and gave water to the thirsty, both of which phrases feature commonly in standard texts; but there are others that are more unusual, while still idealized. One very unusual usage is of the word "hunter," as in, "I was a hunter for my lord," or "I was a hunter for the West," four times in all. Such a use of this term, for a royal agent like Inyotef, is unparalleled.

There is no known tomb for Inyotef, but it is reasonable to assume that this stela came from his funerary monument. Painted or carved tombs of the First Intermediate Period in Thebes are unknown, and it would seem that most officials were content with a rock-cut chapel with a stela such as this as its focus. The likely location for such tombs (including that of Tjetji [cat. no. 13]) is in the area of the modern town of el-Tarif, at the northern end of the necropolis on the West Bank at Thebes.[3]

The stela belongs to a time when Egypt was divided between kings of the Ninth and Tenth Dynasties in the north, probably residing at Herakleopolis, just south of the Fayum, and those of the Eleventh Dynasty in Thebes. The historical importance of this object lies first in the list of kings served by Inyotef. He mentions three of these Theban kings: Wahankh Inyotef,

Nakhtnebtepnefer Inyotef, and Sankhibtawy Mentuhotep. The first two are well known and are normally referred to as Inyotef II and III of the Eleventh Dynasty; the third king is logically the king better known as Nebhepetre Mentuhotep, the successor of Nakhtnebtepnefer Inyotef; but the Horus name Sankhibtawy for this king is not known elsewhere. The text between the two women at the left of the stela indicates that the stela was set up in year 14, the year of the rebellion of Thinis (the capital of the nome [province] of Abydos, probably referring to the whole province). Fighting in the Abydene region is alluded to in other texts, most notably those of the nomarchs of Asyut, and the literary text known as the *Instruction for Merykare*, and Abydos/Thinis seems to have been the boundary between the warring kingdoms; this stela perhaps allows us to date some of the fighting.[4]

Very little is known about the earlier part of the reign of the king better known as Nebhepetre Mentuhotep, and it would appear that he used three Horus names in his long reign. He eventually brought the First Intermediate Period to a close and reunited Egypt, and these name changes perhaps reflect his changing aspirations and achievements: "Sankhibtawy" (on this stela) means "the one who makes the two lands to live;" the next name, known from the middle of his reign, is "Nebhedjet," "possessor of the white crown," perhaps meaning the ruler of all of Upper Egypt; the final name, known from year 39, is "Sematawy," "the uniter of the two lands," indicating that he had completed the process. Thus the stela of Inyotef is an important monument for both the political and the artistic history of Thebes and Egypt. (N.S.)

**Notes**

[1] A recent summary of the art of this period will be found in Robins 1997, pp. 80–89.

[2] Some Middle Kingdom examples of monuments showing more than one wife, including this one, were collected by Simpson (1974b, pp. 100–105); Old Kingdom examples in Kanawati 1976, pp. 149–60.

[3] The extent of the el-Tarif necropolis may be judged from the plans at the end of Arnold, Di. 1976.

[4] The most recent edition of the Asyut texts is Edel 1984. For Merykare, see Parkinson 1997, pp. 212–34, 313, especially 221–22. The sources for the conflict between the two kingdoms are surveyed in Quack 1992, pp. 98–113.

**Bibliography**

*HT* I 1911, pl. 53.

Budge 1914, pl. 7.

PM I, 2 1964, p. 596.

Strudwick/Strudwick 1999, pp. 24, 25.

Text: Clère/Vandier 1978, p. 19; translation (German): Schenkel 1965, pp. 226–28.

# 13

## Stela of Tjetji

From Thebes, tomb of Tjetji
First Intermediate Period, pre-reunification Eleventh Dynasty (ca. 2112–2055 B.C.)
Limestone
Upper 25 $^5/_8$ x 43 $^1/_8$ in. (65 x 109.5 cm)
Lower 34 $^1/_8$ x 43 $^1/_8$ in. (86.5 x 109.5 cm)
EA 614, acquired in 1903

The stela of Tjetji reflects traditions of the late Old Kingdom and anticipates the best of the Eleventh Dynasty. It is divided into three unequal fields. At the top is a fourteen-line autobiographical inscription reading from right to left. The lower left portion depicts Tjetji facing right, in high raised relief, with two members of his staff; a small figure presents offerings before him. The lower right field is an elaborate offering prayer written in five vertical rows, listing wishes for the Afterlife.

Tjetji's autobiography revives an Old Kingdom literary tradition nearly two hundred years after its disappearance.[1] In Tjetji's era, autobiographies typically praise nomarchs' efforts on behalf of their nomes. But Tjetji, a court official, returns to the Old Kingdom ideal of service to the king as the theme of his autobiography. He makes constant reference to his success in carrying out the king's wishes. This ideal continued to dominate subsequent autobiographies written during the Middle Kingdom.

Tjetji recounts his service as overseer of the seal bearers of the king to Wahankh Inyotef II (2102–2063 B.C.) and Nakhtnebtepnefer Inyotef III (2063-2055 B.C.), establishing for historians the order of these kings. He also describes the borders of the Theban kingdom just before the reunification of Egypt under Nebhepetre Mentuhotep II (2055–2004 B.C.). These borders stretch from Elephantine, in the south, to Abydos, in the north.

Unlike later, extended autobiographies carved on tomb walls, this text is limited in length by the size of the stela. Yet Tjetji's use of the Egyptian language is striking and eloquent. Ronald J. Leprohon has recently suggested that this elaborate language, structured in tight grammatical patterns, derives from the deceased's own efforts to attain the ancient Egyptian ideal of "perfect speech."[2]

Many commentators have noted the unusual shapes of some common hieroglyphs in this inscription.[3] For example, the *mes* sign in line 1, used to write the word "to give birth, to create," could be read as an elaborate *ankh* sign used to write the word "to live." The scribe has created a visual pun that the ancient reader would surely have noticed.

The relief, like the text above it, relates to the end of the Old Kingdom and anticipates the mature Theban style of the Eleventh Dynasty. The large figure of Tjetji and the subsidiary figures of his seal bearer, Magegi, and his follower, Tjeru, exhibit the features of this style. Cyril Aldred has identified the sharp ridge defining the edge of the lips, the accentuation of the muscles at the base of the nose, and the long earlobes as typical of both late Sixth Dynasty and mature Eleventh Dynasty relief styles.[4] Edna R. Russmann has identified these same characteristics as elements of the Old Kingdom "second style," ancestor of the Theban style that is recognizable here.[5] The Theban style also included high raised relief, deep sunk relief, and incised details. Gay Robins has pointed out the typically narrow shoulders, high small of the back, and lack of musculature in the male figures.[6] The details of Tjetji's face are also typical of the Theban style. The eye is large, outlined by a flat band representing eye-paint, and extended to form a cosmetic line that widens at its outer end. The inner canthus of the eye dips sharply downward. The eyebrow appears flat, rather than following the curve of the eye. The nose is broad, while the lips are thick and protruding. The lines of the lips end at a vertical line representing the cheek, rather than meeting in a point. The high quality of the relief's execution demonstrates that the arts flourished in Thebes before the political reunification of Egypt. The layout and contents of the offerings spread before Tjetji are also typical of this period.

The vertical columns of the offering prayer

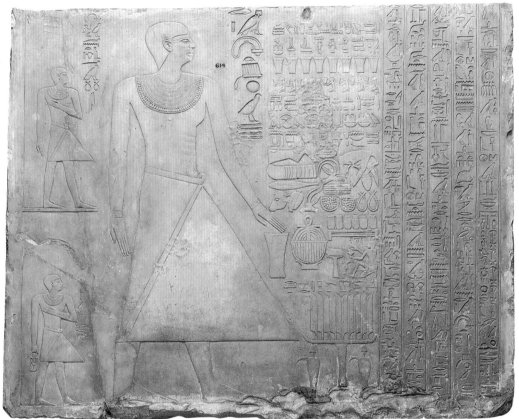

[3] Polotsky 1929, p. 11.

[4] Aldred 1977, p. 5.

[5] Russmann 1995, p. 278.

[6] Robins 1997, p. 84.

**Bibliography**

Blackman 1931, pp. 55–61.

PM I, 2 1964, p. 596.

Lichtheim 1976, pp. 90–93.

Lichtheim 1988, pp. 46–49 and pl. II.

Robins 1997, p. 86 and fig. 85.

# 14

## Offering Bearer from Tomb Doorway

From Thebes, tomb of Tjetji
First Intermediate Period, Pre-reunification Eleventh
Dynasty (ca. 2112–2055 B.C.)
Limestone, painted
Height 33 ¼ in. (84.5 cm)
EA 614a, acquired in 1903

This doorjamb is an example of sunk relief. In
contrast to raised relief, where the surface
surrounding the figure is cut down below the
level of the figures (cf. cat. nos. 6, 16–18), sunk
relief is made by cutting out the outline of the
figure and then working all of the modeling and
the carved details on the figure itself; the
"background" surface, the original surface of the
stone, remains untouched. As a general rule,
sunk relief was used on exterior surfaces and
raised relief on interior walls, but there are
numerous exceptions. In the New Kingdom,
some stelae even have both raised and sunk relief
on the same monument (cat. no. 98).

This relief comes from the doorway of a
tomb at Thebes belonging to a man named
Tjetji, a high official who was also the owner of
catalogue number 13. Tjetji lived just before the
reunification of Egypt under Mentuhotep II,
and his monuments are a good example of the
style of carving at Thebes at that time.

This style had developed after the fall of the
Old Kingdom, during the First Intermediate
Period. It reflects the decentralization of Egypt,
during which provincial centers, particularly in
the south, developed their own variants of the
style of the late Old Kingdom that had
originated at Memphis in the north.[1] The marks
of late Old Kingdom style on this figure are her

and Afterlife wishes, written from right to left,
lead the eye toward the main figure. Previously
the offering prayer was included in the
introduction to the autobiography. Tjetji's stela
illustrates the changed position of the prayer,
which will continue into the Middle Kingdom.

Tjetji's stela clearly demonstrates that high
standards of language and relief carving had
been established in Thebes before political
unification with Lower Egypt. These standards

and their connection to the previous period of
political unity perhaps point toward the early
Eleventh Dynasty's conscious political plans for
reunifying the country. **(E.B.)**

### Notes

[1] Lichtheim 1988, pp. 39ff.

[2] In an oral communication and in an as yet unpublished
paper presented at the Annual Meeting of the American
Research Center in Egypt, Chicago, 1999.

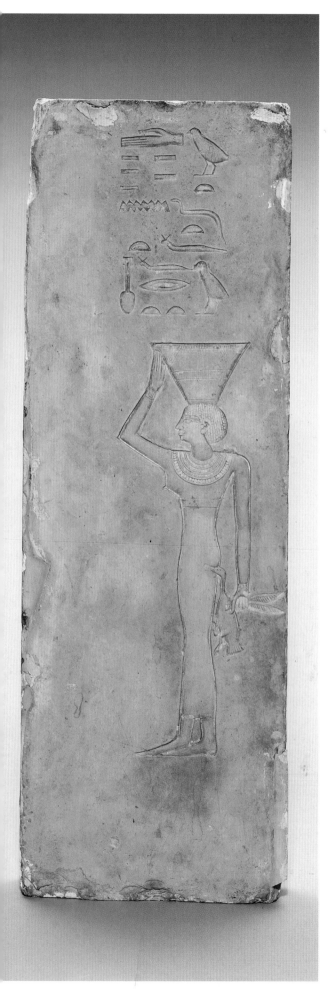

slenderness, her long limbs, and her big eyes (cf. cat. no. 11). Specifically Theban taste is reflected in the depth of the relief and in the wealth of carved detail on her necklace and hair and on the feathers of the duck. Her short, curly hair is also characteristic of this period (cf. cat. no. 18).

The woman is an offering bearer—not a real individual but a generic type, whose sole function was to provide food magically for the tomb-owner's use in the Afterlife. With one hand she balances a basket of food on her head; with the other she holds a live duck by the wings.

Because the figure faces left, which is the subordinate direction in Egyptian two-dimensional art, there is a characteristic reversal in her hanging hand, which looks as if it is shown backward. This indicates that, although she appears to us to be holding the bird in her proper left hand, she is actually holding it in her right, which is the way the hand has been drawn (cf. cat. no. 20). Left or right, the duck seems to be taking advantage of its position to administer an impudent jab at the woman's posterior. (E.R.R.)

**Notes**

[1] Russmann 1995, p. 278.

**Bibliography**

PM I, 2 1964, p. 596.

Robins 1997, p. 85, fig. 84.

# 15

## Head of Mentuhotep II in a White Crown

From Thebes, Deir el Bahri, funerary temple of Mentuhotep II
Middle Kingdom, Eleventh Dynasty, reign of Mentuhotep II (ca. 2055–2004 B.C.)
Sandstone, painted
Height 21 in. (53.2 cm)
EA 720, gift of the Egypt Exploration Fund, 1906

Mentuhotep II, the fifth king of the Eleventh Dynasty, was the first of his line to rule all of Egypt. By reuniting Egypt, he initiated the period that historians call the Middle Kingdom, the second great stage of ancient Egyptian history.

Mentuhotep II built his tomb and funerary temple at the foot of a bay of cliffs on the West Bank at Thebes. Today this place, known as Deir el Bahri, is much more famous for Queen Hatshepsut's later and better preserved funerary temple, which she built just to the north. But enough remains of Mentuhotep's temple to show that, as the first

*Fig. 47. Thebes, Deir el Bahri, Funerary Temple of Mentuhotep II. Eleventh Dynasty (ca. 2055–2004 B.C.).*

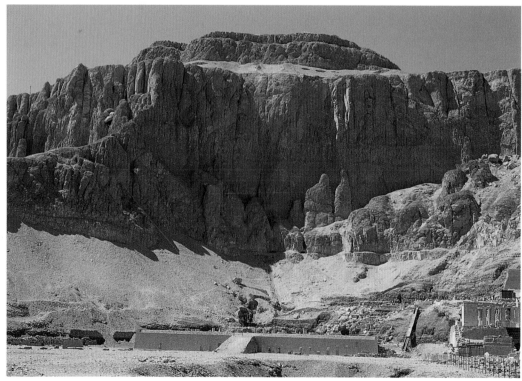

to build on this site, he was able to chose the center of the arc of cliffs (fig. 47). The ruins of his temple were excavated by the Egypt Exploration Fund in the first decade of the twentieth century, by the Metropolitan Museum of Art in the 1920s, and more recently by Dieter Arnold.[1] This head comes from an Osiride statue, which represented the king with his royal headdress but with his body wrapped in a short white cloak.[2] Beneath it, his arms were crossed over his breast, with only his hands exposed. The Osiride royal statue, apparently an innovation of Mentuhotep's reign, expressed the king's assimilation after death with the great god Osiris, the king of the dead.

Since the paint on this head is unusually well preserved, we can see that it followed the standard convention of showing the king's face a dark red, as on most representations of Egyptian men. His eyes and eyebrows were painted black and white. The white crown retains traces of white paint.[3] The uraeus cobra on the front is an early example of a uraeus on a white crown. Until then, this symbol had appeared only on representations of the king wearing the *nemes* headcloth (cf. cat. no. 2).

The style of the head still reflects the Theban style of the First Intermediate Period (cf. cat. nos. 13 and 14), but there is a good degree of fairly naturalistic facial modeling. This shows the influence of Old Kingdom sculpture in the north, which appeared at Thebes soon after Mentuhotep reunited the north and the south. It is thus an early example of archaizing imitation of past works. (E.R.R.)

### Notes

[1] Naville 1907; Arnold, Di. 1974a, 1974b, 1979, 1981.

[2] Arnold, Di. 1979, pls. 25 and 26.

[3] For a similar head of Mentuhotep wearing a red crown, also found at Deir el Bahri (New York MMA 26.3.29), see Arnold, Di. 1979, frontispiece and pl. 24.

### Bibliography

PM II 1972, p. 393 (with earlier bibliography).

James/Davies 1983, p. 25, fig. 24.

Wildung 1984, p. 21, fig. 14.

Robins 1997, p. 94, fig. 94.

*Art and Afterlife* 1999, no. 1, p. 28.

# 16

## Mentuhotep II Embraced by Montu

From Thebes, Deir el Bahri, funerary temple of
Mentuhotep II
Middle Kingdom, Eleventh Dynasty, reign of
Mentuhotep II (ca. 2055–2004 B.C.)
Limestone, painted
31 1/8 x 21 1/8 in. (79 x 53.5 cm)
EA 1397, gift of the Egypt Exploration Fund, 1907

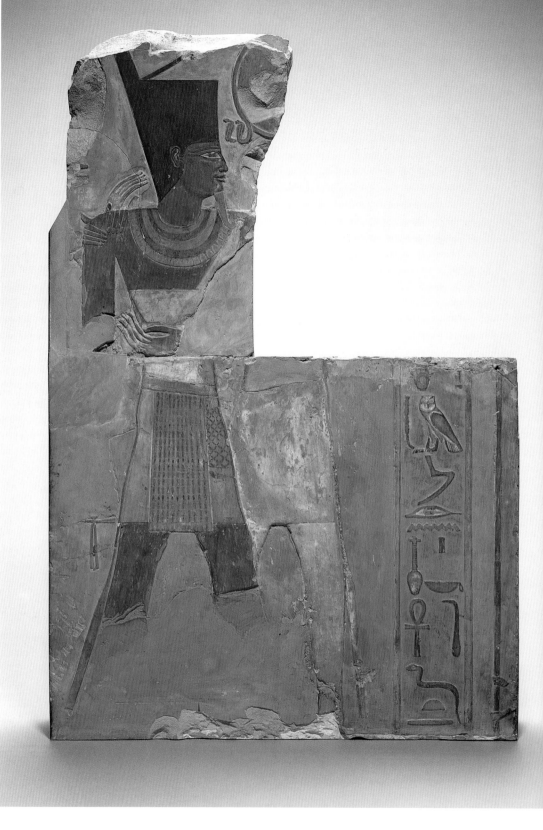

Although the funerary temple of Mentuhotep II
was virtually destroyed (see fig. 47), excavators
have been able to restore most of its elaborate
plan, and they have found many fragments of its
extensive relief decoration. This section of raised
relief, one of the largest to survive, shows
Mentuhotep II, wearing the red crown of Lower
Egypt, embraced by the god Montu.[1]

Montu embraces the king with both hands
as a sign that Mentuhotep is the recipient of the
god's blessings and benefits. This is the way
ancient Egyptians represented love, as a
bestowal of blessings or affection on a recipient
who is thus the center of attention.[2] Usually, as
here, he is also the owner of the monument. By
the same principle, the wife in a pair statue
embraces her husband (cf. cat. no. 56); he is the
center of attention as well as her love—and also
the principal owner of the statue.

Montu was a falcon-headed god of the
Theban area. Although his figure here is almost
entirely gone, he can be recognized from the
traces of his headdress. Montu wore a sun disk
circled by two cobras; part of the disk and the
cobras are still preserved. Behind Mentuhotep
stood a goddess, probably Hathor. But a closer
look at the king's shoulder reveals too many
hands: one hand of Montu and two others, both
of which cannot belong to the goddess. It is
possible that something went awry here when
the relief was restored during the New
Kingdom, as we know it was. But it is also
possible that this was an ancient mistake, which
would have been hidden under plaster and paint;
such things happened.[3]

Mentuhotep II built his funerary temple
over a number of years. The time that elapsed
between the earlier and later sections is reflected
in the varied styles of reliefs from different parts
of the temple. This section came from the

sanctuary, the innermost part of the temple,
which was one of the later parts to be decorated.
It reflects the assimilation of elements of Old
Kingdom style from the north to an even greater
degree than catalogue number 15. In contrast to
the very high relief of fragments from earlier
sections of the temple (cat. no. 18), the relief

here is quite low. The proportions of the figures
are quite natural, and there is a good deal of
modeling in the king's face. Most of the detail,
however, was painted, rather than carved, as on
reliefs in the earlier sections.

The paint is well preserved, although it has
darkened with time and with early preservation

treatments. We can still see that the red crown was indeed red, and we can make out the details of the king's elaborate costume. In addition to the usual collar necklace he wears a single-strap tunic and a plain, short kilt. Attached to the belt is an apron of bead strings. This partially covers a beadwork panel wrapped across one hip, from which is suspended an amulet representing a swallow with a sun disk on its back. This costume ensemble is very ancient; it is represented already on the palette of King Narmer, who, like Mentuhotep, wears it with a red crown.[4] (E.R.R.)

### Notes

[1] For a reconstruction of the entire scene, see Arnold, Di. 1974b, pl. 15.

[2] Simpson 1977.

[3] For similar mistakes, see Fischer 1974, pp. 113–14.

[4] Patch 1995; this relief is no. 15 in her catalogue, on p. 98.

### Bibliography

PM II 1972, p. 391 (with earlier bibliography).

Arnold, Di. 1974b, no. 4,980, pp. 42-43, pl. 15.

Quirke/Spencer 1992, p. 38, fig. 25 (bust of king only).

Robins 1997, p. 95, fig. 96.

# 17

## Fragment of a Battle Scene with Defeated Asians

From Thebes, Deir el Bahri, funerary temple of Mentuhotep II
Middle Kingdom, Eleventh Dynasty, reign of Mentuhotep II (ca. 2055–2004 B.C.)
Limestone, painted
23 3/4 x 26 in. (60.2 x 66 cm)
EA 732, gift of the Egypt Exploration Fund, 1906

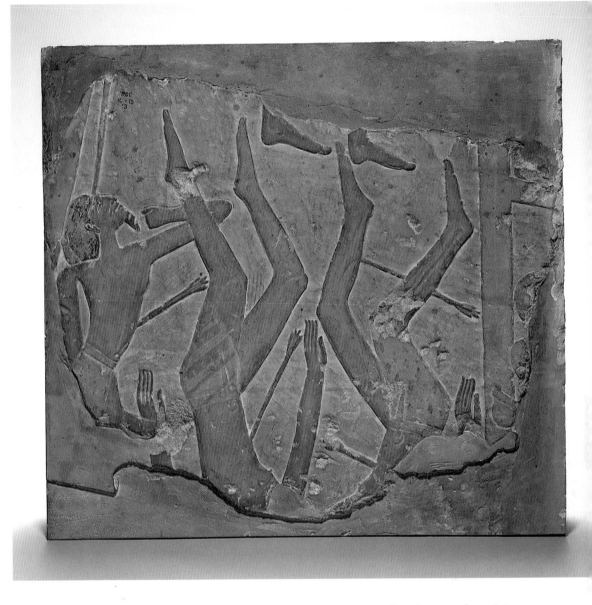

The ancient Egyptians made a universal, cosmic distinction between order and chaos. Order, personified by the goddess Maat, governed every good thing from the regular rising and setting of the sun to the cycle of human life, to the proper behavior of individual human beings. The concept of Maat goes very far to explain why Egyptian culture and society were so resistant to change. They expressed order; they "lived on" Maat. Disorder was identified with death, destruction, evil; it was the realm of the enemy. In this fragment from a much larger composition, the defeat and death of enemies is shown as a chaotic tumble of their arrow-pierced corpses.[1]

The fragment was part of a large composition depicting the siege of a walled Near Eastern city. The edge of the Egyptian siege ladder can be seen along the right edge of this fragment. The men fall from the ramparts to their death, pierced with Egyptian arrows.[2] Similar sieges are depicted on walls and pylons of Karnak and Luxor temples.

The skin of the foreigners is painted yellow, primarily to indicate that they were lighter complexioned than the Egyptians. An ancient Egyptian viewing this scene, however, would also have been aware that yellow was the color used to represent the skin of women. To at least some degree, there would have been a connotation of weakness and passivity. The red hair on the head of the figure falling feet downward also indicates a people fairer in both hair and skin than most Egyptians. The painted designs on the kilts are very faded, but we can still see their variety. Such exotic details were intended to further differentiate the foreigners from Egyptians. In this early example, the details may well be based on reality, whether actual observation or descriptions by returning soldiers. But with the passage of time, and especially in the New Kingdom, such foreign characteristics tended to become stereotyped. (E.R.R.)

### Notes

[1] Miniature battle and hunting scenes on a painted box from the tomb of Tutankhamun show particularly vivid contrasts between Egyptian order and chaotic defeat: Robins 1997, p. 160, fig. 189.

[2] For a reconstruction of this scene, see Smith, W. S. 1965, pp. 148–49, fig. 185.

**Bibliography**

Smith, W. S. 1965, pp. 148–49, fig. 185.

PM II 1972, p. 383 (with earlier bibliography).

Davies, W. V. 1987, pl. 37, fig. 2.

Robins 1997, p. 95, fig. 95 (upside down).

# 18

## The Royal Favorite Kemsit

From Thebes, Deir el Bahri, funerary temple of
Mentuhotep II
Middle Kingdom, Eleventh Dynasty, reign of
Mentuhotep II (ca. 2055–2004 B.C.)
Limestone, painted
Height 16 ¹/₈ in. (41 cm)
EA 1450 (1907 10–15 460), gift of the Egypt
Exploration Fund, 1907

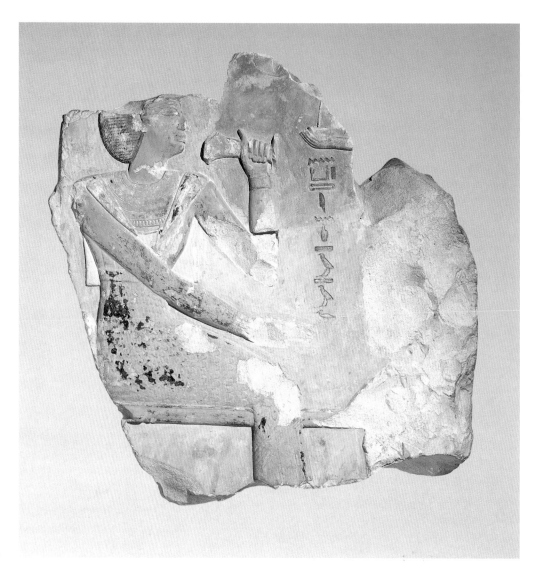

Mentuhotep II had a long reign, and he took a
long time to build his funerary temple (fig. 47).
Dieter Arnold's study of the funerary complex
shows that there were at least three major
building stages.[1] The first stage included the
burial of his main queen, Neferu.[2] It also had the
burials of six "Royal Favorites" and their closet-
size, relief-decorated funerary chapels. One of
those six women was Kemsit, and this relief
fragment is from her funerary chapel.[3]

The exact status of Kemsit and her
colleagues is not altogether clear. The women
were all "Unique Royal Favorites," and Kemsit
was also a priestess of Hathor. Some fragments
from her chapel and others show these women
in a definitely conjugal relationship with King
Mentuhotep II[4] and so they are usually called
concubines. More recently, however, some
scholars have suggested that their actual
importance lay in their role as priestesses. Be
that as it may, Kemsit was doubtless some kind
of wife to the king, and since we know Egyptian
kings had more than one wife, it is probably
most useful to regard her as a minor wife of
King Mentuhotep II.

Kemsit sits on a wide, low-backed chair
holding a vase of scented ointment to her nose.
In front of her was the smaller figure of a male
servant, of which only his hand remains,
holding a small cup that is receiving the stream

of liquid he was pouring into it with his other
hand.[5] This servant was obviously facing
leftward, and since the inscription in front of
him has its signs also facing left, we can be sure
that the inscription belongs to the servant. In
fact, it is what he was saying: "For your *ka*
[spirit] gifts and offerings."

Kemsit has short, curly hair (cf. cat. no. 14).
Her necklace is a broad collar with many
strands and an outer row of drop-shaped
pendants, and she wears cuff-shaped bracelets
made of many strands of tiny beads held in
place by a spacer bead (cf. cat. no. 84). The most
interesting part of her costume is her dress,
which seems to be the usual tight sheath in
shape; the straps are very narrow and appear to
have left the breasts uncovered. The dress is
green, which is not so unusual; but it appears to
consist of a feather-patterned garment, perhaps
an over-wrap, over a pleated underskirt, which
can be seen toward the bottom. Over the dress,
or dresses, she is wearing a little shawl that
seems to consist of a rectangular white cloth.

The ends are brought forward over her
shoulders, and they have been painted green.
This is probably a mistake by a rather sloppy
painter who misinterpreted—or did not bother
to think about—the shawl being different from
the dress and just painted it all one color.[6]

Shawls and capelets are occasionally shown
on both men and women (cf. cat. no. 22). We
almost never know their meaning, if indeed they
had any meaning. However, the feather pattern
on Kemsit's dress must have had religious signif-
icance. Feathered garments were associated with
gods and goddesses; even kings are rarely shown
wearing feather-patterned shirts or skirts.
Kemsit's dress thus aligns her with a goddess—
undoubtedly Hathor, whose priestess she was.
This indicates that she had high rank in the cult,
and it may suggest that, like later queens,[7] Kemsit
could sometimes stand in for the goddess herself.

When one compares this relief with
catalogue number 16, from one of the later
parts of Mentuhotep II's funerary temple, it
becomes clear how much the style changed

during the reign of this one king. Hallmarks of this early style of relief are the extraordinary boldness of the relief and, as in catalogue number 14, the profusion of carved detail: Kemsit's hair, the details of her jewelry, the cross-hatched weave of her shawl, and even the feathers on her dress, each with its interior rib marked in carving. Other signs of the early style of Mentuhotep II are Kemsit's large eye, with its long cosmetic line, the taut line of her mouth,with its emphasized corner, and her elongated fingers.

In contrast to the meticulous carving of this relief, the painting, as noted above, seems to have been rather sloppily applied. It certainly was laid on very thickly; as a result, it has come off in some places—for example, on the brow, eyebrow, and cosmetic line, which were certainly painted black. Traces of red on the servant's hand show that he was a male Egyptian. Kemsit's skin color is now pink, but so are her necklace and bracelets and other parts of the relief. The pink may have been an undercoat, and traces of a darker color on her skin, a brown or dark red, may have been the actual color of her skin when the relief was freshly painted. Other representations of Kemsit (and some of the other Royal Favorites) show her with black skin. It has been argued that the occasional representation of black skin on these women is purely symbolic,[8] having funerary significance because black was the color of fertility and rebirth. That is possible, but it is also entirely possible that Kemsit and some of the other women buried in these chapels were Nubian by birth or by ancestry. Thebes is quite far to the south, relatively close to ancient Nubia, and we know there was a great deal of coming and going, and a certain amount of intermarriage between the peoples of southern Egypt and Nubia. **(E.R.R.)**

### Notes

[1] Arnold, Di. 1979, pp. 39–45.

[2] Fragments of her relief are scattered; many are in the Metropolitan Museum of Art: Hayes 1953, pp. 159–60, figs. 95–96; two are in the Brooklyn Museum of Art: Fazzini/Romano/Cody 1999, no. 17, p. 57.

[3] Reliefs from these chapels are also widely scattered; for those in the Metropolitan Museum of Art, see Hayes 1953, pp. 160–62, figs. 97 and 98.

[4] E.g., another fragment in the British Museum: Bourriau 1988, no. 4, pp. 16–17.

[5] For similar scenes on the sarcophagi of two other "Royal Favorites," Kawit and Ashait, see Saleh/Sourouzian 1987, nos. 68, 69, especially 68b.

[6] Bourriau 1988, p. 14.

[7] Such as Queen Tiye, the wife of Amenhotep III, who is shown wearing a similar costume on a green-glazed statuette, Kozloff/Bryan 1992, no. 22, pp. 202–203.

[8] Bourriau 1988, p. 15

### Bibliography

PM I, 1 1960, p. 385.

Bourriau 1988, no. 3, pp. 14–16.

Robins 1997, p. 88, fig. 86.

Wildung 2000, no. 8, pp. 58, 178

# 19

## Seated Statue of Mery

From Thebes
Middle Kingdom, Eleventh Dynasty, reign of Mentuhotep II (ca. 2055–2004 B.C.)
Limestone
Height 22 7/8 in. (58 cm)
EA 37895, acquired in 1902, purchased via the Reverend C. Murch

In tomb reliefs and statues, Egyptian tomb-owners are frequently shown in several different ways. These variations are clearly deliberate, intended to show—and thus to perpetuate—all aspects of that person. The most noticeable of these variations show the individual in youth and in age (cf. discussions of cat. nos. 8 and 9).[1] Often, however, the differences are much less marked, a matter of varying hairstyles, poses, and details of costume. To contemporaries of the person represented, these variations would have demonstrated his career and his place in society, as well as his hopes for the Afterlife. But they mean frustratingly little to us.

This statue is one of a pair made for the tomb of Mery. The two (very likely the work of the same sculptor) are almost identical in many respects. Both are the same size; both show Mery seated. But whereas this one shows Mery with short, cropped hair and a simple pleated kilt, resting his open left hand and his fisted right hand on his thighs, the other (fig. 48) has short, curly hair, a kilt of *shendyt* type, and arms crossed over the chest.

What do these differences signify? The

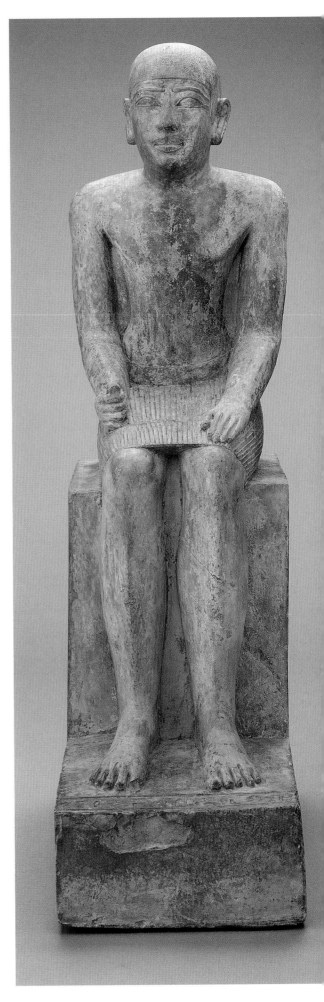

cropped hair on this statue is often found on representations of middle-aged men (see fig. 21). But there are no other signs of age: the pleated kilt is appropriate to a young man, and the position of the hands is found on representations of both young and older men.[2] The companion statue has a youthful hairdo (cf. cat. nos. 123 and 124). Its kilt, though originally symbolic of royalty, had already been appropriated in the Old Kingdom for statues of young men.[3] The crossed arms, a rather rare gesture attested only from the late Old Kingdom into the Middle Kingdom,[4] resembles the Osiride pose, except that Osiride figures of the god or of the king hold divine insignia (cf. cat. no. 89). When represented on private persons, the hands are open—a feature that denoted

passivity.[5] From these details one can guess—and it is only a guess—that the first figure alludes to Mery's career on earth, with its cropped hair suggesting a long life; while the second looks forward to an eternal youth in the Afterlife, when Mery would be assimilated with Osiris, the king of the dead.

Both statues are in the style of Mentuhotep II's reign—a style that, as usual in ancient Egypt, was based on representations of the king himself. The face of this statue closely resembles that of Mentuhotep II (cf. cat. no. 15), as does the simply modeled forms of the body. The thick legs are to be found in even more exaggerated form on seated statues of this king.[6]

Mery was a steward, a responsible but hardly exalted official, and his status is reflected

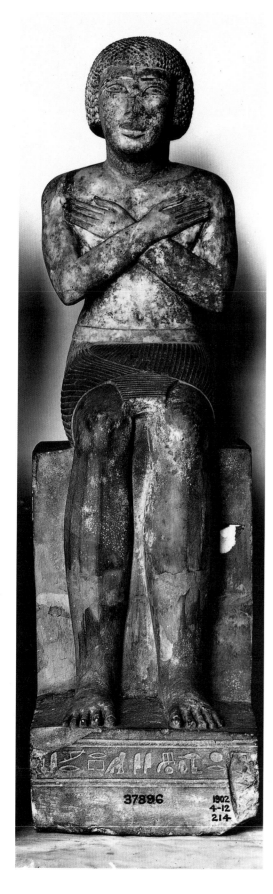

*Fig. 48. Seated Statue of Mery. From Thebes. Eleventh Dynasty, reign of Mentuhotep II (ca. 2055-2004 B.C.). Limestone, ht. 22 7/8 in. (58.1 cm). The British Museum (EA 37896).*

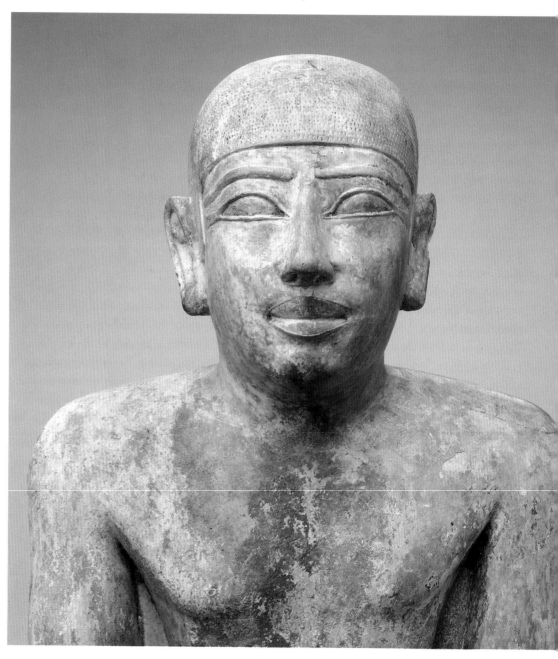

in the rather mediocre quality of these small statues. Nevertheless, they are the work of a professional; Mery's ability to commission two of them reflects the rise of Theban power and wealth under Mentuhotep II. **(E.R.R.)**

### Notes

[1] Also Brooklyn BMA 50.77, 51.1, 53.222, all representations of Metjetjy: Fazzini/Romano/Cody 1999, no. 14, pp. 52–53.

[2] E.g., *Egyptian Art* 1999, nos. 125, 127–28, pp. 365–67, 370–72; also fig. 21 in this catalogue.

[3] Simpson 1988.

[4] For the bust of a larger Eleventh Dynasty statue with the same gesture (and hairstyle), New York MMA 26.7.1393, see Hayes 1953, pp. 208–209, fig. 127.

[5] Schulz 1992, II, pp. 736–42, treats this gesture as one of humility (which, in other contexts, it is). She recognizes the Osiride implications of the gesture on this statue, but her explanation, that it results from imitating the pose as well as the style of Mentuhotep II's sculpture, is not tenable.

[6] E.g., Cairo JE 36195: Saleh/Sourouzian 1987, no. 67.

### Bibliography

PM I, 2 1964, p. 788.

Vandersleyen 1975, fig. 149b (its pair is 149a).

Robins 1997, p. 84, fig. 83.

## 20

## Round-topped Stela of Intef and Sensobek

Probably from Abydos
Middle Kingdom, early Twelfth Dynasty
(ca. 1985–1878 B.C.)
Limestone
24 ³/₈ x 20 ¹/₈ in. (61.7 x 51 cm)
EA 577, acquired in 1839, purchased at the sale of the Anastasi collection

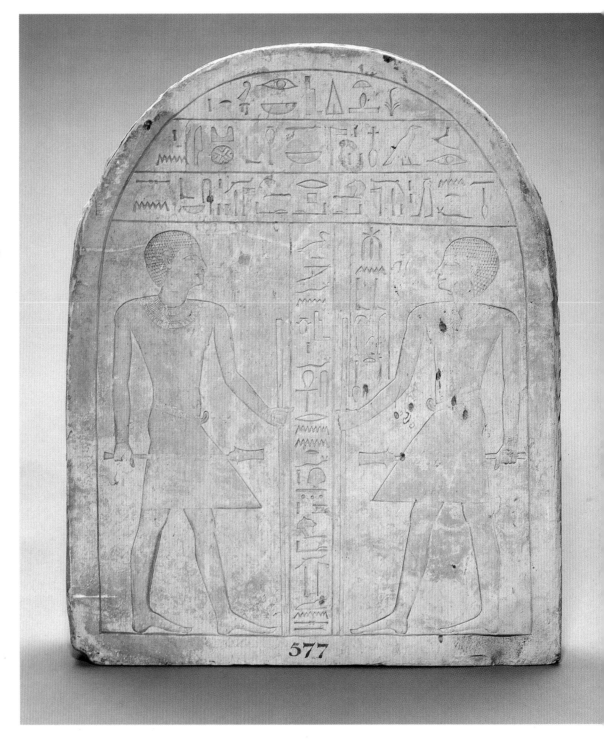

Earlier examples of relief in this catalogue demonstrate ways in which the interaction of hieroglyphs and images helped to determine the look of Egyptian two-dimensional art, both in the details of individual representations (cat. no. 6) and in the composition of whole scenes (cat. no. 2). This Middle Kingdom stela exemplifies the Egyptians' strong preference for balanced, symmetrical designs. But the balance is weighted in an unusual way.

A father and son stand facing each other. Their figures follow the standard two-dimensional conventions of profile head and frontal eye, frontal shoulders and torso in profile but with the navel visible, profile buttocks and legs, with identical single-toed feet. The two are identical in almost every other respect as well: they are the same size; they both have the short, curly hairstyles that were especially popular during the early Middle Kingdom[1]; and their kilts, with stiffened front panels and decorated belts, and their beaded necklaces and bracelets are almost identical.

Each man holds a long staff and a *sekhem* scepter, standard symbols of authority (cf. cat. no. 8). On the figure facing right, it is clear that the staff is held in the left hand and the scepter in the right. The figure facing left, in the secondary position, is represented as a mirror image of the first. But since he, too, must be understood to grasp the staff with his left hand and the scepter with his right, the hands have been reversed (cf. cat. nos. 6 and 14). The need to convey correct information superseded any visually jarring effect.

The long column of text down the center tells us that the stela was dedicated to his father by the count (an honorific title) and overseer of

priests Sensobek, "his beloved son, his favorite, who causes the name of his father to live while he [the father] is still on earth." Such inscriptions appear on many stelae and statues of men or couples, and often the son is also represented, sometimes with other family members as well. But the lesser importance of his figure, and theirs, is almost invariably made clear in one or more ways—leftward orientation, smaller size, reverential pose—and, of course, in the inscriptions.

Here, however, the dominant figure, who faces right like the hieroglyphs, is the son. His name and titles are given a second time in the rightward-facing line just above his head. The father, Intef, also a count and overseer of priests, is identified only once, in the leftward-oriented signs above his head. Even the column of text that invades his space belongs to Sensobek; it names his mother, Bebi. Presumably she was Intef's wife, but that is not stated here.

The secondary position of Intef on "his" stela cannot possibly have been meant to imply disrespect; in ancient Egypt, such treatment of a parent would have been unthinkable. Rather, the unusual composition suggests that this stela was designed for a family offering chapel, where it would have been positioned along the left side, so that Intef faced outward. In this position it would have been auxiliary to one or more stelae dominated by (rightward-oriented) images of Intef himself.

During the Middle Kingdom, many families built little mudbrick chapels at Abydos, along the processional route of the god Osiris.[2] These chapels housed statues (see cat. no. 25) and stelae.[3] It is likely that this stela was made for such a chapel at Abydos, where the spirits of Intef and Sensobek could, as they say in the brief prayer to Osiris at the top, "see the beauty of the Great God, Lord of Abydos." (E.R.R.)

### Notes

[1] For a three-dimensional version, see cat. no. 24. A very similar hairstyle was worn by some women in this period: cat. nos. 14 and 18.

[2] Simpson 1974a, pp. 6–10.

[3] Simpson 1974a collects a number of these family groups of monuments, mostly stelae.

### Bibliography

*HT* IV 1913, pl. 35.

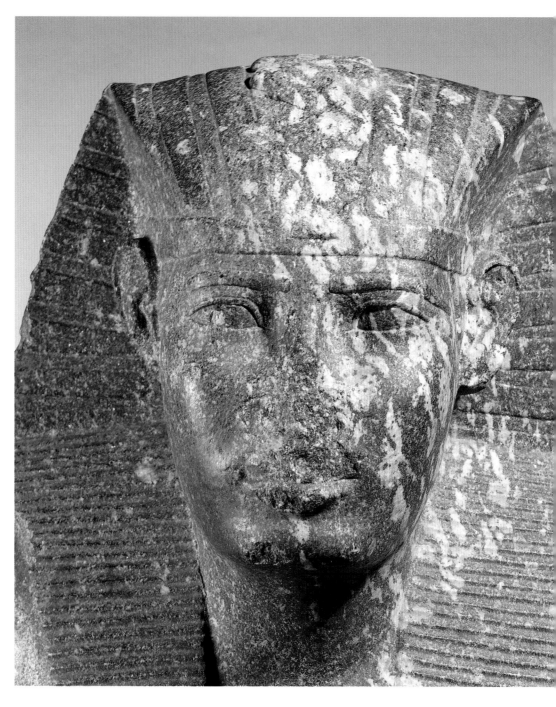

# 21

## Sesostris I

From Karnak
Middle Kingdom, Twelfth Dynasty, reign of Sesostris I (ca. 1965–1920 B.C.)
Granodiorite with large feldspar inclusions
Height 31 in. (78.5 cm)
EA 44, acquired in 1838, gift of R. W. H. Vyse

This forceful image depicts Sesostris I, second king of the Twelfth Dynasty, striding bare-chested and wearing a royal headcloth and a kilt with narrow pleats.[1] Enclosed in a cartouche and carved in large hieroglyphs, the king's prenomen, *Kheperkare*, decorates the center of the wide belt holding his kilt in place. The attitude is traditional, but few of Sesostris I's many preserved statues depict him striding. He is more commonly shown in the form of a sphinx, kneeling, seated on a throne (alone or as part of a group), or in Osiride form. This is the only preserved statue that depicts him both striding and wearing a royal *nemes* headcloth.

The thick body of the royal uraeus cobra, its hood now broken away, completes five turns as it winds over the top of the king's pleated headcloth. The wide back pillar covers

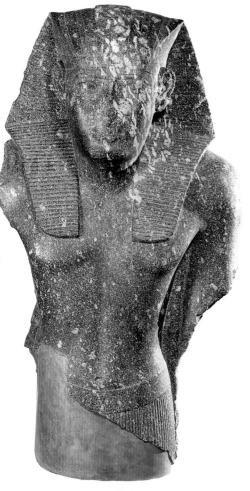

the back of the headcloth and narrows at the top in the form of an obelisk. In the Middle Kingdom, back pillars do not otherwise extend over the headcloth—here it is an archaizing element recalling Old Kingdom royal sculpture.

Presumably, Sesostris I commissioned this statue for the temple he erected for the god Amun-Re at Karnak, where it was found by a British officer, Richard W. H. Vyse, during his 1835–1837 excavations there.[2] This statue does not fit readily into the stylistic framework associated with sculptures of the king at Karnak. The attitudes and the materials of Sesostris I's statuary vary greatly. His long life and reign, his active presence throughout Egypt, and the variety of stones used for his sculptures—each requiring a different approach to the material —are all factors contributing to the remarkable number and variety of his representations. Sesostris I's images include many stylistic variations that evolved during his forty-five years in power. They range from the vigorously pompous colossi found at Tanis[3] to finely modeled and delicately detailed statues with naturalistic features, excavated at Lisht.[4]

Distinct from both of these, statues carved in the style generally associated with Karnak are characterized by cheerful, stylized features, with large eyes and mouths that are almost hieroglyphic in form.[5] While some features are similar on this statue—the rectangular face, the square set of the masculine chin, and the thick stylized ears set high on the head—other features contrast notably with most Sesostris I Karnak sculptures. For example, the dignified expression and the comparatively small, plastically modeled eyes are unique on images of the king associated with Karnak. The possibility that this statue was made elsewhere and then brought to Karnak cannot be excluded, but no good parallels have been found elsewhere, which suggests that this is another of Sesostris I's stylistic variations.[6]

Due to damage, the form of the mouth can only be conjectured. A naturalistic mouth would complete the image aesthetically. However, the extremely wide rounded corners preserved at the sides of the mouth and the full shape of the lower lip suggest that the king's mouth was highly stylized with almost everted lips, significantly altering the apparent naturalism of his expression. (B.F.)

## Notes

1 For the reign of Sesostris I and its monuments, see Simpson 1984a, cols. 890–99. For the king's sculptures, see Altenmüller 1980a, cols. 564–65. Aldred 1971, pp. 37–40, discusses Sesostris I's statuary with a variety of provenances.

2 For details concerning Vyse (1784–1853), see Dawson/Uphill 1995, p. 428.

3 The sculptures of Sesostris I and other Middle Kingdom kings found at Tanis had been moved there from Heliopolis, Memphis and elsewhere by later kings.

4 For example, Fay 1996, pl. 71a.

5 Evers 1929, pls. 26–45, illustrates a selection of Sesostris I sculptures found at Lisht, Karnak, Tanis, Memphis, and in the Fayum. See also Evers's discussion of this sculpture, pp. 97–99, §§ 641–52.

6 Similarities in the shape and carving of the eyes, mouth area, ears, and headcloth appear on Cairo JE 67345, an uninscribed bust from a pair of statues found at Tod, which has most recently been published in Seidel 1996, pp. 61–64, pl. 21a-d, as a representation of Mentuhotep III. Seidel apparently relied on the attribution in Aldred 1971, pp. 32–33, fig. 5. However, Aldred later reascribed the bust to Sesostris I, noting this revision on copies of the article that he distributed to colleagues. Seidel shows (p. 63) why the bust cannot represent Amenemhat I, but his subsequent attempt to show why it cannot represent Sesostris I is undermined by his omission of key sculptures in his discussion. For example, the sphinx head, Cairo CG 42007, found at Karnak and illustrated in Wildung 1984, p. 69, fig. 62, exhibits the features Seidel says do not occur on representations of Sesostris I.

## Bibliography

PM II 1972, p. 276 (with earlier bibliography).
Quirke/Spencer 1992, p. 39, fig. 26.
Fay 1996, p. 57, pl. 71c–d.
Wildung 2000, no. 18, pp. 76, 179.

# 22

## The Nomarch's Retinue

From Bersheh, tomb of Djehutyhotep
Middle Kingdom, Twelfth Dynasty
(ca. 1878–1855 B.C.)
Limestone, painted
14 ⁵/₈ x 66 ⁵/₈ in. (37 x 169 cm)
EA 1147, gift of the Egypt Exploration Fund, 1894

As nomarch of the "Hare" nome (province), Djehutyhotep was the great man in his part of the world. This raised relief fragment from the bottom of a wall in his tomb at Bersheh[1] shows

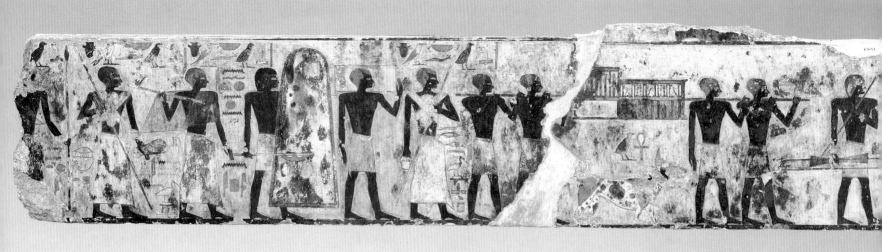

that he traveled with pomp and with protection; the procession is headed by a bowman.

Immediately behind this advance guard come four servants carrying Djehutyhotep's sedan chair.[2] Beneath the chair is his low-slung, curly-tailed hound, Ankhu. The dog is scaled not to the other figures but to his importance to his owner, and therefore he is much larger proportionately than any of the men in this procession. However, perhaps coincidentally, the dog is on nearly the same scale as Djehutyhotep's female family members in the row above (cf. cat. no. 23).

Behind the chair and the dog comes a "trusty seal bearer" carrying Djehutyhotep's seal and a long staff. The seal bearer's servant comes next, carrying a box, probably containing documents or other official impedimenta. Behind him is another soldier carrying a battle-axe and an oversized ox hide-covered shield. Then come three more "trusty seal bearers", the first wearing an unusual, shoulder-covering cape and carrying another kind of battle-axe.[3] The next in line carries a long staff and Djehutyhotep's sandals,[4] and the fragmentary figure of the third of these seal bearers carries a spear and a bow.

Most of the detail on this relief was executed only in paint, so it is very fortunate that the paint is relatively well preserved, although darkened in places. It enables us to see some interesting details that would otherwise have been lost; for example, the heads of the seal bearers and the servants are newly shaven, perhaps in preparation for this journey: their skulls, normally covered with hair, are a lighter color than their faces and bodies. It is also interesting to see the different ways in which an

Egyptian painter approached the rendering of the random patterns on animal skins: in this case, very respectfully when depicting the doubtless purebred dog of Djehutyhotep, and noticeably more loosely and randomly when showing the pattern on the cowhide of the shield. Some of the hieroglyphs also retain very well-painted details, particularly the birds, such as the quail chick, which is a phonetic hieroglyphic sign, "u," and the ibis, which is the writing of the name of the god Thoth. Since the seal bearers were men of good family, their inscriptions include not only their names but also the name of a parent. Two of the parents, like the nomarch himself, were named Djehutyhotep, which means "Thoth is content." The ibises visible in this relief fragment are parts of the names of two of the seal bearers' parents. Thoth, an ibis-headed god, was the most important god in this part of Egypt. **(E.R.R.)**

### Notes

[1] For a reconstruction of this wall, see Smith, W. S. 1951, p. 323, fig. 1.

[2] For an actual sedan chair from the early Old Kingdom, see Saleh/Sourouzian 1987, no. 29.

[3] For the axes, see Davies, W. V. 1987, p. 48.

[4] Sandal bearers were important officials, especially royal sandal bearers; one is represented on the Narmer Palette (fig. 1).

### Bibliography

PM IV 1934, p. 180 (with earlier bibliography).

James 1986, p. 67, fig. 77 (detail).

Reeves/Taylor 1993, p. 29.

Quirke/Spencer 1992, p. 171, fig. 131.

Middleton 1999, pl. 6.

# 23

## The Nomarch's Sister

From Bersheh, tomb of Djehutyhotep
Middle Kingdom, Twelfth Dynasty (ca. 1878–1855 B.C.)
Limestone, painted
28 1/4 x 13 1/4 in. (71.5 x 33.5 cm)
EA 1150, gift of the Egypt Exploration Fund, 1894

This figure stood on the same wall in the Bersheh tomb of Djehutyhotep as catalogue number 22, in the row directly above it and slightly to the right. The woman is the nomarch's sister, whose name is lost. She stood at the head of a row of ten female figures, facing women on a smaller scale. The figure in front of her held a fly whisk, seen at the lower right edge.

The nine women behind her were other female relatives of Djehutyhotep, including daughters.[1] In back of them stood the slightly larger figure of his wife. Finally, there stood Djehutyhotep himself, on a much larger scale, literally overseeing them all.[2]

The woman stands in the typical female pose, with her arms at her sides. The backs of both open hands are shown with their thumbs to the back, a "polite" but wholly impossible pose (cf. cat. no. 13). As on most two-dimensional representations of women, her farther foot is slightly advanced, presumably so that one can see that it really is there. Through the arch of the near foot one can see the heel of its identical pair. These are orthodox conventions for two-dimensional representations inherited from the Old Kingdom (cf. cat. no. 6). But here one has a definite sense that these conventional aspects

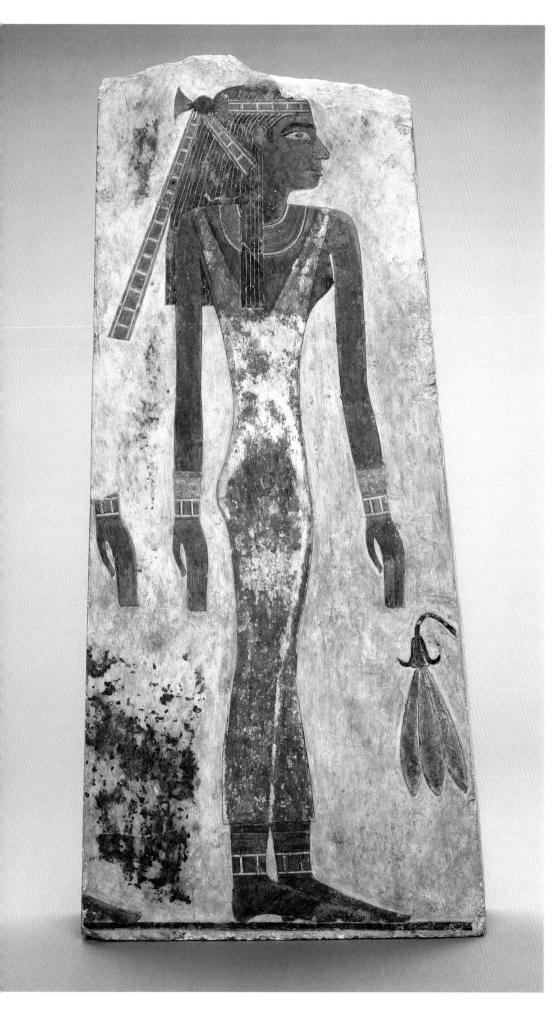

have been deliberately emphasized. The resulting effect is often called stiff [3]; but it would probably be more accurate to call it a purposely old-fashioned look, interpreted with extreme formality—not very different from the attitude often found in more recent cultures among the great ladies of provincial society. **(E.R.R.)**

### Notes

[1] Three daughters from this row are in Cairo (JE 30199): Saleh/Sourouzian 1987, no. 99.

[2] For a reconstruction of this wall, see Smith, W. S. 1951, p. 323, fig. 1.

[3] *Treasures* 1998, p. 52; Saleh/Sourouzian 1987, no. 99.

### Bibliography

PM IV 1934, p. 180 (with earlier bibliography).

Wildung 1984, fig. 137, p. 157.

*Treasures* 1998, no. 8, pp. 52–53.

Middleton 1999, pl. 5/1.

# 24

## Tomb Statue of a Man

From Bersheh, probably the tomb of Gua
Middle Kingdom, Twelfth Dynasty
(ca. 1985–1878 B.C.)
Wood, traces of paint
Height 13 ⁵/₈ in. (34.5 cm)
EA 30715, acquired in 1899

This wooden statuette is believed to come from the tomb of Gua, a physician. The British Museum has other material from Gua's tomb, including his inner and outer coffins, and an ivory headrest.[1] These objects all bear their owner's name and titles, but if this statue had a painted inscription it has disappeared.

The custom of placing small wooden statues in the subterranean part of a tomb, which began in the late Old Kingdom (cf. cat. nos. 9-11), continued well into the Middle Kingdom in some parts of Egypt. Some have been found inside coffins.[2] Statues of this type do not always bear the name of the person represented; presumably this was not considered necessary because of their proximity to the mummy itself.

As was often the case, even on wooden statues as small as this one, the arms, fronts of the feet, and base were made separately. Both of the fists were drilled to hold implements now

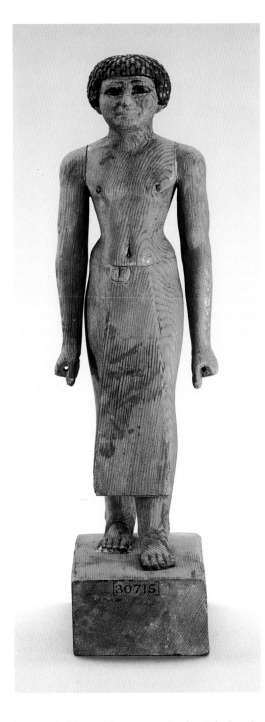

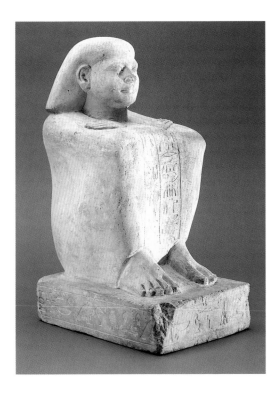

in the Old Kingdom always a sign of middle or old age[3]—may also be meant to indicate maturity here, despite the youthful hairstyle and body. Conceivably, it was a mark of his medical profession, of which we know little.[4] But it may simply reflect the tendency of Middle Kingdom male clothing to cover more of the body, whether with longer kilts (cf. cat. no. 41) or cloaks (cf. cat. nos. 25 and 28).

The body of the statue differs from both the taut muscularity of earlier Old Kingdom statues (fig. 3) and the attenuated slenderness of their late Old Kingdom successors (cf. cat. no. 8). This manly but slightly fleshy physique reflects the forms of Twelfth Dynasty royal statues (cat. nos. 21, 29, 30). **(E.R.R.)**

### Notes

[1] For these objects and the tomb, see PM IV 1934, p. 187.

[2] E.g., Cairo JE 47310: Arnold, Do. 1991, p. 27, fig. 36; New York MMA 20.3.210: Vandier 1958, pl. 57/1.

[3] E.g., Louvre E 11566: a middle-aged representation of Tjetji (cat. no. 8): *Egyptian Art* 1999, no. 191, pp. 465–66.

[4] See Ghalioungui 1963.

### Bibliography

Seipel 1992, no. 55, pp. 181–82.

# 25

## Block Statue and Niche Stela of Sahathor

From Abydos
Middle Kingdom, Twelfth Dynasty, reign of Amenemhat II (ca. 1922–1878 B.C.)
Limestone, traces of paint
Stela 44 1/8 x 25 1/8 x 7 1/8 in. (112 x 63.8 x 18 cm)
Statue 16 3/8 in. (41.5 cm)
EA 569-570, acquired in 1839, purchased at the sale of the Anastasi collection

A man named Sahathor is represented sitting on the ground with his crossed arms resting on his drawn-up knees. His body is covered by a cloak, from which only his open hands and bare feet emerge. Although the shape of the body is suggested, the form is so cubic that this type of statue is known in English as a block statue.

To the ancient Egyptians, crossed arms in the presence of a superior signified respect and

obedience. Since sitting on a chair was a sign of prestige, sitting on the ground was a humble pose. It was also a pose that could be sustained indefinitely—even today, in rural Egypt, caftan-clad village men often adopt this pose to wait or to while away the time.

Block statues were a Middle Kingdom invention. They first appeared early in the Twelfth Dynasty, at the same time that nonroyal persons started to place statues of themselves in temples, while continuing to provide their tombs with funerary statues. Middle Kingdom block statues have been found in temples and also in tombs. But they were not simply a new form of temple statue. As the submissiveness of the pose indicates, the block statue was intended to connect its owner with the cult of a god or the funerary cult of a king, to ensure protection in the Afterlife and also a magical share in the offerings provided for the cult each day. In tombs, Middle Kingdom block statues were placed in a special chapel or even in a room outside the tomb proper. But since this was obviously a less efficient location for connecting to the cult than the temple, so most block statues were dedicated in temples, especially later, in the New Kingdom (cat. nos. 45–47) and the Third Intermediate Period (cat. no. 121).[1]

Sahathor's monument is something of a hybrid. The stela in whose niche it was placed was designed as a combination of a shrine and a false door. Architectural allusions include the

lost, probably a *sekhem* scepter in the right hand, possibly another baton or a rolled cloth in the left. Though the statue may have been entirely painted, all that survives is black on the hair, black and white on the eyes, and white on the finger- and toenails (cf. cat. no. 11). The nipples were indicated by the inlaying of tiny bits of darker wood.

Elegantly made and deceptively doll-like, this small figure exemplifies several Twelfth Dynasty developments in the representation of the male figure. His short curly hairdo was particularly popular during the Eleventh and early Twelfth Dynasties, for both men and women (cf. cat. nos. 18 and 20). His long kilt—

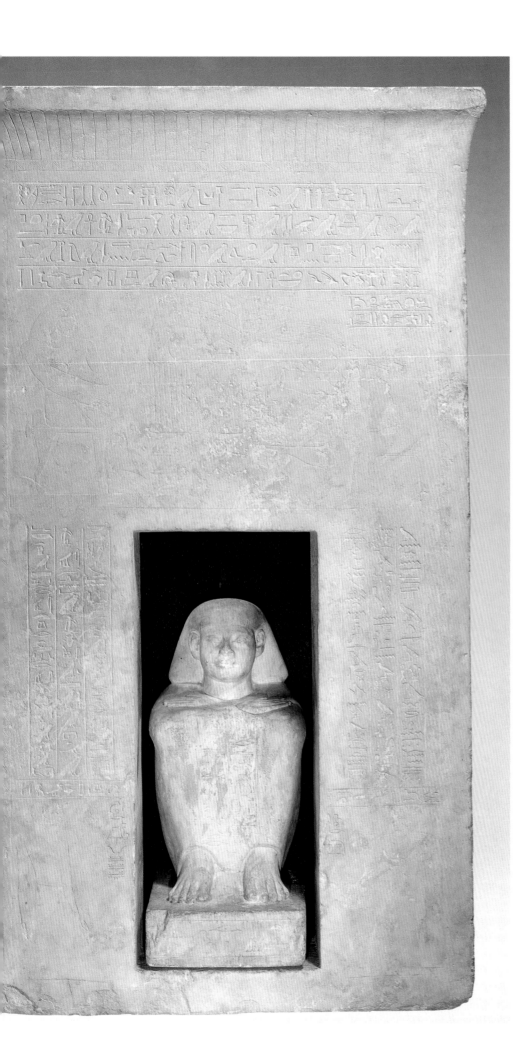

cornice at the top and the figures of Sahathor, facing outward, in the thickness of the "door" (cf. cat. no. 6a-b). Only here, in this protected area, was any of the original paint preserved. Along with the standard offering prayer at the top, the inscriptions contain texts of a type found on tomb walls.[2]

False door elements include the offering scene at the top (cf. cat. no. 6c), which is shared by Sahathor's wife, Meryisis, the arrangement of his inward facing figures below the columns of text above, and the statue itself, since the owner's figure is sometimes shown facing outward from the central "doorway." A false door often had an offering table placed directly in front of it, and so did this.[3]

Although all these details, architecture, and false door are appropriate to the tomb, this monument was not made for a tomb, but rather for a memorial chapel (cf. cat. no. 20), one of many erected during the Middle Kingdom along the processional route at Abydos, which was the main cult center of Osiris and, it was thought, the site of his tomb.[4] With its prayers to Osiris and another Abydos god, Anubis, and its vantage point along the processional way of the Great God, Sahathor's block statue combined the most potent aspects of tomb and temple representations of the deceased. (E.R.R.)

## Notes

[1] This paragraph draws heavily on Schulz 1992 II, pp. 761–66, 776–78, 783–85.

[2] These kinds of text were also found on stelae in the Middle Kingdom and later. They include an appeal to passersby for offerings, a passage of clichéd self-praise, and an all-too-brief account of youthful expeditions to foreign lands; for translations, see Parkinson 1991, pp. 137–39.

[3] Simpson 1974a, p. 17 (ANOC 9.3).

[4] Simpson 1974a.

## Bibliography

PM V 1937, p. 95 (with earlier bibliography).

Simpson 1974a, ANOC 9, 1–2, pp. 17, 23, pl. 18.

James/Davies 1983, p. 14, fig. 12.

Parkinson 1991, pp. 137–39 (translation).

Schulz 1992, I, no. 215, pp. 372–73 (with bibliography), II, pl. 96 a–b.

Robins 1997, p. 106, fig. 114.

Wildung 2000, no. 81, pp. 162, 186.

# 26

## Stela of Minnefer

Provenance unknown
Middle Kingdom, Twelfth Dynasty, year 29
of Amenemhat II (ca. 1937 B.C.)
Limestone, painted
25 5/8 x 21 3/4 in. (65 x 55 cm)
EA 829, acquired in 1857, purchased at the sale of the
Anastasi collection

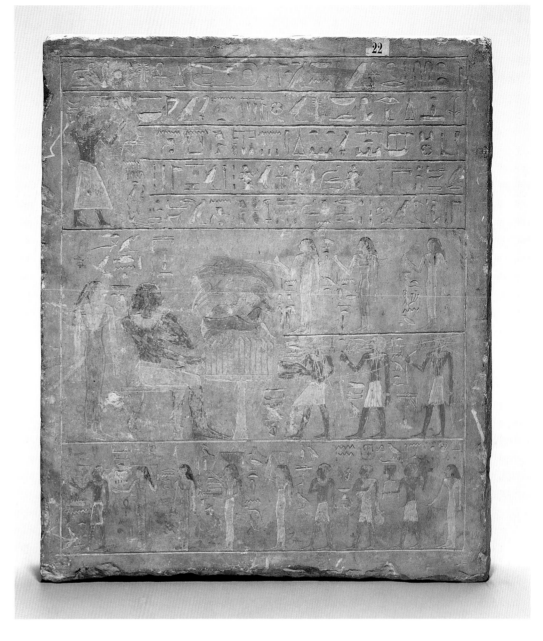

Like the stela of Userwer (cat. no. 27), this stela
of an official named Minnefer includes members
of his family. But whereas Userwer's stela
commemorates his parents, as well as his wives
(whether coeval or consecutive) and, apparently,
their children, Minnefer's is dominated by his
mother, who stands behind him in the main
scene. The women in front of them are, from left
to right, his sister, a relative of his mother, and
finally his wife. Her position, apart from her
husband, does not imply marital discord,[1] but her
place at the end of the line may indicate her
peripheral role as an in-comer by marriage. The
three men below are "her" son (presumably the
mother's son: a half brother of Minnefer?),
Minnefer's father, and his maternal grandfather.

Although Minnefer's stela is less carefully
worked than that of Userwer, it was somewhat
more grandiose in concept, beginning, in the top
line, with its date, year 29 of Amenemhat II.
Then, before a standing figure of Minnefer,
come prayers to Osiris, to other gods of Abydos,
and all the gods of the necropolis, followed by an
appeal for offering prayers for Minnefer (cf. cat.
no. 25), addressed to all who are living upon
earth, all priests and priestesses of the temple
where the stela was placed.

In the main register below, there are a few
signs of carelessness or haste. Minnefer's three
female relatives appear to be shaking their fists at
him, because the blue lotus blossoms they were
meant to be holding were never carved. The
bottom register, which consists of a row of
offering bearers, is clearly unfinished: note the
still-rough surfaces on the limbs and dress of the
two left-most figures. The offerings held by the
third and last figures were merely added in paint
and are now almost invisible.

Only one of these figures is identified as a
relative: the fifth from the left is identified as

"her" (Minnefer's mother's?) daughter. The rest,
presumably servants and employees, have titles
and names, or just names, some of which seem
inappropriate, although traces of painted
hieroglyphs indicate that here, too, the carving
was never finished. Before the feet of one of the
women and one of the men are hieroglyphs in
faded paint that read "daughter" and "son." The
odd placement of these words suggests that they
were additions, perhaps made to add children
who were still unborn when the stela was made,
by usurping the figures of non-relatives. Such
"legitimate" usurpations are known elsewhere.

Though sadly faded, the paint preserves
features that are often lost: the green dresses of
several women (cf. cat. no. 18)[2]; the use of paint
to finish incomplete carving; the possible use of
paint to amend inscriptions and thus to change

the identity of figures. Damage to the painted
surface also draws attention to the scratched
mutilation of the figures of Minnefer's male
relatives. The attacker who singled out their
representations must have been taking revenge
specifically on these men. One can only wonder
whom they had offended, and how. (E.R.R.)

### Notes

[1] This separation is fairly common on middle Twelfth Dynasty
stelae: Malaise 1977, p. 186.

[2] Green dresses seem to have been fairly common during the
Middle Kingdom; for another example, see Saleh/Sourouzian
1987, no. 85.

### Bibliography

*HT* IV 1913, pl. 5.

Robins 1997 p. 103, fig. 110.

# 27

## Unfinished Stela of Sculptor Userwer

Provenance unknown
Middle Kingdom, Twelfth Dynasty
(ca. 1985–1795 B.C.)
Limestone, red and black inks
20 1/2 x 19 in. (52 x 48 cm)
EA 579, acquired in 1834, formerly Sams Collection

The surface of this funerary stela, which is almost square in shape, is divided horizontally into three parts. The uppermost division is the largest and contains five lines of text consisting of an offering formula, followed by an appeal to the living who pass by Userwer's monument. Both are intended to provide offerings for the deceased Userwer, whose figure appears in the register below.

Here, Userwer and his wife Satdepetnetjer sit facing right, before a table piled high with offerings. A woman called "his wife Satameni" stands on the other side of the table, facing Userwer and Satdepetnetjer. On the right, a second seated couple, identified as Userwer's father, Senkhonsu, and his wife, Satnebniut, sit facing left before another table of offerings. On the other side, facing right, a standing male figure, labeled as "his son Sneferuweser" offers a leg of beef to Senkhonsu and his wife.

The lowest register consists of a row of eight standing figures, all facing right toward Senkhonsu and Satnebniut. They are identified as "his son, Horuser; his daughter, Satwedja; his daughter, Satseri; his daughter, Imery; his daughter, Ankhyt; his daughter, Satnebniut; his father, Userwer; his male relative Nebniut."

The stela was never finished. In the bottom register, the last two male figures and the heads and arms of the preceding two female figures were left uncarved. Ruled red lines, forming squared grids on which the figures were sketched out in black ink, can still be seen in the middle and lowest registers where the stone has not been cut away. The grid system seen in use here was developed in the late Eleventh or early Twelfth Dynasty. In it, standing figures spanned eighteen squares between their hairlines and the soles of their feet, and seated figures, fourteen; female figures differed from male figures in having narrower shoulders and a higher small of

the back. The figures depicted on Userwer's stela all conform to this scheme. One grid fits all the standing figures in the lowest register, since they are drawn at the same scale; but in the register above, the seated figures are on a slightly larger scale than the standing ones, and different-sized grids are used for the two poses.

Family relationships on stelae are often hard to understand. Although figures are usually identified by kinship terms, as here, it is frequently unclear to whom the attached possessive pronoun refers. In the case of Userwer's stela, the problem is whether or not "his" always refers to Userwer. Two clues suggest that in the bottom register "his," in fact, refers to Userwer's father, Senkhonsu.

First, the offering ritual is usually performed by a son, but Userwer and his wife Satdepetnetjer are faced by another wife, Satameni. Irrespective of whether Userwer had two wives at the same time or married Satameni after the death of Satdepetnetjer, one would have expected Horuser, the first figure in the lowest register, to have been shown offering to Userwer, if Userwer had been his father.

Second, one would have expected figures relating to Userwer to be oriented toward him. Instead, the figures in the bottom register are turned toward Senkhonsu. They are, therefore, more likely to be his children. The figure labeled "his father, Userwer" could then be understood as the father of Senkhonsu and grandfather of the sculptor Userwer, which would fit well with the Egyptian custom of naming children after a grandparent.

Despite the relatively high quality of the stela's workmanship, Userwer is the only person on the stela with a title, suggesting that his

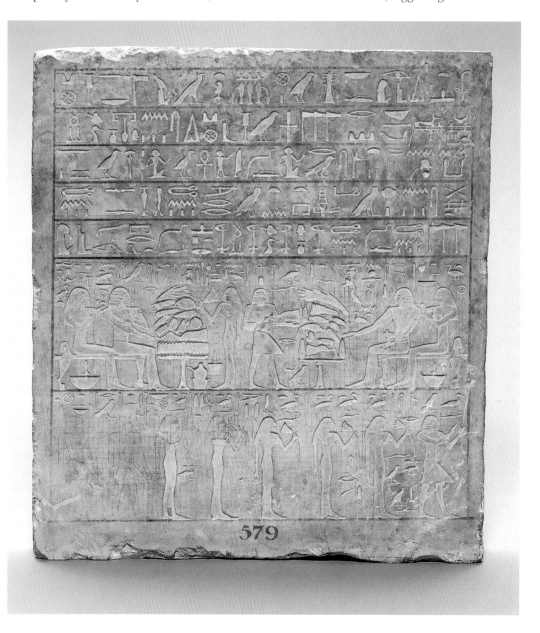

family was not of high status. The quality of the stela may be because Userwer himself was involved in its making. The function of the stela, assuming that it was used, even though unfinished, would have been to perpetuate the memory of Userwer through his name and image, and to serve as a focal point for the performance of offering rituals on his behalf, as indicated by the presence of the offering formula and appeal to the living. (G.R.)

**Bibliography**

Lepsius 1842, pl. 21.

*HT* II 1912, pl. 15 (drawing inaccurate).

Bourriau 1988, no. 20, pp. 29–31.

Robins 1994, pl. 1.2.

Robins 1997, pp. 103, 108, figs. 111, 116, and 117.

# 28

## Standing Cloaked Man

From Athribis
Middle Kingdom, late Twelfth Dynasty
(ca. 1880–1808 B.C.)
Granite
Height 24 1/2 in. (62 cm)
EA 1237, acquired in 1897

This statue, a rare example of fine Middle Kingdom private sculpture from northern Egypt,[1] shows a man wearing a simple shoulder-length wig and a chin beard, standing with his arms crossed over his chest. He is wrapped in a rectangular mantle, which he holds closed with his right hand. The left hand lies flat on his breast. It is likely that the man's name and titles were inscribed on the base of the statue, but that has been lost, along with the feet.

Like the block statue (see cat. no. 25), the standing or seated cloaked male statue was an invention of the Middle Kingdom. It seems to convey much the same message, that of humility in the god's presence and of trust in eternal protection and the provision of offerings. Unlike the block statue, however, standing and seated cloaked statues of the Middle Kingdom seem to have been placed only in temples, not in tombs. This distinction may signify a slightly different meaning between block statues and standing or seated cloaked statues, but it is more likely that the latter poses simply developed a little later in

the Middle Kingdom, as more and more private persons began to place their images in temples.

The man's handsome face, grave but serene, is beautifully in harmony with the submissive quality of his pose. Like the tomb statues of the Old Kingdom (cf. cat. no. 8), this figure is an expression of faith in an eternal Afterlife. But its quiet, almost introspective containment contrasts strongly with the confident, self-satisfied air of the earlier period. This sober quality, found in most fine sculpture of the later Twelfth Dynasty and in extreme form in royal representations (cf. cat. nos. 29–31), reflects a less optimistic but more complex view of man's role in society and in the cosmos.[2]

Cloaked statues were made throughout the Middle Kingdom; they continued (or were revived) in the New Kingdom, during the first half of the Eighteenth Dynasty, and then fell out of favor. That this development was primarily due to a preference for statues (including the kneeling statue, a New Kingdom invention) that could display the elaborate costumes of the later New Kingdom is suggested by the existence of New Kingdom pseudo-block statues wearing complicated wigs, clothing, and jewelry (cf. cat. no. 47).[3] The cloaked figure reappeared briefly at the end of the Third Intermediate Period, in a few archaizing statues,[4] but was then abandoned in favor of statues depicting the heavier skirts and cloaks worn by men in the sixth century B.C. and later (cf. cat. nos. 132 and 141).[5] **(E.R.R.)**

### Notes

[1] It is the only Middle Kingdom statue known to come from the important town of Athribis: Vernus 1978, p. 8. This scarcity is undoubtedly due to accidents of survival and not to an original lack of material.

[2] Also expressed in Middle Kingdom literature; for the most recent remarks on the connection between this literature and Middle Kingdom imagery, see Assmann 1996, pp. 76–77.

[3] For more elaborate New Kingdom examples, some with shrines or divine representations at the front of the kilts, see Schulz 1992, II, pls. 6d, 27–28, 41, 53a–b, 89, 95a, 124c, 157c–d.

[4] The best of them, a seated, cloaked figure of a grandee named Mentuemhat, is very similar to a Middle Kingdom original (Berlin 17271): Priese 1991, no. 102.

[5] For the heavy mantle of the fourth century B.C., see Russmann 1989, no. 88, pp. 91–92; for the draped cloak of the Ptolemaic and Roman Periods in this context, ibid., no. 92, pp. 201–203.

### Bibliography

PM IV 1934, p. 65 (with earlier bibliography).

Vernus 1978, Doc. 7, p. 8 (with further bibliography).

Moore 1981, pp. 32–33.

*Art and Afterlife* 1999, no. 9, p. 36.

# 29

## Standing Statue of Sesostris III

From Thebes, Deir el Bahri, funerary temple of Mentuhotep II
Middle Kingdom, Twelfth Dynasty, reign of Sesostris III (ca. 1874–1855 B.C.)
Granite
Height 56 in. (142.2 cm)
EA 686, gift of the Egypt Exploration Fund, 1905

This statue, one of the most famous Egyptian statues in the British Museum, is one of six very similar figures of Sesostris III that were found below the platform base of the main part of Mentuhotep II's funerary temple (fig. 47), from which they had been thrown at some point in antiquity. All six had lost their legs and bases, and only four still had heads.[1] One of these is now in Cairo, and the other three went to the British Museum.[2]

Sesostris III erected these statues in Mentuhotep's temple to honor his predecessor as the re-unifier of Egypt. They showed Sesostris in an attitude of prayer, standing with his open hands on the stiffened front panel of his elaborately pleated, knee-length kilt. These are evidently the earliest examples of royal figures in this devotional pose, which is also found on representations of his son, Amenemhat III (fig. 7),[3] as well as on Middle Kingdom statues of nonroyal men.[4] Though never very common, the pose continued (or was revived) in the New Kingdom for both royal and private statuary;[5] at least one archaizing example is known from the Late Period.[6]

Sesostris wears a *nemes* headcloth with a uraeus and his characteristic amulet (see cat. no. 30). His kilt is vertically pleated, but the triangular front panel was apparently pleated fanwise, opening up from the corner under his proper left hand. The upper corner is tucked under his belt. At the front of the belt is a cartouche containing his name, and from it hangs an apron-like beaded panel with two cobras at

the bottom. The extraordinary quality of the work is best seen in the subtle modeling of the king's soft but youthful-looking torso and the bravura carving of his incongruously craggy face.

Like all representations of Sesostris III, this face has a tapered structure. Deep indentations at the temples set off sharply prominent cheekbones. The cheeks are flat and the chin rather square. The nose, now damaged, was extremely aquiline, jutting out from its deep root between the brows. The eyes seem to slant slightly downward; they are hooded by heavy lids that appear to fit tightly over the eyeballs. There are no signs of cosmetic enhancement on the eyelids or brows. Furrows descend in diagonal lines from the inner corners of the eyes, from beside the nostrils, and alongside the pouched corners of the mouth, which on this statue turns downward to form two diagonal lines that almost parallel the facial folds. Sesostris's mouth is one of his most distinctive features, with its narrow upper lip, which rises rather steeply to the center, above an only slightly fuller lower lip.

These features characterize all the faces of Sesostris's statues, making them recognizable even when his name is no longer present. But no two of these faces are exactly alike (cf. cat. no. 30 and fig. 22). Even the faces of the three other Deir el Bahri statues differ noticeably from this one and from each other,[7] although they must come from the same sculpture workshop and possibly from the hands of the same sculptor. The differences, among these and among his other statues, lie entirely in small details: the thickness of the eyelids, the sharpness of the cheekbones, the set of the mouth.[8] With the exception of one statue that shows him with a younger face,[9] Sesostris's visages are thus remarkably consistent.[10] Unlike the representations of Amenemhat III, they cannot be differentiated into progressive stages of the aging process.[11]

The greatness of Sesostris's sculpture, however, lies in its expressiveness. In the hands of his finest sculptors—among whom this sculptor must certainly be included—the heavy lids, the pouches under the eyes and beside the corners of the mouth, and especially the insistent pattern of descending folds and furrows convey a sense, not just of age, but of a hauntingly somber emotion that sometimes, as here, seems to approach anguish. According to some scholars, these unforgettable faces reveal

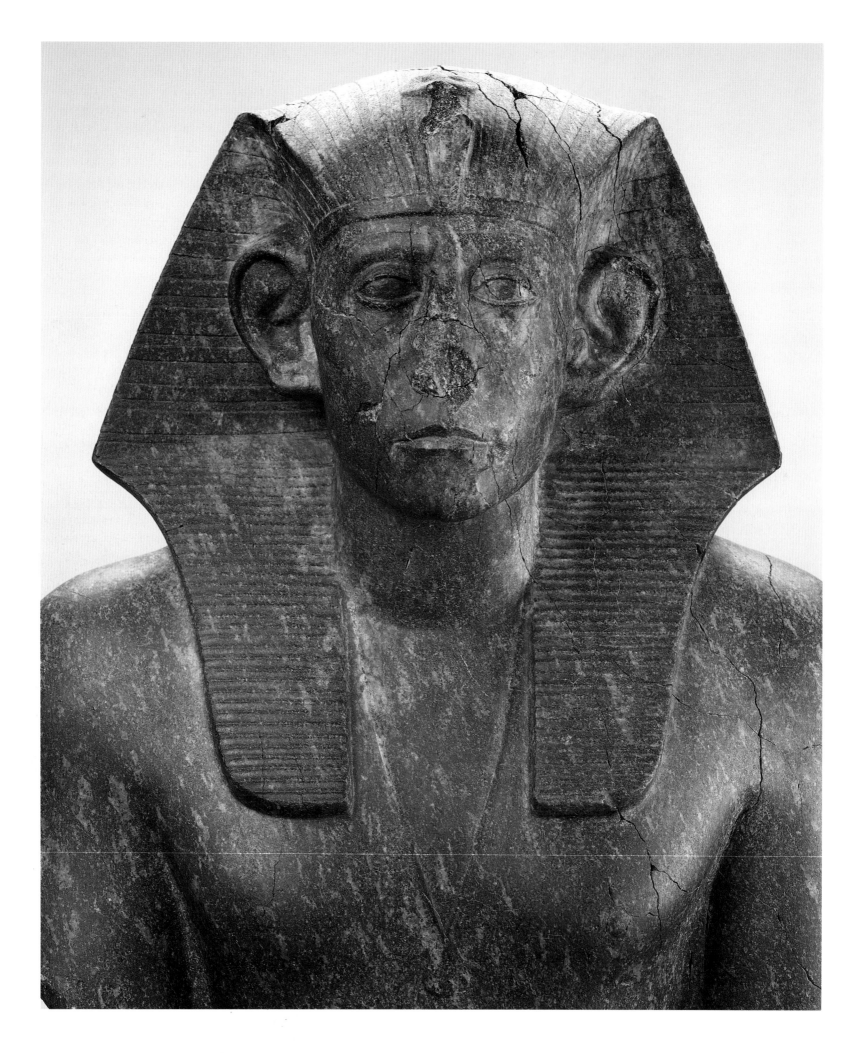

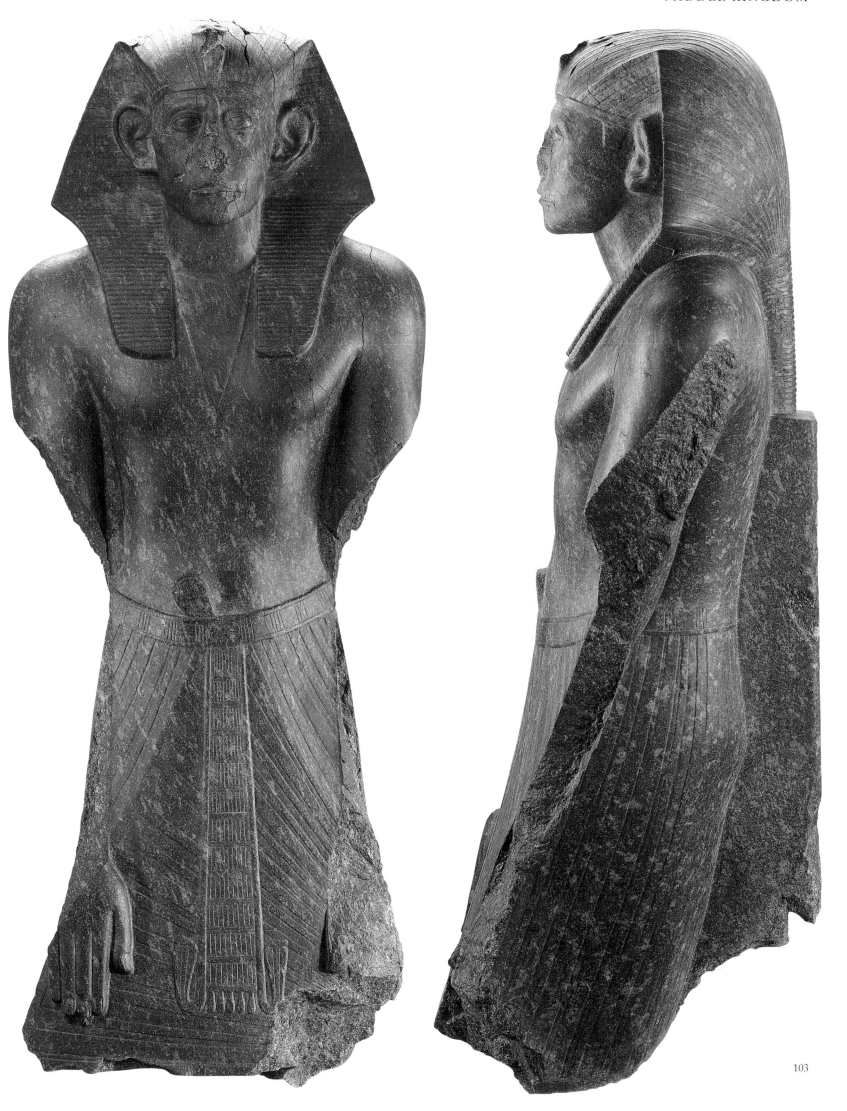

the "inner man," Sesostris's true personality.[12] That, however, is a modern interpretation, and it does not fit the facts. Sesostris's face is an icon of the somber outlook of the later Middle Kingdom. Like the prayerful pose of this statue, like the passive, cloaked forms and sober faces of Twelfth Dynasty private sculpture (cf. cat. nos. 25 and 28), Sesostris's sculpture expresses the pessimism of a culture that had lost faith, not in its gods, but in the goodness of people. This attitude is vividly expressed in Middle Kingdom literature, which also says that the heaviest burden, that of rulership, lay on the king. It is not surprising, therefore, that the most extreme expression of this late Middle Kingdom mood was the king's own face. Sesostris III's images are indeed portraits. But their expressiveness is royal, rather than personal, expression.[13] (E.R.R.)

## Notes

[1] Naville 1907, p. 57, pl. 19.

[2] Cairo TR 18/4/22/4: Saleh/Sourouzian 1987, no. 98; BM EA 684, 685; Naville 1907, pl. 19C–D; Wilson 1989, p. 61, fig. 74. For a discussion of these four, see Vandier 1958, pp. 186–87.

[3] Some of these are from Karnak temple: Saleh/Sourouzian 1987, no. 105.

[4] E.g., Bourriau 1988, no. 42, pp. 55–56.

[5] Royal: Hayes 1959, pp. 95, 120, figs. 52, 62; private: Kozloff/Bryan 1992, p. 239, fig. VIII.2 (an archaizing example with a Middle Kingdom type of wig).

[6] Russmann 1989, no. 86, pp. 185–88; Saleh/Sourouzian 1987, no. 251; this private statue may be based on a New Kingdom royal model: cf. ibid., no. 138.

[7] Cf. Polz 1995, p. 235.

[8] Other examples: Aldred 1971, pp. 42–44, figs. 23–27; Luxor Museum 1979, no. 40, pp. 32–35; Polz 1995, pls. 48–49.

[9] Louvre E 12960: Delange 1987, pp. 24–26.

[10] Cf. Polz 1995, pp. 227–30.

[11] For an opposite opinion, see Bourriau 1988, p. 39.

[12] E.g., Polz 1995, pp. 253–54

[13] For further discussion, see above, pp. 35–36.

## Bibliography

Frequently illustrated.

PM II 1972, p. 384 (with earlier bibliography).

James/Davies 1983, p. 26, fig. 29.

Polz 1995, pl. 48a (bust only).

Robins 1997, p. 112, fig. 120.

# 30

## Bust of a Seated Statue of Sesostris III

Provenance unknown[1]
Middle Kingdom, Twelfth Dynasty, reign of
Sesostris III (ca. 1874–1855 B.C.)
Graywacke
Height 8 ³/₄ in. (22 cm)
EA 36298, acquired in 1868, purchased from
W. D. Cutter

More than one hundred statues and statue
fragments of Sesostris III are known. They
range in size from statuettes to colossi (see fig.
22).[2] Only a few of the smallest have survived
more or less intact[3]; the rest are incomplete or
just fragments. This figure, the upper half of a
seated statue, has lost, along with its lower half,
the name of its royal subject. But the face is
unmistakably that of Sesostris III.

This is a rounder, less heavily modeled
version of the face on the standing statue of
Sesostris III (cat. no. 29). Here, the expression,
though sober, seems more bland. That is probably
due in part to the virtual destruction of the
mouth, which often carries much of the
expression on smaller representations of
Sesostris.[4] The upper eyelids on the bust seem
fleshier than on the standing figure. The upper
lids droop over the lower lids at the outer corners,
a standard mark of age on Egyptian sculpture
from as early as the Second Dynasty,[5] but one
rarely found on representations of Sesostris. The
ears, like the ears on almost all later Twelfth
Dynasty sculpture, royal or private, are huge.[6]

Like the standing Sesostris III, this figure
wears a *nemes*, a uraeus and an amulet suspended
from a beaded cord. This amulet, found on royal
statues from the middle of the Twelfth Dynasty
on,[7] appears on the majority of Sesostris III
statues, rarely on representations of Amenemhat
III,[8] and at least once at the very end of the
Twelfth Dynasty.[9] Since Egyptian kings were
rarely shown wearing jewelry, other than the
standard collar necklace and bracelets,
occasionally paired with armlets and/or anklets,[10]
this amulet is intriguing. To some, it looks like a
little double pouch, pierced by a thorn.[11] To
others it resembles certain amulets of the late
Old Kingdom, some of which are equally
enigmatic.[12] (E.R.R.)

### Notes

[1] According to Franke 1994, p. 60, n. 192, it has been
suggested that the lower part of this statue was found at
Elephantine (Aswan Museum 1361). Since the latter is
described as granite, this possibility seems unlikely; but it
should be investigated.

[2] Also Luxor J 34: Luxor Museum 1979, no. 40, pp. 32–35.

[3] E.g., Brooklyn BMA 52.1: Fazzini/Romano/Cody 1999, no.
22, pp. 22–23.

[4] Such as the Brooklyn statuette cited in note 3.

[5] Cairo JE 32161: Russmann 1989, no. 1, pp. 10–13.

[6] For a symbolic interpretation of large royal ears, see Parkinson
1999, p. 66.

[7] Vienna 5776 (Sesostris II): Seipel 1992, no. 43, pp. 158–59.

[8] Polz 1995, p. 243.

[9] On a torso of the female king Sebekneferu, Louvre E 27135:
Delange 1987, pp. 30–31.

[10] For the most important exception, the Kushite kings of the
Twenty-fifth Dynasty, see cat. no. 120.

[11] For the slight variations in its shape, see Polz 1995, p. 243.

[12] For the later history of this amulet, see Russmann forthcoming.

### Bibliography

Hall, H. R. 1929, p. 157, pl. 30.

Parkinson 1999, p. 66, pl. 9.

Wildung 2000, no. 38, pp. 106, 182.

# 31

## Colossal Head of Amenemhat III

From Bubastis, temple of Bastet, entrance to Great Hall
Middle Kingdom, Twelfth Dynasty, reign of
Amenemhat III (ca. 1854–1808 B.C.)
Granite
Height 30 ¹/₂ in. (77.5 cm)
EA 1063, gift of the Egypt Exploration Fund, 1889

This head of Amenemhat III shows the
dramatic effect of the distinctive portrait style of
the last Twelfth Dynasty kings when this style
was combined with colossal size. The effect
would have been further intensified by the
black-and-white stare of the inlaid eyes.

Like all Egyptian pharaohs, kings of the
Middle Kingdom had a taste for the colossal.
However, very few of their large monuments
have survived. They built pyramids that were
quite sizable, though much smaller than those of
the Old Kingdom, but they did not build well.
Middle Kingdom pyramids today are little more
than heaps of sand and rubble. There were royal

statues of colossal size, but most were later
smashed or usurped by other kings.[1]

This head comes from one of a pair of
fragmentary seated statues excavated in the Nile
Delta at the site of the ancient city of Bubastis.[2]
When they were found, in 1888, the sculpture of
Amenemhat III was still almost unknown.
Inscriptions on the statues naming the Third
Intermediate Period king Osorkon II (cf. cat. no.
113) did not fool the excavator, Edouard Naville,
who recognized them as later usurpations, but he
puzzled over just who might be represented here.

Naville thought the strong features looked
non-Egyptian. Some years before, a group of
sphinxes and other statues with faces similar to
the Bubastis heads had been found at the nearby
site of Tanis.[3] They, too, had been thought to
look non-Egyptian, so they had been attributed
to the foreign Hyksos kings (Fifteenth Dynasty,
ca. 1650–1550 B.C.). Naville added this head
and its companion to the list of "Hyksos
monuments." It took several decades and a
number of scholars to dispel the myth of the
"Hyksos monuments,"[4] but today we know that
the Bubastis heads and the Tanis statues are all
portrait representations of Amenemhat III.

Amenemhat's face is as distinctive as that of
his father, Sesostris III (cat. nos. 29 and 30), but
very different. The son's face is broader; the eyes
are more widely spaced and less heavily hooded.
The lips are fuller. Diagonal muscles under the
lower lip suggest tension in the heavy jaw (cf. fig.
7). Like that of Sesostris, Amenemhat's expression
is somber, but it seems harsher, even brutal.

Although portraits of Amenemhat III are
almost always recognizable, they are far more
varied than those of Sesostris III. A recent
study has divided them into three "styles":
realistic (including fig. 7), idealized, and
stylized (including this head).[5] Outside of these
groups, two more representations seem to show
the king as a young man.[6] Another anomalous
example (not included in the above study) is a
small head wearing the crown of the god Amun
that shows the features of Amenemhat III in
wizened old age.[7] Between these extremes,
some of his other statues show different stages
of advancing middle age.[8] In the loosening of
the flesh around his eyes and chin and the
increasing protrusion of his lower lip, we seem
to see this king age—but only in the face. The
body is always slim and youthful.

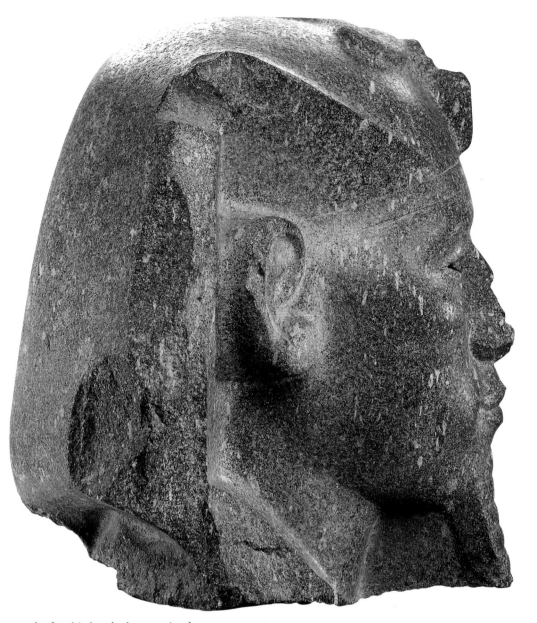

As for this head, characterized as "stylized" in the study cited above, its features differ little from the faces of some "realistic" statues of Amenemhat III, except in being less detailed. This is not stylization, therefore, but a simplification appropriate to its scale.[9] From the Great Sphinx early in the Old Kingdom (fig. 2), to Abu Simbel, in the later New Kingdom (fig. 9), Egyptian colossal statues show awareness of the need to simplify and emphasize the features of faces placed so far from the viewer (cf. cat. no. 52).[10] (E.R.R.)

**Notes**

[1] For a destroyed colossus of Amenemhat III, see PM IV 1934, p. 98; for usurpations of Middle Kingdom colossi, see Sourouzian 1988.

[2] The fragmentary throne and legs are also in the British Museum. The head and throne of the second statue are in Cairo (CG 383, 540): Evers 1929, pls. 113–14 (head), 117 (throne).

[3] The Tanis statues are now in Cairo; for two of them and a related statue from the Fayum, see Saleh/Sourouzian 1987, nos. 102–104; also Russmann 1989, nos. 28–29, pp. 65–68.

[4] Habachi 1978, pp. 80–82.

[5] Polz 1995.

[6] Polz 1995, pp. 230–31; one is Cairo CG 385: Russmann 1989, no. 27, pp. 62–64.

[7] Cairo TR 13/4/22/9: Russmann 1989, no. 30, pp. 68–69.

[8] All these statues are grouped (along with others) as "realistic" by Polz 1995, but age variations are not noted.

[9] Polz 1995 does not discuss scale.

[10] The genre of Egyptian colossal sculpture has received little attention; see also the discussion of cat. no. 52 below.

**Bibliography**

Often illustrated.

Evers 1929, pls. 115–16.

PM IV 1934, p. 28 (with further bibliography).

Aldred 1970, pp. 23–24, fig. 37.

*Art and Afterlife* 1999, no. 2, p. 29.

# 32

## Kneeling Girl Holding Kohl Pot

From Thebes
Middle Kingdom, Twelfth Dynasty
(ca. 1985–1795 B.C.)
Steatite
Height 3 ⅛ in. (7.8 cm)
EA 2572, acquired in 1835 at the sale of the Salt Collection

This little figure kneels holding a vessel on a stand. Though large in relation to her, the pot is small and of the shape used in the Middle Kingdom to hold kohl (eye paint). Though it came from a tomb,[1] this object was first used during the owner's life: the top is scratched by the constant removal and replacement of the lid, which is now lost.

The figure is clearly a young girl, with a high, pointed bosom, a thick pigtail growing from an otherwise shaven head and a calf-length skirt, over which she wears a hip belt of cowrie shells. An amulet in the form of a fish dangles from the curled end of her braid.

Almost a dozen Middle Kingdom eye-paint containers of this type are known,[2] and all are very similar. In a few cases, the kneeling servant is so summarily carved that its gender is uncertain. Among those whose sex can be determined, one or two are definitely male, but most appear to be young girls, wearing a pigtail and a skirt.

The girl's hairdo and jewelry are all typically Middle Kingdom. They were worn by young servants, which she probably is, but also by daughters of good families, because they had a protective, amuletic value. The pigtail, a variation of the sidelock worn by both male and female children since the Old Kingdom (cf. cat. no. 7), could itself be represented as an amulet because of its association with child gods. The fish, a symbol of regeneration, was also associated with Hathor.[3] Worn by children, it may have been thought to protect against drowning.[4] There are several examples of fish amulets with loops at the noses to suspend them in the same manner as the one hanging from this girl's braid. In a tale of the Middle Kingdom, a royal serving maid is described as wearing (and losing) the fish pendant from her hair. On the wall of a Middle Kingdom tomb,

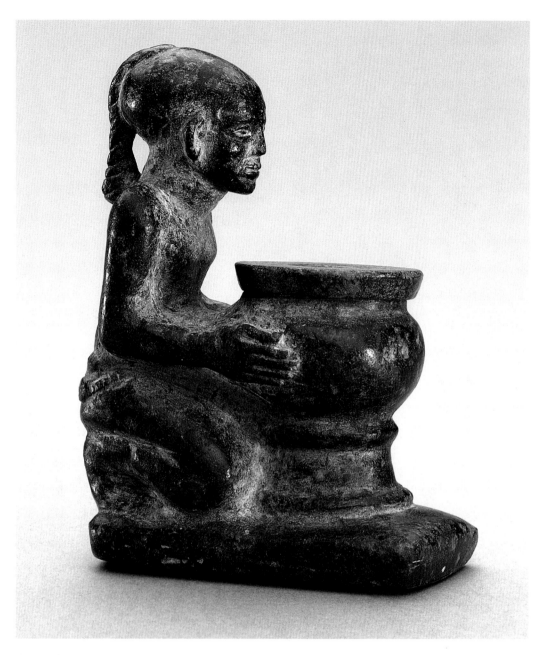

the daughter of the tomb-owner is shown wearing one during an outing in the papyrus marshes.[5] Cowrie shells were thought to resemble female genitalia, and so strings of cowrie shells or gold or silver cowrie amulets were often worn as hip belts by young girls to protect their fertility.[6] Examples of sidelock, fish, and cowrie-shell amulets are all found on catalogue number 36.[7]

There could hardly be a greater contrast than that between this type of rigidly frontal Middle Kingdom figure, with its formulaic pose, and the lively, varied, usually asymmetric poses of the New Kingdom figures carrying cosmetic containers—not to mention the fact that the New Kingdom figures, when female, wear only jewelry (cf. cat. no. 81). The use of such objects had not changed, nor had the

underlying symbolism of regeneration and rebirth that caused them to be placed in the tomb. The differences between objects such as this one and catalogue number 81, for example, are primarily the product of huge changes in social customs and values during the three or four centuries that separated them. **(E.R.R.)**

### Notes

[1] All excavated examples of this type of Middle Kingdom cosmetic vessel were found in tombs.

[2] In addition to eight examples (including this one) listed in Kemp/Merrillees 1980, pp. 148–49, Bourriau 1988, p. 159, cites at least two more; there is another in Berkeley, California, P. A. Hearst Museum (6–1156): *Journey* 1979, p. 19. The only real variant appears to be a single example where the container is held by a standing, clothed man: Bourriau 1988, no. 141, p. 140.

[3] Staehelen 1978, p. 84, who also points out that these

symbolic qualities would also have benefited the owner of such a figure.

[4] Andrews 1994, p. 41; also in *Treasures* 1998, p. 264.

[5] Fischer 1977 discusses all these aspects of the fish amulet and illustrates the daughter as fig. 8, p. 169; for a translation of the story, see Parkinson 1997, pp. 109–12.

[6] Andrews 1994, p. 42; Pinch 1994, p. 107, with an illustration of this figure.

[7] For a hip belt with gold cowrie shells belonging to a Middle Kingdom princess (Cairo CG 53123+53136), see Saleh/Sourouzian 1987, no. 109; Andrews 1990, p. 6.

### Bibliography

Staehelin 1978, pp. 83–84, pl. 2b–c.

Kemp/Merrillees 1980, p. 148, pl. 20a–c.

Bourriau 1988, no. 140, p. 139.

Andrews 1990, p. 173, fig. 156.

*Treasures* 1998, no. 84, pp. 264–65.

## 33

### Shell Amulet with Added Name of Sesostris

Provenance unknown
Middle Kingdom, Twelfth Dynasty (ca. 1985–1795 B.C.)
Gold
Height 1⁷/₈ in. (4.8 cm)
EA 65281, acquired in 1939, bequest of Sir Robert Mond

## 35

### Amuletic Bangle

Provenance unknown
Middle Kingdom (ca. 2055–1650 B.C.)
Gold, silver
Exterior diameter 3 ¼ in. (8 cm)
EA 24787, acquired in 1891, purchased via Sir E. A. W. Budge

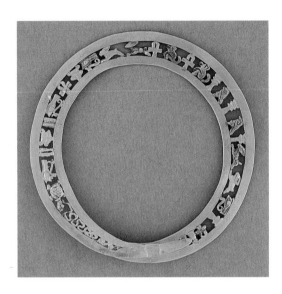

## 36

### Strung Amulets with Clasp

From Thebes (?)
Middle Kingdom (ca. 2055–1650 B.C.)
Electrum, silver, semi-precious stones
Exterior diameter 18 ¹/₈ in. (44 cm)
EA 3077, acquired in 1835 at the sale of the Salt Collection

## 34

### Pectoral Plaque: Amenemhat IV Before Atum

Provenance unknown
Middle Kingdom, Twelfth Dynasty, reign of Amenemhat IV (ca. 1808–1799 B.C.)
Gold
1 ¹/₄ x 1 ¹/₄ in. (3 x 3 cm)
EA 59194, acquired in 1929

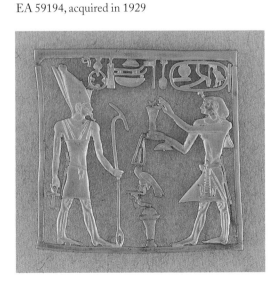

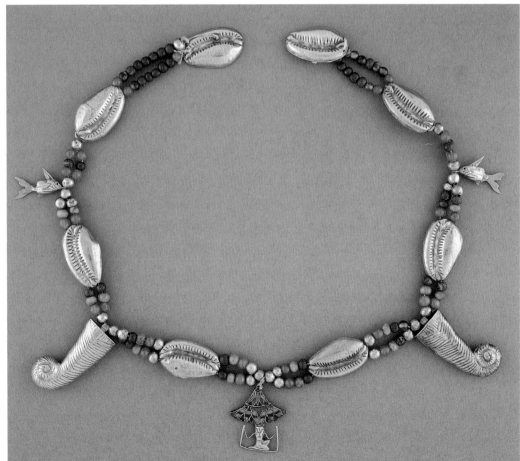

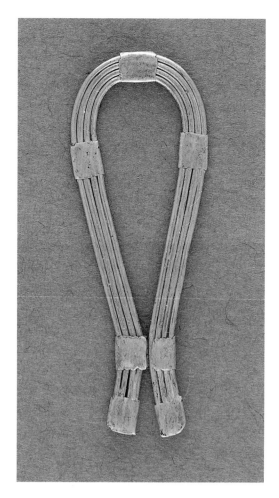

# 37

## Sa-amulet

Provenance unknown

Middle Kingdom (ca. 2055–1650 B.C.)

Electrum wire, gold foil

Height 1 ³/₄ in. (4.2 cm)

EA 65332, acquired in 1939, bequest of Sir Robert Mond

The jewelers of the Middle Kingdom brought this art to a high point, employing precious metals and highly colored semi-precious stones, used mainly to imitate the colors found elsewhere in nature, with their underlying symbolism. Lapis lazuli was the color of the protective night sky; turquoise or green feldspar imitated that of the Nile's life-bringing waters. Carnelian was the color of life's blood, green jasper of fresh vegetation, symbolizing new life. Amethyst alone seems without symbolism. Gold emulated the sun, with its inherent life-enhancing qualities. Silver—rarer, so more highly prized—was linked with the moon.

Electrum, a compound of the two, was particularly favored, being harder wearing than either individual metal.

A characteristic form of Egyptian jewelry, first produced during the Middle Kingdom, was the *cloisonné*-work pectoral, or chest ornament, in which the scene on an openwork metal base plate was reproduced in polychrome by a system of cells, or *cloisons,* inlaid with semi-precious stones. A gold plaque (cat. no. 34) represents the first stage in the development of this technique, called *ajouré*: the scene has been cut out and details incised. Amenemhat IV of the Twelfth Dynasty is depicted offering unguent to Atum, Lord of Heliopolis, god of the setting sun; hieroglyphs name king, god, and material offered. Although three pins are soldered to the reverse, so that it might be inserted into another medium as decoration, almost certainly the plaque was made originally to be the basis of a pectoral.

An openwork bangle (cat. no. 35) consists of a flat gold band with tapering, overlapping ends between whose margins are soldered alternating gold and silver animals and amuletic symbols, their size increasing toward the center. From the lower overlap the insets are as follows: a serpent grasping a turtle's neck, a *wedjat* eye, two two-finger amulets flanking a Bat emblem, another *wedjat*, an *ankh,* another Bat emblem, another *wedjat*, two running hares, an *ankh* and a seated baboon (both repeated), three *djed* pillars flanking two falcons, two more running hares, another *djed,* another *ankh,* two draftsmen (?), and a headless serpent. The turtle symbolized evil, but was rendered harmless by being depicted immobilized. The *wedjat* was the powerfully protective restored lunar eye of the falcon-god Horus. The two fingers perhaps represented embalmer's digits, affording protection. The *ankh* was the hieroglyph for "life." The Bat emblem, the face of a cow-eared goddess, was protective. The hare, noted for its fertility, also survived in the inhospitable desert, death's realm, and thus came to symbolize life itself, or even resurrection. The baboon, herald of the rising sun, was also a moon creature, manifestation of Thoth. The *djed* pillar—perhaps a stylized representation of the backbone of Osiris, god of the dead—as hieroglyph meant "stability." In sloughing its skin, the serpent represented new life.

Contemporary protective magic wands have identical pictorial content.

Parts of a typical Twelfth Dynasty girdle (cat. no. 36) of electrum cowrie shells and a cowrie-shell clasp between lapis lazuli, green feldspar, amethyst, carnelian, and electrum beads, has been restrung with five electrum amulets and a New Kingdom *cloisonné*-work silver lotus-head pendant, inlaid with glass and carnelian. Because of a fancied resemblance to the female genitalia, the cowrie was considered protective of a woman's fertility; worn as part of a girdle, it was close to the anatomical area to be protected. The clasp, too, is a cowrie shell made in two halves, with a tongue-and-groove closing. The amulets depict the kneeling figure of Heh, god of millions of years, grasping palm ribs; the sidelock, worn by a royal or divine heir; and the fish, or *nekhaw,* worn at the end of the plait of young girls or children to ward off drowning. A contemporary cosmetic container (see cat. no. 32) depicts a *nekhaw* and cowrie girdle being worn.

A sheet gold oyster shell with suspension ring (cat. no. 33) is inscribed with the name of Sesostris in a cartouche. Three Twelfth Dynasty pharaohs bore this name, and amulets of this form were most popular then, but peculiarities in the writing suggest that the name was added more recently to an undecorated shell. The shell's name in Egyptian, *wedja,* also means "healthy" or "whole."

An electrum wire *sa*-amulet with gold foil binding (see cat. no. 37) takes the shape of the hieroglyph "sa" meaning "protection." It represents a rolled-up, folded, and tied reed mat used by marsh-dwellers and cattle herders both as portable furniture and as primitive life jacket. (C.A.)

**Bibliography**

cat. no. 33: Andrews 1981, no. 406, p. 63, pl. 32.

cat. no. 34: Andrews 1981, no. 558, p. 76, pls. 30–31; Andrews 1990, p. 89, fig. 65a; Quirke/Spencer 1992, p. 193, fig. 150; Müller, H. W./Thiem 1999, p. 88, fig. 178.

cat. no. 35: Fischer 1968, no. 102, p. 35 (with drawing); Andrews 1981, no. 450, pp. 67–68, pl. 42.; Andrews 1990, p. 55, fig. 39b; Andrews 1994, opp. p. 65, fig. 69b; Pinch 1994, p. 111, fig. 57.

cat. no. 36: Staehelin 1978, p. 83, pl. 2a; Andrews 1981, no. 414, p. 64, pl. 32; Bourriau 1988, no. 154, pp. 145–46; Andrews 1990, p. 55, fig. 39a; p. 85, fig. 61 (detail of clasp);

Andrews 1994, opp. p. 65, fig. 69a; Müller, H. W./Thiem, p. 94, fig. 194.

cat. no. 37: Andrews 1981, no. 409, p. 63, pls. 30–31; Andrews 1994, p. 45, fig. 49d; after p. 64, fig. 64p.

# 38

## Bust of a King

Provenance unknown
Middle Kingdom, Thirteenth Dynasty
(ca. 1795–1650 B.C.)
Granite
Height 16 1/2 in. (42 cm)
EA 1167, acquired in 1895, purchased via the
Reverend C. Murch

The Middle Kingdom came to a close in a period of political destabilization and decentralization that later Egyptians called the Thirteenth Dynasty. Since we have little information about these obscure kings and their often brief reigns, it is not surprising that their statues can be individually identified only in the few cases where the royal name is preserved (cat. no. 39). Thus the king represented here, wearing the royal *nemes* headcloth with a uraeus at the forehead, remains anonymous.

Although nonroyal statues of the Thirteenth Dynasty (cat. nos. 40–42) provide numerous examples of the imitation of features of the Twelfth Dynasty kings Sesostris III (cat. nos. 29 and 30) and Amenemhat III (cat. no. 31), such copying on royal sculpture is comparatively rare.

On this example, features from the aging faces on some statues of Amenemhat III (fig. 7)[1] have been recognizably reproduced—specifically the widely spaced, horizontally set, heavily pouched eyes, and the unsmiling mouth.

When compared with statues actually made for Amenemhat III, however, the bust betrays its Thirteenth Dynasty origin. Here, the eyes are narrower; the mouth is smaller and more indeterminate in shape; the chin is less prominent. Overall, the facial modeling is much less plastic, and the sober expression lacks the brooding, almost brutal quality of the Amenemhat III prototypes. As on other royal representations from the Thirteenth Dynasty, the face is quite long (see fig. 8).[2]

On the basis of similarities between this bust and other early Thirteenth Dynasty royal statues, one scholar has suggested that it represents one of the first kings of the dynasty.[3] So early a date would also help to explain its close stylistic ties to the sculpture of the previous dynasty, particularly since these similarities are not limited to the face: on the upper chest, the breastbone is indicated as a series of ridges. This detail was almost never represented in Egyptian sculpture. Apart from one or two Old Kingdom examples,[4] the few known representations of sternum ridges, aside from this bust, are clustered in the Twelfth Dynasty, when the feature was shown on both royal and nonroyal statues.[5] (E.R.R.)

### Notes

[1] Other examples: Louvre N 464: Delange 1987, pp. 33–35; Cairo CG 42015: Saleh/Sourouzian 1987, no. 105.
[2] Other examples: Louvre A 16, A 17: Delange 1987, pp. 17–21.
[3] Fay 1988, p. 74, n. 62.
[4] Fischer 1965.
[5] Royal: anonymous headless bust in the Brooklyn Museum of Art, BMA 68.178, BMA 1969, p. 46; cf. Evers 1929, II, pl. 8, fig. 56, with par. 635 on p. 95. Nonroyal: a seated figure in the British Museum, EA 100: Budge 1914, pl. 9.

### Bibliography

British Museum 1909s, no. 527, p. 148.
Fay 1988a, p. 74, n. 62.

# 39

## King Meryankhre Mentuhotep VI

Probably from Thebes, said to come from Karnak Temple

Middle Kingdom, Late Thirteenth Dynasty
(ca. 1675-1650 B.C.)

Graywacke

Height 8 ¾ in. (22 cm)

EA 65429, acquired in 1949, purchased from Hugh Algernon Percy, Duke of Northumberland

This small statue is a relic of a very murky period in the history of ancient Egypt. As the Thirteenth Dynasty (cf. cat. no. 38) continued, the breakup of Egypt into the smaller sections of

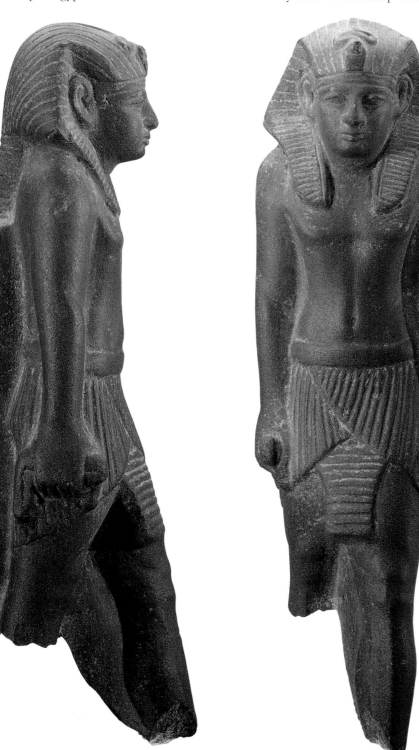

the north and south intensified. The dynasty lasted about 150 years, during which time some fifty kings are attested.[1] Clearly, many of these were ephemeral, and many, especially the later ones, controlled only limited territories. This disintegration was brought to an end by the Hyksos kings from the East, who conquered northern Egypt, which they ruled from their capital in the eastern Nile Delta. Their main opponents, a family of Theban rulers, extended their power in the South and eventually moved against the Hyksos. In about 1550 B.C., the Theban king Ahmose (see cat. no. 110) routed the Hyksos and reunified Egypt, thus founding the Eighteenth Dynasty and inaugurating the period historians call the New Kingdom.

Meryankhre Mentuhotep VI must have lived near the end of the Thirteenth Dynasty,[2] and he may have been recognized only in the Theban area. A headless statuette bearing his name was found at Karnak, as, in all probability, was this one. Without them, we would not even know he had existed. Mentuhotep's name is a further indication of his Theban locale, for it is a pathetic attempt to associate this weak and probably short-lived ruler with the great Mentuhotep II (see cat. nos. 15 and 16), who, starting as a Theban ruler, had reunified Egypt to found the Eleventh Dynasty and the Middle Kingdom. A similar phenomenon is found late in the New Kingdom, when numerous weak kings named themselves Ramesses in imitation of Ramesses the Great.

Considering its inauspicious context, the statuette is a very respectable piece of work. Mentuhotep stands in the traditional pose with left leg advanced, his limbs connected to a back pillar by negative space. He wears a *nemes* with uraeus, and a *shendyt* kilt. His hands, at his sides, hold two different objects. The nature of the one in his proper left hand is unclear (some sort of case?); but that in the right is a folded cloth, with its ends hanging down behind.

The well-proportioned body is simply but effectively modeled with the suggestion of muscles in arms and legs and just the hint of a paunch. There are some nicely observed details, such as the slight flare of the kilt pleats over the buttocks. But there also seems to be uncertainty in the way that the forehead band of the *nemes*, a single strip, has been carved twice over the front and left side of the face, and the way the band descends into very indeterminate shapes in front of the ears. In the Thirteenth Dynasty, a *nemes* might have ear tabs[3] or it might not (cf. cat. no. 38); but this sculptor could not seem to make up his mind. Whether he was also responsible for the inept carving of the inscription on the back pillar we cannot know.

The *nemes* has a shape characteristic of the late Middle Kingdom, rising steeply over the top of the head but rather meager in front view, with small, slanted lappets. The face, too, has a meager quality, due partly to the lack of modeling, but also to the small, short chin. Though the mouth is small in proportion to the nose and eyes, it seems to fill the bottom of the face. The mouth is horizontally set and the eyes rather heavy lidded, features that are found in other royal heads of approximately the same

date.[4] As on the royal bust dated earlier in the Thirteenth Dynasty (cat. no. 38), the ultimate source of these features was probably the portrait statues of Amenemhat III (cf. fig. 7). But it is unlikely that Mentuhotep or his sculptor was aware of this. The great Twelfth Dynasty was far in the past, and its artistic influence diluted almost to invisibility. **(E.R.R.)**

### Notes

[1] Von Beckerath 1977, p. 136.

[2] The list of kings in von Beckerath 1977, p. 138, places him tentatively as no. 35.

[3] E.g., Bourriau 1988, no. 54, pp. 68–69.

[4] Glasgow, Burrell Collection 13/242: Bourriau 1988, no. 54, pp. 68–69; British Museum EA 26935: Seipel 1992, no. 47, pp. 168–169 (here called Amenemhat III; for the correct date, see Davies, W. V. 1981, p. 11, n. 1).

### Bibliography

Davies, W. V. 1981, p. 11, n. 1; no. 40, p. 28 (with earlier bibliography).

Bourriau 1988, no. 53, pp. 54, 67–68.

Seipel 1992, no. 50, pp. 175–176.

# 40

## Standing Woman

Provenance unknown
Middle Kingdom, late Twelfth or early Thirteenth
Dynasty (ca. 1854–1750 B.C.)
Wood
Height 12 ⁵/₈ in. (32 cm)
EA 2373, acquired before 1879

When it was new, this wooden statuette would have been fully painted to show the two straps of the woman's white dress, perhaps a necklace, and most probably her name, on the base (cf. cat. nos. 10 and 11). The figure stands with her feet together and her open hands at her sides. The palms, however, do not face her body, but are turned toward the back in a reverential or prayerful gesture (cf. cat. nos. 13 and 29).

The shape of this woman's body is quite different from female figures of the early or late Old Kingdom (cf. cat. nos. 5 and 11). Her narrow torso, wasp waist, bony hips, and long, swelling thighs represent the ideal of female beauty in the Middle Kingdom. In this case, the effect is fairly natural; but other more extreme

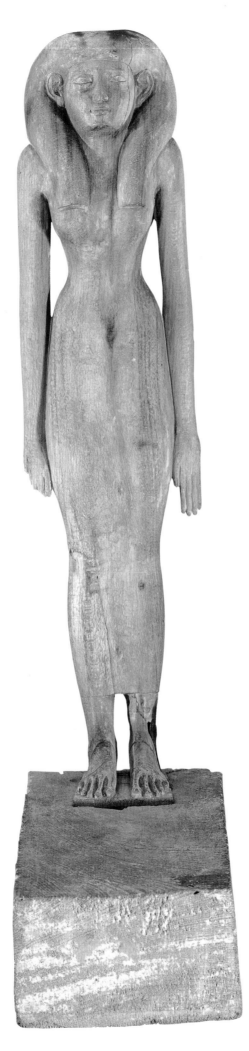

examples[1] suggest that this was an ideal as artificial—and as unattainable—as many more recent feminine fashions.

It is startling to turn from the stylish, youthful body to its stern, heavy, mature-looking face. The face of this woman, like a few representations of late Twelfth Dynasty queens[2] and an even smaller number of other private female statues,[3] is based on the portrait features and expressions of Sesostris III or Amenemhat III. Her narrowed, hooded eyes and full cheeks indicate that the model for this statue was Amenemhat III, rather than Sesostris III. Thus the statue was not made during the reign of Sesostris III, as suggested by a great authority on Middle Kingdom sculpture.[4] But it was not necessarily made under Amenemhat III, either, since sculpture based on the portraits of these two kings continued to be made for several generations, into the Thirteenth Dynasty (cf. cat. no. 41).

In Egyptian art, even female servants were seldom depicted as aging. It is extraordinary, therefore, that a woman of high rank should have had herself immortalized with so unflattering a face. She may have been influenced by the knowledge that the queen was doing it, too. In any case, like all known representations of late Middle Kingdom women with mature faces, she balanced it with a beautiful body.[5] As, indeed, did Sesostris III (cat. no. 29) and Amenemhat III (fig. 7). **(E.R.R.)**

### Notes

[1] E.g., a very beautiful headless ivory figure in the Louvre (E 14697): Delange 1988, pp. 173–74.

[2] E.g., the head of a female sphinx, Paris, Bibliothèque Nationale 24: Fay 1996, pl. 93c–d.

[3] Berlin ÄMP 14475 (now lost): Wildung 2000, no. 67, pp. 143, 185; Moscow 4769.

[4] Evers 1929, I, pl. 93.

[5] See the examples cited in n. 3.

### Bibliography

Evers 1929, I, pl. 93.

Seipel 1992, no. 116, p. 305 (here called Eighteenth Dynasty!).

Wildung 2000, no. 86. pp. 170, 187.

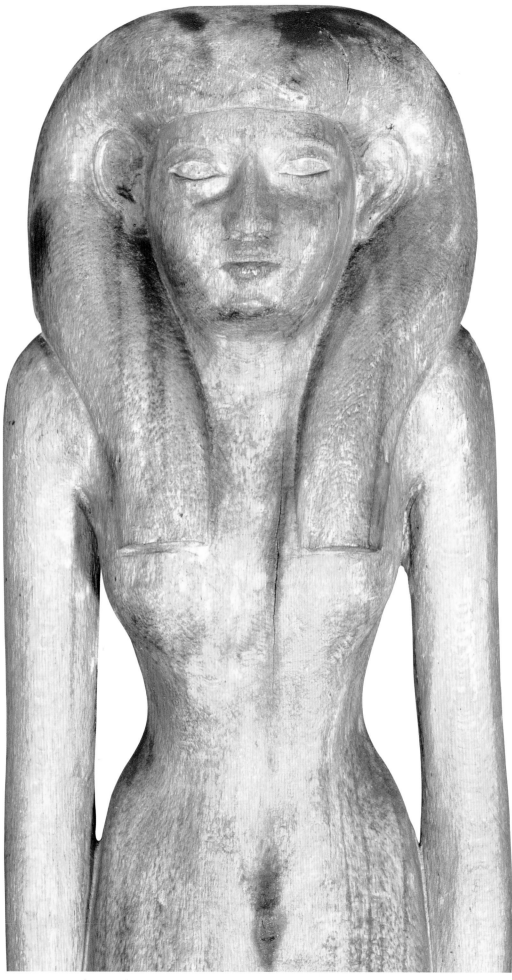

# 41

## Ptahemsaf

Provenance unknown
Middle Kingdom, Thirteenth Dynasty
(ca. 1795–1650 B.C.)
Quartzite
Height 20 ³/₈ in. (51.7 cm)
EA 24385, acquired in 1898

The statue of Ptahemsaf, who was also called Senebtyfy, is carved in quartzite, a hard reddish stone that was especially favored in certain periods, including the later Middle Kingdom and the reign of Amenhotep III (cf. cat. no. 52). Ptahemsaf stands with his left foot advanced and his arms at his sides. His head is slightly raised, an unusual feature, but one found occasionally on Egyptian sculpture of all periods.[1] In this case, Ptahemsaf's upward gaze may be related to the fact that his hands are not fisted, but held open in reverence; the image is one of worshiping the god in whose temple this statue was placed.

For some time after the end of the Twelfth Dynasty, nonroyal people continued to be represented with faces based on the portraits of Sesostris III and Amenemhat III, including their somber expressions. With few exceptions,[2] these "late Middle Kingdom private portraits," as they are often called, are so clearly imitative that they cannot be considered portraits.[3] Nonroyal imitation of royal features was endemic to Egyptian art. However, this appears to be the only time in Egypt's long history when the royal models were past, not present, kings. Ptahemsaf's expression may seem more quizzical than serious, but his face is still a very much simplified version of Amenemhat III, with oval, heavy-lidded eyes, broad cheeks, and a full, rather prominent chin (cf. fig. 7). Almost certainly this statue was made several generations after Amenemhat's death and was based, not on the actual royal portraits, but on subsequent representations of private people derived from them (male versions of cat. no. 40).

The long kilt is another of the enveloping garments favored by the men of the Middle Kingdom (cf. cat. nos. 25 and 28). Wrapped around Ptahemsaf's body with its corners tucked in at the top, it covers him from breast to calf.

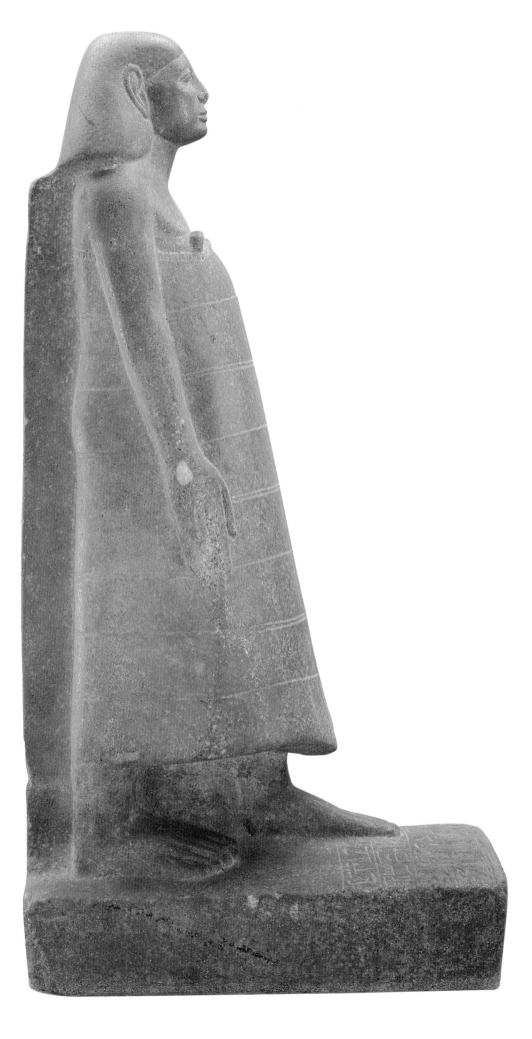
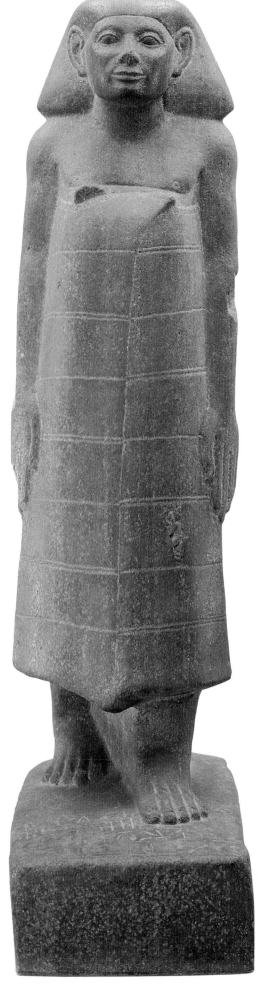

This type of kilt, introduced during the later Twelfth Dynasty, became increasingly voluminous until, on examples such as this one, it balloons in front in a manner difficult to explain—assuming it really looked like this—except by the use of substantial padding.[4]

Garments like these were stored folded, in chests from which, being linen, they emerged well creased. The sculptor has meticulously depicted these folds, showing the sharp inner creases as a single line and the softer outside folds with a double line. The same "realistic" touch had already appeared on a different type of long kilt worn by men of the later Old Kingdom and early Middle Kingdom. On at least one of the earlier examples, a wooden statuette, the folds and creases were lightly modeled in gesso.[5] (E.R.R.)

### Notes

[1] Old Kingdom: cat. no. 8; New Kingdom: Brooklyn BMA 61.196, 37.263E: Bothmer 1966/1967, pp. 58, 59, 64, 65, figs. 2, 4, 9, 10: Late Period: cat. no. 131.

[2] E.g., Cairo JE 43928: Russmann 1989, no. 30, pp. 74–75.

[3] See also Bourriau 1988, pp. 39, 54. Examples: Russmann 1989, nos 31–32, pp. 69–75.

[4] For a similar example, Louvre E 27153, see Delange 1987, pp. 211–13; also her discussion of the garment, p. 163.

[5] Brooklyn BMA 51.1: Fazzini/Romano/Cody 1999, p. 52, center.

### Bibliography

James/Davies 1983, p. 26, fig. 28.

Quirke/Spencer 1992, p. 156, fig. 120.

Robins 1997, p. 117, fig. 128.

## 42

### Head of a Man with a Shaven Cranium

Provenance unknown
Middle Kingdom, Thirteenth Dynasty
(ca. 1795–1650 B.C.)
Sandstone
Height 4 3/8 in. (10.9 cm)
EA 64350, acquired in 1939 from the collection of Lady Carmichael

This arresting small head represents a man with a shaven cranium. It was first exhibited as a late piece of the "Saite period,"[1] and more recently has been assigned even later dates.[2] There can be

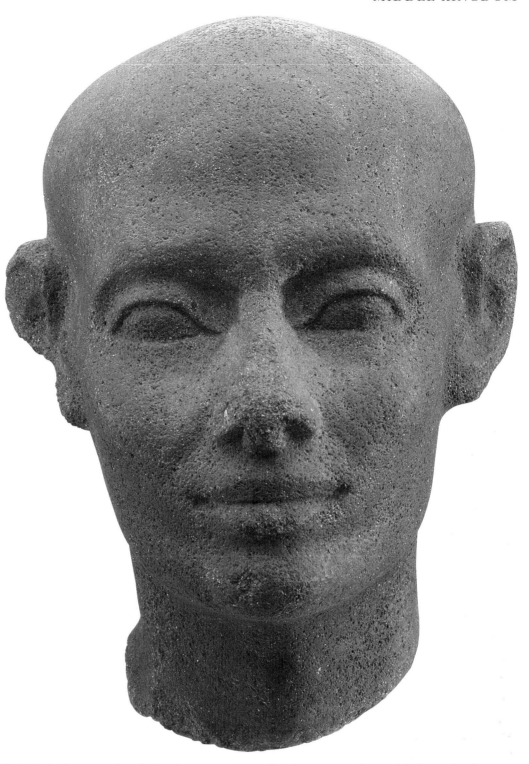

little doubt, however, that the head was made much earlier. The misdatings are instructive, as revealing some of the pitfalls that face the scholar who, for lack of other evidence, must analyze an Egyptian work of art solely on the basis of its style.

Those who assigned a late date to this head erred in focusing on only one feature, the distinctive shape of the skull. This narrow approach directed their attention to the many Late Period and Ptolemaic Period statues of hairless men with complex cranial shapes, of which catalogue numbers 130 and 141 are moderate examples. But it led them to ignore the

fact that statues of men with shaven heads were made at least as early as the Middle Kingdom[3] and continued to be produced during the New Kingdom.[4] It is true that most of the Middle and New Kingdom examples have round, undistinguished crania, but there are exceptions.[5] And although a larger proportion of the hairless statues made during the Late and Ptolemaic Periods show distinctive cranial features, many have simple, domed skulls (cat. nos. 142 and 144).[6] As a dating criterion, skull shape alone is not conclusive.

More significant evidence is provided by the modeling of the man's eyes, which are hooded by

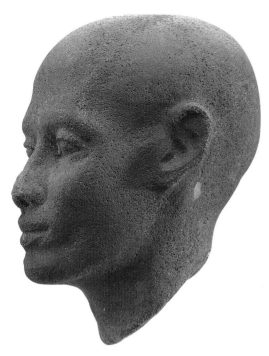

heavy lids shaped rather like flaps. This manner of depicting the eye almost precludes a date in the Late Period or later, when the eyes on statues with non-idealized features tended to be much flatter and the upper lids were shown as narrow rims (for example, cat. nos. 132, 142).[7] Eyes with heavy lids of this type first appeared in the later Middle Kingdom, on portrait statues of the late Twelfth Dynasty king Sesostris III (cat. nos. 29 and 30 and fig. 22). The somber, age-worn images of Sesostris III and of his son, Amenemhat III (cat. no. 31 and fig. 7), exerted a strong influence on the sculpture of nonroyal people during the following Thirteenth Dynasty (see cat. nos. 40 and 41). The two statues of Sesostris III in this catalogue both have the drooping, flap-shaped lids from which this example is derived. Representations of Sesostris III were also the source for the hint of a frown between the brows on this head.

Perhaps the most telling evidence of the statue's origin in the late Middle Kingdom is the extraordinary conformation of the lower face. From the temples, prominent cheekbones descend to become fleshy ridges that meet under the lower lip. Beneath these prominences, long, recessed areas join the hollows of the cheeks to the depression between lip and chin. I know of no other Egyptian three-dimensional head designed in quite this way. The emphatic facial structure—anatomically unrealistic but giving the impression of a real, though unusual, physiognomy—finds its closest parallels in ambitious works of the Thirteenth Dynasty, which drew their inspiration from the great royal portraits of the late Twelfth Dynasty.

This head can be compared with an over-life-size shaven head in the Metropolitan Museum of Art,[8] which also has a distinctively shaped cranium. In this case, there is a ridge along the top. The eyes are rather small but hooded, with long, flap-like lids; there is the suggestion of a frown. The angle between the head's strong cheekbones and long, flat cheeks is so pronounced as to be almost geometric.

As the preceding description indicates, the face of the Metropolitan Museum head looks very different from this one. But the comparison of their features also shows them to be so closely related in style that they must have been made at about the same time. It is interesting, therefore, that the Metropolitan Museum head was at one time tentatively dated to the Late Period by the pioneering scholar of late Egyptian sculpture B. V. Bothmer. Subsequently, however, Bothmer and others recognized it to be a work of the Thirteenth Dynasty,[9] and it is now exhibited in the late Middle Kingdom section of the museum's Egyptian galleries. **(E.R.R.)**

### Notes

1 Burlington 1922, p. 77; at that time, the term "Saite" was often used to indicate the Twenty-sixth through Thirtieth Dynasties (664–343 B.C.). Today, it usually specifies the period of the Saite Twenty-sixth Dynasty (664–525 B.C.), whose home city was Sais, in the Nile Delta.

2 Smith, S. 1939, p. 99: "Roman period"; Seipel 1992, p. 426: Thirtieth Dynasty/Ptolemaic.

3 Vandier 1958, p. 251. The evidence from the Old Kingdom is ambiguous. Both men and women were represented with short-cropped hair, which on older men might reveal a naturally receding hairline (*Egyptian Art* 1999, nos. 44, 138, 145, pp. 229–30, 390, 397); but completely hairless heads from the Old Kingdom are so uncommon (e.g., ibid., no. 47, pp. 236–37) that they may represent a special case.

4 Vandier 1958, p. 481.

5 Middle Kingdom: Engelbach 1923, pl. 10, no. 530 (now in the Ashmolean Museum, Oxford), and the Metropolitan Museum head discussed below; New Kingdom: Louvre N. 2289 (the "Tête Salt"), shown in three views in Vandier 1958, pl. 15:1, 3, 5, (there misdated to the Old Kingdom).

6 For the subgenre of late "egghead" statues, see Bothmer/De Meulenaere 1986, pp. 10–15; this term can be too loosely applied, e.g., Bianchi 1982.

7 Given the extent of late archaizing imitation of the Middle Kingdom, exceptions are surprisingly few; even they, when examined closely, are only superficially similar, e.g., an often-cited Ptolemaic head in Lisbon: Baetjer/Draper 1999, no. 9, p. 27; Bothmer 1960, no. 107, pp. 136–38, pl. 99.

8 MMA 02.4.191: Bothmer 1960, no. 7, pp. 8–9, pls. 6–7; Wildung 2000, no. 71, pp. 149, 185.

9 Bothmer/De Meulenaere 1986, p. 11, n. 34.

### Bibliography

Burlington 1922, p. 77, no. 20, pl. 8.

Smith, S. 1939, p. 99, no. 48, pl. 39.

Seipel 1992, no. 173, pp. 426–27.

# 43

## Head from a Statue of Thutmosis III

Probably from Karnak
New Kingdom, Eighteenth Dynasty, reign of Thutmosis III (ca. 1479–1425 B.C.)
Graywacke
Height 17 1/2 in. (44.5 cm)
EA 986, acquired in 1875, purchased from Selma Harris[1]

For more than a century scholars deliberated over whether this under-life-size royal head wearing the white crown of Upper Egypt represented Thutmosis III or his stepmother and co-regent, Queen Hatshepsut. The uncertainty was warranted because the features of both sovereigns were often rendered with confusing similarity; either can be depicted with large almond-shaped eyes, prominent cosmetic lines, and elegantly arching brows, a slightly aquiline nose, and a gently curved mouth—features this graywacke head exemplifies. Within the last two decades, however, studies focusing on the many statues inscribed for Thutmosis III[2] and Hatshepsut[3] have provided a set of stylistic, iconographical, and technical criteria for each that permits uninscribed images to be identified as one ruler or the other with some confidence.

Soon after Hatshepsut's death and the beginning of his sole rule, Thutmosis III commissioned a Festival Hall for the celebration of his *sed* festival. Evidence suggests that a series of graywacke statues representing the king was included in the sculptural program for this Festival Hall, which was situated behind the Middle Kingdom sanctuary at Karnak.[4] In fact, the physiognomy of the British Museum head is so similar to two graywacke statues inscribed for the king that

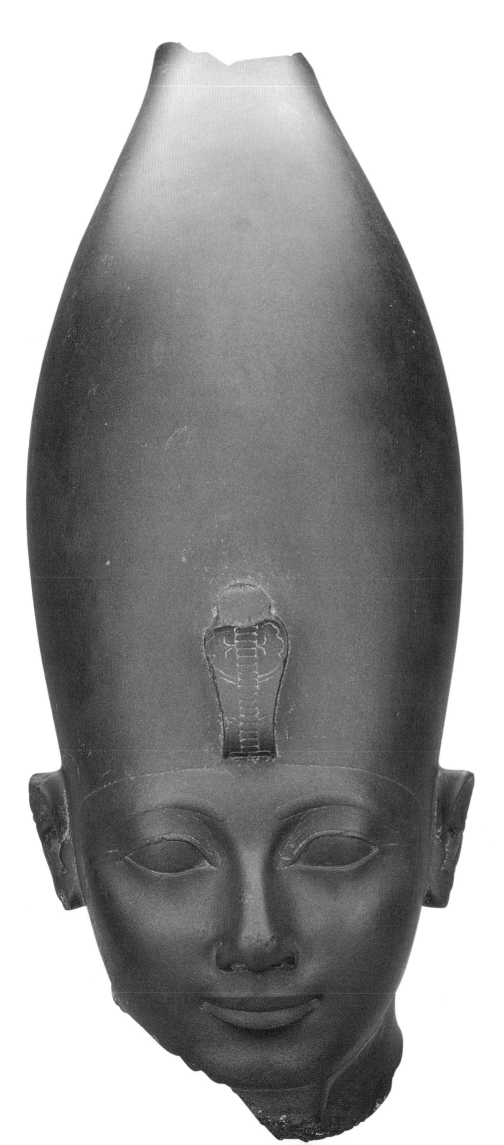

once stood in the Festival Hall that the faces are almost indistinguishable from each other.[5]

Although it is not known what prompted Thutmosis III to choose graywacke for this series, the velvety polish and greenish tint of this fine-grained stone may have influenced him. Symbolic of rebirth in ancient Egypt, green would have been an appropriate color for sculptures intended for a building celebrating the king's own renewal. Equally, Tuthmosis III may well have consciously affirmed his own royal heritage by evoking his illustrious predecessors, some of whom also issued series of statues carved from graywacke.[6]

Whatever motivated Thutmosis III, he is virtually the only Eighteenth Dynasty king who chose graywacke as a sculptural medium.[7] No statue carved of graywacke has been assigned to Hatshepsut—another persuasive factor in support of the identification of the British Museum head as Thutmosis III.

In all likelihood, the British Museum head was broken from a seated statue depicting Thutmosis III wearing the tall crown of Upper Egypt (a crown worn only once by Hatshepsut in association with kingly attire)[8] and the cloak traditionally worn by kings during an episode of the *sed* festival. Stylistic and iconographic features indicate that the British Museum head represents Thutmosis III. (B.F)

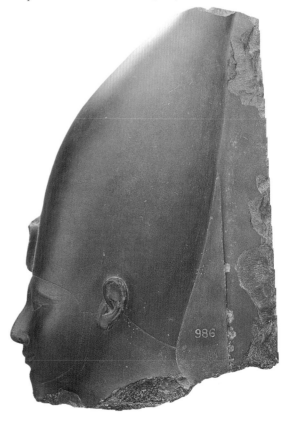

119

## Notes

[1] Harris (1790–1869) was a British merchant and commissariat official in Alexandria who also collected and dealt in Egyptian antiquities. He gave his collection to his daughter Selima, who in turn sold it to the British Museum; see Dawson/Uphill 1995, p. 191.

[2] Fay, 1995, pp. 11–21; Laboury 1998.

[3] Tefnin 1979.

[4] A discussion of these statues is the subject of a forthcoming study by the author.

[5] Fay, 1995, pp. 13–17, pl. 4.

[6] See, for example, statues of Chephren (Cairo CG 15) and Mycerinus (Boston MFA 11.1738, and Cairo JE 46499) illustrated in color in *Egyptian Art* 1999, pp. 253 and 268–73.

[7] A few graywacke statues represent Thutmosis III's son and successor, Amenhotep II, and possibly three represent Amenhotep III; otherwise, however, graywacke was not used for royal statuary during the Eighteenth Dynasty.

[8] New York MMA 30.3.1; Tefnin 1979, pp. 73(4), 75.

### Bibliography

Laboury 1998, pp. 357–59, figs. 236–38 (with earlier bibliography).

*Treasures* 1998, no. 2, pp. 40–41.

*Art and Afterlife* 1999, no. 3, p. 30.

# 44

## Seated Senenmut holding Princess Neferure

Probably from Thebes, Karnak Temple
New Kingdom, Eighteenth Dynasty
(ca. 1479–1472 B.C.)
Granite
Height 28 ⅝ in. (72.5 cm)
EA 174, acquired in 1906

Senenmut was one of the most influential members of the circle supporting Queen Hatshepsut, Egypt's best-known female pharaoh.[1] He headed up the administration of his sovereign's household as her steward, and he served in the same capacity for the household of the state god Amun. Several of Senenmut's statues represented him in another of his roles, as tutor of Hatshepsut's daughter Princess Neferure. Among them, this composition is the most successful.

The steward sits on a conventional block-like seat and holds his royal charge on his lap. With his left hand, he grasps her firmly; with the right he draws his enveloping ankle-length cloak

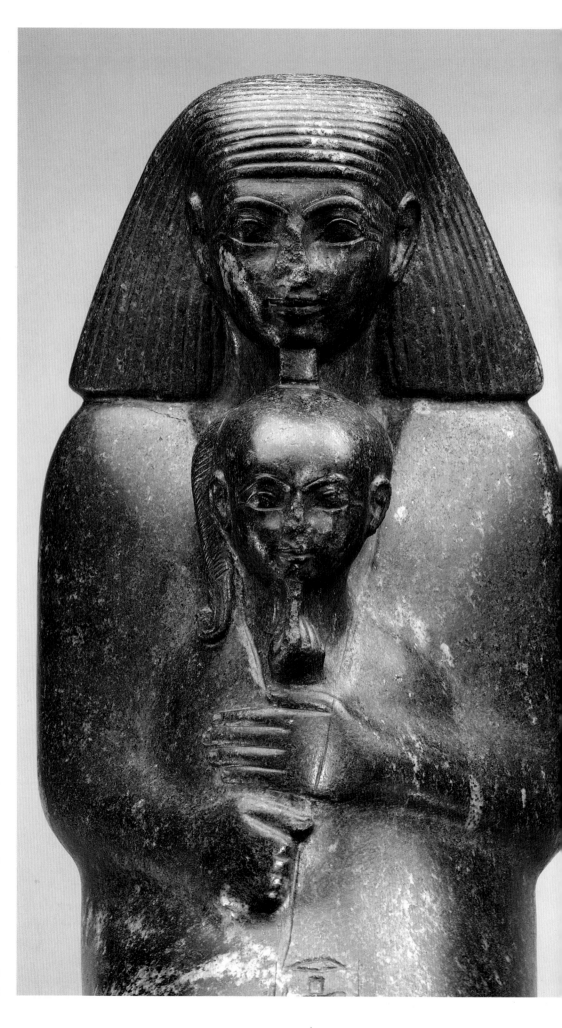

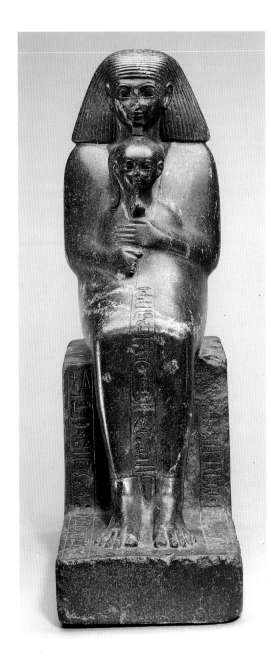

Thutmosis III. Senenmut's youthful physiognomy—above all, his comparatively large and wide-open eyes—and the stylistic means used to render it reflect the royal likeness current at Thutmosis III's accession.[2]

There are more statues known of Senenmut than of any other commoner during the New Kingdom. Two of the twenty-five sculptures now known to have been made for him were cut from bedrock: one above his tomb chapel in western Thebes (TT 71) and the other in his cenotaph at Gebel Silsileh. All the others were freestanding temple statues, like this piece. They vary considerably in material, scale, and composition. Some are one-of-a-kind, while others introduce new types into the sculptural repertoire. Possibly Senenmut himself provided the creative impulse for their invention; certainly his position as "overseer of works" gave him access to the best artists of his day.

Many of Senenmut's monuments provide evidence for purposeful, officially sanctioned attacks on his memory.[3] Hatshepsut, too, was the victim of a *damnatio memoriae*, a campaign to expunge her existence from the historical record. It is all the more surprising, then, to find not only Senenmut's name intact in the inscriptions on this statue but Hatshepsut's cartouche as well. Equally striking is the pristine condition of Amun's name, which occurs repeatedly in Senenmut's titles here. Clearly this statue escaped not only the depredations of Senenmut's enemies and those of Hatshepsut but also the notice of Akhenaten's agents, who were charged with hacking out the name of the god wherever it occurred. These anomalies are explicable by supposing that the statue was not accessible when the assaults began and that it remained sequestered at least until after the end of the Amarna Period.

Another sculpture of the steward, with similarly intact inscriptions was reportedly found with this statue. It, too, was acquired by the British Museum.[4] Recent study suggests that both sculptures came to light shortly after 1900, in or close by a small temple dedicated to the worship of Osiris at North Karnak.[5] The sanctuary was built during the Third Intermediate Period, some four centuries after Senenmut flourished. Probably the original location of both statues was nearby, in association with a structure of Queen Hatshepsut, who is known to have built in the vicinity. (M.E.-K.)

tightly around them both. Otherwise there is no interaction between the figures; Senenmut and Neferure gaze straight ahead. The princess's sidelock and the gesture of placing the forefinger of her right hand to her mouth are iconographic features indicative of childhood.

The schematic, un-anatomical treatment of Senenmut's hands is characteristic of his other tutor statues. Here, the rendering of the hands contrasts markedly with the convincing depiction of the feet, which were regularly neglected by Egyptian sculptors.

The inscriptions on the statue include the information that Hatshepsut commissioned it for Senenmut. The queen is called "god's wife of Amun," a title that dates the sculpture to the period before she arrogated to herself the kingship as nominal co-regent of her stepson

**Notes**

[1] Dorman 1988, pp. 165–81, provides a summary of this official's career.

[2] See Fay 1995, p. 15.

[3] Krauss 1994, pp. 49–53.

[4] BM EA 1513: James/Davies 1983, p. 8, fig. 7.

[5] Eaton-Krauss 1999.

**Bibliography**

PM II 1972, p. 278.

James/Davies 1983, p. 31 with fig. 34.

Dorman 1988, no. 1, supra, p. 188f. (doc. A.2) and *passim*.

Robins 1997, pp. 144–45 with fig. 186.

Treasures 1998, no. 3, pp. 42–43.

Eaton-Krauss 1998a, pp. 107–109 with pl. XXII:1.

# 45

## Block Statue of Inebny

From Thebes

New Kingdom, Eighteenth Dynasty, joint reign of Hatshepsut and Thutmosis III (ca. 1472–1458 B.C.)

Limestone, painted

Height 20 1/2 in. (52 cm)

EA 1131, acquired in 1835 at the sale of the Salt Collection

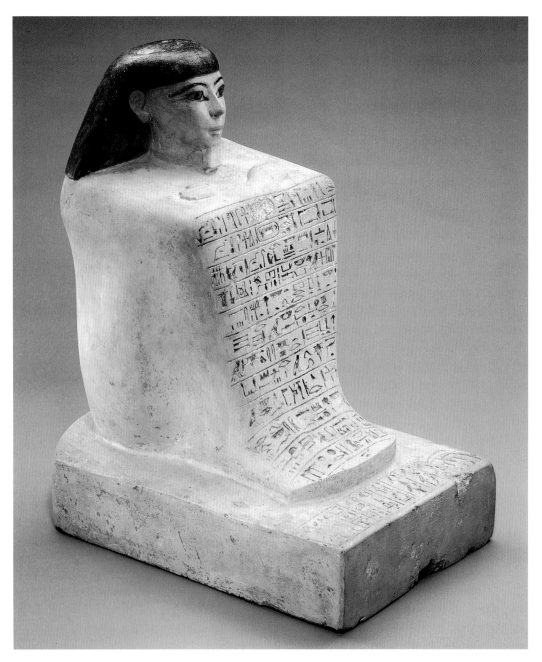

This block statue[1] and the two following examples (cat. nos. 46 and 47) all come from Thebes, and all were made for men who lived under Thutmosis III. Though at this point, early in the New Kingdom, a few block statues were still being made for tombs,[2] this type of statue had essentially become a temple sculpture. Its compact, damage-resistant shape made it particularly well suited for the semi-public and sometimes well-traveled halls and courts of temples; and its large, relatively flat surfaces offered maximum space for texts, some of which were devoted to persuading passersby to offer up a prayer.

In some cases, such as this one and the following (cat. no. 46), the sculptors clearly appreciated how the simple, broad planes of the cloaked form focused attention on the face; here, the effect has been dramatized by unusually sparing use of paint. The whiteness of the stone is broken only by the black of Inebny's wig and eyes, and by blue in the incised hieroglyphs.

Inebny's statue is the earliest of these three block statues, made during the fifteen years or so during which Queen Hatshepsut and her stepson/nephew Thutmosis III shared the rule of Egypt. The outcome of their joint reign is visible in the inscription, where Hatshepsut's cartouche, in the top line, has been erased. Some years after he assumed sole power, Thutmosis III ordered the queen's name and images erased wherever they occurred, even on a monument as small as this, in a very thoroughgoing campaign to destroy any memory of her.[3]

The slightly earlier date of this statue, compared to the following two, is also apparent in the style of Inebny's face, which, with its highly arching brows and tapered jaw, resembles early images of Thutmosis III and especially of Queen Hatshepsut (fig. 11). (**E.R.R.**)

### Notes

[1] For an earlier block statue and a discussion of the origin and meaning of this statue type, see cat. no. 25; for a Late Period example, see cat. no. 121.

[2] Such as the example carved in a niche above the tomb of Senenmut (TT 71): Schulz 1992, I, no. 316, pp. 515–16; II, pl. 134c.

[3] This was not a simple act of revenge, as has often been assumed; see Dorman 1988, pp. 46–65.

### Bibliography

PM I, 2 1964, p. 788 (with earlier bibliography).

Schulz 1992, I, no. 219, pp. 379–80 (with further bibliography); II, pl. 98c–d.

*Treasures* 1998, no. 5, pp. 46–47.

# 46

## Block Statue of Sennefer

From western Thebes
New Kingdom, Eighteenth Dynasty, reign of Thutmosis III (ca. 1479–1425 B.C.)
Granodiorite
Height 35 ³/₈ in. (89.8 cm)
EA 48, acquired in 1829 from the Salt Collection

The block statue of Sennefer is surely one of the finest examples of this type ever produced in Egypt. The form is uncomplicated, with the body shape rendered in smooth curves. No personal details other than the face and hands were carved by the sculptor, and this concentrates our attention on the serene face of Sennefer, superbly carved and polished. The quality of the carving of the body is in sharp contrast to the rather roughly scratched hieroglyphs that make up the text on the front and base; the reason for this discrepancy is not known. Perhaps the statue had to be completed in a rush, or perhaps the master craftsman completed his work with the body and left the text to one of his apprentices. But if the latter was the case, it is difficult to imagine Sennefer being happy with the result, unless of course the

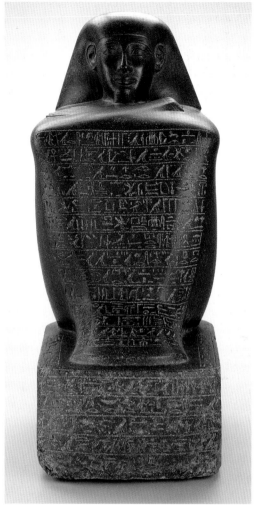

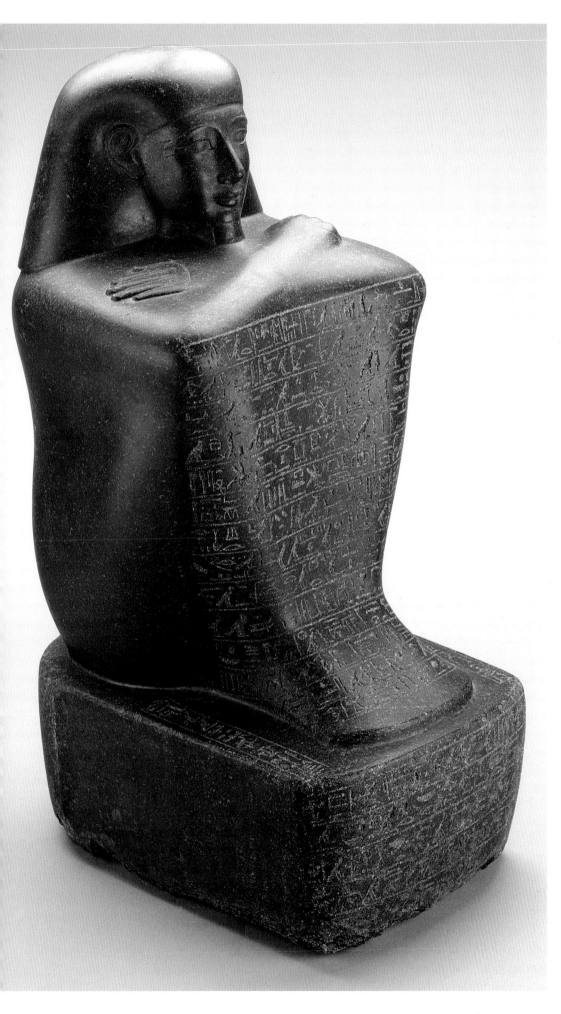

statue were set up in his memory, when he was in no position to object to the inferior work.[1]

The large blank surfaces of the block statue encouraged the Egyptians to fill them with texts. On this statue, the text is in three parts. Most of the front of the statue is taken up with an elaborate prayer for funerary offerings for Sennefer, in which he is accorded an elaborate range of epithets that express his importance to the king, in addition to his basic set of titles. The second part, beginning on the robe over his knees but extending onto the base, is a speech by Sennefer, in which he requests that he be well provided for after his death, in the manner he enjoyed on earth. The final elements are the names of his father, Haydjehuty, and his mother, Satdjehuty, in columns on either side of his feet. But in many ways the most intriguing part is the bottom line, which is centered and quite short; it seems to say "the servant of the overseer of seal bearers, Minnakht." Is this a reference to the person who organized the production of the statue, and does it go any way to explaining the roughness of the text?[2]

The original location in which this statue was set up is far from certain, as records indicate that it was found "behind the statue of Memnon"—in other words, to the west of the funerary temple of Amenhotep III at Thebes. This should probably be taken as meaning that it came from the West Bank; as it is unlikely to have come from his tomb, one possible location might have been the funerary temple of the king whom he served, Thutmosis III. Unfortunately, we know little about the placing of statues in temples, other than Karnak, at this date.

Sennefer's[3] principal title was that of "overseer of seal bearers." In New Kingdom Thebes, the holder of this title was the senior official concerned with financial matters and thus an important person with access to considerable resources. Hence Sennefer was able to obtain the services of the finest craftsmen in the area to carve this beautiful statue (as well as two others, less well preserved and now in the Cairo Museum[4]) and also to cut a large and originally impressive tomb in the Theban hills (Tomb 99[5]). He also possessed a shrine at Gebel Silsileh,[6] and is featured on two monuments of Thutmosis III in Serabit el Khadim in Sinai.[7] A papyrus in the Louvre indicates that he was in office in year 32 of that king's reign. It is clear from a biographical text in his tomb that he did not originally come from Thebes; the titles he holds and those of his father, Haydjehuty, make it most likely that the family came from the eastern Delta. (N.S.)

## Notes

[1] A glance through the plates in Schulz 1992 suggests that there is a far greater disparity between these two aspects of EA 48 than in most other examples.

[2] No comparable title is known. For some other offices associated with the overseer of seal bearers, see Helck 1958, pp. 87–88.

[3] His name is also written Senneferi on other monuments.

[4] a. Cairo CG 1013—PM I, 2 1964, p. 785: Borchardt 1934, pp. 25–26, pl. 160; text Bouriant 1887, p. 86 (58). Almost all of the text on the back repeats that of lines 4–11 on EA 48. b. CG 1112—Borchardt 1934, p. 64. Schulz 1992 . I, pp. 230–31 (123). Photo in Roehrig 1990, pl. 11. There is also a fragment of a black granite block statue in Vienna ÄS 5978: Rogge 1990 no. 6, pp. 22–24; Schulz 1992, I, p. 533 (328), II, 137b.

[5] In course of publication by the present writer. For more information see www.newton.cam.ac.uk/egypt/tt99, and also an article scheduled for publication in *Memnonia* 11.

Substantial parts of Senneferi's burial have been located.

[6] Caminos/James 1963, pp. 37–39, pls. 26, 27, 30, 31.

[7] Temple relief: Gardiner/Peet/Cerny 1952, pp. 158–59; photo Petrie 1906, p. 80, pl. 96; stela: Gardiner/Peet/Cerny 1952, pl. LXV (no. 199), II, pp. 161–62 (no. 199).

[8] Megally 1971, p. 17; pl. XI (A recto XI, 3–4); p. 24, pl. XXVI (A verso XI, 3–4); Megally 1977, p. 159.

### Bibliography

PM II, 1972, p. 457.

*HT* VIII 1939, pl. 5.

Schulz 1992, I, no. 210, pp. 365–66; II, pl. 94.

Strudwick/Strudwick 1999, p. 49.

Helck 1981, pp. 39–41.

# 47

## Pseudo-block Statue of Tety

From Thebes, Karnak Temple
New Kingdom, Eighteenth Dynasty, reign of
Thutmosis III (ca. 1479–1425 B.C.)
Quartzite
Height 23 3/8 in. (59.3 cm)
EA 888, acquired in 1909

This third of the three Eighteenth Dynasty block statues in this catalogue (cf. cat. nos. 45 and 46) represents a man named Tety in the pose of a block statue but without a cloak. This variant form of the block statue (often, for convenience, called a pseudo-block statue) made its first appearance at about the same time as the regular block statue, early in the Middle Kingdom,[1] but it never became as popular.[2] An even more unusual feature of this statue is the heightening of the base at the back, to form a low seat for Tety; this detail did not become common until much later in the New Kingdom.

In the absence of a cloak, the position of the subject's arms can be seen clearly. Just as the seated pose connotes passive, patient attendance, so the crossed arms, resting on the knees indicate meekness and humility.[3] Tety's right hand lies flat on his left upper arm. The left holds a lotus, symbolic of rebirth.

Compared with the faces on catalogue numbers 45 and 46, Tety's face is somewhat more rounded and his features slightly softer. These changes anticipate the style of Thutmosis III's successor, Amenhotep II. Tety certainly lived under Thutmosis III, whose name is

written on his upper right arm, but there is reason to think that he lived during the later part of the reign. Moreover, the statue was apparently commissioned by Tety's son Hori, who has placed his name and titles in the band along the hem of Tety's kilt. Thus the statue would have been made near the end of Thutmosis III's reign or even a little after, which would make it the latest of these three statues.

The statue is busy with details. In addition to a long kilt and perhaps a shirt with long sleeves,[4] Tety is wearing sandals and a leopard-skin vestment (cf. cat. no. 55), which covers his back in a pattern of stylized spots. The tail is indicated in relief beside his right foot. Tety's wig, an early form of the double wig, hangs across his back in a row of fat, corkscrew curls. His short chin beard was fashionable for notables at this time, but its unusually frequent depiction on block statues (cf. cat. nos. 45 and 46) suggests that it was also an artistic device to bridge the gap between the chin and chest.

The inscriptions are written in rather large hieroglyphs, clearly meant to be prominent. A short offering prayer in a band across Tety's knees is followed by nine columns, each listing various official and priestly titles and ending with Tety's name, which in three columns is spelled Tetity, above the bottom band naming his son. On the back pillar, three columns give the names and titles of his father, grandfather, and great-grandfather.[5] In this period, it is very unusual to find so long a genealogy—five generations—on a private monument, but the grandfather and great-grandfather were worth commemorating because they had held the very high office of viceroy of Nubia.[6]

Around his neck, Tety wears a cord from which an amulet hangs over his hands. It is a motto made by combining the hieroglyphic signs *ankh* and *hetep*, which, together read, "life and peace." Other signs are carved on the backs of his hands: on the left, a red crown with a crescent moon and on the right, a white crown with the sun. These hieroglyphs, used as emblems, have no exact parallels; but they clearly refer to the king, Thutmosis III, as ruler of all that the sun and moon encircle.[7] Tety seems to have shared the interests of his older contemporary, Senenmut (cf. cat. no. 44), who boasted of inventing cryptograms.[8]

The statue apparently comes from the same

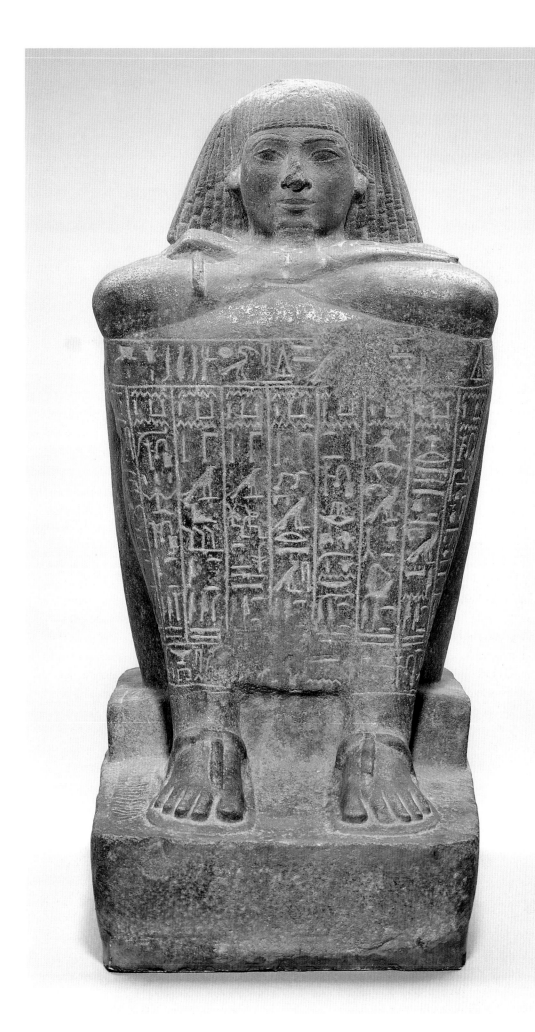

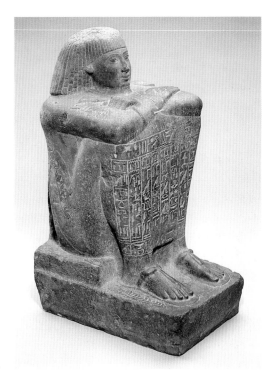

part of Karnak Temple as catalogue number 44 and several other statues in the British Museum. Though they were not found in their original setting, it is likely that they once stood in the same chapel at Karnak.[9] **(E.R.R.)**

### Notes

[1] E.g., Schulz 1992, I, no. 252, pp. 426–27; II, pl. 111.

[2] Schulz 1992, II, pp. 612–14.

[3] Schulz 1992, II, pp. 736–42; for a similar gesture with a different meaning, see cat. nos. 19, 89.

[4] The lines at the wrists are so similar to those used to indicate hands emerging from cloaked block statues (c.f. cat. no. 25) that their use here may represent convention, not reality.

[5] For a translation, see Parkinson 1999, p. 120.

[6] Habachi 1959, pp. 55–56.

[7] Parkinson 1999, p. 120; for a fuller discussion, see Fischer 1976.

[8] Dorman 1988, pp. 124, 137–38, 174–75.

[9] James 1976, pp. 26–30; for a reconsideration of their location, see the entry for cat. no. 44 and Eaton-Krauss 1999.

### Bibliography

Habachi 1959, pp. 45–48, pls. 15–16.

PM II 1972, p. 279 (with earlier bibliography).

Fischer 1976.

James 1976, pp. 17–19.

Schulz 1992, I, no. 218, pp. 377–78; II, pl. 98a–b.

*Treasures* 1998, no. 6, pp. 48–49.

Parkinson 1999, no. 37, pp. 120–21.

# 48

## Stela of Amenhotep

Provenance unknown

New Kingdom, Eighteenth Dynasty, reign of
Thutmosis IV (ca. 1400–1390 B.C.)

Limestone, traces of paint

Height 35 ⅛ in. (89 cm)

EA 902, acquired in 1865 from Lt. Col. Frazer

This round-topped stela is decorated in raised
relief with the carefully balanced symmetrical
composition favored in Egyptian two-

dimensional art. The arc of the stela is filled with
a winged sun disk over the names, in cartouches,
of Thutmosis IV (cf. cat. no. 50). The king's
throne name, Menkheperre, is in the center.
Since all the hieroglyphs in this name happen to
be symmetrical, they can be read with both of
the other cartouches, which contain his given
name, Thutmosis, reading from right to left on
the left and from left to right on the right side.
Beyond the cartouches, and intended to be read
with them, are a sedge plant and a bee, which
form the title "King of Upper and Lower
Egypt." Tucked into the corners are protective
symbols, including the jackal god Anubis and

the *wedjat* eye. Though oriented in the same
directions as the royal inscriptions, these groups
of signs are for the benefit of the owner, whose
figure stands directly beneath each group,
oriented in the same direction.

The owner, whose name, Amenhotep, was
extremely common during the Eighteenth
Dynasty, was the high priest of the god Onuris.
Here he is shown with short-cropped hair,
wearing a leopard-skin vestment over a collar
necklace and short kilt, and sandals. His hands
raised in adoration, he worships a pair of gods
who sit back to back within a shrine with a
cornice topped by cobras bearing sun disks on
their heads.

It is the god Osiris, King of the Dead, who is
shown in the dominant rightward orientation and
thus given precedence. As usual, Osiris wears a
white crown and divine beard, and is entirely
shrouded except for his head and hands. His
collar necklace is held in place by a counterweight
at the back. In one hand, the god holds an *ankh*.
With the other, he holds his three most important
emblems: a flail, a long crook, and, in front of that,
a *djed* pillar. This object, with its flaring base and
crossbars at the top, has been interpreted as a tree
or as part of a backbone. Whatever it depicted, it
was the hieroglyph used to write the word *djed*,
"stability," and it was so closely identified with
Osiris that it could be used to represent him,
sometimes with a pair of eyes between the
crossbars and holding the crook and flail.[1]

The lesser god, Wepwawet, was a jackal-
headed god of the necropolis, like Anubis.
Besides a collar necklace and a short kilt,
Wepwawet has a bull's tail (worn among mortals
only by the king) attached to the back of his belt
and protruding in front of his legs. He holds an
*ankh* and the *was* scepter, exclusive to the gods.

The text below this scene is a prayer to
Osiris and Wepwawet on Amenhotep's behalf,
toward the end of which he boasts of having
followed the king on the battlefield in foreign
lands. That king must have been Thutmosis IV's
father, Amenhotep II, because by the time this
stela was made, Amenhotep's two sons, shown in
the bottom register, were themselves military
men. They are identified as chariot soldiers.[2]

The sons give honor to their father, who is
seated at an offering table with his mother on
the left and his wife on the right. Like his
standing images above, these two represen-

tations of Amenhotep are simply mirror reversals. The sons' figures, however, are differentiated in a more naturalistic rendering of their gestures: each raises his right hand, and each holds something in his correctly positioned left hand (a paw of the leopard skin on the left and a folded cloth on the right). This more naturalistic way of dealing with problems of orientation is frequently found during the New Kingdom, but it did not supplant the old way (cf. cat. no. 20). (E.R.R.)

### Notes

1 Kozloff/Bryan 1992, p. 205, fig. 23a.

2 Thus Van Siclen 1985–86, p. 90, n. 22; for hypotheses about Amenhotep's family and career, see ibid., pp. 89–91.

### Bibliography

*HT* VIII 1939, pp. 8–9, pl. 9

Robins 1997, p. 143, fig. 64.

## 49

### Head of a Queen or Goddess

Possibly from Sais
New Kingdom, Eighteenth Dynasty, reign of
Thutmosis IV (ca. 1400–1390 B.C.)
Black granite
Height 10 ¼ in. (25.8 cm)
EA 956, acquired in 1875, purchased from George Gwilt

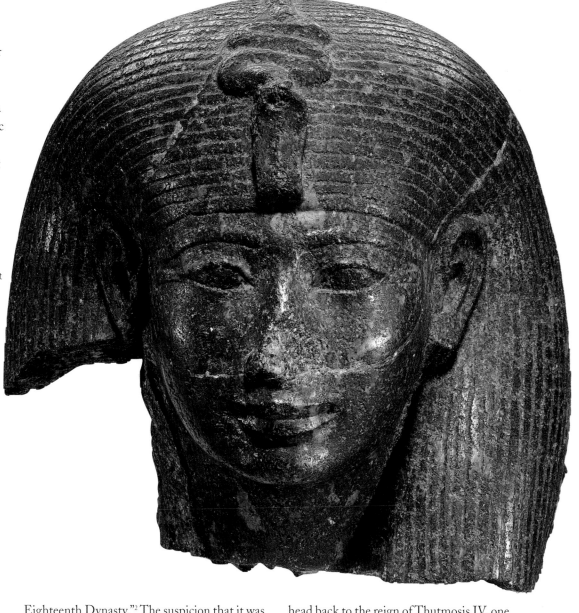

The late Twentieth Dynasty marks the beginning of one of the periods in Egyptian history when a prominent feature of Egyptian culture was archaizing. In terms of art this meant the use of older elements of iconography, typology, and style.[1] Such archaizing did not always entail slavish copying of the past. However, the Twenty-first through Twenty-third Dynasties (ca. 1069–715 B.C.) witnessed the production of a number of works so closely influenced by the art of the pre-Amarna Eighteenth Dynasty that art historians sometimes have difficulty attributing an uninscribed work to one or the other of those periods. Thus this head, long regarded as a work of the New Kingdom, came to be described as presenting "the student of Egyptian sculpture with a problem of identification . . . carved in the tradition of royal portraiture of the mid-

Eighteenth Dynasty."[2] The suspicion that it was a later archaizing imitation was reinforced by the discovery that the head appears to be associated with the Delta site of Sais, from which we have no definite New Kingdom material. It had previously been thought to come from Thebes, where New Kingdom material is abundant. Several scholars have therefore redated the head to the Twenty-second or Twenty-third Dynasty.[3]

Other scholars, however, argue that the head's features correspond in every respect to works of the reign of Thutmosis IV in the Eighteenth Dynasty (cf. the discussion of cat. no. 50). Statuary of Thutmosis IV is known from the Delta, and in any case the head (on its body) might well have been brought to Sais long after it was carved. These considerations make it difficult to view the head as a work of the Twenty-second or Twenty-third Dynasty.[4] As a final argument in favor of reattributing the

head back to the reign of Thutmosis IV, one might also note that the definite examples of archaizing art in the Twenty-second and Twenty-third Dynasties tend to resemble more closely the sculpture of Thutmosis IV's grandfather, the still famous and revered Thutmosis III (cf. cat. no. 43).[5]

Egyptian kingship and queenship were considered divine, and so kings and queens could be represented in ways similar to deities. Hence it is often difficult to determine if an uninscribed female sculpture, including this head with its protective uraeus, is an image of a queen or a goddess. Statues of Eighteenth Dynasty queens wearing a simple striated wig of this type are certainly rare and may not exist before the reign of Amenhotep III (ca. 1390–1352 B.C.).[6] If so, this head, with its surely female visage, would have to be from a statue of a goddess. However, there is a statue with the same wig that has been

claimed to represent Queen Hatshepsut as regent (ca. 1479–1472 B.C.),[7] so the possibility that it is a queen cannot be eliminated. Queen or goddess of the New Kingdom, there are several reasons why it is significant. First and foremost is that it is an extremely fine sculpture. Another is that it is at least a relative rarity, for statues of Egyptian queens are far less numerous than those of Egyptian kings. And if it is a goddess on a significant scale in stone prior to the reign of Amunhotep III it is even a rarer object. (R.A.F.)

### Notes

[1] For some recent comments on archaizing, see Der Manuelian 1994b, Nordh 1996, pp. 147–52, and Fazzini 1997.

[2] James/Davies 1983, pp. 64–65.

[3] Reeves 1989; Seipel 1992, no. 144, pp. 362–63.

[4] Bryan 1991, n. 367 on p. 240, and pl. 17, fig. 47.

[5] E.g., Russmann, in Silverman 1997, no. 30, pp. 106–107 (head of Osorkon II from Tanis).

[6] Fay 1995, p. 20. I owe this reference to Edna Russmann.

[7] Aldred 1981.

### Bibliography

James/Davies 1983, p. 65, fig. 71.

Reeves 1989, pp. 235–37, pls. 33 and 34.

Bryan 1991, p. 213, n. 367 on p. 240, pl. 17, fig. 47.

Seipel 1992, no. 144, pp. 362–63.

# 50

## Statuette of Thutmosis IV

Provenance unknown
Eighteenth Dynasty (ca. 1400–1390 B.C.)
Bronze, silver, calcite
Height 5 ⁷/₈ in. (14.7 cm)
EA 64564, acquired in 1946 from the Ackworth Collection[1]

Thutmosis IV is depicted in an offering pose, kneeling and holding two large *nw*-pots forward at just above waist height. He wears the *nemes* headdress with a uraeus cobra, its head missing, which rises just above the forehead band. Its body forms two asymmetrical curves at the front of the king's head, then runs straight over the top to the crown of the head. The modeling of the king's torso is indistinct—made more so by the overcleaning of the surface of the bronze. The traditional royal *shendyt* kilt is belted by a wide diamond-patterned belt, in the central rectangle

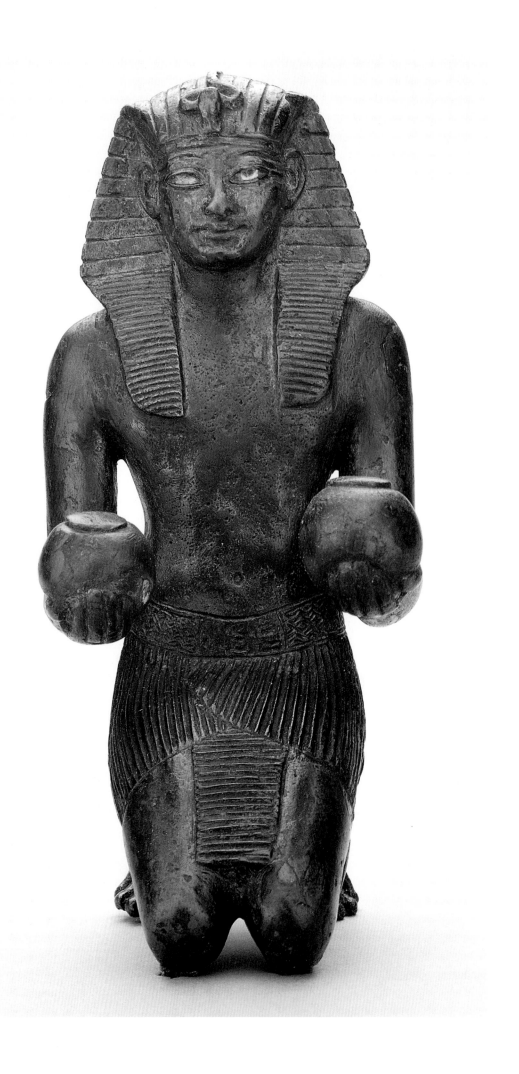

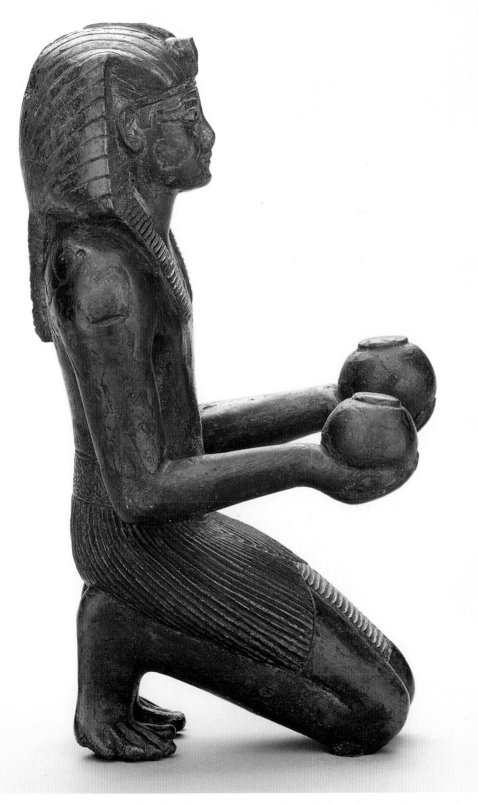

up the small number of statues in bronze and other copper alloys that can be securely dated to the late Middle Kingdom and the New Kingdom. The often-remarked dearth of New Kingdom bronzes seems increasingly likely to be a result of poor survival rates and the general difficulty of dating metal sculpture (cf. cat. no. 82). The production of bronze statues continued from the New Kingdom into the Third Intermediate Period (cf. cat. nos. 114, 115, 117); these fine works stand as a prelude to the bronzes produced in huge quantities in the Late Period.

During the Middle and New Kingdoms, technical aspects of bronzes vary considerably, because of less-standardized methods of manufacture.[3] Thutmosis IV's statuette is a hollow-cast bronze with a very small core that is, moreover, non-conformal—that is, the contours of the core do not follow the body contours of the bronze. The arms are separately attached on square-section tenons that project from flat side surfaces at the shoulder; the ends of these projections were then smeared by hammering to hold the arms in place. The figure was originally set into a base or another object by means of four round tangs projecting from the bottom of each knee and foot.

During the late Middle Kingdom and early New Kingdom, royal bronze statuary assumed increasing importance in Egyptian temple rites. Kneeling bronze statuettes holding offerings concisely summarize the king's acknowledgment of the god's solicitude for Egypt.[4] They were symbolically important accompaniments to the divine images in certain circumstances, probably including occasions when the gods traveled outside the protection of the temple in ceremonial processions, which became more elaborate during this period. **(M.H.)**

**Notes**

[1] Edwards 1952a, p. 56.

[2] Bryan, 1987, particularly pp. 9–10, 20.

[3] For a summary of problems in dating bronzes, see Hill (in press); for technical variability in general and for technical features of this bronze in particular, see Hill 1997, p. 13.

[4] For important reflections on the offering relationship, see Teeter 1997, pp. 76–79.

**Bibliography**

Edwards 1952a.

Quirke/Spencer 1992, p. 172, fig. 132.

of which the hieroglyphic signs of the king's prenomen, written without a cartouche, are somewhat awkwardly inscribed.

Distinctive facial features of Thutmosis IV, who ruled at a time when the artistic style of the powerful and wealthy Eighteenth Dynasty began to change, are clearly incorporated in this small statuette: high cheekbones and a square jaw, a brow line flat near the nose,

narrow almond-shaped eyes, a long nose that broadens at the nostrils nearly to the width of his mouth, and an upper lip that is thicker and more prominent than the lower.[2] The brow and eye-rim inlays, partly missing, are apparently silver, and the sclera of the eye is calcite, painted black to mark the iris.

Five kneeling royal statuettes, including this one, and a few figures in other poses, make

# 51

## Lion of Amenhotep III Reinscribed for Tutankhamun

From Gebel Barkal, originally from Soleb
New Kingdom, Eighteenth Dynasty, reign of
Amenhotep III (ca. 1390–1352 B.C.)
Red granite
43 3/4 x 85 1/8 x 37 5/8 in. (111 x 216 x 95.4 cm)
EA 2, acquired in 1835, gift of Lord Prudhoe

This statue of a lion is one of a pair found in the
Sudan at the Kushite site of Gebel Barkal by
Lord Prudhoe, who presented them to the
British Museum in 1835. According to a
description and sketch by Linant de Bellefonds,
who had seen the lions in situ before they were
moved, the lions were placed facing each other,
flanking the passage to the entrance of a palace.[1]

This lion is depicted in a recumbent pose,
forming a mirror image to its companion piece.
Unlike the traditional type of the lion or sphinx,
which lies straight with its paws resting flat and
parallel to the axis of the sculpture, this lion lies
on its side: the forepaws crossed, the farther of
the hind paws emerging from under the nearer
one, the tail curling forward around the rump
and resting on the base.

The sculpture combines marvelously the
stylized mane and hair with a naturalistic
treatment of the body. The muzzle projects realis-
tically, with solid jawbones and raised veins. A
stylized circular mane frames the head, and the
fur is rendered by a raised surface on the chest, the
shoulders, and the back. The eyes are hollowed
and were probably inlaid. The whiskers are
incised on the muzzle; small, round protuberances
in the ear suggest the tufts of hair. The naturalistic
treatment of the physiognomy is enhanced by
anatomical details—for example, the twisted hind
paws, of which the farther one is turned upward.
On the external side of the paws, the folds are
marked by deep furrows. The rump is treated with
a bold modeling of musculature; and parallel
depressions alternate with raised ribs on the flank.

The companion piece of this lion, also in the
British Museum (EA 1), bears an original
inscription of Amenhotep III and mentions the
temple of Soleb. The two are a pair and were
certainly sculpted by the same workshop. This
lion was later reinscribed several times. First a
four-column text was engraved on the breast,
identifying the monument as "The good god,
lion of rulers, wild when he sees his enemies
treading his path, [it is the king] . . . divine ruler
of Thebes, who brought it." The royal cartouche,
in which only the last signs are preserved, could
belong to Akhenaten, whose activities at Soleb
are well attested.[2] Shortly afterward, a text of
Tutankhamun's was inscribed on the base,
stating that the king renewed this monument for
Amenhotep III. Ultimately, during the reuse of
these lions in Gebel Barkal, the two cartouches
of the Kushite ruler Amanislo were added on
both lions. On the companion piece, they are
engraved on the breast, whereas on this lion they
occupy the left forepaw, because of the anterior
four-column inscription. It was probably also at
that time that the names of Tutankhamun in the
third and fourth cartouches on the base were
erased (with the exception of "Amun" and a
remnant of "*ankh*") to be replaced by those of
Amanislo, on a plaster patch that is now lost,
leaving the original particle of Amun, common

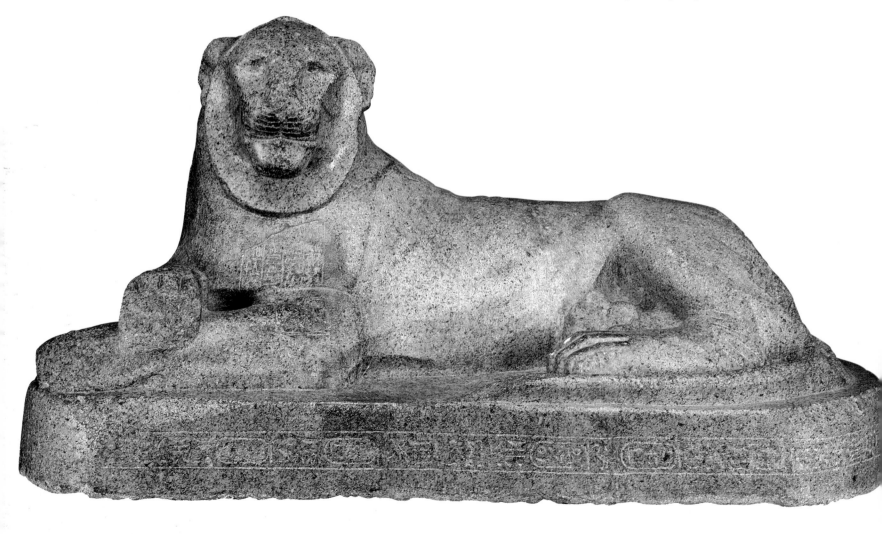

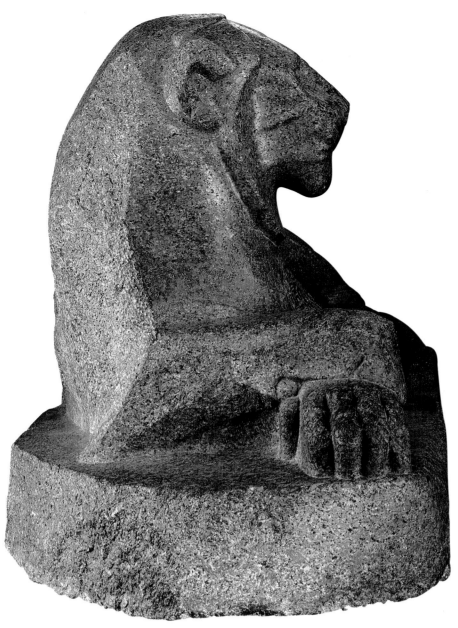

to both names. Thus, it is assumed that before being reused and positioned facing each other at Gebel Barkal, the lions were originally placed in the temple of Soleb. There, they probably faced the viewer and formed part of an avenue of similar statues, aligned symmetrically along the passage of a courtyard.

It is worth noting that two pairs of identical lions were discovered by Pierre Montet in Tanis. One pair is much weathered and has been left in situ, in front of the northern pylon of the temple of Khonsu; the second, found at the eastern entrance of the great temple enclosure, was transported to Cairo and now adorns the municipal garden of Zamaliek. **(H.S.)**

### Notes

[1] Kendall 1997, p. 323, map on fig. 1.

[2] Leclant 1997, pp. 123–24; see also, *Soleb* V, in press.

### Bibliography

Edwards 1939, pp. 3–9.

*HT* VIII 1939, pp. 13–14, pi. 14–15.

PM VII 1951, p. 212 (with earlier bibliography).

James/Davies 1983, p. 20, fig. 17.

Ruffle 1988, p. 82–87, pls. 1–4, 49–52.

Davies, W. V. 1991, p. 314.

Kozloff/Bryan 1992, no. 30, pp. 219–20.

Quirke/Spencer 1992, p. 72, fig. 52.

Leclant 1993, fig. 45.

Kendall 1997, p. 323, map on fig. 1.

# 52

## Head of Amenhotep III

From Thebes, funerary temple of
Amenhotep III
New Kingdom, Eighteenth Dynasty,
reign of Amenhotep III
(ca. 1390–1352 B.C.)
Quartzite
Height 52 ³/₈ in. (133 cm)
EA 7, acquired in 1835 at the sale of the
Salt Collection

This colossal head of Amenhotep III,
wearing a red crown with uraeus, comes from
the ruins of his immense funerary temple on
the West Bank at Thebes, a site known to
visitors today for the "Colossi of Memnon," the
two immense seated figures of this king that
today tower over a barren-looking field.

When complete, this statue, which
measured more than twenty-six feet (eight
meters) tall without its base, showed
Amenhotep standing with feet together and
arms crossed in the Osiride pose, but wearing
the red crown of Lower Egypt and a short royal
kilt. It was one of a set of almost identical statues
that stood between the columns on two sides of
a colonnaded courtyard.[1] Similar statues lined
the opposite side of the court, but they were
made of red granite and wore the white crown of
Upper Egypt.

Despite its huge size, this head has been
carved with infinite care. As on all of
Amenhotep III's large statues, the eyeballs are
noticeably angled back from the top to the
bottom lid so that they appear to look down
toward the viewer.[2] The finishing polish was
deliberately varied, from a glittering smoothness
on the facial surfaces to less polish on the mouth
and eyes—which thus seem slightly different in
color—to quite rough surfaces on the brows and
cosmetic lines.[3]

Amenhotep III outdid all earlier Egyptian
kings in the number and size of his colossal
statues. Almost fifty of his thousand or more
known statues were over nine feet (three meters)
in height, including nine more of these twenty-
six-foot quartzite colossi.[4] Such statues were
meant to be widely visible. And they were meant
to be universally recognizable.[5]

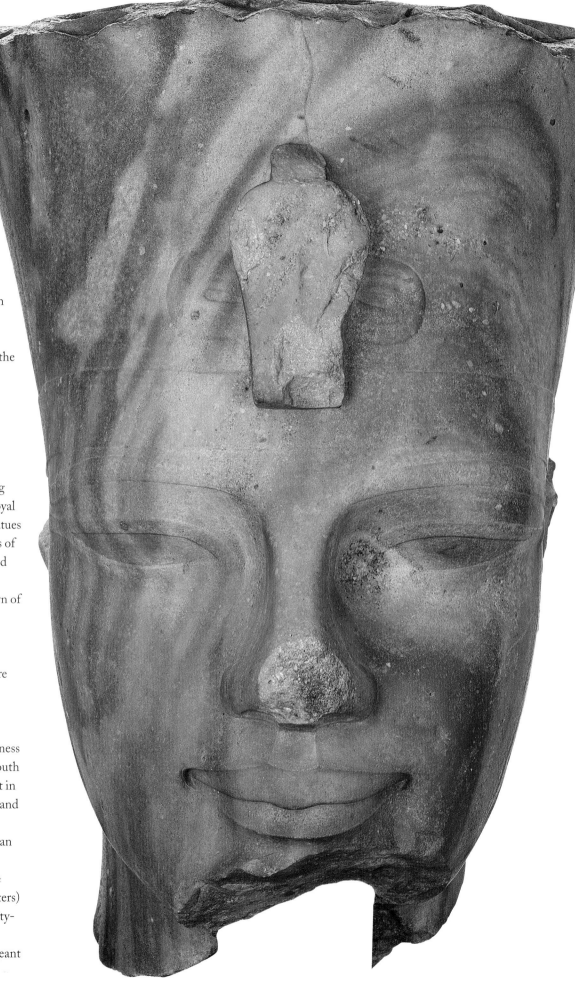

To achieve this, Amenhotep's sculptors—clearly a brilliant group of stylists and technicians—developed a likeness with very distinctive features that were certainly based on the king's own face. It is a round face, with plump, youthful-looking cheeks, and little indication of the underlying bone structure. The eyes are large, long, and often rather narrow, sometimes with a slight slant. Heavily made-up eyebrows and upper lids, indicated in relief, extend back to the temples. The nose is rather broad at the nostrils, with a round tip.

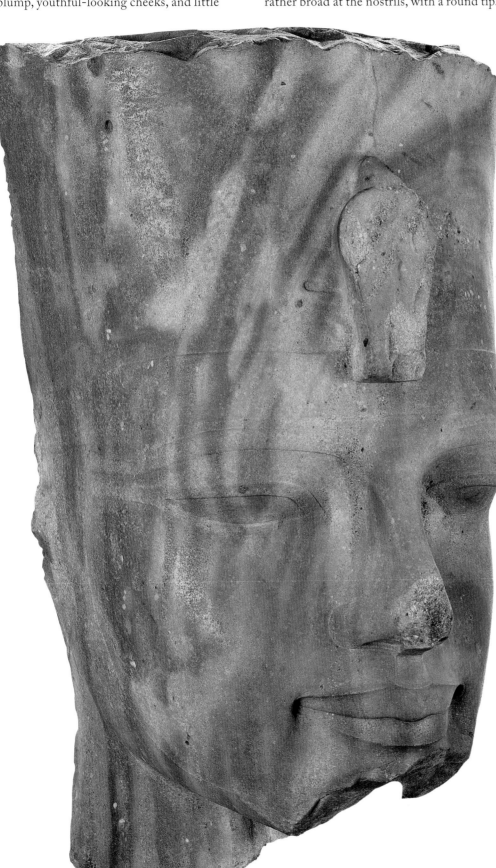

The mouth is full, its contours defined by a crisply cut outline. The upper lip is thicker than the lower, over which it droops in the center. The lower lip curves in a perfect shallow arc up to the open corners of the mouth, which are often emphasized by drill holes, to produce the effect of a slight smile.

These very specific features were reproduced in a variety of ways (cf. fig. 24), from restrained, quite natural-looking examples,[6] to babyish faces,[7] to basilisk visages such as this. All are portraits, but they are programmatic portraits, manipulated to suit the purpose of the statue and the message it is meant to convey. In the case of this statue, we are meant to see Amenhotep as a god.

The Osiride pose of this statue and its mates has been interpreted as a reference to Amenhotep's first *sed* festival,[8] the royal rite of rejuvenation, celebrated in the thirtieth year of his reign. At about this time, and possibly as a result of this celebration, Amenhotep attained full deification while still on earth.[9] He was worshiped through statues such as this one. (E.R.R.)

### Notes

[1] For a reconstruction of the statue and the columns flanking it, see Kozloff/Bryan 1992, p. 130, fig. 10.

[2] Kozloff/Bryan 1992, pp. 472–73, table 5. This is one of the most extreme examples, with a vertical recession of 46 degrees.

[3] Described in detail by Bryan in Kozloff/Bryan 1992, p. 156.

[4] Bryan in Kozloff/Bryan 1992, p. 125.

[5] Compare ibid., pp. 125–26.

[6] E.g., Cleveland 52.513: Kozloff/Bryan 1992, no. 11, pp. 166–67, 187.

[7] Cleveland 61.417: Kozloff/Bryan 1992, no. 8, pp. 124, 159–61.

[8] Bryan in Kozloff/Bryan 1992, p. 157.

[9] Johnson 1999, pp. 42–45. For more on Amenhotep's three *sed* festivals, see Berman in Kozloff/Bryan 1992, pp. 38–41.

### Bibliography

Very frequently illustrated.

PM II 1972, p. 453 (with earlier bibliography).

James/Davies 1983, p. 38, fig. 45.

Müller, M. 1988, pp. IV–27 (with further bibliography) and *passim*, pl. 10a.

Kozloff/Bryan 1992, no. 6, pp. 122, 156–58 and *passim*.

Robins 1997, p. 122, fig. 135.

*Art and Afterlife* 1999, no. 5, p. 32.

# 53

## Standing Figure of Amenhotep III

Provenance unknown

New Kingdom, Eighteenth Dynasty, reign of
Amenhotep III (ca. 1390–1352 B.C.)

Serpentinite

Height 5 ¹/₂ in. (14 cm)

EA 2275, acquired in 1835 at the sale of the Salt
Collection

On this statuette of Amenhotep III, the king
stands with his left leg forward, his proper right
hand holding a crook against his shoulder, and
his left arm at his side. He wears a large collar
necklace and a kilt that reaches to the knees in
back but is wrapped forward above the knees.
Down the front of the kilt hangs a panel,
apparently of beadwork, with a pendant cobra
and a pair of ribbons at either side. The belt,
worn high at the back, dips low in front to
accommodate the king's girth. The head has
been completely broken away. The back pillar,
which would have extended halfway up the
head, is largely intact, but its inscription has
been almost completely erased. Only the
beginning of a standard offering prayer can still
be seen at the top and, faintly, the king's name at
the bottom.[1]

What kind of crown Amenhotep III was
wearing is something of a puzzle. The crown
most frequently represented on his statuettes is a
blue crown; but Amenhotep's version of the blue
crown had streamers at the back (cf. cat. no. 59).
A wood statuette of this king has a tiny loop just
below the neckband of the blue crown, for the
attachment of real streamers in cloth, or perhaps
gold.[2] On the stone statuettes, they were
represented in relief on the negative space
behind each shoulder,[3] but they are not indicated
here. The other headdress frequently represented
on small figures of Amenhotep III is a double
crown, set on top of a short, round wig. On these
statuettes, however, the back pillar rises to about
the same height as the tall crown.[4] Since this wig
went with the double crown and would not have
been shown separately, the best guess for the
British Museum statuette would seem to be that
it wore a blue crown that for some reason was
not accessorized.

Representations of Amenhotep III with a

bulging belly and buttocks and plump thighs
were made late in the king's reign, or after his
death (cf. cat. no. 59). They were not intended,
however, to depict him as an old or aging man.
Rather, they are believed to have emphasized
his association with the fertility gods, who are
depicted with androgynous, fleshy bodies.[5]

Just as Amenhotep III had more colossal
representations than any of his predecessors
(cf. cat. no. 52), in addition to innumerable
life-size and mid-sized statues, he also had an
unprecedented number of small statuettes.[6]
These little figures were made in a number of
materials: wood,[7] glazed steatite,[8] and dark
stone, as here.[9] These statuettes were made for
a variety of purposes, including private
worship in domestic shrines like those known
from the succeeding Amarna Period (cf. cat.
nos. 59, 60).[10] At Amarna (cf. cat. no. 59) and
elsewhere, the king's cult continued after his
death, and some of these statues appear to have
been made posthumously.[11] In this case, the
funerary prayer for offerings on the back pillar
suggests that it, too, was made after the death
of Amenhotep III[12] for a devotee of his cult or
for his own mortuary temple. (**E.R.R.**)

### Notes

[1] For drawings of these signs, see Hall, H. R. 1928,
p. 76, figs. 8, 9.

[2] Brooklyn BMA 48.28: Fazzini/Romano/Cody 1999, no. 48.
pp. 94–95.

[3] As on a similarly garbed representation in Berlin: Bryan
1997, no. 7, pp. 65–66, fig. 5 (right); also MMA 30.8.74:
Kozloff/Bryan 1992, no. 23, pp. 204–205.

[4] E.g., Kozloff/Bryan 1992, nos. 20–21, pp. 198–201.

[5] Bryan in Kozloff/Bryan 1992, p. 205.

[6] Bryan in Kozloff/Bryan 1992, p. 193.

[7] Brooklyn BMA 48.28: see n. 2.

[8] Bryan 1997.

[9] Also MMA 30.8.74: Kozloff/Bryan 1992, no. 23,
pp. 204–206.

[10] Bryan in Kozloff/Bryan 1992, p. 194.

[11] As was the Brooklyn statuette cited in n. 2, according
to Bryan in Kozloff/Bryan 1992, p. 206, n. 12.

[12] Thus Müller 1988, pp. iv–124.

### Bibliography

Hall, H. R., 1928, pp. 75–76, pl. 11.

Müller, M. 1988, pp. IV-123, 124 (with bibliography).

Kozloff/Bryan 1992, pp. 205, 206, n. 12, fig. 23b,
tables 2a, 6.

# 54

## Standing Man

Provenance unknown
New Kingdom, Eighteenth Dynasty, reign of
Amenhotep III (ca. 1390–1352 B.C.)
Yellow limestone
Height 6 ⅝ in. (16.8 cm)
EA 33932, acquired in 1856

Like king, like subject. With only one known
exception,[1] the statues of men and women who
lived under Amenhotep III imitate the royal
face. Since they had several different models to
choose from (cf. the discussion of cat. no. 52),
these private faces can differ quite a bit (cat. nos.
55, 56, 127), but all can be recognized as
products of this reign.

Amenhotep's male subjects also emulated, in
their statues and reliefs, the soft forms of the
king's body. But only a few went so far as to copy
the obesity depicted on certain of his later statues
(cf. cat. no. 53).[2] The fleshy breasts, bulging
paunch, and swollen buttocks of this small male
figure do just that. Pudgier than even the small
figure of catalogue number 53, this body closely
resembles another statuette of Amenhotep III in
the Metropolitan Museum of Art.[3]

If, as some think, the intention of the plump
representations of Amenhotep was to depict, not
age, but the obesity associated with fertility gods
such as Hapy,[4] then the royal prototype for this
statue may have had the relatively youthful type
of face shown here. It is possible, however, that
this man was well along in years, or perhaps he
was just conservative in his tastes. His short chin
beard, though still found at this time (cf. cat. no.
127), was less popular than it had been earlier in
the Eighteenth Dynasty (cf. cat. nos. 44–46).
The other parts of his costume—the double wig,
the tunic with short, floppy sleeves, and the long
kilt with pleated front panel—are all fairly
restrained versions of court dress under
Amenhotep III.

The statuette lacks a back pillar. Instead,
two vertical lines have been incised down the
back to frame an inscription that identifies the
owner as the Osiris (i.e., the deceased), royal
scribe whom he (the king) loves, great general of
the army of the Lord of the Two Lands (the
king), Ka-iabet (?), true of voice. (E.R.R.)

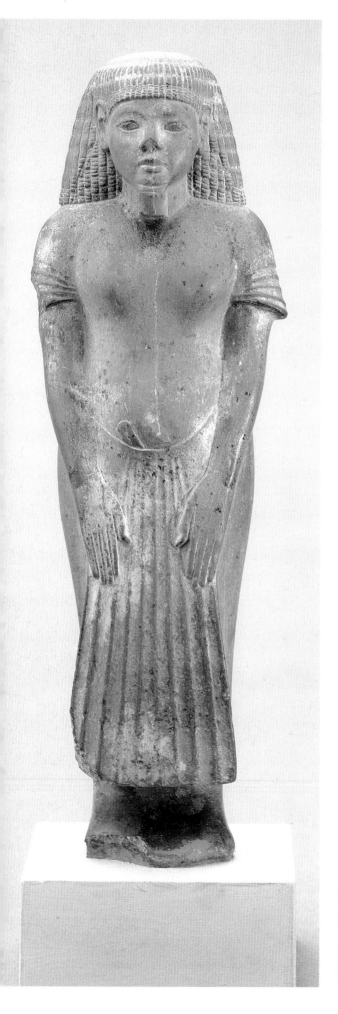

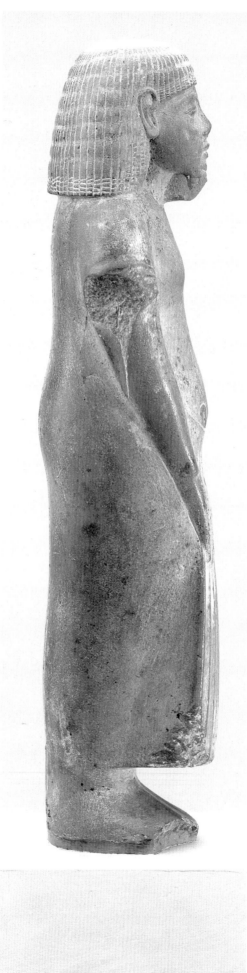

**Notes**

[1] A statue of the very high official Amenhotep, son of Hapu, with an aged face, Cairo CG 42127: Russmann 1989, no. 51, pp. 106–10; see also Sourouzian 1991.

[2] Johnson 1999, p. 46 with fig. 28; Freed/Markowitz/D'Auria 1999, no. 12, p. 204.

[3] New York MMA 30.8.74: Kozloff/Bryan 1992, no. 23, pp. 204–206; Hayes 1959, p. 237, fig. 142.

[4] See Bryan in Kozloff/Bryan 1992, p. 205.

**Bibliography**

Unpublished.

# 55

## Kneeling Priest

Said to be from Thebes
New Kingdom, Eighteenth Dynasty, reign of
Amenhotep III (ca. 1390–1352 B.C.)
Limestone, painted
Height 11 7/8 in. (30.2 cm)
EA 21979, acquired in 1889, gift of the Earl of
Carlisle

During the last eight years of his long reign, Amenhotep III's portraits on many of his statues and reliefs were manipulated to give him the appearance of a child, with huge, oblique eyes, plump cheeks, and an almost babyish fullness to the lips (see fig. 24).[1] When emulated by private persons, this version of the king's features produced the same effect; and when, as here, the juvenile type of face was combined with the fullness of body found on other royal images made late in Amenhotep's reign (cf. cat. nos. 53 and 54),[2] the result is a sloe-eyed little figure who looks like nothing so much as a chubby, pretty child.

He is, of course, a man and probably an important one. In addition to the leopard skin vestment of a priest, he wears a short wig from which hangs a braided, curled sidelock. This headdress was worn by several different kinds of priest, from funerary priests to the High Priest of Ptah at Memphis, at this time probably the second most powerful religious office in the land (after the High Priest of Amun at Thebes) and the most prestigious. Amenhotep III's crowned prince served as High Priest of Ptah, and so, later on, did the crown prince of Ramesses the Great.[3]

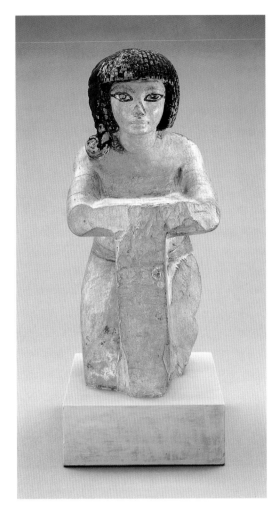

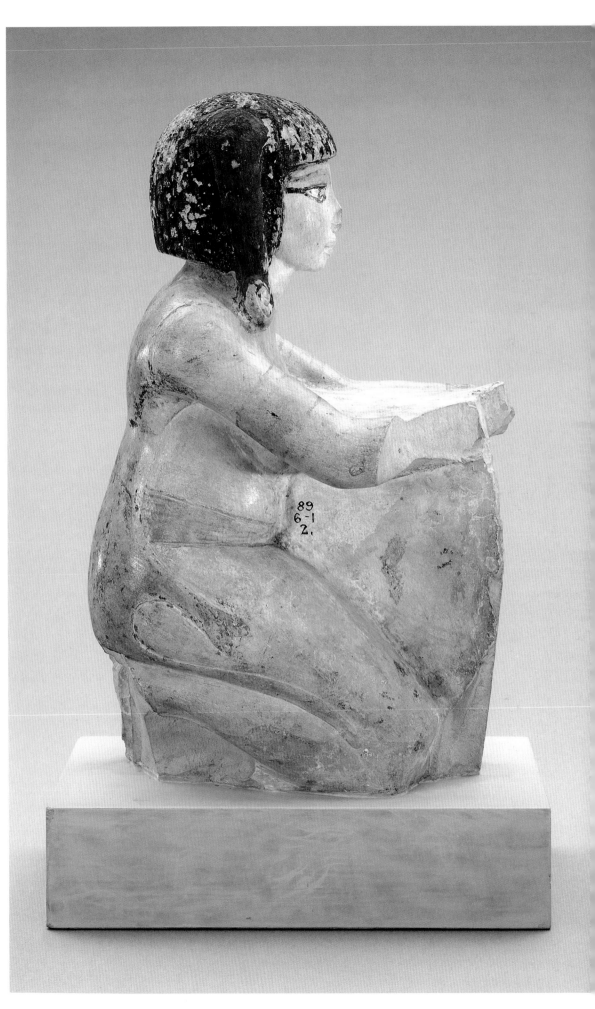

It is probable that the priest's name and titles were inscribed on the front of the object he held, which has been entirely sheared away, along with his hands. What remains is only the negative space connecting his arms and his body to the object. From the shape of the break, however, it appears to have been an offering table on a stand. Kneeling reverently, the figure was presenting offerings to a god.

As with the introduction of the block statue in the Middle Kingdom (cf. cat. no. 25), the first kneeling statues were designed both for tombs, where they were usually placed in niches on the façade, to greet the rising sun,[5] and for temples.[6] But the pose combines so well with the holding of large objects such as offering tables, shrines, and emblems (cf. cat. no. 129) that kneeling statues quickly became one of the most important types of temple sculpture for private people.

The only clues to the status of this man lie in the statue itself, which shows every mark of coming from one of the finest sculpture workshops. Though it is carved in limestone, a relatively soft stone usually reserved for tomb sculpture (cf. cat. no. 56), its material is unusually fine-grained. Taking advantage of its fineness, the sculptor has modeled and finished the surfaces of the figure to give a real sense of smooth skin and soft flesh—as if the figure had been molded rather than carved.[7] The fortuitous preservation of the paint, especially on the head and back, shows that this was applied lavishly and with care, from the unusually naturalistic rendering of the leopard's pelt, including the white strip of belly fur visible along his proper left side, to the use of expensive blue pigment on his sidelock and perhaps elsewhere. Of his jewelry—a "Gold of Honor" necklace of disk beads, armlets, and bracelets[8]—only ghosts remain; one wonders if they might have been gilded.

It seems unlikely that this elaborate, expensive statue was made for a priest of low or middle rank, much less that it was intended to serve as a symbolic funerary priest in someone's tomb, serving to perpetuate the owner's cult. Both suggestions have been made by the only scholar to have studied this statuette in detail. But she also offers a third and most intriguing possibility: that the statuette represents Amenhotep III's firstborn son, Thutmosis, who

was High Priest of Ptah at Memphis but was probably buried at Thebes.[9] The suggestion is admittedly speculative, and we shall probably never know whether it is correct. The quality of the statue, however, makes it plausible. **(E.R.R.)**

### Notes

[1] This effect was deliberate; for its rationale, see Johnson 1999, pp. 42–45.

[2] Discussed in ibid., p. 46.

[3] The well-known Khaemwaset, whose statue is in the British Museum, EA 947: Budge 1914, pl. 36; for other monuments of his, see Gomaà 1973.

[4] E.g., Brooklyn BMA 39.121 (Pepy I): *Egyptian Art* 1999, no. 170, pp. 434–35.

[5] E.g., Brooklyn BMA 37.263E: Bothmer 1966–67, pp. 64–67.

[6] Ibid., pp. 60–63.

[7] As observed by Bryan in Kozloff/Bryan 1992, p. 254.

[8] Part of a bracelet is preserved on his proper left wrist.

[9] Bryan in Kozloff/Bryan 1992, pp. 253–54.

### Bibliography

Kozloff/Bryan 1992, no. 46, pp. 253–54 (with bibliography), 471 (table 4b), 473 (table 5).

# 56

## Khaemwaset and his Wife Nebettawy

From Armant
New Kingdom, Eighteenth Dynasty, reign of Amenhotep III (ca. 1390–1352 B.C.)
Limestone, traces of paint
Height 11 3/8 in. (28.8 cm)
EA 51101, acquired in 1905

Khaemwaset and Nebettawy sit side by side on a low-backed chair. As on most statues of couples, he is on the proper right, which was the dominant side. The statue was made for their tomb, which was probably at Armant, since this town is named several times in the prayers on the base and back.[1]

The pair lived under Amenhotep III; and, as in most representations of this king's subjects (cat. nos. 54 and 55), their faces mimic his round cheeks (artfully made up), slanted eyes, and ingenuous expression (cf. cat. no. 52). As we would also expect from successful people in this wealthy, status-conscious period, their costumes and accessories are carefully depicted, with

nuances we may not fully understand.

Khaemwaset, for example, seems almost modestly dressed. Though his wig resembles a double wig, it consists of just one layer. His kilt is narrow; only the stiffened front panel is pleated. He does not wear the floppy-sleeved shirt that seems to have been standard male dress attire at this time (cat. no. 54). Instead, his torso and left upper arm are wrapped in a length of cloth that has been wound around him twice, as we can see from the careful rendering of the looped selvedge across his chest in two layers. In one hand he holds a rolled, folded cloth that, coincidentally or not, resembles the hieroglyphic sign for "health." Against his chest he holds a club-shaped plant that almost certainly represents a stalk of cos lettuce. This plant, an emblem of the god Min, symbolized virility.[2]

Nebettawy's modish full wig and multistranded collar necklace have relatively little carved detail, but they may have been further elaborated in paint. A filmy, pleated over-wrap covers her left arm and hip. Her right arm passes behind her husband's back, with her hand resting behind his right shoulder. This was a standard gesture for a married woman; almost always, as here, it resulted in an unrealistic elongation of the unseen arm. Her other gesture is much more unusual: with her left hand she touches Khaemwaset's left elbow. To us, this gesture may seem tender and rather sweet. To the Egyptians, however, it seems to have signified something rather different.

Nebettawy's gesture is found on only two other pair statues, both of them made at about the same time, at nearby Thebes.[3] On each of these, the man holds a lettuce stalk in his raised hand and, in at least one case, a folded cloth in the other.[4] Like Nebettawy, the two wives not only touch their husbands' elbows with the left hand but also embrace them with the right. But they differ from her in one illuminating respect: each woman has pushed the long hair of her wig back over her right shoulder, the side near her husband.

Women's hair had strong erotic connotations for the ancient Egyptians. In the New Kingdom, the gesture of a woman pushing her hair back over one shoulder clearly had sexual meaning (fig. 14).[5] Since the women on two of the three pair statues have sexually suggestive hairstyles while all three of the men

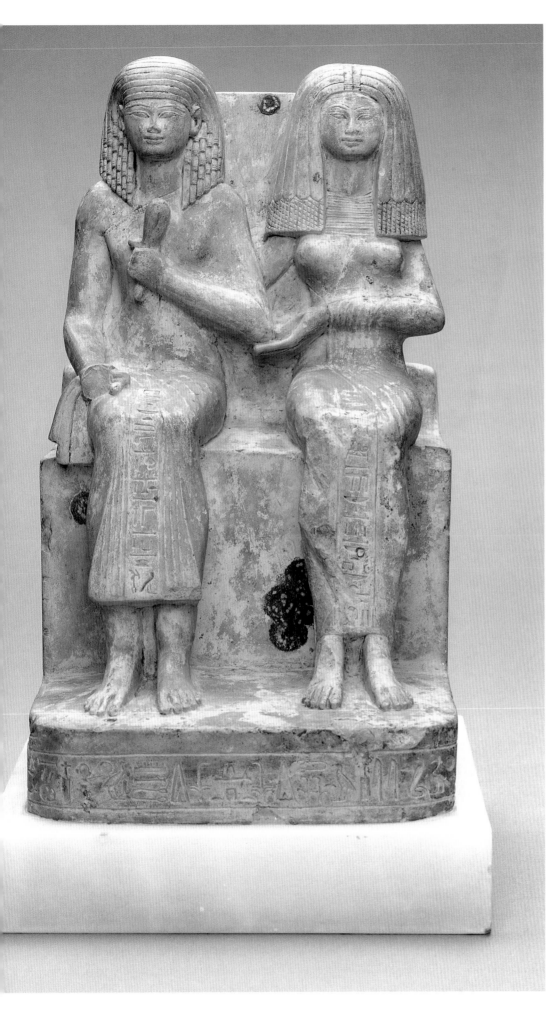

hold emblems of male virility, it is highly likely that the way in which the three women touch their husbands also refers to their marital intimacy. If so, one must wonder why this gesture and the erotically charged female hairstyle were so rarely depicted on statues of married couples. As is often—if not always—the case with Egyptian symbolism, we can identify the general meaning, but the nuances escape us. (E.R.R.)

### Notes

[1] For the inscriptions, see Farid 1983, pp. 66–69.

[2] Germer 1980, col. 939.

[3] Cairo CG 772: Nofret 1985, no. 63, pp. 136–37, and Moscow, Pushkin Museum 1962: Hodjache 1971, pls. 27, 28.

[4] Published photographs of the Moscow statue do not provide a clear view of this hand.

[5] The figure, made as a mirror handle, is nude, and there is erotic meaning in the way she cradles a kitten. Such imagery was especially appropriate for mirrors because of their association with the goddess Hathor; cf. Müller, C. 1984, col. 1148.

### Bibliography

British Museum 1909, p. 115, pl. 13.

Farid 1983, pp. 66–69, pls. 13–14.

Robins 1995, no. 5, pp. 14, 19.

Robins 1997, p. 145, fig. 166.

Treasures 1998, no. 11, pp. 58–59.

# 57

## Fragmentary Royal Face

From Amarna, Great Temple of the Aten
New Kingdom, Eighteenth Dynasty, reign of
Akhenaten (ca. 1352–1336 B.C.)
Indurated limestone
Height 6 ¹/₈ in. (15.6 cm)
EA 13366, acquired in 1853, gift of J. S. Perring

This poignant fragment of a magnificent royal statue apparently comes from one of the statues in the Great Temple of the Aten at Amarna.[1] After Akhenaten's death and the departure from Amarna of the young King Tutankhamun and his court, these statues were smashed. Many of the fragments were dumped on the southeast side of the temple, where Flinders Petrie and Howard Carter found them some fifty years after this head appeared.[2] Many of these

fragments are now in the Metropolitan Museum of Art,[3] and an over-life-size bust of Akhenaten is in the Brooklyn Museum of Art.[4]

The statues from the Great Temple were made of indurated limestone, a hard, marble-like form of limestone that, even more than ordinary fine-grained varieties of the stone (cf. cat. no. 55), could be modeled and polished to approximate the texture of skin. This particular piece, however, was brittle and treacherously veined. The head appears to have broken off from the body, perhaps during manufacture, and to have been reattached by means of a long dowel inserted through a drilled hole, partly preserved as a channel running down the back of the fragment. Considering the unusual technical difficulties of his material, the sculptor's achievement here was nothing less than a triumph.

The style of this fragment, like the style of all the royal statues from the Great Temple, places it within the first few years after Akhenaten's arrival at Amarna. In this period, the extreme exaggeration of the king's portrait features in his early sculpture and reliefs, at Karnak, gave way to softer, more persuasively naturalistic renderings. On this fragment, the smooth, softly modeled facial planes and the exquisitely complex mouth, which in profile looks as if it is about to open, give the impression of an actual face. But the mouth, especially when compared with the width of the nose, is extremely large; and it is not wholly integrated with the face. In front view, the sharp edges of the lips serve to isolate them from the cheeks and chin, and to focus attention on the mouth as a unit, as if it were a hieroglyphic sign. This "hieroglyphic" treatment of the mouth, very pronounced on Akhenaten's early statues,[5] is also found on the sculpture of his father, Amenhotep III (cf. cat. no. 52, fig. 24).

In the last years of Akhenaten's reign, in the Amarna workshop of the brilliant sculptor Thutmose,[6] the increasingly naturalistic style of royal portraiture reached its apogee. Akhenaten's peculiar features were still represented, but they had been manipulated to create a softer, more believable, even rather attractive version of the king's face.[7] Nefertiti—who at Karnak had looked just like her husband, except for her headdress and her clothing—now had her own

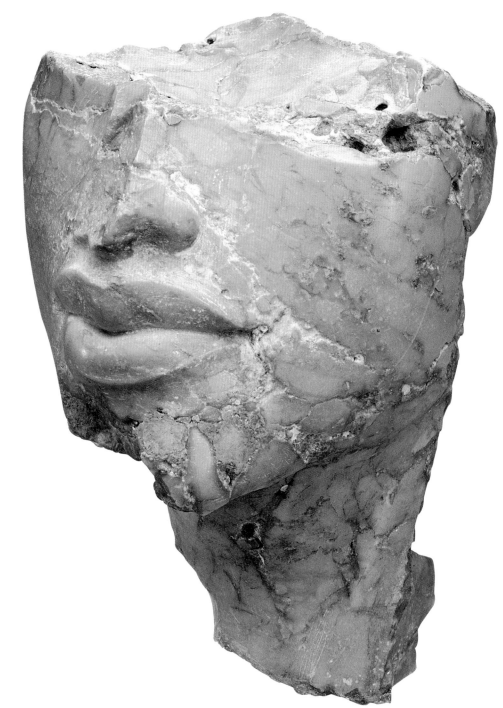

beautiful face, the face by which she is still known.[8] But we know little about the early stages in the development of Nefertiti's portraiture. That poses a problem when considering the identity of the person represented here. It has always been called Akhenaten. But could it represent Nefertiti?

The British Museum fragment appears to lack (at least, on the undamaged proper right side)[9] the stylized crease from nostril to mouth corner found on almost all of Akhenaten's sculpture, from the earliest to the latest.[10] The chin, though badly damaged and difficult to imagine complete, appears to have been less long and pendulous than on the king's representations.[11] The breaks at the sides of the neck,

especially on the proper left side, are sharp and quite straight and slant slightly forward. They may follow the lines of a headdress. If so, it must have been Nefertiti's long, tripartite wig (compare the similar, though simpler, wig on the head of catalogue number 49, and the way it has broken along the proper right side of the neck.) Fragmentary statues of Nefertiti wearing the tripartite wig were found among the Great Temple fragments.[12]

The only intact feature here, the mouth, is also the most enigmatic. Both Akhenaten and Nefertiti were represented with full lips, the upper lip dropping over the lower lip at the center (as also in representations of Amenhotep III: cf. cat. no. 52 and fig. 24). Only on

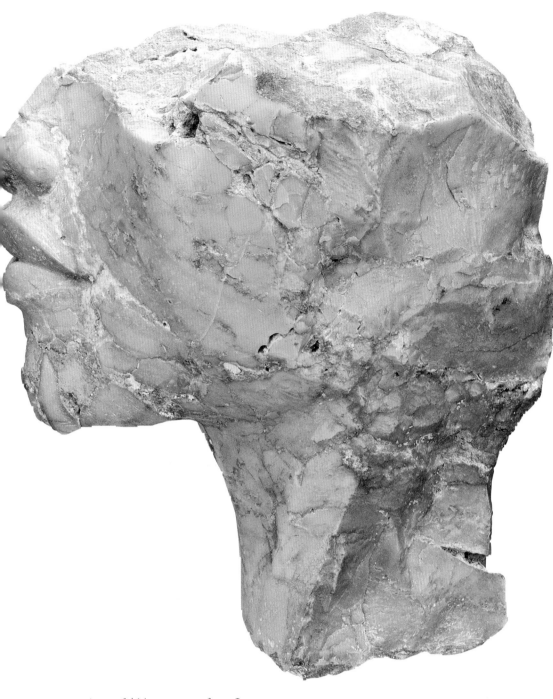

representations of Akhenaten, so far as I can tell, is the central lip element shown as an actual bulge.[13] But Akhenaten's lower lip is thicker than the upper and usually quite pendulous. Here, the upper lip is as thick as the lower lip and describes a very full double curve, rising steeply from each corner. This shape is found in modified form on at least one late portrait of Nefertiti,[14] and in stronger, sometimes exaggerated form on representations of her daughters.[15] It is almost duplicated on a fragmentary mouth and chin in yellow jasper, an equally enigmatic fragment, but one that unquestionably represents a woman.[16] (E.R.R.)

### Notes

[1] For this provenance, see Aldred 1973, p. 90.

[2] Petrie 1894, p. 18, with a reference to this fragment. For Carter's account of the find, in his novice season, see Reeves/Taylor 1992, p. 37.

[3] Their publication is in process: Hill forthcoming.

[4] BMA 58.2; for this and two of the Metropolitan Museum fragments, see Aldred 1973, nos. 3–5, pp. 91–93.

[5] E.g., Freed/Markowitz/D'Auria 1999, nos. 22–24, p. 208.

[6] Arnold, Do. 1996, pp. 41–83.

[7] E.g., Aldred 1973, nos. 94, 95, pp. 166–67.

[8] Especially the famous painted bust, Berlin 21300: Arnold, Do. 1996, pp. 64, 66, figs. 58, 60.

[9] The visible lines appear to be scratches.

[10] Early examples: n. 5; from the Great Temple: Aldred 1973, no. 3, p. 91 (New York MMA 26.7.1395); late (from Thutmose's

studio): examples in n. 7.

[11] See examples cited in nn. 5, 7.

[12] Pendlebury 1951, pl. 61, 4. I owe this reference and the suggestion of a queen's wig to Marsha Hill. I am grateful to Dr. Hill for generously sharing with me her extensive knowledge of the Great Temple fragments.

[13] Example cited in n. 5; also Saleh/Sourouzian 1987, no. 159; Arnold, Do. 1996, p. 24, fig. 16.

[14] Cairo JE 45547: Arnold, Do. 1996, pp. 40, 71, figs. 31, 65.

[15] Ibid., pp. 52, 58, 59, 121, figs. 46, 50, 51, 117.

[16] New York MMA 26.7.1396: Arnold, Do. 1996, pp. 34, 37, figs. 27, 29.

### Bibliography

Aldred 1973, no. 2, p. 90 (with bibliography).

Moore 1981, pp. 40–41.

Müller, M. 1988, IV–124–25.

PM IV 1934, p. 197 (with earlier bibliography).

Seipel 1992, no. 98, pp. 268–69.

## 58

### Face of Tutankhamun or his Queen

Said to be from Amarna[1]
New Kingdom, Eighteenth Dynasty, late reign of Akhenaten or shortly after (ca. 1336 B.C.)
Plaster
Height 5 in. (12.6 cm)
EA 65517, purchased from E. Cassirer, formerly F. W. von Bissing Collection

This face was cast from a single mold. Its rounded edges and uneven, lumpy back surface are typical results of a process in which liquid plaster is poured into an open mold. Numerous study pieces of this type were excavated in the famous workshop of the sculptor Thutmose at Amarna.[2] The plaster works are understood to have been cast from clay models during intermediary stages of the sculptors' work, and it has been suggested that the artists started from fairly realistic sketches of human faces, then transformed the images step by step into more stylized versions. From each version a cast would have been taken. Once the master sculptor was satisfied with the image, the final work could be executed in stone. The symmetrical structure and stylized forms of the face presented here indicate that in this case the process had reached a stage rather close to the definitive stone version.

It is not known at which exact place in the vast area of Amarna the piece was found; but the nature of the plaster material makes a suggestion possible. The surface texture of the British Museum cast is noticeably more gritty and pitted than the one of the Thutmoses works and two other casts found in a workshop near Thutmose's.[3] A similarly gritty texture is seen on a plaster piece found by Petrie among other workshop remains in front of the Great Temple of the Aten at Amarna.[4] If indeed from Amarna, the cast is best understood as a product of this workshop in front of the temple.[5]

Stylistically, the restrained sensitivity and sweetly melancholic expression of the youthful face is closest to works created at the very end of the reign of Akhenaten and after. Indeed, a head of Tutankhamun in the Metropolitan Museum of Art[6] shows a strikingly similar wing-shaped mouth, small chin, and slanted eyes below sharply accentuated brows. The two works are, indeed, close enough to suggest an identification of the British Museum cast with either Tutankhamun himself or his queen, Ankhesenamun, the third daughter of Akhenaten.[7]

There is evidence that King Tutankhamun began his rule of Egypt at Amarna only to remove with his court—and sculptors—in the second year of the reign to the traditional residences at Thebes and Memphis.[8] The British

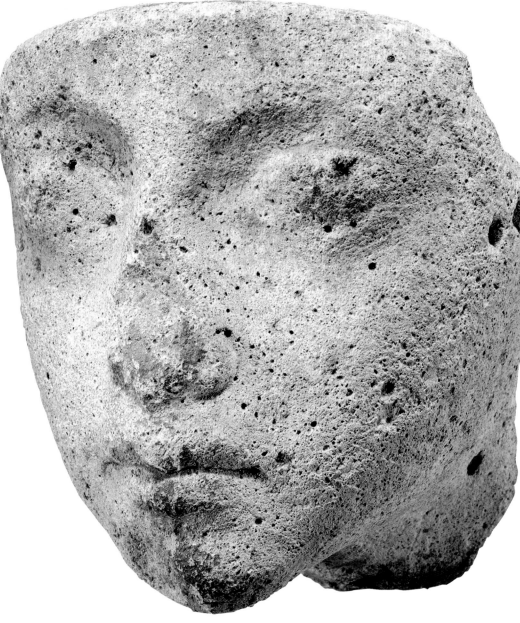

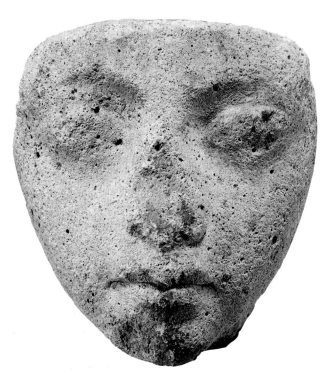

Museum plaster face documents that the distinctive post-Amarna style that dominated the king's imagery began to evolve already during these last years of a royal presence at Amarna. (D.A.)

### Notes

[1] James 1954, pp. 16–17.

[2] Arnold, Do. 1996, pp. 46–51.

[3] Pendlebury 1933, pp. 117–18, pls. 15, figs. 4 and 19, figs. 1–2.

[4] The so-called "death mask of Akhenaten": Petrie 1894, pp. 17–18, pl. 1, fig. 10; Pendlebury 1933, pl. 19, fig. 4. For the sculptors' workshop in front of the temple, see Kemp/Garfi 1993, pp. 55–56.

[5] No remains from this workshop definitely indicate that it served already for the creation of the main temple sculpture during the early Amarna years. For some of these sculptures, see Aldred 1973, pp. 90–93, nos. 2–5; for the demolition dump where they were found, see Kemp/Garfi 1993, pp. 52–53.

[6] New York MMA 50.6: Arnold, Do. 1996, p. 123, fig. 120. A stylistically related piece is the head fragment: Aldred 1973, no. 98, p. 168.

[7] L. Green in Arnold, Do. 1996, pp. 11–12.

[8] Eaton-Krauss 1985, col. 812.

### Bibliography

James 1954.

Müller, M. 1988, pp. IV–125.

# 59

## Shrine Stela with Amenhotep III and Tiye

From Amarna, House of Panehsy
New Kingdom, Eighteenth Dynasty, reign of
Akhenaten (ca. 1352–1336 B.C.)
Limestone, painted
Height 12 ⁷/₈ in. (32.5 cm)
EA 57399, gift of the Egypt Exploration Society, 1924

The loyal courtiers who followed Akhenaten to
Amarna had domestic shrines in which they
placed statuettes or stelae representing members
of the royal family (cf. cat. no. 60).[1] This
example, found in the house of the First Servant
of the Aten, Panehsy, is one of the most
elaborate. The architectural frame, found on
others of these stelae,[2] is richly adorned with a
row of cobras bearing sun disks atop the cornice
(cf. cat. no. 48), flowers and leaves bound to the
side pillars or jambs, and bunches of grapes
hanging, as in an arbor, from the lintel.

Inside the frame, the royal couple sit before
an extravaganza of food and floral offerings piled
on three stands. Across the top are inscriptions
with cartouches containing their names and
versions of the Aten's names that date this work
late in Akhenaten's reign, after his twelfth regnal
year. At center top shines the Aten itself, in the
form ordained by Akhenaten: a uraeus-bedecked
sun disk with rays extending downward and
outward and ending in hands. The two that
come closest to the faces of the king and (passing
behind his head) the queen hold out little *ankh*
signs. As on the other shrine stelae, the figures
sit relaxed, almost slouching, on cushioned
furniture (cf. cat. no. 60). Characteristic Amarna
touches include the differentiation between the
couple's left and right feet,[3] the complicated
rendering of the king's hanging hand,[4] and the
detailed representation of several heads of grain,
which are consequently shown as enormous.[5]

Somewhat surprisingly, the couple to be
worshiped here are not Akhenaten and Nefertiti,
but Akhenaten's parents, Amenhotep III and
Queen Tiye. Amenhotep is identified only by his
prenomen, Nebmaatre, because his second name
incorporated the name of Amun, anathema to
his son. Amenhotep is shown as a full-bodied
man wearing the diaphanous, front-tied robe

shown on several plump representations made
late in his life.[6] The domed shape of his blue
crown is comparable to that on his other
images.[7] Tiye, much of whose head and upper
body have been lost, wears a wig that was
fashionable among Amarna women. One hand
is around her husband's shoulders, with her
fingers resting beside his neck. The position of
her other arm is unclear. Also unclear is the
owner of the hand on her lap, which, however,
seems scaled to fit Amenhotep better than the
slightly smaller figure of his wife.

As a historical document, this stela has been
used to support many, sometimes contradictory,
theories—that Amenhotep III became
physically decrepit; that he chose to be
represented as a plump fertility god; that he had
a long co-regency with his son; that he was
assimilated by Akhenaten with the Aten
itself—to name but a few. These ongoing
discussions and controversies might benefit from
considering several artistic peculiarities of the
piece, which have been largely overlooked. The
stela is carved in raised relief, a technique almost

unknown at Amarna, where sunk relief was universally used, both on walls and on small stelae (cf. cat. no. 60).[8] Whereas Akhenaten and Nefertiti always sit separately, Amenhotep III and Tiye sit side by side in a pose that is not only old-fashioned but derived from funerary representations of nonroyal couples.[9] The unusual amount of architectural ornament mentioned above is echoed in the rich decoration of the figural scene, in the drapes on the chairs and the swags on the offering stands. These differences from the stelae representing Akhenaten and Nefertiti are so varied—differences of theme, of iconography, of composition—that this stela must have been designed to convey a different message. We would know much more about these two kings and about religion at Amarna if we could understand what that difference was. **(E.R.R.)**

**Notes**

[1] For the most recent discussion of the location and nature of these shrines, see Arnold, Do. 1996, pp. 96–105. This stela is discussed on p. 97.

[2] E.g., Cairo JE 44865: Saleh/Sourouzian 1987, no. 167; Freed/Markowitz/D'Auria 1999, p. 106, fig. 70.

[3] In Amarna art, this detail was reserved for royal representations: Russmann 1980; cf. Freed/Markowitz/D'Auria 1999, no. 59, pp. 222–23.

[4] For a comparable hand, see Freed/Markowitz/D'Auria 1999, no. 58, p. 222.

[5] For a fragment of a barley field represented in similar detail (MMA 1985.328.24), see *Ancient Art* 1992, p. 32.

[6] E.g., the statuette in the Metropolitan Museum of Art, MMA 30.8.74: Kozloff/Bryan 1992, no. 23, pp. 204–206.

[7] Akhenaten's blue crown, especially in relief, tends to be much taller; examples: n. 2; Freed/Markowitz/D'Auria 1999, nos. 36, 52, pp. 214, 19.

[8] Fragments of architectural relief that appear to be raised are really just details of large sunk relief scenes; for examples, see Freed/Markowitz/D'Auria 1999, nos. 56, 59, 68, 145–46, pp. 221, 222, 225, 248–49.

[9] This and the preceding point made by Müller, M. 1988, pp. II–112–13.

**Bibliography**

PM IV 1934, p. 201 (with earlier bibliography).

*HT* VIII 1939, pp. 25–26, pl. 22 (with bibliography).

Freed/Markowitz/D'Auria 1999, no. 169, pp. 47, 254.

Kozloff/Bryan 1992, no. 29, pp. 213–14 (with bibliography).

Quirke/Spencer 1992, fig. 57, p. 80.

# 60

## Fragmentary Stela with Akhenaten

From Amarna
New Kingdom, Eighteenth Dynasty, reign of Akhenaten (ca. 1352–1336 B.C.)
Limestone, traces of paint
10 5/8 x 6 in. (27 x 15 cm)
EA 24431, acquired in 1891, purchased via the Reverend C. Murch

This fragment of a stela from a domestic shrine (cf. cat. no. 59) shows Akhenaten seated on a low-backed, cushioned chair with side struts in the form of the ancient royal symbol for the unification of Upper and Lower Egypt, which is partly obscured by the long sash of his pleated kilt. The Aten disk was above him, in the center of the stela. The hands at the ends of its rays reach out to bless its self-proclaimed son. One of Akhenaten's hands was raised, apparently toward a small figure in front of him, who would have been one of his six daughters by Nefertiti. Almost certainly, the complete composition showed Nefertiti seated opposite her husband, and probably more of the royal daughters. To judge from two complete examples, this was a standard composition for such stelae.[1]

The identity of Akhenaten's figure is not in doubt: his names are written in the cartouches before his face. The delicacy of the features and the round breast, which prompted some early observers to suggest that it represents Nefertiti[2] (whose name appears with Akhenaten's in the framing inscriptions), are simply a softened version of his scrawny and strangely androgynous physique.[3] Such details as the large, heavy-lidded eye suggest that the stela was made late in his reign.[4] A date late in Akhenaten's life may have also influenced his being represented with a short, round, curled wig, unusual for this ruler.[5] The same headdress appears on several late representations of his father, Amenhotep III, where the intent was clearly to identify the old king with the child god, Neferhotep, as part of his self-deification program.[6] Neferhotep, part of the pantheon that Akhenaten had repudiated, would not have been acceptable. But the iconography of the juvenile god may well have appealed to this aging son of the Aten.

Like this figure's proportions,[7] its slouching

posture is an innovation of Amarna art. In fact, this way of sitting on a well-cushioned chair, with the back curved and the feet raised by a padded footstool, was reserved for representations of the royal family in images made for veneration, such as the shrine stelae (cf. cat. no. 59) or representations in the tombs of their subjects. The posture has been attributed to Amarna naturalism, to Akhenaten's supposed infirmities, and to an increasingly luxurious and comfort-loving society. Some of these factors may indeed have contributed to the Amarna slouch, as, more certainly, did the desire to suggest intimacy within the family group.

Visually, however, this pose is dominated by the strong curve from neck to knee. Nefertiti's figure would have had the same curve in the opposite direction; thus both figures might have been seen as segments of the Aten disk above them. More striking, however, is the effect of these opposing curves on the whole composition in the two complete stelae.[8] There the eye is led down one back, past both pairs of feet, and up the curve of the other back, traversing an arc almost identical with the lower curve of the Aten. In these devotional icons, the divine royal pair was shown as the image of the Aten upon earth.[9] **(E.R.R.)**

**Notes**

[1] Cairo JE 44865: Saleh/Sourouzian 1987, no. 167; Freed/Markowitz/D'Auria 1999, p. 106, fig. 70; Berlin 14145: Arnold, Do. 1996, p. 98, fig. 88; Freed/Markowitz/D'Auria 1999, p. 119, fig. 81.

[2] PM IV 1934, p. 233: "Queen (?)."

[3] E.g., Saleh/Sourouzian 1987, nos. 160, 164–67.

[4] Compare Brooklyn BMA 16.48: Arnold, Do. 1996, pp. 89–90, fig. 81; Freed/Markowitz/D'Auria 1999, no. 135, p. 245.

[5] The best-known Amarna representation of this wig is worn by a king usually thought not to be Akhenaten (Berlin 15000): Aldred 1973, no. 120, pp. 188–89.

[6] Kozloff/Bryan 1992, nos. 8, 20, pp. 159–61, 198–99.

[7] For an analysis of this figure, see Robins 1994, p. 145, fig. 6.32.

[8] See n. 1.

[9] For a much more elaborate and, to my mind, overly diagrammatic analysis of the composition of the complete stela, Berlin 14145, see Krauss 1991, esp. pp. 30–32 and fig. 15, where his circle, too, corresponds with the arc described here.

**Bibliography**

PM IV 1934, p. 233 (with earlier bibliography).

*HT* VIII 1939, pp. 26–27, pl. 23.

Quirke 1992, fig. 24, p. 43.

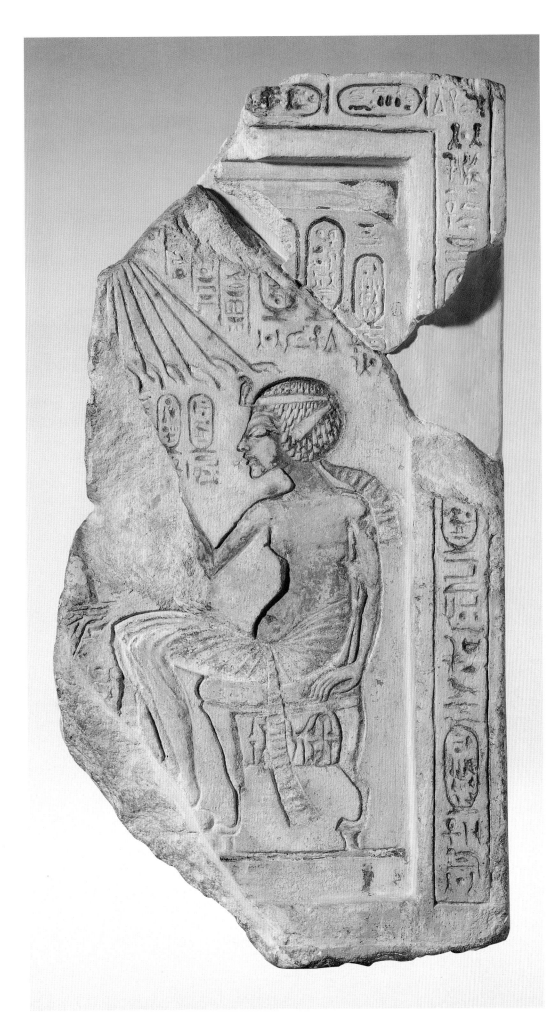

# 61

## Trial Piece with Head of Akhenaten in Sunk Relief

From Amarna, King's House, storerooms
New Kingdom, Eighteenth Dynasty, reign of
Akhenaten (ca. 1352–1336 B.C.)
Limestone
6 5/8 x 5 3/8 in. (16.7 x 13.5 cm)
EA 63631, gift of the Egypt Exploration Society, 1932

On the smooth front of this irregular piece of stone, a sculptor has depicted the head, neck, and shoulders of a royal person. The short, pointed wig and the uraeus cobra on the forehead would identify it as King Akhenaten or his main queen, Nefertiti. Stylistically, however, the piece belongs not to the very early years of the revolutionary Amarna period, when the exaggerated facial features of king and queen are often difficult to differentiate, but to the so-called middle period, when the drooping chin, sharply emphasized corners of the mouth, and pronounced tendons on the neck appear mainly in images of the king. It is therefore doubtless Akhenaten himself whose withdrawn but benign face appears on this stone.[1]

The piece is clearly not a fragment broken off from a larger relief but a small work in its own right. Objects of this type have been found in temples and palaces at Amarna, Akhenaten's newly founded city in middle Egypt, whereas only a few pieces have been excavated in houses.[2] Their sketch-like character, rough shapes, and uneven quality have led to the belief that they were artists' trial pieces. Similar images on more evenly shaped rectangular slabs were identified as models executed by master sculptors.[3] This stone, although of uneven shape, is undoubtedly a masterpiece. The origin of such objects in temples and palaces makes sense because—like tombs—these were the main locations of large-scale relief decoration in the city.[4] What is astonishing, however, is that the vast majority of trial pieces depict royal heads. It is as if the importance of the king—and to a lesser degree the queen—as sole mediators between Amarna's god, Aten, and the people manifested itself even in the minds and practices of the king's artists, making the royal image their primary artistic subject, as well as an object of devotion. (D.A.)

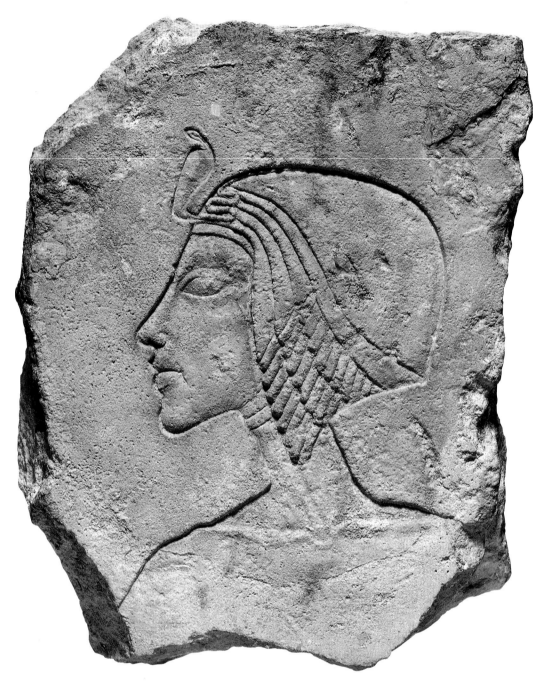

# 62

## Pilaster from Horemheb's First Tomb

From Saqqara, tomb of Horemheb, second courtyard,
south wall
New Kingdom, Eighteenth Dynasty, reign of
Tutankhamun (ca. 1336–1327 B.C.)
Limestone
Height 71 ¼ in. (181 cm)
EA 552, purchased at the sale of the Anastasi
collection

Horemheb, a military man, was chief of staff and
regent for the young king Tutankhamun.
Though his initial rise to the rank of general
must have been as a follower of Akhenaten, he
seems to have spearheaded the counter-
reformation against the worship of the Aten, the
abandonment of Amarna, and the restoration of
the cults of Egypt's traditional gods. Eventually,
Horemheb was to become king himself and to
construct a royal tomb in the Valley of the Kings
at Thebes.[1] While still serving under
Tutankhamun, however, he built himself a
monumental nonroyal tomb in the Memphite
cemetery of Saqqara. Since his wife was buried
there, the Saqqara tomb continued in use as a
funerary cult place after Horemheb's ascendancy
to the throne; but his representations in the
reliefs were brought up to date by the addition of
a uraeus to the forehead.

The whereabouts of Horemheb's tomb was
known in the early nineteenth century, when
sections of its reliefs were removed, among
them, this pilaster and its companion, which is
also in the British Museum (fig. 49).[2]
Subsequently, however, the location was
forgotten until a joint archaeological expedition
of the Egypt Exploration Society and the
Rijksmuseum van Oudheden in Leiden
rediscovered it in 1975.[3]

This pilaster and its pair come from the
south wall of the second court, where they
flanked a large scene of Horemheb presenting
booty and captives from a military campaign in
the Near East to Tutankhamun and his queen,
Ankhesenamun. Although the pilasters, each of
which shows the generalissimo with his hands
raised in prayer, do not seem to relate to the
scene between them, they were clearly designed
for their places: the prayer of this figure, which

### Notes

[1] For the style and the faces of king and queen, see Aldred
1973, pp. 58–66, 109, 111, 113, 126–28.

[2] Temples: Pendlebury 1933, p. 116, pl. 15: figs. 1–3; and
perhaps some of Petrie 1894, pp. 30–31, pl. 1: figs. 5, 6, 8, 9,
pl. 11: figs. 2, 4. Palaces: Pendlebury 1951, pp. 37, 49, 61,
63, 65, 69–73, 88–89, 92, 107, pl. 62: fig. 1, pl. 63: fig: 5, pl.
65: figs. 6–9, 12, pl. 67: figs. 1, 12, pl. 70: figs. 1–6, pl. 71:
figs. 1, 5, 9, pl. 74: figs. 5–7, pl. 75: figs 1-3;
Freed/Markowitz/D'Auria 1999, p. 221, no. 56. Houses:
Peet/Woolley 1923, p. 14, pl. 12: figs. 6, 8; Pendlebury 1951,
p. 22; Aldred 1973, p. 185, no. 115; and perhaps some of
Petrie 1894, pp. 30–31, pl. 1: figs. 5, 6, 8, 9, pl. 11: figs. 2, 4.
More trial pieces from the Petrie excavations are in the
Metropolitan Museum of Art (MMA. 21.9.11-.19; 22.2.2-.20;
66.99.40).

[3] Aldred 1973, p. 98, no. 12, p. 185, no. 115, and pp. 190–91,
no. 121; with trial pieces in ibid., pp. 96, nos. 9, 10, p. 98, fig.
49, p. 101, no. 15, p. 120, no. 38, p. 188, no. 119. See also
Freed/Markowitz/D'Auria 1999, pp. 123–26, p. 219, no. 52,
p. 241, no. 124, p. 245, nos. 134 and 135, p. 246, no. 136,
p. 248, no. 141.

[4] No trial pieces for relief work were found in the city's known
sculptors' workshops where three-dimensional sculptures or relief
inlays were created: Borchardt/Ricke 1980, pp. 87–100, 266–68.

### Bibliography

Pendlebury 1951, I, p. 92, no. 581; II, pl. 74, 7.

Quirke/Spencer 1992, p. 81, fig. 58.

faced east, is offered to the traditional sun god, Re, in his rising; while that on the opposite side, above his figure facing west, is to Osiris, Foremost god of the West (a euphemism for both the necropolis and the Afterworld).

Horemheb wears an extremely elaborate court costume, typical of the late Eighteenth Dynasty: a long, elaborate crimped and curled double wig, to which the uraeus was added, and several layers of clothing—all of it, apparently, in diaphanous pleated linen. Over a shirt with wide, floppy sleeves there seem to be at least two kilts, from one of which hangs a long pointed front panel indicating Horemheb's military status.[4] Fastened to a shoulder strap and hanging down his back is a fan made from a single ostrich plume, insignia of Horemheb's exalted role as "Fan Bearer on the Right of the King"—that is, one who had access to the king's person.[5] Horemheb's sandaled feet are rendered identically; in this tomb, as at Amarna, only royalty were depicted with their left and right feet differentiated (cf. cat. no. 59).[6]

The artistic legacy of Amarna is equally apparent in Horemheb's sweet-looking face with its large, heavy-lidded eye (cf. cat. no. 59), his rather plump, bottom-heavy figure, and his spindly limbs. But, as Robins has shown, the proportions of this and other figures from the end of the Eighteenth Dynasty differ from their Amarna predecessors.[7] As part of the repudiation of Akhenaten, changes—or attempts at change—were being made in his artistic style. **(E.R.R.)**

*Fig. 49. Pilaster from Horemheb's First Tomb. Saqqara, tomb of Horemheb, second courtyard, south wall. Eighteenth Dynasty, reign of Tutankhamun (ca. 1336–1327 B.C.). Limestone, ht. 70⅞ in. (180 cm). The British Museum (EA 550)*

### Notes

[1] KV 57: Hornung 1971.

[2] EA 550: Martin 1989, no. 71, p. 86, pls. 109–10; Robins 1997, p. 164, fig. 195.

[3] Martin 1989, pp. ix–xi. This publication includes both the reliefs still in situ and all known examples in museums.

[4] For representations of Egyptian soldiers wearing similar kilts, see Martin 1989, pls. 99–105 (the scene between the British Museum pilasters).

[5] Pomorska 1987; for Horemheb (including this pilaster), see

pp. 124–25.

[6] E.g., Martin 1989, pl. 108 (Tutankhamun and Ankhesenamun in the scene between the pilasters).

[7] Robins 1994, pp. 148–59; for a discussion of the change in relation to British Museum EA 550 (the companion to this relief), see Robins 1997, pp. 163–65.

**Bibliography**

PM III 1981, p. 660 (with earlier bibliography).

Martin 1989, no. 73, pp. 92–93 (with bibliography), pls. 109–10.

Freed/Markowitz/D'Auria 1999, no. 252, p. 278.

# 63

## Tutankhamun Presenting Offerings

Probably from Thebes, Karnak Temple

New Kingdom, Eighteenth Dynasty

(ca. 1336–1320 B.C.)

Granite

Height 66⅛ in. (167.7 cm)

EA 75, in the collection before 1879

The king, wearing a royal *nemes* headcloth, false beard, beaded broad collar, and elaborately pleated kilt, steps forward to present a chest-high pillar that once tapered toward the statue base (now lost). The three exposed surfaces of the pillar are decorated with low raised relief depicting lotus blossoms, bunches of grapes, pomegranates, sheaves of grain, and clutches of bagged ducks hung by their feet. An adjoining fragment from the lower part of the statue (see fig. 50)[1] preserves the umbels of papyrus plants that "grew" from the base on the proper left side of the sculpture. On analogy with closely comparable statues discussed immediately below, the right side would have shown the flowering sedge, the heraldic plant of Upper Egypt, to complement the papyrus, symbolic of Lower Egypt.

In scale, material, and iconography, this statue closely resembles three other sculptures made during the Eighteenth Dynasty. They have been called depictions of the pharaoh in the guise of the Nile or the god Hapy, who embodied the Nile in flood. But in fact they have nothing in common with traditional personifications of the Nile in art: figures with pendulous breasts and bellies, wearing only a tripartite wig and a belt.[2]

The most fragmentary of the three comparable statues was excavated at Luxor

Temple.[3] All that remains is part of the figure's left leg and a section of the pillar showing grain, lotus blossoms, and ducks, with papyrus plants below on the left side and flowering sedge in the same position on the right. Both remaining statues come from Karnak Temple, the most likely provenance for this sculpture. One of them (Cairo CG 550) is inscribed for Amenhotep III, while the other was commissioned by Thutmosis III (Cairo CG 42056).[4] This last may be the statue of the same type, represented among an array of royal gifts intended for Karnak Temple that was included among the paintings in the tomb of the vizier Rekhmire (time of Thutmosis III—Amenhotep II).

Thutmosis III's statue is the only one of these sculptures whose base is preserved. An inscription on top of it gives the name of the statue, which refers to its function and, by extension, that of the others like it, in the cult. The statue was called "Menkheperre [Thutmosis III's prenomen, or throne name] who offers fresh viands to Amun in Karnak." Thus the king appears in these statues as a priest supplying sustenance to the god. The repertoire of royal statuary includes compositions depicting the king striding, kneeling, or even prostrate, with a variety of offerings, from cult objects to loaves of bread and jars of milk and wine. In this genre, precedence is given to the bounty of the Nile—the flora and fauna that flourished along its banks.

These New Kingdom sculptures were apparently inspired by statues created toward the end of the Twelfth Dynasty during the reign of Amenemhat III. In the earlier compositions the reliefs on the "pillar" depict ducks, lotuses, and fish, the last of which are conspicuously absent from the later examples. But the inclusion of fish in these earlier sculptures is anomalous. Although there is ample documentation for the consumption of fish during pharaonic times, they were traditionally excluded from representations of offerings. The fish in Amenemhat III's statues may have been considered appropriate for a particular deity or an essential reference to a specific cult center. The massive coiffure and the full beard that Amenemhat III wears in his "fish-offering" statues hark back several centuries to the beginning of pharaonic history. This suggests that the sculptors who created them were influenced by significantly earlier works, just as Thutmoside artists took Amenemhat III's 'fish offerers' in turn as the inspiration for their own contribution to the genre. Other sculptures made during the reigns of Thutmosis III and his co-regent, Queen Hatshepsut, similarly refer to and adapt Middle Kingdom prototypes.

The inscription on the back pillar of the British Museum statue, which continues on the fragment in Cairo, reads:

> There lives the perfect god [i.e., the king] who does what is beneficial for his father Amun-Re, the King of Upper and Lower Egypt Djeserkheperure-Setepenre, the son of Re Hor[emheb] beloved of Amun . . .

*Fig. 50. Fragment of the Lower Part of this Statue in the Egyptian Museum, Cairo. Drawings of the side and back by C. Loeben, from photograph in the archives of Chicago House, Luxor.*

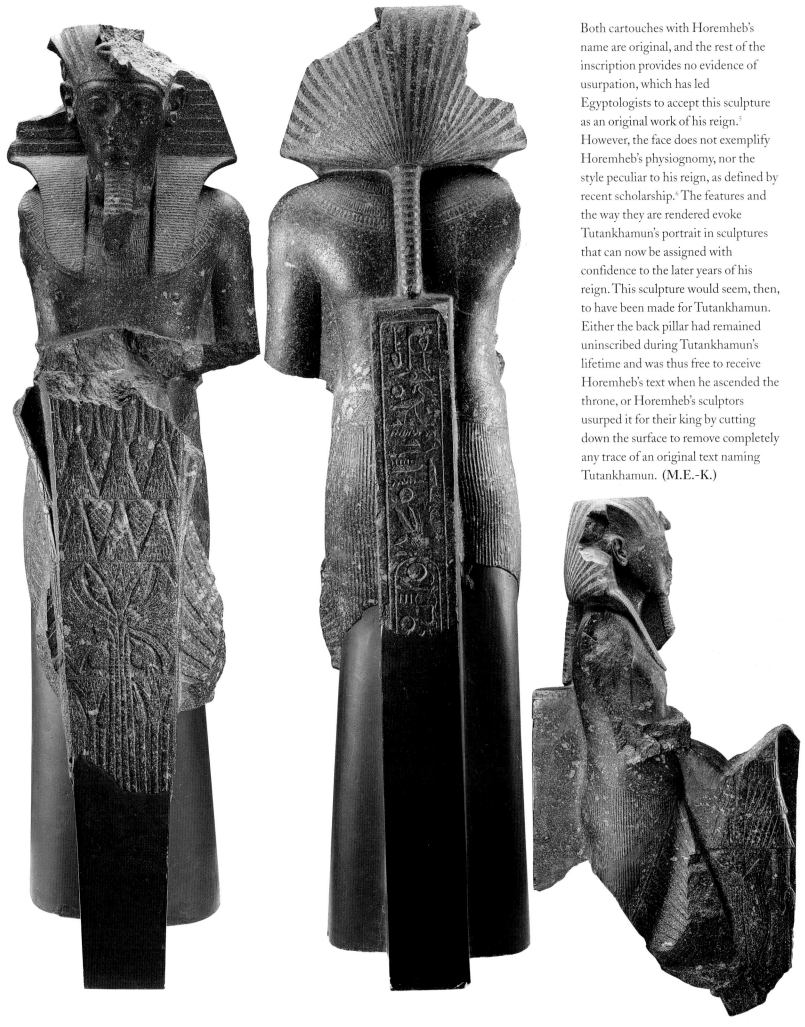

Both cartouches with Horemheb's name are original, and the rest of the inscription provides no evidence of usurpation, which has led Egyptologists to accept this sculpture as an original work of his reign.[5] However, the face does not exemplify Horemheb's physiognomy, nor the style peculiar to his reign, as defined by recent scholarship.[6] The features and the way they are rendered evoke Tutankhamun's portrait in sculptures that can now be assigned with confidence to the later years of his reign. This sculpture would seem, then, to have been made for Tutankhamun. Either the back pillar had remained uninscribed during Tutankhamun's lifetime and was thus free to receive Horemheb's text when he ascended the throne, or Horemheb's sculptors usurped it for their king by cutting down the surface to remove completely any trace of an original text naming Tutankhamun. (M.E.-K.)

## Notes

[1] In 1977 Labib Habachi advised T. G. H. James, then keeper of Egyptian antiquities at the British Museum, of his discovery of a fragment in the collection of the Egyptian Museum, Cairo, that joined EA 75. I learned of its existence from James in 1981. At my request Christian E. Loeben searched for information on the piece among Habachi's papers, which were left in the care of Chicago House, Luxor. I am indebted to Loeben for making a tracing from a photograph that was all that could be found. It is reproduced here with the kind authorization of W. Raymond Johnson, director of Chicago House. Unfortunately, the museum number that Habachi noted for the piece (Temporary register 20/13/41/3) is in error; to date, my efforts to locate the correct entry in the inventory of the Egyptian Museum have been unsuccessful.

[2] See Baines 1985, p. 118, who also noted that such fecundity figures do not present the selection of offerings shown here. An exception is a British Museum statue (EA 8) bearing the names of Osorkon I and Sheshonq II; it represents a Nile god proffering much the same produce as in EA 75, depicted in relief on a tapering pillar: PM II 1972, p. 289.

[3] Aswan, consistently cited as the provenance of this piece, is incorrect; see Laboury 1998, p. 431, n. 1131. Thus this is probably the statue whose existence was remarked at Luxor Temple by Gamer-Wallert 1970, p. 71, n. 128.

[4] In his discussion of this sculpture, Laboury 1998, pp. 136–39, 431, reviews the comparative material, including EA 75.

[5] E.g., Hari 1964, p. 265; Müller, M. 1989, pp. 17f., 22 (no.12).

[6] Johnson 1994, pp. 130–36.

### Bibliography

PM II 1972, p. 533 (with earlier bibliography).

James/Davies 1983, p. 43 with fig. 51.

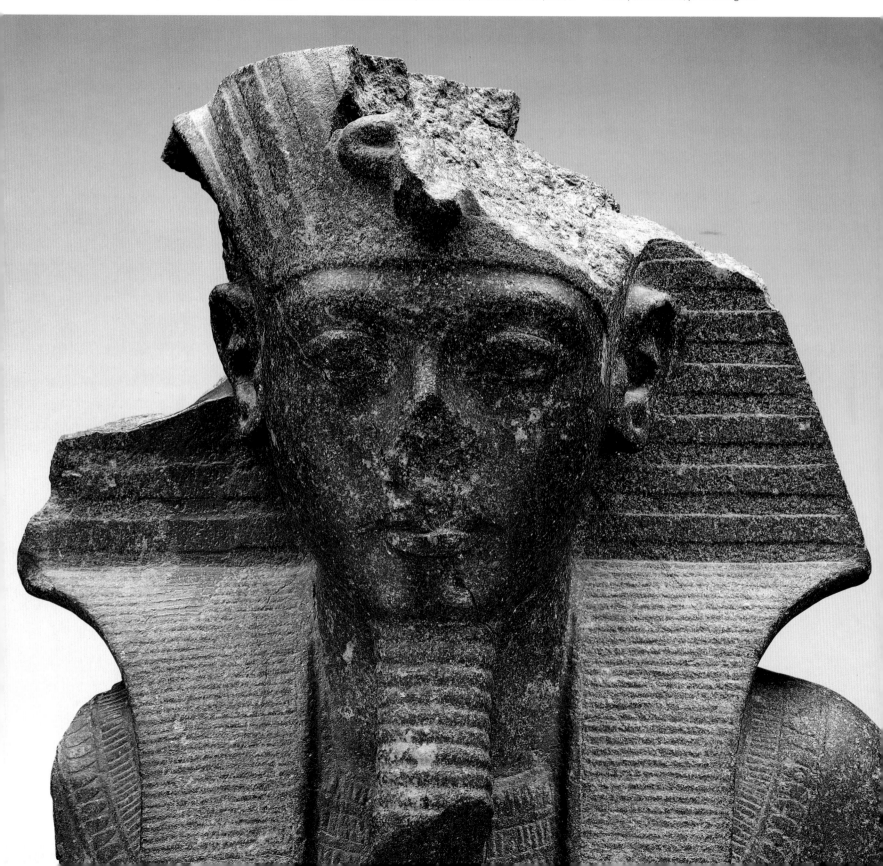

# The Scribe as Artist
## (catalogue numbers 64-69)

Since hieroglyphic inscriptions were an integral part of Egyptian two- and three-dimensional art, many, if not most, painters and sculptors were trained as scribes. Among a largely illiterate population, destined for heavy labor, the scribal professions were relatively privileged.[1] From the establishment of the master sculptor Thutmose at Amarna,[2] it is clear that the heads of royal ateliers could enjoy considerable wealth and social standing.

The scribal training of artists served to maintain the close interrelationships between texts and images already established in the First Dynasty (cf. cat. no. 2). Since the pictorial hieroglyphs had to be drawn to exact specifications in order to be readily recognized, this training fostered the primacy of line drawing, especially the drawing of contours, in painting and also in reliefs, which were always drawn in detail before being carved. Since student scribes and artist-scribes learned by copying (see cat. nos. 66 and 68), their lessons would have reinforced the conservatism of their conservative culture.[3] But they certainly learned to draw. The best Egyptian drawings and sketches have an almost calligraphic fluency of line (cf. cat. no. 78); and the rare examples of finished drawings, not meant to be carved or colored, can be set alongside the most accomplished drawings anywhere (cat. nos. 99 and 104).

All this was achieved with the simplest of tools, the most laborious of methods, and teamwork. A scribe's pens and brushes were twigs or reeds with frayed ends. His inks were cakes of ground pigment to which he added water as needed. The painter's more extensive palette was a series of small bowls (or large clamshells). His assistants ground and mixed each batch of pigment to order. Sculpture and painting workshops must have consisted of one or more masters, assistants, apprentices, and unskilled help. But, except for the painters of Deir el Medina (fig. 51; cat. nos. 78 and 98), who decorated the New Kingdom royal tombs in the Valley of the Kings,[4] we know little about how the work was actually apportioned and carried out. In the case of sculptors, we are not even sure just where certain large statues were made: in the studio, in the stone quarry, or at the final destination.[5] The making of art, like the nature of art, was a subject the ancient Egyptians evidently saw no purpose in discussing in written form. (E.R.R.)

### Notes

[1] A point made at length in a literary composition of the Middle Kingdom: Parkinson 1991, no. 17, pp. 72–76.

[2] Arnold, Do. 1996, pp. 41–45.

[3] On the training of draftsmen at Deir el Medina, see Keller 1991, pp. 51–54.

[4] Keller 1991, pp. 54–56, 60–67; for the extensive literature on the Deir el Medina workmen, see the notes to cat. no. 98.

[5] See, for example, Kozloff/Bryan 1992, pp. 136–38.

*Fig. 51. Thebes, Deir el Medina: Village (left and center) and Cemetery (right, with restored tomb pyramid). Eighteenth–Twentieth Dynasties (ca. 1550–1069 B.C.).*

# 64

## Flask in the Form of a Fat Scribe

Provenance unknown
New Kingdom, Eighteenth Dynasty
(ca.1550–1295 B.C.)
Terracotta, painted
Height 6 ⅛ in. (15.3 cm)
EA 24653, acquired in 1893

This terracotta figure of a scribe depicts him as a very fat man with huge legs,[1] sitting on the ground with one knee drawn up and a papyrus roll spread across his lap.[2] The asymmetry of his pose is accentuated by the slight turn of his head, as he smiles down at his text. With his plain short kilt and nondescript wig, he is clearly not one of the upper-echelon scribes who ran Egypt (cf. cat. no. 122), but a stock character of a much humbler type—a household servant, a military supply clerk[3]—or a not very successful artist.

The figure is a bottle, one of a group of finely made red-ware vessels, sparingly decorated with black paint, that date to the Eighteenth Dynasty (another is cat. no. 80). The other known examples, however, are female figures, a fact that encouraged an early commentator to assume this figure, with its sagging breasts and fat thighs, was also a woman.[4] Some of the female figure vessels are believed to have been made as containers for medicines or nostrums to treat problems of pregnancy, childbirth, and infancy.[5] By that kind of reasoning, this scribe should have been an inkwell, but Egyptian inks were kept in dry form. Like his identity, his function, once obvious perhaps, is now a mystery. **(E.R.R)**

### Notes

[1] It is possible that the legs were enlarged in order to increase the interior volume of the vessel.

[2] This variation of the scribe's cross-legged pose was an invention of the Sixth Dynasty: Russmann 1995, p. 272; it appeared sporadically thereafter.

[3] Scott 1989, p. 358, notes a resemblance between this headdress and those of soldiers at Amarna; but with so simple and generic a shape, the similarity may not be significant.

[4] Murray 1911, no. 57, p. 44. The hairdo, the kilt, and the presence of the papyrus negate this interpretation.

[5] See, for example, Brunner-Traut 1969–70.

**Bibliography**

Parkinson 1999, no. 45, p. 130 (with bibliography).

Scott 1989, no. 131, pp. 358–59.

# 65

## Merire's Scribal Palette

Provenance unknown

New Kingdom, Eighteenth Dynasty, reign of

Thutmosis IV (ca. 1400–1390 B.C.)

Wood, traces of ink

13 1/8 x 2 3/4 in. (33.2 x 7 cm)

EA 5512, acquired in 1848, purchased at Christie's

from the sale of the Andrews Collection

In the New Kingdom, most scribes' palettes were
narrow wooden rectangles like this, lightweight
and sized to fit comfortably in the hand. They
had small round or oval hollows for the cakes of
dry inks and a center slot to hold several slender
reed pens.[1] The only other equipment required
was a container for water.

Since black and red were the only colors
needed for writing,[2] most scribal palettes have
only two ink pans. This example is unusual, but by
no means unique, in having more. One would
expect that the fourteen hollows here held
different colors, as is the case with an ivory palette
in the Metropolitan Museum of Art, which has
six oval wells that still hold blue, green, brown (?),
yellow, red, and black pigments, all of which show
signs of use.[3] This palette, however, has traces only
of black and red around the four lowest wells on
the right side and in the pen slot, where the
predominance of black at the top and red at the
bottom suggests that two ends of a single pen
were used for the two colors and that pens were
replaced in the slot with the more frequently used
black tip toward the top.[4]

A scribe's palette tended to be a very personal
possession; many were inscribed with the owner's
name, and many accompanied their owner to his
tomb. This palette belonged to Merire, the chief
steward of Thutmosis IV, whose name appears in
a cartouche at the top. The palette was specially
prepared for being placed in Merire's tomb. Along
the sides, with his name and title, are funerary
prayers addressed to the dynastic god Amun and
to Thoth, the god of writing and patron of scribes.
These were inscribed, as the bottom line tells us,
by Merire's own scribe. (E.R.R.)

**Notes**

[1] For other examples, see Glanville 1932; Parkinson 1999,
nos. 58–60, pp. 145–46.

[2] For the use of red for highlighting, punctuation, etc., see
Parkinson/Quirke 1995, pp. 44–46.

[3] MMA 26.7.1294: Hayes 1959, pp. 255–56, fig. 154. The
palette, clearly a luxury item, bears the cartouche of
Amenhotep III; but, as Hayes notes, he was not necessarily
its owner or its user.

[4] As observed by Glanville 1932, p. 56.

**Bibliography**

Glanville 1932, pp. 56–57, pls. 7, 3.

Parkinson/Quirke 1995, fig. 17, p. 31.

# 66

## Drawing Board

Provenance unknown

New Kingdom, Eighteenth Dynasty (ca. 1475 B.C.)

Wood, plaster, ink

14 3/8 x 21 1/8 in. (36.5 x 53.4 cm)

EA 5601, acquired in 1835 at the sale of the Salt
Collection

This object consists of a rectangular wooden
board covered with a thin layer of plaster.
Originally a squared grid, ruled in red, covered
the whole of one side of the board; the other side
is blank. The grid still remains on the left half of
the inscribed surface, where a seated figure of a
king has been drawn. At some time, the grid was
erased from the right side. On this part of the
board there is now a well-drawn rendering of the
quail chick hieroglyph; seven awkwardly drawn
versions of a forearm with outstretched hand,
also a hieroglyph; and a small sketch identifiable
as a loaf of bread impressed with the imprint of
fingers, since similar loaves are found among
piles of offerings in temple and tomb scenes.

The clumsy forearms are clearly by a
different hand from those that drew either the
king's figure or the quail chick. In each case, the
outline of the arm itself is ruled, not drawn
freehand, as was the usual practice, and the
length of the thumb in relation to the fingers has
presented a problem in at least two of the
examples. To obtain the correct orientation of the
forearms, one must turn the board upside down.

Two cartouches are drawn in association
with the king's figure; both contain the throne

name Menkheperkare. This name was used by Thutmosis III during the time of his co-regency with Hatshepsut, as an alternative to his more usual prenomen, Menkheperre. It is probable, therefore, that the board dates to this period of the king's reign, a date that suits the style of the figure very well.

The figure is drawn on a squared grid in accordance with a system developed in the late Eleventh or early Twelfth Dynasty from a series of guidelines used by artists in the later Old Kingdom and First Intermediate Period to aid in the drawing of figures. In this system, standing figures spanned eighteen grid squares between the soles of their feet and their hairlines; if the baseline is taken as horizontal 0, horizontal 6 ran through the knee, horizontal 9 at the lower border of the buttocks, horizontal 16 through the junction of the neck and shoulders, horizontal 17 at the bottom of the nose, and horizontal 18 through the hairline (cf. cat. no. 27). Seated figures conformed to the same system but occupied only fourteen grid squares between the baseline and hairline because of

their reduced height. The figure of Thutmosis illustrates this neatly. There are nine squares between the hairline and the lower border of the buttocks, as in standing figures, and the buttocks rest on a seat five squares high. Thus, the total height for the seated figure is fourteen squares. The top of the knee rests on horizontal 6, making a lower leg of six squares, as in standing figures. However, the knee is placed one square above the top of the seat, so that only five squares of the leg are factored into the height of the figure.

Squared grids were a tool used by artists to aid them in obtaining acceptably proportioned figures. Although grids were sometimes employed on small items, they were particularly useful for work on large-scale monuments, such as tomb chapels and temples. In contexts where space was limited or work was carried out from scaffolding, so that artists could not step back from their work to gauge the overall effect, the grid was an effective means of ensuring that all parts of a scene and the figures in it were in proportion.

The image of Thutmosis III on the drawing board could be an artist's practice piece, but the high quality of the drawing suggests that it was made by a master draftsman. Possibly it was meant as a model for producing large-scale images of the king on the walls of a temple or tomb chapel. Although the grid was designed primarily to help artists construct human figures, a secondary use could have been to transfer small model drawings onto larger surfaces through the technique of squaring up (cf. cat. no. 69). (G.R.)

**Bibliography**

Capart 1927, pl. 74.

Iversen 1960, pp. 71–79, pl. 16.

Peck 1978, no. 32.

Lorenzen 1980, pp. 181–99, pl. 5.

James/Davies 1983, p. 17, fig. 14 (reversed).

James 1986, p. 16, fig. 12.

Beinlich-Seeber/Shedid 1987, p. 130.

Schlott-Schwab 1989, fig. 102a.

Wilson 1989, pp. 66–67.

Robins 1994, pl. 5.1.

*Art and Afterlife* 1999, no. 104, p. 102.

# 67

## Ostracon Sketch of Nursing Woman in Pavilion

Probably from Thebes, Deir el Medina
New Kingdom, Nineteenth or Twentieth Dynasty
(ca. 1295–1069 B.C.)
Limestone, painted
Height 6 ½ in. (16.5 cm)
EA 8506, acquired in 1843, purchased at the sale of
the Belmore Collection

# 68

## Ostracon Sketches of Lion Head and Nestlings

Probably from Thebes
New Kingdom, Nineteenth or Twentieth Dynasty
(ca. 1295–1069 B.C.)
Limestone, painted
Height 4 ¾ in. (12 cm)
EA 26706, acquired in 1891, purchased via the
Reverend Greville Chester

Fine, white Theban limestone is brittle and
tends to flake into chips with at least one flattish
surface. Produced in quantity by the excavation
of tombs, and free for the taking, these flakes
were used like scratch pads for student exercises,
sketches, copies, and doodles. Many of these
ostraca have survived; most of them, like these
two examples, date to the later part of the New
Kingdom.[1]

One of these ostraca (cat. no. 68) appears to
be part of a school exercise. The practiced hand
of a professional, perhaps the teacher, has drawn
a lion's head in profile; the space around it has
been filled with less impressive attempts to draw
a fledgling. Since this was a hieroglyphic sign
used to write the word *tja*, "fledgling," and other
words containing the same sound, its shape had
to be exactly right, from the open beak with
tongue extended and the featherless little wings
to the huge three-clawed foot and the tiny curl
of a tail. The largest example, though not as well
drawn as the lion head, looks like professional
work. It is probably the work of another school-
master, whose student or students, to judge from
the smaller copies, still had much to learn.

The other ostracon (cat. no. 67), the style of which indicates that it was drawn by one of the Deir el Medina artists (cf. cat. nos. 78 and 98),[2] appears to be a sketch for a wall painting. It depicts a young woman sitting in a vine-covered bower nursing an infant. Her hair tied atop her head, she appears to be naked except for a cloak (or a sling to carry the child?), elaborate sandals, jewelry, and a belt.[3] Her cushioned stool is distinctive in shape. The fragmentary servant figure below, whose earring and partly shaven hairstyle suggest that she is a Nubian, is proffering a mirror and a tubular container for kohl, complete with applicator stick. Since she is surrounded by the same vine leaves, it is probable that she is also in the pavilion, presenting these objects to the young mother, who, secluded in her bower, is tending to her newborn, regaining her strength, and perhaps undergoing purification.

Depictions of this scene on several other ostraca are so similar in detail[4] as to suggest that it was a standard subject—not in tombs (where it is never found) but in houses, where it was painted on the walls of rooms where conception and birth took place. Though almost no domestic mural painting has survived, the bottom of a scene apparently much like this was recorded in a house at Deir el Medina, and fragments of paintings with related themes—the vines and the protective god, Bes (cf. cat. nos. 74 and 75)—have also been found.[5] Though a few scholars prefer to interpret this scene as illustrating a myth or religious festival,[6] most now agree that it represents a "birth arbor."[7] Thus this sketch provides a glimpse not only into Egyptian domestic painting but also into some of the customs surrounding childbirth. (E.R.R.)

## Notes

[1] For the uses of ostraca by artists, see Keller 1991, pp. 51–54. A compendium of Egyptian figured ostraca is yet to be published. See Brunner-Traut 1956 and 1979; Peck 1978; Hayes 1959, figs. 95–96, 236, 245–48, pp. 174–75, 376, 390–93.

[2] For these artists, see Bierbrier 1982.

[3] For the significance of the belt, see cat. nos. 32, 85.

[4] E.g., Peck 1978, p. 188, fig. 13.

[5] Brunner-Traut 1955; this ostracon is p. 14, fig. 4.

[6] E.g., Bierbrier 1982, p. 74, with fig. 50; Kessler 1988, p. 190.

[7] E.g., Robins 1993, p. 71, fig. 22; pp. 83–84; Pinch 1994, p. 127 with fig. 66; Friedman 1994, pp. 97–111, with fig. 5 on p. 105. For the suggestion that this iconography was already in use in Amarna royal imagery, see Arnold, Do. 1996, pp. 99–100, with fig. 90.

## Bibliography

cat no. 67: frequently illustrated; Peck 1978, p. 89, fig. 14; Robins 1997, p. 191, fig. 229.

cat. no. 68: Peck 1978, p. 170, fig. 102.

# 69

## Inked Grid with Drawing of a Goddess

From Saqqara
Ptolemaic Period (305–30 B.C.)
Limestone, ink
14 3/8 x 9 5/8 in. (36.5 x 24.3 cm)
EA 68002, gift of the Egypt Exploration Society
(by division with the Egyptian Antiquities
Organization), 1971

Both sides of this limestone slab have been
covered with a grid, drawn in ink.[1] At the far left
of one side has been drawn the figure of a
woman who stands facing right, holding an *ankh*
sign and the papyrus scepter of a goddess. Though
now much faded, the drawing was very well
executed. The Hellenistic-looking profile
of the goddess indicates a date in the Ptolemaic
Period. Her position at the far left of the space
suggests that she was meant to be part of a larger
composition, very likely one that showed her being
worshiped by a king (cf. cat. no. 138). Even at this
late date, the deity was automatically given the
dominant rightward-facing orientation, while her
royal audience would have occupied the secondary
position, facing left (cf. cat. nos. 6, 20, 138).

The proportions of the goddess are
canonical and determined by the grid. Unlike
Middle Kingdom and New Kingdom examples
of figures on grids, where horizontal line 18
(counting from the bottom) passes through the
hairline (cf. cat. nos. 27, 66), this figure is laid
out in such a way that horizontal line 21 crosses
her upper eyelid. It is thus an example of the
later grid, which was used to proportion two-
dimensional figures from the Twenty-fifth

*Fig. 52. Detail of catalogue number 69.*

Dynasty onward. The reasons for this change,
which do not substantially affect figural
proportions, are not clear.[2]

This figure (as well as a barely visible figure
of a king on the other side) was presumably a
preparatory drawing, intended for transfer, with
the aid of the grid, to a temple wall. It is closely
paralleled by an earlier example, a gridded
limestone slab with a drawing of the Twenty-
sixth Dynasty king Apries between two gods.[3]
The precision with which both of these
examples have been drawn on carefully prepared,
relatively expensive pieces of stone suggests that
their ultimate destination may have been an

archive, where they would have been kept for
future study or reuse. **(E.R.R.)**

### Notes

[1] On the side not shown here, the grid is partly incised. For the uses of the grid in Egyptian art, see the discussion of cat. no. 66; also Robins 1994.

[2] For the late grid and a possible explanation of the change, see Robins 1994, pp. 160–77.

[3] Louvre E 11551: Seipel 1992, no. 209, pp. 498–500; Robins 1994, fig. 7.1.

### Bibliography

Unpublished.

# Creative Solutions
## (catalogue numbers 70–81)

Grouped together in this section are a variety of images, most of them dating to the New Kingdom, most examples of decorative or "minor" arts, and many representing artistic solutions to non-artistic problems. These problems range from the theological necessity of depicting animal-headed gods and demons to the utilitarian requirements of headrests. The materials cover the spectrum of ancient Egyptian media: stone, wood, papyrus, ceramics, and glass, including a very rare example of early glass sculpture (cat. no. 77).

When the makers of these images had no traditional models to follow, they may have been working from ideas, or even specifications, provided by their clients. But the execution was in their hands. The decorative arts of the New Kingdom, in particular, are full of such delightful—and individual—details as the sleek stylization of the wooden hare (cat. no. 73), the zestiness of the lion, triumphant in both play and love (cat. no. 78), and the meticulously accurate rendering of the lute player's dress and instrument (cat. no. 80). In some cases, notably the small figures carrying cosmetic vessels (cat. no. 81), wealthy customers may even have demanded a certain originality, for no two of these objects are alike. (E.R.R.)

# 70

## The God Khnum

Provenance unknown
New Kingdom, Eighteenth Dynasty
(ca. 1550–1295 B.C.)
Sandstone, traces of paint
19 x 21 ¼ in. (48 x 54 cm)
EA 635, acquired in 1904, gift of Mrs. Bagshaw

On this fragment of raised relief from a temple wall, the god Khnum is shown with one arm extended embracing a king, of whom only the shoulder is preserved (for a similar pose and comments on the god's embrace, see cat. no. 16). Khnum was also holding an *ankh* sign to the king's face; the long base of the looped symbol can still be seen between his thumb and fingers.

As bizarre as Egypt's animal-headed gods may look to modern viewers, they deserve to be recognized as ingenious artistic solutions to problems of grafting two entirely disparate anatomies. The first problem was how large to make the animal's head in relation to the human body. The solution may have been instinctive rather than conscious: it consisted in scaling the head so that its eye was at approximately the same height above the shoulders as a human eye would be. When such heads are imagined with proportionately sized animal bodies, almost all are well over life-size—in the case of bird-headed gods like Horus and Thoth, extravagantly so (cf. cat. nos. 102, 105).

The second problem, the transition between head and shoulders, was dealt with by camouflage: the line of the juncture was concealed by the ubiquitous collar necklace and by the divine wig, a long headdress of vertical tresses with front lappets. In addition to symbolizing divinity, this wig had the virtue of adaptability. When worn by anthropoid gods,[1] it is relatively narrow and short; with animal heads, as here, it fills out the back of the head in a manner suggestive of a mane.

In the case of the sphinx, a human head on a lion's body, the same problems were solved in much the same ways: the animal's massive body was offset by a very much oversized head and the transition masked by a bulging mane-like *nemes* (or, in the case of female sphinxes, a large wig) and a bib-like stylization of the leonine chest hair. More rarely, only the royal face was shown, encircled, as if in a hood, by the lion's ruff, mane, and ears.[2] All of the conventions for representing therianthropic images were established during the Old Kingdom in the burst of creativity during the Third and early Fourth Dynasties.[3] By the time this relief was made, over one thousand years later, the correct scale and placement of the ram's head would have been nearly automatic.

Equally automatic was the form of the head itself, with its long, horizontal, loosely spiraled horns—despite the fact that this kind of sheep had long been extinct. The original domesticated sheep in Egypt, it was represented in predynastic art,[4] and the ram-shaped form of Khnum was established in the Old Kingdom.[5] But during the course of the Middle Kingdom, this species was gradually supplanted by a fleecier breed, one with shorter horns that curled around the ears. This new type of ram became a manifestation of Amun. Eventually, long after the New Kingdom, Khnum's long horns were revised to the curled variety. Meanwhile, however, these long horns were becoming increasingly mythic. Although

the horns on this relief can be seen to arise from the top of the god's head, below his divine *atef* crown, other reliefs of the same date show the horns atop his wig, forming a base for the crown.[6] In this way, Khnum's horns came to be considered part of the *atef* crown and eventually part of the similarly shaped crown of Osiris as well (see cat. no. 105). **(E.R.R)**

### Notes

[1] Examples: *Egyptian Art* 1999, no. 109, pp. 328–30 (Old Kingdom); Kozloff/Bryan 1992, no. 17, pp. 178–81, and fig. 17a (New Kingdom).

[2] Saleh/Sourouzian 1987, no. 102; Fay 1996, pls. 90–92 (Amenemhat III); Russmann 1989, no. 37, pp. 83–86 (Hatshepsut).

[3] The earliest known sphinxes are Fourth Dynasty: a female example from the reign of Djedefre: Fay 1996, App. 1, p. 62, pl. 83a–d. The Great Sphinx of Giza (fig. 2) is attributable to Chephren, as are emplacements and fragments of others: ibid., App. 1, nos. 2–7, pp. 62–63.

[4] E.g., the "Libyan" palette: Saleh/Sourouzian 1987, no. 7.

[5] For the earliest preserved representation (Fifth Dynasty), see Bickel 1991, p. 57, fig. 1.

[6] Bickel 1991, p. 59, fig. 5. This entire paragraph draws heavily on Bickel's article.

**Bibliography**

Quirke/Spencer 1992, p. 62, fig. 43.

# 71

## Gazelle(?)-Headed Guardian Demon

From Thebes, Valley of the Kings, tomb of Horemheb
New Kingdom, Eighteenth Dynasty, reign of
Horemheb (ca. 1323–1295 B.C.)
Wood
Height 16 in. (40.5 cm)
EA 50703, acquired in 1912

# 72

## Turtle-Headed Guardian Demon

From Thebes, Valley of the Kings, tomb of Horemheb
New Kingdom, Eighteenth Dynasty, reign of
Horemheb (ca. 1323–1295 B.C.)
Wood
Height 14 ³/₄ in. (37.2 cm)
EA 50704, acquired in 1912

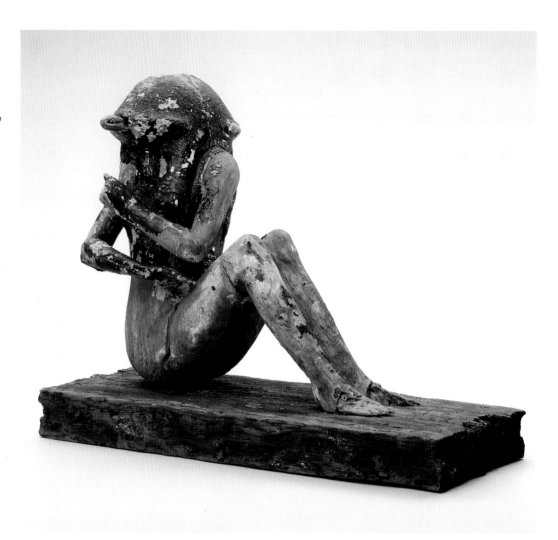

On these two guardian figures, the Egyptians' long practice in placing animal heads on human bodies (cf. cat. no. 70) was exploited to demonic effect. The contorted pose of these creatures, who sit with their lower halves in profile and their upper bodies turned toward the viewer, is eerily menacing, as if the monsters were ponderously swinging around to confront an interloper. In fact, the divided orientation of their bodies so resembles the conventions of Egyptian two-dimensional arts as to suggest prototypes in relief or painting. If there were two-dimensional precedents for these figures, however, they have not survived.

The head of one monster is some kind of antelope—probably a gazelle, to judge from the shape of the preserved horn.[1] Of the nature of the head on the second demon, there can be no doubt: it is a turtle—a whole turtle, with its head extended. As on representations of animal-headed gods (cf. cat. no. 70), a divine wig has been used to mask the juncture between animal and human. Here, however, a clever vagueness has been employed—it is unclear whether the wig passes over or under the turtle's shell.

Both the turtle, a mud dweller, and the antelope, who inhabited the wild lands of the deserts, were considered creatures of chaos, dangerous to the living and enemies of the gods. In the Middle Kingdom, however, they were depicted on jewelry (see cat. no. 35), magical implements, and even children's drinking cups,[2] thus transforming their threat into protective power.

These more mythical forms of the beasts were also apotropaic: designed to protect the king in his journey to the Afterlife and in his travels with the sun god, Re. They appear to be the earliest of their kind; nothing similar was found among the magical statuettes in the tomb of Tutankhamun, whose reign preceded that of

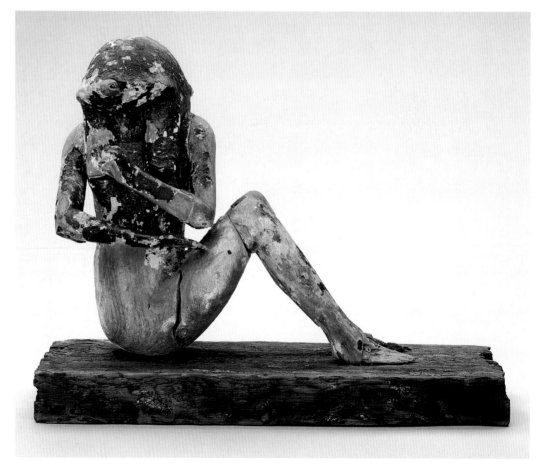

Horemheb by only a few years. Two almost identical but less complete statuettes were found in the tomb of Horemheb's successor, Ramesses I.[3] Subsequently, these and other apotropaic demons were represented on the walls of the royal tombs.[4] **(E.R.R).**

## Notes

[1] For a weight in the form of a gazelle with similarly shaped horns in the Metropolitan Museum of Art (MMA 68.139.1), see Arnold, Do. 1995, no. 4, p. 11.

[2] E.g., Fischer 1968, p. 11, fig. 5; pp. 30–33, pls. 19, 20 (the child's cup).

[3] Both are now in the British Museum: EA 61416 (turtle-headed), 61417 (gazelle-headed): Hornemann 1957, pls. 501, 502; compare Reeves/Wilkinson 1996, pp. 134–35; also Romer 1981, pp. 65–66.

[4] Waitkus 1987, esp. pp. 65, 81–82 (no. 11).

## Bibliography

cat. no. 71: Hornemann 1957, pls. 505–506; *Africa* 1996, no. 9, pp. 48–49; Reeves/Wilkinson 1996, p. 132.

cat. no. 72: Hornemann 1957, pls. 503–504; Fischer 1968, p. 11 with n. 28, pl. 3; *Africa* 1996, no. 10, pp. 48–49; Quirke/Spencer 1992, fig. 78.

# 73

## Headrest in the Shape of a Hare

Provenance unknown
New Kingdom (ca. 1550–1069 B.C.)
Tamarisk wood
Height 7 7/8 in. (20 cm)
EA 20753, acquired in 1888, purchased via Sir E. A. W. Budge

As a support for the most vulnerable part of the body when it was most at risk from powers of darkness, the headrest was a potent symbol of protection. A headrest amulet was often included in the mummy's wrappings,[1] and the *Book of the Dead* contains a headrest spell that promises, "Your head shall not be taken away from you forever."[2] Actual headrests were often magically fortified by protective symbolism (see cat. no. 74). After serving their owners in life, they frequently went with them into the tomb.

It is clear, therefore, that this cleverly designed headrest, in the form of a desert hare whose long ears formed a cantilevered cradle for the sleeper's head, had a meaning deeper than its charming, perhaps deliberately humorous appearance. At least one other headrest[3] and numerous amulets[4] depicting a hare in the same crouching position show that its symbolism was well known to the ancient Egyptians. But this meaning is much less obvious to us.

As a desert creature, the hare was considered, like the gazelle and other antelopes (cf. cat. no. 71), to be a creature of chaos and potentially dangerous. The running hares on an amuletic bangle of the Middle Kingdom (cat. no. 35) show that the threat of this animal, like that of the gazelle and the turtle, could be magically reversed to provide protection. Though hare headrests and amulets may also be apotropaic images, the fact that they are shown crouching, rather than running, suggests that they had a different meaning.

The animal's alertness, fleetness and fertility have been suggested as positive symbolic meanings, as well as a Greek and Roman belief, possibly also held by the Egyptians, that it slept with its eyes open.[5] Although this last trait would seem especially fitting for a headrest animal, this hare's eyes appear to be almost closed.

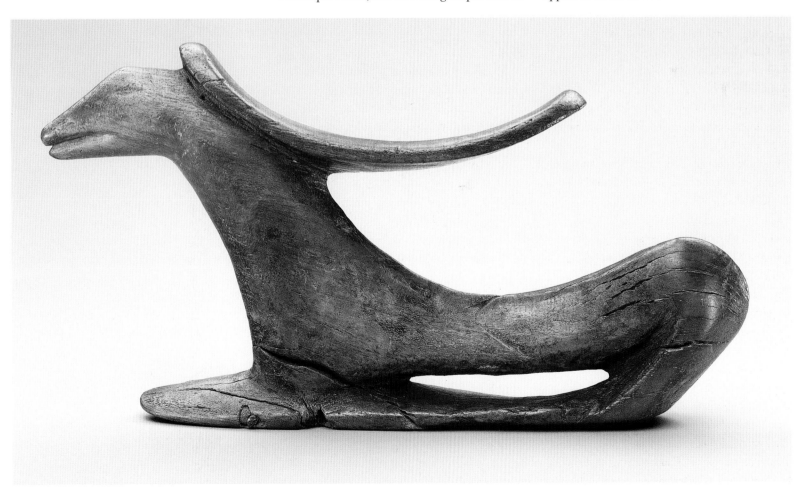

The crouching hare was also a hieroglyph, with the sound value *wn* (wen). Among its most frequent uses was in writing a word meaning, "to be," "to exist." This hieroglyphic meaning, rather than any qualities of the animal itself, has been suggested to be the source of its amuletic significance.[6] This explanation (to my mind the most plausible) shows yet another aspect of the complex intermeshing of writing and imagery in ancient Egypt. (E.R.R).

### Notes

[1] Andrews 1994, pp. 94–96 with fig. 95.

[2] Faulkner 1985, p. 161, spell 166.

[3] Petrie 1927, no. 35, p. 35, pl. 32.

[4] Andrews 1994, p. 61, fig. 60e; Arnold, Do. 1995, no. 21, p. 23.

[5] Arnold, Do. 1995, p. 23; Andrews 1994, pp. 63–64.

[6] Costa 1988, pp. 44–45, with reference to this headrest.

### Bibliography

Phillips 1995, no. 1.53, p. 90 (with bibliography).

# 74

## Folding Headrest

From Akhmim
New Kingdom, Eighteenth Dynasty, reign of
Amenhotep III to Horemheb
(ca. 1390–1295 B.C.)
Wood
7 1/2 x 7 5/8 in. (19.2 x 19.4 cm)
EA 18156, acquired in 1887

While they slept, ancient Egyptians rested their heads on low wooden or stone supports. The fundamental design form of the Egyptian headrest—a flat base, a straight shaft, and a neckpiece curved to accommodate the head—appeared as early as the First Dynasty (ca. 3100–2890 B.C.) and continued through the Ptolemaic Period. Similar headrests are still manufactured in west Africa.[1]

This late Eighteenth Dynasty example displays an unusual variation of the traditional type. The base and shaft have been replaced by two legs in the form of ducks' heads and necks that are pierced by a pivot so that the piece could be folded shut for easy storage and transportation. The artisan who designed this piece was inspired by construction of the Egyptian folding stool. Folding furniture first appeared during the

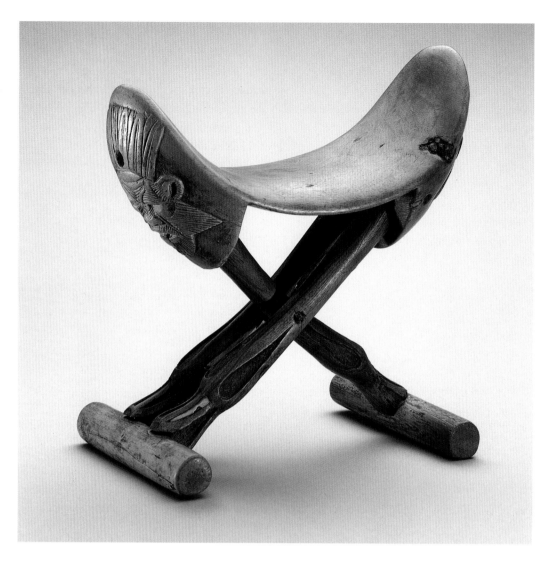

Middle Kingdom in the form of simple camp stools. By the Eighteenth Dynasty, the convenience of folding furniture had increased its desirability and cost, until such items became highly coveted status symbols for the Egyptian nobility. Craftsmen, always ready to accommodate wealthy clients, lavished great care on folding furniture, producing pieces of elegance and refined design.[2] Perhaps the finest example is the folding bed from the tomb of Tutankhamun.

Archaeologists have found numerous New Kingdom headrests in houses at Amarna and Deir el Medina, where they functioned as standard pieces of bedroom furniture. An unusually large number, however, were discovered in tombs. Often they were placed in coffins, either next to the mummy's head or supporting it.[3] Like any burial gift, headrests served to assist the deceased in his or her quest for immortal life.

The *Book of the Dead*, a series of magical funerary spells written in the New Kingdom, mentions that the headrest was an important

burial offering that protected and preserved the deceased's head in the Afterlife. These magical associations derive from the image of a round head nestled in a curved support. For the Egyptians, the arrangement recalled the hieroglyph for "horizon": the sun (the head) rising between two mountains (the ends of the support). The sun's daily reemergence over the eastern horizon signified glorious solar rebirth, a literal renewal of existence after the dark lifelessness of night. Just as the sun was "reborn" each day at dawn, so too could the deceased assume the role of the sun and experience physical rebirth after death if an actual headrest, or even a tiny amulet reproducing the basic form, was included in the burial.

According to Egyptian mythological texts, various malevolent forces, including snakes, scorpions, and demons, menaced the newly born sun god. Each day the solar infant survived these dangers with the help of a strange demigod often called Bes.[4] This guardian wears a high, plumed headdress; his face has wide, penetrating

eyes, a broad, flat nose, and an open mouth with a thick red tongue projecting over his lower lip. Complete figures of Bes (see cat. no. 75) invariably show him with short limbs, a stocky torso, and a tail; some brandish swords or knives to ward off evil. As the protector of the infant sun, Bes was an appropriate image for headrests. On this example, faces of Bes adorn both ends of the curved support, literally cradling the sleeper's head with divine protection. Specific features of these two images, including his thick eyebrows and the two flesh folds running along his cheeks, help date the headrest to the late Eighteenth Dynasty. (J.F.R.)

### Notes

1 Green/Yurko 1996, pp. 46–49.

2 Killen 1980, pp. 40–42.

3 Ruffle 1977, p. 141.

4 Romano 1998, pp. 89–105.

### Bibliography

*Treasures* 1998, no. 75, p. 240.

Der Manuelian/Romano 1982, no. 47, p. 75.

Ruffle 1977, p. 141, fig. 108.

# 75

## Lamp with Figure of the God Bes

Provenance unknown

Roman Period, probably first to early second centuries A.D.

Terracotta

Height 8 1/2 in. (21.5 cm)

EA 15485, acquired in 1877, purchased via the Reverend Greville Chester

Egypt became a province of Rome in 30 B.C., soon after Octavian (later Caesar Augustus) defeated the Egyptian navy led by Marc Antony and Cleopatra VII at the battle of Actium. Foreign rule was nothing new to the Egyptians. For nearly three hundred years, they had been governed by the Ptolemies, descendants of Alexander's Macedonian general Ptolemy, who founded a dynasty of "pharaohs" in 305 B.C.; Cleopatra was the last of the Ptolemies.

During the Ptolemaic Period, the Egyptians had been willing to adopt specific elements of Greek religion and art, but they were careful never to forsake their own traditions, which had

guided and inspired them for more than three thousand years. When the Romans seized power, the Egyptians continued the practice of accepting some of the new but retaining much of the old. This charming terracotta lamp, a hybrid of Egyptian and Roman cultures, demonstrates how skillfully Egypt's artisans could combine such different artistic traditions. The sculpted base represents an Egyptian god commonly known as Bes (see cat. no. 74). Atop his head, in place of Bes's familiar feathered headdress, is a Roman lamp with two nozzles and a decorative leaf-shaped attachment over the handle. Archaeologists have found similar lamps, without the appended Bes figure, throughout the Roman world, from Egypt to Greece, Italy, and Britain. Most can be dated to the first and early second centuries A.D.; a few were used as late as the early fourth century, probably as heirlooms.[1]

Bes belonged to a group of male demigods, including Aha, Hayet, and Menew, who safeguarded the home against malevolent forces both real (scorpions and snakes) and imagined (demons). The god's most important role was that of protector of new mothers and infants during the perilous period during and immediately after delivery. Images of Bes and his fellow guardians appear on a variety of Egyptian household items including chairs, beds, mirrors, cosmetic containers, and even an infant's feeding cup. The classic Bes image, with a huge head, beard, open mouth with projecting tongue, short, thick limbs, stocky torso, full stomach, and fleshy buttocks, first appeared in the mid-Eighteenth Dynasty (ca. 1400 B.C.). Over the ensuing centuries, the basic form remained constant, but details changed. In the Twenty-second Dynasty (ca. 945–715 B.C.), for example, artisans depicted the deity with a long mustache. Elements of the Bes on the British Museum lamp, such as his high arching eyebrows and a beard consisting of long strands ending in tight curls, began in the Twenty-sixth Dynasty (664–525 B.C.) and continued with little variation throughout the Roman Period.[2] Bes normally appears naked from the waist down; as a concession to Roman taste, the artisan who designed the lamp clothed Bes in a short skirt that covers his genitals.

Like most Roman lamps, this piece was produced in a mold. The craftsman began by sculpting a model or patrix in clay or wood. Molds

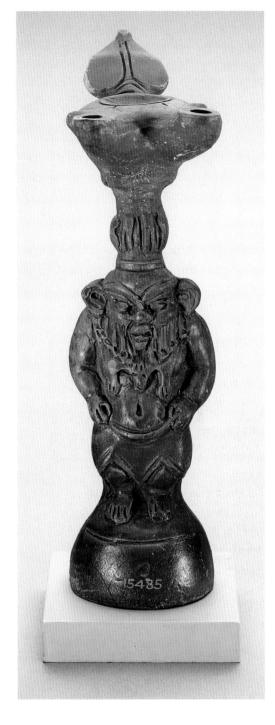

were then fashioned by covering one half of the patrix in clay. After the clay was dry, the process was repeated, creating a mold for the other side of the model. The two halves of the mold were then fired in a kiln until hard; then they were ready for use. A thin layer of wet clay was then poured into each half of the mold and any excess trimmed away. While the clay was still moist, the two molds were pressed together. After the clay had dried completely, the molds were separated and the lamp removed. Next, the artisan carefully smoothed away the seam marking the juncture of the two molds. Finally, the lamp was allowed to dry, covered with glaze, and fired.[3] (J.F.R.)

**Notes**

[1] Shier 1978, p. 33.

[2] Romano 1998, pp. 89–105.

[3] Bailey 1963, pp. 13–16.

**Bibliography**

Bailey 1963, p. 32, pl. B.

James 1988, p. 73, fig. 47.

# 76

## Bottle in the Form of a *Bolti*-fish

From Amarna[1]

New Kingdom, Eighteenth Dynasty, reign of
Amenhotep III or Akhenaten
(ca. 1390–1336 B.C.)

Polychrome glass

Length 5 ¾ in. (14.5 cm)

EA 55193, gift of the Egypt Exploration Society,
1921

Of the several surviving fish-shaped vessels in
glass made in or near the Amarna Period,[2] this is
the most complete, the most spectacular, and the
most fish-like. Its staring eyes, gaping, turned-
out mouth, and slightly curving dorsal fin, even
the water-like blues of its bright coloring, evoke
both the remoteness and the immediacy of an
aquatic animal in its habitat. The vessel was
treasured by its last owner, who buried it, along
with several other small luxury containers,
beneath the floor of a house at Amarna.

The fish represented is a *bolti* (genus
*Tilapia*), found in shallow parts of the Nile and
then, as now, an important food fish.[3] Because of
its association with the fecund papyrus marshes
and also, perhaps, because the female hatches and
shelters her young in her mouth, the *bolti* was a
symbol of rebirth and regeneration, frequently
worn as an amulet (cf. cat. no. 32). This little
bottle would have held scent—presumably of a
flowery rather than a fishy kind.

The fish form lent itself well to the New
Kingdom technique for making glass vessels,
which was to apply and heat the glass over a core
of clay and organic matter. Rods of different-
colored glass were then softened, wrapped
around the body, and trailed to produce swags,
chevrons, or, as here, ripply scales.[4] The tail and
fins were added separately. When a piece was
finished, the core would be scraped out. It is no
coincidence that the colors on this fish are those
of turquoise, lapis lazuli, and yellow jasper. The
ancient Egyptians loved these bright,
unfading—and symbolic—glass colors; for
them, glass was primarily a more versatile and
somewhat less expensive substitute for
semiprecious stones. (E.R.R.)

**Notes**

[1] Found under a plaster floor in a room east of House N. 49. 20:
Peet/Woolley 1923, pp. 23–24, pl. 12/3.

[2] E.g., Brooklyn BMA 37.316E: *Golden Age* 1982, no. 179, p.
165; Cooney 1976, no. 1754, p. 146. For the argument that it
was made outside of Amarna, probably at Malqata, under
Amenhotep III, see Kozloff in Kozloff/Bryan 1992, pp. 386–88.

[3] Brewer/Friedman 1989, pp. 76–79.

[4] For the most recent discussion of core forming, see Nicholson
in Nicholson/Shaw 2000, pp. 203–204 with fig. 8.4.

**Bibliography**

Often illustrated.

Cooney 1976, no. 1753, p. 146, pl. 7 (with bibliography).

Kozloff/Bryan 1992, p. 370, pl. 49; no. 95, pp. 386–88 (with
bibliography).

Quirke/Spencer 1992, p. 182, fig. 142.

Freed/Markowitz/D'Auria 1999, no. 212, p. 265.

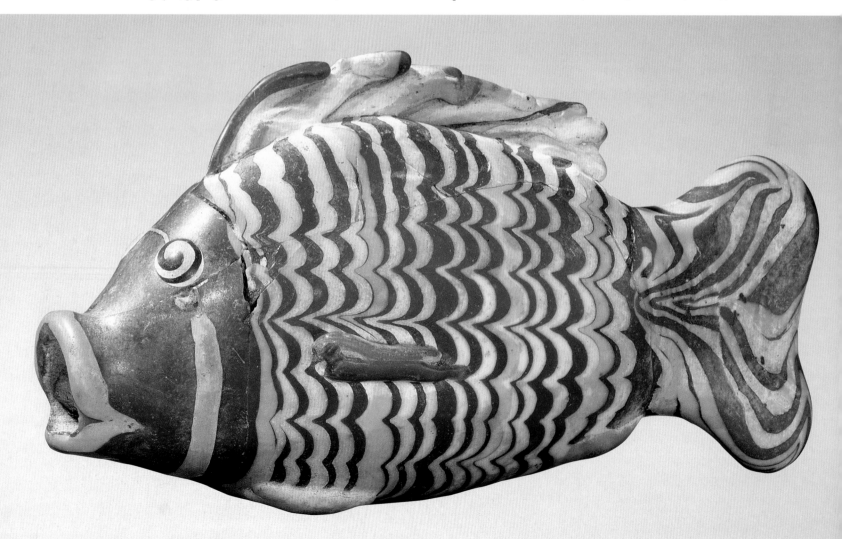

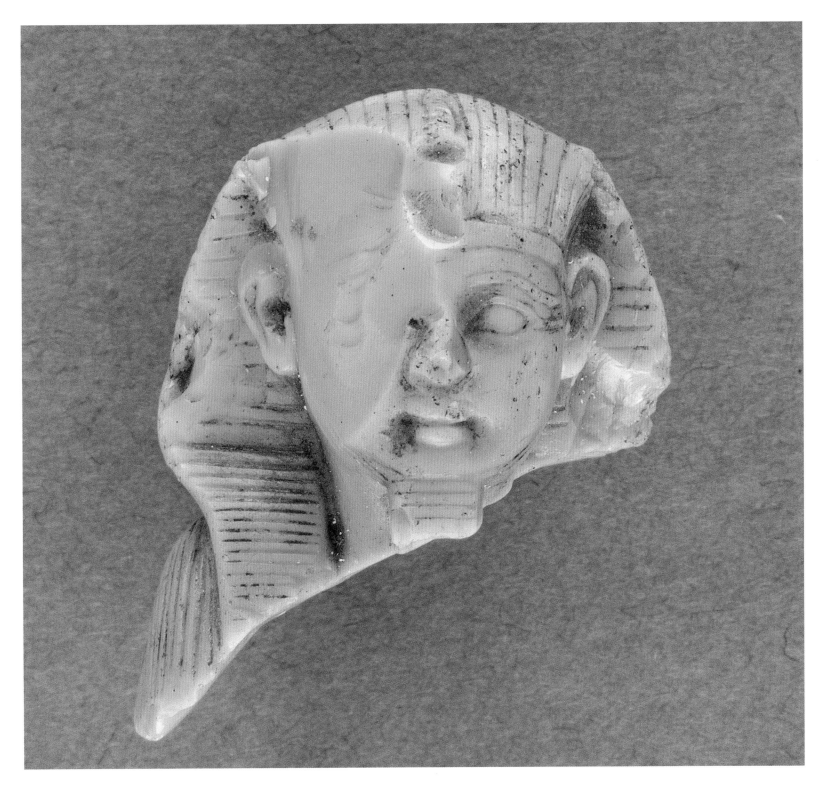

# 77

### Head of a Glass Sphinx of Thutmosis IV (?)

Provenance unknown
New Kingdom, Eighteenth Dynasty, probably reign
of Thutmosis IV (ca. 1400–1390 B.C.)
Glass
Height 1 ¼ in. (3.2 cm)
EA 16374, acquired in 1869, purchased from Mr. Leider

This minute light-blue head of a sphinx—the only sphinx in this catalogue—is a rare example of Egyptian glass sculpture, made in a mold and finished with details carved in the cooled glass. Though the Egyptians had long experience in molding and cold-finishing small statuettes in faience (cat. no. 79) and in the glass-like Egyptian blue,[1] they did not take to glass as a sculpture medium. That may have largely been due to technical difficulties, which, as described in the most recent discussion of Egyptian glass

molding, seem to have been nearly insuperable.[2] Yet the quality of this head, and of the three pieces related to it, is superb.

This cluster includes two *shabtis* in light blue glass, made for high officials who were close to the king: the chief steward of Amenhotep II and the tutor for the children of his successor, Thutmosis IV.[3] The third example is a head from a royal statuette (not a sphinx) in medium blue glass now covered by a buff-colored substance, the result of weathering. The facial features of

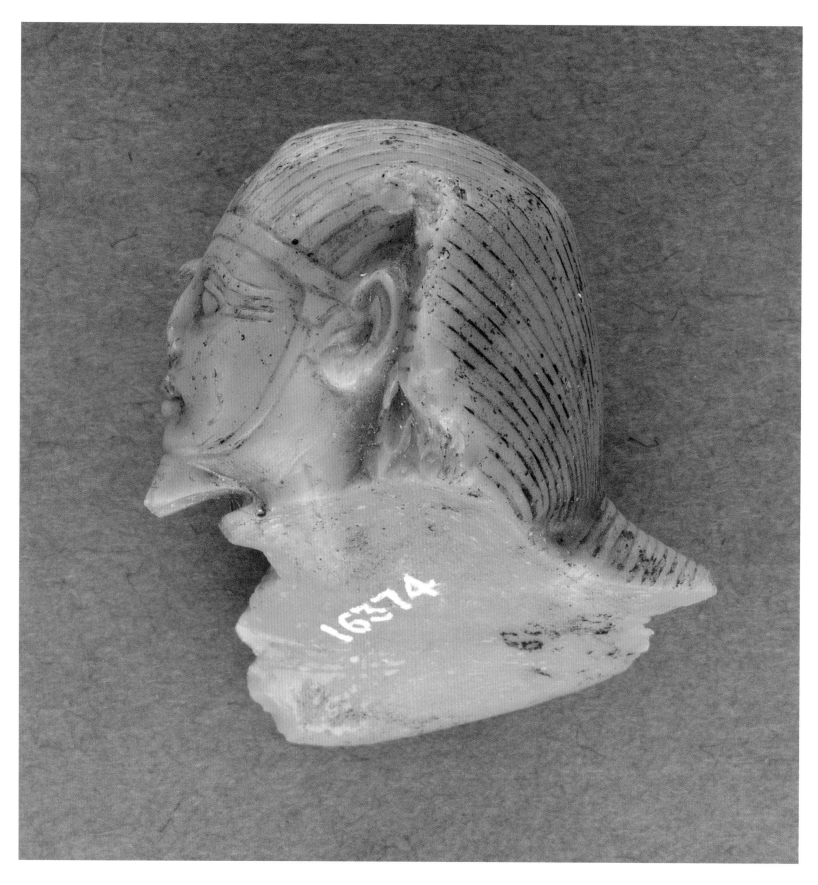

that head are so well preserved that it can be identified as a representation of Amenhotep II.[4] The apparent similarity of the glass used for these three statuettes, their closeness in time, and their royal connections strongly suggest that they are products of the same royal glass studio.[5] In all

probability, that studio was the source of the sphinx from which this head was broken.

This head appears to have been more softly modeled than the glass head of Amenhotep II. It is rounder and shorter in the chin, and the mouth has large, round depressions at the

corners. These characteristics suggest the round-faced representations of Amenhotep III, but the distinctive details of his eyes and mouth, which should be recognizable even on so small a scale,[6] are lacking (cf. cat. no. 52 and fig. 24).

A detail of the royal iconography points to a

date earlier than Amenhotep III: on almost all representations of that king wearing a *nemes*, the body of the uraeus cobra loops up behind its head and hood to form an oblique curve on either side.[7] On the undamaged side of this head, no such loop is visible. The uraeus follows the form on representations of earlier Eighteenth Dynasty kings.[8]

I suggest that this glass sphinx represented Amenhotep III's father, Thutmosis IV (cf. cat. no. 50), some of whose statues depict him with a broad, short-chinned face.[9] It may have been the last of its kind; after this reign, the manufacture of fine glass sculpture seems to have ceased. From the time of Amenhotep III, New Kingdom glass sculpture was much less ambitious, limited to tiny figures[10] and to faces and other body parts to be assembled into composite statues.[11] (E.R.R.)

### Notes

[1] For Egyptian blue, see Nicholson/Shaw 2000, p. 178; for a sculptural example, a winged sphinx of Amenhotep III, see Kozloff/Bryan 1992, p. 233, fig. 32b.

[2] Nicholson/Shaw 2000, p. 202; unfortunately, the only glass sculpture considered is an even tinier and artistically inferior royal figure from the tomb of Tutankhamun (Cairo JE 60719: Cooney 1960, p. 16, fig. 5).

[3] Cooney 1960, pp. 12–13, figs. 1–4 (the second example is decorated with gold foil).

[4] Goldstein 1979, pp. 8–16, figs. 1–4 (Corning Museum of Glass 79.1.4).

[5] Compare Goldstein 1979, p. 16, who discusses the stylistic differences among the three objects in this context.

[6] As they are, for example, on the face of a faience sphinx about the same scale, New York MMA 1972.126: Kozloff/Bryan 1992, no. 32. pp. 223–24.

[7] Kozloff/Bryan 1992, *passim*; there are exceptions, e.g., Russmann 1989, no. 45, p. 100.

[8] E.g., Saleh/Sourouzian 1987, nos. 134–35: Bryan 1991, pl. 15, figs. 41a–b, the latter also Russmann 1989, no. 44, pp. 97, 99.

[9] Bryan 1991, pl. 14–16. The list of his monuments, ibid., p. 212, includes a very broad glass face for a composite statue (Victoria and Albert Museum 422.1917: see Cooney 1960, p. 22, figs. 12–13). This head, however, is not mentioned.

[10] Such as the Tutankhamun figurine; see n. 2.

[11] These are discussed by Cooney 1960, pp. 21–29.

### Bibliography

Cooney 1960, p. 17, figs. 6, 7.

Cooney 1976, no. 1783, p. 153.

# 78

## Papyrus with Satirical Vignettes

Probably from Thebes
New Kingdom, Nineteenth or Twentieth Dynasty
(ca. 1295–1069 B.C.)
Polychrome painting on papyrus
6 1/8 x 23 1/2 in. (15.5 x 59.7 cm)
EA 10016/1, acquired in 1834

"This is one of two sheets of figured scenes in which animals ape human activities, but in a topsy-turvy world, they act against their natural instincts. The lion does not attack the gazelle but plays a board game, probably *senet*, with her. The pair grasp the playing pieces with great difficulty; the lion also holds a dice made from an animal bone. Even when the lion wins, he claims his reward in the bedroom: although the end of the papyrus is damaged, it is surely the same gazelle who is depicted there lying on her back on the bed. The rampant lion who overwhelms her certainly wears the same triumphant expression.

"Framed by these two scenes is one in which goats and geese are driven along by their natural predators the hyena, fox, and wild cat who walk upright like human herdsmen, wielding a goad, carrying their possessions in a bag slung over a pole carried on the shoulder, leaning on a staff or playing a double flute. As a further irony the cat cradles a gosling."[1]

Carol Andrews's lively description of the "Animal Fable" vignettes on this fragment of papyrus captures their zest and satirical humor —qualities not often associated with Egyptian art. Scenes of this type were drawn or painted during a fairly brief period during the second half of the New Kingdom, and they seem to have been produced mainly, if not exclusively, at Thebes. Most consist of single vignettes on flakes of limestone called ostraca (see fig. 12),[2] but at least three more extensive and elaborate versions, including this one, were painted on papyrus.[3] Whether on papyrus or stone, the great majority are unmistakably the work of trained artist-scribes.

Although no two of these vignettes are exactly alike, their tone is remarkably consistent, and certain themes recur: the predator herdsmen, cats waiting on mice, battles between cats and mice.[4] They seem to originate in a common source, which some scholars think must have been the type of popular literature known as "Animal Fables."

It is entirely possible that the ancient Egyptians, like many other peoples, had a tradition of satirical or moralizing tales in which animals acted in human ways. If so, however, it was entirely an oral tradition. Virtually no trace of such stories has been found in the extensive body of surviving texts, which include literary, moralizing, and satirical works.[5]

Since a satirical edge seems undeniable in most of the "Animal Fable" vignettes, it is tempting to see their popularity during the later New Kingdom as a reaction to the society in which they were produced.[6] This was a period of recurrent political tensions within the royal family and increasing problems with the economy. The artisans of Deir el Medina (see fig. 51), whose principal occupation was to decorate the royal tombs (see cat. no. 98), went on strike several times because they had not received the food and other supplies with which they were paid.[7] And it is the artist-scribes of Deir el Medina who are believed to have produced most of these vignettes.

Some scholars, however, noting the importance and ubiquity of animals in Egyptian religion, have argued that the "Animal Fable" scenes embody religious symbolism.[8] This argument gains some support from the fact that after the New Kingdom, scenes of "Animal Fable" type were carved on the walls of temples.[9]

Whatever their meaning, the antics of the animal actors are so true to human life that details from this papyrus are often used to illustrate activities of the ancient Egyptians.[10] (E.R.R.)

### Notes

[1] C. A. R. Andrews in *Treasures* 1998, p. 234. The second surviving section of this fragmentary papyrus is EA 10016/2: Parkinson 1999, no. 81, p. 171, pl. 29.

[2] Brooklyn BMA 37.51E: Fazzini/Romano/Cody 1999, no. 67, p. 115; others: Peck 1978, p. 147; Brunner-Traut 1956, frontispiece, pls. 2, 33–34.

[3] The other two: Cairo JE 31199: Saleh/Sourouzian 1987, no. 232; and the "Turin Erotic Papyrus": Omlin 1973.

[4] The themes are enumerated by Brunner-Traut 1979, pp. 11–18.

[5] For such evidence as there is, see Brunner-Traut 1979, pp. 14–18.

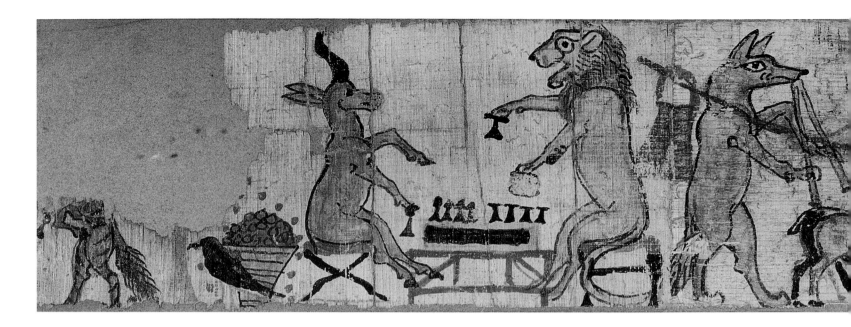

6 Omlin 1973, pp. 57, 76, emphasizes the satirical aspect
and argues that even religious practices are parodied.

7 Bierbrier 1982, p. 41.

8 Kessler 1988, especially pp. 178–85.

9 Most famously on a Twenty-fifth Dynasty block from the
temple at Medamud (Cairo JE 58924): *Centenaire* 1981,
no. 59, pp. 94–96; also illustrated in Houlihan 1996,
p. 216, fig 153.

10 E.g., Anderson 1976, p. 5 (playing double pipes);
Decker/Herb 1994, II, pl. 374 (board game).

**Bibliography**

Prisse 1879, pl. [9], pp. 142–47.

Prisse 1991, pl. II.9, p. 376.

Peck 1978, pp. 144-46.

James 1986, pp. 2–3 and pp. 60–61, figs. 69–70.

Robins 1997, p. 192, fig. 232.

Treasures 1998, no. 72, pp. 234–35.

Details frequently illustrated elsewhere,
e.g., Quirke/Spencer 1992, p. 131, fig. 102.

# 79

## Monkey Riding a Horse

Provenance unknown
Ptolemaic Period (305–30 B.C.)
Faience
Height 3 in. (7.5 cm)
EA 48014, acquired in 1926

Monkeys sometimes appear in "Animal Fable"
vignettes (see cat. no. 78).[1] More often, however,
they are shown making pests of themselves in all
too human-like ways. These antics amused the
ancient Egyptians, who often kept them as pets.[2]

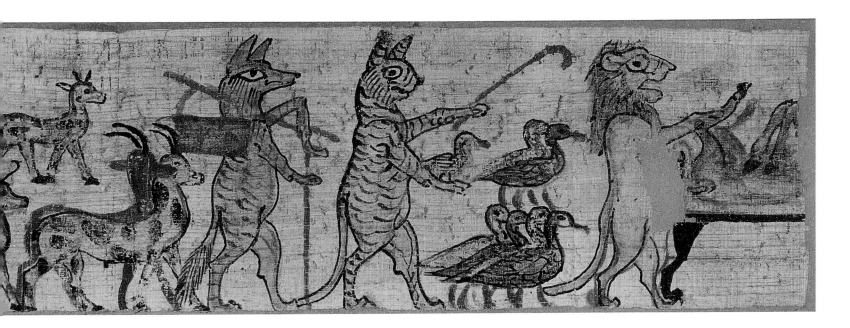

This faience statuette shows an oversized simian hitching a ride on an undersized horse. The monkey has apparently just landed on the back of the horse, which is rearing in surprise. The animals' heads face in opposite directions: the horse is about to turn one way, while the monkey is looking back, furtively or defiantly. He certainly knows he is doing something wrong—horses were much-prized animals. Though they were bred and trained as chariot animals, horses are shown in a few representations apparently being ridden bareback.[3]

Although it may have a satirical undertone, this small group seems to be a comparatively rare example of an object made purely for enjoyment, with no underlying symbolic message. It is also a good example of the Egyptians' skill in working faience, a glazed, non-clay ceramic, invented in Egypt before the First Dynasty[4] and used for vessels, amulets, and jewelry, as well as statuettes.[5] **(E.R.R.)**

**Notes**

[1] Houlihan 1996, p. 211, fig. 146.

[2] Vandier d'Abbadie 1966.

[3] E.g., Martin 1989, pls. 32, 34.

[4] Egyptian faience is entirely different from European faience, which is pottery; compare Nicholson/Shaw 2000, pp. 177–78.

[5] For a comprehensive catalogue of faience objects, see Friedman 1998.

**Bibliography**

Unpublished.

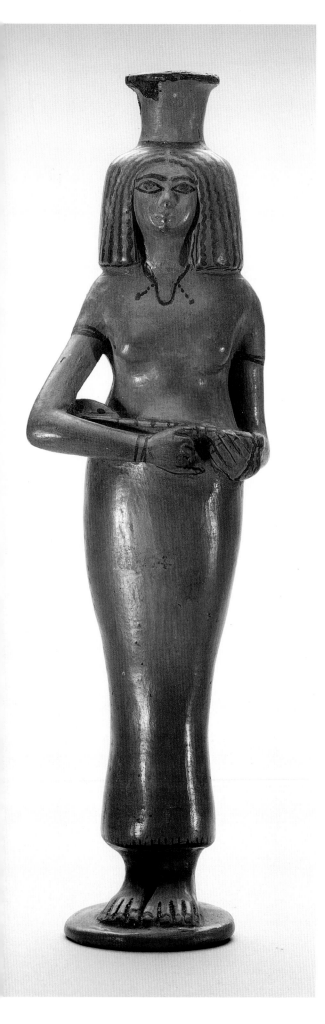

# 80

## Bottle in the Form of a Female Lute Player

From Thebes
New Kingdom, mid-Eighteenth Dynasty
(ca. 1479–1352 b.c.)
Terracotta, painted
Height 9 1/8 in. (23 cm)
EA 5114, acquired in 1836 from the collection of
James Burton

Like the pottery scribe (cat. no. 64), this figure of a woman playing a lute is an example of the fine red-ware figure vessels made during the middle of the Eighteenth Dynasty.[1] These figure vessels show great variety in their subject matter, and most, like catalogue number 64, seem to be unique[2]; the exception is a group of bottles representing nursing women, which may have been containers for human milk.[3] The nature of the intended contents of other figures is not known; in the case of this figure, traces of the contents may remain in the black stains around the top.

At first glance, the figure appears quite simple, but in fact it is full of detail. After molding, the face, fingers, and toes were enhanced with a tool. Black paint was applied, as usual, to the hair and eyes, and to outline the fingers and the toenails.[4] On the woman's tunic dress, we can see not only the short sleeves and the keyhole neckline with its little tie strings, but even the stitching of the side seams and the fringe of the hem. The lute is also realistically detailed, from the tassels for fixing the two strings, to the frets, holes in the sound box, and plectrum.[5] A checkerboard pattern on the back of the sound box represents the tortoiseshell of which such objects were made.

This figure looks quite staid and seems to have little in common with female lute players in the banquet scenes painted on tomb walls at about the same time. Those women are naked except for jewelry and a belt, and they seem to be dancing or gyrating as they play. They were certainly meant to be suggestively erotic,[6] like the nude figure in this catalogue who carries a cosmetic vessel (cat. no. 81). The differences between that figure and this one may be partly due to their different functions, the former holding a container for a luxury substance reserved for personal use and the latter a purpose-designed bottle for medicine or some

other commodity. But they also reflect social changes occurring during the Eighteenth Dynasty, at least among the elite classes: the loosening of some protocols; ever greater ostentation; and increasingly frank expressions of sensuous delight. **(E.R.R.)**

### Notes

[1] Bourriau 1987.

[2] This may, of course, be an accident of survival; for two comparable vessels, see Bourriau 1987, p. 92.

[3] Ibid., pp. 93–96, esp. p. 94, with references.

[4] Normally, the nails were painted white: cf. cat. nos. 11, 24. Here the intent was probably to emphasize the positions of the fingers on the instrument.

[5] Anderson 1976, pp. 3, 4.

[6] Mekhitarian 1954, p. 33; the sexual meaning is even clearer on ostracon sketches, e.g., Peck 1968, pl. 7.

### Bibliography

Often illustrated.
Anderson 1976, pp. 3–4, fig. 4.
Bourriau 1981, no. 49, pp. 35–36.
*Golden Age* 1982, no. 366, p. 261.
Bourriau 1987, p. 92, pls. 30, 31.
Quirke/Spencer 1992, p. 178, fig. 139.

# 81

## Cosmetic Vessel Held by a Girl

Provenance unknown
New Kingdom, Eighteenth Dynasty
(ca. 1390–1336 b.c.)
Wood
Height 6 1/8 in. (15.5 cm)
EA 32767, acquired in 1867, purchased from the
duc des Blacas

This plump young girl wears only a pair of large earrings with rosette centers. Her hair is plaited into three skinny pigtails, two of which hang down in front and the other behind. On her head she carries a rectangular four-legged casket, which is evidently rather precariously balanced: she grasps one of the legs to hold it steady.[1] She is bent slightly forward under the weight of the box, and she is walking very carefully.

Small male and female figures carrying relatively large vessels were popular luxury items during the reigns of Amenhotep III and Akhenaten. Though some are made of stone, the

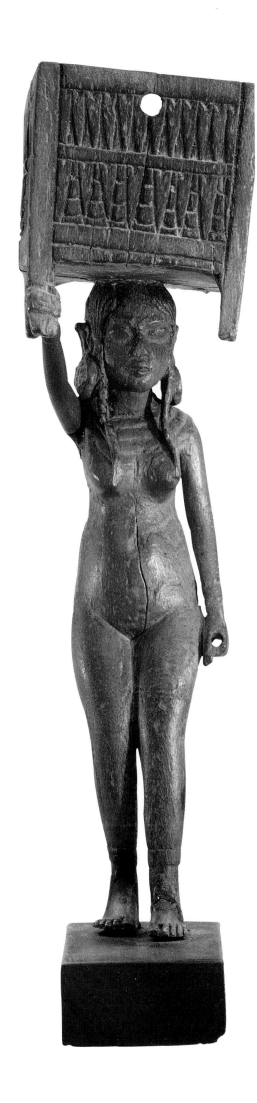

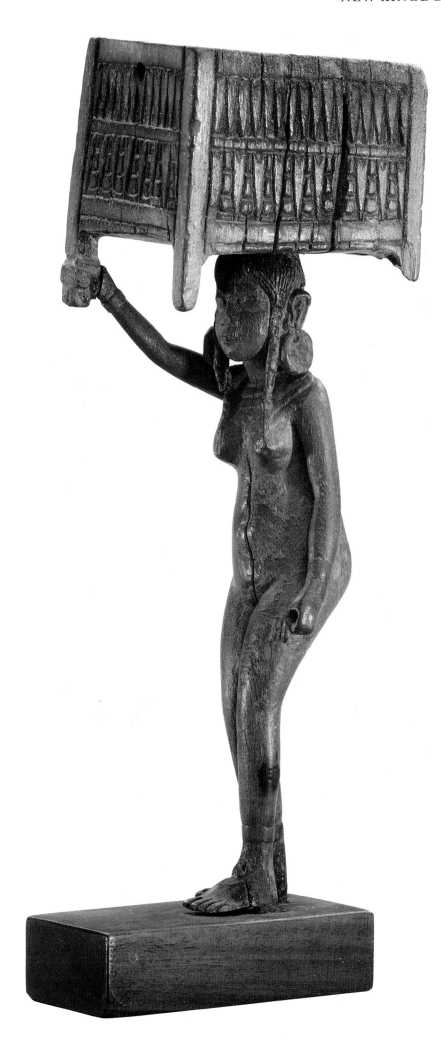

finest examples, like this one, are wood. The male figures clearly represent domestic servants: one is aged,[2] several are dwarfs,[3] and one, wearing an exotic patterned kilt, is a foreigner.[4] The female figures, presumably also household servants, are all nude, except for their jewelry, and all look very young. One has a Nubian hairstyle,[5] and the unusual hairstyles of this and the other two finest examples[6] suggest that all the female figures may represent foreigners.

In strong contrast to the staid and stereotyped Middle Kingdom kneeling figures holding cosmetic vessels (cf. cat. no. 32), every one of these New Kingdom figures is different. However, all but one are shown struggling with the size and weight of their burdens, which are balanced uncomfortably on a shoulder, on the back of the neck, or on an out-flung hip. One male figure is struggling to rise from his knees.[7] Only the Nubian girl has found a solution: she balances the foot of her dish on the head of a standing monkey.[8] The amusement here undoubtedly lay in imagining the confusion that was soon to reign when the monkey, inevitably, scampered off.

Waxy or greasy residues in some of these vessels indicate that they held cosmetics or scented ointments. The hole pierced through this girl's hanging hand[9] was probably intended to hold the handle of an applicator. (E.R.R.)

**Notes**

[1] The hand is ancient, but the rest of the arm to the shoulder is a modern restoration, as is the base.

[2] Liverpool M 13519: Freed/Markowitz/D'Auria 1999, no. 209, p. 264.

[3] E.g., Boston MFA 48.296: ibid., no. 208, p. 264; *Golden Age* 1982, no, 240, p. 205.

[4] Paris, Bibliothèque Nationale: Capart 1927: pls. 42, 43.

[5] London, University College Petrie Museum 14210: Kozloff/Bryan 1992, no. 88, pp. 362–63.

[6] Durham N.752: Kozloff/Bryan 1992, no. 87, pp. 361–62; *Golden Age* 1982, no. 239, pp. 204–205; Leiden AH 116a: ibid., no. 238, p. 204.

[7] Cairo JE 31382: Saleh/Sourouzian 1987, no. 158.

[8] Petrie Museum 14210: see n. 5.

[9] There is a similar hole in the hand of a male figure (Liverpool M 13519); see n. 2.

**Bibliography**

Capart 1927, p. 31, pl. 44.

Hall, H.R. 1929, p. 236, pl. 38.

## Gold, Substance of the Gods
### (catalogue numbers 82–88)

**The flesh of the gods is gold, and their bodies are made of other precious materials such as silver and lapis lazuli.[1] This ancient Egyptian idea of the gods' substance was not meant entirely literally[2] (compare the silver flesh of cat. no. 82); but in their desire to be "one body" with the god after death, those who could afford it often had the faces of their mummy masks or anthropoid coffins gilded (cf. cat. no. 106), while the masks and coffins of kings, such as Tutankhamun, were of solid gold, decorated with other precious materials.**

**Religious symbolism encouraged a connection between gold and the idea of kingship, kings being divinity upon earth. One of the five main royal titles was "Golden Horus." Of course, kings also controlled access to the gold mines and to gold brought from foreign lands as tribute. In the New Kingdom, gold was abundant. Even the richness of the metal in Tutankhamun's tomb can only faintly reflect the quantities buried with more powerful kings, used in the palaces for vessels, jewelry, and furniture ornament, bestowed on courtiers, and distributed to the temples for cult statues, for temple equipment, and even, in some cases, to gild certain particularly holy reliefs on the temple walls.**

**But gold was not entirely a royal monopoly. Though most of the gold jewelry in this section was made for royalty, gold amuletic beads, like those of catalogue number 85, have been found in quite modest burials. These people, like their rulers, valued the metal both for its innate preciousness and for its talismanic symbolism. (E.R.R.)**

**Notes**

[1] Hornung 1982, p. 134, with n. 83.

[2] Hornung 1982 suggests that "gold" is meant to convey radiance.

# 82

### Figure of Amun
Probably from Thebes
New Kingdom, Early Nineteenth Dynasty(?)
(ca. 1295–1213 B.C.)
Silver, gold
Height 8 3/8 in. (21.3 cm)
EA 60006, acquired in 1835, formerly Salt Collection

This figure was cast in silver and decorated with gold overlays on the headdress, collar necklace, and kilt. His divine beard shows that he is a god, and his headdress identifies him as Amun. Though he was sometimes depicted as a ram, with short curling horns (or, in his Nubian temples, as a ram-headed god), Amun was primarily an anthropoid god. His crown, similar in shape to the red crown, is topped by two tall feathers and a sun disk, symbolic of his assimilation with the sun god, Re, as Amun-Re.

This assimilation, in which neither god lost his identity, was part of the process by which Amun, originally a local god of Thebes, rose to national status during the great Theban Twelfth and Eighteenth Dynasties, in the Middle and New Kingdoms. These kings' loyalty to their "family" god, especially in the wealthy Eighteenth Dynasty, led them to make his main temple complex at Karnak, in Thebes, one of the largest and wealthiest in all Egypt.

The use of silver and gold for this figure suggests that it was made as a cult statue. Temple records describe such figures as made of precious materials and quite small.[1] Among the very few surviving statues of this type is another Amun, a solid gold figure made early in the Third Intermediate Period,[2] and a richly gilded and inlaid silver figure of a seated falcon-headed god.[3]

Until quite recently, metal statues of high quality were routinely dated to the Third Intermediate Period or later. Although a few New Kingdom bronze statuettes were known (cf. cat. no. 50), it was generally assumed that almost all early metal sculpture had been melted down in order to recycle the bronze, silver, or gold. During the past few decades however, fine Middle Kingdom statues of copper alloy, made during the late Twelfth Dynasty, have become known, and increasing numbers of New

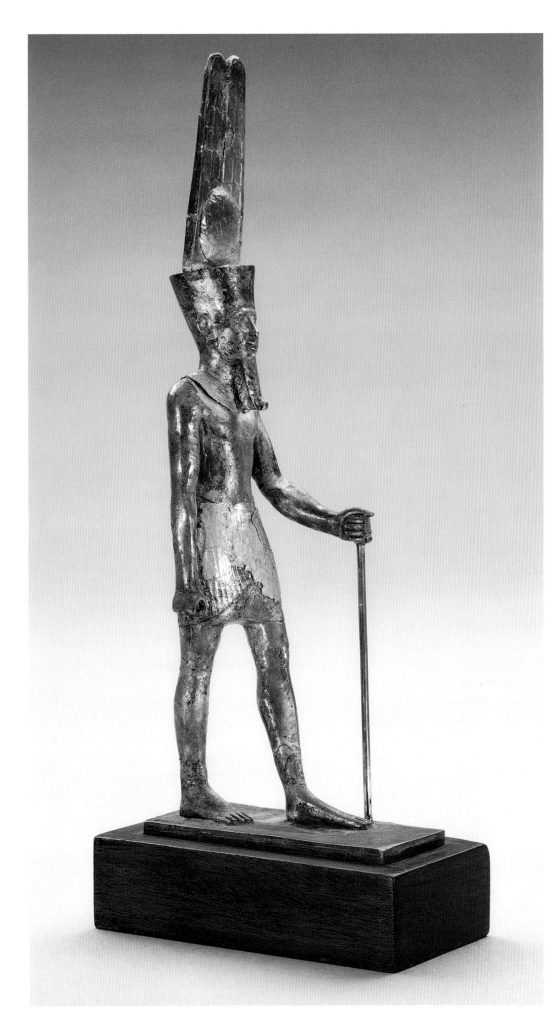

Kingdom bronze statuettes are coming to light.[4] Of particular interest with regard to this figure of Amun is the silver falcon god described above, which has recently been attributed, on stylistic grounds, to the early Nineteenth Dynasty.[5] The statues are comparable in several respects, particularly in the rendering of their torsos. These figures should be further studied; for now, however, they may be attributed to the early Ramesside Period, a time when large quantities of silver were fashioned into vessels and statuettes.[6] (E.R.R.)

**Notes**

[1] Helck 1980.

[2] New York MMA 26.7.1412: Aldred 1956.

[3] Miho Museum (Japan): Miho 1997, no. 5, pp. 18–20; Reeves/Taylor 1993, fig. on p. 172.

[4] Vassilika 1997; Hill 1997.

[5] Miho 1997, pp. 18–20.

[6] Ogden 2000, p. 170.

**Bibliography**

Quirke/Spencer 1992, p. 76, fig. 55.

## Jewelry

Although ancient Egyptians valued jewelry for its precious materials and for the color it added to their predominately white costumes, they also counted on its amuletic qualities. Some forms of jewelry, such as large, heavy rings (see cat. no. 87), may not have been worn at all but carried as amulets. Since appropriate protective symbols and motifs were specific and rather limited in number, innovation in jewelry design was largely restricted to new ways of combining the standard motifs.[1] By the beginning of the New Kingdom, however, some new motifs, such as ducks, and even a new type of jewelry—earrings—had been successfully introduced. Some of these innovations reflect foreign influence. Others suggest that new ideas, or new adaptations of old ideas, were born out of the turbulence of the Second Intermediate Period. (B.F.)

**Notes**

[1] Ingenious and elaborate compositions are very noticeable in some of Tutankhamun's jewelry, e.g., Saleh/Sourouzian 1987, no. 193.

# 83

## Lion Bead

Provenance unknown
Second Intermediate Period, Seventeenth Dynasty
(ca. 1650–1550 B.C.)
Gold
Height ¾ in. (1.8 cm)
EA 24788, acquired in 1891, purchased via
Sir E. A. W. Budge

Beads in the form of couchant lions, pierced front to back, harnessed the power of the animal for the owner's protection. Since the king was often equated with the lion (cf. cat. no. 51) this image was especially appropriate for royal women. Pairs of bracelets belonging to two Middle Kingdom princesses have pairs of lion beads on a single strand with colored beads; separated by a short section of these colored beads, the animals sit facing each other.[1] Lion beads were especially popular in the Middle Kingdom but continued into the New Kingdom and later.[2] This example has big, downturned eyes and other exotic features that reveal Near Eastern influence.[3] It is thus an example of the foreign contacts that were to continue for the rest of the New Kingdom. (E.R.R.)

### Notes

[1] Andrews 1990, pp. 40, 125, figs. 29, 108a.

[2] For a list of examples, see Andrews 1981, p. 91, App. B.

[3] Andrews 1981, p. 79, n. 1: "may be Syrian in origin or inspiration."

### Bibliography

Andrews 1981, no. 566, p. 79, pl. 43.

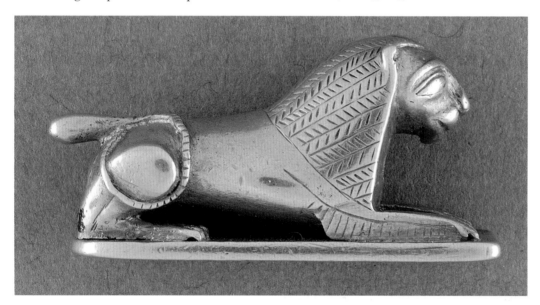

# 84

## Pair of Spacer Bars with Cats

Probably from Edfu
Second Intermediate Period, Seventeenth Dynasty, reign of Nubkheperre Intef (ca. 1650 B.C.)
Gold
Width 1¼ in. (3 cm)
EA 57699–57700, gift of C. W. Dyson Perring, 1924

In this spacer bar, trios of cats recline on low rectangular bases, through each of which pass twelve tubes of sheet gold. These spacer bars are designed to hold in place bracelets composed of twelve strands of small beads. Egyptian bracelets were typically worn in pairs, one on each limb; these mirror images are all that remain from a pair of presumably identical bracelets.

The bracelets belonged to Queen Sebekemsaf, whose name, along with her husband's, is inscribed on the bottom of each base. Presumably they came from her tomb at Edfu, south of Thebes.[1] Sebekemsaf and her husband were forebears of King Ahmose (cf. cat. no. 110), who founded the Eighteenth Dynasty and the New Kingdom; and this is the earliest known use of cats on jewelry.

Cats were associated with goddesses, including Bastet and, in New Kingdom Thebes, especially, Hathor. They were thus especially suitable for royal women. Three minor wives of Thutmosis III, who were buried together later in the Eighteenth Dynasty, each had a pair of bracelets with cat spacer bars.[2] (E.R.R.)

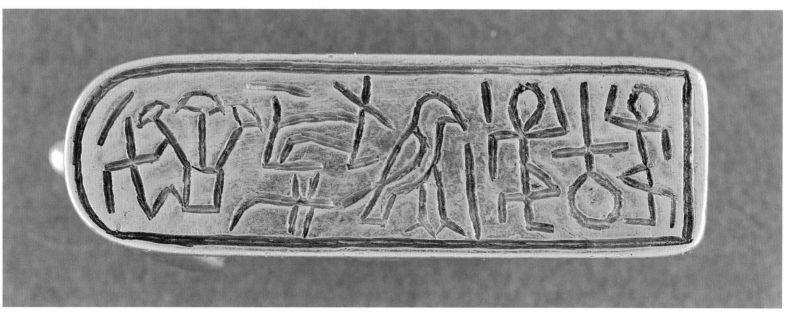

(cf. cat. no. 89) is decorated with sleeping ducks. On each, a pair of the birds lies side by side, their joint bodies indicated by a lump of lapis lazuli.[3] Ducks symbolized the teeming life and fertility of the papyrus marshes where they lived, but the significance of the sleeping variety has not been discovered.[4] **(E.R.R.)**

**Notes**

[1] For just such a belt, see Andrews 1990, p. 23, fig. 14. Other examples of beads and belts: Andrews 1981, p. 96, App. Z.

[2] For objects in this form and for the pose itself, see Hermann 1932.

[3] Andrews 1990, p. 90, fig. 67; Saleh/Sourouzian 1987, no. 210.

[4] For a visually similar, but thematically different, contemporary group of cosmetic vessels in the form of plucked ducks with hanging heads, see Fay 1998a.

**Bibliography**

Andrews 1981, no. 567, p. 79, pl. 43.
Andrews 1990, pp. 172–73, fig. 158b.
Andrews 1994, fig. 43b (after p. 40).

# 86

## Pair of Earrings

Provenance unknown
New Kingdom, Eighteenth Dynasty
(ca. 1550–1295 B.C.)
Gold
Diameter 1 1/8 in. (2.6 cm)
EA 54317–54318, acquired in 1897, bequest of
Sir A. W. Franks

The first use of earrings is found on representations and in burials of women at the end of the Middle Kingdom,[1] probably under Nubian influence. By the New Kingdom, they were worn

**Notes**

[1] Compare PM V 1937, p. 205.

[2] One is illustrated in Andrews 1990, p. 153, fig. 134.

**Bibliography**

Burlington 1922, p. 18, pl. 50/2.
Andrews 1981, nos. 577–78, pp. 80–81 (with bibliography), pl. 43.
Andrews 1990, p. 89, fig. 65b.
Andrews 1994, fig. 48b (opposite, p. 41).

# 85

## String of Amulets

Provenance unknown
New Kingdom, Seventeenth–Eighteenth Dynasty
(ca. 1650–1295 B.C.)
Gold
Length 6 1/8 in. (15.5 cm.)
EA 14696, acquired in 1872 from the collection of
Alessandro Castellani

This string of gold amulets was re-strung in modern times. At one end is a double flower, probably a lotus, symbol of rebirth, and at the other end a snake head, protection against snakebite. The rest are sleeping ducks and wallet beads. Wallet beads (so called because those who first catalogued them thought they looked like little stitched purses) were a New Kingdom stylization of the cowrie-shell amulets of the Middle Kingdom (cf. cat. nos. 32 and 36). They were worn in the same way, strung on hip belts to protect a young woman's fertility. These beads each have two holes, so they also served as spacer bars on a two-stranded belt.[1]

The ducks are shown in profile with their heads resting on their backs. The duck was an extremely popular decorative element during the New Kingdom. The bird, or just its head and neck, shows up on cosmetic spoons, folding stools (cf. cat. no. 74), and implement handles. Often, as here, the head is turned to the back, in the position of sleep.[2] A pair of massive gold bracelets with the name of Ramesses the Great

by both men and women in the form of increasingly elaborate hoops and studs.[2] From the late Eighteenth Dynasty onward, pierced ears are indicated on statues and reliefs by circular or oval depressions on the lobes (cf. cat. no. 63). On the gold mask of Tutankhamun, the lobes are actually pierced, with rather large round holes.[3]

The pair of earrings shown here was a type favored by women and sometimes worn two on each lobe. Each consists of five hollow, triangular tubes soldered together, with a longer center tube to fit through the lobe. At the beginning of this extension a little five-petaled flower has been soldered on in such a position that it would have rested against the lobe. (E.R.R.)

### Notes

[1] Bourriau 1988, no. 117, p. 124.

[2] Some spectacular royal examples: Andrews 1990, pp. 113–14, figs. 92–94.

[3] Saleh/Sourouzian 1987, no. 174.

### Bibliography

*Golden Age* 1982, no. 294, p. 229.

Andrews 1990, p. 112, fig. 91f.

*Treasures* 1998, no. 89, pp. 280–81.

# 87

## Ring with Incised Figure of a Child King

Provenance unknown
New Kingdom, Eighteenth Dynasty
(1390–1327 B.C.)
Gold
Length of bezel ⁵⁄₈ in. (1.5 cm)
EA 32723, acquired in 1900, purchased via the Reverend C. Murch

The motif incised into the bezel of this solid gold ring represents a child king with a uraeus squatting above hieroglyphic signs that can be read "Lord of the Two Lands" (a standard royal epithet). He holds a large *ankh* sign and a feather symbolic of Maat. Above him is the sun, flanked by two cobras, and behind him is a long feather associated with the god Shu.

The image of the king as a child emphasized his role in the cycle of regeneration and rebirth as the son of the gods. This symbolism was especially prominent at the end of the

Eighteenth Dynasty, under Amenhotep III, Akhenaten, and Tutankhamun. The slouching, bottom-heavy form of this figure suggests the style of Akhenaten (cf. cat. no. 60), who may be the king represented here. (E.R.R.)

### Bibliography

*Golden Age* 1982, no. 333, pp. 245–46, fig. 148.

Andrews 1990, p. 165.

Freed/Markowitz/D'Auria 1999, no. 194, p. 260.

# 88

## Earring with Cartouche of Tawosret

Thebes, Valley of the Kings, Tomb no. 56
New Kingdom, Nineteenth Dynasty
(ca. 1200–1186 B.C.)
Gold
Exterior diameter 1 in. (2.3 cm)
EA 54459, acquired in 1919

This hollow, barrel-shaped earring with the cartouche of Queen Tawosret was found, not in her tomb, but in the tomb of a royal child.[1] Finds such as this show that royal jewelry was routinely given to family members and also to favored courtiers. This earring is of a type that was slipped over the lobe by means of a slit in the incomplete circle. But the slit here is positioned so low that when the earring was

worn, the Queen's name would be upside down. Perhaps it was never meant to be worn. (E.R.R.)

### Notes

[1] PM I, 2 1964, p. 567; cf. Reeves/Taylor 1992, p. 119.

### Bibliography

Andrews 1990, p. 112, fig. 91d.

Reeves/Taylor 1992, p. 119.

# 89

## Bust of a Standing Statue of Ramesses II

From Aswan, Elephantine Island
New Kingdom, Nineteenth Dynasty, reign of Ramesses II (ca. 1279–1213 B.C.)
Pink granite
Height 56 in. (142 cm)
EA 67, acquired in 1840, gift of W. R. Hamilton

This bust was found by W. R. Hamilton at Aswan, on Elephantine Island[1] and given to the British Museum in 1840. It derives from a colossal statue that represented Ramesses II standing, hands crossed over the chest, and holding the insignia of royalty, the flail and the crook. Measuring 22 ⁷⁄₈ inches (58 cm) high, the base of the statue supporting the royal feet was unearthed much later in the temple of the god

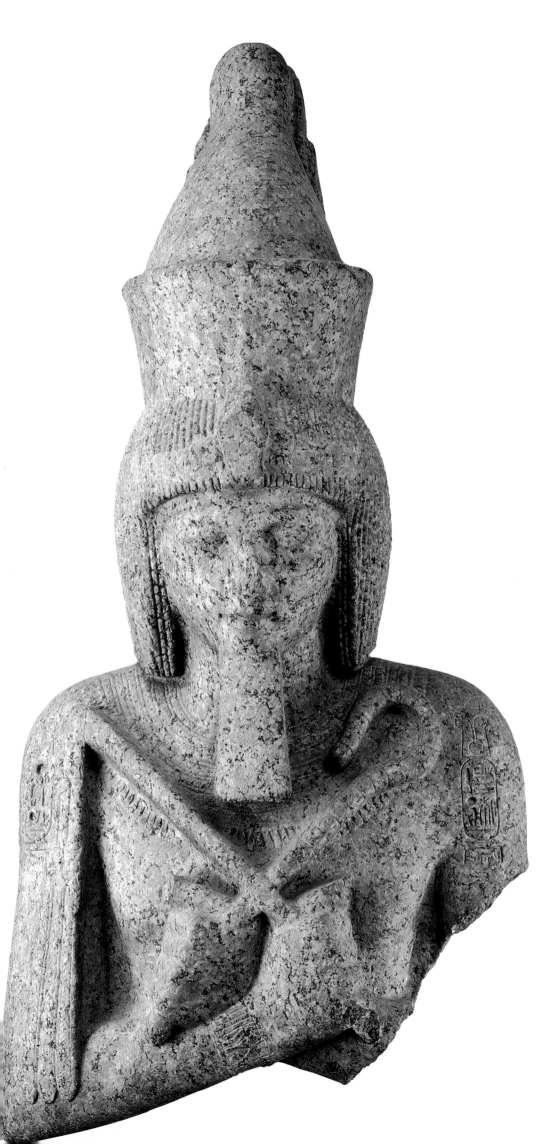

Khnum at Elephantine and recently identified by the author of this entry as belonging to the bust.[2]

The middle part of the statue has not been found, and the left elbow is broken. Aside from the damage to the nose, the sculpture is in good condition and displays very good workmanship. The surfaces are smoothly polished, with the exception of the band on the forehead, the eyebrows, and the cosmetic bands around the eyes, which were left unpolished, probably to facilitate the application of paint. All the decorated elements of the king's attire are finely chiseled.

Ramesses wears a double crown upon a curled wig. The royal uraeus is fixed at the forehead. A decorated fillet, tied in the back, encircles the wig and ends with two streamers falling on the sides, each supporting a uraeus crowned by the sun disk. A ceremonial beard is attached under the royal chin. A broad collar, fringed by a row of drop-like pearls, surrounds his neck, and a bracelet adorns each of his wrists, the one on the right decorated with an incised *wedjat* eye, symbol of soundness.

The royal costume was certainly a kilt, completed with an animal tail hanging between the legs. The tip of the tail is still preserved on the lower part of this sculpture, which is kept on Elephantine.

The visage is almost round, with full cheeks. Under the wide forehead, the eyebrows, depicted in raised relief, form two symmetrical arches on the protruding brow-bone. A faint depression separates them from the heavy upper eyelids. The eyes, placed horizontally and framed by cosmetic bands, gaze slightly downward. The narrow root of the nose expands gently toward the base, which is broken. The mouth, slightly slanting, is articulated by well-defined edges. Two little hollows mark the corners of the lips. The rounded chin overlaps the top of the tapering beard. The neck is broad, the chest schematic, with large shoulders.

On the arms of the sovereign are engraved his birth and throne names: "Usermaatre Setepenre" on the right arm, and "Ramesses Meriamun" on the left. The cartouches are surmounted by a double plume flanking a disk, and placed on the hieroglyphic sign for gold.

The back pillar bears two vertical columns of a delicately incised hieroglyphic inscription that ends on the lower part of the statue. The full

royal titulary includes the Horus name: "Mighty Bull beloved of Maat"; the Two Ladies' name: "Who protects Egypt and subdues the foreign countries"; the Golden Horus name: "Rich in years and Great of Victories." The text describes Ramesses as "the perfect god, son of Khnum, and born from Anuket, Lady of Elephantine." Thus the king is considered a son of the two major deities of the cataract region.

The temple of Khnum on Elephantine contained a similar sculpture, of which only the lower part of the feet is now preserved. It is kept in the museum on the site, with the corresponding part of a back inscription symmetrical to the one in question.

This type of statue, frequently attested in the New Kingdom, has an Osiride pose; but instead of Osiris's mummy shroud, the king wears a ceremonial costume. Such statues were generally placed against pillars enclosing a court or stood in front of pylons or temple entrances. **(H.S.)**

### Notes

1 Hamilton 1809, pp. 57–58.

2 Sourouzian 1998, pp. 281–84.

### Bibliography

PM V 1937, p. 243 (with earlier bibliography).

*HT* IX 1970, no. 67, p. 9, pl. 5, 5a.

Valbelle 1981, no. 149, p. 19 (with bibliography).

James/Davies 1983, pp. 41–42, fig. 49.

Quirke/Spencer 1992, p. 71, fig. 51.

Sourouzian 1998, pp. 281–84, figs. 1, 2, pls. 42, 43.

*Treasures* 1998, no. 1, p. 38.

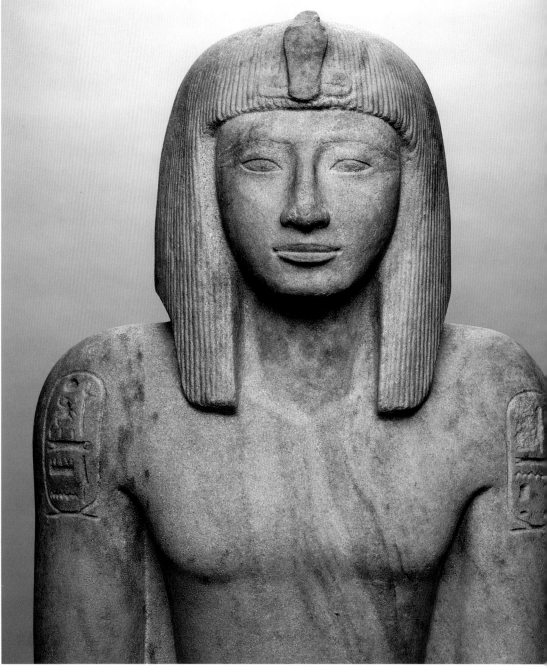

## Sety II Seated, Holding an Emblem of Amun-Re

From Thebes, Karnak Temple

New Kingdom, Nineteenth Dynasty, reign of Sety II (ca. 1200–1194 B.C.)

Sandstone

Height 64 7/8 in. (164.7 cm)

EA 26, acquired in 1823 at the sale of the Salt Collection

Discovered in 1816 by Belzoni at Karnak, presumably in the temple precinct of the goddess Mut, this statue represents King Sety II seated on a throne, holding on his knees a shrine surmounted by a ram's head, emblem of the god Amun-Re. Despite damage on the face of the ram and the head of the uraeus, this is one of the most complete sculptures from ancient Egypt.

The king wears a shoulder-length wig with longer strands in front and a uraeus on the forehead. The pleated kilt is held by a large belt bearing a rhomboid decoration, from the back of which emerges a piece of pleated material. An animal tail, hanging between the legs and sandals, completes the royal attire.

The narrow throne with low back is equipped, exceptionally, with a cushion, on which the king sits. The sides of the throne are decorated with the heraldic plants of Upper and Lower Egypt, bound together to symbolize the union of the Two Lands. These plants are generally placed to correspond with the direction of the statue and occupy the same position on each side. Here, however, their positions are inverted: on the throne's right side we find the papyrus near the back and the lotus near the front, while on the left side, we observe the contrary.

In spite of the cushion, the seated attitude is rigid. The sculpture is static, with elongated proportions, a slender torso, and oversized limbs. The oval face, with full cheeks that fall heavily toward the broad chin, has a stern expression. On the wide forehead, the eyebrows, carved in relief, are arched and lengthened by tapering

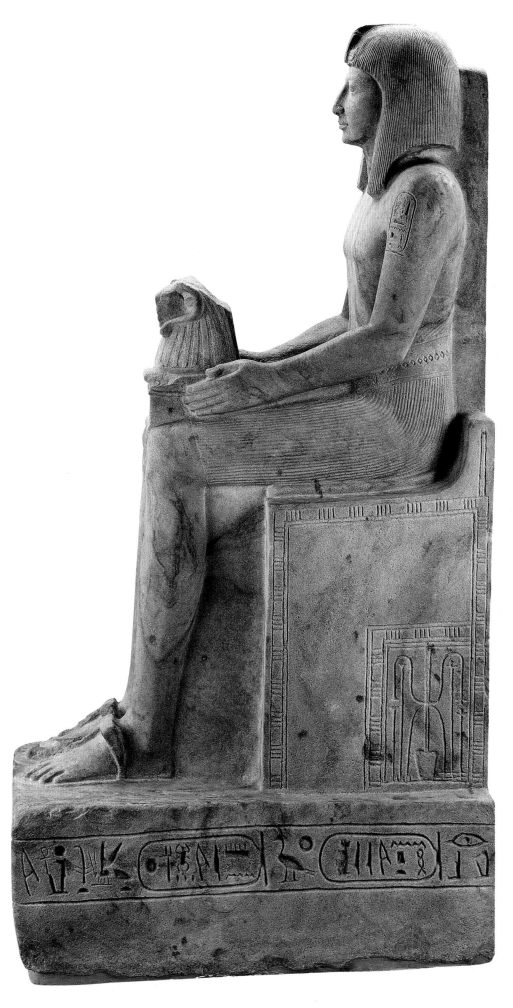

cosmetic bands. Similar lines, in shallow relief, frame the eyes. The straight nose surmounts a horizontal mouth with lips of equal length articulated by finely raised ridges and a small hollow at each corner. The head is set on a straight neck that is narrowed by the plunging flaps of the wig and, in profile, seems to disappear completely. Large, rounded shoulders, marked by converging grooves to indicate the deltoid muscle, dominate the torso. Two oblique ridges mark the clavicles, and a summary modeling renders the chest. The waist is thin, framed by massive arms and schematic hands with long, parallel fingers whose nails are depicted with care. The treatment of the elongated legs is more elaborate, with delicately modeled knees and well-defined muscle and bone structure. The well-sculptured feet are shown wearing sandals with pointed soles and thick straps in high relief.

The royal names are engraved on the shoulders: Userkheperure-Meriamun on the right one, Sety-Merenptah on the left. A text on the statue's back begins with the epithets "The perfect god, valiant in arm, and great of strength like Montu, Lord of Thebes" and ends with the two cartouches. The royal titulary is also inscribed around the base; flanking the central cartouches topped by the sun disk. Sety II is "beloved of Osiris-Khentamenti" on one side, "Ptah-Sokar-Osiris" on the other. These were gods of the necropolis, adored at Abydos, Memphis, and Thebes.[1]

Twenty statues and statue fragments of Sety II are known. The majority are carved in sandstone and originate from Karnak. For the most part, the king appears as a standard bearer; a few examples depict him kneeling. This is the only seated statue of Sety II, and a rare example of a king seated with an emblem on his knees. Statues of kings holding an emblem or an offering usually show them kneeling or, less frequently, prostrate or standing. **(H.S.)**

### Notes

[1] KRI IV, p. 267a; cf. Grimal 1986, p. 411.

### Bibliography

Mayes 1959, pp. l48, 268, 330 (616).

*HT* IX 1970, pp. 14–15, no. 26, pls. IX–IX A.

PM II 1972, p. 288 (with earlier bibliography).

James/Davies 1983, p. 42, fig. 50.

Quirke/Spencer 1992, p. 44, fig. 30.

# 91

## Standing Man

Provenance unknown
New Kingdom, late Eighteenth or early Nineteenth
Dynasty (ca. 1336–1279 B.C.)
Wood, traces of paint
Height 13 in. (33 cm)
EA 2320, acquired at the sale of the Salt Collection

As in the late Old Kingdom (see cat. nos. 8–11) and the Middle Kingdom (see cat. no. 24), some tomb-owners of the New Kingdom equipped their tombs with small wooden statues of themselves. Like their earlier counterparts, some of these statuettes were placed in the burial chamber, near or inside the coffin.[1] Possibly they all were—or at least those that have survived, in the relative protection of their underground locations.

From the beginning of the Old Kingdom, if not earlier, sculpture in wood had been treated differently from stone statuary. Wooden figures seldom had back pillars; their limbs were not connected to the torso by negative space, but were freely articulated; and the emblematic or abbreviated objects enclosed within the fists of stone statues[2] were replaced by miniature representations of the objects themselves. In most cases, these have been lost.

To a large extent, the conventions for wooden statuary remained in force throughout the New Kingdom, giving many Eighteenth and Nineteenth Dynasty wooden statuettes the same qualities of delicacy and sometimes almost doll-like charm that we find in the small wooden statues of earlier periods. In addition, the elaborate wigs and costumes of the New Kingdom lend an almost foppish air to some of these little figures. But when we compare them with contemporary wooden figurines of servants holding cosmetic vessels (see cat. no. 81), the staid and dignified treatment of elite men and women in these statuettes is evident. Their poses and gestures remain traditional, with little of the asymmetry and implied movement that New Kingdom sculptors in wood bestowed on representations of less exalted persons.

The titles and name of this man were probably inscribed on the base, which is lost (the feet and base are modern restorations), as is the

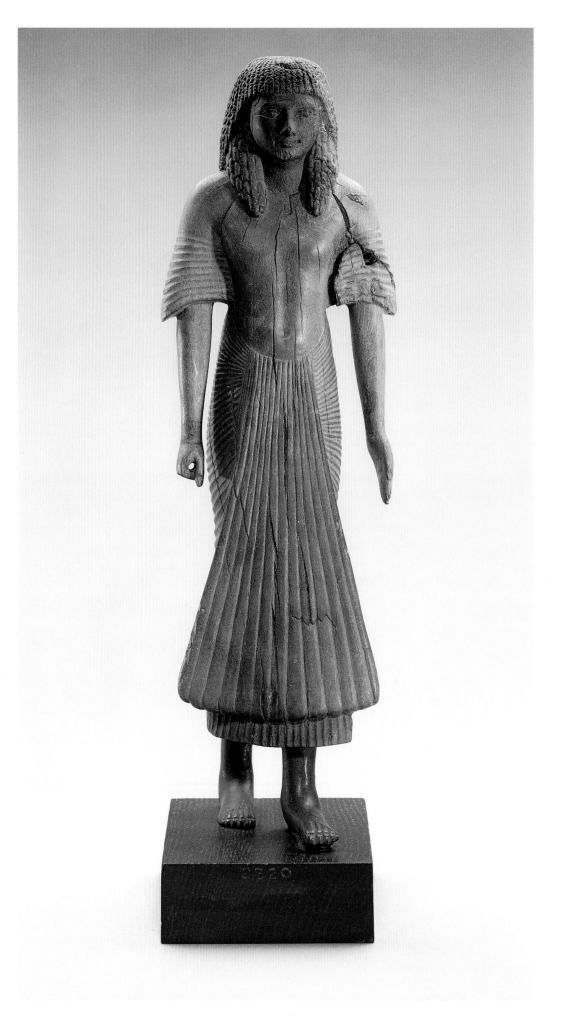

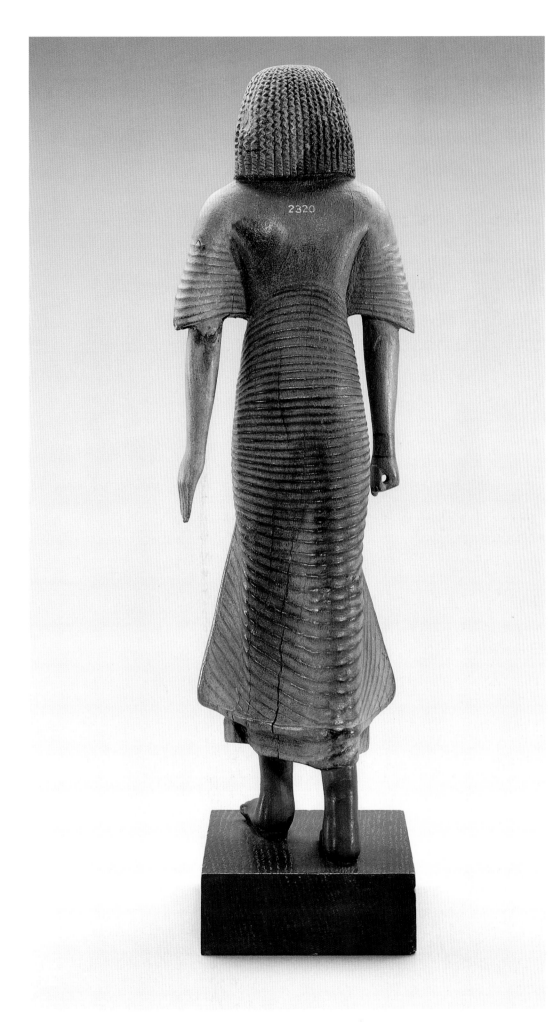

object—undoubtedly an emblem of office—that he once held in his proper right hand. His high status is proclaimed, however, by the quality of his statue and by the complexities of his costume. These factors failed to impress the first scholar to study this figure: he described it as "pompous" and having a "self-satisfied smirk."[3]

In fact, the statuette tells us nothing of its owner's personality, nor was it intended to. The face is idealized; the smile is derived ultimately from the benign curve in the lips of Amenhotep III (cf. cat. no. 52), whose slight smile was emulated during the Amarna Period, at the end of the Eighteenth Dynasty, and eventually on some representations of Ramesses II in the Nineteenth Dynasty (see cat. no. 89).

The man's costume places him in the last decades of the Eighteenth Dynasty or the first years of the Nineteenth. A comparison with catalogue number 54, the statue of a man who lived under Amenhotep III and who, like this man, wears a double wig, shirt, and kilt, shows how these fashions had changed. The front sections of the double wig had grown into larger and fuller bunches of curls, spilling down onto the chest. The shirtsleeves were now much longer, wider, and floppier. The kilt is entirely pleated, and the tucking and flouncing of its front panel are more intricate than ever and more mysterious.[4] These details appear on other male statues datable to the reigns of Tutankhamun and Horemheb at the end of the Eighteenth Dynasty.[5] As the Nineteenth Dynasty progressed, masculine wigs and costumes were to become even more ostentatious.[6] (E.R.R.)

### Notes

[1] E.g., Russmann 1989, no. 52, pp. 110–11.

[2] These objects are discussed by Fischer 1975.

[3] Hall, H. R. 1930a, p. 39.

[4] What, for example, is the function of the narrow, vertically pleated strip beside the top of the panel, on the proper right side?

[5] For an example in stone (Cairo CG 42194), see Russmann 1989, no. 66, pp. 142–45.

[6] E.g., Fazzini/Romano/Cody 1999, nos. 64–65, pp. 112–13 (a statuette and a relief from the mid-Nineteenth Dynasty or later).

### Bibliography

Hall, H. R. 1930a, pp. 39–40, pl. 13, 1–2.

Robins 1997, p. 142, fig. 163.

Treasures 1998, no. 9, pp. 54–55.

# 92

## Standing Woman

Provenance unknown

New Kingdom, early Nineteenth Dynasty
(ca. 1295–1213 B.C.)

Wood, painted

Height 5 ¼ in. (13.1 cm)

EA 32772, acquired in 1868 from the collection of
Robert Hay

Dressed in the high style of the late Eighteenth
and early Nineteenth Dynasties, this woman
wears a long wig that envelops her shoulders.
Each thick tress is individually curled, plaited,
and bound at the tip. Two shorter strands frame
her face. Her broad diadem is of gold, simulated
here by yellow paint. A lotus blossom at the
front, its stems crossing over her head to the
back of the band, was probably artificial and may
well have been part of the diadem.[1]

Her dress was a large rectangular piece of
sheer pleated linen, which was wrapped around
the body with one fringed edge running down
the front. Another section was pulled over the
left shoulder and arm, and the whole was held
together by a knot beneath the right breast.[2]
This garment must have had the grace of a sari
—and it probably required as much practice to
wear with confidence. The woman's left foot is
lost,[3] but—unusually—both her accessories have
been preserved. She holds a lotus blossom in her
hanging proper right hand and a formal bouquet
of stacked flowers in her left.[4]

During the reign of Ramesses II, queens
and goddesses were sometimes represented with
extremely long, thin bodies.[5] This long-limbed
slenderness, which was doubtless a reaction
against the bottom-heavy figures of the Amarna
Period (cf. cat. nos. 59 and 60), can also be found
on some private representations in less
exaggerated form.[6] This woman's slimness, along
with her idealized facial features, thus dates her
to the early Nineteenth Dynasty. In this period,
her dress was still the height of fashion, but her
wig, a type already current in the reign of
Amenhotep III[7], may have seemed a trifle out of
date. As women's wigs, like those of men, grew
in length, they no longer fell around the
shoulders but were separated into front and back
sections (cf. cat. no. 94).[8]

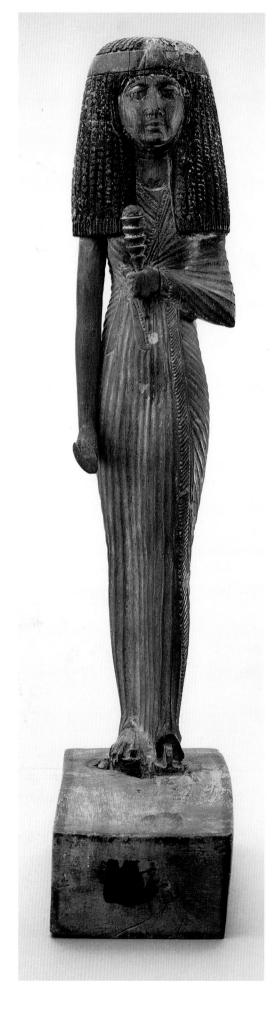

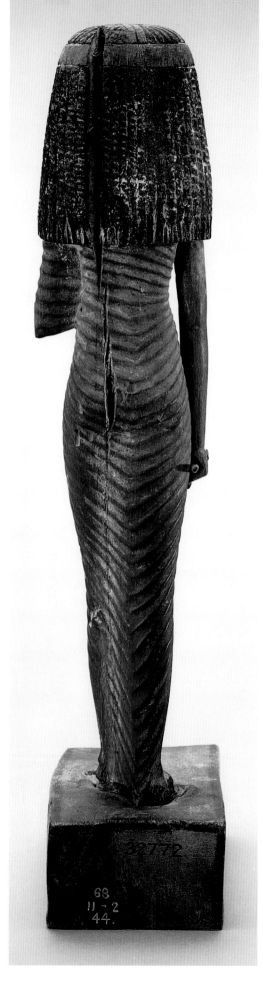

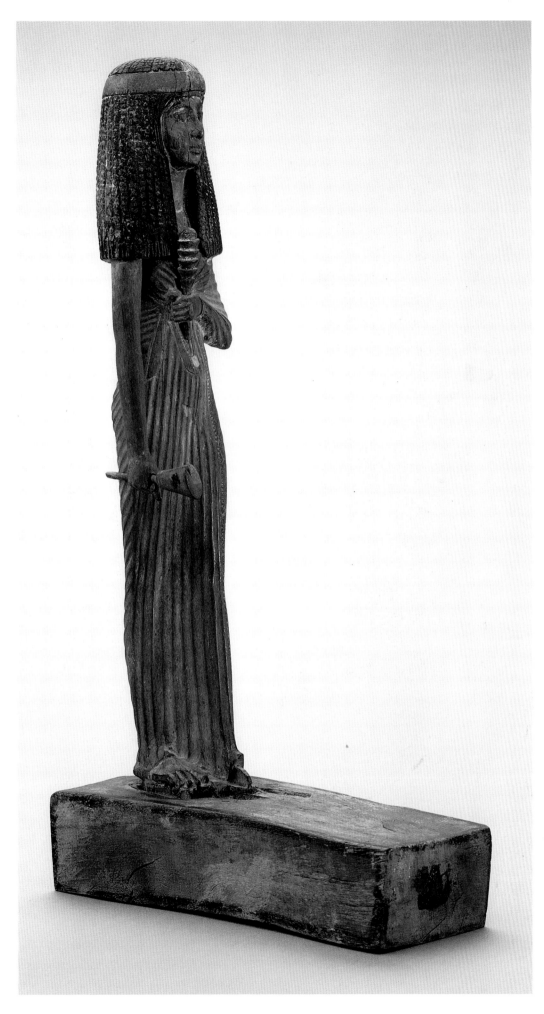

Statues of standing women made during the Old and Middle Kingdoms showed them with their feet together (see cat. nos. 5, 10, 11). In New Kingdom sculpture the woman's left foot is usually slightly advanced.[9] This stance is still more passive than the striding pose of standing male figures. It may have been inspired or encouraged by the conventions for representing women in relief and painting, where the leg farthest from the viewer was always shown a little in front, so as not to hide it altogether (see cat. nos. 6, 14, 23). Unlike earlier female statues, these representations of New Kingdom women often hold objects in both hands, one of which is held to the breast while the other hangs at her side.[10] These objects, as here, were often flowers, symbolic of rebirth. Sometimes, however, the woman holds a sistrum or other ritual object to indicate her participation in temple rituals (see cat. no. 94). **(E.R.R.)**

### Notes

[1] The closest surviving parallel is the gold diadem of Tutankhamun, where the body of the uraeus cobra passes over the head to the back of the band: Andrews 1990, p. 108, fig. 88.

[2] For an example in stone, dating to the reign of Tutankhamun, see Russmann 1989, no. 63, p. 136; Saleh/Sourouzian 1987, no. 196.

[3] Also the base; the present base, though ancient, is from another statue.

[4] For a slightly simpler version of this bouquet, held by a slightly earlier female statuette, see Saleh/Sourouzian 1987, no. 155.

[5] Sourouzian 1989, pl. 6c–d.

[6] For another, slightly later example (Turin 3105) see Seipel 1992, no. 135, p. 343.

[7] Worn by a queen: Russmann 1989, no. 45, pp. 98–101; worn by a nonroyal woman: Arnold, Do. 1996, p. 127, fig. 124, p.136 (cat. no. 54).

[8] For another example, see the figure cited in n. 6.

[9] Vandier 1958, p. 437.

[10] Ibid, p. 438, with further examples on pls. 140:5, 145:1, 5.

### Bibliography

Hall, H. R. 1929, p. 238, pl. 41, 3–4.

Seipel 1992, no. 134, pp. 340–42 (with bibliography).

*Treasures* 1998, no. 10, pp. 56–57.

# 93

## Standing Man

Provenance unknown
New Kingdom, Nineteenth Dynasty
(ca. 1295–1203 B.C.)
Wood, gessoed and painted
Height 18 ⁵/₈ in. (47.2 cm)
EA 2319, acquired in 1835

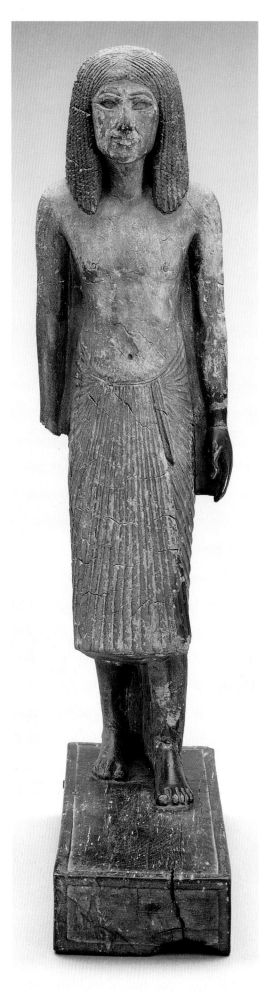

This very fine statuette of a standing man is one
of the relatively few wooden statues made
according to the conventions for stone sculpture,
with negative space connecting the limbs and a
back pillar. On the negative space behind the
man's advanced proper left leg is the raised relief
figure of a naked small boy.

Considering the ostentatious styles of the
period in which he lived, this man is quite simply
dressed. His wig, parted in the center, is fairly
short. He is shirtless and his pleated kilt has only
a narrow pleated apron, rather than the broader
flounced panels worn by many of his high-
ranking contemporaries (cf. cat. no. 91).

Seen in profile, the man's body is thickened
through the abdomen and hips. This suggestion
of maturity is confirmed by his distinctive face,
with its broad, flat cheeks, square jaw, and firm
but fleshy chin. Age lines run from the nostrils to
the corners of the mouth. The mouth is relatively
large, with a full lower lip. The nose is straight
and rather narrow. The tautness of the facial
features suggests a strong, determined character,
and this impression would have been intensified
by the inlaid eyes and eyebrows, now lost.

Wooden statues carved according to the rules
for stone sculpture, with back pillar and/or
negative space, were made more frequently in the
Nineteenth and Twentieth Dynasties than at any
other time. Virtually all of these Ramesside
figures are male, and the great majority of them
stand holding a long staff or standard topped by
the image or emblem of a god.[1] Wooden standard-
bearing statues (some were also made in stone)
were not tomb statues; they were intended for the
temple of the god indicated on the standard. By
far the finest and most distinctive of this group of
wooden statues is a somewhat battered example
in the Brooklyn Museum of Art, which, like this
figure, had the unusual feature of inlaid eyes and
eyebrows.[2] The Brooklyn standard bearer is more

ostentatiously dressed than this figure. He is much thicker through the middle, and his face is round and fat, with a double chin and a ring of flesh on the neck. Though their features differ, these two distinctive faces, as well as the anatomies and costumes that go with them, are so similar in concept and in carving technique that they may well come from the same sculpture workshop, and from the hand of the same master.

This statue does not bear a standard, however, so one must wonder why its owner chose to include a back pillar and negative space. Clearly the decision was not made to gain space for inscriptions, which are lacking. But it may well have been done in order to depict the child. On stone statues of Ramesses II and Merenptah, the crown prince was often represented in this space respectfully touching, as this boy does, the nearest part of his father's anatomy.[3] The child was presumably this man's son, but it seems odd that he was not identified in the space above him.

Although the boy has a pierced earlobe for earrings, he wears no jewelry or clothing. He must be quite a young child, for he is not yet circumcised. The sculptor has tried to convey his extreme youth by giving him a large head and eye, a plump cheek, and several folds of baby fat on the tummy. The result has an awkward charm, but it leaves no doubt that this sculptor was more comfortable depicting mature men. **(E.R.R.)**

### Notes

[1] E.g., Vandier 1958, pls. 161:4, 6, 169:1, 2.

[2] Brooklyn BMA 47.120.2: Fazzini/Romano/Cody 1999, no. 64, p. 112; Vandier 1958, pl. 163:1, 3. This statue is believed to come from Asyut.

[3] E.g., Sourouzian 1989, pls. 3, 15, 16, 19, 22.

### Bibliography

Hall, H. R. 1930a, p. 39, pl. 12.

# 94

## Bust of a Woman

Provenance unknown
New Kingdom, Nineteenth Dynasty,
reign of Ramesses II or Merneptah
(ca. 1279–1203 B.C.)
Basalt
Height 13 3/8 in. (33.8 cm)
EA 37887, acquired in 1853

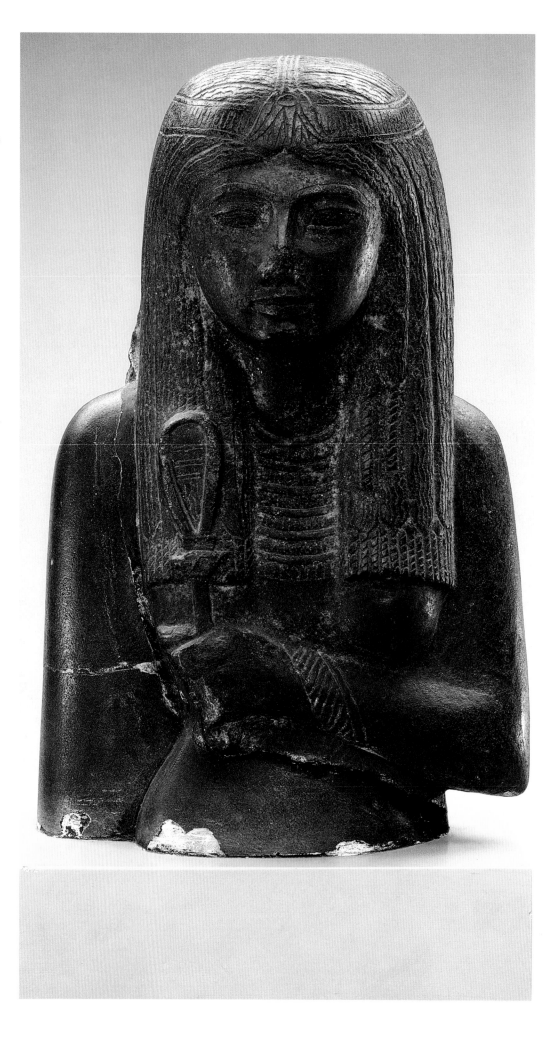

This woman, garbed in the finery of the Ramesside Period, holds a sistrum, a musical instrument used by women in temples and especially favored by the goddess Hathor. This type of sistrum was a bronze loop mounted on a handle topped by the head of the archaic cow-eared goddess Bat, which, by the New Kingdom, had become an emblem of Hathor. The interior of the loop was spanned by wires; these have been indicated by the sculptor, but he has neglected to show the round metal disks that were strung on the wires, so that they jingled when the sistrum was shaken.

The sistrum identifies the woman as a musician of a deity, a priestly status. The use of dark, hard basalt for her statue, instead of limestone, suggests that it was made for a temple, rather than her tomb. This is noteworthy because statues of nonroyal women were not often erected in temples. Though entrance to temples was controlled, they were still, it seems, a little too public for a well-brought-up woman to linger in unescorted, even in effigy.[1] This woman's apparent immunity to this sort of impropriety suggests that she was of very high status indeed, a surmise that is also supported by the unusual quality of her statue.

The woman's garment covers her proper left shoulder and arm and was fastened by a knot under the right breast. It is exactly the same costume as that worn by the slightly earlier female figure, catalogue number 92; but since the fabric is not pleated, the only surviving indication is the fringed edge passing over her wrist. The rest of her costume follows the Ramesside fashion principle: more is better. Her collar necklace is very large.[2] Her diadem is the same as on catalogue number 92, but instead of a pair of face-framing tresses, she has two on each side. The rest of the wavy locks, too long to encircle the shoulders, have been divided into front and back sections. It is nonetheless a rather short version of this type of New Kingdom female wig, which could be very long.[3] As on most Egyptian statues, the woman's face was based on representations of her king, in this case Ramesses II (cat. no. 89) or Merenptah. Royal likenesses provided the models for her round-cheeked, expressionless visage, the rather small mouth, and the indication of her arched eyebrows partly in relief and partly by incision.

Royal models were also the source for the lingering traces of the artistic legacy from Amarna and the reign of Tutankhamun. These can be discerned in the plasticity of her upper eyelids and her rather shapely lips, with the bottom of the upper lip still drooping slightly in the middle (cf. cat. nos. 58, 63). **(E.R.R.)**

### Notes

[1] Russmann 1989, p. 157.

[2] For a comparable example of about the same time, see Saleh/Sourouzian 1987, no. 208 (Cairo CG 600).

[3] E.g., Seidel 1992, no. 135, p. 343 (Turin 3105).

[4] Ramesses II: Saleh/Sourouzian 1987, no. 202; Merenptah: Sourouzian 1989, pls. 15, 16; 19.

### Bibliography

Seipel 1992, no. 82, pp. 238–39 (with bibliography).

# 95

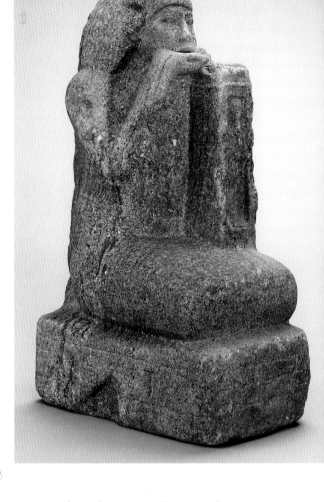

## Mendicant Statue of Peraha

Provenance unknown
New Kingdom, Nineteenth Dynasty
(ca. 1295–1213 B.C.)
Quartzite
Height 17 3/8 in. (44 cm)
EA 501, acquired in 1927

In this statue of a man named Peraha, a number of elements, some of them fairly rare, have been brought together in a combination that is extremely unusual, if not unique. The result is also quite odd. The sculptor responsible for this statue must have been well regarded: the carving of Peraha's facial features shows his competence in working hard stone, such as quartzite. What he lacked, perhaps, was creativity. Challenged to create an unusual composition, he did not entirely rise to the occasion.

In its general type, Peraha's statue is an example of the New Kingdom temple statue representing a nonroyal person, almost always a man, who holds a representation or an emblem of the deity in whose temple the statue was to be placed. Such a statue not only put the owner under the protection of the god or goddess but also enabled his spirit to partake magically of the daily offerings to the deity. The object of Peraha's devotion was Ptah, a very important god whose main temple was at Memphis. The god—or more specifically, a cult statue of the god—is represented standing in a small naos, or shrine.

Normally, a statue of this type showed the owner as a block statue[1] or in a kneeling pose (cf. cat. no. 129). But Peraha is represented sitting cross-legged on the ground with his legs and feet covered by his long kilt. This pose, an invention of the Middle Kingdom, never quite disappeared during the New Kingdom and Late Period (cf. cat. no. 122), but it was never very popular. That this sculptor was unused to the pose is suggested by his failure to allow enough space for the leg area, which can give the viewer the disturbing sense that Peraha was deformed.

As was often the case with kneeling statues holding cult images, Ptah's shrine is balanced on one thigh, the proper left, and held by Peraha's corresponding left hand. But here, too, the sculptor has blundered by making the shrine so high that it impinges on his chin. The reason for doing this, apparently, was to support Peraha's raised hand. And it was very likely that hand, with its uncommon gesture, that caused most of this sculptor's trouble.

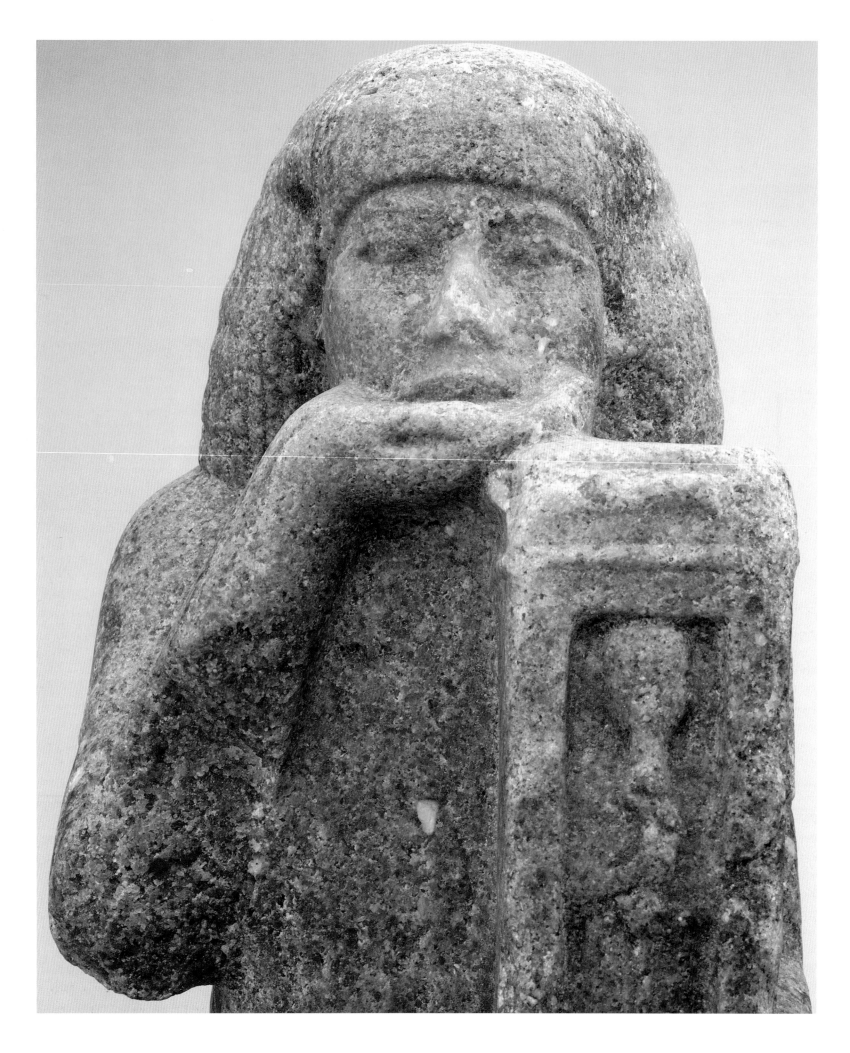

The gesture, hand to mouth with palm upward and thumb awkwardly forward, was one of begging offerings from the god.[2] It first appeared on statues in the Nineteenth Dynasty—perhaps about the time this statue was made—and lasted into the Late Period.[3] Almost all of the few known statues with this begging gesture come from the Theban area and were made for men connected with special cults of Hathor or related goddesses (see cat. no. 96). Whether Peraha belonged to a comparable cult of Ptah, whether he was adapting a specific cult gesture for his own, more generalized purpose, or whether, indeed, he invented its use on statues, the novelty of his requirements from his sculptor survives in the awkwardness of his statue. (E.R.R.)

### Notes

[1] E.g., British Museum EA 81: Schulz 1992, II, pl. 95a.

[2] Vandier 1958, pp. 458–59.

[3] For one of the most famous examples, the seventh-century bust of Mentuemhat (Cairo CG 647), see Russmann 1989, no. 79, pp. 173–75.

### Bibliography

Hall, H. R. 1927a, p. 41, pl. 22a.

Hornemann 1957, pl. 397.

Quirke/Spencer 1992, p. 158, fig. 122.

# 96

## Head of a Man with a Tonsure

From Thebes, Deir el Bahri
New Kingdom, late Eighteenth to early
Nineteenth Dynasty (ca. 1336–1279 B.C.)
Limestone
Height 2 5/8 in. (6.7 cm)
EA 43132, gift of the Egypt Exploration Fund, 1906

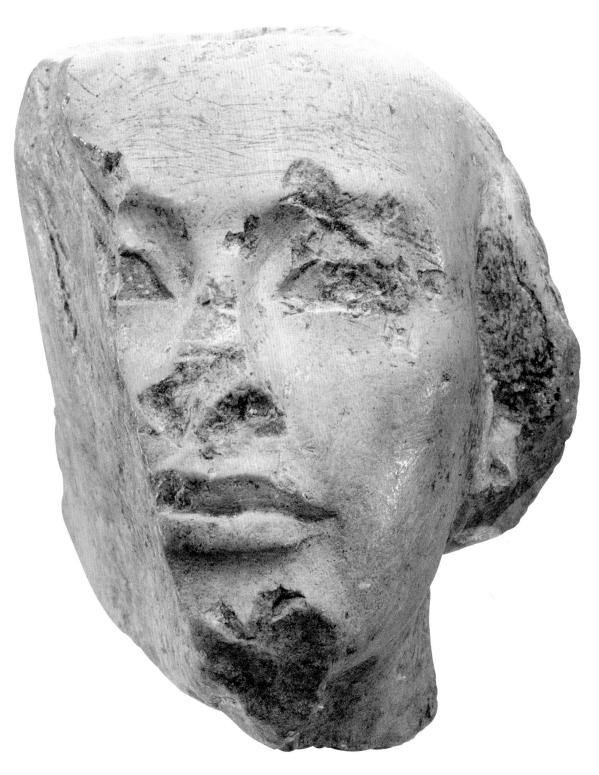

This fragmentary head of a statue has been included not only for its exceptional quality, but also because of the man's distinctive hairstyle: he is bald on top, with wavy locks at the sides and back, flaring out to partially cover his ear and the nape of his neck. Balding men had been depicted in Egyptian art since the Old Kingdom. Most are workingmen, whose scanty and sometimes scruffy hair emphasizes the fact that they are not wearing wigs.[1] But the close-cropped hair on middle-aged figures of tomb-owners might also reveal a receding hairline.[2] By contrast, this head, extensively bald but with well-groomed hair, is so different from conventional Egyptian representations of baldness that some have suggested it is a foreign style.[3]

This example is not unique, however. About a dozen statues made during the later New Kingdom and the Late Period show their owners with the same semi-bald heads and flaring side and back hair. A recent study of the inscriptions on the better preserved of these statues has shown that these men called themselves "Bald Ones" of Hathor.[4] Apparently this hairdo was a kind of tonsure for a special cult devoted to Hathor and related goddesses.

Statues representing the "Bald Ones" of Hathor were erected in her chapels. Most of them were kneeling figures or block statues; they held emblems of the goddess and, in most cases, had one hand cupped below their lips in the same gesture as on catalogue number 95. According to some of the inscriptions, this begging gesture was directed at passersby from whom the Bald One requested offerings,

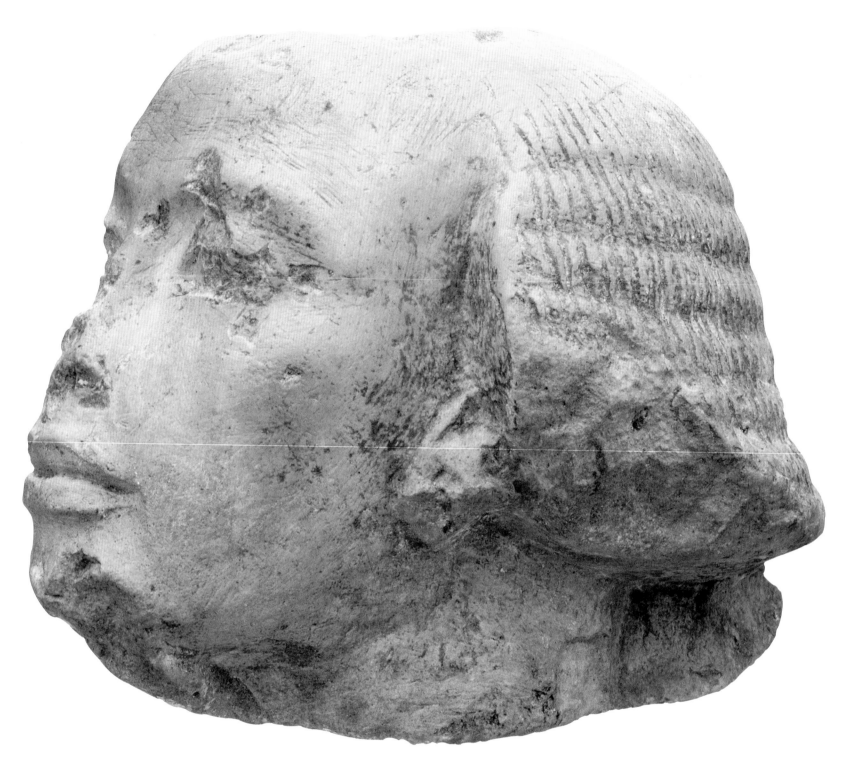

promising in return to intercede for them with the Great Goddess.

Hathor was one of the most important goddesses on the West Bank of the Nile at Thebes, where she had a number of chapels, including several at Deir el Bahri, where this head and several other statues of "Bald Ones" of Hathor were found. One of these other statues in particular suggests how the figure from which this head was broken may have looked when it was complete.[6] It represents a man who lived under Ramesses II. His hairstyle is the same, although the individual strands are not

indicated. The figure is a block statue with the sistrum-shaped emblem of Hathor resting on his feet before his knees.[7] His proper left hand rests on his knees, and the right is cupped under his chin. Despite the fragmentary condition of the present head, two small bits of evidence suggest that its original form was very similar. In the first place, the damage to the chin suggests that something was attached across the bottom; since it was not a beard, the likeliest possibility is that it was his cupped hand. Secondly, we can see from the angle of the neck that the head was slightly raised. This rather uncommon detail is

found occasionally on most types of Egyptian statues, but it appears with greatest frequency on block statues.

Whatever its precise original appearance, there can be no doubt that this statue was of extraordinarily high quality. The form of the eyes and the lovely, generous mouth suggest a date in the late Eighteenth Dynasty, during the reign of Tutankhamun (cf. cat. no. 63). However the cult of the "Bald Ones" does not seem to have really started before the beginning of the Nineteenth Dynasty.[8] Thus this head may represent the survival of late Eighteenth

Dynasty sculptural style—in the hands of one of its finest practitioners—into the early years of the Ramesside Period.[9] **(E.R.R.)**

### Notes

[1] E.g., *Egyptian Art* 1999, p. 405, fig. 126, no. 193, pp. 468–71 (Old Kingdom); Clère 1995, pp. 2–4, figs. 1–5 (New Kingdom).

[2] E.g., Cairo CG 34: Russmann 1989, no. 9, pp. 30–31; Saleh/Sourouzian 1987, no. 40.

[3] Seipel 1992, p. 334.

[4] Clère 1995; to his examples, add a very fine miniature head with the same tonsure, New York MMA 64.225 (unpublished).

[5] Clère 1995, pp. 8–9.

[6] Clère 1995, pp. 87–94, pls. 6–7. (Though virtually complete, this statue has lost its face, and much of its right hand.)

[7] The emblem is similar to that held by cat. no. 129.

[8] One small tonsured head may be as early as Amenhotep III: Clère 1995, pp. 171, 173, pl. 27a–b.

[9] For a composite statue of Sety I somewhat comparable in style, see Russmann 1989, no. 67, pp. 146–48; Saleh/Sourouzian 1987, no. 201.

### Bibliography

PM II 1972, p. 394 (with bibliography).

Seipel 1992, no. 131, pp. 334–35.

Clère 1995, no. II, pp. 171–72, pl. 27c (with bibliography).

# 97

## Niche Statue of Maanakhtef

Possibly from Thebes
New Kingdom, Nineteenth Dynasty
(ca. 1279–1213 B.C.)
Limestone, traces of paint
Height 20 1/2 in. (52 cm)
EA 296, acquired in 1834, formerly Sams Collection

The great majority of Egyptian statues are complete, freestanding objects. When tombs and temples were hewn into the rock, however, rather than being built, statues might be carved into the walls themselves.[1] Most rock-cut tomb statues were carved in interior rooms,[2] but in the New Kingdom they sometimes appeared on the tomb façade flanking the entrance,[3] or in a niche above[4].

This statue comes from such a niche over the façade of an unlocated tomb belonging to a man named Maanakhtef. Only his head, the fingers of his hands (held open in adoration),

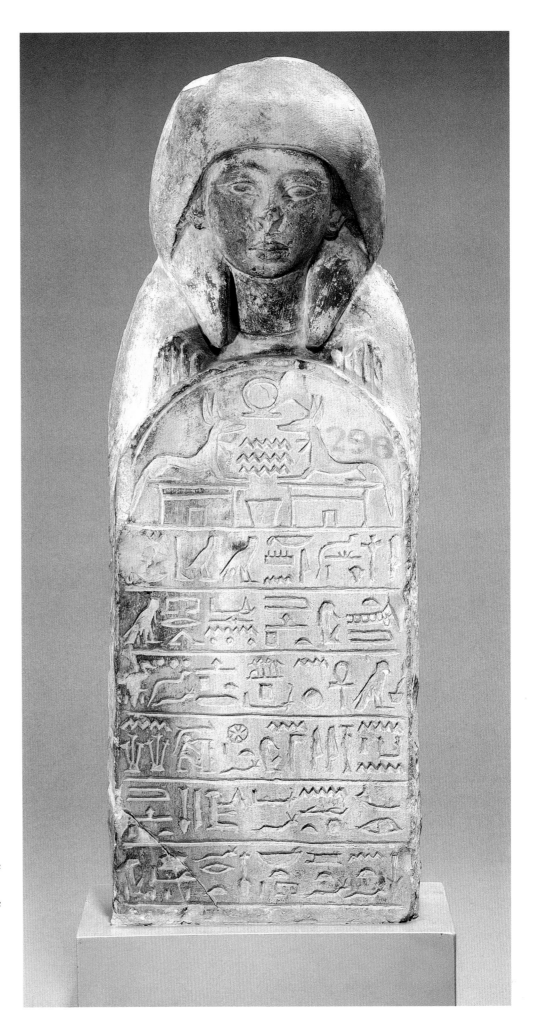

and the stela in front of him have been carved. The text of the stela indicates the purpose of this statue. Topped by a series of protective symbols, including two figures of the jackal god Anubis, it offers a prayer to the gods Amun and Atum, as manifestations, respectively, of the rising and setting sun, praying that they enable Maanakhtef to "go forth as a living *ba*."[5] Thus the statue is intended to associate its owner with the solar cycle of daily awakening and rebirth. Almost certainly it faced east, and was thus in an ideal position to greet the sun each morning.

Many New Kingdom tombs at Thebes had a small pyramid[6] constructed above the chapel (cf. fig. 51) with a niche in the front (eastern) face. In it was placed a kneeling statue of the tomb owner, holding a stela with a prayer or hymn to the sun.[7] Since these small pyramids were built structures, rather than rock-cut, these statues were separate, freestanding works, and many have survived.[8] Maanakhtef's statue is of the same type, but the fact that it was carved as part of its niche suggests that it may have been positioned in a flat part of a rock-cut façade, rather than in a pyramid.

All that can be seen of Maanakhtef's costume is his double wig, which, because the tresses and curls of hair are not indicated, looks more like a hood. The long, rather puffy-looking front lappets are in the style of the Nineteenth Dynasty (cf. cat. no. 128). His round face and attractive but undistinguished features are based on representations of Ramesses II (cf. cat. no. 89), under whom he probably lived.[9] His earlobes are pierced for earrings. Though both men and women had worn earrings since the beginning of the New Kingdom, this detail was not represented on two- or three-dimensional figures until the Amarna Period.[10] Tutankhamun's images have pierced ears (cf. cat. no. 63), and this fashion endured throughout the rest of the New Kingdom. Earring holes are most often visible on male figures, whose hairstyle left their earlobes uncovered, as on catalogue numbers 93 (the child), 96, and 128. But men of the later New Kingdom were never shown actually wearing earrings. Most women wore wigs that covered their ears (see cat. nos. 92, 96), but royal women, whose headdresses sometimes left their ears bare, were sometimes depicted with earrings,[11] and earrings are often found on the heads of female anthropoid

coffins, where they may be very large (see cat. no. 107) or even worn two to an ear.[12]  (E.R.R.)

### Notes

[1] As on the rock-cut temples at Abu Simbel: Vandersleyen 1975, pls. 86–88; Schulz/Seidel 1998, figs. 127–30, pp. 214–15.

[2] E.g., *Egyptian Art* 1999, pp. 42, 48, figs. 18, 27 (Old Kingdom); Robins 1997, p. 138, fig. 156 (New Kingdom).

[3] As on the tomb of the Nineteenth Dynasty vizier Paser (Theban Tomb 106): PM I, 1 1960, p. 219.

[4] Schulz 1992, II, pl. 134c.

[5] The last line also names his wife, Nefretkhaw.

[6] It should be remembered that in this period royal tombs, in the Valley of the Kings, did not have pyramids.

[7] For the relationship to earlier block statues in niches above tombs (discussed in cat. no. 25) see Schulz 1992, II, p. 763.

[8] E.g., Brooklyn BMA 37.263E; without stela but with inscription on kilt: Bothmer 1966–67, pp. 64–67, figs. 9–12; British Museum EA 480: Robins 1997, p. 145, fig, 167; New York MMA 17.190.1960: Hayes 1959, p. 160, fig. 88.

[9] Vandier 1958, p. 472, suggests that this type of statue fell out of use in the early Nineteenth Dynasty; if he is correct, this would be a late example of the type.

[10] E.g., Saleh/Sourouzian 1987, nos. 159–60, 162–66.

[11] E.g., Saleh/Sourouzian 1987, no. 208 (Cairo CG 600).

[12] Saleh/Sourouzian 1987, no. 218 (Cairo JE 27309).

### Bibliography

*HT* II 1925, p. 5, pl. 5

PM I, 2 1964, p. 789 (with bibliography).

Robins 1995, no. 16, p. 19 (not illustrated).

# 98

## Stela of Neferhotep

From Thebes, Deir el Medina[1]
New Kingdom, Nineteenth Dynasty
(ca. 1241–1199 B.C.)
Limestone, traces of paint
Height 18 in. (45.5 cm)
EA 1516, acquired in 1911

This stela, commissioned from a relief carver by an artist-scribe named Neferhotep, shows the seated figures of the early New Kingdom king Amenhotep I (ca. 1525–1504 B.C.) and Queen Ahmose Nefertary before an offering table. The pair hold *ankh* signs, and the king also holds a crook and flail, emblems of Osiris; these divine symbols indicate their semi-deified status. In

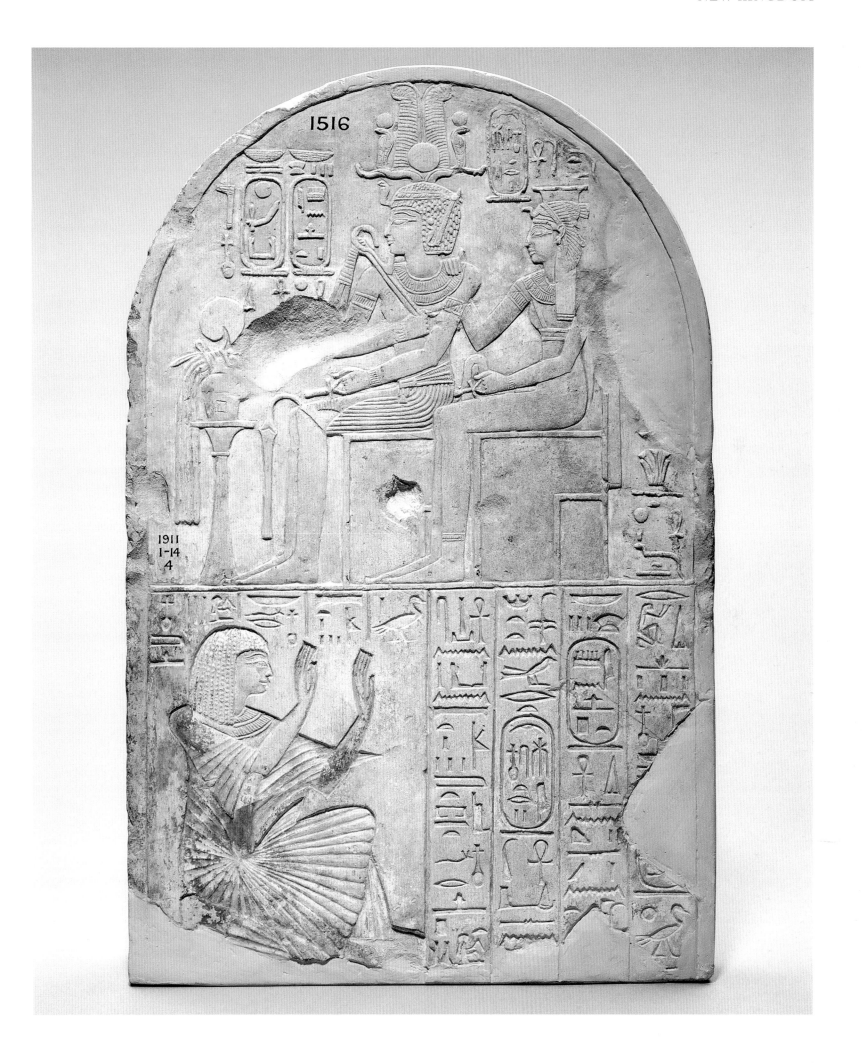

the lower register Neferhotep kneels in adoration with a prayer to the royal couple. Neferhotep's figure and texts are carved in sunk relief, but the royal figures, their offerings, and their inscriptions are all in raised relief. This honorific use of raised relief for royal and divine images appears on a number of private stelae and statues made during the later New Kingdom. It may be meant to indicate that these seated figures, rendered in such great detail, are cult statues. Though the carving is extremely competent, this sculptor was clearly more comfortable working on sunk than on raised relief. He has had trouble with the spacing of the raised relief hieroglyphs, because of their thicker outlines, and has even made the queen's cartouche a little crooked, in order to fit it in.

Neferhotep probably erected this stela in a chapel at Deir el Medina, where he lived and where the royal pair were worshiped as patron saints. Deir el Medina (a modern name) was a village on the West Bank at Thebes (see fig. 51) built to house the artist-scribes who worked in the nearby Valley of the Kings, decorating the royal tombs. Since these artists had to draw both figures and inscriptions, they were trained as scribes, with the result that the literacy rate in Deir el Medina was far above average. Even some of the village women seem to have been at least partly literate.[2] Though the village is now in ruins, quantities of documents have been found there, ranging from ostraca with sketches and practice texts to religious and legal writings, to personal letters, absentee records, and even laundry lists.[3] These have yielded a great deal of information about the lives of Neferhotep, some of his colleagues, and their families—though never, of course, all that we would like to know.

Neferhotep was "Foreman on the Right Side," which means he was in charge of one of the two crews of artist-scribes who decorated a royal tomb, one crew on each side of the long descending halls and the burial chamber.[4] During his long career, Neferhotep worked on the tombs of Ramesses II (cf. cat. no. 89), Merenptah, and Amenmessu. He also built himself the largest, most imposing tomb in the cemetery at Deir el Medina.[5] Even more than this stela, Neferhotep's tomb shows how prosperous a senior artist at Deir el Medina could be.

Neferhotep had inherited his position from his father, Nebnefer, who had received it from

his father, also named Neferhotep. The younger Neferhotep, however, was childless, and so he fostered one Paneb, the son of a fellow workman, as his heir apparent. Unfortunately, Paneb turned out to be vicious and violent[6] and threatened to kill Neferhotep, who then turned his attention to a young male slave named Hesunebef. With Neferhotep's patronage, Hesunebef grew to adulthood as a royal artist-scribe and a free member of the community. In gratitude, Hesunebef named his son and daughter after Neferhotep and his wife, and he commissioned a stela to honor his patron.[7]

Neferhotep lived into his seventies, but his death was violent. According to his brother, he was killed by "the enemy." This probably means that he was a victim of the fighting that erupted at Thebes during the succession struggle between Amenmessu and Sety II (see cat. no. 90).[8] But some, pointing to the fact that the wicked Paneb took over Neferhotep's job, suspect that the old man was murdered by his former protégé.[9] (E.R.R.)

### Notes

[1] Bierbrier in *HT* X 1982, p. 27, n. 1.

[2] Janssen 1992; for his remarks on women, see pp. 89–91.

[3] For a selection of these documents, see McDowell 2000. The literature on Deir el Medina is extensive; see Haring 1992; also the works cited here and that cited (in cat. no. 67) as Friedman 1994.

[4] For his life and career, see Davies, B.G. 1999, p. 298 (index), chart 6; Bierbrier 1982, pp. 29–32.

[5] Theban Tomb 216, now in ruins: PM I, 1 1960, pp. 312–15; façade illustrated in Bierbrier 1982, p. 30, fig. 15; copies of the surviving texts: KRI III, pp. 587–93.

[6] For Paneb's turbulent and criminal career, see Bierbrier 1982, pp. 107–11.

[7] Bierbrier 1982, p. 31, fig. 17 (Manchester Museum 4588); for Hesunebef's life, see Janssen 1982, pp. 109–15.

[8] Bierbrier 1982, pp. 31–32; for a discussion of the evidence see Janssen 1997, especially pp. 102–104.

[9] Hoffmeier 1988, p. 220.

### Bibliography

Bierbrier 1982, pp. 29, 30, fig. 16.

*HT* X 1982, p. 27, pl. 64 (with bibliography).

Hoffmeier 1988, p. 219, pl. 28:3.

Robins 1993, fig. 47, p. 123.

## Painting and Drawing: The World and the Underworld
### (catalogue numbers: 99–105)

Catalogue numbers 99–105 are sections from papyrus rolls containing the *Book of the Dead*. This modern name designates a group of magical spells, which, from the New Kingdom into the Ptolemaic Period, were written on papyrus for nonroyal individuals and placed in their tombs, to protect and help them in the Afterlife.[1]

Each spell had its own vignette. These small images range from simple illustrations, such as a headrest for the headrest spell, to symbolic images of the Afterworld. Some, like the weighing of the heart as the deceased is judged before Osiris (see cat. nos. 102, 105), are complete scenes.[2] Many *Books of the Dead* were written and drawn using only red and black ink (see cat. nos. 99, 104). Some however, had polychrome illustrations. The most lavish of the fully painted *Books of the Dead* come from New Kingdom Thebes. Of these, the finest known examples are in the British Museum.[3]

In their style and some of their subject matter, *Book of the Dead* paintings are very closely related to the wall paintings in Theban private tombs of the Eighteenth Dynasty. It has often been assumed that tomb painters also painted the papyrus scenes, most of which date to the Nineteenth Dynasty. Given the strength of Egyptian traditions, this is certainly possible and even likely. Investigation of the artist's identity is complicated, however, by the differences between the two genres. The brushwork on the vignettes is usually less detailed and often tighter than on the larger tomb figures. Since there seems to be less mixing of different pigments, the palette is more limited, and the tan color of the papyrus renders the tonality darker than on the whitewashed or color-washed tomb walls. Whether or not the painters of papyrus were also mural painters, they clearly understood that the miniature paintings required somewhat different techniques and followed somewhat different rules.

This selection includes two fine examples of the under-appreciated Egyptian art of

drawing (cat. nos. 99, 104), one of which is rather unusual in coming from a place other than Thebes (cat. no. 99, from Memphis). Three polychrome vignettes, two of them from the famous papyrus of Ani (cat. nos. 101, 103; the third is cat. no. 100), are scenes derived directly or indirectly from Eighteenth Dynasty tomb paintings. Another sheet from Ani's papyrus shows the weighing of his heart in the Hall of Judgment (cat. no. 102), and a much later version of the same scene shows a continuation of this subject in a very different style (cat. no. 105). (E.R.R.)

### Notes

1 Hornung 1999, pp. 13–22.

2 For the various vignettes, see Faulkner 1985.

3 Faulkner 1985 is illustrated entirely with British Museum papyri. Faulkner et al. 1994 is a facsimile (not photographic) reproduction of the British Museum's papyrus of Ani (here also cat. nos. 101–103).

# 99

## *Book of the Dead*, Papyrus of Nebseny: Offering Scene

From a Memphite cemetery, probably Saqqara
New Kingdom, Eighteenth Dynasty
(ca. 1400–1390 B.C.)
Papyrus, black and red inks
14 1/8 x 26 in. (35.8 x 65.8 cm)
EA 9900/32, acquired in 1836 from the collection of James Burton

This sheet from Nebseny's papyrus roll *Book of the Dead* shows him and his wife, Senseneb, in a traditional offering scene (for an Old Kingdom version, see cat. no. 6c). The couple are to be understood as seated side-by-side on a broad chair with a high back and lion legs, only three of which are shown. Nebseny holds a rolled, folded piece of cloth, and Senseneb sniffs a fragrant blue lotus. Beneath them are characteristic possessions: a mirror and ointment jar for Senseneb and a carrying case for scribal equipment for Nebseny, who was a copyist in the temple of Ptah at Memphis and in the temples of Upper and Lower Egypt, and a draftsman in the sculptors' workshop. The foodstuffs and

flowers heaped before the couple are being offered to them by their son, Ptahmose. Because he is acting as a funerary priest, Ptahmose wears a priest's sidelock (cf. cat. no. 55). Along with the traditional collar necklace, he wears an amulet in the shape of a heart. Red ink has been used for some details, including the design on Nebseny's scribal case, which is the most conspicuous object in the entire composition. The visual emphasis on this object has been underscored by also giving it a label: "Holder for writing." The case was the emblem of Nebseny's professional identity, and he has left no doubt as to its importance to him.

Though the couple face left, the hieroglyphic signs in the prayer above their heads face right, an apparent breach of the rule that people and their inscriptions should be oriented in the same direction (cf. cat. no. 20). This was doubtless done so that the signs would have the same orientation as the son, to indicate that he is uttering the prayer. However, the writing is also retrograde: instead of reading the columns from right to left, the normal direction for reading rightward-facing hieroglyphs, one must start at the top of the leftmost column, where the opening phrase of the prayer has been helpfully written in red. Retrograde writing was

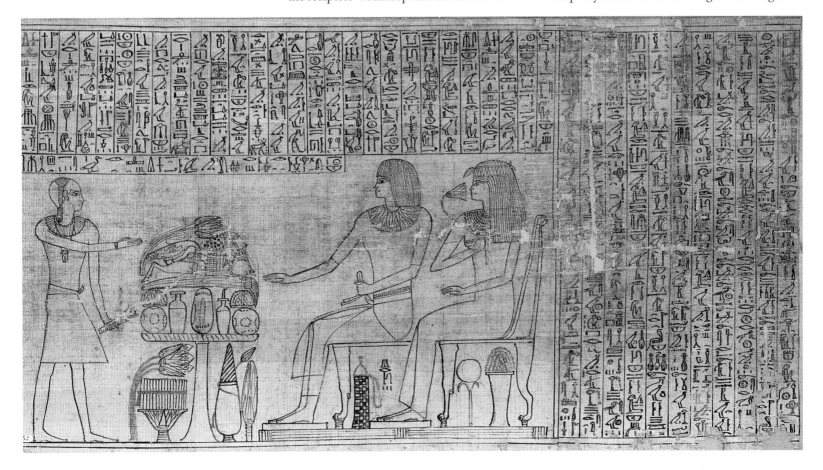

often used for religious texts, but its use here was probably to retain the same positions for the words as they would have had in the more usual reverse direction—thus the couple's names and titles would appear, as usual, above their heads.[1]

Though Egyptian artists have left many sketches, vignettes, and preliminary drawings for reliefs or paintings, formal drawings such as this one are comparatively rare. The offering scene was not, properly speaking, part of the spells and vignettes that made up the *Book of the Dead* proper. In this case, it has been treated as a kind of set piece. Not only is it more carefully and elaborately drawn than the other vignettes in this papyrus,[2] but it is also clearly the work of a different artist's hand. Since Nebseny's titles indicate that he was an artist-scribe, it is tempting to think that he himself might have drawn this special scene. If so, Nebseny's high forehead and large, prominent jaw, though too stylized to be considered a portrait, may at least suggest his actual (or desired) appearance. **(E.R.R.)**

### Notes

[1] Fischer 1972, p. 22; Fischer 1986, especially pp. 124–25.

[2] For illustrations of some of the vignettes, see Faulkner 1985, figs. on pp. 37, 51, 101, 103, 104, 109, 125 (above and below), 129, 161, 165.

### Bibliography

This papyrus is not yet fully published; for this scene, see Parkinson/Quirke 1995, p. 55, fig. 36; for other vignettes see n. 2.

# 100

## *Book of the Dead,* Papyrus of Nakht: Worshiping Osiris

Provenance unknown

New Kingdom, late Eighteenth or early Nineteenth Dynasty (ca. 1336–1294 B.C.)

Papyrus, painted

15 ⁵/₈ x 36 ³/₄ in. (39.7 x 93.2 cm)

EA 10471/2, acquired in 1888, purchased via Sir E. A. W. Budge

The boundaries between this world and the Afterworld are blurred in this representation of a couple named Nakht and Tjuiu worshiping Osiris and Maat, before the mountains of the western desert. The West was the realm of Osiris, the land of the dead. Above appear the breasts and arms of the sky goddess Nut, who receives the sun at sunset. But the couple appear to be on their estate, flanked by their house and an artificial lake surrounded by trees. The artist has emphasized the ambiguity of this setting with an extraordinary detail: a grapevine at the corner of the lake (where vines were not normally planted) seems irresistibly attracted to the face of Osiris, which sometimes, as here, is colored green to symbolize the god's association with plant germination and growth.

Nakht was a scribe and a military man, Tjuiu a musician of the god Amun, in token of which she holds a sistrum (cf. cat. no. 94), together with two blossoms of fragrant blue lotus. Both are in gala attire with cones of perfumed ointment on their heads, filmy linen garments and a great deal of jewelry, including earrings so large that the one we can see on Tjuiu's head displaces the tress beside her face. With their slightly dumpy figures and their huge eyes, on which the crease of the eyelid is indicated, the couple so closely resemble figures in tombs decorated during the reign of Tutankhamun as to suggest that this papyrus must have been painted at the same time or only slightly later.

Although the combination of elements in this scene may be unique, almost all of its components have close parallels in Eighteenth Dynasty private tombs at Thebes. The house and the tree-shaded lake are drawn in the typical Egyptian manner, by combining architectural-style plans and elevations. Like the rules for drawing human figures, this way of representing buildings and landscape elements was intended to provide information, rather than to create an illusion of reality. Perspective was disregarded, so much so that the small size of the lake should not be understood to indicate that it was some distance away. It is far more likely that this feature was simply scaled to fit the available space.

Like all dwellings in ancient Egypt, including palaces, Nakht's house would have been built of sun-dried mud bricks and whitewashed. Though it appears to be a small one-storied structure, it rests on a platform and has an imposing door. The contraptions on the

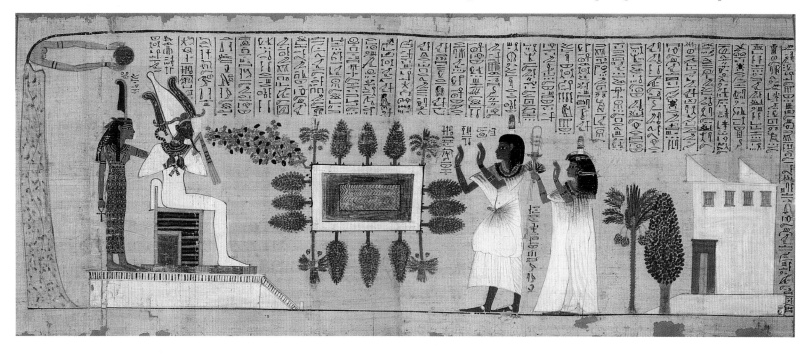

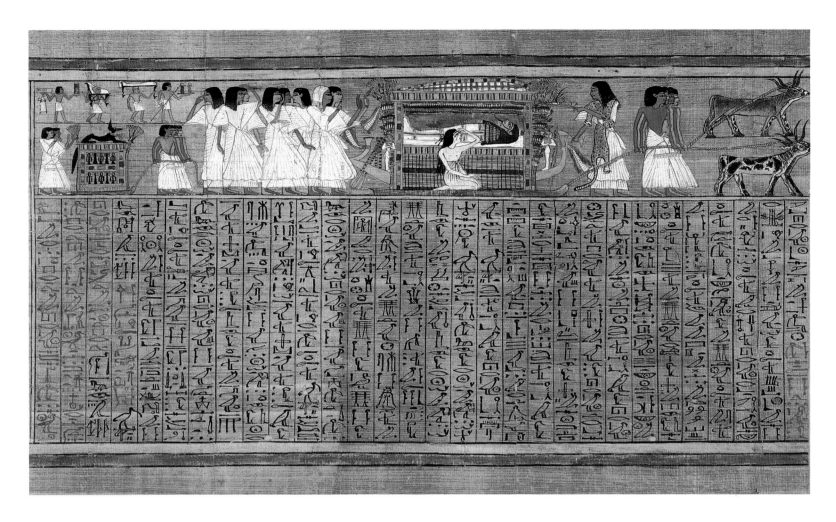

roof are ventilation hoods that face north, to catch cooling breezes and direct them into the interior.[1] Among the relatively few representations of houses in tomb paintings,[2] I know of only one example with a representation of roof ventilators.[3] Similar devices may still be found on the roofs of traditional Egyptian houses,[4] as can the small windows set high in the wall, for ventilation as well as privacy.[5] The window grills, made of stone or wood,[6] may be considered forerunners of the intricately carved openwork screens that cover the windows of traditional Arabic buildings. (E.R.R.)

## Notes

[1] Endruweit 1994, pp. 90–104.

[2] For a list, see PM I, 1 1960, p. 465; some illustrations and discussion in Davies, N. de G. 1929; also Strudwick/Strudwick 1997, pp. 37–40.

[3] Davies, N. de G. 1929, p. 246, fig. 10, with a comment (p. 248) that they are wrongly placed back to back.

[4] Endruweit 1994, pls. 10A, 11A.

[5] Ibid., pl. 10B.

[6] Actual examples: ibid., pls. 5B, 6A; Freed/Markowitz/D'Auria 1999, no. 163, p. 253.

### Bibliography

The papyrus is not fully published; some vignettes are illustrated in Faulkner 1985. This scene also in Schulz/Seidel 1998, p. 392, fig. 107; James 1986, pp. 52–53, fig. 57.

Illustrations and discussions of the house:

Davies, N. de G., 1929, fig. 11, p. 247.

Roik 1988, I, pp. 64, 205–206, II, figs. 100, 318a–b.

Doyen 1998, pp. 347–348 with n. 18, fig. 1 on p. 349.

# 101

## *Book of the Dead*, Papyrus of Ani: The Funeral Procession

From Thebes
New Kingdom, Nineteenth Dynasty
(ca. 1295–1186 B.C.)
Papyrus, painted
16 3/4 x 24 1/2 in. (42.3 x 62 cm)
EA 10470/5, acquired in 1888, purchased via Sir E. A. W. Budge

Ani was a scribe, whose titles indicate that he specialized in accounting. The three sections in this catalogue from his funerary papyrus (see also cat. nos. 102, 103) give only a taste of this amazing work, the total length of which is some 78 feet (almost 24 meters), with every vignette beautifully painted. It is perhaps the finest and certainly the best preserved of the *Books of the Dead* that have polychrome vignettes.[1]

This sheet shows Ani's funeral procession as it moves toward his tomb, where it will be met by grieving women and where the coffin will be stood erect for the last rites and the widow's last farewell before being taken into its final resting place.[2] As on catalogue number 99, the writing of the long spell below is retrograde. Here, however, the backward writing presumably had a magical meaning.[3]

Two pairs of oxen, guided by four men, haul the sledge bearing the coffin, which is preceded by a priest in a leopard-skin vestment(cf. cat. no. 55). He turns back toward the coffin, to wave an incense burner and pour liquid from a tall libation vase. The large bier has the prow and stern of a boat, like the boat in which the sun god traveled across the sky. Large formal bouquets and statuettes of Nephthys and Isis flank the head and the foot of the anthropoid coffin, which is evidently on public display during its slow, final journey. Ani's widow,

kneeling beside the bier, has bared her breast in her sorrow and tears from her kohl-rimmed eyes track down her cheek.

Behind the coffin walk Ani's most important mourners, male relatives and colleagues, one of whom is a white-haired elder. The last man in the group turns his head away, apparently to hide or wipe away tears. The hand held over the hair of the next figure to the right indicates that he is casting dust on his head. All these men's gestures were standard gestures of mourning. A second sledge, pulled by four men, holds a chest decorated with the *djed* pillar of Osiris and the *tiyet* knot of Isis and topped by a recumbent figure of Anubis. This is a container for the four canopic jars which held the separately mummified internal organs. Two lesser mourners follow. At the tail of the procession, here squeezed into an upper register, some of Ani's servants bear possessions that will be left in the tomb. These certainly do not represent everything buried with Ani, but include some of the most important, such as his scribal palette and carrying case (cf. cat. no. 99).

Funeral processions were represented in almost every New Kingdom tomb and almost every *Book of the Dead* papyrus, though no two depictions are exactly alike. Certain details of this version, such as the representation of white hair, have parallels in tombs painted during the Nineteenth Dynasty, when this papyrus was decorated. Other features are more generic to Egyptian painting. For example, the alternating light and dark skin colors on groups of two or more identically posed figures are clearly based not on reality but on the need to clarify the number of people represented. And, as so often in the sub-scenes on Egyptian paintings and reliefs (cf. cat. no. 14), there is a hint of humor—as one bearer staggers under the weight of a bed, a second has managed to poke his head through the bottom of the chair he is carrying. **(E.R.R.)**

### Notes

[1] See also the remarks by T. G. H. James in his entry for catalogue number 102.

[2] This section is illustrated in Faulkner 1985, p. 38 (below); Faulkner et al. 1994, pl. 6.

[3] Discussed by Goelet in Faulkner et al. 1984, p. 156.

### Bibliography

See bibliography for cat. no. 102. Also,

Faulkner 1985, p. 38 (above).

Faulkner et al. 1994, pp. 156–58, pl. 5 ("facsimile" reproduction).

# 102

### *Book of the Dead*, Papyrus of Ani: Ani's Judgment

From Thebes
New Kingdom, Nineteenth Dynasty
(ca. 1295–1186 B.C.)
Papyrus, painted
16 ⅝ x 26 ⅛ in. (42 x 66.3 cm)
EA 10470/3, acquired in 1888, purchased via
Sir E. A. W. Budge

To pass from life to the realm of the dead—the Afterlife—was seen to be literally a "moment of truth" for an ancient Egyptian. At this moment, he or she faced judgment. From the New Kingdom into the Roman Period, some provision could be made for the suitably resourced Egyptian to meet this trial of judgment with the help of spells or utterances included in the *Book of the Dead*, a copy of which would be buried with the deceased. Spell 125 became an essential component of any personal copy of the *Book*; it contained a declaration of innocence by the deceased, often called the "negative confession," in which the person declares his innocence of forty-two crimes,

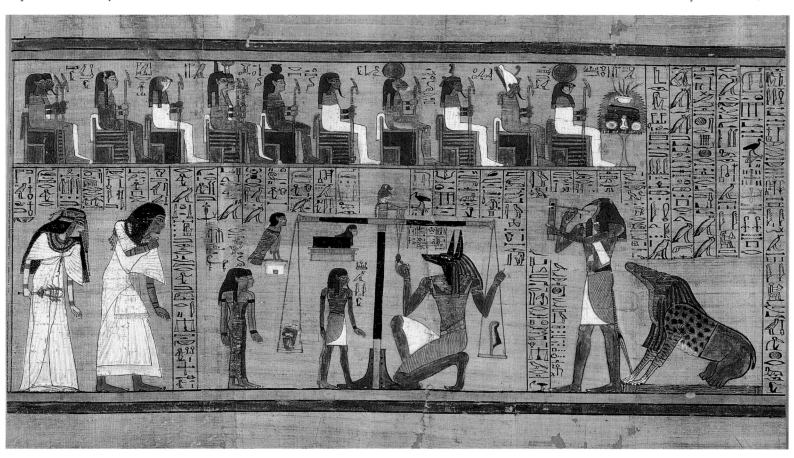

addressed to the forty-two assessor deities in the Hall of Judgment.[1] This text is usually accompanied by an illumination, or vignette, illustrating the process of judgment.

In the papyrus of Ani, vignettes illustrating the judgment and Ani's introduction to the god Osiris come before the text of Spell 125; they are generally considered to be the finest vignettes of judgment to have survived from antiquity. Ani was not a person of great importance in the official administration at Thebes in the Nineteenth Dynasty; he was a king's scribe. His tomb in the Theban necropolis has not been identified; but his papyrus roll has survived, a magnificent and complete document 78 feet (23.78 meters) long, now cut into thirty-seven convenient lengths, mounted under glass.[2] The texts inscribed from the standard Theban version of the *Book of the Dead* are not carefully copied; but the vignettes are superlative.

The scene is the Hall of Judgment. Centrally placed is a balance, holding in its two pans Ani's heart (on the left) and a feather (on the right) representing Maat, the divine personification of truth and order. The crossbar of the balance hangs from a feather-shaped peg attached to the upright support, on the top of which squats a small baboon. This creature is a form of the god Thoth, who acts in a different form and with a different duty elsewhere in this "trial." The god Anubis, here shown as a jackal-headed, human-bodied, kneeling deity, described as "he who is in the place of embalming," holds the cord of the right-hand pan, and steadies the plumb bob of the balance. To the right of the balance stands Thoth, here in human form with ibis head; he is the scribe of the gods, and he holds a scribe's palette and a reed brush, ready to note down the results of Ani's interrogation. On a mat behind Thoth sits a monster ready to spring forward to consume Ani's heart if he fails to pass the test. This creature has the head of a crocodile, the forepart of a lion, and the hindquarters of a hippopotamus.

At the top of the scene the great gods of Egypt are shown, formally seated on thrones, waiting to deliver judgment: Re-Harakhty, Atum, Shu, Tefnut, Geb, Nut, Isis and Nephthys, Horus and Hathor, joined by gods personifying the divine word (Hu) and

perception (Sia). Other deities observe the proceedings: to the left of the balance, Shay (fate) and, strangely, two birth goddesses, Renenutet and Meskhenet. Ani's soul or *ba* bird, which will allow him freedom of movement in and out of the tomb after death, perches on a shrine-shaped building, ready to be released if judgment is given in Ani's favor.

Into this formidable gathering comes Ani, accompanied by his wife Tutu. They enter from the left, bending forward in proper humility, and Ani mutters the words of Spell 30B of the *Book of the Dead*, which are addressed to his heart in the balance: "My mother, heart of my mother, heart of my forms, do not stand against me as a witness, do not oppose me in the tribunal, do not turn away from me in the presence of the controller of the balance.[3] You are my *ka*, which was in my body. . . ." All, it seems, goes well for Ani, and Thoth, who has supervised the judging, declares to the Great Ennead,[4] in the presence of Osiris: "Hear ye in very truth this statement; I have judged the heart of this Osiris [i.e., Ani], his soul standing as witness for him. His deeds are true upon the great balance; no evil has been found in him . . . Whereupon, the Great Ennead proclaims to Thoth, "This utterance of yours is true. The Osiris, king's scribe Ani, justified, is without evil. We have nothing to accuse him of . . ." At last Ani is given the epithet "justified," literally "true of voice"; he has qualified for the Afterlife, and in the next sheet of the papyrus he is shown being led by Horus into the presence of Osiris, the lord of the Afterlife himself.

The necessary texts and the illustrative elements of this crucial episode in Ani's judgment are most skillfully set out, rather generously, in the available space on the papyrus. It is not known how the layout, incorporating text and figures, may have been composed. In the simplest way, the texts could be written by a scribe skilled in the special forms of script used for the *Book of the Dead*, while the vignettes may have been drawn and painted by a different artist-scribe, or even by a small team of similar specialists. It may be that one scribe was responsible for the whole production. In this case, the various figures are so neatly integrated with the columns of text that at the very least a close liaison between text-scribe and artist-scribe must be postulated. The figures, especially those of Ani and Tutu, are executed with

consummate confidence, while the scribal artist seems only marginally to observe the common devotion of the Egyptian artist to preliminary drawing. Instead, we find a similarly confident freedom of line and the application of free-drawn detail, even though the text does contain errors and corruptions.[5] It would be very satisfying if one could be certain of recognizing, in the composition of this part of Ani's papyrus, the hand of a single artist-scribe. **(T. G. H. J.)**

### Notes

[1] The ideas of judgment are succinctly explained in Quirke, 1992; in particular pp. 66f., l62f.

[2] An account of the discovery of the papyrus is given in Budge 1920, pp. 140f. It may not be factually precise in all details.

[3] On the heart scarab and Spell 30B, see Quirke/Spencer, 1992, p. 94.

[4] For the Great or Heliopolitan Ennead, see Quirke 1992, p. 30.

[5] For the illumination in Ani's papyrus, see James forthcoming.

### Bibliography

The Ani papyrus is much published, and the sheet discussed here even more frequently illustrated. The following are the principal publications of the the whole papyrus:

British Museum 1890.

British Museum 1894.

Dondelinger 1979.

Faulkner 1972; includes a full translation, but not a total coverage of the papyrus.

# 103

## *Book of the Dead*, Papyrus of Ani: Life in the Afterworld

From Thebes
New Kingdom, Nineteenth Dynasty
(ca. 1295–1186 B.C.)
Papyrus, painted
16 5/8 x 24 1/2 in. (42.2 x 62 cm)
EA 10470/35, acquired in 1888, purchased via
Sir E. A. W. Budge

In this third of the three segments in this catalogue from Ani's *Book of the Dead* (see cat. nos. 101, 102), Ani has passed judgment and entered paradise. The large scene on the left is the vignette for Spell 110,[1] the title of which reads in part: "Here begin the spells of the Field of Offerings and spells of going forth into the day; of coming and going in the realm of the

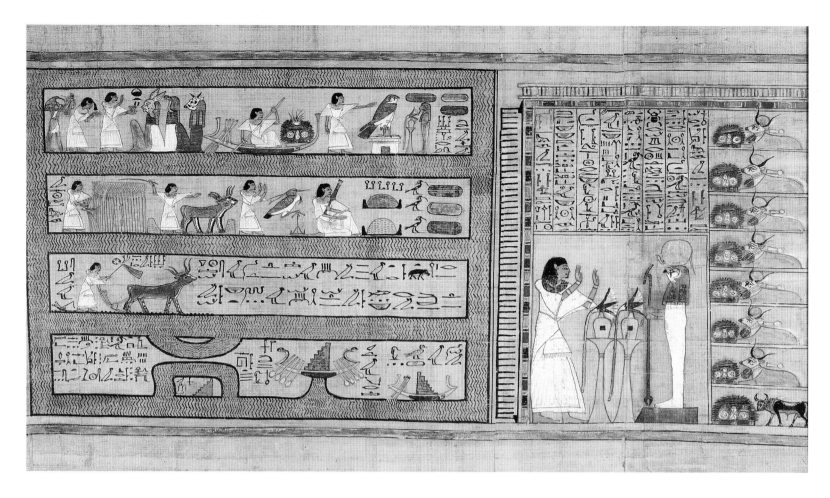

dead, of being provided for in the Field of Reeds which is in the Field of Offerings . . . doing everything that used to be done on earth by Ani."

In fact, he is shown doing things he is unlikely to have done on earth, not only greeting various gods of the Underworld, but also paddling his own boat in the top register, which is labeled, at the far right, "Field of Offerings." In the second register, he harvests flax and drives oxen over a threshing floor, and he is plowing with oxen in the third, which is labeled over the cattle's backs as the "Field of Reeds."[2] Other captions in the scene make it clear that this is a blessed land, a land of abundance. The labors of Ani, who is here referred to only as Osiris, will ensure provisions for himself and these celestial spirits. Ani will join them soon—already his boat has the same shape as the one in which the sun god travels the sky.

As in most examples of this vignette, the fields are shown as surrounded by water. There are two small islands and an inlet or harbor for one of the boats. It is questionable, however, whether the four large registers should be interpreted as separate islands, since their numbers vary in different compositions. Like the house and lake in Nakht's papyrus (cat. no.

100), the fields are drawn as a combination of a plan and elevations. Here, however, the plan takes the form of a highly schematic, and of course imaginary, map. Even before the First Dynasty, Egyptian artists had shown maplike settings for human activities.[3] The technique was developed most extensively, however, in representations of the ways to the Afterworld and the "place" itself: in Middle Kingdom coffins,[4] on the walls of New Kingdom royal tombs,[5] and in funerary papyri during the New Kingdom and later. Like other *Book of the Dead* vignettes, the Field of Offerings was sometimes represented in private tombs of the later New Kingdom. The finest example by far, in the tomb of Sennedjem at Deir el Medina, fills an entire wall of one small chamber.[6]

To the right is part of Spell 148, "For making provision for a spirit in the realm of the dead," and its vignette. This scene is composed within an architectural framework, as if it is taking place in a temple or shrine. The unrealistically narrow doors, one of which is visible on the left, are open. Inside, Ani prays to the sun god Re,[7] here shown as a mummiform falcon-headed figure. The text of this spell is abbreviated; in its full form, the deceased

person's claim to provisions is justified by his or her knowledge of the names of seven cows and their bull and of the four steering oars. Here the cows are shown wrapped in red shrouds, each wearing a necklace and a sun disk between her horns. The bull has no signs of divinity. The animals are not named here, though we know their names from other sources. On the other side of this vignette, the four steering oars are depicted, with their names. **(E. R. R. )**

### Notes

[1] Like the title *Book of the Dead,* the numbering of spells (sometimes called chapters) is modern; see Goelet in Faulkner et al. 1994, p. 141.

[2] For translations of the captions and a detailed description of the figures and objects, see Faulkner et al. 1994, pl. 34 and p. 169.

[3] Quibell 1900, pl. 26C.

[4] E.g., Hornung 1999, p. 10, fig. 3.

[5] Examples: ibid., pp. 26ff.

[6] Theban Tomb 1: Robins 1997, p. 185, fig. 218; other examples listed in PM I, 1 1960, p. 473 (36d).

[7] Like the texts in cat. nos. 99 and 101, this prayer is written retrograde.

[8] For the full vignette, captions, and a detailed description, see Faulkner et al. 1994, pl. 35 and pp. 169–70.

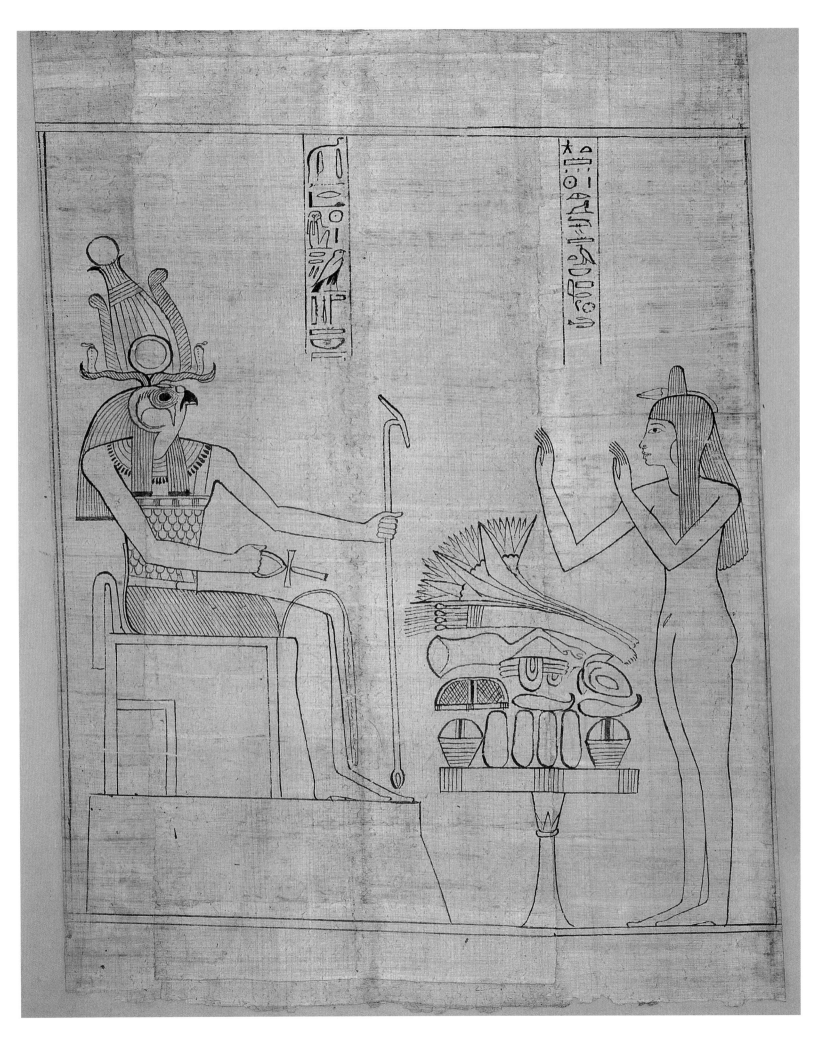

**Bibliography**

See bibliography for cat. no. 102. Also:

Faulkner et al. 1984, pp. 169–70, pls. 34, 35 ("facsimile" reproductions).

Faulkner 1985, pp. 110–11 (left side only).

*Art and Afterlife* 1999, no. 99, pp. 92–93.

# 104

### *Book of the Dead*, Papyrus of Nestanebetisheru: Adoring Re-Harakhty

From Thebes
Third Intermediate Period,
Twenty-first Dynasty (ca. 950 B.C.)
Papyrus, ink
21 ⁵/₈ x 17 ³/₈ in. (54.8 x 44 cm)
EA 10554/61, acquired in 1910, gift of Mrs. Mary Greenfield

This funerary papyrus roll, made for a woman named Nestanebetisheru, was almost 123 feet (about 37 meters) in length.[1] The vignettes, drawn in black ink, are of uniformly high quality, and the large illustrations, such as this one, are beautifully executed.[2] The daughter of the High Priest of Amun, Pinodjem II, Nestanebetisheru was of royal lineage and herself a priestess of high rank. Her mummy, in its nested coffins, was among the royal mummies reburied in the "royal cache," a secret tomb near Deir el Bahri, which first came to the attention of archaeologists in 1881. The royal cache contained other grave goods of Nestanebetisheru,[3] and it is probable that this papyrus was found there as well.

Nestanebetisheru is shown adoring Re-Harakhty, a falcon-headed manifestation of the sun god at his rising. The god, who is drawn in great detail, is enthroned on a high dais. He wears an *atef* crown on a divine wig, a collar necklace, a feather-patterned vest and a traditional kilt with a pleated panel. Attached to the back of the belt is a royal bull's tail, the lower end of which emerges from under his knees. He holds an *ankh* sign and a *was* scepter, standard equipment for most male deities.

Nestanebetisheru stands behind a table piled with the flowers, vegetables, meat, and bread that she is offering to the god, her hands raised in the conventional gesture of adoration. She wears a very long wig, on which is set a

perfumed ointment cone (cf. cat. no. 100) and a lotus bud. Other than the wig and a large half-hidden earring, she appears to be wearing nothing. Presumably this is an error: after drawing the upper line of her necklace, the artist for some reason neglected to add the billowing outlines of the draped robe fashionable in Nestanebetisheru's day (cf. cat. no. 118) and worn by her in almost all the vignettes. The garment hides neither her navel nor the plump hips and thighs of the female figure type considered beautiful during the Third Intermediate Period (cf. cat. nos. 113, 118).

Even more than most formal Egyptian drawings (cf. cat. no. 99), the drawing here shows a wonderful control of line. This artist-scribe was a master of the iconic image, able to produce a perfect freehand drawing that appears, as the Egyptians would have wanted it, perfectly free of spontaneity. He did, however, have one idiosyncrasy: on almost all of the representations of Nestanebetisheru, her navel is drawn, as here, to look like a diagonal slit. This seems a curious detail to serve as an artistic "signature," but if other works by this master have survived, it might identify them as such. (E. R. R.)

**Notes**

[1] It was divided into 96 sections: Budge 1912, p. v; see Budge 1912 also for pictures of the unrolled papyrus.

[2] Fully illustrated in Budge 1912; some vignettes in Faulkner 1985: pp. 102, 110, 149, 153.

[3] PM I, 2 1964, p. 666.

**Bibliography**

Budge 1912, pl. 71.

# 105

### *Book of the Dead*, Papyrus of Hor: Judgment Scene

From Akhmim
Ptolemaic Period (ca. 300 B.C.)
Papyrus, painted
16 ³/₄ x 28 ¹/₄ in. (42.4 x 71.5 cm)
EA 10479/6, acquired in 1890, purchased via the Reverend C. Murch

This vignette from the funerary papyrus of a priest named Hor shows the same judgment scene as that in Ani's papyrus (cat. no. 102).

Although almost a thousand years separate this version from Ani's, the scenes are virtually the same. The greatest single difference, the presence of Osiris, with the goddesses Isis and Nephthys, can be paralleled on other *Books of the Dead* from Ani's time.

Since T. G. H. James's description of catalogue number 102 can serve to describe this vignette as well, I will only note a few additional details and variations. Osiris wears an *atef* crown with the horns of the ram god Khnum, from whom they had been more or less inadvertently appropriated (cf. cat. no. 70). His face is green (cf. cat. no. 100), and he holds his identifying crook and flail. As so often in Ptolemaic and Roman Period representations of Osiris, his

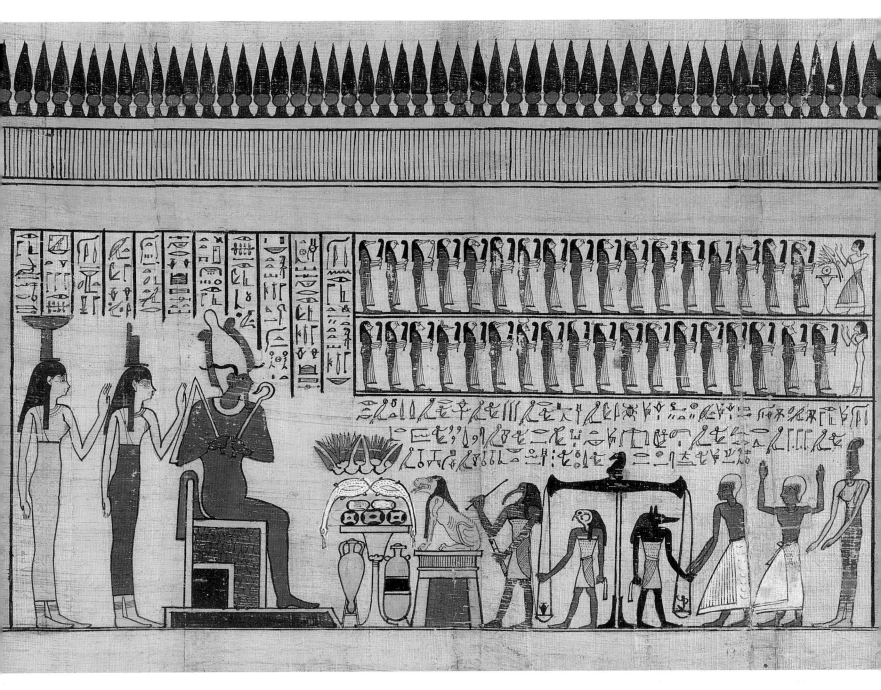

shroud is colored red. The forty-two assessor gods have here been reduced to thirty-five, probably for lack of space. Each holds a feather of Maat. Maat herself is present too—not as a feather in the balance, as in catalogue number 102, and not as a woman with a feather on her head, as in catalogue number 100, but literally as a feather head. Such bizarre combinations are not uncommon in representations of Underworld creatures, both threatening and beneficent (cf. cat. no. 72). The devouring monster here has the head of a hippopotamus and the body of a lion.

The weighing of the heart is carried out here by two gods, Anubis and Horus. Hor's heart is in the pan to the left; but in the right-hand pan, where we would expect to see the feather of Maat, is instead a tiny seated figure colored black. In other late scenes of judgment, such a figure, representing the shadow, an aspect of the soul, is sometimes shown waiting near this scene, much as Ani's *ba* appears in catalogue number 102. If this manikin is Hor's shadow, he is certainly in the wrong place.

It is clear that the artist-scribe of this vignette was primarily a draftsman rather than a painter. He or an assistant merely filled in the outlines with a limited range of colors, many in dark tones that look rather muddy against the tan papyrus. Like many draftsmen of the Ptolemaic Period, this one tended to render detail with little quick lines. He has curious mannerisms, especially in the way he draws the human eyes as a dot within a circle, which is set off by two or three curved lines above and one below. But at his best, he is quite effective—the slavering monster, hopefully hanging on Osiris's verdict, is a gem. The well-drawn details of the crocodile at the top left suggest that the same man also drew these small vignettes for spells of repulsing evil animals. (E.R.R.)

## Bibliography

Faulkner 1985, pp. 30–31.

Robins 1997, p. 249, fig. 301.

*Art and Afterlife* 1999, no. 102, pp. 99–101

# The Mummy as Statue
## (catalogue numbers 106–111)

## Mummy Masks

If one believes, as the ancient Egyptians did, that an image of a deceased person—or for that matter of a god—is both a representation of that being and, when animated through ritual, in some sense the being itself, a certain ambiguity is created. Is the image a surrogate, a representative, an aspect, or even a servant of its subject? And when multiple images were made, were they thought to relate to each other, as well as to their common subject? Such questions may seem unnecessarily theoretical; there is little evidence that the Egyptians gave them much conscious thought. However, they are very pertinent—and particularly puzzling—when applied to the images closest to the mummy: the *shabti* figures, the coffins and mummy masks, and the mummy itself.

In ancient Egyptian belief, the preservation of the body was essential to the eternal survival of the spirit of the deceased. Statues and two-dimensional representations could receive offerings on its behalf, but the mortal remains served as the physical locus on which the soul depended, and to which certain aspects of the soul, such as the *ba*, might need to return. That was the whole point of mummification and of the precautions taken to protect the mummy in the tomb.

The elaborate and invasive technique of mummification[1] had the effect, however, of making the body, empty of its spirit and most of its internal organs, into a representation of the deceased—or so the Egyptians seem to have thought, in their constant concern for its appearance. Throughout the long history of ancient Egypt, this concern, combined with other factors such as improvements in the techniques of mummification, shifts in funerary beliefs, and developments in the architecture and decoration of tombs, resulted in a series of changes that affected not only the appearance of mummies, but also, and more dramatically, the shapes and decoration of the masks and coffins in which they were enclosed.

Fragmentary pottery face masks, dating to the late Predynastic Period, have recently been found in a cemetery at Hierakonpolis,[2] though it is still too early to surmise whether these were placed on bodies or used in funeral rituals. By the early Old Kingdom, however, the linen outer wrappings of mummies were stiffened with plaster, modeled and painted to imitate facial and anatomical features, and dressed in imitation clothing.[3] Later in the Old Kingdom, these details were modeled in an added layer of plaster.[4] In the Eighteenth Dynasty, the wrapped heads, their faces painted, were provided with false hair and false eyes; in the Nineteenth Dynasty, the body cavities were carefully packed to retain their lifelike proportions.[5] These cosmetic treatments, which in effect made the mummy a wrapped statue, reached their peak during the early Third Intermediate Period, when the limbs of royal mummies were also padded, as were their cheeks, which made them all look a bit like chipmunks.[6] (E.R.R.)

### Notes

[1] For a detailed discussion of the treatment of mummies, see Ikram/Dodson 1998, pp. 103–31.

[2] Adams 1999a, cover and pp. 4–5.

[3] Shultz/Seidel 1998, p. 460, figs. 60–61; Ikram/Dodson 1998, pp. 110–111, 156; *Egyptian Art* 1999, no. 94, p. 306.

[4] Ibid., no. 197, p. 476; Ikram/Dodson 1998, p. 155, fig. 173.

[5] Ibid., p. 101.

[6] Ibid., pp. 124–28, with figs. 128, 131, 133–34.

# 106

## Mummy Mask of Satdjehuty

Provenance unknown
New Kingdom, early Eighteenth Dynasty
(ca. 1500 B.C.)
Cartonnage, painted and gilded
Height 13 in. (33 cm)
EA 29770, acquired in 1880, purchased at Morten
& Sons from the sale of the collection of Samuel Hull

During the First Intermediate Period and the early Middle Kingdom, the head of the mummy began to be protected with a cartonnage mask placed over the wrappings. These were meant to represent the deceased, but since the dead man or woman was now identified with Osiris, the face was sometimes painted green (cf. cat. nos. 100 and 105) or gilded.[1] Mummy masks remained in use through the Eighteenth Dynasty (cat. no. 107). The finest examples were often gilded.[2]

On this splendid female mask, gold leaf not only covers the woman's face, but also her huge collar necklace and the bird wings that embrace the front and sides of her voluminous, lapis lazuli-colored wig. The wings are examples of protective symbolism that, like the feather patterns on many anthropoid coffins of the Seventeenth and early Eighteenth Dynasties, evokes the guardianship of Isis and other deities.[3] This woman's name, once written at the bottom of each column of hieroglyphs, has been lost, but recent detective research by John Taylor has established that she was most probably a very high-ranking member of the court of Ahmose (cf. cat. no. 110), named Sat-djehuty.[4] (E.R.R.)

### Notes

[1] Ikram/Dodson 1998, pp. 158, 168, figs. 176–78, 193–95; the first example, the mask of Wah, is gilded.

[2] Tutankhamun's mask, like the innermost of his three anthropoid coffins, is solid gold.

[3] The size and placement of the wings refute the theory of Dodson (1998) that the intent of this design and the feather-patterned (*rishi*) coffins is to depict the deceased in the image of a *ba*, as a bird with a human face.

[4] Taylor 1995, 1996a.

### Bibliography

James/Davies 1983, p. 27, fig. 27.

Robins 1977, p. 146, fig. 170.

Taylor 1995.

Taylor 1996a.

Dodson 1998, pp. 94–5, 98, pl. 14/3.

Ikram/Dodson 1998, p. 170, fig. 197.

Art and Afterlife 1999, no. 122, p. 126.

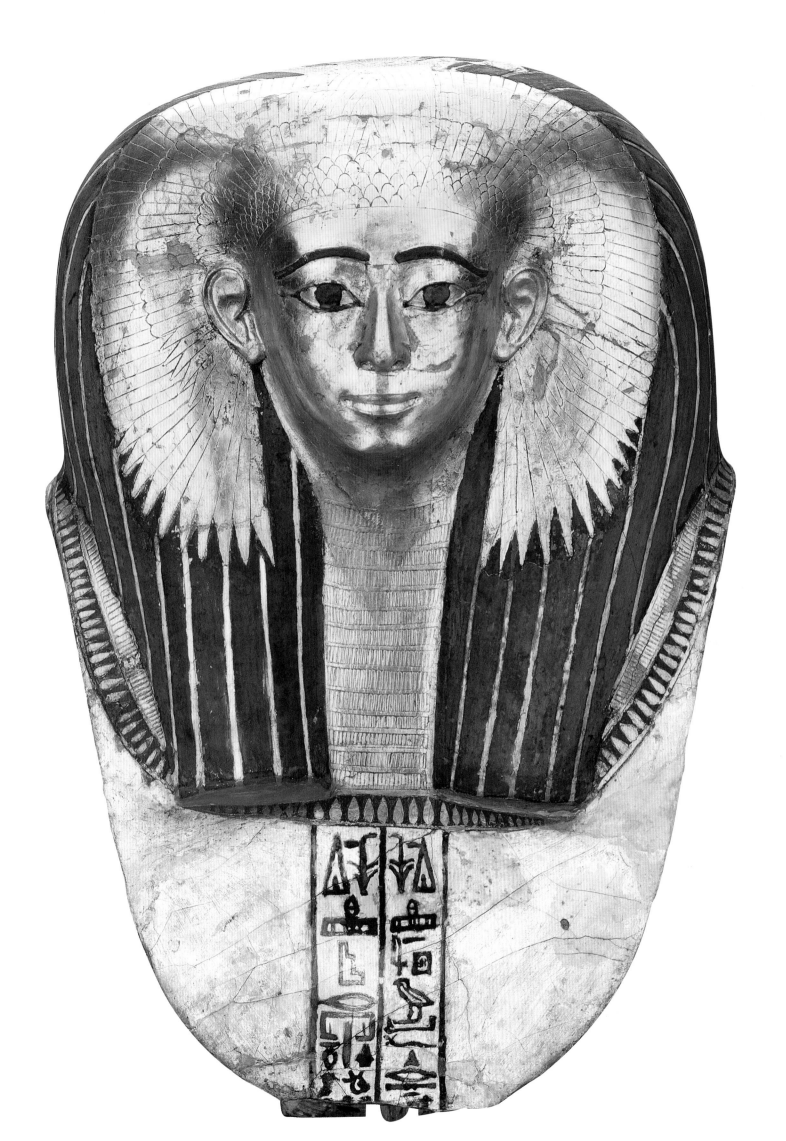

## Coffins

In the Old Kingdom, coffins were made in the shape of very stylized buildings. In the Middle Kingdom, most were simple boxes.[1] Anthropoid coffins, which first appeared during the Twelfth Dynasty, were presumably inspired by the slightly earlier mummy masks, to which they were at first very similar. Like them, the first anthropoid coffins were made of cartonnage, and they had the same types of faces, sometimes gilded or painted green. Most significantly, these coffins were mummiform—an image not of the deceased but of the mummy itself. Like uncased Middle Kingdom mummies, they lay on their sides in box coffins.[2]

With the New Kingdom, wooden anthropoid coffins became standard and ever more elaborate; eventually, they were provided as nested sets of two or three, sometimes with a mask or additional lid as well. They were no longer representations of the mummy, but of the deceased person as Osiris, with arms crossed in the Osiride pose and sometimes a divine beard. They were increasingly decorated with protective spells and vignettes. And they began to be designed to stand erect.

Representations of New Kingdom funerals on tomb walls and in *Book of the Dead* papyri indicate that the last rites were performed in front of the tomb, on the erect anthropoid coffin.[3] The "Opening of the Mouth" ritual was also used to animate tomb statues. Evidently this ceremony did take place in the way it was depicted, for anthropoid coffins developed large, flat foot ends; and the figural decoration, which had hitherto run horizontally along the sides,[4] was placed vertically down the front and the back.[5] For an example of this kind of decoration, see catalogue number 107 and the description by John Taylor. Now, the coffin really was a statue. This assimilation was carried even further from the late Third Intermediate Period into the Ptolemaic Period, when anthropoid coffins had bases under the feet, as well as back pillars.[6]  (E.R.R.)

### Notes

[1] Ikram/Dodson 1998, pp. 193–204; Taylor 1989, pp. 7–26.

[2] Ikram/Dodson 1998, p. 202, fig. 253.

[3] E.g., Faulkner 1985, p. 38 (below); Ikram/Dodson 1998,

p. 17, fig. 4.

5 E.g., Taylor 1989, pp. 31–33, figs. 23, 24–25.

11 Two early examples: Ikram/Dodson 1998, p. 216, fig. 283, pl. 30; coffin set: Schulz/Seidel 1998, pp. 476–77, figs. 99–100.

6 Examples: Ikram/Dodson 1998, pp. 234–42.

# 107

## Lid of the Anthropoid Coffin of an Unidentified Woman

From Thebes

Third Intermediate Period (ca. 1000 B.C.)

Wood, gessoed, with paint and varnish

Length 72 7/8 in. (185 cm)

EA 24907, acquired in 1893

The epitome of the eternal image, the mummy was created to enable the deceased to experience rebirth. Through the manual processes and rituals of embalming, the corpse was transformed into a new body, "filled with magic" and endowed with the attributes of the *akhu*, the transfigured dead who dwelled in the hereafter.[1] The mummified body was referred to as the *sah*, and the unification of this physical form with the *ka* and the *ba* (spiritual aspects of the individual) made possible the deceased's resurrection and eternal existence after death.

The familiar canonical appearance of the *sah* —the body confined within a white shroud, from which the head emerges, framed by a wig and adorned with a collar necklace—was created during the First Intermediate Period. Appearing approximately a century later, around 2000 B.C., the earliest mummiform or anthropoid coffins functioned as substitutes for the mummy and hence reproduced the appearance of the *sah*. During the New Kingdom, the anthropoid coffin continued to serve as an image of the deceased but was further adapted so as to fulfill the symbolic role of tomb-in-miniature that had formerly been played by rectangular coffins (by then largely obsolete in private burials).

The constantly evolving relationship between tomb and coffin fluctuated during succeeding centuries and was reflected in the changing iconography of the latter. In the Third Intermediate Period, when many individuals were buried in communal graves without wall decoration, the coffin played a

major part in supplying the need for magical images and texts to equip the deceased for the Afterlife. The surfaces of coffins, both inside and out, were covered with a profusion of vignettes, figures of gods, symbols, and individual hieroglyphs, all projecting the notions of rebirth and eternal life. This *horror vacui* finds its culmination in the coffins painted in the temple workshops of Thebes during the Twenty-first Dynasty.

This coffin lid of an anonymous woman is typical of the period. Only the general shape and the upper body reflect the coffin's function as eternal image of its occupant. The face is framed by a large tripartite wig, colored blue (traditionally suggesting lapis lazuli, the material from which the hair of the gods—and thus by extension the deceased—was made). A floral fillet encircles the head, and three lotus blossoms are positioned on the top of the head. Such flowers, symbolizing regeneration, were worn by the living on festal occasions and are frequently depicted placed on the heads of mummies. The woman's ears are concealed beneath her wig, but her large and elaborate ear-studs, decorated with rosettes, are displayed. She wears a bead necklace and a large collar made of floral garlands. Her crossed arms are concealed beneath this, only the hands (made separately and now lost) protruding in the center. In the space between the hands is a miniature scene showing the sun god at dawn, represented both as the scarab beetle and as the solar disk on the horizon, raised in the barque of the morning above the *djed* pillar, which symbolizes the realm of Osiris in which the sun god has passed the night.

The space below the collar is filled with a complex mass of small images arranged in two zones. The first section, reaching from the edge of the collar to a little below the knees, is dominated by three large figures with outspread wings: a solar disk, the goddess Neith, and a falcon. The intervening spaces are occupied by symmetrical groupings of figures and symbols conveying the ideas of resurrection and protection, in a generalized way. Each group centers on a scarab beetle supporting the solar disk, flanked by divinities and sphinxes and protected by the outstretched wings of goddesses and falcons. The lower zone is subdivided into three columns of

compartments, whose focal elements are once again solar disks, scarab beetles, and enthroned deities, but whose arrangement does not illustrate any specific spell or episode of funerary literature. Apart from a few signs giving the names of the deities, all of these scenes are devoid of inscriptional commentary; the only written matter to be found on the coffin lid is contained in three short columns on the foot, which provide only standard formulas placing the deceased under the protection of Osiris.

As was the case with statuary, anthropoid coffins not only presented an idealized image of the subject, but also were sometimes prefabricated, their features being created without reference to the age or appearance of the deceased. On the coffins of the Twenty-first Dynasty, indications of the owner's sex were restricted to a few relatively minor aspects: the presence or absence of a beard, the inclusion or omission of the ears (present on men's coffins, absent on most of those made for women), and the attitude of the hands (clenched fists for men, fingers extended for women). These attributes were easily altered should a coffin be reused for an owner whose sex differed from that of the previous occupant. Such adaptations were frequently carried out at Thebes in the Twenty-first Dynasty, highlighting the paradox that an image designed for eternity did not necessarily remain permanent and immutable. ( J.T.)

**Note**

[1] Assmann 1989, pp. 138–39.

**Bibliography**

British Museum 1924, pp. 62–63.

Edwards 1938, p. 42.

PM I, 2 1964, p. 638 (the attribution to Bab el Gasus is unfounded).

Niwinski 1988, no. 268, p. 153.

Andrews 1990, p. 115, pl. 95.

Taylor 1996a, p. 29.

# 108

### Coffin of a Woman

From Akhmim
Ptolemaic or Roman Period (ca. 50 B.C.–A.D. 50)
Wood, painted
Length, 43 in. (109 cm)
EA 29587, acquired in 1898

# 109

### Panel Portrait of a Woman

Said to be from er Rubayat
Roman Period (ca. A.D. 160–170)
Limewood, encaustic, gold leaf
17 ¹/₂ x 8 ¹/₄ in. (44.2 x 20.7 cm)
EA 65346, acquired in 1939, bequest
of Sir Robert Mond

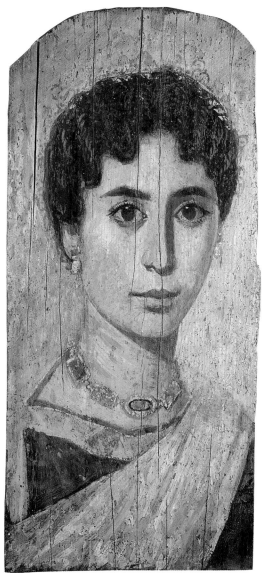

The development of the coffin and of the mummy itself as statues of the deceased reached its culmination during the Roman occupation of Egypt, when, more than ever before, their images showed them as living persons. Although mummification was still practiced and traditional symbols of Egyptian funerary beliefs were still incorporated in the decoration of mummy coverings, the deceased were usually shown wearing Greco-Roman hairstyles, clothing, and jewelry.

The representation of a young woman on the lid of her coffin (cat. no. 108), made at the beginning of the Roman Period, was clearly designed as a standing figure; and the traditional Egyptian funerary motifs on the sides of the box are also drawn vertically, but she herself wears the clothing and jewelry of a cosmopolitan woman in touch with the Hellenistic fashions of her day.[1] The vignettes behind her figure are actually painted on the sides of the lid. But she appears to be standing at the opening of her coffin, still engaged with the world while protected by the scenes of the old religion and by the red and green shroud pattern, symbolic of Osiris, painted at the back.

Other mummies of the Roman Period were not placed in coffins. Some, wrapped in elaborately patterned or painted bandages, were provided with a cartonnage mask and foot case.[2] On others, the mummy wrappings held in place a portrait of the deceased, painted on a wooden panel.[3] These panel paintings not only showed their subjects wearing Greco-Roman fashions, but were painted in Hellenistic style. Many, like catalogue number 109, are beautiful in their own right; as a group, they offer by far the richest surviving evidence of the techniques and styles of Greco-Roman portrait painting.

The richly bejeweled woman in the panel portrait is portrayed with elegance and sophistication.[4] Apparently, however, some uncoffined mummies with painted portraits of this kind were not entombed, but were kept at home, standing erect, as objects of veneration in the family's ancestor cult.[5] Looking at this woman's sweet, refined features, it is hard to imagine her as the object of a custom that seems to us so bizarre. On the other hand, it is easy to understand her survivors' wanting to keep her memory alive. **(E.R.R.)**

### Notes

[1] For a detailed description, see Walker/Bierbrier 1997, pp. 35–36.

[2] For examples of this type of Roman mummy, see Walker/Bierbrier, nos. 57, 60, pp. 80, 82–83.

[3] Examples of the type of mummy: ibid., nos. 11, 12, 99, 115, pp. 37–40, 106–107, 118–19.

[4] For a discussion of her costume, see ibid., p. 95.

[5] For the most recent discussion of this custom, see Borg 1997.

### Bibliography

cat. no. 108: Walker/Bierbrier 1997, no. 9, pp. 35–36 (with bibliography).

cat. no. 109: Borg 1996, p. 224 (index); Walker/Bierbrier 1997, no. 86, pp. 95–96 (with bibliography); Ikram/Dodson 1998, pl. 22, following p. 176.

## Shabtis

Like the anthropoid coffin, the small funerary figure known by its ancient Egyptian name *shabti* was an innovation of the Middle Kingdom, and the mummiform shape of early *shabtis* imitated that of the Middle Kingdom coffins.[1] As time passed and anthropoid coffins changed, *shabtis* changed accordingly. When, at the beginning of the New Kingdom, coffins assumed the Osiride pose, with crossed arms and exposed hands, so did *shabtis* (see cat. no. 110). As on royal coffins, the *shabtis* of kings often held the crook and flail of Osiris.[2] On figures made for nonroyal people, these divine emblems were sometimes replaced with protective symbols or, increasingly, agricultural implements: a hand hoe and mattock supplemented by one or more seed baskets that might hang down from the hands, as on catalogue number 111, or be suspended down the back.

For a short period in the later New Kingdom, a few inner coffins and coffin boards showed the deceased dressed as if he or she were alive.[3] At just that time, some *shabtis* began to show their subjects in the garb of the living.[4] Unlike the other major *shabti* changes, based on changes in coffins, this type of *shabti* continued to be produced long after its coffin prototypes had become extinct. It survived, however, in a specialized form. As *shabtis* proliferated in the later New Kingdom and Third Intermediate Period, sometimes

numbering hundreds in a single set, the figures were organized into gangs of ten mummiform workers, each gang headed by an overseer *shabti* in the dress of the living.[5]

When coffins changed again, in the late Third Intermediate Period, acquiring a statue base and back pillar, *shabtis* reverted to a uniformly mummiform shape with a base and a back pillar.[6] At this final stage, the *shabti* figure might be described as a statuette of the deceased represented as a coffin in the guise of a statue!

Ludicrous as this may seem, it underscores the ambiguity at the heart of Egyptian concepts of the *shabti*, which represented both its owner and a servant who was supposed to undertake the heavy labors required of the owner in the Afterlife. This dual identity is unmistakable in the inscriptions on *shabtis*, which, as on catalogue numbers 110 and 111, are usually versions of the "*Shabti* Spell," Spell Six in the *Book of the Dead*.[7] Not surprisingly, the servant or slave function of these figures grew increasingly to supersede their identification with the deceased.[8] The continued use of coffin imagery may have served to reinforce that identification or, paradoxically, to weaken it. (B.F.)

### Notes

[1] For theories about their simultaneous appearance, see Schneider 1977, I, pp. 62–70.

[2] Saleh/Sourouzian 1987, no. 182 (Tutankhamun).

[3] Ibid., no. 218; Taylor 1989, pp. 37–38, figs. 28–29.

[4] Stewart 1995, pp. 19–20, figs. 13–15.

[5] Schneider 1977, I, pp. 266–67, 321, 336, 342; Stewart 1995, pp. 21, 26, 27, figs. 17, 23, 25.

[6] Stewart 1995, p. 30, fig. 30.

[7] For this spell, see Schneider 1997, I, chap. III.

[8] The changing concepts and roles are discussed in detail throughout Schneider 1977, I; cf. most recently, Poole 1998.

# 110

### *Shabti* Statuette of Ahmose

Provenance unknown, presumably from Thebes
New Kingdom, Eighteenth Dynasty,
reign of Ahmose (ca. 1550–1525 B.C.)
Limestone
11 3/8 in. (28.7 cm)
EA 32191, acquired in 1899

# 111

## *Shabti* Statuette of a Woman

Provenance unknown, probably from Thebes
New Kingdom, Nineteenth Dynasty
(ca. 1295–1186 B.C.)
Limestone, painted
Height 10 in. (25.3 cm)
EA 24428, acquired in 1891, purchased via the
Reverend C. Murch

*Shabtis* vary widely in quality. Most are routine
or even crude productions, which are objects of
interest rather than works of art. However, some,
like these two examples, which date from the
early and the later New Kingdom, are fine
miniature statues that combine the conventions
of the *shabti* with the sculptural style of their day.

The earlier *shabti* (cat. no. 110) is an
important historical document in its own right,
for it is one of only three surviving represen-
tations of the warrior king Ahmose, founder of
the Eighteenth Dynasty, who vanquished the
foreign Hyksos rulers, reunited Egypt, and
initiated the New Kingdom. Presumably this
figure comes from his tomb, which is believed to
have been at Thebes, but which has not been
located. Like Ahmose's other two images, which
are heads from life-size statues,[1] the features on
this small face hark back to royal Theban
sculpture of the early Middle Kingdom. Unlike
the two larger examples, however, the *shabti's*
face is tapered, and the eyebrows and upper
contours of the eyes are strongly arched. These
details foreshadow the Thutmoside style of
Ahmose's successors, including Hatshepsut and
Thutmosis III and their subjects (cf. cat. nos.
43–45). The inscription gives Ahmose's names
in cartouches, followed by the "*shabti* spell,"
Spell 6 in the *Book of the Dead*.

The second *shabti* (cat. no. 111) was made
during the Nineteenth Dynasty, for a woman
who was a musician of Amun at Thebes. The
figure is mummiform and holds the standard
*shabti* equipment of hoe, mattock, and seed
baskets; but the luxuriant wig is the hairstyle of a
living woman. The paint on the upper part of
this statuette is well preserved, enabling one to
see that alternate lines of her *shabti* text were
colored yellow, to simulate gold, and that a row
of dots was painted just under the front of her

wig to indicate the fringe of her natural hair.
The white limestone of the face was left
unpainted, except for red on the lips and black to
mark the line dividing the lips, as well as the eyes
and eyebrows. This partial painting of the face
on reliefs and statues carved in fine white stone
was a stylistic mannerism of the late Eighteenth
and Nineteenth Dynasties.[2] It is harder to
explain the apparent absence of paint elsewhere
on the figure: on the agricultural tools and
especially on the woman's large, presumably
showy, collar necklace. (E.R.R.)

.

### Notes

[1] One of these heads (currently on exhibition in the Brooklyn
Museum of Art), is published in Romano 1976, pp. 103–105,
pls. 28–29. The second was found south of Egypt, in the
present-day Sudan, and is now in the Khartoum Museum.
[2] E.g., Saleh/Sourouzian 1987, no. 208 (Cairo CG 600).

### Bibliography

cat. no. 110: Hall, H. R. 1931, pp. 10–11, pl. 2; Vandersleyen
1971, p. 204, pl. 4; Romano 1976, p. 104; Lindblad 1984, no.
A2, pp. 15–16, pl. 2; Stewart 1995, pp. 16–18, fig. 11.
cat. no. 111: unpublished.

# 112

## Column Capital with Hathor Emblem

From Bubastis, temple of Bastet, Festival Hall of
Osorkon II
Third Intermediate Period, Twenty-second Dynasty,
reign of Osorkon I-II (ca. 924–850 B.C.)
Red granite, once painted
Height 77 ¼ in. (196 cm)
EA 1107, gift of the Egypt Exploration Fund, 1891

This is the major part of a Hathor capital that
once crowned a colossal column in the temple of
the goddess Bastet in the eastern Nile Delta city
of Bubastis.[1] The column was one of four in a
hypostyle hall adjacent to the great gateway
decorated with scenes from the *sed* festival of
Osorkon II (cat. no. 113).[2] It was on the north
side of the hall, a location indicated by the red
crown of Lower Egypt on the heads of the
cobras flanking the face. Behind the snakes were
papyrus plants, also symbols of the North.[3]
Traditionally, the columns have been dated to
the Middle Kingdom, but a recent study proves

them to be much later.[4] The surviving royal
inscription and the classicizing style of the face
indicate that they were made under Osorkon I
and erected (or usurped) by Osorkon II.[5]

Each main surface of the capital front and
back represented a female face with stylized
cow's ears and a plaited, curled wig, on top of
which was a platform decorated with a row of
cobras bearing solar disks on their heads. This
composition was the emblem or fetish of the
goddess Hathor. In its full form it represented a
sistrum in the shape of a naos, set in a handle
topped by the goddess' face. Slender, stylized
horns that terminate in spirals rise on either side
of the naos. The naos sistrum, like the loop
sistrum with a wigless, cow-eared face (cf. cat.
nos. 94 and 100), was shaken in temple
ceremonies for Hathor and for other deities as
well. Numerous examples have survived in the
form of faience votive objects.[6] As a fetish, it is
often held by statues (see cat. no. 129). From at
least the Eighteenth Dynasty, the emblem was
adopted for column capitals in temples of
Hathor (see fig. 12),[7] and in the temples of other
goddesses as well.[8]

The presence of Hathor capitals in Bastet's
temple does not necessarily mean that Hathor
was worshiped there. The Egyptian religion was
fluidly syncretistic.[9] Though most gods and
goddesses had separate identities, their
boundaries often tended to merge. Certain
divine emblems, including the sun disk of Re
and the crook and flail of Osiris, were such
potent symbols and so universally understood
that they might be shown with another deity to
emphasize a shared quality. This did not
normally imply a loss of identity by either god.
The Hathor symbol had a similar universality,
signifying a great goddess, whoever was
worshiped in the temple where the emblem
appeared.

Occasionally one deity did assimilate
another. Over the course of the Middle
Kingdom, Hathor assimilated the goddess Bat.[10]
This process was expedited by similarities
between the two goddesses, both of whom were
manifested as cows. But it may have been the
appropriation for the Hathor sistrum of Bat's
archaic fetish, a cow-eared face with curving
horns (see fig. 1), that most encouraged this
process.[11] The loop sistrum retained the Bat
image almost unchanged (see cat. nos. 94 and

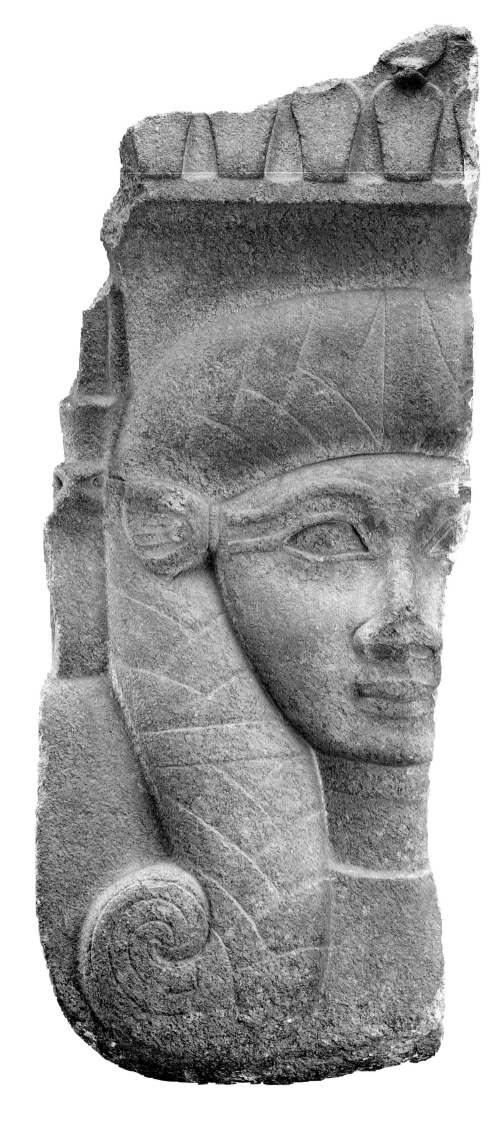

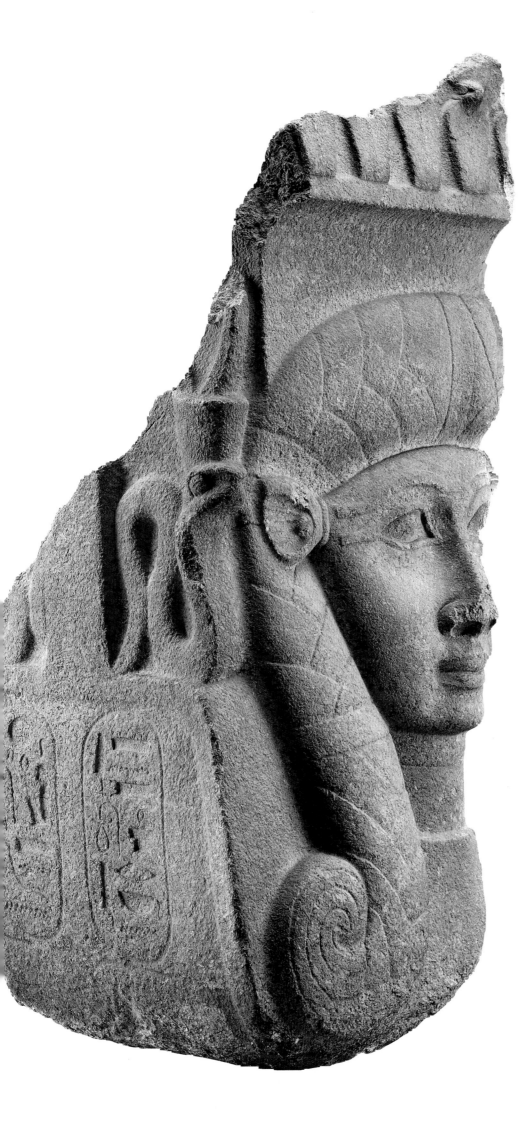

100).[12] On the naos-shaped sistrum and emblem, Bat's image also persists, in the cow ears and in the slender, spiraling remnants of her curved horns.[13]

The mask-like quality of the face on this capital is emphasized by its flatness and by the broad plane down the length of the nose. Though they have been handled with considerable sophistication here, such features derive from the difficulties Egyptians encountered when they tried to adapt their rules for portraying the figure in relief or painting to the rendering of faces or bodies in frontal view. From the Early Dynastic Period into the Old Kingdom, and even later, this problem appears to have been approached with an idea of combining two standard profile views. The results are predictably awkward and sometimes ludicrous.[14] The flattened frontal face on several frequently recurring images—especially the hieroglyphic sign in the form of a face,[15] but also the Bat fetish—helped to perpetuate this awkward convention and may even have made it seem the appropriate way to represent the faces of deities in front view.[16] Thus the face of the Hathor emblem usually shows some degree of flattening, which often, as on catalogue number 129, is quite noticeable.[17] (E.R.R.)

## Notes

[1] Smaller fragments of this capital are also in the British Museum.

[2] The other three capitals are in Boston, Paris, and Berlin; four similar capitals from smaller columns were also found: PM IV 1934, p. 29.

[3] Haynes 1996, p. 404.

[4] Haynes 1996; cf. Haynes in Thomas 1995, no. 15, pp. 97–99.

[5] The argument (Haynes 1996, p. 408) that they may be as early as Ramesses II is not, in my opinion, persuasive.

[6] E.g., Friedman 1998, no. 91, cover and pp. 102, 215–16, with the suggestion that this and other faience sistra may also have been used as instruments.

[7] E.g., Schulz/Seidel 1998, p. 186 (Deir el Bahri, Eighteenth Dynasty), pp. 296, 299–301 (Dendera, Roman Period).

[8] In addition to Bubastis, see ibid., pp. 278, 303 (Isis Temple at Philae).

[9] Hornung 1982, especially pp. 91–99, 126, 235–36.

[10] Fischer 1962, pp. 7–15.

[11] Ibid., p. 15.

[12] For an actual example, see Capel/Markoe 1996, no. 35b, p. 99.

[13] For another discussion of Bat and Hathor imagery, and

especially the "Hathoric" wig on this capital and elsewhere, see Haynes 1996, pp. 399–404; her term "Bat-capital" is, in my view, inaccurate.

[14] Der Manuelian 1994a, pp. 68–69, figs. 4.12, 4.13.

[15] Illustrated ibid., p. 70, fig. 4.14.

[16] This continued into the Roman Period: Schulz/Seidel 1998, p. 305 (the sky goddess Nut).

[17] See also the sistrum cited in n. 6.

**Bibliography**

PM IV 1934, p. 29 (with bibliography).

# 113

### Relief from a *Sed* Festival Gateway

From Bubastis, temple of Bastet
Third Intermediate Period, Twenty-second
Dynasty, reign of Osorkon II[1] (ca. 874–850 B.C.)
Red granite
43 1/8 x 67 in. (109.5 x 170 cm)
EA 1105, gift of the Egypt Exploration Fund, 1891

The city of Per-Bastet (meaning "House/Estate of the goddess Bastet"), which the Greeks called Bubastis, was located in the Egyptian Delta and was occupied from the early third millennium B.C. until some time after the mid-seventh century A.D. One of the high points of its history was the Twenty-second ("Bubastite") Dynasty, which used Per-Bastet as a royal residence. Two kings of this dynasty, Osorkon I and his like-named grandson, built major temples to Bastet and her divine family.[2] One of the structures commissioned by Osorkon II was a monumental gateway in granite. Although only some blocks of this gateway survived until the last century, when they were excavated, their decoration demonstrates that the gateway was adorned with a representation of the king's *sed* festival, often translated as "jubilee."[3] This festival was generally believed to have reaffirmed a king's right to rule by renewing his kingly power or some of its aspects via various rites, some performed in parallel for Upper and Lower Egypt (cf. cat. nos. 1 and 43).

The block shown here was from a part of the gate adorned with rituals associated with Osorkon II as king of Lower Egypt and includes parts of two scenes. The row of fish at the top is part of a scene of offering of fishes and fowl. The lower decoration is part of a scene in which Osorkon II is seated in a *sed* festival kiosk, wearing the red crown of Lower Egypt. Before the kiosk stands the goddess Bastet. It appears to have been in this dynasty that Bastet first came to be shown in the guise of a cat, but she long retained, as here, her leonine-headed form. Behind her are an offering and priests. At the foot of the kiosk's stairs is a figure described as a priest who recites an offering formula and opens doors, presumably of the kiosk. Before him are two men running (toward figures not preserved), demanding obeisance by crying "to the ground". In the register below are priests and two royal daughters.

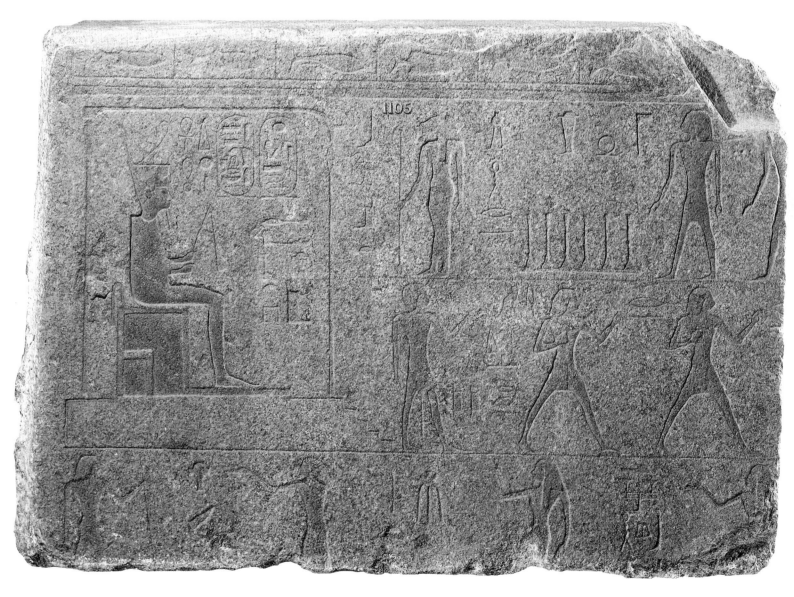

By the time of the Twenty-second Dynasty, the representation of princesses in *sed* festivals already had a long history in Egyptian art. Sometimes queens were also prominently featured in such a context, an example being the depiction of Osorkon II's queen Karomama on another block from the Bubastis gateway in the British Museum (fig. 53). "The queen's figure exhibits the large breast, buttocks, and thighs that became fashionable during the Third Intermediate Period."[4] A more restrained version of this type of full female figure appears in the present relief, on the figure of Bastet. This has been called a Bubastite figure style[5] and regarded as evolving out of the art of the New Kingdom. However, the term is somewhat misleading, in that the style began in the previous, Twenty-first, Dynasty[6]; moreover, the style differs dramatically from late New Kingdom female figural style.

Another queen represented prominently in *sed* festival scenes was Tiye, wife of King

*Fig. 53. Osorkon II and Queen Karomama. From Bubastis, temple of Bastet,* sed *festival gateway. Red granite, 70 ¹/₈ in. (178 cm). The British Museum (EA 1077).*

Amenhotep III, and there are certain links between his *sed* festival scenes at a temple in Soleb, south of Egypt, and those of Osorkon II's gateway.[7] In fact, the royal wife, a key to the continuity of the monarchy, had significant roles to play in the *sed* festival, including those associating her with the goddess Hathor, who played a major role in divine and royal renewal.[8]

Amenhotep III claimed to have celebrated his first *sed* festival according to the ancient rules, and the long *sed* garment he was shown wearing at Soleb has much older prototypes. It was not depicted again, however, until the images on Osorkon II's gateway.[9] An archaizing tendency is also apparent in the style of the faces in Osorkon II's reliefs, especially in the main figure, whose small scale in hard stone appears to have presented some difficulties in the carving.[10] (R.A.F.)

## Notes

[1] Sometimes numbered as Osorkon III.

[2] For Bubastis in general, see Van Siclen 1999, pp. 776–78.

[3] For a recent discussion of these temples and a recent publication of the block of this entry, see Arnold, Di. 1999, pp. 336–39: and Robins 1997, pp. 196–98, with fig. 237. For various discussions of the scenes on this gateway and attempts at their reconstruction, see, e.g., Naville 1892; Uphill 1965; Barta 1978; Van Siclen 1991; Gohary 1992, pp. 18–26; and Kuraszkiewicz 1996.

[4] Robins 1997, p. 196.

[5] Munro 1973, p. 12, and pl. 1/1–2.

[6] Thus it also long predates the arrival of the Kushite Twenty-fifth Dynasty, which is often assumed to have brought this style from the south.

[7] Cf. Gohary 1992, pp. 11–18, where it is noted (p. 12) that some of Amenhotep III's scenes may not depict the *sed* festival proper. For a Ptolemaic Period gateway in which a queen also appears, see Sambin 1995, pp. 406–407 and 412–17. For some comments on other representations linking royal women to the *sed* festival, see Sourouzian 1994, pp. 499–500.

[8] See, e.g., Wente 1969; Traunecker 1987 (in connection with Queen Nefertiti); Sambin 1995, p. 412; and Sambin 1988, pp. 322–24, where the author cites a text of King Osorkon II saying, "As for the great royal wife . . . Karoma, you will cause her to stand before me in all my jubilee festivals . . . you will cause her children . . . to live . . ."

[9] Sourouzian 1994, pp. 499–502.

[10] Myśliwiec 1988, pp. 22–24; Fazzini 1997, p. 115.

**Bibliography**

PM IV 1934, p. 29 (with earlier bibliography).

Uphill 1965.

Barta 1978.

Van Siclen 1991.

Gohary 1992, pp. 18–26.

Kuraszkiewicz 1996.

Robins 1997, pp. 196–98.

Arnold, Di. 1999, pp. 336–39.

# 114

## Bronze Statuette of Pimay

Provenance unknown
Twenty-second Dynasty (ca. 773–767 B.C.)
Height 10 ¹/₄ in. (26 cm)
EA 32747, acquired in 1880, purchased from
H. E. E. T. Rogers

Pimay is depicted in the standard offering pose, kneeling with a slight graceful forward motion, unusual among bronzes of this type, and raising small *nw* pots to chest height. He wears the white crown with a frontlet and edging and with two horizontally ribbed streamers hanging from the back edge; a uraeus cobra with ornamented hood extends its tail nearly to the bulb of his crown. The king's broad collar is carefully indicated with two rows of tube beads and a third of drop beads. His diamond-patterned belt has a centrally located cartouche reading "Usermaatre Setepenre." This cartouche is repeated on his left shoulder, while on his right shoulder may be read, "Beloved of Amun, Son of Bastet, Pimay, Good God, Ruler of [probably Thebes]."[1] The rich surface ornamentation and the system by which his separately cast arms are slotted into his body are features associated with Third Intermediate Period bronzes. It is quite possible that the bronze was once gilded at least on the necklace, kilt, and crown, though all traces of this have disappeared.

Pimay was a king of the Twenty-second Dynasty in Tanis. Little is known of him. He ruled during what may be termed the later phase of the Third Intermediate Period—that is, the period when the establishment of a rival dynasty, the Twenty-third, had initiated a period of further political fragmentation, culminating eventually in the invasion and rule of the Kushite Twenty-fifth Dynasty.

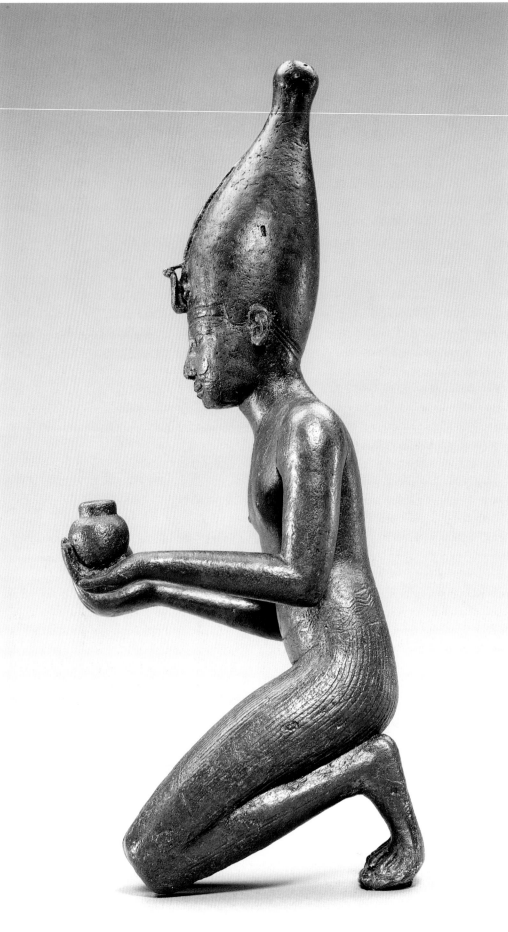

The king's face is delicately drawn, with pencil-thin brows and cosmetic lines surrounding eyes with irises in raised relief, and with a slightly smiling mouth in a full-cheeked oval face. His features bear little resemblance to those known for earlier Third Intermediate Period kings, who generally chose Thutmoside and Ramesside models. It may be said to exemplify a tendency of archaism in the later Third Intermediate Period to be based on diverse, if not new, models.[2]

Pimay's statuette also exemplifies other aspects of the innovation and energy characteristic of the art of his period. Among these are the marked irises, a feature that became particularly popular in bronze statuary and relief after the time of Osorkon II in the mid-Third Intermediate Period. The modeling of Pimay's torso as a series of three horizontal units, identified by Cyril Aldred as a primary example of the tripartitite torso modeling typical of the Third Intermediate Period[3], can now be more precisely described as one of several variant forms, one which seems to be found predominantly in the later part of the period.

Although the kneeling pose for small royal figures in bronze can be traced from the late Middle Kingdom onward (cf. cat. no. 50), a significantly greater number of such bronzes appear to have been produced in the later Third Intermediate Period, suggesting a new, more focused interest in the king's subordinate relationship to the gods, perhaps expressive of a new religious tenor and surely a prelude to developments in the Kushite period. (M.H.)

### Notes

[1] The reading of the name and identification of the statuette are given in Yoyotte 1988, especially pp. 158, 164–66 and pls. 4–5.

[2] For illuminating comments on the art of the Third Intermediate Period in general and remarks on a number of the particular features discussed here, see Fazzini 1997.

[3] Aldred 1956, pp. 3–7.

### Bibliography

James/Davies 1983, p. 40, fig. 47.

Yoyotte 1988, pp. 158, 164–66, pls. 4–5.

Quirke/Spencer 1992, p. 47, fig. 32.

Schulz/Seidel 1998, p. 325, fig. 4.

# 115

## Divine Consort or Queen

Probably from the Theban area
Late Third Intermediate Period, Twenty-fifth Dynasty (ca. 716–656 B.C.)
Bronze, gold and silver inlays
Height 8 3/8 in. (21.3 cm)
EA 54388, acquired in 1919

The Egyptians often enhanced the visual effect of metal sculpture by inlaying or overlaying the figures with other metals in contrasting colors (cf. cat. no. 82). This coloristic approach reached its peak in the richly inlaid bronze statues of the Third Intermediate Period. The most famous of these, a two-foot (60 cm) tall standing figure of the Twenty-second Dynasty Divine Consort of Amun Karomama, in the Louvre, was inlaid with four different-colored metals, and her skin was covered in gold leaf.[1] This figure, though only about a third the size of Karomama, was almost as sumptuously inlaid.

The woman, who stands with her left leg slightly advanced, wears a traditional tight-fitting dress, the skirt of which is inlaid in a pattern that may represent a beaded overskirt. The hem, the waistband, and the two straps of the bodice are inlaid with linear patterns. A small necklace is indicated, but most of the space between the straps is filled with a figure of Osiris inlaid in gold, facing right, and wearing an *atef* crown. The woman's long wig is studded with tiny strips of metal, which represent little gold or silver rings, threaded on the tresses.[2] On her wig is a cap in the form of a vulture with wings outspread beside her face. The bird's head, which may have been replaced by a uraeus, is broken off. Also lost are the tall headdress, which fitted over the post on the top of the head; the arms, which had been made separately; and the feet, with the base to which they were attached. Perhaps the worst damage of all is that inflicted on the face, which has lost not only its inlaid eyes but almost all details of the features. It is likely that the face was covered with sheet gold, which was roughly pried off for the value of the metal.

In ancient Egypt, the vulture cap, as worn by this figure, was almost exclusively the prerogative of queens. Thus this woman was royal, but a more precise identification hinges on

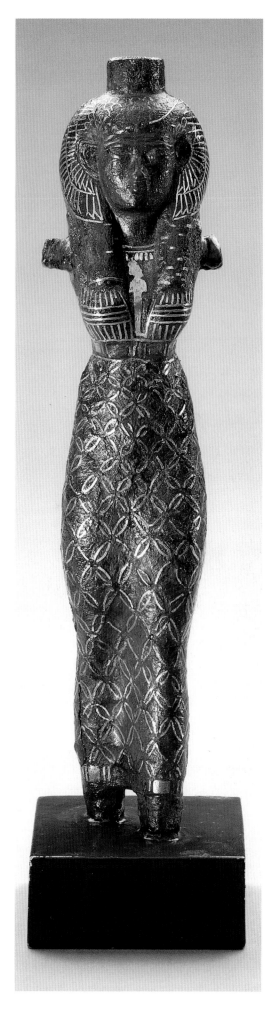

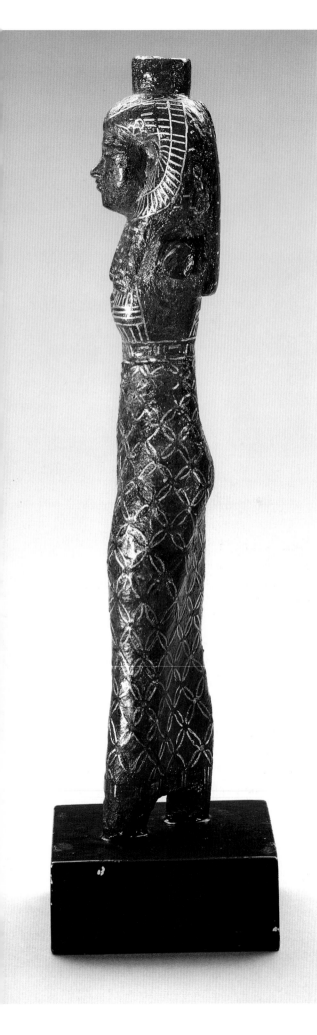

her date. Given the timelessness of her costume and the lack of a name or other inscriptions, the figure can only be dated only on the basis of its style, which is fortunately quite distinctive. Unlike bronze statues of women made early in the Third Intermediate Period, which are either very slim[3] or, much more often, bulgy and misproportioned,[4] this figure has a high, narrow waist, from which a long continuous line joins the hips to the low-slung curve of the thighs. This version of the female form was developed during the Middle Kingdom (cf. cat. no. 40) and went out of fashion at the beginning of the Eighteenth Dynasty. It was revived as an archaizing style late in the Third Intermediate Period, during the Twenty-fifth Dynasty.[5] The round, broad face further supports a Twenty-fifth Dynasty date for this figure.

The Twenty-fifth Dynasty comprised a family of kings from Kush, in what is today the Sudan. There is not a great deal of evidence concerning the Kushite queens who accompanied their husbands to Egypt, but what there is strongly suggests that they kept to their own traditional Kushite costumes and hairstyles. They do not seem to be represented in Egyptian style.[6] At Thebes, however, Kushite royal daughters, who succeeded the daughters of earlier kings in the exalted priesthood of the Divine Consort of Amun, are always represented as Egyptian, in both costume and figure. It was for them that the Middle Kingdom figure style was revived. Though they were not queens, Kushite Divine Consorts were occasionally shown wearing the vulture cap.[7] Thus it is likely that this richly adorned figure represents the Kushite Divine Consort Amenirdas I or one of the Kushite princesses who succeeded her. If so, the statue will have come from the area of Thebes, where these women held sway. **(E.R.R.)**

### Notes

[1] Louvre N 500: Schulz/Seidel 1998, p. 287, fig. 28.

[2] Actual examples in the Metropolitan Museum of Art: Andrews 1990, p. 104, fig. 83.

[3] E.g., Karomama, see n. 1.

[4] E.g., Raven 1993, p. 138, fig. 1; Taylor et al. 1998, p. 10, fig. 2.

[5] E.g., Saleh/Sourouzian 1987, no. 244 (Cairo CG 565, Amenirdas I).

[6] Russmann 1997, pp. 31–34, with references.

[7] On the famous alabaster statue of Amenirdas I, cited in n.5.

**Bibliography**

Quirke/Spencer 1992, p. 73, fig. 53.

Seipel 1992, no. 80, pp. 234–35.

# 116

## Pair of Rigid Hinged Cuff Bracelets of Prince Nimlot

Said to be from Sais
Third Intermediate Period, Twenty-second Dynasty, reign of Sheshonq I (ca. 945–924 B.C.) or Osorkon I (ca. 924–889 B.C.)
Gold with lapis lazuli and decayed polychrome glass inlays
Height 1 ⁵⁄₈ in. (4 cm)
EA 14594–95, acquired in 1850, purchase

Egyptian hinged bracelets often came in pairs. The inner side of the smaller segment of each of this pair of bracelets is inscribed for a man with the Libyan name of Nimlot (also rendered as Nemareth or the like).

In the late Twentieth and the Twenty-first Dynasties, Egypt began to come under the sway of Libyan-Egyptians and Libyans. Sheshonq I, from a line of Libyan chieftains resident in Egypt, became the first king of the Twenty-second Dynasty. One of his sons, the Nimlot who owned these bracelets, was "Commander of the Entire Army;" he also bore the title "King's Son of Ramesses," perhaps also a military title in honor of the famous warrior pharaoh Ramesses II of the Nineteenth Dynasty (ca. 1279–1213 B.C.).[1]

The external decoration of each bracelet consists of geometric decoration and a figure of a child god. The god is represented in a typical ancient Egyptian manner for a male child: nude, wearing a long sidelock of hair and with a finger to the mouth. That this is not a mere human child, however, is indicated by his crook-shaped scepter of rule, the uraeus on his forehead, and his headdress, which is a lunar crescent and disk. Two uraei guard the lunar symbols. Presumably, they represent the protective goddesses of Upper and Lower Egypt, which the Egyptians often equated with the ordered universe.

A child god is a symbol of the renewal of a deity, often on a daily basis, as with the solar cycle viewed in terms of birth—death—rebirth, or creation—degeneration—renewal/re-

creation. And the blue lotus, on several of which the deity squats, is a symbol of creation from the primordial ocean, from which the sun first rose, and of birth and rebirth, presumably because that flower rises above the water when it opens each dawn. Perhaps this decoration was seen as a magical aid to Nimlot's being vigorous in life and experiencing daily rebirth after death. Certainly the fact that he wore jewelry with such symbolism accords well with the religion and art of his era.

Prominent features of the religion of the late Twentieth to the Twenty-fourth Dynasties were a rise in the importance of divine family triads (e.g., that of Osiris, Isis, and their child Horus), with the royal family and such divine families regarded as reflections of each other; of child gods; and of what has been called a theology of birth. The deity depicted on these bracelets is most probably Harpocrates (Horus-the-Child).[2]

Expressions of such religious beliefs naturally became common in the art of the era, which was marked by great skill in metalworking in terms of both jewelry and sculpture (e.g., cat. nos. 115 and 118).[3] Although these bracelets are said to be from the city of Sais, in the western Nile Delta,[4]

they display typological and stylistic details similar to contemporary and near-contemporary objects from Tanis in the eastern Delta, which could raise questions about the Saite origin of these bracelets, or alternatively, point to the existence of similar tastes in the two different cities.[5] (R.A.F.)

### Notes

[1] Collombert 1996, pp. 23–24 (Doc. A) and pp. 29–35.

[2] For a summary discussion in English of these matters with references and some illustrations, including one of the Nimlot bracelets, see Fazzini 1988, pp. 8–14, 30–33 and pls. 3–8 and 23.

[3] See, e.g., Ziegler 1987 and Stierlin 1997, pp. 138–214.

[4] Wiedemann 1884, p. 544; Málek 1984, n. 18.

[5] For the possibility of some Twenty-sixth Dynasty objects destined for Sais having been mentioned at Memphis, see Málek 1984, n. 16. For typological and stylistic parallels from the royal tombs at Tanis, see Stierlin 1997, pp. 163 (upper row), 188, 192, 204–205, and 210.

### Bibliography

Andrews 1990, p. 155, with fig. 136.

Robins 1997, pp. 199–200, with fig. 240.

*Treasures* 1998, no. 103, pp. 321, 324–25 (EA 14594).

Müller, H. W./Thiem 1999, figs. 460–61, p. 224 (EA 14594).

# 117

## Upper Part of a Standing Man

Said to have been found at Giza
Third Intermediate Period, Twenty-second Dynasty (ca. 945–915 B.C.)
Bronze, traces of gilt
Height 16 ⅝ in. (42 cm)
EA 22784, acquired in 1889, gift of James Dandord Baldry

This fragmentary statue of a standing man wears a type of wig that was especially popular during the Twenty-first and Twenty-second Dynasties, and a modified version of the New Kingdom tunic, with less floppy sleeves (cf. cat. no. 91). There seems to be no indication of the kilt or sash that one would expect with this garment. The man's bland, handsome face, a blend of several New Kingdom styles, resembles representations of Osorkon II[1] and other figures of the Twenty-second Dynasty, when this bronze was probably made. Traces of gold show that it was at least partly gilded. It must have looked splendid when standing to its full height.[2]

The apparent upsurge of interest in metal sculpture during the Third Intermediate Period

produced not only richly inlaid figures, such as the divine consort or queen (cat. no. 115), but also a number of large bronze statues, some of which, like this one, approached 40 inches (1 m) in height.[3] These ambitious statues were hollow cast and made in sections. In this case, the man's wig is quite clearly a separate piece. Ambitiously large bronze statues continued to be made during the later Third Intermediate Period. Among the Egyptian statues found in the archaic Greek temple on the island of Samos are fragments of several that would have been over 40 inches (1 m) in height, including a magnificent male torso wearing a leopard skin, in Twenty-fifth Dynasty style.[4] Large bronze statues are also known from the early Late Period (see cat. no. 130). After the Twenty-sixth Dynasty, fine bronze-casting is often said to have become debased as the mass production of small votive statues increased exponentially.[5] But an over-life-size royal head in Hildesheim, most probably made during the first half of the fourth century B.C.,[6] shows that this was not entirely the case.

Like temple statues in stone, quantities of bronze figures were buried in the temple precincts when they became obsolete.[7] But much metal sculpture would eventually have been melted down for its metal. This fact, combined with the uncertain dates of many figures in bronze or precious metals, makes generalization about the history of this Egyptian art form extremely difficult. Despite the addition of a number of Eighteenth and Nineteenth Dynasty examples to the list of New Kingdom statues in recent years (see the discussions of cat. nos. 50 and 82), the list remains too short to permit a satisfactory assessment of New Kingdom metal sculpture. As for the Middle Kingdom, until about twenty-five years ago, it was believed that all cast bronzes of this period were crude and very small. Then came the discovery of a group of very fine copper alloy statues, including the head and torso of a statue of Amenemhat III (the king represented by cat. no. 31); the king's portrait features are beautifully rendered and the upper half of his figure is nearly 20 inches (50 cm) high.[8]

Since the appearance of sizeable bronze sculpture in the Third Intermediate Period was not without precedent, we cannot assume that it

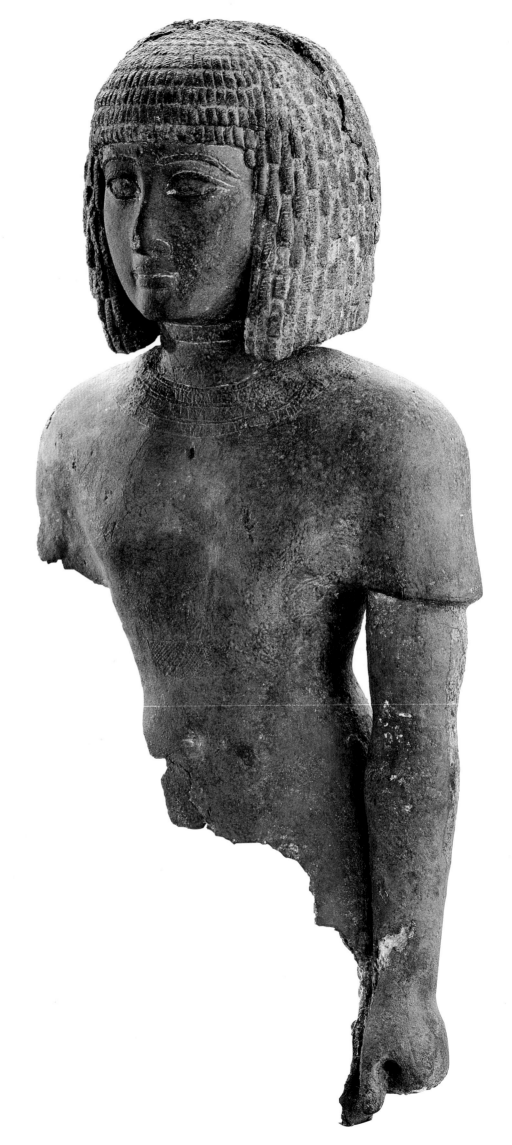

was a new development. Nonetheless, certain features of some large Third Intermediate Period bronzes suggest that the bronze-casters were experimenting.[9] On this figure, analysis of the metal has shown it to be an unusual alloy of copper, with 3.5 percent arsenic and 25 percent lead.[10] (E.R.R.)

### Notes

[1] E.g., Philadelphia E 16199: Silverman 1997, no. 30, pp. 106–107.

[2] A fragment of the lower part of this figure is also in the British Museum (EA 71459).

[3] Raven 1993, pp. 133–34, lists eight examples of large female statues; the British Museum examples are discussed in Taylor et al. 1998.

[4] Jantzen 1972, pp. 9–10, pls. 1–2; the head was also found, but the face is destroyed: ibid., pl. 3.

[5] Ogden 2000, p. 160.

[6] Ibid., p. 159.

[7] Taylor et al. 1998, p. 14; Ogden 2000, p. 156.

[8] Schulz/Seidel 1998, p. 140, fig. 65; cf. Ogden 2000, p. 158.

[9] Raven 1993, pp. 130–31.

[10] Taylor et al. 1998, p. 12.

### Bibliography

Taylor et al.1998, pp. 11–14, figs. 4, 8.

# 118

## Funerary Stela of Deniuenkhonsu

Probably from Thebes
Third Intermediate Period (ca. 950–900 B.C.)
Sycamore wood, painted
13 1/8 x 10 5/8 in. (33.2 x 27 cm)
EA 27332, acquired in 1896

This stela was made for a woman named Deniuenkhonsu, a musician of Amun (cf. cat. no. 100) and the wife of Ankhkhonsu. She wears a long, full wig embellished with a floral fillet, a perfume cone (cf. cat. nos. 100–104), and lotuses. Her voluminous pleated robe is sheer enough to reveal the flesh creases on her belly and her rather plump hips and thighs. In the Third Intermediate Period, a full female figure was the mode (cf. fig. 53).

Deniuenkhonsu worships a falcon-headed god named Re-Harakhty-Atum, a composite or synthesis of all the main solar gods. The all-inclusiveness of this figure is borne out by his regalia: in addition to the cobra-encircled sun disk on his head and the *ankh* sign in one hand, he holds a crook and flail, usually associated with Osiris, and the *was* scepter in his other hand is crowned by the feather of Maat and another *ankh*. Solar imagery dominates the arch of the stela. Under a blue border representing the sky,[1] the winged sun disk, propelled by the scarab beetle, rises from his nocturnal travels in the Underworld, symbolized by two figures of the jackal god, Anubis.

The offerings include lotuses; a plucked, eviscerated fowl; a bowl of grapes (?); round, decorated loaves of bread; and, beneath the table, two stalks of cos lettuce (cf. cat. no. 56) and a beer jar set in a stand and wound with a lotus stem. The lower border of the stela is a reddish strip lined with a row of little green plants. Since red and pink were used to represent desert land (cf. cat. no. 100), in contrast to the black earth of the Nile Valley, this must represent a plant-bedecked strip of desert. On a few painted stelae of this type, the lower border contains a representation of the tomb in the

desert cemetery, complete with its little garden.[2] This desert "garden" may thus refer to the locale of the tomb, or it may allude more generally to the West, the land of the dead.

Painted wooden stelae, on which the deceased was shown worshiping a solar god or Osiris, or both, were in vogue at Thebes during the Third Intermediate Period, and many of them were made for women.[3] Though the owners of these stelae were socially elite, they ranked well below such royal descendants as Nestanebetisheru. It is interesting therefore to compare Deniuenkhonsu's stela with Nestanebetisheru's papyrus representation of the same subject (cat. no. 104). The similarity in the drawing of the women's figures and especially their faces indicates that they are close in time. But despite the shared style of drawing, the almost austere spareness of the papyrus vignette has little in common with the sense of crowding on the stela, crammed with both material details and symbols. (E.R.R.)

### Notes

[1] It is actually a curved version of the hieroglyphic sign for "sky," but it is badly drawn.

[2] E.g., Saleh/Sourouzian 1987, no. 243.

[3] Examples include that cited in n. 2; also, British Museum EA 8447, EA 22916: *HT* XI 1987, pp. 12, 16, pls. 10:1, 18:2.

### Bibliography

James 1986, p. 67, fig. 80.

*HT* XI 1987, pp. 15–16, pls. 18/1, 19/1.

Quirke/Spencer 1992, p. 59, fig. 41.

Robins 1997, p. 204, fig. 245.

*Art and Afterlife* 1999, no. 23, p. 51.

# 119

## Tomb Stela of Psusennes

From Abydos
Third Intermediate Period,
Twenty-first Dynasty (ca. 950 B.C.)
Limestone
37 ¼ x 24 ¼ in. (94.5 x 61.5 cm)
EA 642, gift of the Egypt Exploration Fund, 1900

This stela, found at Abydos in the tomb of its owner, Psusennes,[1] shows him offering to Osiris, to his son the falcon-headed Horus, and to his

wife, Isis. The spirit of the New Kingdom persists here in Psusennes' elaborate costume and wig, the ragged edge of which represents curled ends, and to some extent in the proportions of the figures.[2]

As always, the divine figures are rendered in a more conservative manner. Instead of the flowing robes typically shown on female figures

of the Twenty-first and Twenty-second Dynasties, Isis wears the traditional tight sheath dress, and her figure lacks the bulging thighs depicted on mortal women of this time (cf. cat. no. 118). As Osiris' queen, Isis here wears a vulture cap (cf. cat. no. 115), with the bird's tail standing out behind her head like a little ruffle. The cap is crowned with a platform for

hieroglyphs that spell her name. Horus' royal status is symbolized by his double crown and bull's tail. Osiris, mummiform, wears a white crown flanked by Maat feathers, a divine beard, and a large collar necklace, like those represented on anthropoid coffins of this period (cf. cat. no. 109), with a counterweight at the back.

Though the sunk relief figures are well carved, they are very crowded. Apparently the draftsman who drew the scene had been instructed to make the figures as large as possible. In doing so, he drew Psusennes' arm in such a way that it hides part of Osiris' crook, flail, and *was* scepter. This looks strange to us because, assuming the two figures are facing each other directly, that arm ought to be on the far side of the god's attributes. But to many ancient Egyptians the image of a mortal partially blocking that of a god would have looked even stranger: certainly disrespectful and possibly sacrilegious.

Had those Egyptians seen this stela in its original state, they would have been even more disapproving. Instead of an Isis knot, which has obviously been recarved over an erasure, Psusennes was originally proffering a figure of the goddess Maat.[3] While Maat (truth) was a very good thing to offer the gods, that offering was strictly a royal prerogative. Psusennes —who was the son of the quasi-royal Menkheperre, High Priest of Amun at Thebes—may have felt himself entitled to make this gesture, but others clearly thought otherwise. The offering was probably changed soon after the stela was erected, at about the time that a new line of kings, the Twenty-second Dynasty, took power and reasserted control over Thebes and Abydos. They would certainly have considered Psusennes' offering of Maat to be unacceptable. (E.R.R.)

## Notes

[1] For a recent description of this tomb and its location near what was believed to be the tomb of Osiris, see Dodson 1997–98, p. 46.

[2] Discussed by Robins 1997, p. 208, caption to fig. 251.

[3] Compare Quirke 1992, caption to fig. 55 on p. 98.

## Bibliography

PM V 1937, p. 68 (with bibliography).

Quirke 1992, p. 99, fig. 55.

Robins 1997, p. 208, fig. 251.

# 120

## Head of a Kushite King, Probably Shabako

Provenance unknown, possibly from Heliopolis
Third Intermediate Period, Twenty-fifth Dynasty, reign of Shabako (ca. 716–702 B.C.)
Granite, formerly gilded
Height 6 7/8 in. (17.2 cm)
EA 63833, acquired in 1934, gift of Miss Barlow Webb

This royal head, which wears a composite crown on top of a *nemes*, was long considered a work of the late Ramesside Period. More recently, it was assigned to the Twenty-second or Twenty-third Dynasty.[1] It is time, I think, that this head be recognized as what it is: one of the finest surviving examples of royal sculpture of the Twenty-fifth, or Kushite, Dynasty.[2]

These kings, from a ruling family long established in the kingdom of Kush, in present-day Sudan, took advantage of the political tensions and divisions in Egypt during the Third Intermediate Period to invade and conquer the land, which they ruled for about seventy-five years. Devotees of the Egyptian gods, especially Amun, who had an important cult in their homeland, they insisted on their legitimacy as traditional pharaohs. In support of this, they had their artists imitate royal monuments of earlier times. By so doing, they provided a new impetus to the archaizing trends established earlier in the Third Intermediate Period. Their own images are a hybrid of Egyptian and Kushite traditions. Statue poses, body forms, costumes, and most headdresses were entirely Egyptian, with a marked preference for Old Kingdom models (cf. fig. 28).

But these traditional-looking figures also wear jewelry peculiar to the Kushites, with amuletic representations of a ram's head with curled horns. In Kush, Amun was worshiped primarily in his manifestation as a ram-headed man. Though Kushite kings wore Egyptian crowns, they were more often represented wearing their indigenous royal headdress, which consisted of an elaborate diadem worn on their uncovered, short-cropped hair. Instead of a uraeus at the forehead, they wore a pair of uraeus cobras, and their broad, slightly smiling faces appear to be renderings of Kushite features that have been modified, perhaps with a view to making them look somewhat Egyptian.[3]

This sophisticated amalgamation cannot have been achieved without Egyptian advice. The Kushites had strong support in Thebes and other parts of southern Egypt, and possibly family connections as well. Their studied manipulation of Egyptian tradition was not limited to royal imagery. Analogous examples can be found in their constructions at Karnak and in other temples, and in their written records.[4]

The uraeus on the British Museum head is the first clue to its identity. The cobra's hood is very broad, too broad for a single uraeus. Originally it was two, the Kushite double uraeus. The pair were smoothed into one by a later usurper. Almost certainly this was Psamtik II, the third king of the succeeding Twenty-sixth Dynasty, who took over the monuments of his Kushite predecessors. He erased their names and often replaced them with his own, scraped off their ram's-head amulets, and converted the two uraei into one.[5]

The face of this statue confirms its Twenty-fifth Dynasty date. It is broad, with full cheeks bulging along the line between nose and mouth. The slightly upturned mouth is small, not much wider than the broad base of the nose. These are all characteristics of Kushite royal images. The three main Kushite kings—Shabako, Shebitku, and Taharqa—seem to have been depicted with slightly different features that made their likenesses recognizable. Surviving examples of heads still bearing royal names are too few to enable us to trace these variations with precision. However, this face, in its extreme breadth and roundness, and in the faint suggestion of a horizontal ridge of flesh on each cheek beside the nostrils, closely parallels three statue images with the name of Shabako.[6] There is thus a strong possibility that the British Museum head represents this king, the first of the Kushite kings to rule in Egypt.[7]

Both the *nemes* and the incomplete crown are striped with alternating bands of rough and polished stone. In other periods of Egyptian art, especially from the fourth century B.C. onward, this technique was deliberately employed for a coloristic effect. The Kushites, however, seem to have left stone surfaces rough only where they

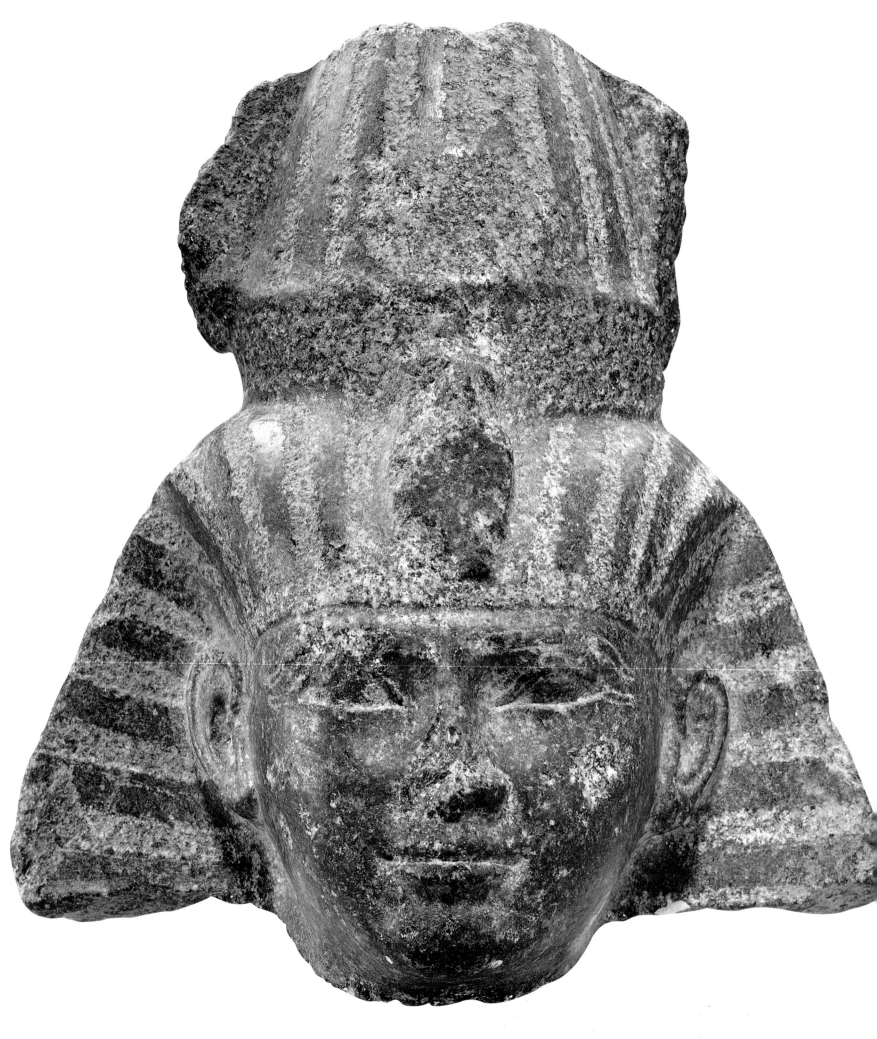

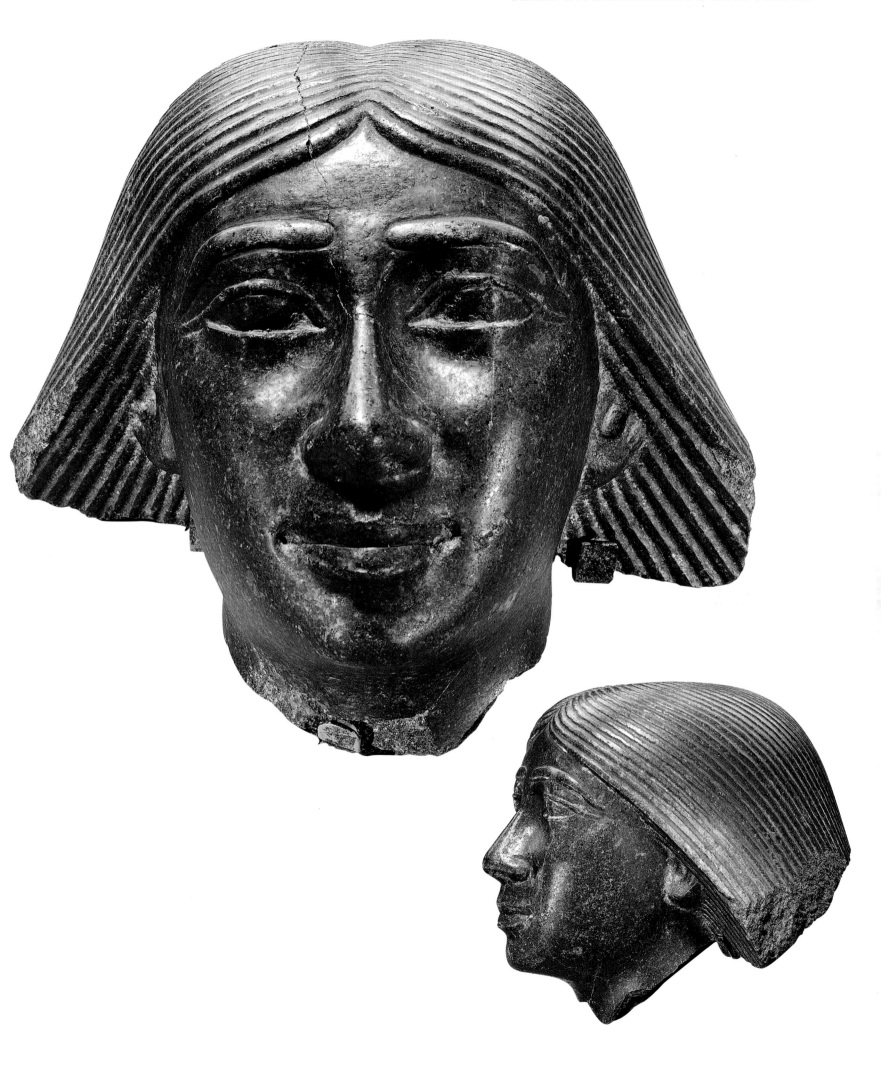

# 127

## Head of a Man

Provenance unknown
New Kingdom, Eighteenth Dynasty, reign of
Amenhotep III (ca. 1390–1352 B.C.)
Limestone
Height 4 ¼ in. (10.8 cm)
EA 2339, acquired in 1843

# 128

## Bust of a Man

Provenance unknown
New Kingdom, Nineteenth Dynasty
(ca. 1295–1186 B.C.)
Limestone, traces of paint
Height 7 ⅜ in. (18 cm)
EA 2338, acquired in 1843, purchased from
H. O. Cureton

# 129

## The Vizier Nespakashuty with a Symbol of Hathor

Probably from Thebes
Late Period, Twenty-sixth Dynasty,
reign of Psamtik I (656–610 B.C.)
Gray granite
Height 29 ⅛ in. (74 cm)
EA 1132/1225, acquired in 1893 and 1897

Like many fine statues of the seventh century
B.C., this archaizing image of the vizier
Nespakashuty combines elements from several
previous periods (cf. cat. no. 122). His
elaborately detailed double wig and short chin
beard have New Kingdom prototypes, most
closely paralleled by wig and beard styles of the
middle of the Eighteenth Dynasty (e.g., cat. nos.
54 and 127). But his short, pleated kilt,
frequently found on sculpture of the Old and
Middle Kingdoms (cf. cat. no. 19), was rarely
represented on statues of the Eighteenth
Dynasty and later New Kingdom, most of which
are more elaborately costumed.

Nespakashuty's kneeling figure holds a
symbol of the goddess Hathor in the form of a

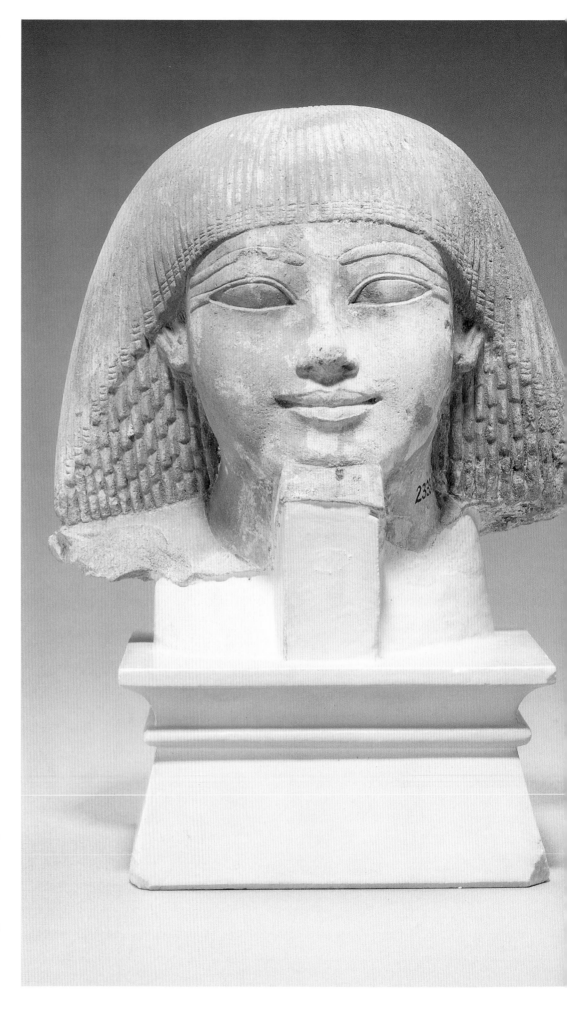

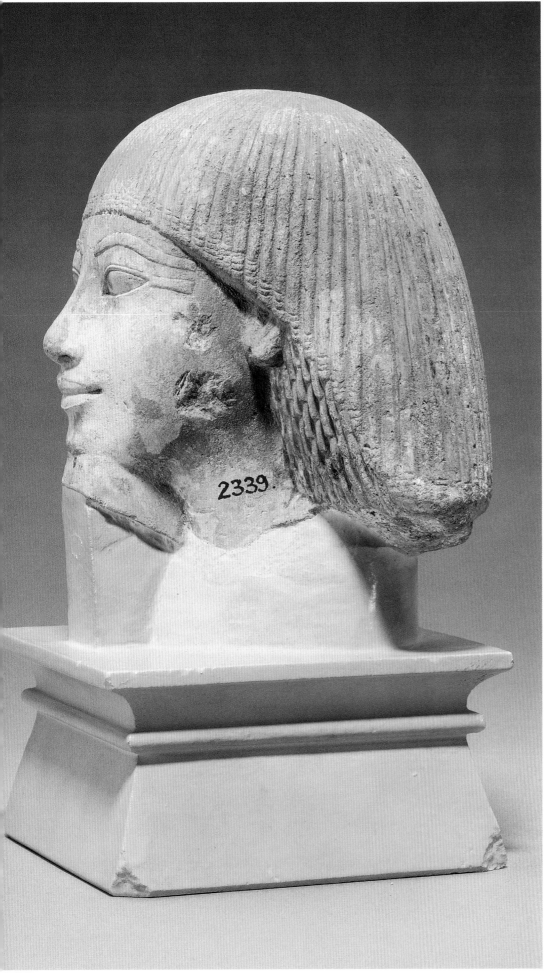

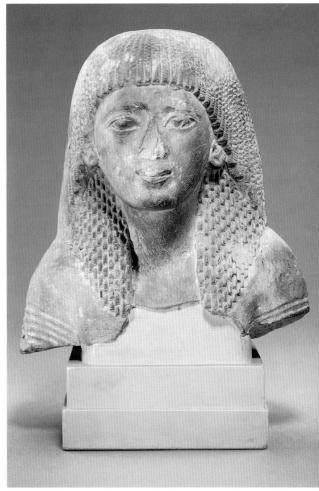

stylized sistrum, with the goddess' cow-eared face at the top of the handle.[1] It is possible that this composition was also archaizing. Kneeling statues of nonroyal persons first appeared in the Eighteenth Dynasty, and some from mid-dynasty hold Hathor symbols similar to this one.[2] But since neither the pose nor the symbol had ever fallen out of use, their appearance here might simply represent a continuing tradition. The inscription on the statue invokes, not Hathor, but the lesser goddess Nebet-hetepet,[3] who was sometimes identified with Hathor.[4]

Nespakashuty's face on this statue is clearly no portrait, but neither is it archaizing. With its almond-shaped eyes and sober expression, it is a fine example of sculptural style at Thebes just before the appearance of the northern Saite style, which reached the South with the advent of the Twenty-sixth Dynasty under its first king, Psamtik I. An early Theban example of this imported style is found on the face of another statue of Nespakashuty, which has narrow, slanted eyes and the definite suggestion of a smile. This statue is also archaizing; it shows the vizier seated on the ground in the pose of a scribe, derived from Old Kingdom prototypes. On a third archaizing statue of Nespakashuty, he sits in an asymmetric scribal pose (the same pose as cat. no. 64). Here, the anatomy, the wig, and, to some extent, even the face, seem based on Middle Kingdom models.[5]

Nespakashuty, who inherited the title of vizier from his father, Nespamedu, served under Psamtik I.[6] The vizier was the highest administrative official in ancient Egypt. During the reign of Psamtik I (as through most of the Late Period), there were two viziers, one for the north and the other, Nespakashuty, in the south. His activities were undoubtedly centered at Thebes, which was the most important town in the South, and it was here that he was buried. His tomb was cleared by the Metropolitan Museum of Art in the 1920s; sections of relief from its walls are exhibited there and also in the Brooklyn Museum of Art and the Oriental Institute Museum of the University of Chicago, with additional blocks and fragments in the Walters Art Museum, Baltimore, and other American museums.[7]

The bust and the lower part of this statue were acquired separately, in 1893 and 1897. Since the bust (on which Nespakashuty's name

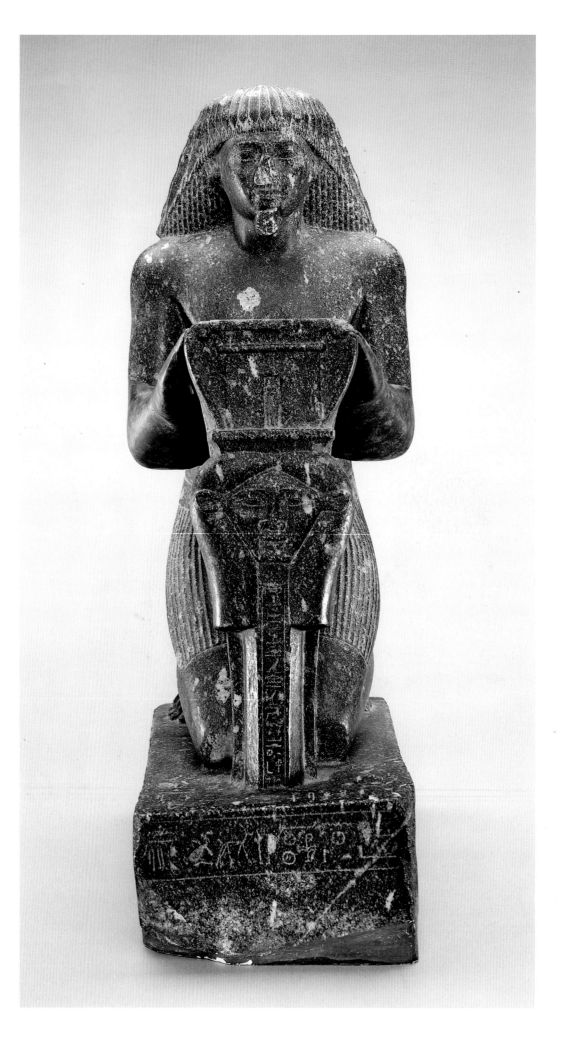

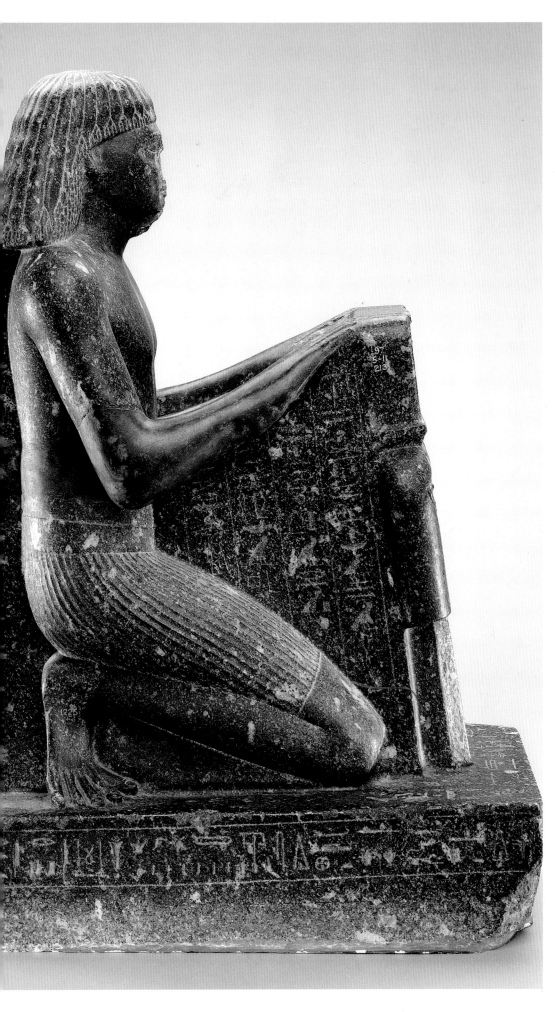

does not appear) was believed to come from Thebes and the lower section had been acquired at Edfu, the fact that they belonged together was not recognized for some time.[8] It is not entirely impossible that the statue came from a temple in Edfu. But since Nespakashuty's other monuments are all from Thebes, it is far more likely that the lower half, already separated from the bust, was taken to Edfu by a nineteenth-century antiquities dealer.[9] Like the other two statues described above, this figure of Nespakashuty was probably made for a Theban temple.[10] (E.R.R.)

### Notes

[1] For a discussion of this symbol, see cat. no. 112.

[2] E.g., Brooklyn BMA 74.97: Fazzini/Romano/Cody 1999, no. 41, p. 86.

[3] Vandier 1965, p. 96.

[4] Vandier 1965, pp. 115–16.

[5] The statues, both from Karnak, are Cairo JE 36662 and JE 37000: Russmann 1989, nos. 82, 83, pp. 176–81.

[6] For his family and career, see the works cited in Pischikova 1998, p. 97, nn. 1–3.

[7] Pischikova 1998.

[8] British Museum 1909s, nos. 789, 790, p. 218.

[9] See also PM I, 2 1964, p. 790. Another possibility, however, is the Thinite nome, north of Thebes, where Nespakashuty had family ties; the inscription refers to a sanctuary there: Vandier 1965, p. 96, n. 8.

[10] Compare the dealer's provenance for catalogue number 133, which is probably correct.

### Bibliography

PM I, 2 1964, p. 790 (with earlier bibiography).

Robins 1997, p. 227, fig. 272.

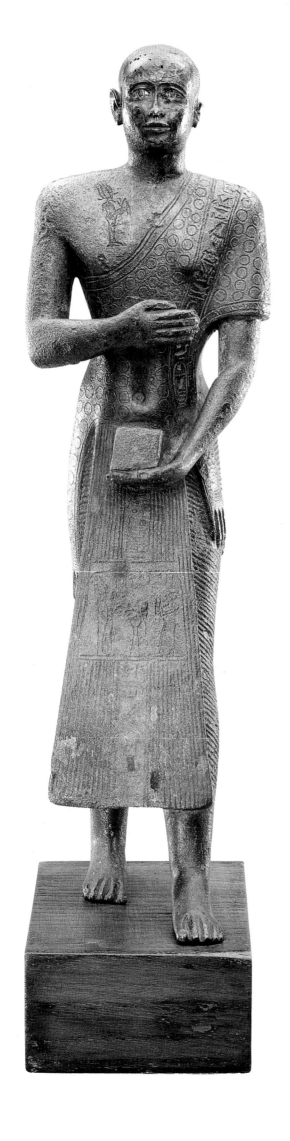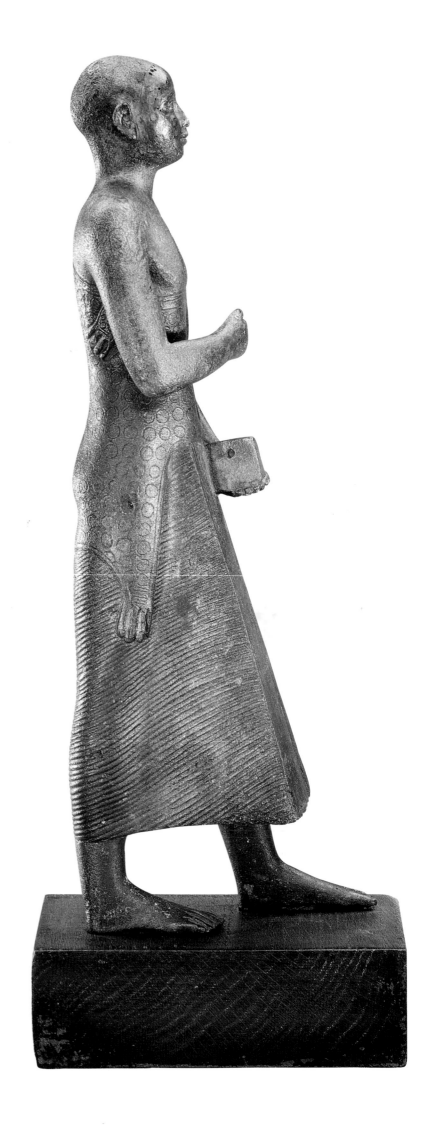

# 130

## Standing Figure of Khonsuirdas

Provenance unknown

Late Period, Twenty-sixth Dynasty,

reign of Psamtik I (664–610 B.C.)

Bronze, silver inlay

Height 14 1/8 in. (35.8 cm)

EA 14466, acquired in 1927, gift of H. R. H. Hall

The continuation of fine, large bronze sculpture from the Third Intermediate Period (cf. cat. no. 117) into the Late Period is exemplified by this remarkably well-preserved statue of Khonsuirdas, who lived under the first king of the Twenty-sixth Dynasty, Psamtik I. As "Governor of Upper Egypt," Khonsuirdas was one of the highest officials in the administration, but he is shown here as a priest with a shaven head and a leopard-skin vestment. In his proper left hand he holds the base of a statue that he supported with his right hand. That figure, made separately, is now lost but it was undoubtedly an image of Osiris.

Khonsuirdas's figure is covered with a wealth of incised detail, but apart from silver inlay in the eyes, there is apparently no evidence of precious metal inlays. On his proper right shoulder is a cartouche of Psamtik I and above his right breast a figure of Osiris in profile facing right, similar in pose to the gold figure of Osiris on catalogue number 115. The leopard skin is here clearly an imitation, probably in cloth: the spots are shown as rows of circles, the "paws" are neatly fitted at the hips, and the tail hangs down behind. A band over the left shoulder, of a kind frequently represented on these vestments during the Twenty-fifth and Twenty-sixth Dynasties,[1] gives Khonsuirdas' names and titles and again names his king. Although his long kilt is elaborately pleated and has a stiffened front panel, it is narrow and relatively simple, more in the style of the Middle Kingdom than the New Kingdom. A narrow strip down the center of the panel continues Khonsuirdas' inscription, interrupted by a vignette that shows him worshiping Osiris. Thus the figure he held must have represented that god.

Since there seems to have been relatively little modeling, as opposed to engraved detail, the figure's large navel and the trench-like depression leading down to it are very noticeable, though these details would have been largely hidden when the image of Osiris was in place. The figure's broad shoulders and long limbs increase the sense of monumentality in this large bronze.

I know only one other Twenty-sixth Dynasty bronze statue to which this figure can be compared in quality and impressiveness. That statue was found in Turkey, in the ancient Greek city of Ephesus and is now in the Ephesus Museum in Selçuk.[2] It is about the same size as the statue of Khonsuirdas, and it also represents a man with a shaven head and leopard skin. The inscribed band on the vestment indicates that this statue was made under the second king of the Twenty-sixth Dynasty, Necho II, but like many other inscriptions of that reign, the cartouches were later altered to those of Necho's son and successor, Psamtik II. **(E.R.R.)**

### Notes

[1] E.g., on the bronze figure cited in the next note.

[2] Shubert 1989, p. 32 (with bibliography), pl. 13. I question his conclusion that the two are contemporary products of a single workshop.

### Bibliography

Hall, H. R 1930, pp. 1–2, pls. 1–2.

Hornemann 1957, pl. 283.

Pinch 1994, p. 71, fig. 35.

Shubert 1989, p. 31, pl. 12b

# 131

## Kneeling Figure of Nekhthorheb

Provenance unknown

Late Period, Twenty-sixth Dynasty, reign of Psamtik II (595–589 B.C.)

Quartzite

Height 44 3/8 in. (112.5 cm)

EA 1646, acquired in 1914, purchased from J. Backshall, formerly in the collections of H. T. Montresor and E. Coke

Nekhthorheb is shown kneeling, his head slightly raised and his hands lying flat on his thighs. His unadorned headdress and short, plain kilt enhance the viewer's impression of deliberate simplicity and a kind of monumental tranquility. In Nekhthorheb's face and body, however, there is a considerable amount of modeled detail.

A comparison with the kneeling statue of Nespakashuty (cat. no. 129), made some fifty years earlier at the beginning of the Twenty-sixth Dynasty, shows how greatly sculptural style changed in the later part of this dynasty. Archaizing elements dwindled and eventually almost disappeared (for an unusual late example, see cat. no. 133). Traditional wigs were often replaced by the simple rounded head covering worn by Nekhthorheb. This is usually referred to as a bag wig, though it more nearly resembles some kind of headcloth. Garments were simple short or long kilts or, at the end of the dynasty, a new style of male clothing not previously represented (cf. cat. no. 132).

Nekhthorheb's almond-shaped eyes and the high-set, horizontal line of his eyebrows, as well as the sickle-shaped curve of his slight smile, follow the pattern for facial features set early in the Twenty-sixth Dynasty (cf. cat. no. 126). But this face is broad and full, consonant with the body, which, though not fat, looks soft and fleshy. This effect was achieved by a new manner of modeling the torso. On male figures of the Twenty-fifth and early Twenty-sixth Dynasties, the torsos, derived from Old Kingdom models, are typically lean with high-placed pectorals and a median groove running down the center (cf. fig. 28, cat. no. 123). Nekhthorheb's torso, however, is designed as three sets of swelling curves placed one below the other and comprising the breast, the rib cage, and the abdomen. The large round navel is set within a bulge shaped rather like a teardrop.

These late Twenty-sixth Dynasty changes in sculptural style were to be extremely influential, for they provided the artistic vocabulary for rendering faces and bodies in sculpture and relief for the Thirtieth Dynasty and much of the Ptolemaic Period (cf. cat. nos. 135, 136, 138, 139). Because we know so little about Egyptian art during the troubled period between the Twenty-sixth and the Thirtieth Dynasties, it is unclear whether this was a stylistic continuum or whether art of the Thirtieth Dynasty was archaizing to the Twenty-sixth.

In fact, modern historians have often had trouble distinguishing late Twenty-sixth from Thirtieth Dynasty examples. Encouraged by the fact that Nekhthorheb's name was the same as that of the Thirtieth Dynasty king Nectanebo II,[1] scholars long considered this statue and a very

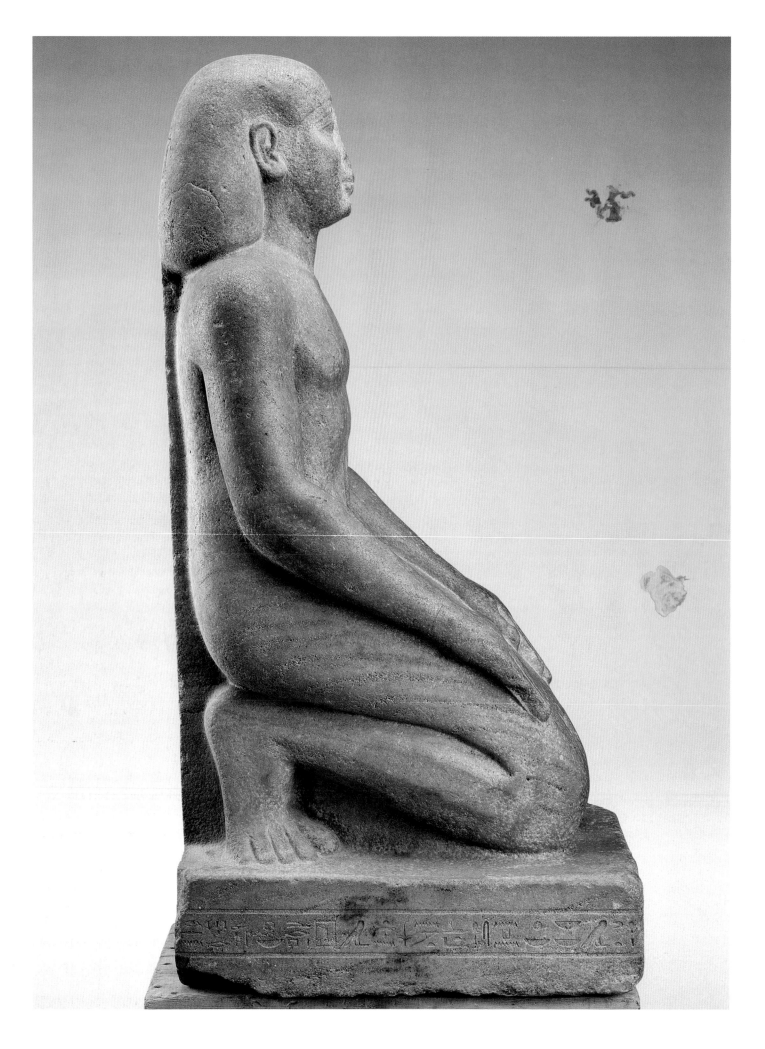

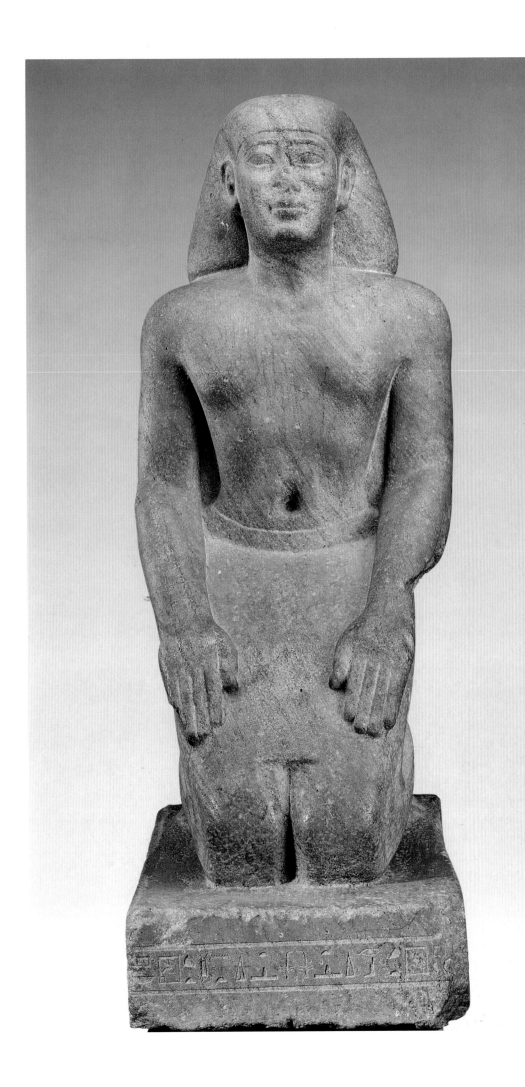

similar kneeling quartzite statue of him in the Louvre[2] to be products of the later period. On other monuments of this man, however, Psamtik II is named, leaving no doubt as to Nekhthorheb's Twenty-sixth Dynasty date.[3] (**E.R.R.**)

### Notes

[1] Nectanebo is a Greek form of Nekhthorheb; see the Chronology elsewhere in this catalogue, pp. 260–61.

[2] Louvre A 94: Andreu/Rutschowscaya/Ziegler 1997, no. 92, pp. 185–86.

[3] As demonstrated by Posener 1951.

### Bibliography

James/Davies 1983, p. 59, fig. 66.

Shubert 1989, p. 32, pl. 12a.

## 132

### Standing Figure of Amenhotep Holding a Naos

Probably from Sais
Late Period, late Twenty-sixth Dynasty
(570–526 B.C.)
Graywacke
Height 16 in. (40.6 cm)
EA 41517, acquired in 1905, purchased from Rollin & Feuardent, formerly in the collection of Callarlay

A man with the old-fashioned name of Amenhotep[1] stands holding a naos in which is a figure of the goddess Neith. He wears a bag wig (cf. cat. no. 131) and a long kilt that appears to be a length of heavy fabric, wrapped high under the arms and fastened by tucking in the ends, much as one fastens a bath towel. His handsome face has features similar to those of Nekhthorheb (cat. no. 131), but in contrast to that smiling countenance, Amenhotep looks serious or even sad.

Amenhotep's garment, here making one of its first appearances in Egyptian art, continued to be represented into the Ptolemaic Period (cat. no. 141). For a long time, it was believed to be a "Persian wrap," introduced to Egypt by the Achaemenid Persians, who defeated the last king of the Twenty-sixth Dynasty to rule Egypt for 120 years as the Twenty-seventh Dynasty. Since the Persian rulers are known to have been very unpopular with many of their Egyptian

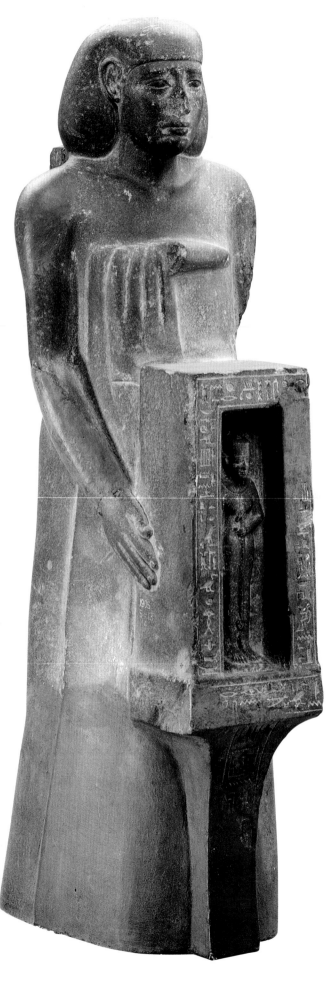

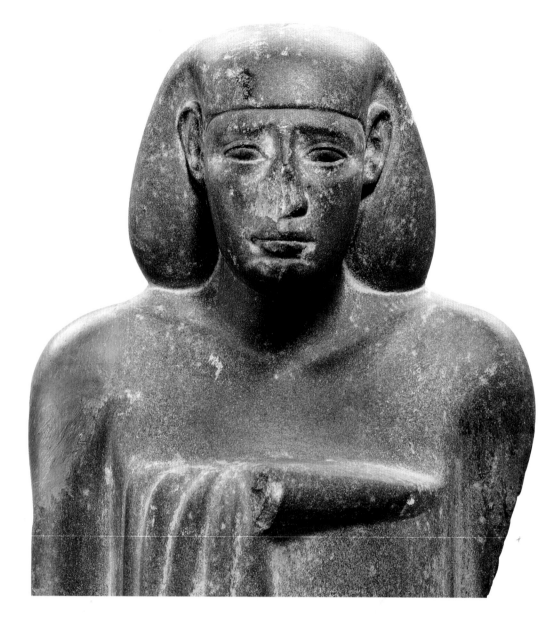

subjects, unsmiling faces, like Amenhotep's, were presumed to reflect political discontent in this period, perhaps as a kind of silent protest.

We now know, however, that the "Persian wrap" was already represented on statues made under Amasis, the penultimate king of the Twenty-sixth Dynasty.[2] Thus it must have been an Egyptian garment, presumably standard masculine attire in Amenhotep's day.[3] As archaism slowly went out of style at the end of the Twenty-sixth Dynasty, the simple kilts copied from Old Kingdom and Middle Kingdom prototypes (as on cat. no. 131) could sometimes be replaced by what men were actually wearing.

On the whole, late Twenty-sixth Dynasty style is highly idealized, with soft, broad, smiling faces like that of Nekhthorheb (see cat. no. 131), but this style could also lend itself to less idealized, more detailed renderings, of which catalogue number 133 is an extreme example. Among these exceptional renderings are several

with serious or sad expressions.[4] Since Amenhotep lived at the end of the Twenty-sixth Dynasty, he may have survived into the Twenty-seventh, so it is not impossible that his statue was made in the first years under Persian rule. But it is thoroughly Twenty-sixth Dynasty in style.

Amenhotep and his family were priests at Sais, the main center of the goddess Neith.[5] Almost certainly, this statue was made and erected at Sais, especially since Neith herself is represented in the naos. (E.R.R.)

### Notes

[1] Called Wahibremeryneith by Shubert 1989, p. 38, pl. 19b. That is the name of Amenhotep's father.

[2] Shubert 1989, p. 34.

[3] Long cloaks had already begun to make their appearance early in the dynasty: Smith, W. S. 1998, p. 235, fig. 394 (Theban tomb, 279, Pabasa).

[4] As on two statues from Saqqara, one in Toronto: Hastings

1997, no. 30, pp. 14–15, pls. 22–25; the other in Cairo: Russmann 1989, no. 86, pp. 185–88.

[5] For a genealogy of this family see El-Sayed 1975, pp. 152–53.

**Bibliography**

Shubert 1989, p. 38, pl. 19b.

# 133

## Portrait Head of a Man

Said to be from Memphis
Late Twenty-sixth Dynasty (ca. 570–526 B.C.)
Quartzite
Height 9 5/8 in. (24.3 cm)
EA 37883, acquired in 1875, purchased from Selma Harris

Early attempts to date statue heads of the Late Period could produce wildly diverse results. In 1879, when this striking head was first discussed in print, it was admiringly compared to a Holbein portrait, said to represent a foreigner, and dated to the Fourth Dynasty.[1] One wonders whether these judgments reflected the ideas of the author, the well-known early French Egyptologist Emile Prisse d'Avennes,[2] or the editor of the *Texte*, an "ancien rédacteur de *La Revue des Beaux-Arts*."

When the British Museum acquired the head in 1875, the keeper, Samuel Birch, ascribed it to the later Eighteenth Dynasty.[3] Soon, however, he also decided that its "Mongol" features looked foreign, and dated it to the Hyksos period (Fifteenth Dynasty, ca. 1650–1550 B.C.).[4] In the 1920s the head, now apparently regarded as Thirteenth Dynasty, was correctly reattributed to the Twenty-sixth Dynasty.[5] But it was not until 1927 that H. R. Hall showed it to be an archaizing work of the Late Period, based on Middle Kingdom prototypes.[6] The limited information then available, however, led him to date the head to the Twenty-fifth Dynasty, over a century too early. He also concluded that it "very probably" came from Thebes, which, almost certainly, it did not.

Prisse d'Avennes' publication states that the head was found in 1854, beneath the great temple of Ptah at Memphis.[7] But Prisse did not see the head until 1858, in Alexandria, in the collection of the merchant A. C. Harris,[8] from whose daughter the British Museum later

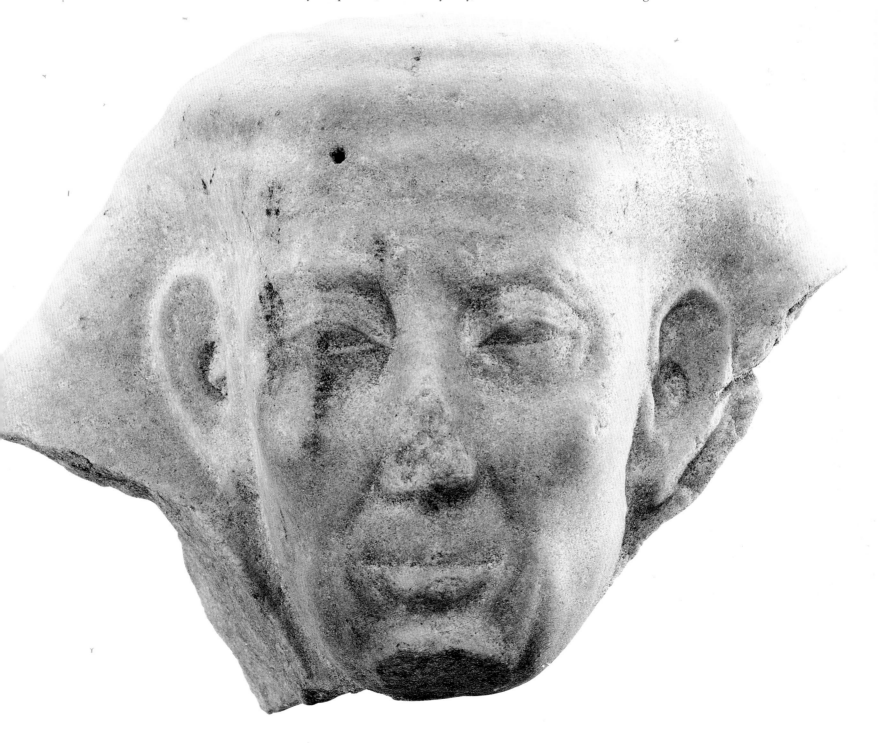

acquired it.[9] Harris must have been the source for the story of the head's discovery, and his informant would have been the dealer from whom he bought it. Since nineteenth-century dealers did not have to worry much about laws against smuggling or unauthorized excavation, their stories about provenance are generally considered more reliable than most modern equivalents. Nonetheless, these stories are essentially hearsay and should always, if possible, be checked.[10]

In this case, there is reason to think that the head did come from a Memphite statue, or at least from one made in Lower Egypt. It is carved in a pale, almost white quartzite. During the Late Period (as in some earlier periods), hard, whitish stone seems to have been favored more in Memphis and other northern sites than in Thebes or the South.[11]

A Memphite origin is also suggested by the style of the face, which further permits it to be dated near the end of the Twenty-sixth Dynasty, probably to the reign of the penultimate king, Amasis. A trend toward softer modeling of the body, which had begun in the middle of the dynasty (see cat. no. 131) seems to have been largely northern in origin. The same sensibility was soon expressed in faces with soft, sagging flesh and wrinkles. The smiles on these faces are less pronounced than on those of earlier Twenty-sixth Dynasty statues (cf. cat. no. 126); when combined with the downward lines of their facial folds and wrinkles, the effect is a curiously ambiguous expression. The few late Twenty-sixth Dynasty statues of this type with a reliable provenance come from the Memphite area.[12] None of these, however, has so aged a physiognomy, with such a wealth of droops and wrinkles. Perhaps the most singular detail of this face is the indication of wrinkles on the upper lids, a feature elsewhere attested only briefly, in the New Kingdom.[13]

Within their puffy lids, the eyes have symmetrically curved upper and lower rims with pointed corners. Their shape is typical of the Twenty-sixth Dynasty, but they are smaller and narrower than usual, and slightly slanted. These details, doubtless meant to increase the impression of age, are what struck the first modern commentators as foreign or "Mongol." In fact, statues with slanted eyes were fairly common throughout the Twenty-sixth Dynasty,[14]

most notably a series of royal heads attributable to King Amasis, in which the eyes are consistently slanted, narrowed, and sometimes quite small.[15]

The unmistakably Middle Kingdom form of the wig[16] leaves no doubt that the head belongs to the genre of late archaizing representations of aged men derived from the private "portrait" sculpture of the late Middle Kingdom (see cat. nos. 41 and 42). But this is no copy of an earlier work. It clearly reflects stylistic trends of the later Twenty-sixth Dynasty. It is, however, by far the most detailed representation of age known from this time. For that reason, it may well be the likeness of a specific individual, even though the late Twenty-sixth Dynasty seems to have been a period with relatively little interest in portraiture.[17] (E.R.R.)

## Notes

[1] Prisse 1879, II, pl. [33], top; *Texte*, p. 409.

[2] For Prisse's career, see M. J. Raven in Prisse 1991, pp. 1–6.

[3] For Birch's career at the British Museum, see the essay in this catalogue by T. G. H. James.

[4] Hall, H. R. 1927b, pp. 27–28; for another "Hyksos" head, see cat. no. 31.

[5] Weigall 1924, p. 320.

[6] Hall, H. R. 1927b.

[7] Prisse 1879, p. 409; followed by Bothmer 1960, p. 12, and PM III 1981, p. 848.

[8] Olaf E. Kaper, in Prisse 1991, p. 383.

[9] Hall, H. R. 1927b, p. 27. For Harris and his daughter, see Dawson/Uphill 1995, p. 191.

[10] For a provenance that was confused by a dealer's actions, see cat. no. 129.

[11] Examples include a statue in Lisbon from Lower Egypt: Baetjer/Draper 1999, no. 8, p. 26; Bothmer 1960, no. 29, pp. 34–35, pl. 27; probably also no. 131 in this catalogue, which, though it lacks a provenance, represents a man active in the north.

[12] Cairo CG 784: Russmann 1989, no. 86, pp. 185–88; Toronto 969.137.1: Hastings 1997, no. 30, pp. 14–15, pls. 22–25; Louvre N. 2454: Bothmer 1960, no. 67, pp. 81–83, pls. 64–65; Cairo CG 726 (perhaps slightly later): Russmann 1989, no. 87, pp. 188–90; Bothmer 1960, no. 65, pp. 78–79, pls. 61–62.

[13] The detail, first attested on some heads of Amenhotep III (fig. 24), persisted through the Amarna Period. Isolated examples occur on early Nineteenth Dynasty figures imitating the style of Amenhotep III: Munich GI WAF 38: Schoske/Wildung 1985, no. 59, pp. 83–86 (there attributed to the Eighteenth Dynasty).

[14] From early in the dynasty, the Lisbon statue cited above, n. 11; from mid-dynasty, busts in the MMA 66.99.68: Bothmer 1960, no. 52A, pp. 59–61, pls. 48–49; and the Walters Art

Gallery, Baltimore, no. 22.198: ibid., no. 49, p. 56, pl. 45.

[15] E.g., Walters Art Gallery 22.415 (fig. 25); also New York MMA 66.99.78: Bothmer 1960, no. 54, pp. 62–63, pl. 51. For these and other examples, see Josephson 1992.

[16] Middle Kingdom examples of this wig include Brooklyn BMA 62.77.1: Fazzini/Romano/Cody 1999, no. 25, pp. 66–67; Berlin 15700: Priese 1991, no. 39, pp. 60–61.

[17] See, however, the recognizable likenesses of Amasis cited above, n. 15; see also the entry for cat. no. 132.

### Bibliography

Prisse 1879, II, pl. [33]; *Texte*, p. 409.

Hall, H. R. 1927b, pp. 27–29, pls. 11–12.

Bothmer 1960, pp. 8, 12.

Vandersleyen 1975, no. 214.

PM III 1981, p. 848 (with earlier bibliography).

Prisse 1991, p. 383, pl. II.33.

*Treasures* 1998, no. 4, pp. 44–45.

# 134

## Architectural Slab of Nectanebo I

Found at Alexandria,[1] believed to have come originally from Heliopolis
Late Period, Thirtieth Dynasty, reign of Nectanebo I (380–362 B.C.)
Hard dark stone
48 1/4 x 15 3/8 in. (122.6 x 39 cm)
EA 22, acquired in 1766, presented by King George III

This architectural slab is one of five examples, decorated on both sides in sunk relief with offering scenes above a niche-patterned dado and crowned by a cavetto cornice. Atop the cornice, on the better-preserved side of this slab, a row of falcons faced forward; only the legs and feet have survived. The corresponding decoration on the other side has been lost, but it probably consisted of a row of erect cobras.[2]

The more damaged side was decorated with an offering scene and part of another one. To the left, an animal-headed god stands facing right. The king kneels before him in a semi-prostrate position, with one leg extended back.[3] At the right is another standing god from a second, similar scene. The inscriptions name the king as Nectanebo I. The damage inflicted on this side is of several kinds and may have occurred several times during antiquity. The figures have been attacked with a chisel, though the inscriptions

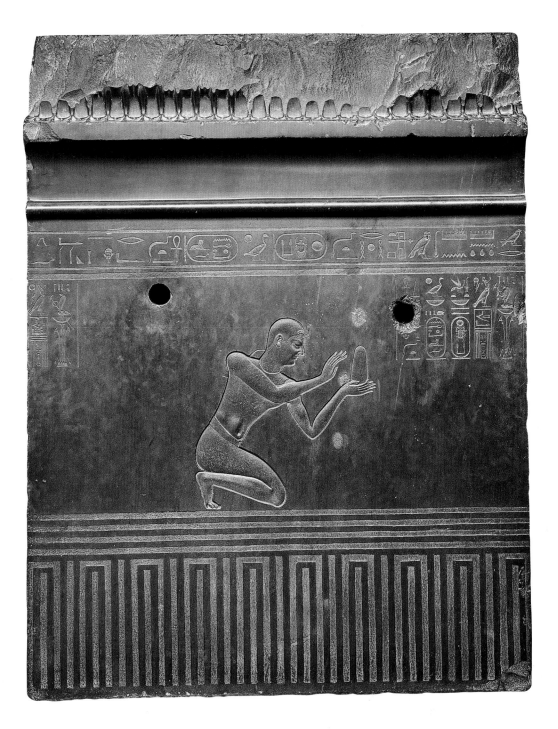

It may be that Nectanebo's sculptors developed a portrait likeness for him, alongside the idealized faces on all of his other known representations. But, as is so often the case with what seem at first to be ancient Egyptian portraits, the suggestion of a portrait style for this king does raise questions. The first is the apparent absence of any "portrait" representations of Nectanebo I in the round.[5] Because of the strictures imposed by Egyptian conventions for representing figures in two dimensions, portraits, such as those of Sesostris III (cat. nos. 29, 30), were normally developed in three dimensions, and three-dimensional portraits were much more numerous than those in relief.

A second problem is posed by the fact that the three Nectanebo architectural slabs are imitations of earlier Twenty-sixth Dynasty slabs, of which two have survived: one made for the first king of the Twenty-sixth Dynasty, Psamtik I,[6] and the other usurped by Psamtik II from an earlier king, probably his father, Necho II.[7] The earlier kings, shown in the same offering poses, also wear skullcaps and have distinctive, fleshy faces that are totally unlike their other imagery. Since the odd faces of all three kings, and their little caps, seem exclusive to these slabs, it is possible, even probable, that both of these characteristics were related to this specific context. Unfortunately, that context is very obscure.

Although all five slabs had been removed in antiquity from their original site, some of the inscriptions suggest that they were made for a structure in Heliopolis. Since the earlier and later examples are the same size and have identical architectural decoration, in addition to their very similar figural scenes, all were apparently part of the same structure. They are usually referred to as intercolumnar slabs—that is, low screen walls between huge columns at the entrances to late temples (see fig. 12). But such a wall is typically a single piece of stone. On some of these slabs, scenes, such as that begun to the right on the damaged side of this slab, were carried over onto a second block. This fact lends support to the theory that they formed "a long, low barrier at Heliopolis."[8] (E.R.R.)

were left intact. The protruding parts of the cornice were cut back to make a flat surface, presumably an adaptation for reuse.

The better-preserved side, also inscribed for Nectanebo I, has a single figure of the king kneeling to present a tall loaf of bread. This pose, like the semi-prostrate position, was traditional for kings making offerings. Here and on the other slabs in this group the pose has been designed to show only one leg and an inadequate number of toes. This mannered rendering was probably derived from New Kingdom temple reliefs. The modeling of Nectanebo's body, with the breast, rib cage, and round abdomen as discrete units,

follows the style of the late Twenty-sixth Dynasty (cf. cat.no. 131). Characteristically Thirtieth Dynasty, however, is the representation of the hands with their long, waving fingers.

The most noteworthy feature of this figure is its head—crowned only with a very unusual tight-fitting cap and a uraeus. The face is striking, both beaky and jowly, with the eye set in a large, round socket; small, rather delicate nostril and lips; and the hint of a double chin. It is understandable that this face is usually considered to be a portrait likeness of Nectanebo, especially since the same features are depicted on the two other architectural slabs that bear his name and image.[4]

**Notes**

[1] The Museum's earliest records of this piece indicate that it had probably been moved to Alexandria from Rosetta, which would not have been its original location. For a related piece

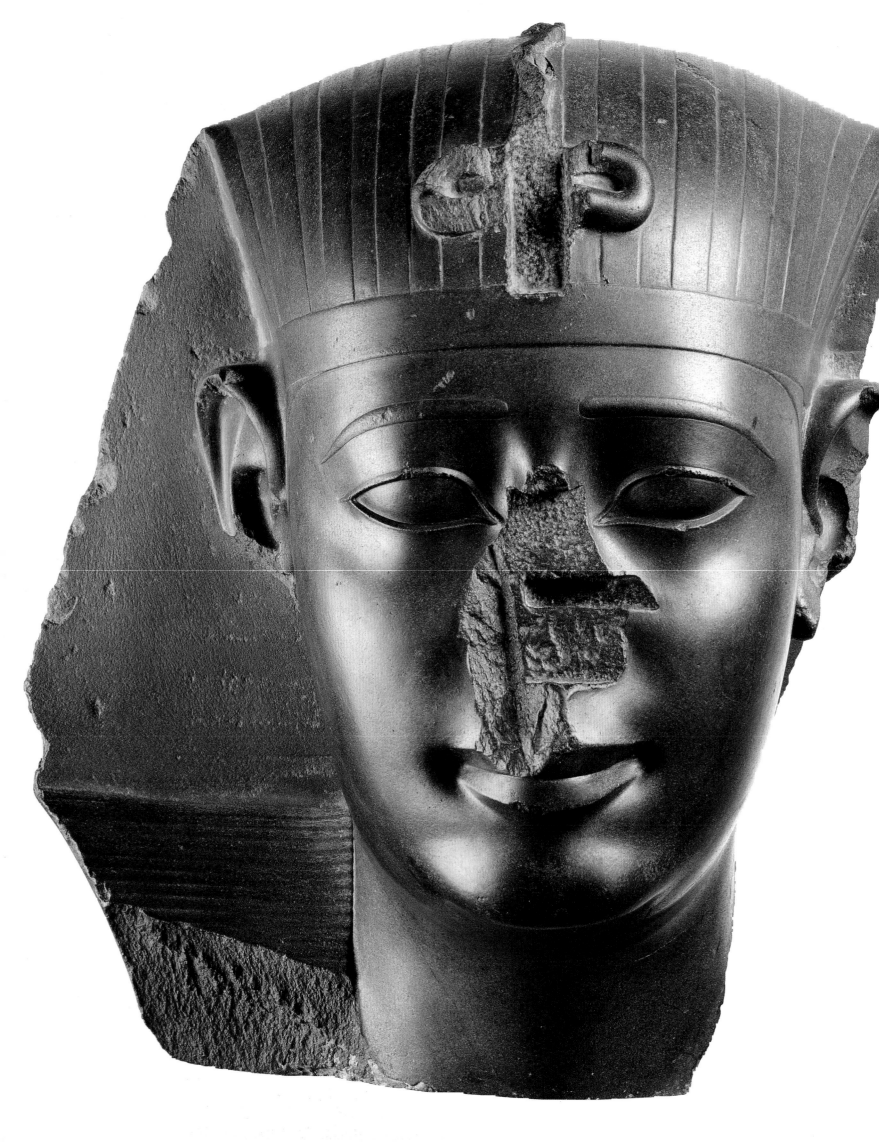

found at Rosetta (EA 998), see PM IV 1934, p. 2.

2 As on the slab Vienna 123; for the two sides, see Eaton-Krauss 1992, pl. 29/3, and Myśliwiec 1988, pl. 53b.

3 This traditional royal offering pose occurs on others of the five slabs, e.g., Myśliwiec 1988, pl. 53b.

4 They are British Museum EA 998 and Bologna 1870; for the latter, see Josephson 1997, pl. 5a (detail).

5 A head in Paris and a face in Munich, formerly attributed to him because of their resemblance to these reliefs, are now generally recognized to be late Ptolemaic; see, most recently, Stanwick 1999, I, pp. 291–93; II, pp. 457–60 (D7–8).

6 British Museum EA 20: Myśliwiec 1988, pls. 53a, 54.

7 Vienna 213; for illustrations, see n. 2; on its usurpation, see Eaton-Krauss 1992.

8 Bothmer 1960, p. 91.

### Bibliography

PM IV 1934, p. 5 (with bibliography).
Myśliwiec 1988, pp. 69 (with bibliography), 79, pl. 86c (detail of head).
Robins 1997, p. 232, fig. 279.

# 135

## Head of a King

Provenance unknown
Late Period, Thirtieth Dynasty,
probably reign of Nectanebo I (380–362 B.C.)
Graywacke
Height 15 1/4 in. (38.5 cm)
EA 97, acquired in 1814, purchased from Peregrine Townley, formerly Townley Collection and collection of the duc de Chaulnes

This splendid royal head wears a *nemes* with a uraeus, the hood of which was a separate piece, probably of gold or some other metal, which is now gone.[1] Apart from the loss of its nose, which was further damaged by at least one attempt to repair it, the face is extremely well preserved. But for many years there was considerable uncertainty about its date. In the 1980s it was attributed to "possibly Amasis or Nectanebo I."

Those two kings are separated by at least one hundred and fifty years. Two decades earlier, it had been suggested that the head might represent Ptolemy II[2]—another century added to the range of dates. More recently, however, close analysis of its style and comparisons with inscribed royal statues have located the head firmly in the Thirtieth Dynasty, most probably

in the reign of its first king, Nectanebo I.[3] Recurrent problems in dating sculpture of the late Twenty-sixth and Thirtieth Dynasties arise from the fact that the sculptors of the Thirtieth Dynasty who revived (or possibly continued) the earlier style reproduced their models with unusual fidelity. Egyptian archaism was never mere copying; these sculptors did "improve" upon their models, but they did so by minute alterations of small details.[4]

The overall effect of Thirtieth Dynasty changes to late Twenty-sixth Dynasty facial style was to render features that were already highly idealized as even more mannered and artificial. This face is far more mask-like than the Twenty-sixth Dynasty face of Nekhthorheb (cat. no. 131). Since the sculptors of the time were perfectly capable of rendering distinctive facial features (see cat. no. 134),[5] this form of mannered idealism was deliberately chosen. Whatever it was meant to express also appealed to the early Ptolemies, who adopted the style with, at first, very little change (cf. cat. no. 138).
(E.R.R.)

**Notes**

1 Similar inlaid uraei, all lost, appear on other Thirtieth Dynasty royal heads, e.g., Josephson 1997, pl. 8b.

2 Bothmer 1960, p. 122.

3 Josephson 1997, pp. 23–24.

4 Such details are analyzed, ibid.

5 Though private portrait representations in this period were rare, they did exist; e.g., BMA 55.175: Fazzini/Romano/Cody 1999, no. 81, p. 133.

**Bibliography**

James/Davies 1983, p. 60, fig. 67.
Josephson 1997, pp. 23–24, pl. 8b.

# 136

## Bust of a Woman, Possibly a Goddess

Provenance unknown
Late Period, Thirtieth Dynasty (380–343 B.C.)
Graywacke
Height 8 in. (20.3 cm)
EA 37901, acquired in 1853, gift of Arthur Annesely

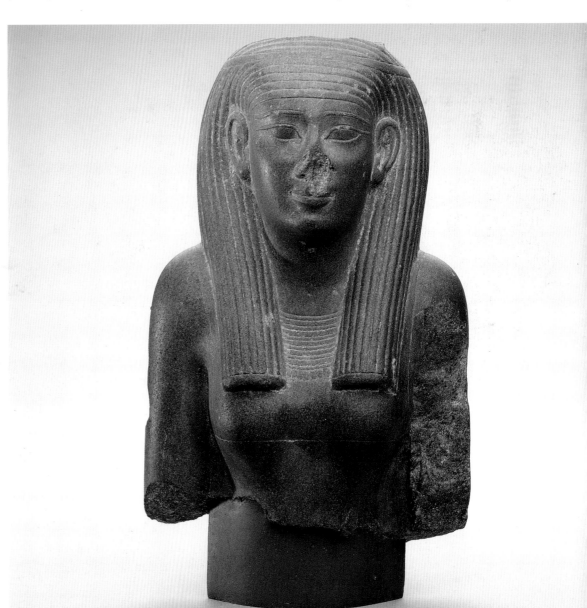

# 137

## Standing Figure of a Woman

Provenance unknown
Late Period, Twenty-sixth Dynasty
(664–525 B.C.)
Wood
Height 11 in. (27.8 cm)
EA 32734, acquired in 1867, purchased from
Rollin & Feuardent

These two quite different statues of women show female imagery in the Late Period. For most of this long period, female sculpture consists mainly of bronze statuettes of goddesses. Other statues of women are quite rare for several reasons. Much less sculpture was being placed in tombs, the main locus for women's statues. As always, they were seldom represented in temples, with the exception of Divine Consorts (cf. cat. no. 115) and queens. But after the Twenty-sixth Dynasty, the office of Divine Consort disappeared, while queens of the Late Period seem to have been kept largely in the background. Catalogue number 137 represents a nonroyal woman standing with her open hands at her sides and her left leg advanced. The skirt of her traditional tight dress is stretched between her legs; the two straps, like those on catalogue number 136, would have been indicated in paint. She wears a short, curly hairdo peculiar to female statues of the Twenty-sixth Dynasty. It may have had some religious or ritual significance, for it appears on a statue of a Twenty-sixth Dynasty Divine Consort of Amun,[1] as well as on an unidentified female figure in silver which has the cartouche of Necho II.[2]

This woman also has the mature-looking figure characteristic of Twenty-sixth Dynasty female statuettes. Her full breasts are so low that they seem to be sagging, and though she seems quite slim from the front, the low swelling curves of her belly and buttocks are noticeable in profile. The buttocks protrude in such a way that she seems, from some angles, to be bending slightly forward. The silver statuette mentioned above[3] has a similar figure, as do Twenty-sixth Dynasty bronze statuettes of goddesses.

The small size of this figure and the fact that it was made in wood suggest that it is a rare Late Period tomb statue. A statuette of a woman in Berlin, with a very similar figure and hairstyle, is

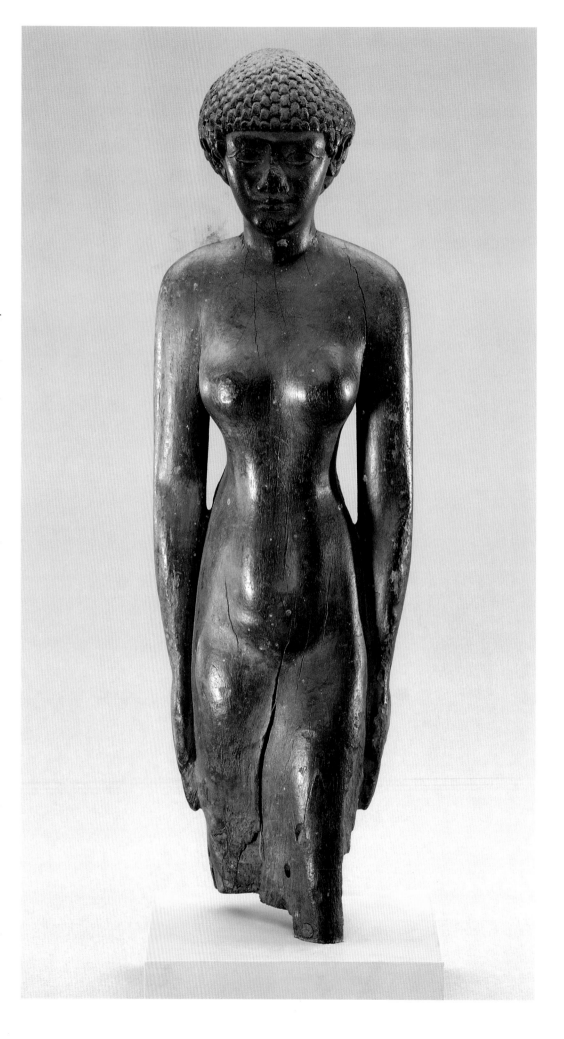

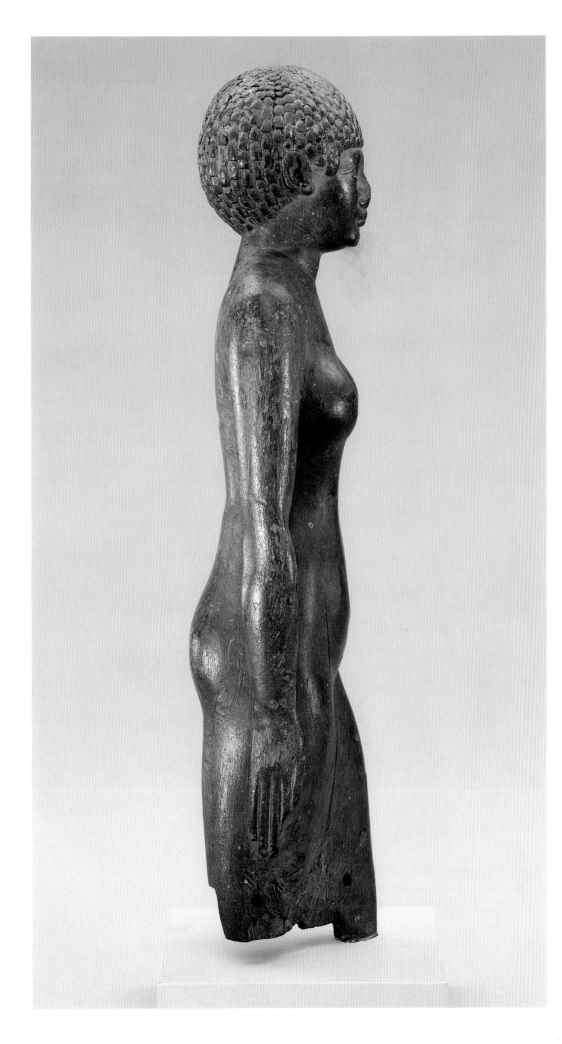

one of a trio of small wooden figures, including her husband and her son, which are believed to have been placed in their tomb.[4]

The broad, mask-like face and the mannered features of catalogue number 136 so resemble Thirtieth Dynasty royal representations, such as catalogue number 135, that it can be assigned the same date. But the lack of female statuary in this period makes it difficult to be sure what kind of woman she was—private person, queen, or goddess. Like most, if not all, representations of women in this period, she wears the traditional sheath with two straps over the breasts and an equally traditional collar necklace. Since she does not have a uraeus, a vulture cap, or other signs of royalty, she is probably not a queen.[5]

The form of the woman's wig, with its flat-bottomed front lappets and simple vertical striations, strongly suggests that she is a goddess. The fact that she wore, on this wig, some kind of crown or headdress, now broken off, makes it even more likely that she was divine. One small detail of her costume, however, remains enigmatic: the narrow ribbon tied around her wig, with its hanging ends represented in relief on the sides of the back pillar. A similar fillet was sometimes shown on funerary representations of the mourning Isis and Nephthys. In Late Period statuary, however, the only examples of this ribbon fillet known to me occur on figures of mortal women.[6] **(E.R.R.)**

### Notes

[1] Russmann 1989, no. 85, pp. 182–85.

[2] Like other later Twenty-sixth Dynasty examples, this version is more stylized and resembles a cap; New York MMA: 30.8.93: Becker et al. 1994, especially figs. 1–4.

[3] See n. 2.

[4] Berlin 8813, with 8812, 8814: Berlin 1967, nos. 943–45, pp. 94–95 (illustrated).

[5] A Thirtieth Dynasty bust of a queen in the Walters Art Museum, Baltimore, wears a vulture cap: Capel/Markoe 1996, no. 52, pp. 118–20.

[6] Female figures in Richmond, Virginia, and in Cairo, the first somewhat and the second considerably later than this bust: respectively, Capel/Markoe 1996, no. 7, pp. 57–58; *La gloire* 1998, no. 8, p. 42.

### Bibliography

cat. no. 136: Seipel 1992, no. 104, pp. 406–407.

cat. no. 137: unpublished.

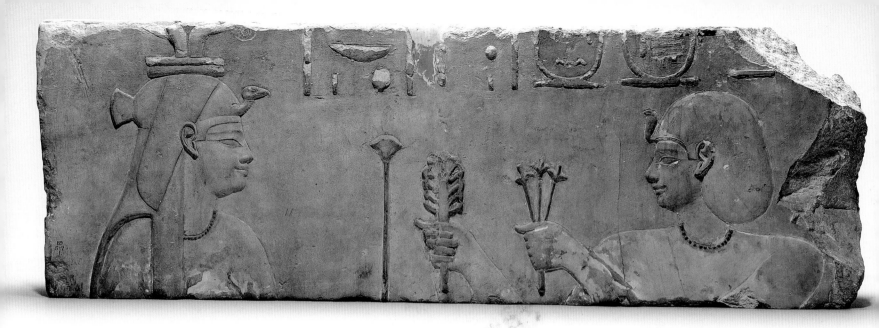

# 138

## Ptolemy I Offering to Hathor

From Kom Abu Billo
Ptolemaic Period, reign of Ptolemy I
(305–282 B.C.)
Limestone, traces of paint
13 ³/₈ x 41 ³/₄ in. (34 x 106 cm)
EA 649, gift of the Egypt Exploration Fund, 1889

Found at Kom Abu Billo, ancient Terenuthis, in the western Nile Delta,[1] this fragment of raised relief from a temple wall shows Ptolemy I wearing a bag wig, presenting to Hathor the heraldic plants of Upper and Lower Egypt, respectively a lily-like sedge and a papyrus. The plants, which are rendered as stiff little baubles, may well depict royal gifts to the temple, made of gold and other precious materials. Hathor holds the papyrus scepter of a goddess (cf. cat. no. 69) and wears a vulture cap, topped by a platform that supported her emblematic cow horns and sun disk.

Both figures look well fed, pleased with themselves and with each other. But this should not be interpreted to indicate a weakening or trivialization of religious belief in this time, any more than do comparably cozy religious images from, say, the European Renaissance. Though the Ptolemies contributed funds for temple construction and decoration and had themselves represented in traditional pharaonic poses, mainly for political reasons, the actual building and relief carving were supervised by Egyptian priests who, as they always had, placed great emphasis on tradition. For them, however, traditional artistic style was embodied in the plump, smiling figures of the Thirtieth Dynasty (cf. cat. nos. 135, 136). Ptolemaic images like these continued that tradition. (E.R.R.)

### Notes

[1] For other reliefs from here, see PM IV 1934, p. 68.

### Bibliography

Myśliwiec 1988, pp. 85 (with bibliography), 87, pl. 99b (detail, head of king).

# 139

## "Sculptor's Model" of a Royal Head

Provenance unknown
Ptolemaic Period, third century B.C.
Limestone
Height 4 ¹/₈ in. (10.5 cm)
EA 21916, acquired in 1887, purchased via the Reverend Greville Chester

From as early as the Twenty-sixth Dynasty,[1] but especially in the Thirtieth Dynasty and the Ptolemaic Period, numerous reliefs and statue heads or busts were carved in limestone for purposes that are not entirely clear. Most of these objects are small, and most represent kings, deities, or, in relief only, hieroglyphic signs, usually birds.[2] All are finely carved, but many appear to be unfinished.[3] For that reason they have come to be known as sculptor's models. But it seems certain that some, if not most, were votive objects deposited in temples.[4]

Like many "sculptor's models" representing royal heads, this head is incomplete. The surface behind the ears and the partially destroyed side panels of the *nemes* is a flat plane, but it is devoid of the incised grid very often found on the backs of similar heads. The facial features represent the Ptolemaic version of Thirtieth Dynasty style, exemplified by catalogue number 135. Here, the face is fatter and the features proportionately smaller, but individual features, especially the eyes and brows, have much the same shape. The small, hoodless uraeus also suggests a Ptolemaic date, although somewhat earlier examples of this detail may exist.[5]

"Sculptor's models" are notoriously difficult to date with precision. The majority are usually assigned to the early Ptolemaic Period, especially the reign of Ptolemy II,[6] a date that is plausible for this example. (E.R.R.)

### Notes

[1] Bianchi 1979.

[2] Liepsner 1980, col. 169; at least 2000 are in public or private collections. For a representative sample, see Seipel 1992, nos. 198–206, 208, pp. 478–93, 496–98; for more unusual subjects, ibid., nos. 194–97, pp. 470–77.

[3] See Robins 1994, pp. 177–81.

[4] Liepsner 1980, cols. 172–74; for additional bibliography, see Bianchi 1979, especially n. 6.

[5] E.g., Josephson 1997, pl. 12a.

[6] Liepsner 1980, col. 171.

### Bibliography

Unpublished.

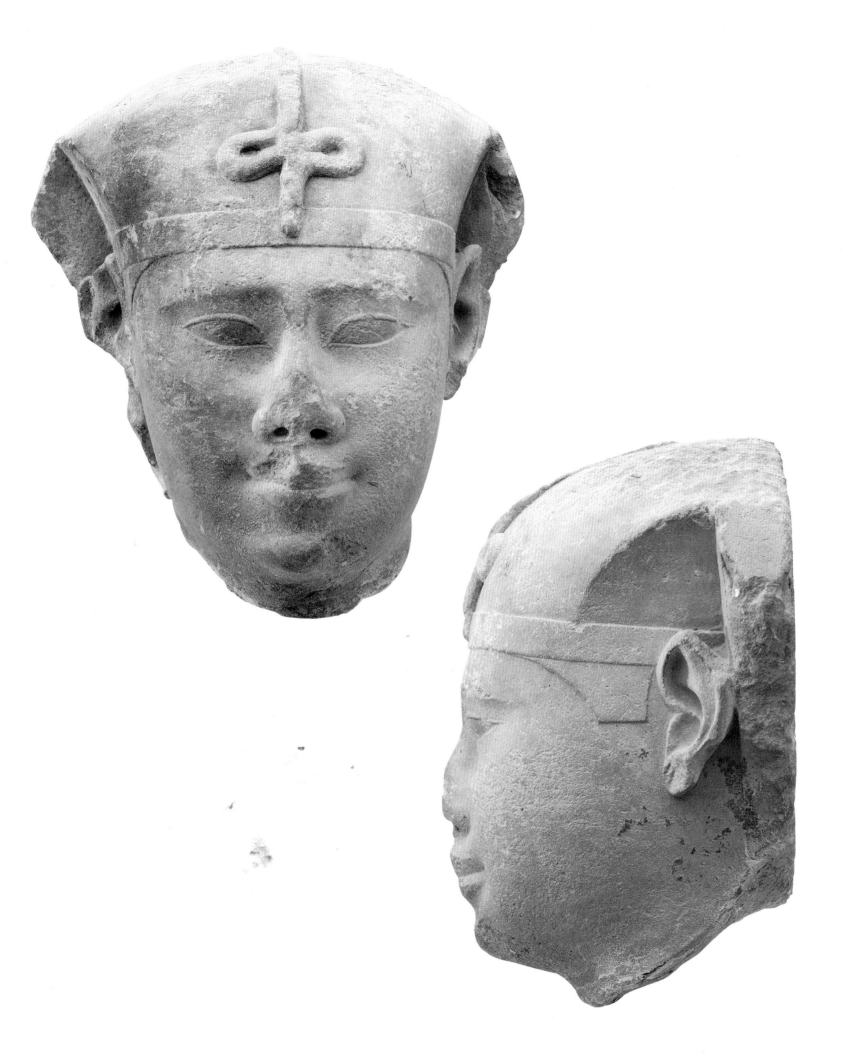

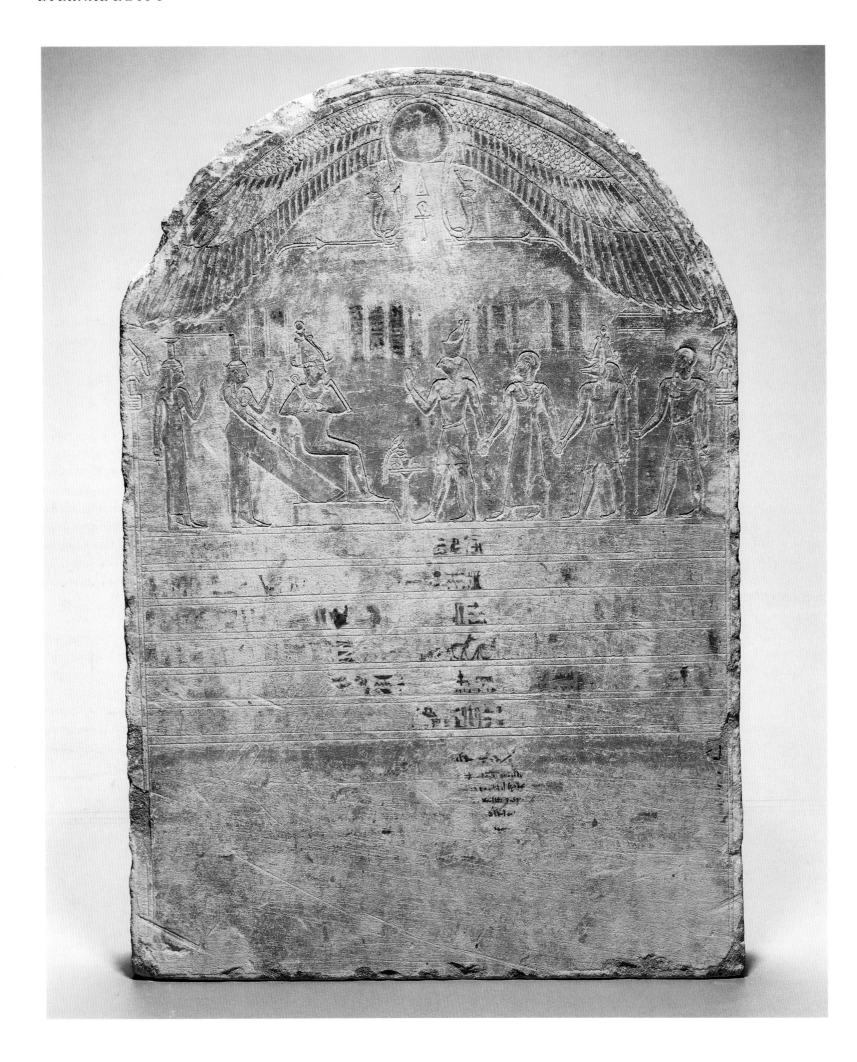

# 140

## Funerary Stela of Petobastis-Imhotep

From Saqqara
Roman Period, reign of Augustus, Year 7
(A.D. 23)
Limestone
29 ⁵/₈ x 20 ¹/₂ in. (75 x 52 cm)
EA 188, acquired in 1835 at the sale of the Salt Collection

The idealizing relief style of the early Ptolemaic Period, seen in catalogue number 138, persisted until the end of Ptolemaic rule and even beyond, as we see in this sunk-relief stela of the High Priest of Ptah Petobastis-Imhotep. Petobastis served under the last Ptolemy, the famous Cleopatra VII, but was buried under Caesar Augustus, at which time this stela was made. Considering that these two reliefs were separated by almost three centuries, they are remarkably similar in style. There are differences, to be sure, but they are minor, and most can be ascribed to different hands carving, respectively, in raised and sunk relief.

The arch of the stela is occupied by an unusually large winged sun disk, from which are suspended two cobras wearing a red crown and a white crown and deploying long-handled, ostrich-plume fans; between the snakes are the words "given life." In the register below, Osiris sits, guarded by the wings of his wife, Isis, with their sister Nephthys b ehind. Petobastis is being led before the god by the falcon-headed Harendotes, who wears a double crown, and the jackal-headed Anubis, rather unusually wearing an *atef* crown. Behind them is Imhotep, an anthropoid deity wearing a cap and carrying a *was* scepter and *ankh* sign. A large *was*, combined with *ankh* and *djed* signs, forms a border along each edge. The inscription below has two sections, the upper lines carved in hieroglyphs and the lower lines with the same information painted in demotic script. Since the hieroglyphs were used to write ancient Egyptian in its classical form and demotic was employed for the very different late form of the language, this inscription is virtually bilingual, and the two texts contain slightly different information.[1]

Petobastis wears a long kilt wrapped high on the breast and, by virtue of his office as High Priest of Ptah, a leopard-skin vestment and a sidelock on his shaven head. The High Priest of Ptah, one of the most powerful priesthoods in Egypt, had become even more powerful during the Ptolemaic Period, by virtue of its incumbents' allying themselves closely with the Ptolemies. The office had come to be monopolized by one family.[2] Petobastis, as this stela tells us, inherited the office from his father at the age of seven and died at sixteen. His early death coincided with the invasion of Augustus and the death of Cleopatra. This may well have been mere coincidence; but the political unrest of the time probably explains the fact, also recorded here, that he was not buried until almost seven years later, by his cousin, who, in addition to carrying on the family profession of High Priest of Ptah, was now also a priest of Caesar Augustus.

From the stelae of Petobastis' parents, we learn that after having three daughters, the couple prayed to Imhotep for a son and that the god appeared to the husband in a dream, promising him a son in return for work on his temple.[3] When the promised son was born, he was named after Imhotep, who, not many years later, was also pictured on the young man's funerary stela. (E.R.R.)

### Notes

[1] For a translation of both texts into French, see Quaegebeur 1972, pp. 83–88.

[2] Monuments of this family, many of them in the British Museum, are translated and discussed by Quaegebeur 1972.

[3] Wildung 1977, pp. 71–72.

### Bibliography

Quaegebeur 1972, pp. 83–88.

Wildung 1977, no. 46, pp. 70–73 (with bibliography), pls. 10/2, 11/2.

PM III 1981, p. 744 (with bibliography).

# 141

## Sematawy Holding a Naos

Provenance unknown
Ptolemaic Period, mid-second–first century B.C.
Basalt
Height 22.¹/₈ in. (56 cm)
EA 65443, acquired in 1951, bequest of H. Swainson-Cowper

A priest named Sematawy stands holding a naos containing a figure of the god Atum recognizable by his main attribute, a royal double crown. Sematawy wears a late, very stylized version of the misnamed "Persian wrap" (cf. cat. no. 132) over an undergarment with one knotted strap. The most noteworthy feature of the statue is, of course, its overlarge head, which, in contrast to the simple forms of the body and the rudimentary representation of the little divine figure, is elaborately modeled to show the shape of the skull and the wrinkled, sagging flesh of the highly individualized aging face. The carving of head and body are so different that they might have been done by two different sculptors—the head, clearly meant to be the focal point of this figure, being assigned to a specialist in portraiture.[1]

Throughout the Ptolemaic Period, concurrent with the idealizing style inherited from the Thirtieth Dynasty and predominant on both royal and private monuments (cf. cat. nos. 138–40), a smaller but significant number of nonroyal male statues were made with portrait heads. Unlike portrait representations of the Ptolemies themselves, which appeared relatively late in the period and were derived from their portraits in Hellenistic style (cf. cat. no. 143), Ptolemaic private portraits began as a purely Egyptian development based on the individualized representations of the Late Period (see cat. no. 133). The features and expressions of early Ptolemaic private portraits are wholly within the Egyptian tradition.[2] At least as early as the second century, however, elements of Hellenistic portrait style began to appear in combination with Egyptian features (cf. fig. 26). On this face, for example, the bone structure of the skull and face and the indication of wrinkles and fleshy folds have many parallels in earlier Egyptian representations of bald, aging men. But the way in which the eyes are set deep under overarching brow ridges and the form of the small, almost lipless mouth derive from the Hellenistic artistic vocabulary.

Classically oriented collectors of the nineteenth and early twentieth centuries prized Egyptian Ptolemaic portrait heads like this because they looked so "Roman." Since the Egyptian genre long preceded the origins of Roman Republican portraiture, any influence must have passed from Egypt to Rome. Nevertheless, these Eurocentric collectors

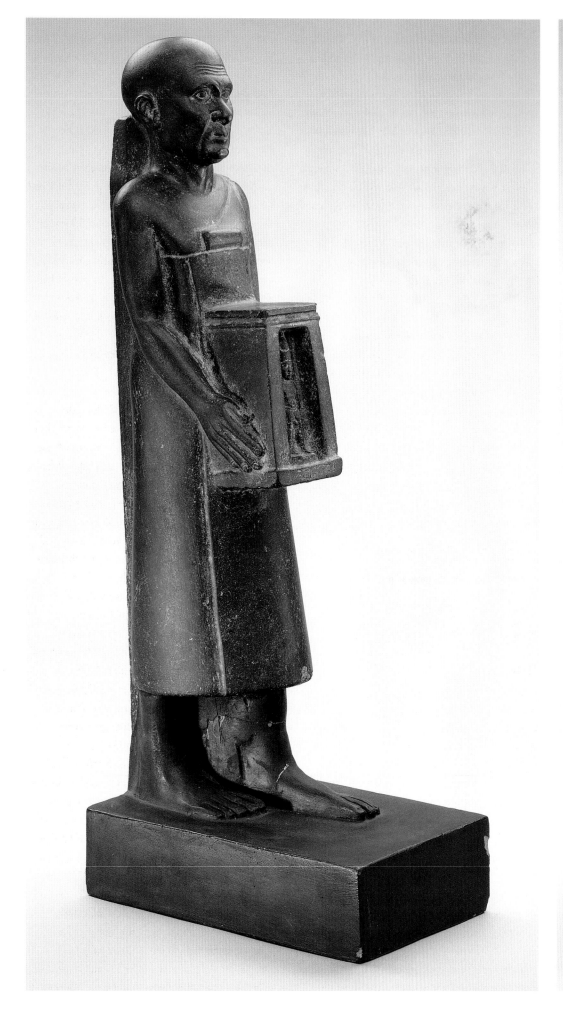
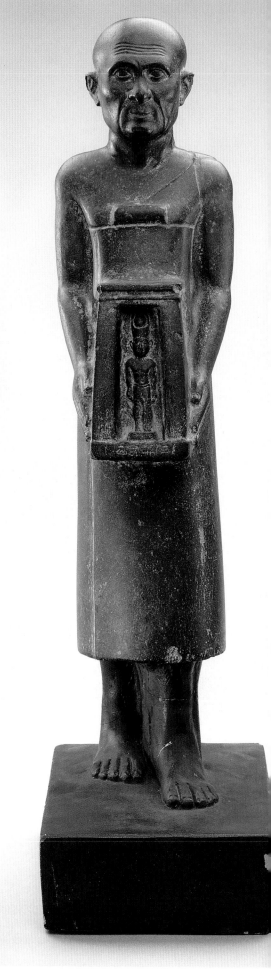

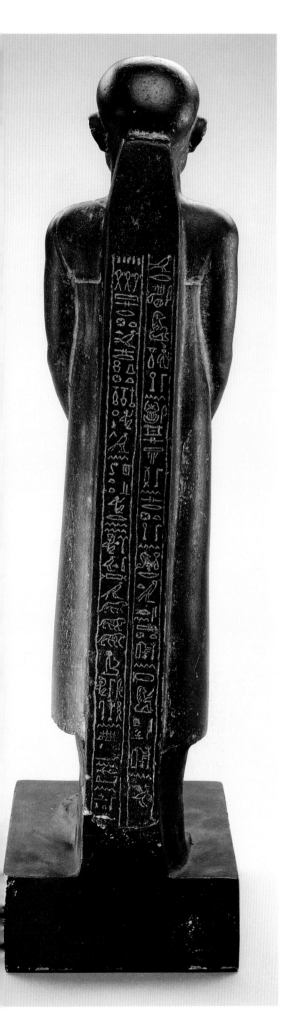

considered the bodies of the Egyptian statues to detract from the classical quality of their heads, with the consequence that today the great majority of Ptolemaic portrait heads lack their bodies. Some were broken off in modern times to make them more marketable. This cultural vandalism is responsible for much of the difficulty of dating Ptolemaic portrait statues; even worse, it undermines our understanding and appreciation of one of the most intriguing genres in ancient Egyptian sculpture. An unusual example of an almost intact portrait statue,[3] Sematawy's figure appears to us in the way he intended. **(E.R.R.)**

### Notes

[1] A comparable discrepancy between head and body occurs on another statue holding a naos, variously dated from the mid-second to the first century B.C. (Hanover 1935.200.773): Bothmer 1960, no. 115, pp. 148–49, pl. 107.

[2] E.g., Bothmer 1960, no. 93, pp. 117–18, pl. 87; fig. 50 on pl. 94.

[3] The feet and base are modern restorations.

### Bibliography

Edwards 1952, pp. 71–72, pl. 27a.

Bothmer 1988, pp. 57, 62, fig. 15.

Quirke/Spencer 1992, p. 57, fig. 38.

Schmidt 1997, pp. 17–18, fig. 7a-b.

Kaiser 1999, pp. 248, 253 (table 1), pl. 35g.

# 142

## Bald Head

Provenance unknown
Ptolemaic Period, first century B.C.
Granite
Height 12 7/8 in. (32.5 cm)
EA 1316, acquired in 1900

The speckled stone of this head, combined with the destruction of its nose and other damage to the surface, makes its features difficult to read. When the statue from which it was broken was intact, however, it would have been an impressive figure, somewhat over life-size, almost certainly standing, and looking slightly upward.

The head is entirely bald, with a round, low skull that bulges a little at the back. Like the skull, the face has little modeling, apart from the rounding of the full cheeks beside the nose and mouth and the indication of a double chin. Under the brows, indicated in relief, the eye sockets are shallow except in proximity to what was apparently a large nose. The eyes are quite round, with an incised rim along the upper lid and bulging eyeballs. The mouth gives the impression of a small smile; the lower lip is fuller than the upper, which is very narrow.

For a statue of late Ptolemaic date, this head is remarkably traditional in style, with scarcely a hint of the Hellenistic influence that, by the first century B.C., can be discerned to a greater or lesser degree in almost all ambitious private sculpture (cf. cat. nos. 141, 144).[1] In particular, the very Egyptian-looking eyes, with their shallow sockets, in which there is no indication of eyelids, and most especially, the representation of the eyebrows in relief are quite surprising.

Plastically rendered eyebrows are seen on statues from at least the early Old Kingdom. This artificial-looking feature subsequently held its own, alongside more natural versions of the brow; though used frequently for idealized faces, it appeared on some portrait images as well. Toward the end of the Twenty-sixth Dynasty, however, the plastic eyebrow began to disappear from naturalistic representations (cat. nos. 132, 133). This trend may have accelerated through the Thirtieth Dynasty, though the plastic eyebrow can still be found on formal, royal images (cf. cat. no. 135). By the Ptolemaic Period, the feature was virtually gone from private sculpture, and it was dropped from royal images also (cf. cat. nos. 139, 141, 144).

Despite this anachronistic detail, there are several reasons to assign this head to a date late in the Ptolemaic Period, when large private statues seem to have been made in greater numbers than before—all, apparently, standing. The pleasantly noncommittal expression on this head is very different from the scowl on a colossal "portrait" statue of the mid-third century B.C.[2] Though statues with raised heads like this one occur occasionally throughout Egyptian art (cf. cat. nos. 8, 41, 96, 131), there seems to be a cluster of them toward the end of the Ptolemaic Period,[3] possibly under the influence of Hellenistic representations of apotheosis, which go back to portraits of Alexander the Great, with his dramatic upward gaze.[4] The round, bulging eyes can be compared

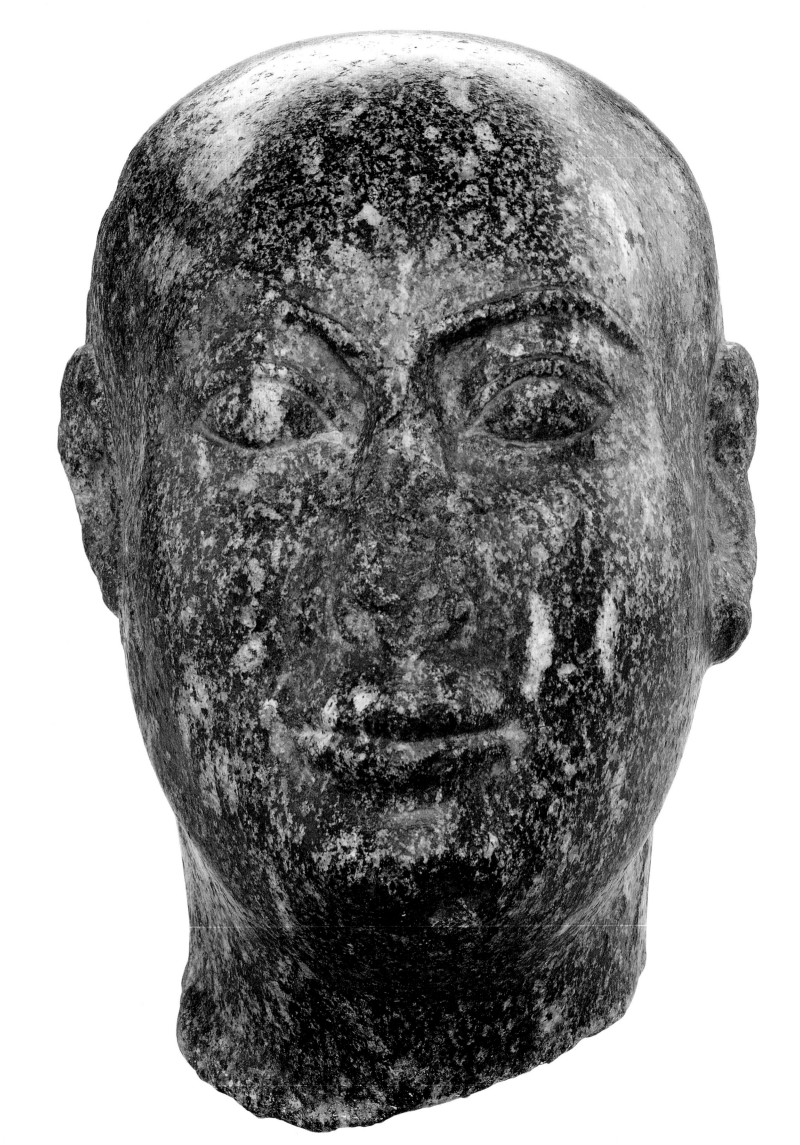

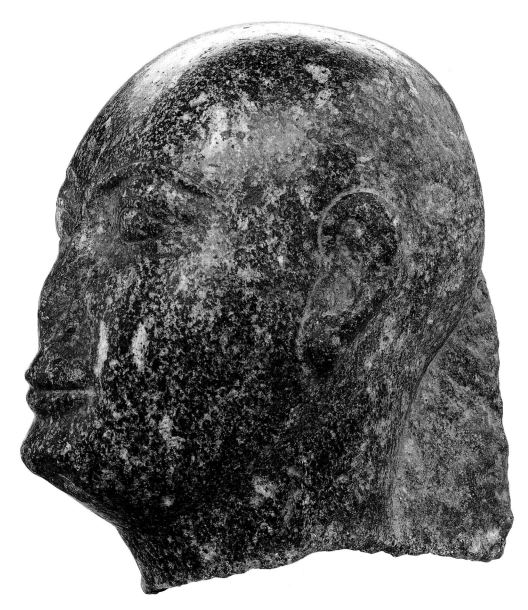

century B.C. The anatomy of the figure—its stylized knees, its muscular but fleshy form, and, especially, the doughnut-like rendering of the belly—also reflect fourth-century style, particularly the statues of the Thirtieth Dynasty king Nectanebo I.[3] But the large face, with its round, staring eyes, fleshy cheeks, and prominent chin is unmistakably the face of a Ptolemy.

The Ptolemaic Dynasty was Macedonian in origin and Hellenistic in culture and lifestyle. Resident in Alexandria, the city founded by Alexander the Great on the Mediterranean coast, they ruled Egypt for three centuries; but they always remained foreigners in their adopted land. Nonetheless, they claimed to rule Egypt by right, as traditional pharaohs, and to that end they supported the construction and renovation of temples, where they also erected traditional-looking statues of themselves.

Portraits of the Ptolemaic kings and queens in Hellenistic style, which appear on their coins, were also produced as statues for their palaces and Greek temples. Hellenistic portraits were rarely placed in Egyptian temples, where the Ptolemies emphasized their orthodoxy.[4] Often, however, these otherwise unremarkable statues were given the ruler's face, in the form of a stylized version of his or her Hellenistic portraits.[5] The effect, as here, is usually rather incongruous. Egyptianized versions of Ptolemaic royal faces are notoriously difficult to identify. Only two scholars have ventured opinions on this statue;[6] one believes it to represent Ptolemy IV,[7] the other, Ptolemy IX or X.[8]

In its unfinished state, the statue shows how little Egyptian sculptural techniques had changed over the millennia. The chisel-dressed surface is much the same as that on a similarly incomplete hard-stone statue of the Old Kingdom.[9] And like the earlier sculpture, this would have been smoothed and brought to its final polish by a laborious rubbing with progressively finer abrasives. **(E.R.R.)**

### Notes

[1] A dealer's attribution; cf. Stanwick 1999, p. 460.

[2] E.g., *Egyptian Art* 1999, no. 67, p. 270 (as part of a dyad).

[3] Josephson 1997, pl. 3b; for the relief version of this figure, see cat. no. 134.

[4] E.g., Bothmer 1960, nos. 105, 109, 114, pls. 98, 101, 106.

[5] For examples, see Smith, R. R. R. 1988; Kyrieleis 1975.

[6] It is not discussed in Smith, R .R. R. 1988 or Kyrieleis 1975.

with the large, round eyes on several especially fine private statues made at the end of the Ptolemaic Period.[5] **(E.R.R.)**

### Notes

[1] See, most recently, Bothmer 1996.

[2] Cairo CG 700, possibly archaizing to Twenty-fifth Dynasty prototypes: Bothmer 1960, fig. 250, pl. 94. De Meulenaere would now date it from the third to the second centuries: Kaiser 1999, p. 253, with n. 9 on p. 252.

[3] Bothmer 1960, p. 176.

[4] On Alexander's raised head and its significance, see Smith, R. R. R. 1988, p. 47. Its influence on Egyptian art is discussed in Bothmer 1960, p. 175, with examples: nos. 134, 138, pls. 126, 130.

[5] Brooklyn BMA 58.30: Fazzini/Romano/Cody 1999, no. 93, p. 147; Cairo CG 697: Russmann 1989, no. 92, pp. 201–203.

### Bibliography

British Museum 1909, p. 243.

# 143

## Unfinished Statue of a Ptolemaic Pharaoh

From Athribis[1]
Ptolemaic Period, reign of Ptolemy IV(?)
(ca. 222–205 B.C.)
Gray granite
Height 36 1/2 in. (92.5 cm.)
EA 1209, acquired in 1897

Except for its distinctive face, this unfinished statue of a standing king is entirely traditional. The standing pose, with left leg forward and fisted hands at the sides, and the use of a back pillar and negative space go back to the royal sculpture of the Old Kingdom.[2] The *nemes* headcloth and the *shendyt* kilt are equally ancient, although the relatively small size of the *nemes* and the shortness of the kilt are late developments, characteristic of the fourth

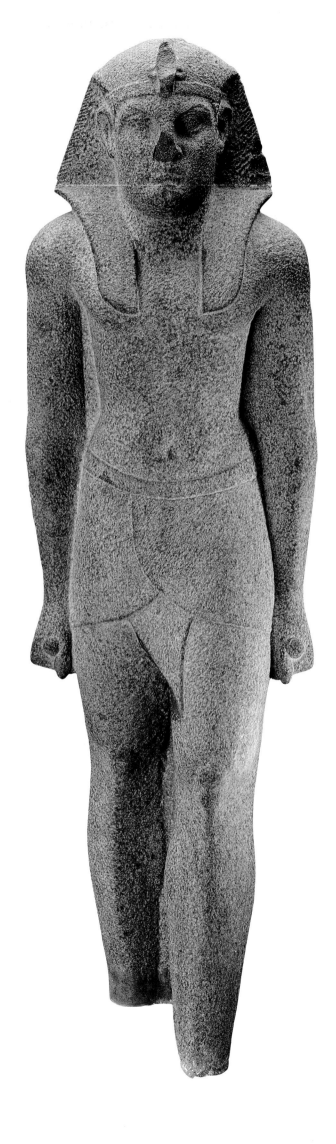

[7] Jucker 1975, p. 23.

[8] Stanwick 1999, p. 293.

[9] Seipel 1992, no. 187, p. 457, right; and compare nos. 188–91, pp. 458–65.

**Bibliography**

PM IV 1934, p. 66 (with earlier bibliography).

Jucker 1975, p. 23, pls. 9: 1–2.

Stanwick 1999, no. D9, pp. 293, 460–61 (with further bibliography), pl. 96.

# 144

## Balding Head

Provenance unknown[1]
Late Ptolemaic Period, first century B.C.
Red granite
10 1/4 (25.8 cm)
EA 55252, acquired in 1874, purchased via the
Reverend Greville Chester

This head, with its almost fiercely cheerful expression, may be approximately contemporary with catalogue number 142, but its sculptor has taken quite a different stylistic direction. The large eyes, set almost vertically under strong brow ridges, show Hellenistic influence (cf. cat. no. 141), as does the thick, curly hair, or what is left of it. Short curls worn in the Greek manner were favored by many Egyptian Ptolemaic sculptors, or their clients, though the Egyptians generally rendered the locks in a more stylized manner.[2] In late Ptolemaic examples, the curls were sometimes combined with a very receding hairline.[3]

Like the face of catalogue number 142, this face is fleshy and full; the plump ridges of the cheeks along the nose and upper lip may also be intended to emphasize the smile. The most unusual feature of this head is the bony protrusion of the skull above the forehead. Bald portrait heads from earlier in the Ptolemaic Period sometimes have elaborately modeled skulls, and frontal protrusions may be indicated,[4] but I know of no other instance where this feature is so isolated from the rest of the cranium, almost as if it were a cap.

As catalogue numbers 142 and 143 demonstrate, Egyptian

sculptors of the late Ptolemaic Period had numerous stylistic options available to them. It is significant that neither of these heads makes any pretense of being a naturalistic portrait. This head may presage developments at the very end of the Ptolemaic Period, when Egyptian and Hellenistic styles seem to have been on the verge of blending into a new and dramatic way of representing the human face.[5] Since this artistic development did not survive the coming of the Romans, we cannot know how it would have handled the possibilities of portraiture.

### Notes

[1] Said by the owner to come from Tell Basta (Bubastis). This is a dealer's provenance, which, like those discussed for cat. nos. 129 and 133, cannot be considered reliable without corroborating evidence.

[2] For the Ptolemaic rendering of hair, see Bothmer 1996, pp. 215–18.

[3] E.g., Russmann 1989, no. 92, pp. 201–203; Bothmer 1960, nos. 119, 131, pls. 110, 122.

[4] E.g., Bothmer 1960, nos. 107, 111, 127, pls. 99, 102–103, 118–119.

[5] Brooklyn BMA 58.30: Fazzini/Romano/Cody 1999, no. 93, p. 147; Cairo CG 697: Russmann 1989, no. 92, pp. 201–202.

### Bibliography

Bothmer 1972, pp. 29–30, figs. 11–12, n. 13 on p. 31 (with bibliography).

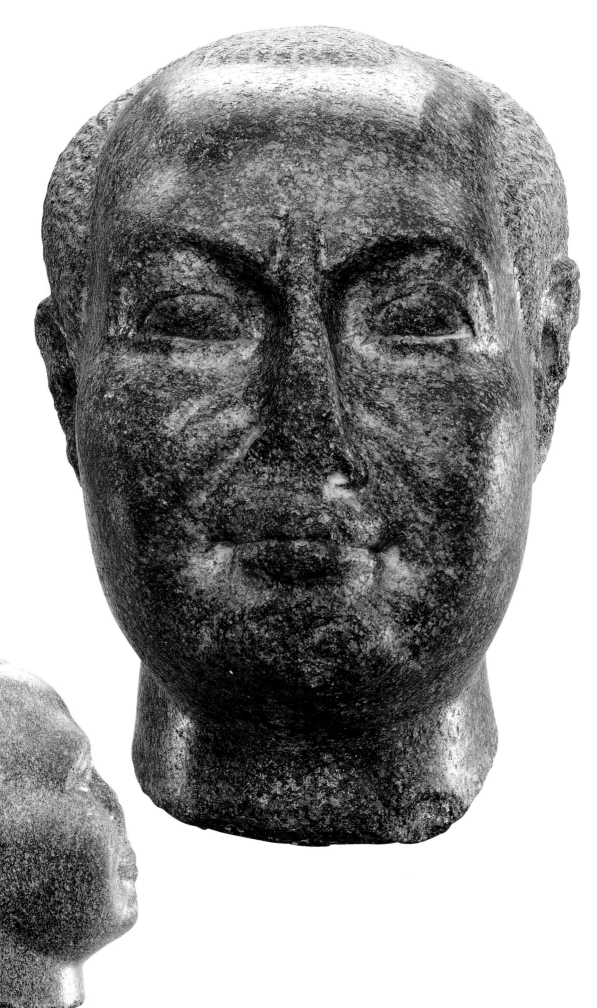

# Chronology

All dates before 690 B.C. are approximate. Overlapping dates indicate co-regencies or competing dynasties.

Royal names in boldface are discussed or mentioned in the text. Alternate forms are given in parentheses; italicized versions are based on Greek spellings.

PREDYNASTIC PERIOD, ca. 5000–3100 B.C.
    **Narmer,** ca. 3100 B.C.

EARLY DYNASTIC PERIOD, ca. 3100–2686 B.C.
    First Dynasty, ca. 3100–2890 B.C.
      Aha
      **Djer**
      Djet
      **Den,** ca. 2985 B.C.
      Anedjib
      Semerkhet
      Qaa
    Second Dynasty, ca. 2890–2686 B.C.
      Hetepsekhemwy
      Raneb
      Nynetjer
      Peribsen
      **Khasekhemwy** (Khasekhem), ca. 2600 B.C.

OLD KINGDOM, ca. 2686–2181 B.C.
    Third Dynasty, ca. 2686–2613 B.C.
      Sanakht
      Netjerkhet (**Djoser,** Zoser), ca. 2667–2648 B.C.
      Sekhemkhet
      Huni
    Fourth Dynasty, ca. 2613–2494 B.C.
      **Sneferu** (Snofru), ca. 2613–2589 B.C.
      *Cheops* (Khufu), ca. 2589–2566 B.C.
      **Djedefre** (Radjedef), ca. 2566–2558 B.C.
      *Chephren* (Khafre), ca. 2558–2532 B.C.
      *Mycerinus* (Menkaure), ca. 2532–2503 B.C.
      Shepseskaf, ca. 2503–2498 B.C.
    Fifth Dynasty, ca. 2494–2345 B.C.
      Userkaf, ca. 2494–2487 B.C.
      Sahure, ca. 2487–2475 B.C.
      Neferirkare, ca. 2475–2455 B.C.
      Shepseskare, ca. 2455–2448 B.C.
      **Neferefre** (Raneferef), ca. 2448–2445 B.C.
      Niuserre (Nyuserra), ca. 2445–2421 B.C.
      Menkauhor, ca. 2421–2414 B.C.
      Djedkare Isesi, ca. 2414–2375 B.C.
      **Unas** (Wenis), ca. 2375–2345 B.C.

Sixth Dynasty, ca. 2345–2181 B.C.
    Teti, ca. 2345–2323 B.C.
    Userkare, ca. 2323–2321 B.C.
    Meryre **Pepy I,** ca. 2321–2287 B.C.
    Merenre, ca. 2287–2278 B.C.
    Neferkare **Pepy II,** ca. 2278–2184 B.C.

FIRST INTERMEDIATE PERIOD, ca. 2181–2040 B.C.
    Seventh/Eighth Dynasties, ca. 2181–2125 B.C.
    Ninth/Tenth Dynasties, ca. 2160–2025 B.C.
    Eleventh Dynasty (pre-reunification rulers of Thebes), ca. 2125–2040 B.C.
      Mentuhotep I
      Sehertawy Inyotef I (Intef)
      **Wahankh Inyotef II** (Intef)
      **Nakhtnebtepnefer Inyotef III** (Intef)

MIDDLE KINGDOM, ca. 2040–1650 B.C.
    Eleventh Dynasty (post-reunification kings of Egypt), ca. 2040–1985 B.C.
      Nebhepetre **Mentuhotep II,** ca. 2055–2004 B.C.
      Sankhkare **Mentuhotep III,** ca. 2004–1992 B.C.
      Nebtawyre Mentuhotep IV, ca. 1992–1985 B.C.
    Twelfth Dynasty, ca. 1985-1795 B.C.
      Sehetepibre Amenemhat I (*Ammenemes*), ca. 1985–1955 B.C.
      Kheperkare *Sesostris* I (Senusret, Senwosret), ca. 1965–1920 B.C.
      Nubkaure Amenemhat II (*Ammenemes*), ca. 1922–1878 B.C.
      Khakheperre *Sesostris II* (Senusret, Senwosret), ca. 1880–1874 B.C.
      Khakaure *Sesostris III* (Senusret, Senwosret), ca. 1874–1855 B.C.
      Nymaatre **Amenemhat III** (*Ammenemes*), ca. 1854–1808 B.C.
      Maakherure Amenemhat IV, ca. 1808–1799 B.C.
      Sobekkare Sobekneferu, ca. 1799–1795 B.C.
    Thirteenth Dynasty, ca. 1795–1650 B.C.
      Sekhemkare **Amenemhat V**
      **Meryankhre Mentuhotep VI,** ca. 1675–1650 B.C.

SECOND INTERMEDIATE PERIOD, ca. 1750–1550 B.C.
    Fourteenth Dynasty, ca. 1750–1650 B.C.
    Fifteenth Dynasty (**Hyksos**), ca. 1650–1550 B.C.
    Sixteenth Dynasty (rulers of Thebes), ca.1650–1580 B.C.
    Seventeenth Dynasty (rulers of Thebes), ca.1580–1550 B.C.
    Seqenenre Tao
    Wadjkheperre Kamose

NEW KINGDOM, ca. 1550–1069 B.C.
    Eighteenth Dynasty, ca. 1550–1295 B.C.
      Nebpehtyre **Ahmose** (*Amasis* I), ca. 1550–1525 B.C.
      Djeserkare **Amenhotep I** (*Amenophis*), ca.1525–1504 B.C.
      Aakheperkare Thutmosis I (Tuthmosis, Thutmose), ca. 1504–1492 B.C.
      Aakheperenre Thutmosis II (Tuthmosis, Thutmose), ca. 1492–1479 B.C.

Maatkare **Hatshepsut**, ca. 1472–1458 B.C.

Menkheperre **Thutmosis III** (Tuthmosis, Thutmose),
ca. 1479–1425 B.C.

Aakheperure Amenhotep II (*Amenophis*), ca. 1427–1400 B.C.

Menkheperure **Thutmosis IV** (Tuthmosis, Thutmose),
ca. 1400–1390 B.C.

Nebmaatre **Amenhotep III** (*Amenophis*), ca. 1390–1352 B.C.

Neferkheperure Amenhotep IV (*Amenophis*), later
Akhenaten, ca. 1352–1336 B.C. (Amarna Period)

Neferneferuaten Smenkhkare, ca. 1338–1336 B.C.

Nebkheperure **Tutankhamun**, ca. 1336–1327 B.C.

Kheperkheperure Ay, ca. 1327–1323 B.C.

Djeserkheperure **Horemheb**, ca. 1323–1295 B.C.

Nineteenth Dynasty (Ramesside Period),ca. 1295–1186 B.C.

Menpehtyre Ramesses I, ca. 1295–1294 B.C.

Menmaatre **Sety I**, ca. 1294–1279 B.C.

Usermaatre **Ramesses II**, ca. 1279–1213 B.C.

Baenre **Merenptah**, ca. 1213–1203 B.C.

Menmire **Amenmessu**, ca. 1203–1200 B.C.

Userkheperure **Sety II**, ca. 1200–1194 B.C.

Siptah, ca. 1194–1188 B.C.

**Tawosret** (Tausret), ca. 1188–1186 B.C.

Twentieth Dynasty (Ramesside Period), ca. 1186–1069 B.C.

Setnakht, ca. 1186–1184 B.C.

**Ramesses III**, ca.1184–1153 B.C.

Ramesses IV, ca. 1153–1147 B.C.

Ramesses V, ca. 1147–1143 B.C.

Ramesses VI, ca. 1143–1136 B.C.

Ramesses VII, ca. 1136–1129 B.C.

Ramesses VIII, ca. 1129–1126 B.C.

Ramesses IX. ca. 1126–1108 B.C.

Ramesses X, ca. 1108–1099 B.C.

Ramesses XI, 1099–1069 B.C.

THIRD INTERMEDIATE PERIOD, ca. 1069–656 B.C.

Twenty-first Dynasty, ca. 1069–945 B.C.

*Smendes* (Nesbanebded), ca. 1069–1043 B.C.

*Psusennes* I (Pasebakhaenniut), ca. 1039–991 B.C.

Amenemope, ca. 993–984 B.C.

Siamun, ca. 978–959 B.C.

*Psusennes* II (Pasebakhaenniut), ca. 959–945 B.C.

Twenty-second Dynasty, ca. 945–715B.C.

**Sheshonq I**, ca. 945–924 B.C.

Osorkon I, ca. 924–889 B.C.

Sheshonq II, ca. 890 B.C.

Takelot I, ca. 889–874 B.C.

**Osorkon II**, ca. 874–850 B.C.

Takelot II, ca. 850–825 B.C.

Sheshonq III, ca. 825–773 B.C.

Sheshonq IV, ca. 785–773 B.C.

**Pimay** (Pami), ca. 773–767 B.C.

Sheshonq V, ca. 767–730 B.C.

Twenty-third Dynasty, ca. 818–715 B.C.

Twenty-fourth Dynasty, ca. 727–715 B.C

Twenty-fifth Dynasty (Kushite), ca. 716–656 B.C.

**Piankhy** (Piye), ca. 747–716 B.C.(first invasion and conquest of
Egypt)

**Shabako**, ca. 716–702 B.C.

Shebitku (Shabataka), ca. 702–690 B.C.

**Taharqa**, ca. 690–664 B.C.

**Tantamani** (Tanutamun), 664–656 B.C.

LATE PERIOD, 664–343 B.C.

Twenty-sixth Dynasty (Saite), 664–525 B.C.

**Psamtik** I (*Psammetichus*), 664–610 B.C.

*Necho* II (Nekau), 610–595 B.C.

**Psamtik II** (*Psammetichus*), 595–589 B.C.

*Apries*, 589–570 B.C.

*Amasis* (Ahmose II), 570–526 B.C.

Psamtik III (*Psammetichus*), 526–525 B.C.

Twenty-seventh Dynasty (Persian kings), 525–404 B.C.

Twenty-eighth Dynasty, 404–399 B.C.

Twenty-ninth Dynasty, 399–380 B.C.

Thirtieth Dynasty, 380–343 B.C.

*Nectanebo* I (Nekhtnebef), 380–362 B.C.

Djedhor (*Teos*), 362–360 B.C.

*Nectanebo* II (Nekhthorheb), 360–343 B.C.

SECOND PERSIAN OCCUPATION, 343–332 B.C.

GRECO-ROMAN PERIOD, 332 B.C.–A.D. 642

Macedonian kings, 332–305 B.C.

**Alexander the Great**, 332–323 B.C.

Philip Arrhidaeus, 323–317 B.C.

Alexander IV, 317–305 B.C.

Ptolemaic Period, 305–30 B.C.

Ptolemy I, 305–282 B.C.

Ptolemy II, 284–246 B.C.

**Ptolemy III**, 246–222 B.C.

Ptolemy IV, 222–205 B.C.

Ptolemy V, 205–180 B.C.

Ptolemy VI, 180–145 B.C.

Ptolemy VII, 145 B.C.

**Ptolemy VIII**, 170–116 B.C.

**Ptolemy IX**, 116–107 B.C.

**Ptolemy X**, 107–88 B.C.

**Ptolemy IX** (restored), 88–80 B.C.

Ptolemy XI, 80 B.C.

Ptolemy XII, 80–51 B.C.

**Cleopatra VII**, 51–30 B.C.

Roman Occupation, 30 B.C.–A.D. 642

**Augustus**, 30 B.C.–A.D. 14

**Septimius Severus**, 193–A.D. 211

# Glossary

Preliminary note on spellings: when Egyptian words or names are transcribed into modern languages, sometimes through an intermediate form in Greek or Arabic, the resultant spellings often vary. Alternate forms of royal names appear in the Chronology, but with a few exceptions, alternate spellings are not noted here. Spellings that differ in only one vowel (Amen or Amon instead of Amun; Aton instead of Aten) usually represent the same name or word.

*akh* (pl. *akhu*): the transfigured one; an aspect of the soul.

**alabaster**: see **calcite**

**Amarna Period**: the reign of Akhenaten (ca. 1352–1336 B.C.), derived from the modern name for the site of the city (Akhetaten) that he founded in his fifth regnal year.

**Amun**: a god of Thebes, where he had several temples; the main temple was at Karnak. He was depicted as a man with a cylindrical crown topped by two tall feathers or, especially in his Nubian temples, with the head of a ram with curling horns. His main consort was the goddess Mut; their son was Khonsu, a moon god. During the Theban Eighteenth Dynasty, Amun was elevated to national status as Amun-Re. (Also see Divine Consort of Amun.)

**Amun-Re**: Amun as a national god; a status expressed by his assimilation with the sun god Re.

**Amun-Re-Kamutef**: see Min.

**ankh**: a hieroglyphic sign, perhaps representing a belt or sandal strap, with the phonetic value *ankh*, which was also the word for life. Thus it became a symbol for life, one of the most powerful and enduring of all ancient Egyptian symbols.

**anthropoid**: having human form. In Egyptian art, used to describe gods and goddesses with fully human forms; also objects with human shapes, such as coffins and vessels.

**Anubis**: a jackal-headed god of embalming, guardian of the cemetery and of the deceased, for whom he performed the weighing of the heart before Osiris in the Afterworld.

**apotheosis**: the act of a human being's becoming, or being considered, a god. In representations of Alexander the Great, his apotheosis was indicated by his upraised head and eyes, a gesture imitated in portraits of Ptolemaic rulers in Hellenistic style, and also in some Egyptian private portrait heads of the Ptolemaic Period.

**apotropaic**: having the power to avert evil; providing magical protection.

**archaic**: in art, a precanonical or preclassical stage of development.

**archaism (archaizing)**: the deliberate imitation or evocation of discontinued styles, costumes, etc.

*atef* **crown**: an elaborate crown compounded of several elements, worn by the king and by many gods.

**Aten**: literally, the disk of the sun; its light was Akhenaten's sole god, worshiped in unroofed temples and represented in the quasi-hieroglyphic form of a disk with a uraeus and many rays ending in hands. Akhenaten's subjects participated in the cult by worshiping the royal family.

**Atum**: a god represented as a man wearing a double crown; the creator god, according to the creation myth of Heliopolis, where he was also worshiped as the manifestation of the setting sun.

*ba*: an aspect of the personality or soul that remained active after death and was able to return to the tomb to receive offerings; usually pictured as a human-headed bird.

**back pillar (back slab)**: a rectangular pillar rising from the base at the back of standing figures and other types of statues in stone and occasionally in wood; usually narrower than a single figure, but often widened to a slab for group statues. Its purpose and/or symbolism have not been satisfactorily explained. It is not an archaic feature, since it does not appear until the Fourth Dynasty.

**Bastet**: a goddess originally manifested as a lioness, but later shown with the head of a cat. Her main temple was in the eastern Delta city of Bubastis. In the Late Period and Ptolemaic Period, her worshipers presented her with votive gifts of cat statuettes or mummified cats, which have survived in great numbers.

**Bat**: an important early cow goddess, represented on the Narmer Palette (fig. 1); during the Middle Kingdom, assimilated by another cow goddess, Hathor, along with Bat's emblem, a frontal female face with cow ears and spiraling horns that appears as an amulet and on the handles of sistra.

**beard, divine**: a long, narrow, artificial beard with a fastening strap, a plaited pattern, and an upward curl at the end; represented on almost all human-headed gods and often on royal and private anthropoid coffins, where the deceased were identified with Osiris.

**beard, royal**: a rectangular or slightly flaring chin beard often shown on representations of kings; it is clearly artificial, fastened with a strap that is usually indicated in relief or paint.

**Bes**: a protective god with a leonine head, fierce expression, and stocky, pot-bellied body, usually shown in an aggressive stance. His magic guarded the vulnerable—women in childbirth, children, and those asleep—from dangers and diseases, whether from animals or demonic spirits. Numerous amulets bear his image, as do beds, headrests, and other objects of intimate domestic use.

**block statue:** a statue of a nonroyal person, almost always a man, sitting on the ground with his crossed arms resting on his drawn-up knees. The figure is usually covered by a cloak, producing a blocky effect; but examples without a cloak are numerous and may, for convenience, be called pseudo-block statues. Block statues, both cloaked and uncloaked, were introduced during the Middle Kingdom and remained popular into the Ptolemaic Period.

**blue crown:** a distinctively shaped, helmet-like royal crown, in colored representations shown as blue and, in the most elaborate depictions, covered with small disks. The latest of the major crowns, it was introduced at the beginning of the New Kingdom.

*Book of the Dead:* a collection of spells and accompanying vignettes, intended to protect the deceased on the journey to the Afterlife and to guarantee sustenance there. Typically written on papyrus and placed in tombs of the New Kingdom and later, but sometimes painted or inscribed on tomb walls; part of a long tradition of funerary spells, going back to the Pyramid Texts of the Old Kingdom.

**bull's tail:** a royal attribute, found already on the Narmer Palette (fig. 1). It was attached to the back of the king's belt; on seated royal statues, the end of the tail is often represented in relief between the lower legs.

**calcite:** the correct name for the whitish or yellowish Egyptian stone often called alabaster (or, more precisely, Egyptian alabaster), which is different from true alabaster. Both terms appear in this catalogue.

**cartonnage:** layers of linen soaked in plaster and shaped while still damp; frequently used for mummy masks and cases.

**cartouche:** a modern name for the oval frame within which the names of kings, queens, and some deities were written. Representing a loop of rope with the ends bound together at one end, the cartouche is an elongated form of the circular *shen* sign, which has the symbolic meaning of "all that the sun encircles."

**Colossi of Memnon:** two colossal seated statues of Amenhotep III, still in situ at the entrance to the site of his funerary temple on the West Bank of Thebes. The Greeks and Romans called the northern statue Memnon, after a Greek mythological hero whose name sounded similar to their pronunciation of Amenhotep. This statue became famous for emitting a tone at sunrise, probably due to expansion of the stone in the sun's heat. The phenomenon seems to have been caused by an earthquake soon after the Romans conquered Egypt; it so impressed the emperor Septimius Severus that he ordered a restoration, which had the unintended effect of restoring the statue to silence.

**Divine Consort of Amun** (often translated as God's Wife of Amun): a princess who served as a mortal wife to the Theban god Amun. She was thus the highest priestess imaginable; officially celibate, she passed on her office by adoption. During the Third Intermediate Period and Twenty-sixth Dynasty, Divine Consorts acted as royal surrogates at Thebes and, in the Twenty-sixth Dynasty, even held the office of High Priest of Amun.

**double crown:** a crown that combined the white crown of Upper Egypt and the red crown of Lower Egypt, to symbolize the king's role as "King of Upper and Lower Egypt." Also worn by a few deities, including Atum.

**double wig:** a modern name for an elaborate male wig of the New Kingdom and Late Period, which combined long tresses or curls over the head with an undersection of stylized small curls beside the face; in the later New Kingdom, these were often extended into lappets on the chest.

*djed* **pillar:** a pillar of unknown composition, with a flaring base and four or five horizontal crossbars near the top. A fetish and symbol of Osiris and, as a hieroglyph, used phonetically to write the word *djed*, meaning stability or permanence. One of the most popular types of amulet.

**Egyptian blue:** an Egyptian material used much like faience, but with a characteristic blue color and the appearance of dull or matte glass. It is closely related to glass, being composed of crystalline particles held within a glassy matrix.

**Ennead:** (Egyptian *pesdjet*) a group of nine gods; in Egyptian creation myths, the first nine to be created. The "Great Ennead" usually refers to the deities named in the version of the myth associated with the important solar cult at Heliopolis. They are: Atum, who created the first couple, Shu and Tefnut; from them came Geb and Nut, whose offspring were Osiris, Isis, Nephthys, and Seth. Given the nature of each of these gods (see entries in this glossary), this divine genealogy serves as a description of the origin of the cosmos and of the beginnings of human society. Since the number nine is the plural of a plural (3x3), Egyptians sometimes also used the term to refer to an indeterminate number of gods.

**faience** (more accurately called Egyptian faience): a glazed ceramic made, not from clay, but from ground quartz or sand; most often colored blue from copper oxides, but in the New Kingdom produced in a wide range of colors. Used for almost every kind of small object, from jewelry and cosmetic vessels to wall decorations and statuettes, including *shabtis*.

**false door:** a representation of a door, usually in relief but sometimes in paint; a symbolic boundary between this world and the next. It consists of jambs and a lintel covered with inscriptions and images of the owner, framing a very narrow "doorway." In Old Kingdom tombs, a window-like rectangle above the lintel contained an offering scene; the Old Kingdom false door was typically located above the burial chamber and served as the focus of the offering cult. False doors also appear in later tombs and, less frequently, in temples and ceremonial palaces.

**Geb:** the earth god, shown in human form. As the father of Osiris (see Ennead), he was considered the founder of kingship.

**guilloche:** a decorative border design in which two or more bands are interwoven so as to make spaces between them.

**Hapy:** a fecundity god of the Nile who personified the life-renewing power

of the annual inundation and the fertile black silt that it brought with it. He was usually represented as a fat man with a sagging belly and large, woman-like breast, carrying offerings and crowned with a clump of papyrus.

**Harakhty:** "Horus of the Horizon," a manifestation of the sun in its rising; depicted as a falcon-headed man with a sun disk on his head and often mummiform. Frequently compounded as Re-Harakhty.

**Harendotes:** Greek version of Egyptian *Hor-nedj-itef*, "Horus the protector of his father." Worshiped especially at Hierakonpolis, with a major role also in the cult of Osiris at Abydos, where he was the dutiful son who avenged his father's murder and gave him a proper burial. Hence, a protector of all the deceased.

**Harpocrates:** Greek version of *Hor-pa-khered*, Egyptian for "Horus the child," a manifestation of the god as an infant, under the maternal care and protection of Isis, and thus himself a symbol of protection.

**Hathor:** a goddess represented as a woman, a cow, or occasionally a woman with a cow's head. Her headdress was a sun disk between cow's horns; her emblem or fetish, the head of a woman with cow's ears, often appears on the handles of sistra and on the capitals of columns. As the daughter of Re, Hathor was important in cosmic mythology, where a dark, destructive side is sometimes in evidence. Her cow imagery emphasizes her maternal, nurturing aspect. Her name means "the House of Horus." In her cult center at Dendera, her consort was Horus of Edfu; their son, the child god Ihy, was a god of music.

**"Hathor wig":** a female wig characterized by two thick front tresses ending in spiral curls, often wound around disks; in back, the hair falls in a broad strip. The wig is shown on queens and private women, especially in the Middle Kingdom, and on some, but by no means all, Hathor emblems; contrary to the assumption implied in its name, it was probably not a symbol of her cult.

**High Priest of Amun:** the head of the large priesthood of Amun at Thebes, and of Karnak and Luxor temples; one of the two most important religious positions in ancient Egypt, together with the High Priest of Ptah.

**High Priest of Ptah:** the head of the large priesthood and the great temple of Ptah at Memphis; with the High Priest of Amun, one of the two most powerful religious offices, and perhaps the most prestigious.

**Horus:** a sky god, shown as a falcon or a falcon-headed man; he had cult centers at Hierakonpolis and Edfu. As the son of Osiris, simultaneously a protector and a manifestation of the reigning king. At Edfu, his consort was Hathor of Dendera. Horus had many aspects indicated by specialized names, such as Harakhty, Harendotes, and Harpocrates.

**Horus the Child:** see Harpocrates.

**Hyksos:** Greek form of the Egyptian *heqa khasut*, "rulers of foreign lands";

applied to Near Easterners who, from their capital of Avaris (present-day Tell el Daba) in the eastern Nile Delta, gained control over northern Egypt and claimed to be kings (Fifteenth Dynasty, ca. 1650–1550 B.C.). Bitterly opposed by a line of Theban rulers, at least one of whom died in battle before King Ahmose succeeded in expelling them and reuniting Egypt to found the New Kingdom.

**hypostyle hall:** (Greek) A hall with a roof supported by rows of columns. In the hypostyle halls of Egyptian temples, the most famous of which is at Karnak, the columns are often very tall, and those forming the central passage, or nave, are even taller.

**icon:** a pictorial image of beliefs or ideas, religious or otherwise, conveyed through the use of widely understood symbols.

**Imhotep:** an official of King Djoser of the Third Dynasty, probably the architect of Djoser's Step Pyramid. Remembered as a wise man, by the New Kingdom he was regarded as a holy man; in the Ptolemaic Period he was worshiped as a god, the son of Ptah, with temples at Memphis.

**Isis:** a goddess, sister and wife of Osiris, sister of Nephthys and Seth; mother of Horus, whom she conceived magically by reassembling her murdered and dismembered husband. The main mourner, often with Nephthys, of Osiris and of all the deceased; from the New Kingdom onward, increasingly the great maternal goddess, who hid the infant Horus from the jealous Seth and protected him until he could claim his father's throne. Her main attribute is the hieroglyph of her name, a throne, worn on her head.

*ka*: an aspect of the personality or soul that was born with a person and survived after death; it could receive offerings for the deceased. Sometimes represented as a twin image of a person, the *ka* was a kind of life force. Kings and gods also had *kas*.

*khat*: a royal headcloth, white in color and gathered at the nape of the neck to form a broad flap behind; less elaborate than the *nemes*, and much less frequently represented. Similar to headcloths worn by certain deities, especially by Isis and Nephthys in their role as mourners in funerary scenes.

**Khnum:** a ram-headed god whose main temple was on Elephantine Island at Aswan. As the creator of the human body and its *ka*, he is often shown molding them on a potter's wheel.

**Kush:** indigenous name for a land far to the south of Egypt in what is now the Sudan; at times, it also controlled the Nile Valley northward to the ancient Egyptian border at Aswan. The oldest known African kingdom outside of Egypt, Kush first rose to power during the Egyptian Middle Kingdom. As an ally of the Hyksos kings in northern Egypt during the Second Intermediate Period, it posed a threat to the Theban Dynasty; so after expelling the Hyksos, Ahmose and his successors decimated Kush. Egypt occupied the area throughout most of the New Kingdom. Following the Egyptian withdrawal, a strong Kushite dynasty arose and eventually extended its control over Egypt, ruling as the Kushite Twenty-

fifth Dynasty (ca. 716–656 B.C.). Driven out of Egypt by Assyrian invaders, the Kushites gradually shifted their focus to Meroe, far to the south. This later phase of the kingdom, known as Meroitic, lasted well into the time of the Roman Empire.

**lotus, blue**: a fragrant water lily (*Nymphaea caerulea*) that opens in the morning and closes at sunset; these qualities were equated with the eternal cycle of the sun and of life, making this flower one of the most potent and frequently represented symbols of rebirth.

**Lower Egypt**: the lower Nile Valley in Egypt; that is, northern Egypt, including the vast Nile Delta.

**Lower Egyptian crown**: see red crown.

*maat*: a ruling principle of rightness, order, and justice believed by the Egyptians to permeate the cosmos, from the solar cycle and the annual Nile flood to the actions of individuals. The king was the guarantor of *maat* on earth. In the weighing of the heart, the deceased was judged according to *maat*, which was symbolized by a stylized ostrich plume. *Maat* was often personified as a goddess with the feather on her head or, occasionally, instead of her head. The opposite of *maat* was chaos.

**Middle Egypt**: a modern term for the central part of Egypt south of Cairo (and ancient Memphis), including the oasis-like Fayum.

**Min**: a very ancient fertility god of Koptos; represented as a mummiform figure with an erect penis, an upraised arm holding a flail, and a crown with two plumes, similar to that worn by Amun. As Kamutef, "the bull of his mother," Min was considered a creator god. In the New Kingdom, this title was often appropriated by Amun-Re-Kamutef, who was then represented with the characteristics of Min.

**Montu**: a war god of the Theban area, represented as a falcon-headed man with a headdress consisting of a sun disk encircled by two uraei and topped by two falcon plumes. His name often appears in the personal names of Thebans, such as Mentuhotep ("Montu is content").

**mummiform**: in the form of a mummy; that is, entirely shrouded except for the head and sometimes, if the arms are crossed on the chest in the Osiride pose, the hands.

**naos** (pl. **naoi**): in Greek, a temple, the house of a god; in terms of ancient Egypt, the shrine used to house the statue of a deity. Egyptian naoi could be as large as small buildings, but most were small enough to stand on altars; naoi containing divine figures are often carried by statues of the New Kingdom and later.

**negative space**: material left as fill between the limbs and in other open spaces on almost all stone statues and a few wooden statues; in the Old Kingdom, often painted black to indicate that it was theoretically nonexistent.

**Neith**: a goddess represented as a woman wearing a red crown, whose main temple was in the Delta city of Sais.

*nemes*: a royal headcloth with two lappets in front and the back section bound into a queue; usually shown as entirely or partly pleated and often, in the New Kingdom, with the stripes colored alternately blue and yellow.

**Nephthys**: a goddess, sister to Isis and Osiris. In Egyptian mythology, she was married to their brother Seth, but she disowned him when he murdered Osiris; with Isis, she was the main mourner of Osiris and thus of all the deceased. Her attribute is the hieroglyphic writing of her name, worn like a headdress.

**nome**: one of the administrative districts of ancient Egypt; in the fullest counts, they numbered forty-two. Though some were bureaucratic creations, others were probably remnants of the independent political units of the late Predynastic Period.

**nomarch**: the ruler of a nome.

**Nut**: a goddess, personification of the sky, often shown with her body arched over the earth. In solar mythology, she swallowed the sun at sunset and gave birth to it at dawn; thus she was important in the symbolism of rebirth and was often represented on coffin lids, arched over the mummy.

*nw*-**pot**: a globular offering vessel with a small, rimmed opening; used for offering of liquids, such as milk.

**Onuris**: a hunting and war god, shown as a man with a headdress of four feathers and carrying a lance and a rope. His name, "He who brings the distant one," indicates his mythical role of restoring to Re strayed goddesses or stolen divine elements, such as the *wedjat* eye.

**Oside**: in the form of Osiris; that is, with arms crossed over the chest and hands holding the crook and flail emblems of the god or other symbols such as ankh signs. Osiride figures are often shrouded like Osiris, but not always.

**Osiris**: one of the most important Egyptian gods, with his foremost cult center at Abydos; brother of Isis, Nephthys, and Seth and married to Isis, with whom he fathered Horus. A mythical king, he was murdered by Seth, who claimed his throne but was eventually defeated by Horus. Osiris became king of the Afterworld, where he presides over the weighing of the heart; if the judgment is in the deceased's favor, he or she becomes a manifestation of Osiris. As a king, Osiris is shown with a tall crown and holding power emblems in the form of a crook and flail; as deceased, he is mummiform, with his arms crossed on his chest and only his head and hands exposed. He is often shown with black or green skin, to symbolize his close association with the fertility of Nile silt and the regeneration of plant life.

**ostracon** (pl. **ostraca**): a flake of limestone or sherd of pottery used for drawings or writings not worthy of expensive papyrus: school exercises,

preliminary drafts and sketches, copies, doodles, and the like.

**palette**: with reference to ancient Egypt, designates small stone slabs on which pigments for eye makeup were ground. Produced during most of the Predynastic Period, they were often deposited in graves; amuletic significance is indicated by the animal shapes of later examples. Toward the end of the Predynastic Period, much larger palettes were decorated in relief with motifs of hunting (fig. 46) and royal conquest (fig. 1). Most of these relief-decorated palettes are believed to refer, directly or symbolically, to the events that culminated in the unification of Egypt at the beginning of the First Dynasty; some, if not all of them were dedicated in temples.

**pharaoh (pharaonic)**: from the Egyptian *per aa*, "great house," meaning the palace and, by extension, the royal court. The term was not applied to the king himself until the New Kingdom; in the Ptolemaic and Roman Periods, it was used as a royal title. Because of its changing meanings, the word has been used sparingly in this catalogue.

**provenance**: where an ancient object comes from; usually, where it was found.

**Ptah**: an anthropoid god represented mummiform, wearing a skullcap and holding a composite scepter. One of the great gods of Egypt, with his main temple at Memphis, Ptah was a creator god who, according to the "Memphite Theology," created the world by speaking it; he was also the patron of artists and craftsmen. His consort was the fierce lion goddess Sakhmet, and their son was the child god Nefertem.

**pylon**: as applied to ancient Egypt, a form of monumental temple gateway comprising two wide, shallow towers that taper slightly from bottom to top. The broad surfaces were decorated with representations of the temple's deity with the king or—especially on the sides facing outward—scenes of royal protection, such as the smiting scene (fig. 16) or foreign wars. Great temples like that at Karnak were entered through a series of pylons, built by successive kings.

**Pyramid Texts**: modern name for the religious texts carved on the walls of rooms inside the pyramids of late Old Kingdom kings and queens, beginning with Unas, the last king of the Fifth Dynasty. Intended to help the deceased in the Afterworld, the texts are a selection of hymns, incantations, and magical spells; no two selections are exactly alike. In the First Intermediate Period and Middle Kingdom, versions of some Pyramid Texts were inscribed in the tombs and on the coffins of private people. These are known as Coffin Texts; they were the forerunners of the *Book of the Dead* and other collections of funerary spells in tombs of the New Kingdom and later.

**raised relief**: see relief

**Re** (often spelled Ra): the main sun god, usually represented as a man with the head of a ram. His cult center was at Heliopolis, near Memphis; but because of the importance of the sun in Egyptian life and religion, he was considered a universal god, whose qualities could also be manifested in other great gods, such as Amun-Re and Re-Osiris. One of the king's most important titles was "Son of Re" (see royal names and titles).

**Re-Harakhty**: see Harakhty.

**Re-Harakhty-Atum**: a compound deity comprising the three main aspects of the sun in its daily cycle.

**red crown**: the traditional crown of Lower Egypt, already shown on one side of the Narmer Palette and attested even earlier; it is a short, flaring red cylinder with a tall back piece, from the base of which a slender element juts forward and up, to end in a spiral.

**relief**: two-dimensional carving; in Egypt, usually in stone, but sometimes in wood and occasionally in other materials, such as ivory or faience. In raised relief, the original surface is cut back around the figures and scenes, leaving them raised above it. In sunk relief, figures and scenes are carved into the surface, which remains at its original level.

**royal names and titles**: from the Middle Kingdom on, the Egyptian king's titulary consisted of five "great names," each with its own title. The first, the Horus name, was written inside a rectangular representation of a palace elevation and plan known as a *serekh*, and presided over by a Horus falcon; the most ancient type of royal name, it can be seen on the Narmer Palette (fig. 1) and the Den plaque (cat. 2). The second name was preceded by the title *nebty*, which is translated as "Two Ladies." The *nebty* were the tutelary goddesses of Upper and Lower Egypt, Nekhbet and Wadjet, represented as a vulture and a cobra. The third name, which followed an image of a falcon on the hieroglyphic sign for "gold," is known as the Golden Horus name. Fourth in the sequence was the prenomen, or throne name, which was preceded by the title "King of Upper and Lower Egypt," and written in a cartouche; chosen by the king at his accession, this was his most important name. The last name, the nomen, was the name he had been given at birth (and in most cases, the name by which he is best known today); it, too, was written in a cartouche, following the title "Son of Re."

*sa*: an ancient Egyptian "life preserver," made of looped papyrus stalks bound together at the ends; as a hieroglyph, used to write the word *sa*, "rotection," and sometimes an amulet with the same meaning (cat. 37).

*sah*: Egyptian word for "mummy."

**Sakhmet**: a lion goddess, whose name means "the powerful one." She was a fierce warrior, who destroyed the enemies of Re and of the king, being thus a champion of Egypt. She was also the patroness of physicians, some of whom were her priests. Her main cult center was at Memphis, where she was considered the consort of Ptah; their son was the child god Nefertem.

**Saite**: a word derived from Sais, a city in the western Nile Delta; used to designate the kings of the Twenty-sixth Dynasty (664–525 B.C.), who came from Sais, and also for such characteristic elements of this period as Saite art and Saite style.

*sed* festival: (Egyptian *heb sed*; sometimes translated "jubilee") an elaborate ritual intended to renew the king's physical and magical powers; attested from predynastic to Greco-Roman times.

*sekhem* scepter: a scepter or baton in the shape of the hieroglyph used to write the word *sekhem*, "power"; held as a symbol of office by high-ranking officials.

*senet* game: a popular board game played by two people; it was also symbolically equated with the journey to the Afterworld.

*shabti* (also called *shawabti, ushebti*): a small figure of stone, faience, wood, bronze, or sun-dried mud; *shabtis* were placed in royal and private tombs, sometimes in large numbers, to perform manual labor that might be demanded of the deceased; they are often shown holding agricultural implements. Most *shabtis* are mummiform, but some New Kingdom and Third Intermediate Period examples are dressed like the living. Many are inscribed with the "*shabti* spell" (Spell 6 in *The Book of the Dead*).

*shendyt* kilt: a distinctive form of short royal kilt, usually but not always pleated, wrapped to overlap in front, where a narrow panel hung down almost to the knees. The most frequently represented garment on kings of the Old Kingdom; less often depicted in the Middle and New Kingdoms, but it never entirely disappeared. Due to archaism from Old Kingdom prototypes, it again became the primary royal costume in the Twenty-fifth Dynasty and remained so through the Roman Period.

Shu: the god of the air, with anthropoid form. In creation mythology, born with his sister Tefnut, the goddess of moisture; the pair separate the earth god Geb from the sky goddess Nut, thus forming the world.

sistrum (pl. sistra): a musical instrument used in temple rites that consisted of a framework holding wires on which metal disks were threaded; when shaken, it produced a jingling sound pleasing to deities and especially beloved by Hathor. The two main types of sistra were a loop-shaped frame on a handle topped by a Bat face and one shaped like a naos, with a handle bearing the face of Hathor.

smiting scene: a representation of the king striding toward one or more foreign captives whom he grasps by the hair. His other hand is upraised, holding a mace or other weapon which he is about to bring down on their heads. An icon of the king as defender of *maat*, it was already represented on the Narmer Palette (fig. 1) and the Den plaque (cat. no. 2) and is found throughout the pharaonic period (fig. 16).

sphinx: the body of a recumbent lion with the head of a king or, less often, a royal woman; a manifestation of royal might, first appearing in the Fourth Dynasty. In one variant form, only the royal face is shown, framed by the lion's mane and ears; on other sphinxes, the lion's forelegs are replaced by human arms and hands, which usually hold offering vessels.

stela (pl. stelae): an upright slab of stone, or less often wood, with carved or painted figures and inscriptions; erected in temples, where they might be very large, and in or before tombs. Old Kingdom stelae often have the form of a false door; in the New Kingdom and Late Period, stelae are sometimes held by statues.

sunk relief: see relief

Tefnut: the lion-headed goddess of moisture. She and Shu (air) were the first gods created by Atum at the beginning of creation; with Geb (the earth) and Nut (the sky), they constitute the world.

therianthropic: combining elements of animal and human forms. Examples in Egyptian art include animal-headed gods and sphinxes.

Thoth: a god represented as an ibis-headed man or as an ibis or a baboon. His main cult center was at Hermopolis, in central Egypt, but he was worshiped all over Egypt. A lunar god, he presided over the calendar and was thus the god of mathematics and writing; this made him the patron god of scribes. He was present at the weighing of the heart, to record the verdict on the deceased.

Two Ladies: see royal names and titles.

Two Lands: an ancient Egyptian name for their land, as comprising Upper Egypt and Lower Egypt. Though the term refers primarily to the unification of the two lands by the semi-mythical King Menes at the beginning of the First Dynasty, the physical contrasts between the narrow valley in the south and the expansive delta in the north helped to perpetuate the idea of Egypt as a land of two parts.

Upper Egypt: the upper Nile Valley in Egypt; that is, southern Egypt.

Upper Egyptian crown: see white crown.

uraeus (pl. uraei): the rearing cobra at the forehead of kings, queens, and some deities. Associated with several powerful goddesses, the uraeus was both a protective symbol and a manifestation of divine royal power.

Valley of the Kings: the modern name for the desert valley west of Thebes where kings of the New Kingdom were buried in tombs tunneled out of the cliffs. Some of the sons of Ramesses II were also buried in the valley in a huge multi-chambered tomb, and a few favored nonroyal individuals had tombs there as well.

vizier: a modern name (from the Arabic *wazir*) for the highest official in the royal administration. In the New Kingdom and later, there were two viziers, one for Upper Egypt and one for Lower Egypt.

*was* scepter: a scepter held by gods, based on a highly stylized representation of an unidentified animal with large, leaf-shaped ears and a long narrow snout; the legs at the bottom are reduced to a small fork. Also the

hieroglyph for writing *was*, "prosperity," in which sense it often appears in amulets and mottoes.

*wedjat* eye (sometimes spelled *udjat*): a human eye and eyebrow with very stylized falcon markings beneath. It represents one of the eyes of Horus, which were equated with the sun and moon. In various myths, one eye is injured or stolen, but always it is healed or returned. In cosmic symbolism, this represented the phases of the moon and the changing constellations; in Osiris mythology, it symbolized the cycle of rebirth so powerfully that it was one of the most popular types of amulet.

weighing of the heart: the judgment of the deceased in the Afterlife, in a divine court presided over by Osiris. The person's heart is weighed in a balance against the feather of *maat*; this is usually done by Anubis, and the verdict is recorded by Thoth. Should the heart prove heavier than the feather, it would be devoured by a monstrous beast, thus annihilating its unworthy owner.

Wepwawet: a jackal god of Asyut; a cemetery god, his name means "The Opener of the Ways." Like Anubis, closely associated with Osiris.

white crown: a tall, cylindrical white crown that tapers toward the top, then widens to a small bulbous finial; the traditional crown of Upper Egypt, already shown on the Narmer Palette (fig. 1).

# Abbreviations and Bibliography

*ÄA*
*Ägyptologische Abhandlungen* (Wiesbaden)
*ÄF*
*Ägyptologische Forschungen* (Glückstadt, Hamburg, New York)
*AVDAIK*
*Archäologische Veröffentlichung der Deutschen Archäologischen Instituts Abteilung Kairo* (Mainz)
*ASE*
*Archaeological Survey of Egypt* (London)
*BACE*
*Bulletin of the Australian Centre for Egyptology* (Sydney)
*BdÉ*
*Bibliothèque d'Étude*, Institut Francais d'Archéologie Orientale du Caire (Cairo)
*BES*
*Bulletin of the Egyptological Seminar* (New York)
*BIFAO*
*Bulletin de l'Institut Français d'Archéologie Orientale due Caire* (Cairo)
**BMA**
Brooklyn Museum of Art
*BMA*
*Brooklyn Museum Annual* (Brooklyn)
*BMMA*
*The Metropolitan Museum of Art Bulletin* (New York)
*BMQ*
*British Museum Quarterly* (London)
*BSFÉ*
*Bulletin de la Société Français d'Égyptologie* (Paris)
*CAA Wien*
*Corpus Antiquitatum Aegyptiacarum. Kunsthistorisches Museum Wien, Ägyptisch-orientalische Sammlung* (Mainz)
**Cairo TR**
Egyptian Museum, Cairo: Temporary Register
*CdÉ*
*Chronique d'Égypte* (Brussels)
*CG*
*Catalogue Générale des Antiquités Égyptiennes du Musée du Caire*, Egyptian Museum, Cairo
**EEF**
Egypt Exploration Fund, London
*EVO*
*Egitto e Vicino Oriente* (Pisa)
*GM*
*Göttinger Miszellen* (Göttingen)
**HÄB**
*Hildesheimer Ägyptologische Beiträge* (Hildesheim)
*JARCE*
*Journal of the American Research Center in Egypt* (Winona Lake, Ind., Eisenbrauns)

*JE*

*Journal d' Entrée*, Egyptian Museum, Cairo

*JEA*

*Journal of Egyptian Archaeology* (London)

*JGS*

*Journal of Glass Studies* (Corning, New York)

*JNES*

*Journal of Near Eastern Studies* (Chicago)

*JSSEA*

*Journal of the Society for the Study of Egyptian Antiquities* (Toronto)

*KMT*

*KMT: A Modern Journal of Ancient Egypt* (San Francisco)

*KRI*

K.A. Kitchen, *Ramesside Inscriptions* (Oxford)

*LÄ*

*Lexikon der Ägyptologie* (Wiesbaden)

L*AAA*

*Annals of Archaeology and Anthropology* (Liverpool)

MÄS

*Münchner Ägyptologische Studien* (Mainz)

*MDAIK*

*Mitteilungen des Deutschen Archäologischen Instituts Abteilung Kairo* (Mainz)

MFA

Museum of Fine Arts, Boston

*MIFAO*

*Mémoires publiés par les membres de l'Institut Française d'Archéologie Orientale du Caire* (Cairo)

*MIO*

*Mitteilungen des Instituts für Orientforschung* (Berlin)

MMA

The Metropolitan Museum of Art, New York

*MMJ*

*Metropolitan Museum Journal* (New York)

*OLA*

*Orientalia Lovaniensia Analecta* (Louvain)

*RdÉ*

*Revue d'Égyptologie* (Paris)

*RT*

*Recueil de Travaux* (Paris)

*SAGA*

*Studien zur Archäologie und Geschichte Altägyptens* (Heidelberg)

*SAK*

*Studien zur altägyptischen Kultur* (Hamburg)

*SAOC*

*Studies in Ancient Oriental Civilizations* (Chicago)

*SDAIK*

Deutsches Archäologisches Institut Abteilung Kairo, *Sonderschrift* (Mainz)

*TSBA*

*Transactions of the Society of Biblical Archaeology* (London)

*WdO*

*Die Welt des Orients* (Göttingen)

*VA*

*Varia Aegyptiaca* (San Antonio, Texas)

*ZÄS*

*Zeitschrift für ägyptische Sprache und Altertumskunde* (Leipzig, Berlin)

**Adams 1999a**

Barbara Adams, "More Surprises in the Locality HK6 Cemetery," *Nekhen News* 11 (Milwaukee, Wisconsin, Milwaukee Public Museum), pp. 4-5

**Adams 1999b**

Barbara Adams, "The Painted Tomb at Hierakonpolis," *Nekhen News* 11 (Milwaukee, Wisconsin, Milwaukee Public Museum), pp. 23-25

*Africa* 1996

*Africa, The Art of a Continent: 100 Works of Power and Beauty* (exhib. cat.) (New York, Guggenheim Museum)

**Aldred 1956**

Cyril Aldred, "The Carnarvon Statuette of Amun," *JEA* 42, pp. 3-7

**Aldred 1970**

Cyril Aldred, "Some Royal Portraits of the Middle Kingdom in Ancient Egypt," *MMJ* 3, pp. 27-30 = *Ancient Egypt in the Metropolitan Museum Journal* (New York, The Metropolitan Museum of Art, 1977), pp. 1-24

**Aldred 1973**

Cyril Aldred, *Akhenaten and Nefertiti* (exhib. cat.) (Brooklyn/New York, The Brooklyn Museum/Viking Press)

**Aldred 1981**

Cyril Aldred, "An Unconsidered Trifle," in William Kelly Simpson and Whitney Davis, eds., *Studies in Ancient Egypt, the Aegean and the Sudan: Essays in Honor of Dows Dunham on the Occasion of His 90th Birthday, June 1, 1980* (Boston, Museum of Fine Arts, Boston), pp. 11-13

**Alexanian 1999**

Nicole Alexanian, "The Relief Decoration of Khasekhemwy at the Fort," *Nekhen News* 11 (Milwaukee, Wisconsin, Milwaukee Public Museum), pp. 14-15

**Altenmüller 1980**

Hartwig Altenmüller, "Königsplastik: MR," *LÄ* III, cols. 564-68

*Ancient Art* 1992

*Ancient Art: Gifts from the Norbert Schimmel Collection, BMMA* 49/4

**Anderson 1976**

R. D. Anderson, *Catalogue of Egyptian Antiquities in the British Museum*, III: *Musical Instruments* (London, British Museum Publications)

**Andreu/Rutschowscaya/Ziegler 1997**

Guillemette Andreu, Marie-Hélène Rutschowscaya, and Christiane Ziegler, *Ancient Egypt at the Louvre* (Paris, Hachette)

**Andrews 1981**

Carol Andrews, *Catalogue of Egyptian Antiquities in the British Museum*, VI: *Jewellery*, I: *From the Earliest Times to the Seventeenth Dynasty* (London, British Museum Publications)

**Andrews 1990**

Carol Andrews, *Ancient Egyptian Jewellery* (London, British Museum Press)

**Andrews 1994**

Carol Andrews, *Amulets of Ancient Egypt* (London, British Museum Press)

**Arnold, Di. 1974a**

Dieter Arnold, *Der Tempel des Königs Mentuhotep von Deir el-Bahari*, I: *Architektur und Deutung* (*AVDAIK* 8)

**Arnold, Di. 1974b**

Dieter Arnold, *Der Tempel des Königs Mentuhotep von Deir el-Bahari*, II: *Die Wandreliefs des Sanktuares* (*AVDAIK* 11)

**Arnold, Di. 1976**

Dieter Arnold, *Gräber des Alten und Mittleren Reiches in El-Tarif* (*AVDAIK* 17)

**Arnold, Di. 1979**

Dieter Arnold, *The Temple of Mentuhotep at Deir el-Bahari*, from the notes of Herbert Winlock (*Publications of the Metropolitan Museum of Art Egyptian Expedition* 21) (New York, The Metropolitan Museum of Art)

**Arnold, Di. 1981**

Dieter Arnold, *Der Tempel des Königs Mentuhotep von Deir el-Bahari*, III: *Die königlichen Beigaben* (*AVDAIK* 23)

**Arnold, Di. 1999**

Dieter Arnold, *Temples of the Last Pharaohs* (New York/Oxford, Oxford University Press)

**Arnold, Do. 1991**

Dorothea Arnold, "Amenemhat I and the Early Twelfth Dynasty at Thebes," *MMJ* 26, pp. 5-48

**Arnold, Do. 1995**

Dorothea Arnold, "An Egyptian Bestiary," *BMMA* 52/4, pp. 3-64

**Arnold, Do. 1996**

Dorothea Arnold, *The Royal Women of Amarna: Images of Beauty from Ancient Egypt* (exhib. cat.) (New York, The Metropolitan Museum of Art/Harry N. Abrams, Inc.)

**Arnold, Do. 1999**

Dorothea Arnold, *When the Pyramids Were Built: Egyptian Art of the Old Kingdom* (exhib. cat.) (New York, The Metropolitan Museum of Art/Rizzoli International Publications, Inc.)

***Art and Afterlife* 1999**

*Art and Afterlife in Ancient Egypt: From the British Museum* (exhib. cat.) (Tokyo, Asahi Shimbum)

**Assmann 1989**

Jan Assmann, "State and Religion in the New Kingdom," in William Kelly Simpson, ed., *Religion and Philosophy in Ancient Egypt* (*Yale Egyptological Studies* 3) (New Haven, Yale University Press), pp. 55-88

**Assmann 1991**

Jan Assmann, *Stein und Zeit: Mensch und Gesellschaft im alten Ägypten* (Munich, Wilhelm Fink)

**Assmann 1996**

Jan Assmann, "Preservation and Presentation of Self in Ancient Egyptian Portraiture," in Peter Der Manuelian, ed., *Studies in Honor of William Kelly Simpson* I (Boston, Museum of Fine Arts)

**Baetjer/Draper 1999**

K. Baetjer and J. D. Draper, eds., *"Only the Best": Masterpieces of the Calouste Gulbenkian Museum, Lisbon* (exhib. cat.) (New York, The Metropolitan Museum of Art)

**Bailey 1963**

Donald M. Bailey, *Greek and Roman Pottery Lamps.* (London, Trustees of the British Museum)

**Baines 1985**

John Baines, *Fecundity Figures: Egyptian Personifications and the Iconology of a Genre.* (Warminster, Aris and Phillips)

**Bankes 1830**

W. J. Bankes, ed., *Narrative of the Life and Adventures of Giovanni Finati, Native of Ferrara*, vol. II (London)

**Barberi/Parola/Toti 1995**

O. Lollio Barberi, G. Parola, and M. P. Toti, *Le Antichità Egiziane di Roma Imperiale* (Rome, Istituto Poligrafico e Zecca dello Stato)

**Bard 1999**

Kathryn A. Bard, compiler and editor, *Encyclopedia of the Archaeology of Ancient Egypt* (London/New York, Routledge)

**Barta 1978**

W. Barta, "Die Sedfest-Darstellung Osorkons II. im Tempel von Bubastis," *SAK* 6, pp. 25-42.

**Becker et al. 1994**

Lawrence Becker, Lisa Pilosi, and Deborah Schorsch, "An Egyptian Silver Statuette of the Saite Period—A Technical Study," *MMJ* 29, pp. 37-56

**von Beckerath 1997**

Jürgen von Beckerath, *Chronologie des pharaonischen Ägypten* (*MÄS* 46)

**Belzoni 1822**

Giovanni-Battista Belzoni, *Narrative of the Operations and Recent Discoveries within the Pyramids, etc.*, I (2nd ed., London, J. Murray)

***Berlin* 1967**

*Ägyptisches Museum Berlin* (Berlin, Brüder Hartmann)

**Berman 1999**

Lawrence M. Berman, *Catalogue of Egyptian Art: The Cleveland Museum of Art* (New York, Hudson Hills Press)

**Bianchi 1979**

Robert S. Bianchi, "Ex-Votos of Dynasty XXVI," *MDAIK* 35, pp. 15-22

**Bianchi 1982**

Robert S. Bianchi, "The Egg-Heads: One Type of Generic Portrait from the Egyptian Late Period," *Wissenschaftliche Zeitschrift der Humboldt-Universität zu Berlin* 31, pp. 149-51

**Bianchi 1988**

Robert S. Bianchi, "The Pharaonic Art of Ptolemaic Egypt," in *Cleopatra's Egypt: Age of the Ptolemies* (exhib. cat.) (Brooklyn, The Brooklyn Museum), pp. 55-80

**Bickel 1991**

Susanne Bickel, "L'iconographie du dieu Khnoum," *BIFAO* 91, pp. 55-67

**Bierbrier 1982**

Morris L. Bierbrier, *The Tomb-Builders of the Pharaohs* (London, British Museum Publications)

**Bierbrier 1988**

Morris L. Bierbrier, "The Lethieullier Family and the British Museum," in John Baines et al., eds., *Pyramid Studies and Other Essays Presented to I. E. S. Edwards* (London, Egypt Exploration Society), pp. 220-28

**Bierbrier 1993**

Morris L. Bierbrier, "The Sloane Collection of Egyptian Antiquities," in

L. Limme and J. Strybol, *Aegyptus Museis Rediviva: Miscellanea in Honorem Hermanni De Meulenaere* (Brussels, Musées Royaux d'Art et d'Histoire), pp. 15-33

**Bierbrier 1997**
M. L. Bierbrier, "Fayum Cemeteries and Their Portraits," in M. L. Bierbrier, ed., *Portraits and Masks: Burial Customs in Roman Egypt* (London, British Museum Press), pp. 16-18

**Blackman 1931**
Aylward M. Blackman "The Stele of Thethi, British Museum No. 614," *JEA* 17, pp. 55-61.

**Borchardt 1934**
Ludwig Borchardt, *Statuen und Statuetten von Königen und Privatleuten im Museum von Kairo*, Teil 4 (*Catalogue Général des Antiquités Égyptiennes du Musée du Caire*) (Berlin, Reichsdruckerei)

**Borchardt/Ricke 1980**
Ludwig Borchardt and Herbert Ricke, *Die Wohnhäuser in Tell el-Amarna: Ausgrabungen der Deutschen Orientgesellschaft in Tell El-Amarna* V (Berlin, Mann)

**Borg 1996**
Barbara Borg, *Mumienporträts: Chronologie und kultureller Kontext* (Mainz, Verlag Philipp von Zabern)

**Borg 1997**
Barbara Borg, "The Dead As a Guest at Table? Continuity and Change in the Egyptian Cult of the Dead," in M. L. Bierbrier, ed., *Portraits and Masks: Burial Customs in Roman Egypt* (London, British Museum Press), pp. 26-32

**Bothmer 1960**
Bernard V. Bothmer, Herman De Meulenaere, and Hans Wolfgang Müller, *Egyptian Sculpture of the Late Period, 700 B.C. to A.D. 100* (exhib. cat.) (Brooklyn, The Brooklyn Museum)

**Bothmer 1966–67**
Bernard V. Bothmer, "Private Sculpture of Dynasty XVIII in Brooklyn," *BMA* 8, pp. 55-89

**Bothmer 1972**
Bernard V. Bothmer, "The Head That Grew a Face: Notes on a Fine Forgery," *Miscellanea Wilbouriana* (Brooklyn)1, pp. 25-31

**Bothmer 1988**
Bernard V. Bothmer, "Egyptian Antecedents of Roman Republican Verism," in *Quaderni de 'La ricerca scientifica'*, 116 (Rome, Consiglio Nazionale delle Ricerche), pp. 47-65

**Bothmer 1994**
Bernard V. Bothmer, "Block Statues of Dynasty XXV," in Catherine Berger, Gisèle Clerc, and Nicolas Grimal, eds., *Hommages à Jean Leclant* II (*BdÉ* 106/2), pp. 60-68

**Bothmer 1996**
Bernard V. Bothmer, "Hellenistic Elements in Egyptian Sculpture of the Ptolemaic Period," in *Alexandria and Alexandrianism* (Malibu, J. Paul Getty Museum), pp. 215-30

**Bothmer/De Meulenaere 1986**
Bernard V. Bothmer and Herman De Meulenaere, "The Brooklyn Statuette of Hor, Son of Pawen (with an Excursus on Eggheads)," in L. H. Lesko, ed., *Egyptological Studies in Honor of Richard A. Parker* (Hanover/London, University Press of New England)

**Bouriant 1887**
U. Bouriant, "Petits monuments et petits textes recueillis en Égypte," *RT* 9, pp. 81-100

**Bourriau 1981**
Janine Bourriau, *Umm el-Ga'ab: Pottery from the Nile Valley before the Arab Conquest* (exhib. cat.) (Cambridge, Cambridge University Press)

**Bourriau 1987**
Janine Bourriau, "Pottery Figure Vases of the New Kingdom," *Cahiers de la céramique égyptienne* 1 (Cairo, Institut Française d'Archéologie Orientale), pp. 81-96

**Bourriau 1988**
Janine Bourriau, *Pharaohs and Mortals: Egyptian Art in the Middle Kingdom* (exhib. cat.) (Cambridge, Cambridge University Press)

**Brewer/Friedman 1989**
Douglas J. Brewer and Renée F. Friedman, *Fish and Fishing in Ancient Egypt* (Warminster, Aris and Phillips)

**British Museum 1890**
*Facsimile of the Papyrus of Ani in the British Museum* (London, British Museum)

**British Museum 1894**
*Facsimile of the Papyrus of Ani in the British Museum*, 2nd ed. [much improved] (London, British Museum)

**British Museum 1909**
*A Guide to the Egyptian Collections in the British Museum* (London, British Museum)

**British Museum 1909s**
*A Guide to the Egyptian Galleries (Sculpture)* (London, British Museum)

**British Museum 1924**
*A Guide to the First, Second and Third Egyptian Rooms* (3rd ed., London, British Museum)

**Brock 1995**
Lyla Pinch Brock, "The Amarna 'Royal Red Fabric,'" *JSSEA* 25 (published 1998), pp. 7-14

**Brunner 1975**
Helmut Brunner, "Archaismus," *LÄ* I, cols. 386-95

**Brunner-Traut 1955**
Emma Brunner-Traut, "Die Wochenlaube," *MIO* 3, pp. 11-30

**Brunner-Traut 1956**
Emma Brunner-Traut, *Die altägyptischen Scherbenbilder (Bildostraka) der deutschen Museen und Sammlungen* (Wiesbaden, Franz Steiner)

**Brunner-Traut 1969–70**
Emma Brunner-Traut, "Das Muttermilchkrüglein: Ammen mit Stillumhang und Mondamulett," *WdO* 5, pp. 145-64

**Brunner-Traut 1979**
Emma Brunner-Traut, *Egyptian Artists' Sketches: Figured Ostraka from the Gayer-Anderson Collection in the Fitzwilliam Museum, Cambridge* (Istanbul, Nederlands Historisch-Archaeologisch Instituut te Istanbul)

**Bryan 1987**
Betsy M. Bryan, "Portrait Sculpture of Thutmose IV," *JARCE* 24, pp. 3-20.

**Bryan 1991**

Betsy M. Bryan, *The Reign of Thutmose IV* (Baltimore/London, The John Hopkins University Press)

**Bryan 1997**

Betsy M. Bryan, "Striding Glazed Steatite Figures of Amenhotep III: An Example of the Purposes of Minor Arts," in Elizabeth Goring, Nicholas Reeves, and John Ruffle, eds., *Chief of Seers: Egyptian Studies in Memory of Cyril Aldred* (London/New York, Kegan Paul International), pp. 60-82

**Budge 1886**

E. A. W. Budge, "Memoir of Samuel Birch, LL.D., D.C.L., F.S.A. Etc., President," *TSBA* 9, pp. 1-41

**Budge 1912**

E. A. Wallis Budge, *The Greenfield Papyrus in the British Museum* (London, British Museum)

**Budge 1914**

E. A. Wallis Budge, ed., *Egyptian Sculptures in the British Museum* (London, British Museum)

**Budge 1920**

E. A. W. Budge, *By Nile and Tigris* (London, J. Murray)

**Burlington 1922**

Burlington Fine Arts Club, *Catalogue of an Exhibition of Ancient Egyptian Art* (London, Burlington Fine Arts Club)

**Burridge 1993**

Alwyn L. Burridge, "Akhenaten: A New Perspective: Evidence of a Genetic Disorder in the Royal Family of 18th Dynasty Egypt," *JSSEA* 23 (published 1996), pp. 63-74

**Caminos/James 1963**

Ricardo A. Caminos and T. G. H. James, *Gebel Es-Silsilah* I. *The Shrines* (*ASE* 31)

**Capart 1927**

Jean Capart, *Documents pour servir a l'étude de l'art égyptien* I (Paris, Les Éditions du Pégase)

**Capart 1930-31**

Jean Capart, "Note sur un fragment de bas-relief au British Museum," *BIFAO* 30, pp. 73-75, pl. [7]

**Capel/Markoe 1996**

Anne K. Capel and Glenn E. Markoe, eds., *Mistress of the House Mistress of Heaven: Women in Ancient Egypt* (exhib. cat.) (Cincinnati, Cincinnati Art Museum)

**Caygill 1992**

Marjorie Caygill, *The Story of the British Museum* (2nd ed., London, British Museum Press)

*Centenaire* **1981**

*Centenaire de l'Institut Français d'Archéologie Orientale* (exhib. cat.) (Cairo, Service des Antiquités de l'Égypte)

**Cherpion 1989**

Nadine Cherpion, *Mastabas et hypogées d'ancien empire: Le problème de la datation* (Brussels, Connaissance de l'Égypte ancienne)

**Cherpion 1998**

Nadine Cherpion, "La statuaire privée d'Ancien Empire: Indices de datation," in Nicolas Grimal, ed., *Les critères de datation stylistiques à l'Ancien Empire* (*BdÉ* 120), pp. 97-142

**Cialowicz 1998**

Krzysztof M. Cialowicz, "Once More the Hierakonpolis Wall Painting," in C. J. Eyre, ed., *Proceedings of the Seventh International Congress of Egyptologists* (OLA 82), pp. 273-79

**Clère 1995**

Jaques Jean Clère, *Les chauves d'Hathor* (*OLA* 63)

**Clère/Vandier 1948**

Jacques Jean Clère and Jacques Vandier, *Textes de la première période intermédiare et de la XIème dynastie* (Brussels, Édition de la Fondation Égyptologique Reine Élisabeth)

**Collombert 1996**

P. Collombert, "Les 'fils royaux de Ramses': Une nouvelle hypothèse," *GM* 151, pp. 23-35

**Cooney 1960**

John D. Cooney, "Glass Sculpture in Ancient Egypt," *JGS* 2, pp. 10-43

**Cooney 1976**

John D. Cooney, *Catalogue of Egyptian Antiquities in the British Museum* IV *Glass* (London, British Museum Publications)

**Costa 1988**

Barbara Costa, "Preparazione per un *corpus* dei poggiatesta nell'antico Egitto: Classificazione tipologica," *EVO* 11, pp. 39-50

**Curling 1954**

J. Curling, *Edward Wortley Montagu* (London, Andrew Melrose)

**Davies, B. G. 1999**

Benedict G. Davies, *Who's Who at Deir el-Medina: A Prosopographic Study of the Royal Workmen's Community* (Leiden, Nederlands Instituut voor het Nabije Oosten)

**Davies, N. 1963**

Nina de Garis Davies, *Scenes from Some Theban Tombs* (*Private Tombs at Thebes* 4) (Oxford, Griffith Institute)

**Davies, N. de G. 1929**

Norman de Garis Davies, "The Town House in Ancient Egypt," *Metropolitan Museum Studies* I, 2 (New York, The Metropolitan Museum of Art), pp. 233-55

**Davies, N. de G. 1933**

Norman de Garis Davies, *The Tomb of Nefer-hotep at Thebes I* (New York, The Metropolitan Museum of Art)

**Davies, W. V. 1981**

W. V. Davies, *A Royal Statue Reattributed* (*Occasional Paper* 28) (London, British Museum)

**Davies, W. V. 1987**

W. V. Davies, *Catalogue of Egyptian Antiquities in the British Museum* VII *Tools and Weapons* I *Axes* (London, British Museum Publications)

**Davies, W.V. 1991**

W. V. Davies, "'Egypt and Africa' in the British Museum," in W. V. Davies, ed., *Egypt and Africa: Nubia from Prehistory to Islam* (London, British Museum Press/Egypt Exploration Society), pp. 314-20

**Dawson 1937**

Warren R. Dawson, "The First Egyptian Society," *JEA* 23, pp. 259-60

**Dawson/Uphill 1995**

Warren R. Dawson and Eric P. Uphill, *Who Was Who in Egyptology*, 3rd rev. ed. by M. L Brierbrier (London, The Egypt Exploration Society)

**De Meulenaere 1983**

H. De Meulenaere, "Une famille de haute dignitaires Saites," in H. De Meulenaere and L. Limme, eds., *Artibus Aegypti: Studia in Honorem Bernardi V. Bothmer a Collegis Amicis Discipulis Conscripta* (Brussels, Musées Royaux d'Art et d'Histoire), pp. 35-41

**Decker/Herb 1994**

Wolfgang Decker and Michael Herb, *Bildatlas zum Sport im alten Ägypten*, 2 vols. (*Handbuch der Orientalistik* 14) (Leiden/New York/Cologne, E. J. Brill)

**Delange 1987**

Elisabeth Delange, *Musée du Louvre: Catalogue des statues égyptiennes du Moyen Empire: 2060-1560 avant J.-C.* (Paris, Éditions de la Réunion des Musées Nationaux)

**Der Manuelian 1994a**

Peter Der Manuelian, "The Giza Mastaba Niche and Full Frontal Figure of Redi-nes in the Museum of Fine Arts, Boston," in David P. Silverman, ed., *For His Ka: Essays Offered in Memory of Klaus Baer* (*SAOC* 55), pp. 55-78

**Der Manuelian 1994b**

Peter Der Manuelian, *Living in the Past: Studies in Archaism of the Egyptian Twenty-sixth Dynasty* (London/New York, Kegan Paul International)

**Derchain 1975**

P. Derchain, "La perruque et le cristal," *SAK 2*, pp. 55-74

**Dewachter 1979**

Michel Dewachter, "A Propos de quelques édifices méconnus de Karnak-Nord," *CdÉ* 54, pp. 8-25

**Dodson 1997–98**

Aidan Dodson, "The So-called Tomb of Osiris at Abydos," *KMT* 8/4, pp. 37-47

**Dodson 1998**

Aidan Dodson, "A Funerary Mask in Durham and Mummy Adornment in the Late Second Intermediate Period and Early Eighteenth Dynasty," *JEA* 84, pp. 93-99, pls. 14-15

**Dondelinger 1979**

E. Dondelinger, *Papyrus of Ani* (*Codices selecti* 62) (Graz, Akademische Druck- und Verlagsanstalt)

**Dorman 1988**

Peter F. Dorman, *The Monuments of Senenmut: Problems in Historical Methodology* (London/New York, Kegan Paul International)

**Doyen 1998**

Florence Doyen, "La figuration des maisons dans les tombes thébains: Une relecture de la maison de Djehutynefer (TT104)," in C. J. Eyre, ed., *Proceedings of the Seventh International Congress of Egyptologists* (*OLA* 82), pp. 345-55

**Dreyer 1998**

Günter Dreyer et al., "Umm el-Qaab: Nachuntersuchungen im frühzeitlichen Königsfriedhof, 9./10. Vorbericht," *MDAIK* 54, pp. 77-168

**Eaton-Krauss 1977**

Marianne Eaton-Krauss, "The *Khat* Headdress to the End of the Amarna Period," *SAK* 5, pp. 21-39

**Eaton-Krauss 1985**

Marianne Eaton-Krauss, "Tutanchamun," *LÄ* VI, cols. 812-16

**Eaton-Krauss 1992**

Marianne Eaton-Krauss, "A Falsely Attributed Monument," *JEA* 78, pp. 285-87, pl. 29/3

**Eaton-Krauss 1998a**

Marianne Eaton-Krauss, "Four Notes on the Early Eighteenth Dynasty," *JEA* 84, pp. 205-10

**Eaton-Krauss 1998b**

Marianne Eaton-Krauss, "Non-royal Pre-canonical Statuary," in Nicolas Grimal, ed., *Les critères de datation stylistiques à l'Ancien Empire* (*BdÉ* 120), pp. 209-25

**Eaton-Krauss 1999**

Marianne Eaton-Krauss, "The Fate of Sennefer and Senetnay at Karnak Temple and in the Valley of the Kings," *JEA* 85, pp. 113–29, pls. 18–19

**Edel 1984**

Elmar Edel, *Die Inschriften der Grabfronten der Siut-Gräber in Mittelägypten aus der Herakleopolitenzeit* (Opladen, Westdeutscher Verlag)

**Edwards 1938**

I. E. S. Edwards, *A Handbook to the Egyptian Mummies and Coffins Exhibited in the British Museum* (London, the British Museum)

**Edwards 1939**

I. E. S. Edwards, "The Prudhoe Lions," *LAAA* 26, pp. 3-9

**Edwards 1952a**

I. E. S. Edwards, "Egyptian Antiquities from the Ackworth Collection," *BMQ* 15, pp. 55-57

**Edwards 1952b**

I. E. S. Edwards, "Two Egyptian Statuettes," *BMQ* 17/4, pp. 71-72, pl. 27

**Egyptian Art 1999**

*Egyptian Art in the Age of the Pyramids* (exhib. cat.) (New York, The Metropolitan Museum of Art, Harry N. Abrams, Inc.)

**El-Sayed 1975**

Ramadan El-Sayed, *Documents relatifs à Saïs et ses divinités* (*BdÉ* 69)

**Emery 1967**

W. B. Emery, "Preliminary Report on the Excavations at North Saqqâra, 1966-67," *JEA* 53, pp. 21-26

**Endruweit 1994**

Albrecht Endruweit, *Städtischer Wohnbau in Ägypten: Klimagerechte Lehmarchitektur in Amarna* (Berlin, Gebr. Mann Verlag)

**Engelbach 1923**

R. Engelbach, *Harageh* (London, British School of Archaeology)

**Evers 1929**

Hans Gerhard Evers, *Staat aus dem Stein*, 2 vols. (Munich, Verlag F. Bruckmann)

**Farid 1983**

Adel Farid, "Two New Kingdom Statues from Armant," *MDAIK* 39, pp. 59-69, pls. 12-14

**Faulkner 1972**

Raymond O. Faulkner, *The Book of the Dead*, 2 vols. (New York, Limited Editions Book Club)

**Faulkner 1985**

Raymond O. Faulkner, trans., *The Ancient Egyptian Book of the Dead*, Carol Andrews, ed. (rev. ed., London, British Museum Publications)

**Faulkner et al. 1994**

Raymond Faulkner, trans., *The Egyptian Book of the Dead: The Book of Going Forth by Day*, with contributions by Ogden Goelet and Carol Andrews (San Francisco, Chronicle Books)

**Fay 1988**

Biri Fay, "Amenemhat V–Vienna/Assuan," *MDAIK* 44, pp. 67-77, pls. 18-29

**Fay 1995**

Biri Fay, "Thutmoside Studies," *MDAIK* 51, pp. 11-22, pls. 2-9

**Fay 1996**

Biri Fay, *The Louvre Sphinx and Royal Sculpture from the Reign of Amenemhat II* (Mainz, Verlag Philipp von Zabern)

**Fay 1998a**

Biri Fay, "Egyptian Duck Flasks of Blue Anhydrite," *MMJ* 33, pp. 23-48

**Fay 1998b**

Biri Fay, "Royal Women As Represented in Sculpture During the Old Kingdom," in Nicolas Grimal, ed., *Les critères de datation stylistiques à l'Ancien Empire* (*BdÉ* 120), pp. 159-86

**Fazzini 1972**

Richard A. Fazzini, "Some Egyptian Reliefs in Brooklyn," *Miscellanea Wilbouriana* (Brooklyn) 1, pp. 34-70

**Fazzini 1988**

Richard A. Fazzini, *Egypt, Dynasty XXII-XXV* (*Iconography of Religions* XVI, 10) (Groningen/-Leiden, Brill)

**Fazzini 1997**

Richard A. Fazzini, "Several Objects and Some Aspects of the Art of the Third Intermediate Period," in Elizabeth Goring, Nicholas Reeves, and John Ruffle, eds., *Chief of Seers: Egyptian Studies in Memory of Cyril Aldred* (London/New York, Kegan Paul International), pp. 113-37

**Fazzini/Romano/Cody 1999**

Richard A. Fazzini, James F. Romano, and Madeleine E. Cody, *Art for Eternity: Masterworks from Ancient Egypt* (Brooklyn, Brooklyn Museum of Art/London, Scala Publishers)

**Fechheimer 1923**

Hedwig Fechheimer, *Die Plastik der Ägypter* (Berlin, Bruno Cassirer Verlag)

**Feucht 1992**

Erika Feucht, "Fishing and Fowling with the Spear and the Throw-stick Reconsidered," in U. Luft, ed., *The Intellectual Heritage of Egypt: Studies Presented to László Kákosy* (*Studia Aegyptiaca* 14) (Budapest, La Chaire d'Égyptologie), pp. 157-69

**Firth/Quibell 1935**

Cecil M. Firth and J. E. Quibell, *The Step Pyramid*, 2 vols. (Cairo, Imprimerie de l'Institut Française d'Archéologie Orientale)

**Fischer 1962**

Henry George Fischer, "The Cult and Nome of the Goddess Bat," *JARCE* 1, pp. 7-18

**Fischer 1963**

Henry G. Fischer, "Varia Aegyptiaca," *JARCE* 2, pp. 17-51

**Fischer 1965**

Henry G. Fischer, "Anatomy in Egyptian Art," *Apollo* (September 1965), pp. 13-19

**Fischer 1968**

Henry G. Fischer, *Ancient Egyptian Representations of Turtles* (New York, The Metropolitan Museum of Art)

**Fischer 1972**

Henry G. Fischer, "L'orientation des textes," in *Textes et langages de l'Égypte pharaonique* (Cairo, Institut Française d'Archéologie Orientale), pp. 21-23

**Fischer 1974**

Henry G. Fischer, "The Mark of a Second Hand on Ancient Egyptian Antiquities," *MMJ* 9, pp. 5-34= *Ancient Egypt in the Metropolitan Museum Journal* (New York, The Metropolitan Museum of Art, 1977), pp. 113-42

**Fischer 1975**

Henry G. Fischer, "An Elusive Shape Within the Fisted Hands of Egyptian Statues," *MMJ* 10, pp. 9-21= *Ancient Egypt in the Metropolitan Museum Journal* (New York, The Metropolitan Museum of Art, 1977), pp. 143-55

**Fischer 1976**

Henry G. Fischer, "More Emblematic Uses from Ancient Egypt," *MMJ* 11, pp. 125-28= *Ancient Egypt in the Metropolitan Museum Journal* (New York, The Metropolitan Museum of Art, 1977), pp. 177-80

**Fischer 1977**

Henry G. Fischer, "Some Iconographic and Literary Comparisons," in Jan Assmann, Erika Feucht, and Reinhard Grieshammer, eds., *Fragen an die altägyptische Literatur: Studien zum Gedenken an Eberhard Otto* (Wiesbaden, Dr. Ludwig Reichert), pp. 161-65

**Fischer 1986**

Henry George Fischer, "L'écriture rétrograde," in Fischer, *L'écriture et l'art de l'Égypte ancienne* (Paris, Presses Universitaires de France), pp. 105-30

**Franke 1994**

Detlev Franke, *Das Heiligtum des Heqaib auf Elephantine: Geschichte eines Provinzheiligtums im Mittleren Reich* (*SAGA* 9)

**Freed/Markowitz/D'Auria 1999**

Rita E. Freed, Yvonne J. Markowitz, and Sue H. D'Auria eds., *Pharaohs of the Sun: Akhenaten, Nefertiti, Tutankhamen* (exhib. cat.) (Boston/New York/London, Museum of Fine Arts, Boston, in Association with Bullfinch Press and Little, Brown and Company)

**Friedman 1994**

Florence D. Friedman, "Aspects of Domestic Life and Religion," in Leonard H. Lesko, ed., *Pharaoh's Workers: The Villagers of Deir el Medina* (Ithaca/London, Cornell University Press), pp. 95-117

**Friedman 1998**

Florence Dunn Friedman, ed., *Gifts of the Nile: Ancient Egyptian Faience* (London, Thames and Hudson/Providence, Rhode Island School of Design)

**Gamer-Wallert 1970**

Ingrid Gamer-Wallert, *Fische und Fischkulte im alten Ägypten* (*ÄA* 21)

**Gardiner/Peet/Cerny 1952**

Alan H. Gardiner and T. Eric Peet, *The Inscriptions of Sinai* I, 2nd ed., rev. and augmented by Jaroslav Cerny (London, Egypt Exploration Society/Geoffrey Cumberlege, Oxford University Press)

**Germer 1980**

Renate Germer, "Lattich," *LÄ* III, cols. 938-39

**Ghalioungui 1963**
Paul Ghalioungui, *Magic and Medical Science in Ancient Egypt* (London, Hodder and Stoughton)

**Glanville 1931**
S. R. K. Glanville, "An Archaic Statuette from Abydos," *JEA* 17, pp. 65-66

**Glanville 1932**
S. R. K. Glanville, "Scribes' Palettes in the British Museum," *JEA* 18, pp. 53-61

*La gloire* **1998**
*La gloire d'Alexandrie* (exhib. cat.) (Paris, Paris-Musées/AFAA)

**Godron 1990**
Gérard Godron, *Études sur l'Horus Den et quelques problèmes de l'Égypte archaïque* (*Cahiers d'Orientalisme* 19) (Geneva, P. Cramer)

**Gohary 1992**
S. Gohary, *Akhenaten's Sed-festival at Karnak* (London/New York, Kegan Paul International)

*Golden Age* **1982**
*Egypt's Golden Age: The Art of Living in the New Kingdom 1558-1085 B.C.* (exhib. cat.) (Boston, Museum of Fine Arts)

**Goldstein 1979**
Sidney M. Goldstein, "A Unique Royal Head," *JGS* 21, pp. 8-16

**Gomaà 1973**
Farouk Gomaà, *Chaemwese: Sohn Ramses' II. und Hoherpriester von Memphis* (*ÄA* 27)

**Green/Yurko 1996**
Rebecca L. Green and Frank J. Yurko, "Headrests," in Theodore Celenko, ed., *Egypt in Africa* (exhib. cat.) (Indianapolis, Indianapolis Museum of Art), pp. 46-49

**Grimal 1981**
N.-C. Grimal, *La stèle triomphale de Pi(ankh)y au Musée du Caire: JE 48862 et 47086-47089* (*MIFAO* 105)

**Grimal 1986**
Nicolas-Christophe Grimal, *Les termes de la propagande royale égyptienne: de la XIXe dynastie à la conquête d'Alexandre* (Paris, Imprimerie National/Diffusion de Boccard)

**Grimal 1998**
Nicolas Grimal, ed., *Les critères de datation stylistiques à l'Ancien Empire*, *BdÉ*, 120, pp. xx

**Gunn/Engelbach 1931**
Battiscombe Gunn and B. Engelbach, "The Statues of Harwa," *BIFAO* 30, pp. 791-815, with 7 pls.

**Habachi 1959**
Labib Habachi, "The First Two Viceroys of Kush and Their Family," *Kush* (Khartoum) 7, pp. 45-62, pls. 15-18

**Habachi 1978**
Labib Habachi, "The So-called Hyksos Monuments Reconsidered: Apropos of the Discovery of a Dyad of Sphinxes," *SAK* 6, pp. 79-92

**Hall, E. S. 1986**
Emma Swan Hall, *The Pharaoh Smites His Enemies: A Comparative Study* (*MÄS* 44)

**Hall, H. R. 1927a**
H. R. Hall, "Egyptian Antiquities," *BMQ* 2/1, pp. 41-42, pl. 22

**Hall, H. R. 1927b**
H. R. Hall, "The Head of an Old Man (no. 37883) in the British Museum," *JEA* 13, pp. 27-29, pls. 11-12

**Hall, H. R. 1928**
H. R. Hall, "Objects of Tutankhamun in the British Museum," *JEA* 14, pp. 74-77, pls. 8-11

**Hall, H. R. 1929**
H. R. Hall, "Some Wooden Figures of the Eighteenth and Nineteenth Dynasties in the British Museum. Part I," *JEA* 15, pp. 236-38, pls. 38-41

**Hall, H. R. 1930a**
H. R. Hall, "Some Wooden Figures of the Eighteenth and Nineteenth Dynasties in the British Museum. Part II," *JEA* 16, pp. 39-40, pls. 12-14

**Hall, H. R. 1930b**
H. R. Hall, "Two Middle Kingdom Statues in the British Museum," *JEA* 16, pp. 167-68, pls. 25-26

**Hall, H. R. 1931**
H. R. Hall, "Three Royal Shabtis in the British Museum," *JEA* 17, pp. 10-12, pls. 2-3

**Halls 1834**
J. J. Halls, *The Life and Correspondence of Henry Salt, Esq. Late HBM Consul-General in Egypt*, vol. II (London, R. Bentley)

**Hamilton 1809**
W. R. Hamilton, *Remarks on Several Parts of Turkey*, Part 1, *Aegyptiaca* (London)

**Hari 1964**
Robert Hari, *Horemheb et la reine Moutnedjemet: Ou la fin d'une dynastie* (Geneva, Imprimerie La Sirène)

**Haring 1992**
B. Haring, "A Systematic Bibliography on Deir el-Medîna 1980-1990," in R. J. Demarée and A. Egberts, eds., *Village Voices: Proceedings of the Symposium "Texts from Deir el-Medina and Their Interpretation,"* (Leiden, Leiden University), pp. 111-40

**Harvey 1994**
Julia Carol Harvey, *A Typological Study of Egyptian Wooden Statues of the Old Kingdom* (dissertation, University College London)

**Hastings 1997**
Elizabeth Ann Hastings, *The Sculpture from the Sacred Animal Necropolis at North Saqqara 1964-76* (*Sixty-first Excavation Memoir*) (London, Egypt Exploration Society)

**Hayes 1953**
William C. Hayes, *The Scepter of Egypt I from the Earliest Times to the End of the Middle Kingdom* (New York, The Metropolitan Museum of Art)

**Hayes 1959**
William C. Hayes, *The Scepter of Egypt II The Hyksos Period and the New Kingdom* (New York, The Metropolitan Museum of Art)

**Haynes 1996**
Joyce L. Haynes, "Redating the Bat Capital in the Museum of Fine Arts, Boston," in Peter Der Manuelian, ed., *Studies in Honor of William Kelly Simpson* I (Boston, Museum of Fine Arts)

**Helck 1958**
Wolfgang Helck, *Die Verwaltung des mittleren und neuen Reichs* (Leiden, E. J. Brill)

**Helck 1980**
Wolfgang Helck, "Kultstatue," *LÄ* III, cols. 859-63

**Helck 1981**
Wolfgang Helck, "Die Datierung des Schatzmeisters Sennefer," *GM* 43, pp. 39-41

**Hermann 1932**
Alfred Hermann, "Das Motiv der Ente mit zurückgewendetem Kopfe im ägyptischen Kunstgewerbe," *ZÄS* 68, pp. 86-105

**Hill 1997**
Marsha Hill, "A Bronze Statuette of Thutmose III," *MMJ* 32, pp. 5-18

**Hill** *in press*
Marsha Hill, "Egyptian Bronze Statuettes," in *The Oxford Encyclopedia of Ancient Egypt* (New York/Oxford, Oxford University Press)

**Hill** *forthcoming*
Marsha Hill, "The Temple Sculpture," in Dorothea Arnold et al., *Amarna Art at The Metropolitan Museum of Art*

**Hodjache 1971**
S. Hodjache, *Les antiquités égyptiennes au Musée des Beaux-Arts Pouchkine* (Moscow, "Izobrazitelnoïé Iskousstvo")

**Hoffmeier 1988**
James K. Hoffmeier, "A Relief of a 'Chief of the Gang' from Deir el-Medineh at Wheaton College, Illinois," *JEA* 74, pp. 217-20

**Hornemann 1957**
Bodil Hornemann, *Types of Ancient Egyptian Statuary II* (Copenhagen, Ejnar Munksgaard)

**Hornung 1971**
Erik Hornung, *Das Grab des Haremhab im Tal der Könige* (Bern, Francke Verlag)

**Hornung 1982**
Erik Hornung, *Conceptions of God in Ancient Egypt: The One and the Many*, trans. by John Baines (Ithaca, Cornell University Press)

**Hornung 1999**
Erik Hornung, *The Ancient Egyptian Books of the Afterlife*, trans. by David Lorton (Ithaca/London, Cornell University Press)

**Houlihan 1996**
Patrick F. Houlihan, *The Animal World of the Pharaohs* (Cairo, American University in Cairo)

**HT I 1911**
*Hieroglyphic Texts from Egyptian Stelae etc., in the British Museum* I (London, British Museum)

**HT I² 1961**
T. G. H. James, ed., *Hieroglyphic Texts from Egyptian Stelae etc.* I (2nd ed., London, British Museum)

**HT II 1912**
*Hieroglyphic Texts from Egyptian Stelae etc., in the British Museum* II (London, British Museum)

**HT IV 1913**
*Hieroglyphic Texts from Egyptian Stelae etc., in the British Museum* IV (London, British Museum)

**HT VII 1925**
H. R. Hall, *Hieroglyphic Texts from Egyptian Stelae etc., in the British Museum* VII (London, British Museum)

**HT VIII 1939**
I. E. S. Edwards, ed., *Hieroglyphic Texts from Egyptian Stelae etc.* VIII (London, British Museum)

**HT IX 1970**
T. G. H. James, ed., *Hieroglyphic Texts from Egyptian Stelae etc.* IX (London, British Museum)

**HT X 1982**
M. L. Bierbrier, ed., *Hieroglyphic Texts from Egyptian Stelae etc.* X (London, British Museum Publications)

**HT XI 1987**
M. L. Bierbrier, ed., *Hieroglyphic Texts from Egyptian Stelae etc.* XI (London, British Museum Publications)

**Ikram/Dodson 1998**
Salima Ikram and Aidan Dodson, *The Mummy in Ancient Egypt: Equipping the Dead for Eternity* (London/New York, Thames and Hudson)

**Iversen 1960**
E. Iversen, "A Canonical Master-drawing in the British Museum," *JEA* 46, pp. 71-79, pl. 16

**James 1954**
T. G. H. James, "Two Egyptian Plastic Objects of the New Kingdom," *BMQ* 19/1, pp. 16-17

**James 1976**
T. G. H. James, "Le prétendu 'sanctuaire de Karnak,' selon Budge," *BSFÉ* 75, pp. 7-30

**James 1981**
T. G. H. James, *The British Museum and Ancient Egypt* (London, British Museum Publications)

**James 1982**
T. G. H. James, ed., *Excavating in Egypt: The Egypt Exploration Society 1882-1982* (Chicago, University of Chicago Press)

**James 1986**
T. G. H. James, *Egyptian Painting and Drawing in the British Museum* (Cambridge, Mass., Harvard University Press)

**James 1988**
T. G. H. James, *Ancient Egypt—The Land and Its Legacy* (London, British Museum Publications)

**James 1991**
T. G. H. James, "Ramesses II-Appearance and Reality," in Edward Bleiberg and Rita Freed, eds., *Fragments of a Shattered Visage: The Proceedings of the International Symposium on Ramesses the Great* (Memphis, Tenn., Memphis State University), pp. 38–49

**James 1997**
T. G. H. James, *Egypt Revealed* (London)

**James** *in press*
T. G. H. James, "Vignettes in the Papyrus of Ani," in *Colour and Painting in Ancient Egypt*

**James/Davies 1983**
T.G.H. James and W. V. Davies, *Egyptian Sculpture* (London, British Museum)

**Jansen-Winkeln 1997**
Karl Jansen-Winkeln, "Eine Grabübernahme in der 30. Dynastie," *JEA* 83, pp. 169-78, pls. 20-22

**Janssen 1982**

Jac. J. Janssen, "Two Personalities," in R. J. Demarée and Jac. J. Janssen, eds., *Gleanings from Deir el-Medina* (Leiden, Nederlands Instituut voor het Nabije Oosten), pp. 109-31

**Janssen 1992**

Jac. J. Janssen, "Literacy and Letters at Deir el-Medîna," in R. J. Demarée and A. Egberts, eds., *Village Voices: Proceedings of the Symposium "Texts from Deir el-Medina and Their Interpretation"* (Leiden, Leiden University), pp. 81-94

**Janssen 1997**

Jac. J. Janssen, "Amenmesse and After: The Chronology of the Late Nineteenth Dynasty Ostraca," in Janssen, *Village Varia: Ten Studies on the History and Administration of Deir el-Medina* (Leiden, Nederlands Instituut voor het Nabije Oosten), pp. 99-109

**Janssen/Janssen 1990**

Rosalind M. and Jac. J. Janssen, *Growing Up in Ancient Egypt* (London, The Rubicon Press)

**Jantzen 1972**

Ulf Jantzen, *Ägyptische und orientalische Bronzen aus dem Heraion von Samos* (*Samos* 8) (Bonn, Rudolf Habelt Verlag)

**Johnson 1994**

W. Raymond Johnson, "Hidden Kings and Queens of the Luxor Temple Cachette," *Amarna Letters* 3 (San Francisco), pp. 128-49

**Johnson 1999**

W. Raymond Johnson, "The Setting: History, Religion, and Art," in Freed/Markowitz/D'Auria 1999, pp. 38-49

**Jones 1990**

Mark Jones, ed., *Fake? The Art of Deception* (exhib. cat.) (Berkeley/Los Angeles, University of California Press)

**Josephson 1992**

Jack A. Josephson, "Royal Sculpture of the Later XXVIth Dynasty," *MDAIK* 48, pp. 93-97

**Josephson 1997a**

Jack A. Josephson, *Egyptian Royal Sculpture of the Late Period: 400-246 B.C.* (*SDAIK* 30)

**Josephson 1997b**

Jack A. Josephson, "Egyptian Sculpture of the Late Period Revisited," *JARCE* 34, pp. 1-20

***Journey* 1979**

*Journey to the West: Death and the Afterlife in Ancient Egypt* (exhib. cat.) (Berkeley, Calif., Lowie Museum of Anthropology)

**Jucker 1975**

Ines Jucker, "Zum Bildnis Ptolemaios' III. Euergetes I.," *Antike Kunst* (Basel) 18, pp. 17–25, pls. 4-10

**Kahl/Kloth/Zimmermann 1995**

Jochem Kahl, Nicole Kloth, and Ursula Zimmermann, *Die Inschriften der 3. Dynastie: Eine Bestandsaufnahme* (*ÄA* 56)

**Kaiser 1999**

Werner Kaiser, "Zur Datierung realistischer Rundbildnisse ptolemäisch-römischer Zeit," *MDAIK* 55, pp. 237-63, pls. 35-39

**Kanawati 1976**

Naguib Kanawati, "Polygamy in the Old Kingdom?" *SAK* 4, pp. 149-60

**Kanawati 1987**

Naguib Kanawati, *The Rock Tombs of el-Hawawish: The Cemetery of Akhmim* 7 (Sydney, Macquarie University)

**Keller 1991**

C. A. Keller, "Royal Painters: Deir el-Medina in Dynasty XIX," in Edward Bleiberg and Rita Freed, eds., *Fragments of a Shattered Visage: The Proceedings of the International Symposium on Ramesses the Great* (Memphis, Tenn., Memphis State University), pp. 50-86, with pls. 1-30

**Kemp 1968**

B. J. Kemp, "The Osiris Temple at Abydos," *MDAIK* 23, pp. 138-55

**Kemp/Garfi 1993**

Barry Kemp and Salvatore Garfi, *A Survey of the Ancient City of El-'Amarna* (*Occasional Publications* 9) (London, Egypt Exploration Society)

**Kemp/Merrillees 1980**

Barry J. Kemp and Robert S. Merrillees, *Minoan Pottery in Second Millennium Egypt* (Mainz am Rhein, Verlag Philipp von Zabern)

**Kendall 1997**

Timothy Kendall, "Excavation at Gebel Barkal 1996. Report of the Museum of Fine Arts, Boston, Sudan Mission," *Kush* (Khartoum) 18

**Kessler 1987**

Dieter Kessler, "Zur Bedeutung der Szenen des täglichen Lebens in den Privatgräbern (I): Die Szenen des Schiffsbaus und der Schiffahrt," *ZÄS* 114, pp. 59-88

**Kessler 1988**

Dieter Kessler, "Der Satirisch-erotisch Papyrus Turin 55001 und das 'Verbringen des schönen Tages,'" *SAK* 15, pp. 171-96

**Killen 1980**

G. Killen, *Ancient Egyptian Furniture* I *4000-1300 B.C.* (Warminster, Aris and Phillips)

**Kozloff/Bryan 1992**

Arielle P. Kozloff and Betsy M. Bryan with Lawrence M. Berman, *Egypt's Dazzling Sun: Amenhotep III and his World* (exhib. cat.) (Cleveland, Cleveland Museum of Art/Bloomington, Indiana University Press)

**Krauss 1991**

Rolf Krauss, "Die amarnazeitliche Familienstele Berlin 14145 unter besonderer Berücksichtigung von Massordnung und Komposition," *Jahrbuch der Berliner Museen* 33, pp. 7-36

**Krauss 1994**

Rolf Krauss, "Tilgungen und Korrekturen auf Senenmut's Denkmälern Berlin 2066 und 2096," *JARCE* 31, pp. 49-53

**Kuraszkiewicz 1996**

K. Kuraszkiewicz, "Bemerkungen zur Rekonstruktion des Jubiläumsportal Osorkons II," *GM* 151, pp. 79-93

**Kyrieleis 1975**

Helmut Kyrieleis, *Bildnisse der Ptolemäer* (Berlin, Gebr. Mann)

**Laboury 1998**

Dimitri Laboury, *La statuaire de Thoutmosis III: Essai d'interprétation d'un portrait royal dans son contexte historique* (Liège)

**Lacau 1913**

Pierre Lacau, "Suppressions et modifications des signes dans les textes funéraires," *ZÄS* 51, pp. 1-64

**Leclant 1954**

Jean Leclant, *Enquêtes sur les sacerdoces et les sanctuaires égyptiens à l'époque dite "éthiopienne" (XXV dynastie)* (*BdÉ* 17)

**Leclant 1961**

Jean Leclant, *Montouemhat: Quatrième prophète d'Amon, prince de la ville* (*BdÉ* 35)

**Leclant 1993**

Jean Leclant, "Soleb et Sedeinga," *Connaissance des Arts N.S.* 36, pp. 40-47

**Leclant 1997**

Jean Leclant, "L'Égypte au Soudan, Le Nouvel Empire," in *Soudan: Royaumes sur le Nil* (exhib. cat.) (Paris, Flammarion/Institut du Monde Arabe) [English edition: Dietrich Wildung, ed., *Sudan: Ancient Kingdoms of the Nile* (Paris/New York, Flammarion)]

**Lepsius 1842**

K.R. Lepsius, *Auswahl der wichtigsten Urkunden des aeguptischen Alterthums* (Leipzig, G. Wigand)

**Lichtheim 1976**

Miriam Lichtheim, *Ancient Egyptian Literature*. Vol. 1. (Berkeley, University of California Press)

**Lichtheim 1988**

Miriam Lichtheim, *Ancient Egyptian Autobiographies Chiefly of the Middle Kingdom: A Study and an Anthology* (Freiburg, Universitätsverlag Freiburg Schweiz)

**Liepsner 1980**

Thomas F. Liepsner, "Modelle," *LÄ* IV, cols. 168-80

**Lilyquist 1979**

C. Lilyquist, *Ancient Egyptian Mirrors from the Earliest Times Through the Middle Kingdom* (Munich/Berlin, Deutscher Kunstverlag)

**Lindblad 1984**

Ingegerd Lindblad, *Royal Sculpture of the Early Eighteenth Dynasty in Egypt* (Stockholm, Medelhavsmuseet)

**Lorenzen 1980**

I. Lorenzen, "The Canonical Figure 19 and an Egyptian Drawing Board in the British Museum," *SAK* 8, pp. 181-99, pl. 5

**Luxor Museum 1979**

*The Luxor Museum of Ancient Egyptian Art: Catalogue* (Cairo, American Research Center in Egypt)

**Macadam 1949, 1955**

M. F. Laming Macadam, *The Temples of Kawa I-II* (Oxford, Oxford University Press)

**MacGregor 1994**

A. MacGregor, ed., *Sir Hans Sloane* (London)

**Malaise 1977**

Michel Malaise, "La position de la femme sur les stèles du Moyen Empire," *SAK* 5, pp. 183-98

**Málek 1984**

Jaromir Málek, "Sais," *LÄ* V, cols. 353-57

**Manniche 1997**

Lise Manniche, "Reflections on the Banquet Scene," in R. Tefnin, ed., *La peinture égyptienne ancienne: Un monde de signes à préserver* (*Monumenta Aegyptiaca* 7) (Brussels, Fondation Égyptologique Reine Élisabeth), pp. 29-36

**Martin 1989**

Geoffrey Thorndike Martin, *The Memphite Tomb of Horemheb Commander-in-Chief of Tut'ankhamun* I *The Reliefs, Inscriptions, and Commentary* (London, Egypt Exploration Society)

**Mayes 1959**

Stanley Mayes, *The Great Belzoni* (London, Putnam)

**McDowell 2000**

Andrea G. McDowell, *Village Life in Ancient Egypt: Laundry Lists and Love Songs* (London, Oxford University Press)

**Megally 1971**

M. Megally, *Le papyrus hiératique comptable E. 3226 du Louvre* (*BdÉ* 53)

**Megally 1977**

M. Megally, *Recherches sur l'économie, l'administration et la comptabilité égyptiennes à la XVIII<sup>e</sup> dynastie d'après le papyrus E. 3226 du Louvre* (*BdÉ* 71)

**Mekhitarian 1954**

Arpag Mekhitarian, *Egyptian Painting* (Geneva/Paris/New York, Éditions d'Art Albert Skira)

**Middleton 1999**

Andrew Middleton, "Polychromy of Some Fragments of Painted Relief from el-Bersheh," in W. V. Davies, ed., *Studies in Egyptian Antiquities: A Tribute to T. G. H. James* (*British Museum Occasional Paper* 123) (London, The British Museum), pp. 37-44, pls. 5-6

**Miho 1997**

*Miho Museum: South Wing* ([Japan], the Miho Museum)

**Moore 1981**

Henry Moore, *Henry Moore at the British Museum* (New York, Harry N. Abrams, Inc.)

**Müller, C. 1984**

Christa Müller, "Spiegel," *LÄ* V, cols. 1147-150

**Müller, H. W./Thiem 1999**

Hans Wolfgang Müller and Eberhard Thiem, *Gold of the Pharaohs* (Ithaca, New York, Cornell University Press)

**Müller, M. 1988**

Maya Müller, *Die Kunst Amenophis' III. und Echnatons* (Basel, Verlag für Ägyptologie)

**Müller, M. 1989**

Maya Müller, "Über die Büste 23725 in Berlin," *Jahrbuch der Berliner Museen* (N.F.) 31, pp. 7-24

**Munro 1973**

Peter Munro, *Die spätägyptischen Totenstelen* (*ÄF* 25)

**Murray 1911**

M. A. Murray, "Figure-vases in Egypt," in *Historical Studies* (*British School of Archaeology in Egypt* 19) (London, University College/Bernard Quaritch), pp. 40-46

**Myśliwiec 1988**

Karol Myśliwiec, *Royal Portraiture of the Dynasties XXI-XXX* (Mainz, Verlag Philipp von Zabern)

**Naville 1891**

Edouard Naville, *Bubastis (1887-1889)* (London, Egypt Exploration Fund)

**Naville 1892**

Edouard Naville, *The Festival-Hall of Osorkon II in the Great Temple of*

*Bubastis* (London, Egypt Exploration Fund)

**Naville 1907**

Edouard Naville, *The XIth Dynasty Temple at Deir el-Bahari* I (London, Egypt Exploration Fund)

**Neureiter 1994**

Sabine Neureiter, "Eine neue Interpretation des Archaismus," *SAK* 21, pp. 219-54

**Nicholson/Shaw 2000**

Paul T. Nicholson and Ian Shaw, eds., *Ancient Egyptian Materials and Technology* (Cambridge, Cambridge University Press)

**Niwinski 1988**

Andre Niwinski, *21st Dynasty Coffins from Thebes* (Mainz, Verlag Philipp von Zabern)

*Nofret* **1985**

*Nofret–Die Schöne: Die Frau im Alten Ägypten* (exhib. cat.) (Mainz, Verlag Philipp von Zabern)

**Nordh 1996**

K. Nordh, *Aspects of Ancient Egyptian Curses and Blessings: Conceptual Background and Transmission* (Uppsala, University/Stockholm, Almquist and Wicksell)

**Ogden 2000**

Jack Ogden, "Metals," in Paul T. Nicholson and Ian Shaw. eds., *Ancient Egyptian Materials and Technology* (Cambridge, Cambridge University Press), pp. 148-76

**Omlin 1973**

Jos. A. Omlin, *Der Papyrus 55001 und seine Satirisch-erotischen Zeichnungen und Inschriften* (*Catalogo del Museo Egizio di Torino I Monumenti e Testi III*) (Turin, Edizioni d'Arte Fratelli Pozzo)

**Parkinson 1991**

R. B. Parkinson, *Voices from Ancient Egypt: An Anthology of Middle Kingdom Writings* (Norman, University of Oklahoma Press)

**Parkinson 1997**

R. B. Parkinson, *The Tale of Sinuhe and other Ancient Egyptian Poems, 1940-1640 B.C.* (Oxford, Clarendon Press)

**Parkinson 1999**

R. B. Parkinson, *Cracking Codes: The Rosetta Stone and Decipherment* (exhib. cat.) (Berkeley, University of California Press)

**Parkinson/Quirke 1995**

Richard Parkinson and Stephen Quirke, *Papyrus* (Austin, University of Texas Press)

**Patch 1995**

Diana Craig Patch, "A 'Lower Egyptian' Costume: Its Origin, Development, and Meaning," *JARCE* 32, pp. 93-116

**Peck 1978**

William H. Peck, *Egyptian Drawings*, with photographs by John G. Ross (New York, E. P. Dutton)

**Peet/Woolley 1923**

T. Eric Peet and C. Leonard Woolley, *The City of Akhenaten I Excavations of 1921 and 1922 at El-Amarneh* (London, Egypt Exploration Society)

**Pemberton 1992**

D. Pemberton, *Ancient Egypt* (London, Viking)

**Pendlebury 1933**

John D. S. Pendlebury, "Preliminary Report of the Excavations at Tell El-Amarnah, 1932-1933," *JEA* 19, pp. 113-18

**Pendlebury 1951**

John D. S. Pendlebury, *The City of Akhenaten III The Central City and the Official Quarters, 2 vols.* (London, Egypt Exploration Society/Geoffrey Cumberlege, Oxford University Press)

**Petrie 1892**

William Matthew Flinders Petrie, *Medum* (London, David Nutt)

**Petrie 1894**

William Matthew Flinders Petrie, *Tell El Amarna* (London, Methuen and Co.)

**Petrie 1900**

William Matthew Flinders Petrie, *The Royal Tombs of the First Dynasty* I (London, Egypt Exploration Fund)

**Petrie 1903**

William Matthew Flinders Petrie, *Abydos* II (London, Egypt Exploration Fund)

**Petrie 1906**

William Matthew Flinders Petrie, *Researches in Sinai.* (London/New York, E.P. Dutton and Co.)

**Petrie 1925**

William Matthew Flinders Petrie, *Tombs of the Courtiers and Oxyrhynkos* (London, British School of Archaeology)

**Petrie 1927**

William Matthew Flinders Petrie, *Objects of Daily Use* (London, British School of Archaeology in Egypt/Bernard Quaritch); repr. 1974 (Warminster, Aris and Phillips/Encino, Joel L. Malter)

**Petrie/Brunton 1924**

William Matthew Flinders Petrie and Guy Brunton, *Sedment* I (London, British School of Archaeology in Egypt)

**Phillips 1995**

Tom Phillips, ed., *Africa: The Art of a Continent* (exhib. cat.) (London, Royal Academy of Arts/Munich-New York, Prestel)

**Pinch 1993**

Geraldine Pinch, *Votive Offerings to Hathor* (Oxford, Griffith Institute/Ashmolean Museum)

**Pinch 1994**

Geraldine Pinch, *Magic in Ancient Egypt* (London, British Museum Press)

**Pischikova 1998**

Elena Pischikova, "Reliefs from the Tomb of the Vizier Nespakashuty: Reconstruction, Iconography, and Style," *MMJ* 33, pp. 57-101

**PM I, 1 1960**

Bertha Porter and Rosalind L. B. Moss, assisted by Ethel W. Burney, *Topographical Bibliography of Ancient Egyptian Hieroglyphic Texts, Reliefs, and Paintings* I *The Theban Necropolis*, Part 1 *Private Tombs*, 2nd ed. (Oxford, Clarendon Press)

**PM I, 2 1964**

Bertha Porter and Rosalind L. B. Moss, assisted by Ethel W. Burney, *Topographical Bibliography of Ancient Egyptian Hieroglyphic Texts, Reliefs, and Paintings* I *The Theban Necropolis*, Part 2 *Royal Tombs and Smaller Cemeteries*, 2nd ed., rev. and augmented (Oxford, Clarendon Press)

**PM II 1972**

Bertha Porter and Rosalind L. B. Moss, assisted by Ethel W. Burney, *Topographical Bibliography of Ancient Egyptian Hieroglyphic Texts, Reliefs, and Paintings* II *Theban Temples*, 2nd ed., rev. and augmented (Oxford, Clarendon Press)

**PM III 1981**

Bertha Porter and Rosalind L. B. Moss, *Topographical Bibliography of Ancient Egyptian Hieroglyphic Texts, Reliefs, and Paintings* III *Memphis*, 2nd ed., rev. and augmented by J. Málek (Oxford, Griffith Institute/Ashmolean Museum)

**PM IV 1934**

Bertha Porter and Rosalind L. B. Moss, *Topographical Bibliography of Ancient Egyptian Hieroglyphic Texts, Reliefs, and Paintings* IV *Lower and Middle Egypt* (Oxford, Clarendon Press)

**PM V 1937**

Bertha Porter and Rosalind L. B. Moss, *Topographical Bibliography of Ancient Egyptian Hieroglyphic Texts, Reliefs, and Paintings* V *Upper Egypt: Sites* (Oxford, Griffith Institute/Ashmolean Museum)

**PM VI 1939**

Bertha Porter and Rosalind L. B. Moss, *Topographical Bibliography of Ancient Egyptian Hieroglyphic Texts, Reliefs, and Paintings* VI *Upper Egypt: Chief Temples (Excluding Thebes)* (Oxford, Griffith Institute/Ashmolean Museum)

**PM VII 1951**

Bertha Porter and Rosalind L. B. Moss, assisted by Ethel W. Burney, *Topographical Bibliography of Ancient Egyptian Hieroglyphic Texts, Reliefs, and Paintings* VII *Nubia, the Deserts, and Outside Egypt* (Oxford, Oxford University Press)

**Polotsky 1929**

Hans J. Polotsky, *Zu den Inschriften der 11lten Dynastie* (Leipzig, C.J. Hinrichs)

**Polz 1995**

Felicitas Polz, "Die Bildnisse Sesostris' III. und Amenemhets III. Bemerkungen zur königlichen Rundplastik der späten 12. Dynastie," *MDAIK* 51, pp. 227-54

**Pomorska 1987**

Irena Pomorska, *Les flabellifères à la droite du roi en Égypte ancienne* (Warsaw, Éditions Scientifiques de Pologne)

**Poole 1998**

Federico Poole, "Slave or Double? A Reconsideration of the Conception of the Shabti in the New Kingdom and the Third Intermediate Period," in C. J. Eyre, ed., *Proceedings of the Seventh International Congress of Egyptologists* (*OLA* 82), pp. 893-901

**Posener 1951**

G. Posener, "La date de la statue A 94 du Louvre," *RdÉ* 6, pp. 234-35

**Priese 1991**

Karl-Heinz Priese, ed., *Staatliche Museen zu Berlin: Ägyptisches Museum und Papyrussammlung* (Mainz, Verlag Philipp von Zabern)

**Prisse 1879**

E. Prisse d'Avennes, *Histoire de l'art égyptien d'après les monuments. Atlas* II; *Texte* by P. Marchandon de la Faye (Paris)

**Prisse 1991**

E. Prisse d'Avennes, *Atlas of Egyptian Art*, reprint of *Histoire de l'art égyptien d'après les monuments. Atlas* I-II, with additional material by M. Raven and others (Cairo, Zeitouna)

**Quack 1992**

J. F. Quack, *Studien zur Lehre für Merikare* (Wiesbaden, Otto Harrassowitz)

**Quaegebeur 1972**

Jan Quaegebeur, "Contribution à la prosopographie des prêtres memphites à l'époque ptolémaïque," *Ancient Society* 3 (Louvain), pp. 77-109

**Quibell 1900**

J. E. Quibell, *Hierakonpolis. Part 1* (*Egyptian Research Account*, 4th Memoir) (London, Quaritch)

**Quibell 1913**

J. E. Quibell, *Excavations at Saqqara (1911-1912): The Tomb of Hesy* (Cairo, Institut Française d'Archéologie Orientale)

**Quibell/Green 1902**

J. E. Quibell and F. W. Green, *Hierakonpolis. Part 2* (Egyptian Research Account, 5th Memoir) (London, Quaritch)

**Quirke 1992**

Stephen Quirke, *Ancient Egyptian Religion* (London, British Museum Press)

**Quirke/Spencer 1992**

Stephen Quirke and Jeffrey Spencer. *The British Museum Book of Ancient Egypt* (London, British Museum Press)

**Rauschenbach 1996**

Boris V. Rauschenbach, "Ancient Egyptian Representation of Space and Spatiality," *GM* 155, pp. 77-86

**Raven 1993**

Maarten J. Raven, "The Lady of Leiden: A Monumental Bronze Figure and its Restoration," in L. Limme and J. Strybol, *Aegyptus Museis Rediviva: Miscellanea in Honorem Hermanni De Meulenaere* (Brussels, Musées Royaux d'Art et d'Histoire), pp. 129-40

**Reeves 1989**

Nicholas Reeves, "Belzoni, the Egyptian Hall, and the Date of a Long-known Sculpture," *JEA* 75, pp. 235-37, pls. 33-34

**Reeves/Taylor 1993**

Nicholas Reeves and John H. Taylor, *Howard Carter Before Tutankhamun* (New York, Harry N. Abrams, Inc.)

**Reeves/Wilkinson 1996**

Nicholas Reeves and Richard H. Wilkinson, *The Complete Valley of the Kings* (London, Thames and Hudson)

**Riefstahl 1944**

Elizabeth Riefstahl, *Patterned Textiles in Pharaonic Egypt* (Brooklyn, The Brooklyn Museum)

**Robins 1993**

Gay Robins, *Women in Ancient Egypt* (Cambridge, Mass., Harvard University Press)

**Robins 1994**

Gay Robins, *Proportion and Style in Ancient Egyptian Art* (Austin, University of Texas Press)

**Robins 1995**
Gay Robins, *Reflections of Women in the New Kingdom* (exhib. cat.) (Atlanta, Michael C. Carlos Museum at Emory University)

**Robins 1997**
Gay Robins, *The Art of Ancient Egypt* (London, British Museum Press/Cambridge, Mass., Harvard University Press)

**Roehrig 1990**
Catherine H. Roehrig, *The Eighteenth Dynasty Titles Royal Nurse (mn`t nswt), Royal tutor (mn` nswt), and Foster Brother/Sister of the Lord of the Two Lands (sn/snt mn` n nb t3wy)* (dissertation, University of California Berkeley)

**Rogge 1990**
Eva Rogge, *Statuen des Neuen Reiches und der Drittem Zwischenzeit* (*CAA Wien, Lfg. 6*)

**Roik 1988**
Elke Roik, *Das altägyptische Wohnhaus und seine Darstellung im Flachbild*, 2 vols. (*European University Studies*, series 38, *Archaeology*, vol. 15) (Frankfurt/Bern/New York/Paris, Peter Lang)

**Romano 1976**
James F. Romano, "Observations on Early Eighteenth Dynasty Royal Sculpture," *JARCE* 13, pp. 97-111

**Romano 1998**
James F. Romano, "Notes on the Historiography and History of the Bes-image in Ancient Egypt," *BACE* 9, pp. 89-105, pls. 17-21

**Romer 1981**
John Romer, *Valley of the Kings* (New York, William Morrow and Company)

**Ruffle 1977**
John Ruffle, *The Egyptians: An Introduction to Egyptian Archaeology* (Ithaca, Cornell University Press)

**Ruffle 1998**
John Ruffle, "Lord Prudhoe and His Lions," *Sudan and Nubia: The Sudan Archaeological Research Society Bulletin* (London) 2, pp. 82-87, pls. 1-4, XLV-LII

**Russmann 1974**
Edna R. Russmann, *The Representation of the King in the XXVth Dynasty* (*Monographies Reine Élisabeth* 3) (Brussels, Fondation Égyptologique Reine Élisabeth/Brooklyn, The Brooklyn Museum)

**Russmann 1980**
Edna R. Russmann, "The Anatomy of an Artistic Convention: Representation of the Near Foot in Two Dimensions Through the New Kingdom," *BES* 2, pp. 57-81

**Russmann 1983**
Edna R. Russmann, "Harwa As Precursor of Mentuemhat," in H. De Meulenaere and L. Limme, eds., *Artibus Aegypti: Studia in Honorem Bernardi V. Bothmer a Collegis Amicis Discipulis Conscripta* (Brussels, Musées Royaux d'Art et d'Histoire), pp. 137-46

**Russmann 1989**
Edna R. Russmann, *Egyptian Sculpture: Cairo and Luxor, with photographs by David Finn* (Austin, University of Texas Press)

**Russmann 1995**
Edna R. Russmann. "A Second Style in Egyptian Art of the Old Kingdom," *MDAIK* 51, pp. 269-79

**Russmann 1997**
Edna R. Russmann, "Mentuemhat's Kushite Wife (Further Remarks on the Decoration of the Tomb of Mentuemhat, 2)," *JARCE* 34, pp. 21-39

**Russmann** *forthcoming*
Edna R. Russmann, "Mentuemhat's Necklace"

**Ryan 1988**
Donald P. Ryan, *The Archaeological Excavations of David George Hogarth at Asyut, Egypt* (dissertation, The Union for Experimenting Colleges and Universities, Cincinnati, Ohio)

**Saad 1969**
Zaki Y. Saad, *The Excavations at Helwan: Art and Civilization in the First and Second Egyptian Dynasties* (Norman, University of Oklahoma Press)

**Saleh/Sourouzian 1987**
Mohamed Saleh and Hourig Sourouzian, *Official Catalogue: The Egyptian Museum Cairo* (Mainz, Verlag Philipp von Zabern)

**Sambin 1988**
C. Sambin, *L'offrande de la soi-disant 'clepsydra,'* (*Studia Aegyptiaca* 11) (Budapest, Chaire d' Égyptologie)

**Sambin 1995**
C. Sambin, "A *Sed*-festival Gate of Ptolemy II Reemployed in the Temple of Montu at Medamoud," *BIFAO* 95, pp. 383-457

**Schäfer 1974**
Heinrich Schäfer, *Principles of Egyptian Art*, edited by Emma Brunner-Traut, translated and edited by John Baines (Oxford, Clarendon Press)

**Schenkel 1965**
Wolfgang Schenkel, *Memphis. Herakleopolis. Theben* (*ÄA* 12)

**Schlott-Schwab 1989**
A. Schlott-Schwab, *Schrift und Schreiber im alten Ägypten* (Munich, C. H. Beck)

**Schmidt 1997**
Stefan Schmidt, "Tradition und Modernität: Kunst im ptolemäischen Ägypten und in Alexandria," in Stefan Schmidt, *Katalog der ptolemäischen und kaiserzeitlichen Objekte aus Ägypten im Akademischen Kunstmuseum Bonn* (Bonn, Biering und Brinkmann), pp. 9-35

**Schneider 1977**
Hans D. Schneider, *Shabtis: An Introduction to the History of Ancient Egyptian Funerary Statuettes* (Leiden, Rijksmuseum van Oudheden te Leiden)

**Schoske/Wildung 1985**
Sylvia Schoske and Dietrich Wildung, *Ägyptische Kunst München* (Munich, Karl M. Lipp)

**Schulz 1992**
Regine Schulz, *Die Entwicklung und Bedeutung des kuboiden Statuentypus*, 2 vols. (*HÄB* 33, 34)

**Schulz/Seidel 1998**
Regine Schulz and Matthias Seidel, eds., *Egypt: The World of the Pharaohs* (n.p., Könemann)

**Scott 1989**
Gerry Dee Scott, III, *The History and Development of the Ancient Egyptian Scribe Statue* (dissertation, Yale University)

**Seidel 1996**

Matthias Seidel, *Die königlichen Statuengruppen I Die Denkmäler vom Alten Reich bis zum Ende der 18. Dynastie* (HÄB 42)

**Seipel 1992**

Wilfried Seipel, *Gott. Mensch. Pharao: Viertausend Jahre Menschenbild in der Skulptur des alten Ägypten* (exhib. cat.) (Vienna, Kunsthistorisches Museum Wien)

**Shedid/Seidel 1996**

Abdel Ghaffar Shedid and Matthias Seidel, *The Tomb of Nakht: The Art and History of an Eighteenth Dynastie Official's Tomb at Western Thebes* (Mainz, Verlag Philipp von Zabern)

**Shier 1978**

Louise A. Shier, *Terracotta Lamps from Karanis, Egypt: Excavations of the University of Michigan* (*The University of Michigan/Kelsey Museum of Archaeology Series* 3) (Ann Arbor, University of Michigan Press)

**Shubert 1989**

Steven Blake Shubert, "Realistic Currents in Portrait Sculpture of the Saite and Persian Periods in Egypt," *JSSEA* 19, pp. 27-47, pls. 9-20

**Silverman 1997**

David P. Silverman, ed., *Searching for Ancient Egypt: Art, Architecture, and Artifacts from the University of Pennsylvania Museum of Archaeology and Anthropology* (exhib. cat.) (Dallas, Dallas Museum of Art/Philadelphia, University of Pennsylvania Museum)

**Sim 1969**

Katherine Sim, *Desert Traveller: The Life of Jean Louis Burckhardt* (London, Victor Gollancz)

**Simpson 1974a**

William Kelly Simpson, *The Terrace of the Great God at Abydos: The Offering Chapels of Dynasties 12 and 13* (New Haven, Yale University/Philadelphia, University of Pennsylvania)

**Simpson 1974b**

William Kelly Simpson, "Polygamy in Egypt in the Middle Kingdom?" *JEA* 60, pp. 100-105

**Simpson 1977**

William Kelly Simpson, "Amor Dei...and the Embrace," in Jan Assmann, Erika Feucht, and Reinhard Grieshammer, eds., *Fragen an die altägyptische Literatur: Studien zum Gedenken an Eberhard Otto* (Wiesbaden, Dr. Ludwig Reichert), pp. 493-98

**Simpson 1978**

William Kelly Simpson, *The Mastabas of Kawa, Khafkhufu I and II* (*Giza Mastabas* 3) (Boston, Museum of Fine Arts, Boston)

**Simpson 1984**

William Kelly Simpson, "Sesostris I," *LÄ* V, cols. 890-99

**Simpson 1988**

William Kelly Simpson, "A Protocol of Dress: The Royal and Private Folds of the Kilt," *JEA* 74, pp. 203-204.

**Smith, R. R. R. 1988**

R. R. R. Smith, *Hellenistic Royal Portraits* (Oxford, Clarendon Press/New York, Oxford University Press)

**Smith, S. 1939**

Sidney Smith, "The Carmichael Head, from Egypt," *BMQ* 13, pp. 998-99

**Smith, W. S. 1949**

William Stevenson Smith, *A History of Egyptian Sculpture and Painting in the Old Kingdom* (2nd ed., Boston, Museum of Fine Arts/London, Oxford University Press)

**Smith, W. S. 1951**

William Stevenson Smith, "Paintings of the Egyptian Middle Kingdom at Bersheh," *American Journal of Archaeology* (Boston) 55, pp. 321-32

**Smith, W. S. 1965**

William Stevenson Smith, *Interconnections in the Ancient Near East* (New Haven/London, Yale University Press)

**Smith, W. S. 1998**

William Stevenson Smith, *The Art and Architecture of Ancient Egypt*, 3rd ed., rev., with additions by William Kelly Simpson (New Haven/London, Yale University Press)

**Solé/Valbelle 1999** *in press*

Robert Solé and Dominique Valbelle, *La Pierre de Rosette* (Paris, Seuil)

*Soleb* V

*in press*

**Sourdive 1984**

Claude Sourdive, *La main dans l'Égypte pharaonique: Recherches de morphologie structurale sur les objets égyptienne comportant une main* (Bern, Peter Lang)

**Sourouzian 1988**

Hourig Sourouzian, "Standing Royal Colossi of the Middle Kingdom Reused by Ramesses II," *MDAIK* 44, pp. 229-54

**Sourouzian 1989**

Hourig Sourouzian, *Les monuments du roi Merenptah* (*SDAIK* 22)

**Sourouzian 1991**

Hourig Sourouzian, "La statue d'Amenhotep fils de Hapou, âgé, un chef-d'oeuvre de la XVIII$^e$ dynastie," *MDAIK* 47, pp. 341-55

**Sourouzian 1994**

Hourig Sourouzian, "Inventaire iconographique des statues en manteau jubilaire de l'époque thinite jusqu'à leur disparition sous Amenhotep III," in Catherine Berger, Gisèle Clerc, and Nicolas Grimal eds., *Hommages à Jean Leclant* I (*BdÉ* 106/1), pp. 499-530

**Sourouzian 1998**

Hourig Sourouzian, "Raccords Ramessides," *MDAIK* 54, pp. 279-92, pls. 40-47

**Spencer 1980**

A. J. Spencer, *Catalogue of Egyptian Antiquities in the British Museum* V *Early Dynastic Objects* (London, British Museum)

**Spiegelberg 1918**

W. Spiegelberg, "Die Darstellung des Alters in der älteren ägyptischen Kunst vor dem Mittleren Reich," *ZÄS* 54, pp. 67-73

**Staehelin 1978**

Elisabeth Staehelin, "Zur Hathorsymbolik in der ägyptischen Kleinkunst," *ZÄS* 105, pp. 76-84

**Stanwick 1999**

Paul Edmund Stanwick, *Egyptian Royal Sculptures of the Ptolemaic Period* (dissertation, New York University)

**Stewart 1995**

Harry M. Stewart, *Egyptian Shabtis* (Aylesbury, Shire Publications)

**Stierlin 1997**

Henri Stierlin, *The Gold of the Pharaohs*, trans. by P. Snowdon (Paris, Finest S.A./Éditions Pierre Terrail)

**Stracmans 1952**

Maurice Stracmans, "Un rite d'initiation à masque d'animal dans la plus ancienne religion égyptienne," *Annuaire de l'Institut de Philologie et d'Histoire Orientales et Slaves* 12, pp. 427-40

**Strudwick 1994**

Nigel Strudwick, "Change and Continuity at Thebes: The Private Tomb after Akhenaten," in Christopher Eyre, Anthony Leahy, and Lisa Montagno Leahy, eds., *The Unbroken Reed: Studies in the Culture and Heritage of Ancient Egypt in Honour of A. F. Shore* (London, Egypt Exploration Society), pp. 321-36

**Strudwick 1999**

Nigel Strudwick, *www.newton.cam.ac.uk/egypt/tt 99*

**Strudwick/Strudwick 1997**

Helen and Nigel Strudwick, "The House of Amenmose in Theban Tomb 254," in R. Tefnin, ed., *La peinture égyptienne ancienne: Un monde de signes à préserver* (*Monumenta Aegyptiaca* 7) (Brussels, Fondation Égyptologique Reine Élisabeth), pp. 37-47

**Strudwick /Strudwick 1999**

Helen and Nigel Strudwick, *Thebes in Egypt* (Ithaca/New York, Cornell University Press)

**Taylor 1989**

John H. Taylor, *Egyptian Coffins* (Aylesbury, Shire Publications)

**Taylor 1995**

John H. Taylor, "Tracking Down the Past," *British Museum Magazine* no. 21, pp. 8-10

**Taylor 1996a**

John H. Taylor, "An Egyptian Mummy-mask in the British Museum: A New Date and Identification of the Owner," *Apollo* vol. 144, no. 413 (n.s.), pp. 33-38

**Taylor 1996b**

John H. Taylor, *British Museum Pocket Treasury: Mummies* (London, British Museum Press)

**Taylor et al. 1998**

John Taylor, Paul Craddock, and Fleur Shearman, "Egyptian Hollow-cast Bronze Statues of the Early First Millennium B.C.," *Apollo* (July, 1998), pp. 9-14

**Teeter 1997**

Emily Teeter, *The Presentation of Maat: Ritual and Legitimacy in Ancient Egypt* (*SAOC* 57)

**Tefnin 1979**

Roland Tefnin, *La statuaire d'Hatshepsout: Portrait royal et politique sous la 18e dynastie* (*Monumenta Aegyptiaca* 4) (Brussels, Fondation Égyptologique Reine Élisabeth)

**Terrace/Fischer 1970**

Edward L. B. Terrace and Henry G. Fischer, *Treasures of Egyptian Art from the Cairo Museum* (Boston, Museum of Fine Arts/New York, The Metropolitan Museum of Art)

**Thomas 1995**

Nancy Thomas, *The American Discovery of Ancient Egypt* (exhib. cat.) (Los Angeles, Los Angeles County Museum of Art)

**Tiradritti 2000**

Francesco Tiradritti, "Haroua et sa tombe (TT 37). Essai d'interprétation," *BSFÉ* 147, pp. 10-33

**Traunecker 1987**

Claude Traunecker, "Amenophis IV et Néfertiti: Le couple royal d'après les talatates du ixe pylône de Karnak," *BSFÉ* 107, pp. 17-44

**Treasures 1998**

*Treasures from the British Museum, with text by Carol Andrews* (exhib. cat.) (Hong Kong, Provisional Urban Council of Hong Kong)

**Uphill 1965**

Eric Uphill, "The Egyptian Sed-Festival Rites," *JNES* 24, pp. 365-83

**Valbelle 1981**

Dominique Valbelle, *Satis et Anoukis* (Mainz am Rhein, Verlag Philipp von Zabern)

**van Siclen 1985-86**

Charles C. van Siclen III, "The Mayor of This Amenhotep and His Father Nebiry," *BES* 7, pp. 87-91

**van Siclen 1991**

Charles C. van Siclen III, "The Shadow of the Door and the Jubilee Relief of Osorkon II from Tell Basta," *VA* 7, pp. 81-87

**van Walsem 1998**

René van Walsem, "The Interpretation of Iconographic Programmes in Old Kingdom Elite Tombs of the Memphite Area. Methodological and Theoretical (Re)considerations," in C. J. Eyre, ed., *Proceedings of the Seventh International Congress of Egyptologists* (*OLA* 82), pp. 1205-213

**Vandersleyen 1971**

Claude Vandersleyen, *Les guerres d'Amosis: Fondateur de la XVIIIe dynastie* (*Monographies Reine Élisabeth* 1) (Brussels, Fondation Égyptologique Reine Élisabeth)

**Vandersleyen 1975**

C. Vandersleyen, *Das Alte Ägypten* (*Propyläen Kunstgeschichte* 15) (Berlin, Propyläen-Verlag)

**Vandier 1958**

Jacques Vandier, *Manuel d'archéologie égyptienne* III *Les Grandes Époques: La statuaire* (Paris, Éditions A. et J. Picard)

**Vandier 1964**

Jacques Vandier, *Manuel d'archéologie égyptienne* IV *Bas-reliefs et peintures: Scènes des la vie quotidienne* (Paris, Éditions A. et J. Picard)

**Vandier 1965**

Jacques Vandier, "Iousâas et (Hathor)-Nébet-Hétépet," *RdÉ* 17, pp. 89-176

**Vandier d'Abbadie 1966**

J. Vandier d'Abbadie, "Les singes familiers dans l'ancienne Égypte (Peintures et bas-reliefs) III. Le Nouvel Empire," *RdÉ* 18, pp. 143-201

**Vassilika 1997**

Eleni Vassilika, "Egyptian Bronze Sculpture Before the Late Period," in Elizabeth Goring, Nicholas Reeves, and John Ruffle, eds., *Chief of Seers: Egyptian Studies in Memory of Cyril Aldred* (London/New York, Kegan Paul International), pp. 291-300

**Vernus 1978**

Pascal Vernus, *Athribis* (*BdÉ* 74)

**Vittmann 1998**

Günter Vittmann, "Tradition und Neuerung in der demotischen Literatur," *ZÄS* 125, pp. 62-77

**Waitkus 1987**

Wolfgang Waitkus, "Zur Deutung einiger apotropäischer Götter in den Gräbern im Tal der Königinnen und im Grabe Ramses III," *GM* 99, pp. 51-82

**Walker/Bierbrier 1997**

Susan Walker and Morris Bierbrier, *Ancient Faces: Mummy Portraits from Roman Egypt* (London, British Museum Press)

**Ward 1986**

W. Ward, *Essays on Feminine Titles of the Middle Kingdom and Related Subjects* (Beirut, American University of Beirut)

**Weigall 1924**

Arthur Weigall, *Ancient Egyptian Works of Art* (London, T. Fisher Unwin Ltd.)

**Wente 1969**

Edward Wente, "Hathor at the Jubilee," in *Studies in Honor of John A. Wilson* (*SAOC* 35), pp. 83-91

**Wiedemann 1884**

A. Wiedemann, *Ägyptische Geschichte*, 2. Teil: *Von den Tode Tutmes' III. bis auf Alexander den Grossen* (Gotha)

**Wild 1963**

Henri Wild, "Une danse d'exorcisme (?)," in *Les danses sacrées; Égypte ancienne, Israel, Islam, Asie centrale, Inde, Cambodge, Bali, Java, Chine, Japon* (*Sources Orientales* 6) (Paris, Éditions du Seuil), pp. 76-77

**Wildung 1977**

Dietrich Wildung, *Imhotep und Amenhotep: Gottwerdung im alten Ägypten* (*MÄS* 36)

**Wildung 1984**

Dietrich Wildung, *Sesostris und Amenemhet: Ägypten im Mittleren Reich* (Munich, Hirmer Verlag)

**Wildung 2000**

Dietrich Wildung, ed., *Ägypten 2000 v. Chr.: Die Geburt des Individuums* (exhib. cat.) (Munich, Hirmer Verlag)

**Wilson 1989**

Sir David M. Wilson, ed., *The Collections of the British Museum* (Cambridge/New York, Cambridge University Press)

**Yoyotte 1951**

Jean Yoyotte, "Le martelage des noms royaux éthiopiens par Psammétique II," *RdÉ* 8, pp. 215-39

**Yoyotte 1988**

Jean Yoyotte, "Des lions et des chats. Contribution à la prosopographie de l'époque libyenne," *RdÉ* 39, pp. 155-78, pls. 2-6

**Ziegler 1987**

Christiane Ziegler, "Les arts du métal à la Troisième Période Intermédiaire," in Jean Yoyotte et al., *Tanis: L'or des pharaons* (exhib. cat.) (Paris, Ministère des Affaires Étrangères/Association Française d'Action Artistique), pp. 85-101

# Index

Page numbers in italics refer to illustrations.